Published by Eaglemoss Ltd. 2018
1st Floor, Kensington Village, Avonmore Road, W14 8TS, London, UK.

 $^{\text{TM}}$ & © 2018 CBS Studios Inc. © 2018 Paramount Pictures Corp. STAR TREK and related marks and logos are trademarks of CBS Studios Inc. All Rights Reserved.

All rights reserved. No part of this publication may be reproduced, stored in a retrieval system or transmitted in any form or by any means, electronic, mechanical, photocopying, recording or otherwise, without the prior permission of the publisher.

General Editor: Ben Robinson Project Manager: Jo Bourne

Most of the contents of this book were originally published as part of STAR TREK – The Official Starships Collection and STAR TREK DISCOVERY – The Official Starships Collection by Eaglemoss Ltd. 2013-2018

To order back issues: Order online at www.shop.eaglemoss.com

Standard edition: ISBN 978-1-85875-530-4

Variant Books-A-Million edition: ISBN 978-1-85875-545-8

STARFLEET SHIPS 2294-THE FUTURE

THE ENCYCLOPEDIA OF STAR TREK SHIPS

CONTENTS

CHAPTER 1: SMALL TRANSPORTS

10: *U.S.S. RAVEN* NAR-32450

16: STARFLEET RUNABOUT

22: FEDERATION MISSION SCOUT SHIP

28: **DELTA FLYER**

34: SIZE CHART

CHAPTER 2: FIGHTERS

38: MAQUIS RAIDER

44: STARFLEET ACADEMY

FLIGHT TRAINING CRAFT

50: FEDERATION ATTACK FIGHTER

56: SIZE CHART

CHAPTER 3: MULTI-MISSION EXPLORERS

60: U.S.S. LANTREE NCC-1837

66: U.S.S. STARGAZER NCC-2893

72: *U.S.S. ENTERPRISE* NCC-1701-C

78: NEBULA CLASS

84: U.S.S. PHOENIX NCC-65420

90: U.S.S. ENTERPRISE NCC-1701-D

96: U.S.S. SARATOGA NCC-31911

102: *U.S.S. DEFIANT* NX-74205

110: CHEYENNE CLASS

114: SPRINGFIELD CLASS

118: CHALLENGER CLASS

122: FREEDOM CLASS

126: NIAGARA CLASS

132: **NEW ORLEANS CLASS**

138: U.S.S. EQUINOX NCC-72381

146: *U.S.S. PASTEUR* NCC-58925

152: **FEDERATION TUG**

156: U.S.S. VOYAGER NCC-74656

162: STEAMRUNNER CLASS

168: SABER CLASS

174: NORWAY CLASS

180: *U.S.S. PROMETHEUS* NX-59650

188: U.S.S. CENTAUR NCC-42043

194: U.S.S. CURRY NCC-42254

200: *U.S.S. ENTERPRISE* NCC-1701-E

206: SIZE CHART

CHAPTER 4: THE FUTURE

212: U.S.S. ENTERPRISE NCC-1701-J

216: U.S.S. RELATIVITY NCV-474439-G

222: FEDERATION TIMESHIP AEON

228: SIZE CHART

230: CLASS LISTING

234: **INDEX**

ACKNOWLEDGMENTS

This book would not have been possible without all of the writers, producers, production designers, concept artists and modellers (both traditional and CG) who have worked on *STAR TREK* over the years.

In particular we'd like to acknowledge the work of Foundation Imaging,
Digital Muse, Eden FX and Blue Sky /VIFX who created many of the CG models that
fill the pages of this book. Before that Greg Jein, Bill George, Adam Buckner and
Tony Meininger's Brazil Fabrications were responsible for many of the physical models,
which were recreated by our own talented CG modellers Fabio Passaro and
Ed Giddings.

We'd also like to thank Rob Bonchune and Adam 'Mojo' Lebowitz, who not only introduced us to Ed and Fabio, but also created many of the renders you will find inside this book.

We'd especially like to acknowledge the work of the modellers at the CG companies. Sadly we don't always know the names of everyone involved, but we know that particular thanks are due to Pierre Drolet, Brandon MacDougall and Koji Kuramura.

We'd also like to thank all the VFX supervisors and producers whose role in creating the final ships is often overlooked.

Mike Okuda and Doug Drexler have always been there to help us and we could not wish for better friends, and Alex Jaeger provided us with the reference that allowed us to recreate the ships he designed for STAR TREK: FIRST CONTACT.

We'd like to thank our friends at CBS Consumer Products: Risa Kessler, Marian Cordry and John Van Citters.

And of course, we'd like to thank Gene Roddenberry and Matt Jefferies for imagining a very different starship all those years ago and establishing a design aesthetic that survives to this day.

FOREWORD

This is the second book in a new series that will build into a detailed reference work covering all the ships that have appeared in STAR TREK over the years. This book and its sister volume cover Starfleet ships: the first volume covers the ships from STAR TREK: ENTERPRISE, STAR TREK: DISCOVERY and the original series; this volume covers the STAR TREK: NEXT GENERATION era and the handful ships of that we know about from the early years of the 24th century. Other volumes will cover geographical areas, such as the Delta Quadrant, or races such as the Klingons. The plan is that eventually we will cover every part of the STAR TREK universe.

The ships that are in this book are all canon ships that have appeared in one of the STAR TREKTV series or movies, however briefly. All are from the Prime timeline and don't take account of the vessels that can be found in the movies made since 2009, or in some of the parallel realities that we have seen on the show. This is not the place for ships that have only appeared in books, games, calendars, or the animated STAR TREK series. For now at least there won't be any ships that have only been referred to in dialogue or seen as graphics on a computer display.

What this book does contain is detailed in-universe profiles of every ship along with plan views. The computer generated artwork will give you the chance to look at things in unprecedented detail, something that is particularly relevant for ships that only made the briefest of appearances on screen.

This book starts just after Kirk's death aboard the Enterprise-B and ends in the distant future, when the Federation will be operating timeships rather than starships and the Enterprise-J will dwarf its predecessors. It includes all the Starfleet ships from STAR TREK: THE NEXT GENERATION, STAR TREK: DEEP SPACE NINE and STAR TREK: VOYAGER. We've said before that it's something we think people have been waiting for, and we hope that it's everything they want. It has been a great privilege to work with the talented artists who created the ships, and to bring all these ships together in one place.

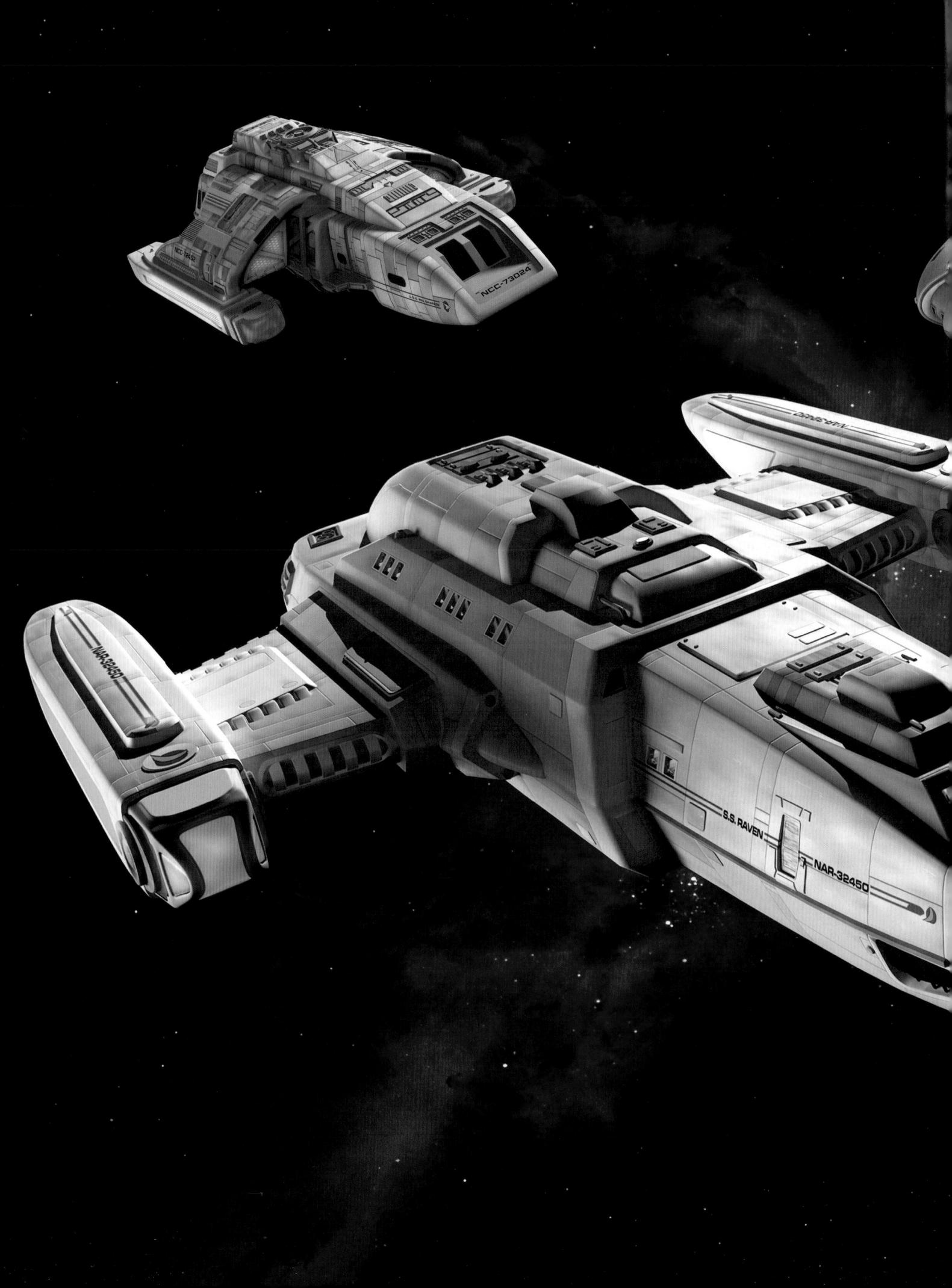

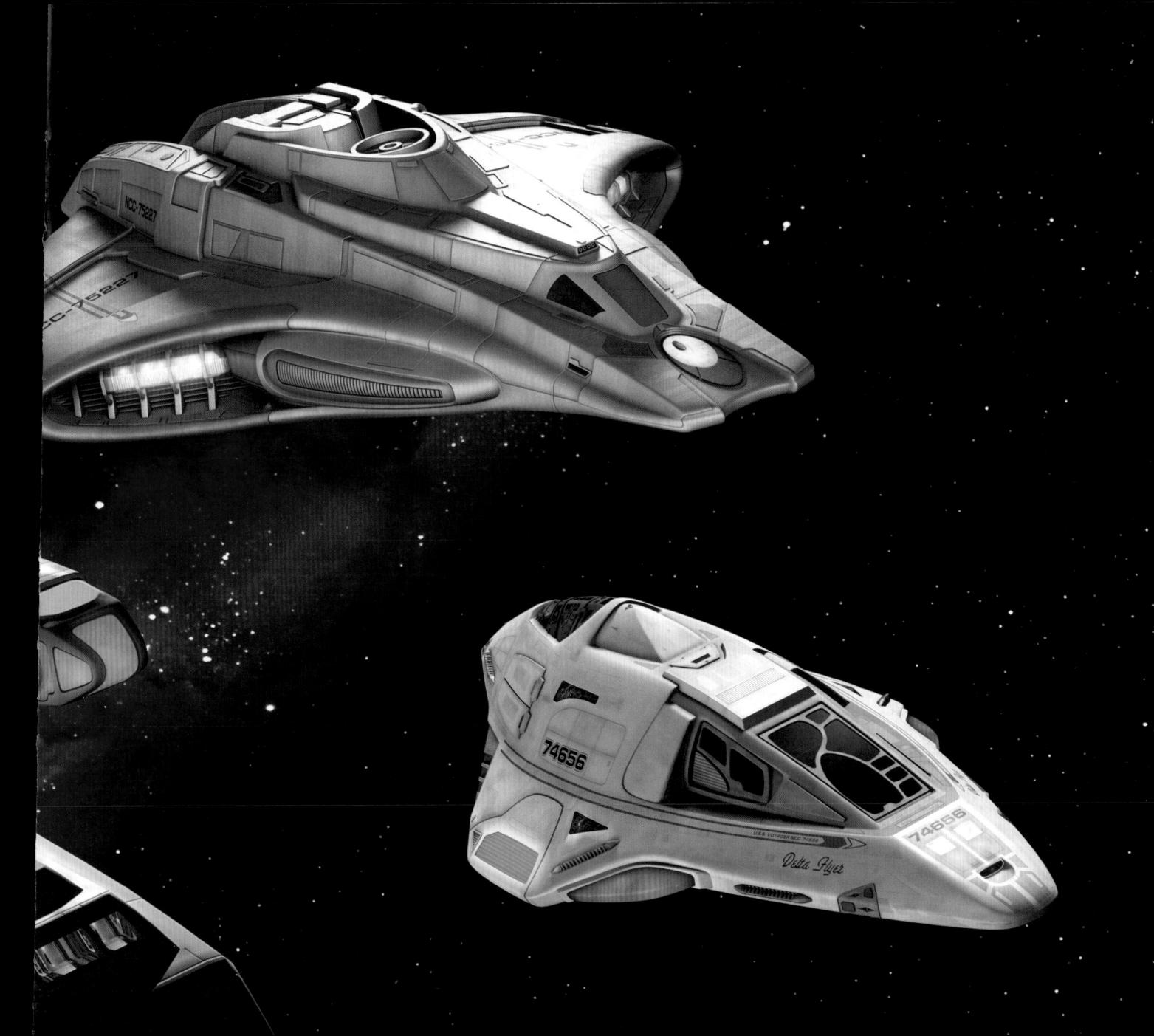

CHAPTER 1 SMALL TRANSPORTS

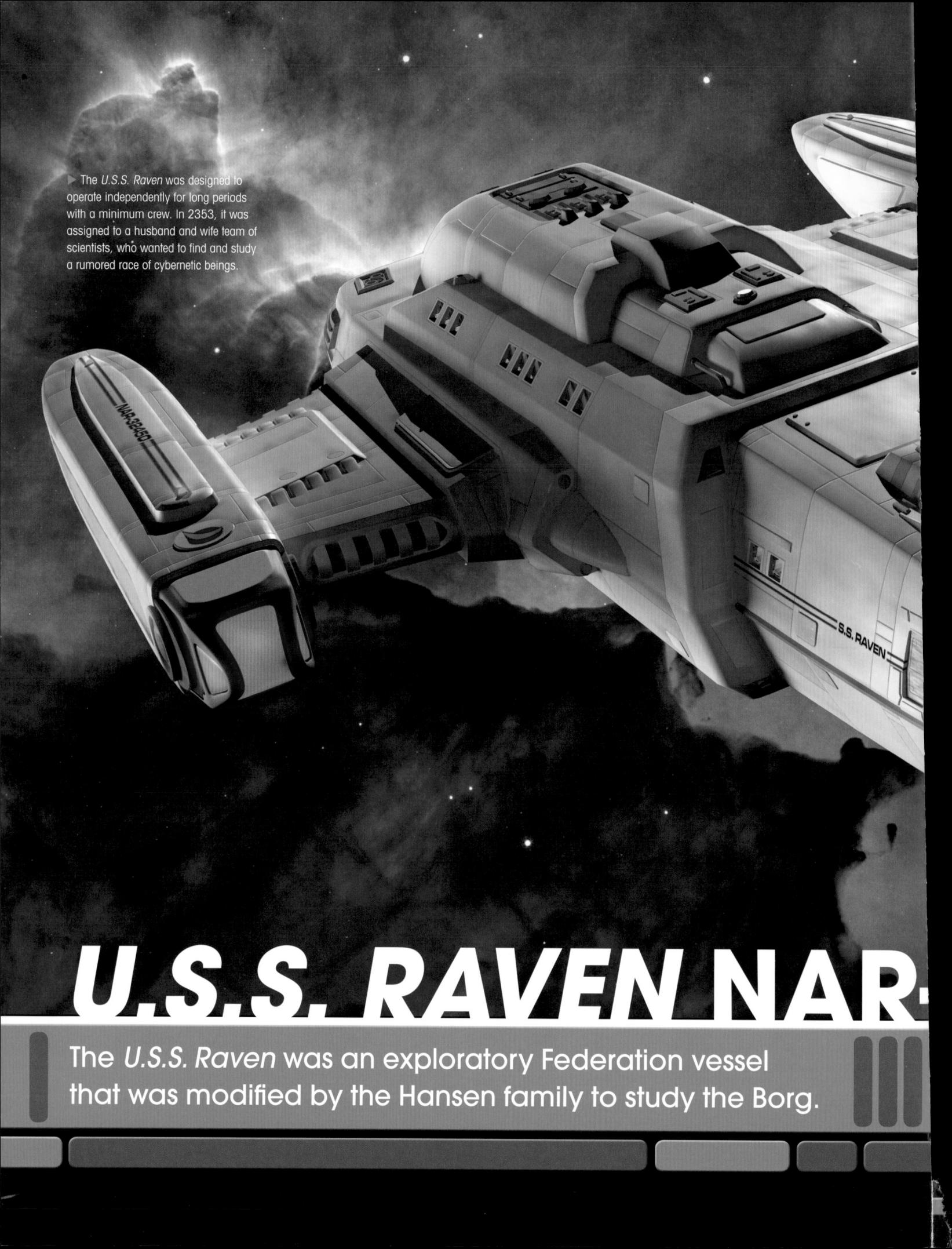

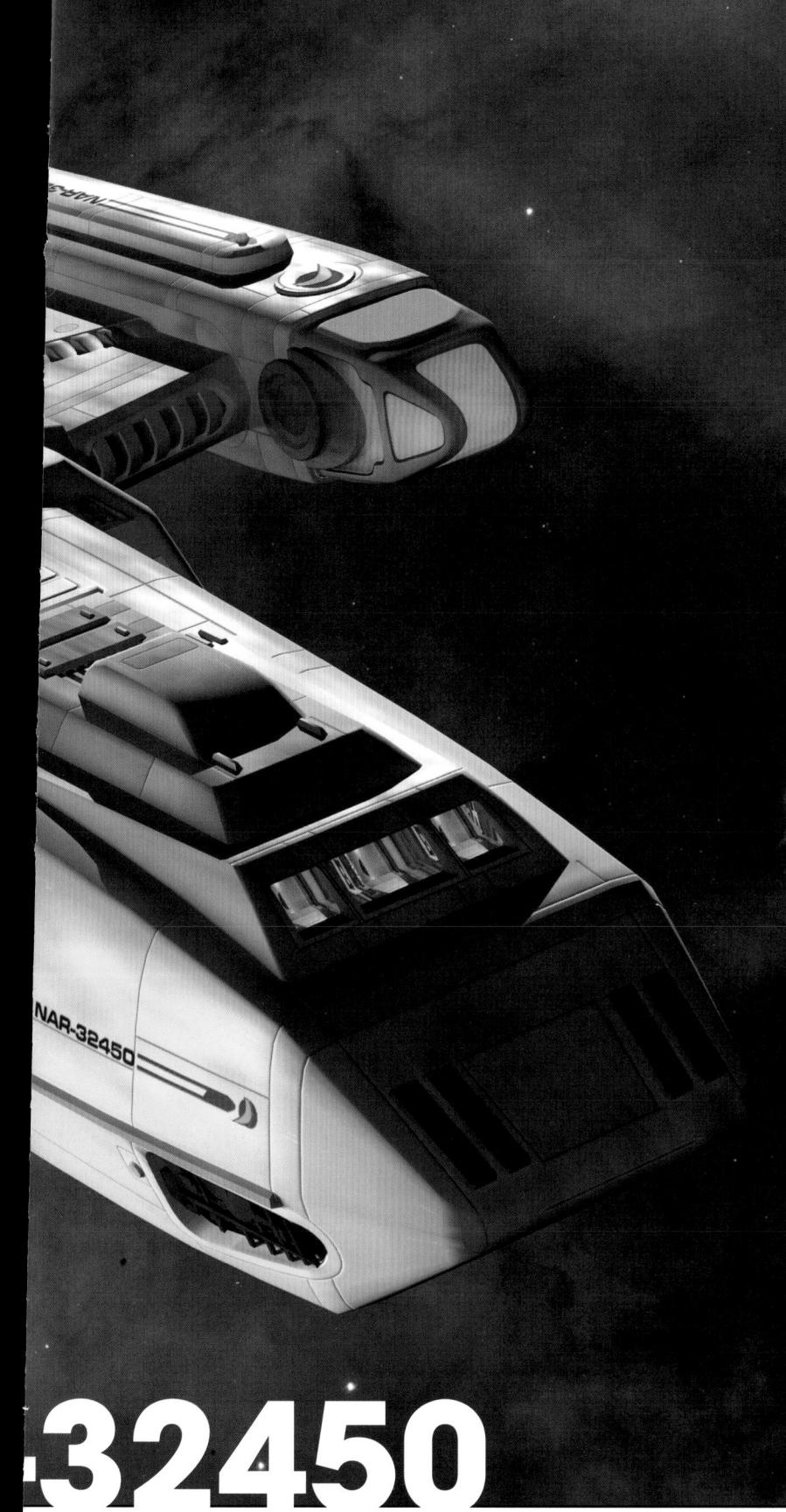

he *U.S.S. Raven* NAR-32450 was a long-range Federation vessel, about 90 meters in length and similar in style to a *Danube*-class Runabout. It was used mainly for exploratory and scientific purposes. In 2353, the *Raven* was assigned to Federation exobiologists Magnus and Erin Hansen. They successfully petitioned the Federation research council to grant them the resources to pursue and study a rumored cybernetic species that was eventually revealed to be the Borg.

The Raven had four decks and was capable of functioning independently for extended periods of time. Of course, the dilithium supply for the warp engines was limited, but the Hansens could gather new supplies from planets without having to return to a starbase. This was important since their mission ended up taking them far from Federation space.

MOBILE HOME

The extended nature of the *Raven*'s mission meant that it served as the Hansens' only home for nearly three years. The family, which also included their daughter Annika who was just four years old when they left, principally occupied just a single deck. The other decks contained cargo bays and equipment necessary for their protracted journey.

The basic design of the *Raven* comprised three components: the rectangular main section, the slimmer forward module that included the bridge,

▲ The Hansens were maverick exobiologists, and many considered them unorthodox. They took the brave, some might say foolhardy, decision to try to track the Borg. They had little time for Starfleet or the Federation, preferring instead to follow their own agenda.

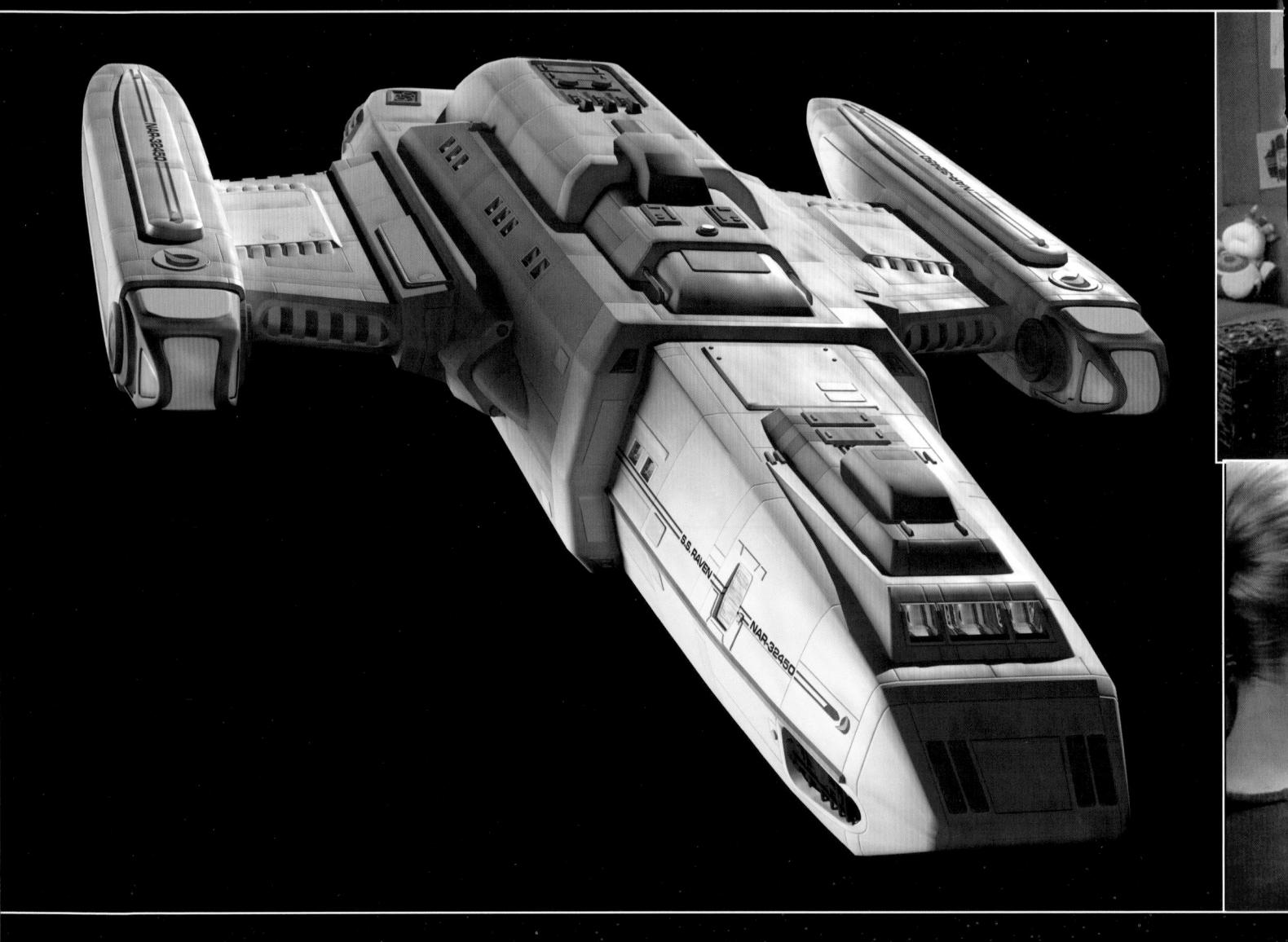

At approximately 90 meters in length and with four decks, the Raven was somewhere between a Runabout and a small fully-fledged starship. With its suite of sophisticated sensors, it was perfect for extended scientific missions, but it was never intended to operate independently for nearly three years, especially not on the other side of the Galaxy in the Delta Quadrant.

and the warp nacelles. Like a Runabout, the *Raven* also had landing gear, warp engines and sophisticated sensors.

In 2352, the Hansens set off in the *Raven* to see if the Borg were more than the "rumor and sensor echoes" some people claimed. Many of their colleagues, who had held them in high regard, believed that they were wasting their time.

The last recorded sighting of the *Raven* was at the remote Drexler outpost in the Omega sector. Thereafter, they deviated from their flight plan, crossed the Neutral Zone separating Federation and Romulan space, and even disobeyed a direct order to return. In going on, Magnus and Erin realized they were burning their bridges with the Federation and could not rely on their help.

The Hansens tracked potential Borg readings for eight months without success, before finally stumbling upon a Borg cube. While monitoring the massive ship, the *Raven* became caught in a transwarp conduit, and emerged on the other side of the Galaxy in the Delta Quadrant. Instead of panicking, the Hansens decided to begin their study of the Borg in earnest.

PIONEERING TECHNOLOGY

During this time, they invented a number of technologies to help them. Principal among them was multi-adaptive shielding, which kept the *Raven* invisible to Borg sensors. They also invented a device called a biodampener, which created a field around the body that simulated the physiometric conditions within a Borg vessel. Each biodampener was tailored to its user's physiology, allowing them to transport to a Borg cube and observe drones in action without being detected.

Using the device, Magnus was able to transmit visual and audio data from the cube back to Erin

- The Raven became home for the Hansens for nearly three years. They did their best to turn the main living area into a more domestic setting by putting Annika's paintings on the wall.
- The Hansens equipped the *Raven* with multi-adaptive shielding that hid their ship from Borg sensors. It allowed them to study a Borg cube and its drones up close without being detected.

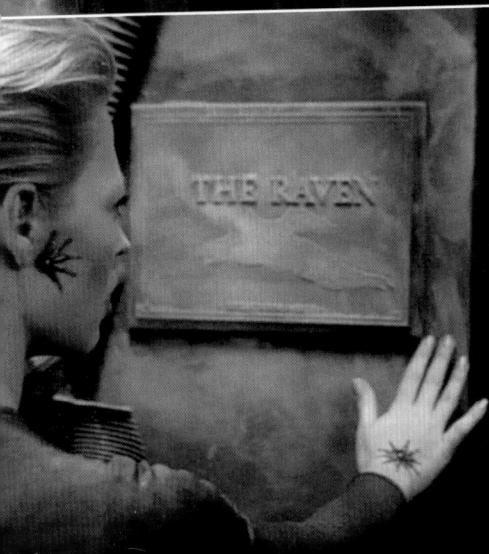

After the multi-adaptive shielding briefly failed, the *Raven* was detected by the Borg. Several Borg drones beamed over to the ship and assimilated the Hansens. The *Raven* ended its days in a crumpled heap after it crash-landed on a desolate moon in B'omar space. The craft continued to emit a Borg resonance frequency which eventually drew Seven to its location.

▲ Seven could not remember being assimilated until she reached the crash site of the Raven. When she uncovered the ship's plaque, her memories come flooding back.

on the *Raven*. The couple learned a great deal about the Borg in a short period, such as the fact that drones from different sub-units interacted, and that the Collective must logically have a queen. They even developed pet names for the drones, such as Junior, Bill and Needle Fingers.

The Hansens even beamed drones back to their ship during regeneration cycles to make more

detailed physiological examinations. Magnus scanned the body while Erin worked on the cranium, and they tagged the drones they wished to keep observing with a subdermal probe.

In 2356, during their third year of study, the Hansens' luck finally ran out. The *Raven*'s multi-adaptive shielding failed for just 13.2 seconds during an ion storm. It was enough time for the Borg to detect them. The Hansens tried masking their warp trail, but it was too late, and they were caught and assimilated.

Nearly two decades later, the wreck of the *Raven* was discovered by *U.S.S. Voyager* NCC-74656 crew members Lt. Commander Tuvok and Seven of Nine – formerly Annika Hansen. The ship had been partially assimilated by the Borg and was still emitting a Borg homing signal. Shortly after this, what was left of the *Raven* was destroyed by a highly territorial race known as the B'omar.

The Raven was partly assimilated by the Borg, and crashed into an M-class moon in B'omar territory. The wreck remained there until 2374 when it was destroyed by the B'omar. They reacted violently after Seven of Nine made an unauthorized journey into their space looking for the ship.

COMPREHENSIVE STUDY

Magnus and Erin Hansen were the first humans to study the Borg. Like all good scientists, they kept extensive field notes, detailed journals and biokinetic analyses. They made more than 9,000 log entries, comprising 10 million terraquads of data. As time went on, the Hansens became bolder in their investigation of the Borg, despite occasional close calls. On one occasion, Magnus had to spend the night in a maturation chamber aboard a Borg cube when the *Raven*'s transporter went offline.

Even after this scare, the Hansens did not abandon their study, and in fact went further by transporting regenerating drones back to the *Raven*. They were so engrossed in their study that they did not appear to recognize the danger they were in, or just how vulnerable they were in the Delta Quadrant.

▲ The Raven acted as a mobile research facility for Magnus and Erin —lansen as they obsessively compiled copious notes on the Borg.

Warp nacelle + Port formation light -OSPSE-RAN Shuttlepod storage + Impulse exhaust vents + Starboard formation light + Crew windows

DATA FEED

In 2375, the crew of the *U.S.S. Voyager* incorporated the same multi-adaptive shielding that had been used on the *Raven* into the systems of the *Delta Flyer.* This shuttlecraft was then used to facilitate a rescue mission of Seven of Nine, who was being held captive by the Borg Queen in the Unicomplex.

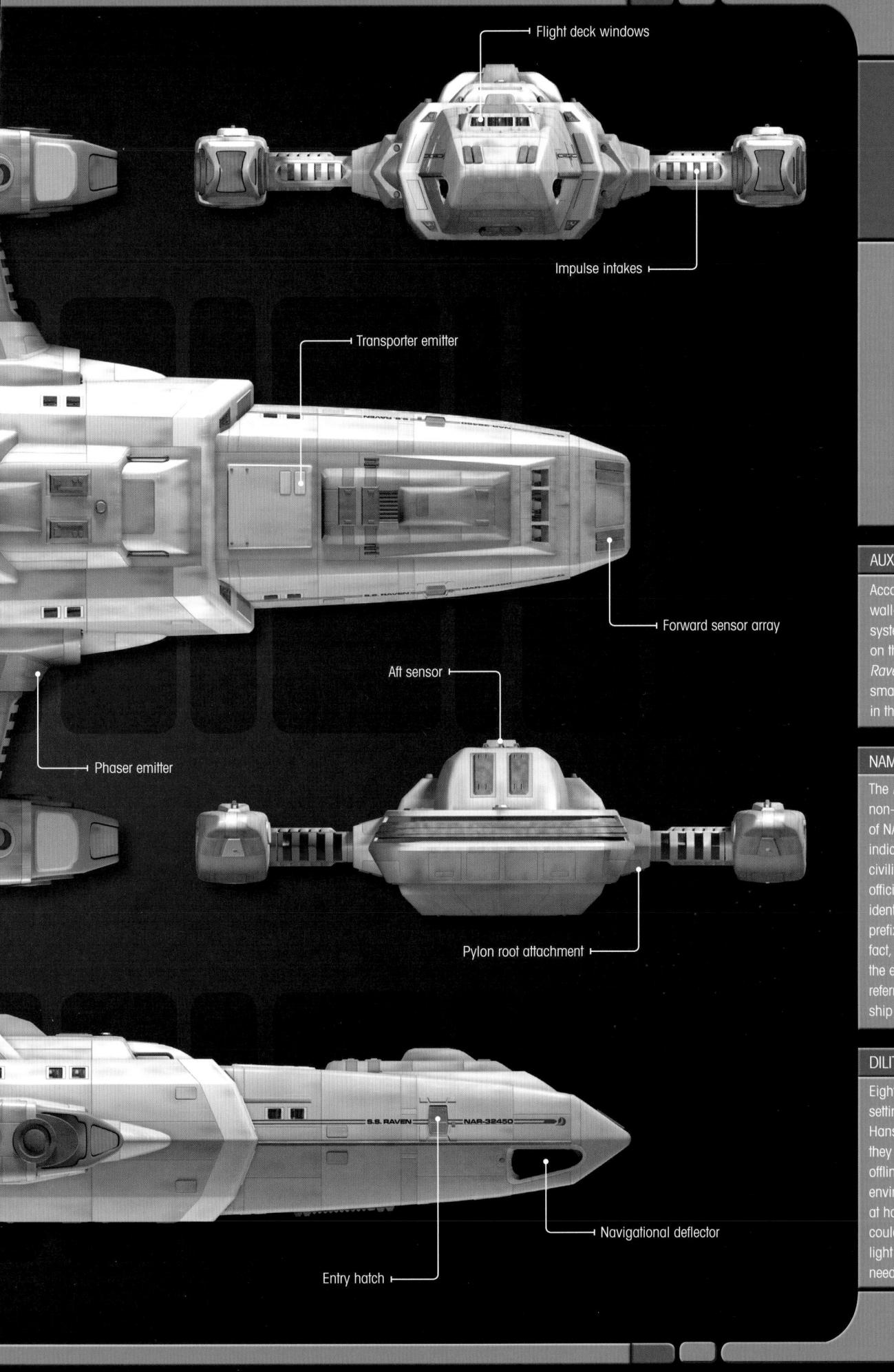

AUXILIARY CRAFT

According to the large, wall-mounted master systems display seen on the bridge of the *Raven*, the ship had a small shuttlepod stored in the aff section.

NAME CONFUSION

The Raven had a non-Starfleet registry of NAR-32450, indicating it was a civilian ship, although official Starfleet records identified it with the prefix of U.S.S. In fact, a display seen in the episode 'The Giff' referred to the Hansens' ship as the 'Jefferies.'

DILITHIUM SUPPLY

Eight months after setting out, Magnus Hansen stated that if they took the replicators offline and ran environmental systems at half power, the *Raven* could travel another 20 light years before they needed to refuel.

unabout was the generic name for the Danube class, small warp-capable Starfleet starships that were in operation in the latter half of the 24th century. At 23.1 meters in length, they were larger than standard shuttlecraft, but smaller than fully-fledged starships. This meant they were capable of more protracted missions and carrying more cargo than shuttles, but without wasting the resources and manpower that a full-sized starship would require.

Runabouts were designed to carry out a number of roles such as scientific expeditions, personnel and cargo transportation, covert tactical missions, and even act as mobile defense platforms.

ADAPTABLE VESSEL

The prototype runabout was called the *U.S.S.*Danube NX-72003, and in keeping with Starfleet tradition, this type of vessel became known as the Danube class. Typically, runabouts were operated by a crew of two to four from the cockpit, while a habitat module with rudimentary sleeping quarters was located at the rear of the vessel. The mid-section contained a detachable module that could be changed for different mission profiles. This meant it could carry science, medical, defense or cargo payloads, depending on what assignment it was undertaking.

The runabout's most ground-breaking feature, as well as its most useful, was its compact warp reactor core. This ingenious piece of engineering was located in the middle of the spine that ran along the top of the vessel, and worked in conjunction with the nacelles. Despite being much smaller than the warp cores found on full-sized starships, it was still capable of propelling the ship to speeds as high as warp 5.

STARFLEET RUNABOUT

Resembling an enlarged shuttlecraft, runabouts were multi-purpose ships often assigned to space stations.

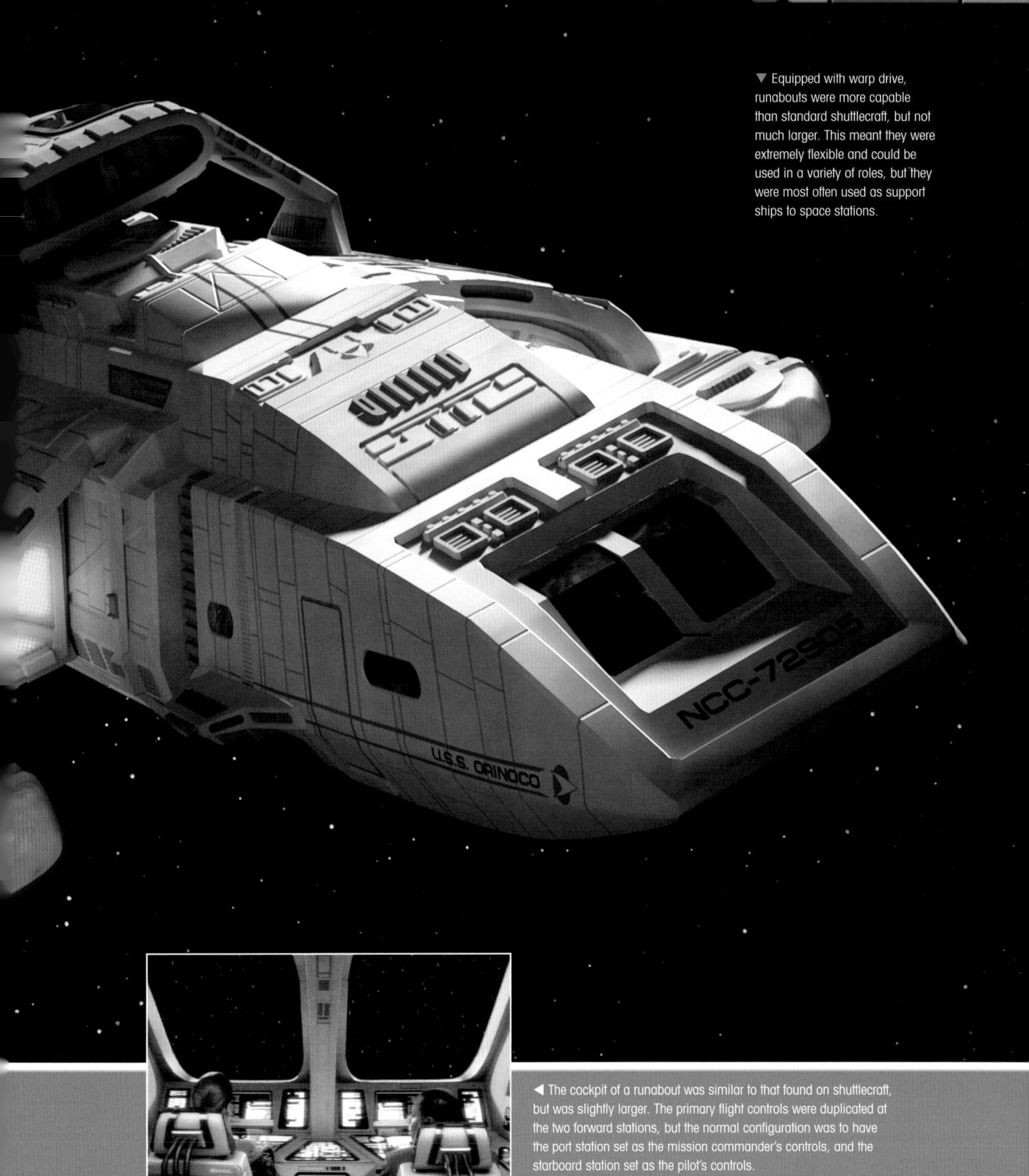

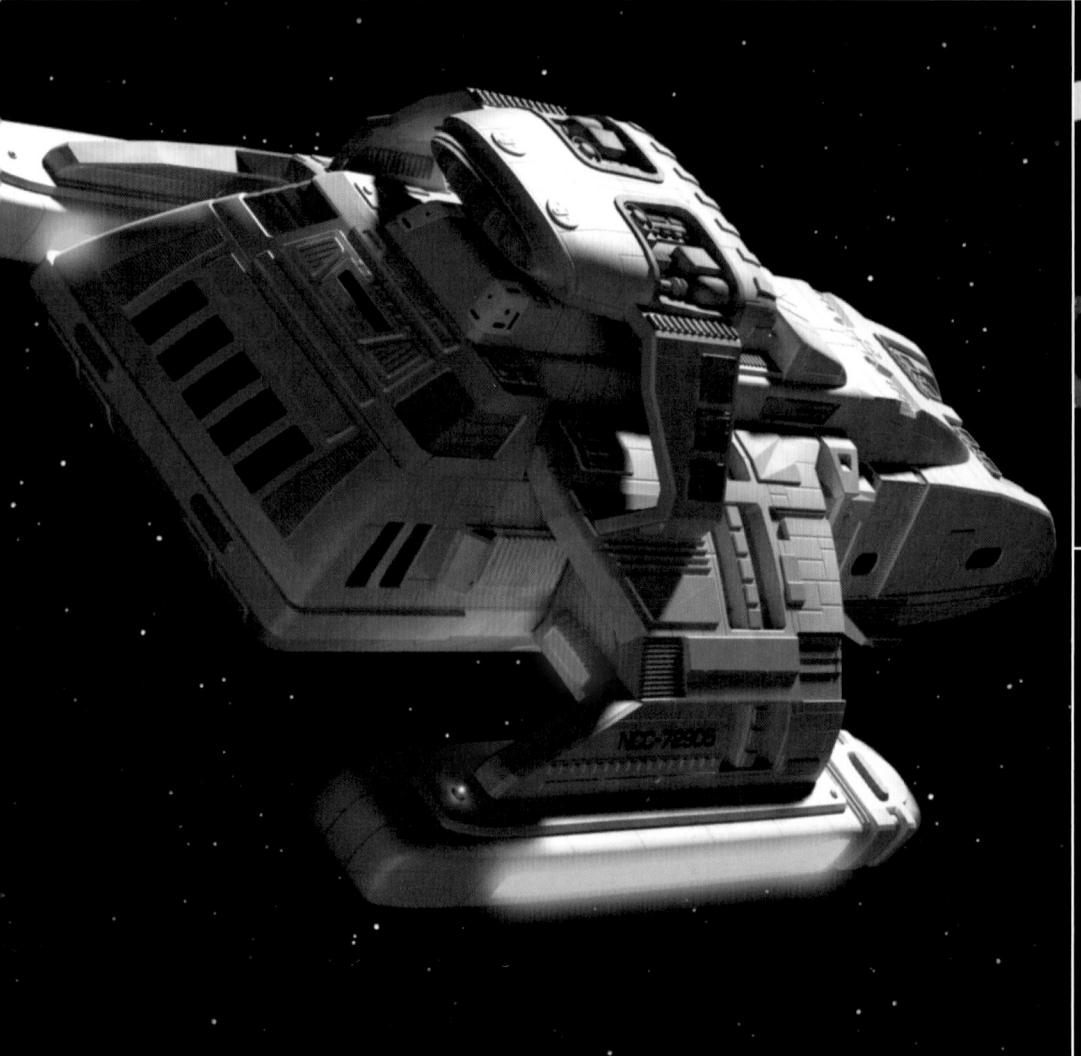

➤ Runabouts featured a two-person transporter that in their original design was located at the rear of the cockpit. Personnel could beam down to a planetary surface, leaving the runabout unmanned in standard orbit.

▲ The runabout was designed to allow a small crew to undertake longer interstellar missions than was possible with a standard shuttle. This was mainly due to its small, flattened warp core that in conjunction with its warp nacelles was capable of powering it to speeds as high as warp 5. It was also fitted with thrusters that allowed it to make planetary landings.

This ability to travel at relatively high warp speeds meant that runabouts were able to travel between planetary systems to carry out missions, unlike impulse-only shuttlecraft. They could also land and take off from planetary surfaces, as they were fitted with vertical lift vents under the winglets.

For defense, the runabout was armed with six phaser strips and a microtorpedo launcher that was located at the front of the vessel, under the cockpit. These armaments, together with its defensive shields, meant the runabout was able to engage much larger vessels in combat.

Additional sensors could be added to runabouts in the form of a roll bar module that was fitted over the top of the ships. These removable bars could be added for specific types of missions and extended the ship's sensor capabilities.

Other features of the runabout included a twoperson transporter and a food replicator that were initially located immediately behind the cockpit stations. Later these facilities were moved further back in the ship and a secondary tactical console was positioned in the cockpit. The exterior of the vessel featured an aft tractor beam emitter that was powerful enough to tow a ship at least as large as a Cardassian *Galor*-class warship.

SPACE STATION SUPPORT

Deep Space 9 initially took delivery of three runabouts in 2369, and they were housed in dedicated launch bays situated around the habitat ring. These vessels were called the U.S.S. Ganges, the U.S.S. Yangtzee Kiang, and the U.S.S. Rio Grande – all additional runabouts that were supplied to Deep Space 9 over the following years were also named after Earth rivers.

These runabouts provided the primary method of transport for people living on *Deep Space 9*, in

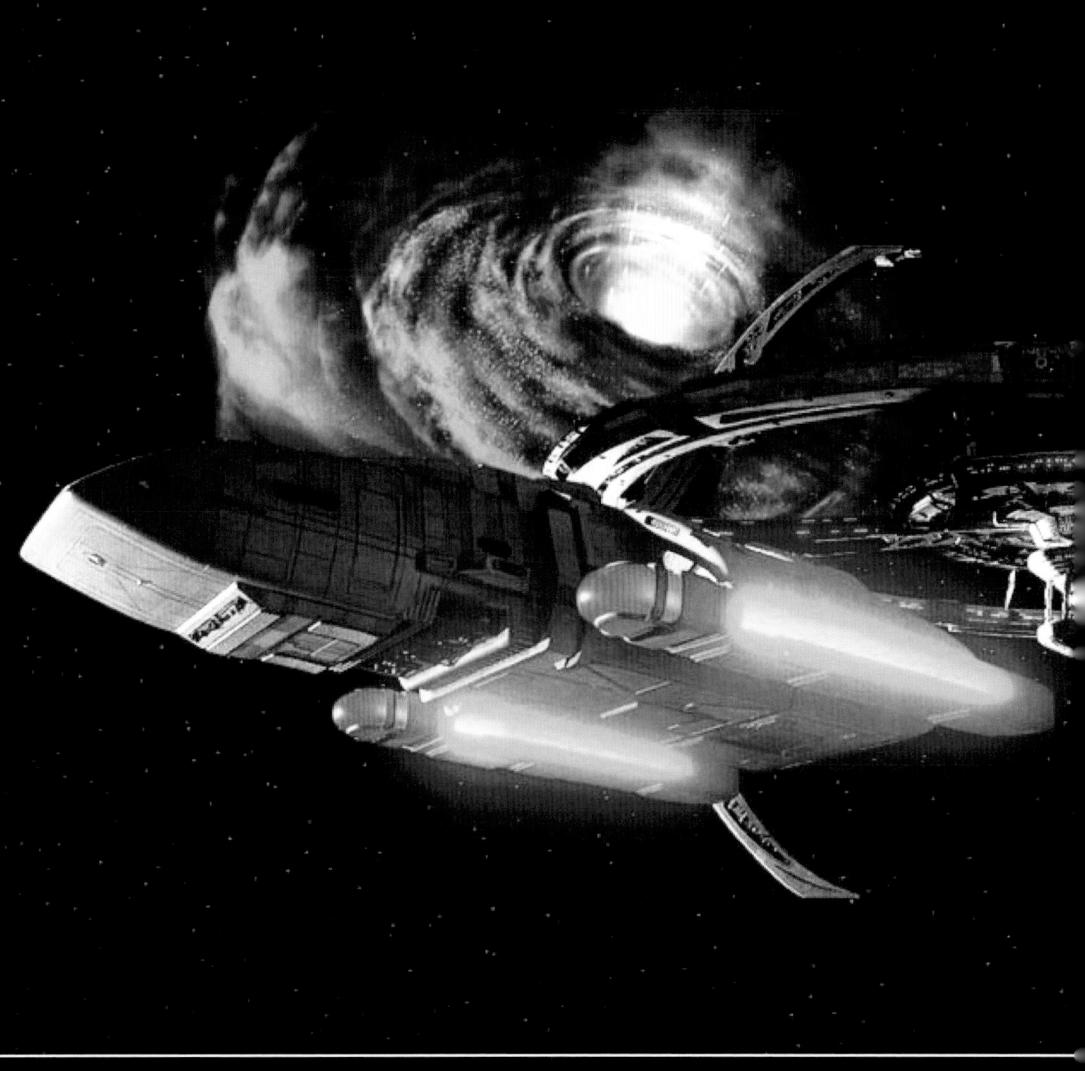

addition to providing defensive support. During their first few of years of service the runabouts proved particularly useful in helping to evacuate the inhabitants during violent plasma storms in 2370 and when the Circle, a separatist group, tried to seize control of the station. They were used extensively in the Badlands to track down members of the renegade Maquis organization. They were also used for exploration and were instrumental in discovering many new worlds in the Gamma Quadrant, as well as the Bajoran wormhole itself.

As the threat from the Dominion rose, it became clear that the runabouts did not provide sufficient protective cover for *Deep Space 9*, and in 2371 the *U.S.S. Defiant* NX-74205 was brought in to bolster the space station's defenses. Nevertheless, runabouts were still widely used in a number of capacities, such as in 2373 when a runabout took

part in a covert mission to rescue Enabran Tain and Dr. Bashir from a Dominion prison, Internment Camp 371. Runabouts continued to play an important role throughout the Dominion War and were used in exercises with the Ninth Fleet in 2374. At the climax of the war, Colonel Kira Nerys used a runabout to travel to Cardassia Prime in order to help with Damar's resistance movement.

▲ Three runabouts were initially assigned to Deep Space 9 in 2369. They provided a means of transportation off the station and remained its primary defensive support until the arrival of the U.S.S. Defiant.

DATA FEED

Runabouts could be equipped with a 'roll bar' mounted pod over the spine of the vessel. These pods were easily removable and normally contained sensor equipment.

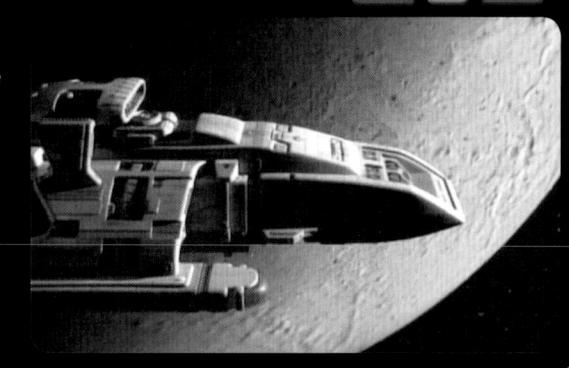

CREATURE COMFORTS

The habitat module at the rear of the runabout provided everything the crew needed to keep them comfortable on extended missions. The main feature of the compartment was a large meeting/dining table where the crew could discuss their mission objectives, relax and eat. A replicator provided food and drinks, but if it failed there were backup supplies in the form of emergency rations. Small bunk beds were located on each side of the exit leading to the middle section so that the crew could sleep. There was also a computer console with a chair on one side of the compartment where the crew could access a comprehensive library for research purposes, record the activities of their mission, and access some of the ship's primary systems. This section housed medical kits, four emergency EVA pressure suits, and a selection of hand phasers.

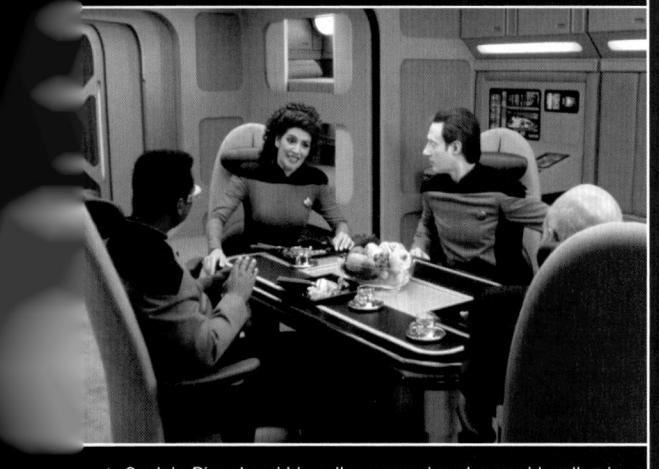

▲ Captain Picard and his colleagues enjoyed a meal together in the habitat module of a runabout on their way back to the *U.S.S. Enterprise* NCC-1701-D after attending a psychology conference.

DATA FEED

Defensive payloads, special laboratories, emergency habitats or additional living quarters were just some of the different modules that could be fitted to the swappable central section of a runabout between the cockpit and the habitat area.

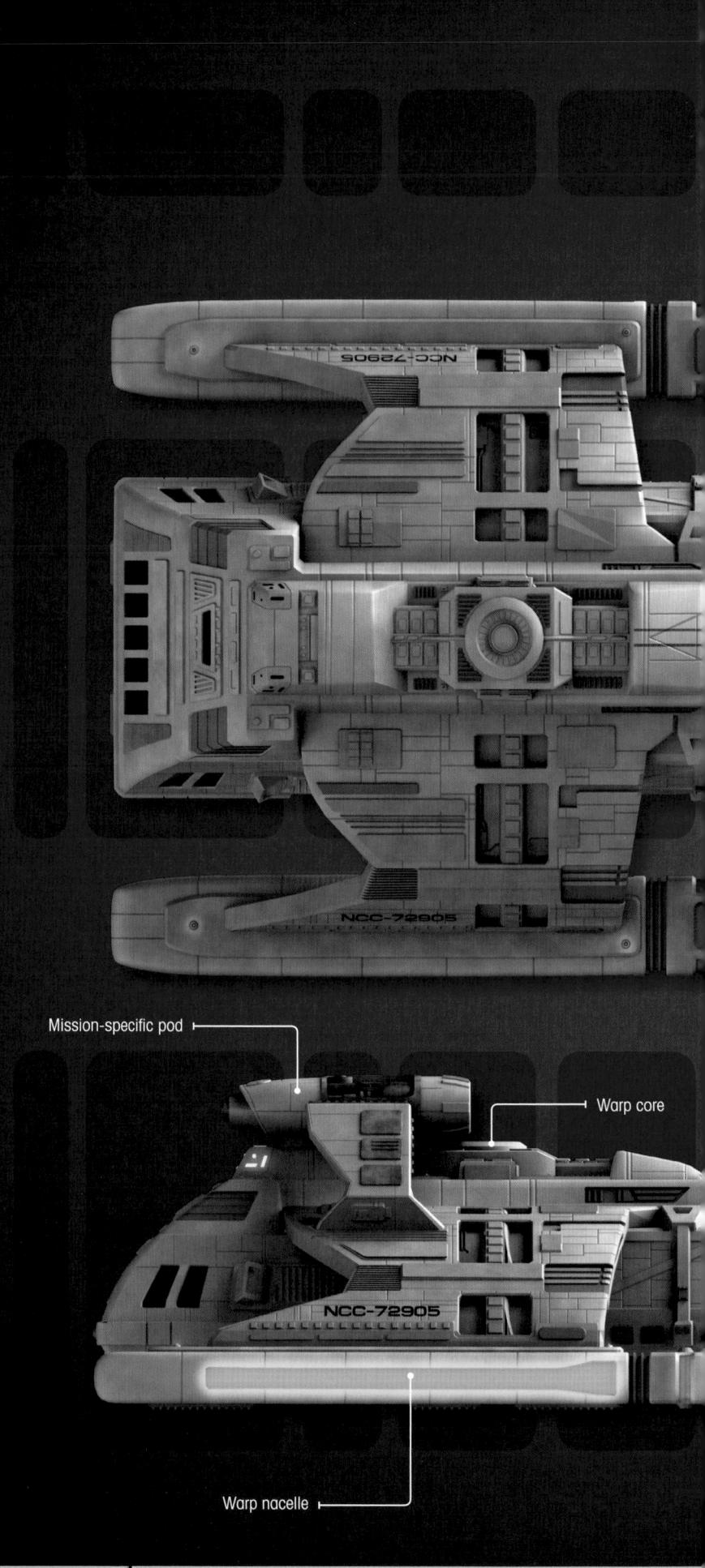

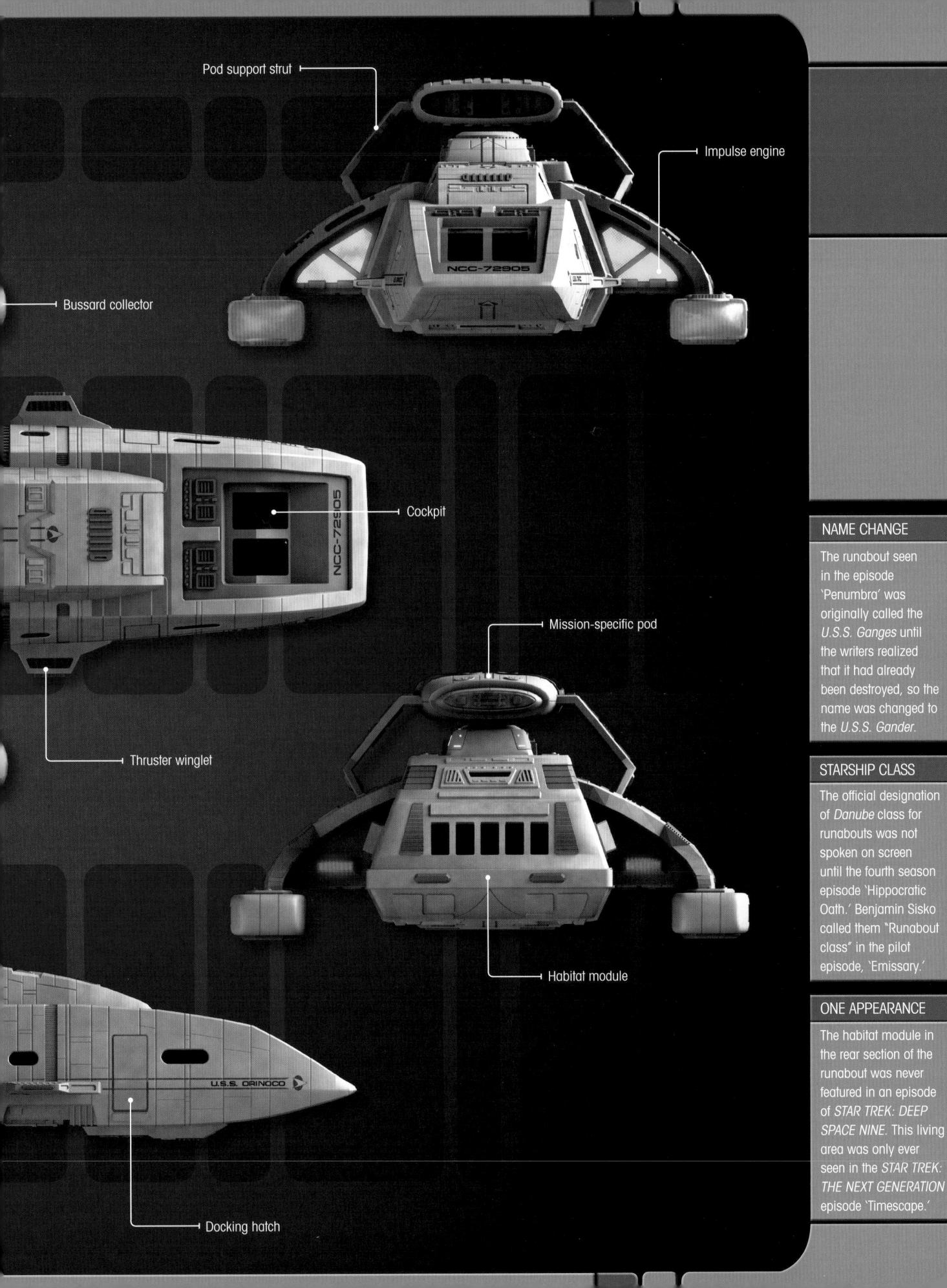

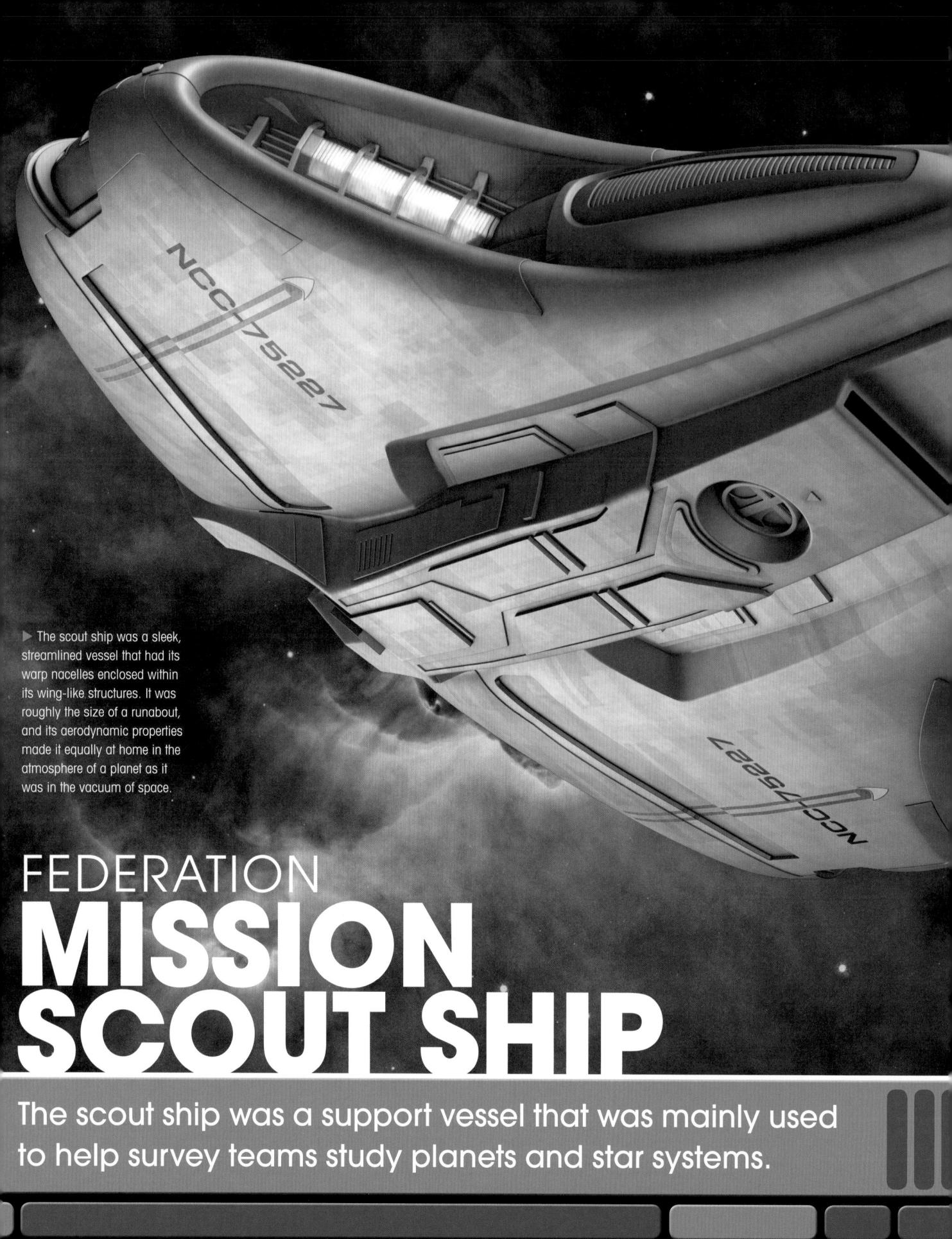

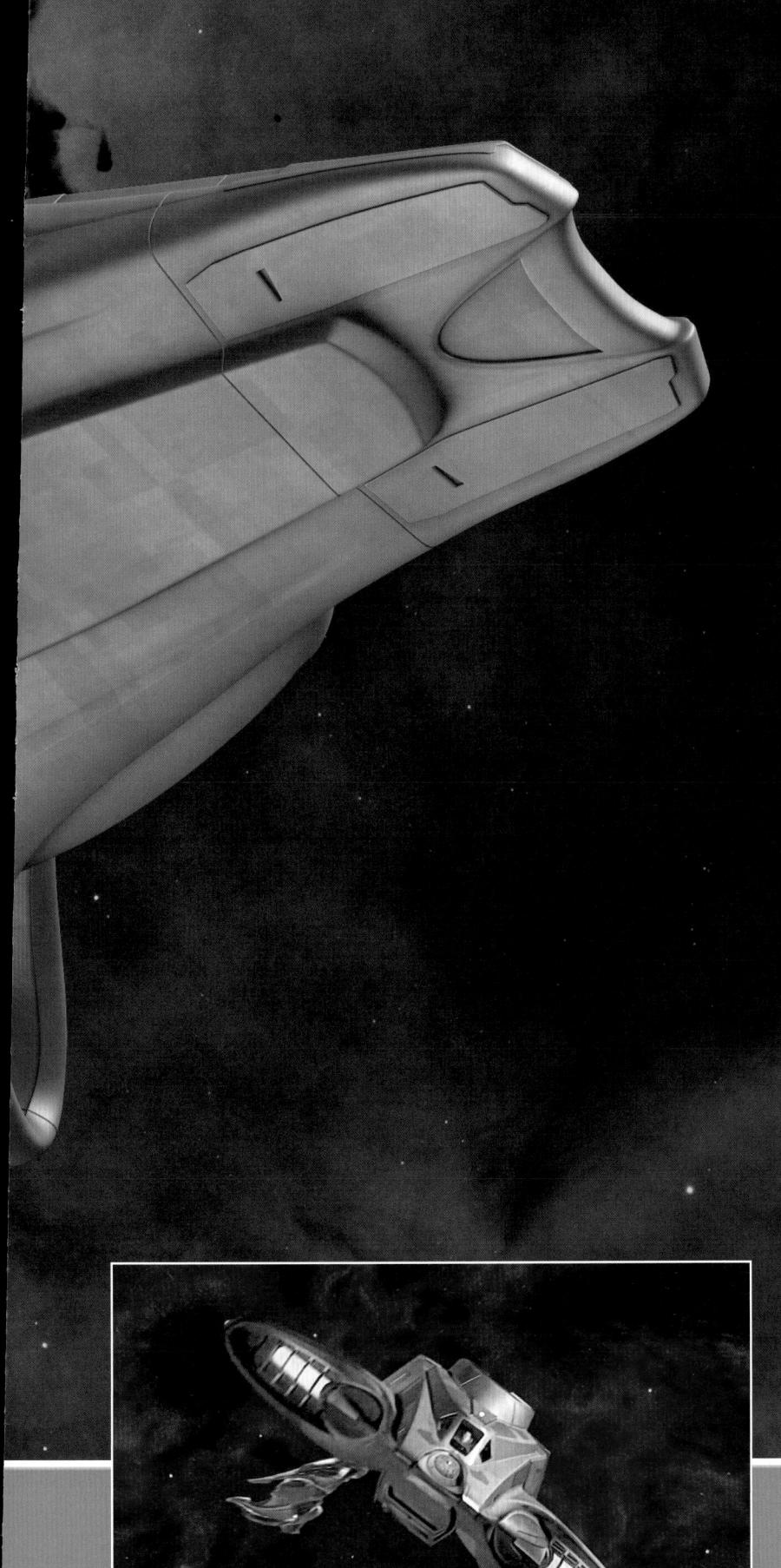

The Federation scout ship was a 24th century-vessel that was primarily used in research missions to gather scientific data and aid in planetary and cultural surveys. These vessels were ideal in scenarios where a larger, fully-fledged starship would have been a waste of resources.

At approximately 24 meters in length, the scout ship was roughly six meters longer than a Type-11 shuttlecraft, but still small enough to be carried aboard a standard Starfleet vessel's shuttlebay. The scout ship only required one pilot, who sat in a cockpit that was similar to the one found aboard Type-9 shuttlecraft. The only major difference was a set of panoramic windows at the front that allowed the pilot an excellent view ahead, to the sides and above. The rear interior of the craft included a number of science stations and room for five to ten passengers.

RUGGED AND NIMBLE

In many ways the scout ship was like a runabout, but it was more agile and robust. Its warp nacelles were encased within the 'wings' for better protection, and it was capable of reaching a top speed of warp 5 for limited periods. Impulse engines were located within two spurs that projected from the back of the main body.

The design of the scout ship was sleeker and more streamlined than a runabout or a shuttlecraft, and its aerodynamic properties really paid off when it was flying within a planetary atmosphere. Thanks to its RCS thrusters, it was capable of performing high-speed intricate

■ The scout ship had a sophisticated array of sensor equipment,
making it ideally suited for research duties, but it was also well armed
with phasers and torpedoes. The Son'a found this out when Data
attacked Ru'afo's flagship and caused significant damage to its outer
hull, before retreating quickly back to the safety of the Ba'ku planet.

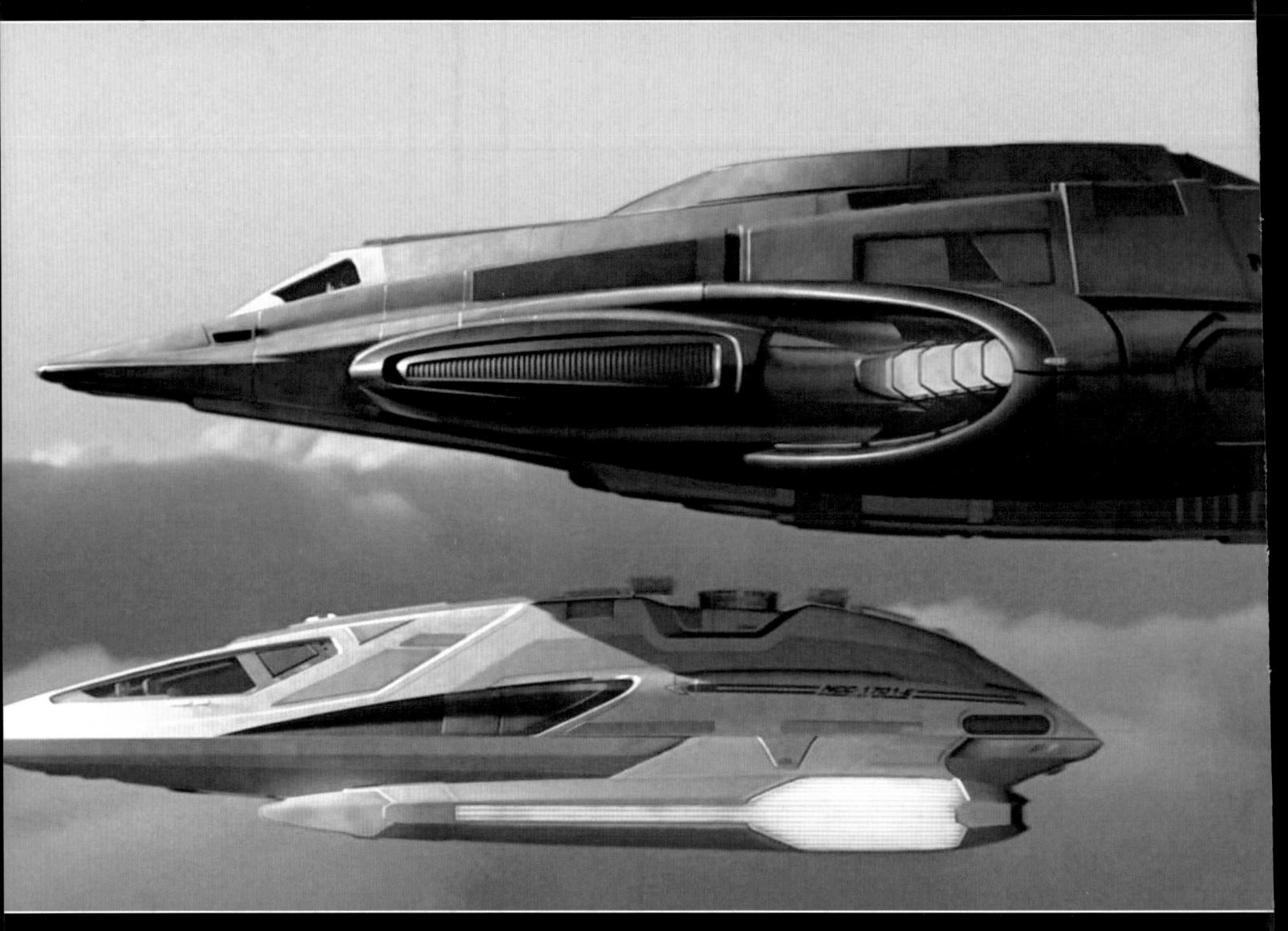

▲ The scout ship was noticeably larger than a Type-11 shuttlecraft, as was seen when Captain Picard flew his craft directly below Data's ship. Picard wanted to stop Data by extending the emergency hatch on top of his vessel and docking it with the hatch on the bottom of the scout ship. He hoped Worf could then climb between the two ships and neutralize Data.

maneuvers and extreme swoops and spins, much like an old-style jet fighter.

While the scout ship was primarily used as a support vessel in collecting sensor readings for planetside research stations, it could be used for military reconnaissance, providing aerial intelligence on enemy troop movements. It could also perform reconnaissance of entire star systems, collating information on the attack capabilities of an enemy force. This could obviously be a dangerous undertaking, and the scout ship was armed with dual-mounted phaser banks and torpedo launchers to defend itself.

In 2375, a Federation scout ship with the suffix NCC-75227 was employed by a joint Federation-Son'a surveillance team, who were covertly observing a Ba'ku settlement on a planet in the Briar patch. It was hijacked by an apparently malfunctioning Lt Commander Data, and he used

it to attack the Son'a flagship that was in high orbit of the planet. He made a surprise attack, emerging from a low-density gas cloud before blasting away with phaser blasts and multiple photon torpedoes. Data then retreated to the surface of the Ba'ku planet in the scout ship, without explanation for his actions.

SECURING DATA

Once Captain Picard was informed of Data's bizarre behavior, he elected to take the *U.S.S. Enterprise* NCC-1701-E to the planet's location to try and safely capture Data.

Picard and Worf then took a Type-11 shuttlecraft towards the planet, transmitting a wide band co-variant signal to attract Data's attention. As they were flying over the planet, Data suddenly appeared in the scout ship, firing a phaser blast that hit their shuttle. As Picard performed extreme

The scout ship had a tough, robust look to it, not unlike the *U.S.S. Defiant*. It was certainly able to carry out swift attacks, as Data proved when he launched an assault on the Son'a.

▼ The tactical ability of the scout ship was superior to the Type-11 shuttlecraft, but Picard managed to gain an advantage by distracting Data, and then flying inches below the craft so Data could not see him.

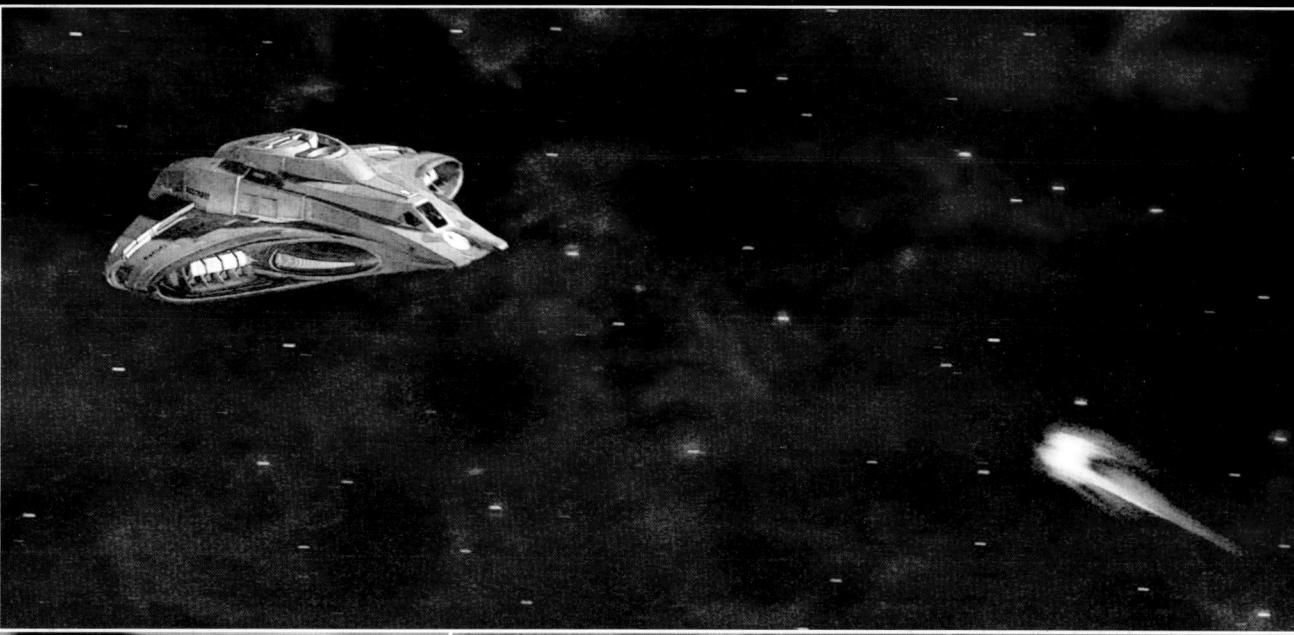

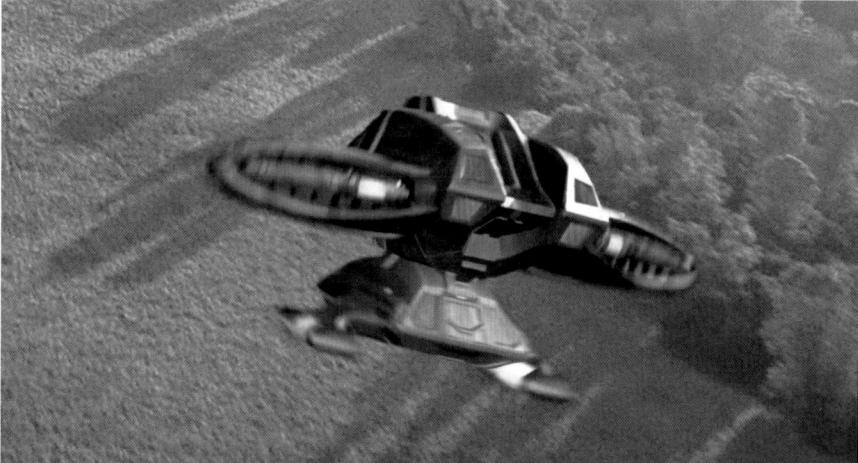

evasive maneuvers to avoid more phaser blasts, he tried to open communications with Data, but the android refused to acknowledge them and continued his attack.

Attempts to beam Data off the scout ship failed, as the android had anticipated their plan and activated a transporter inhibitor. As the battle continued into the atmosphere of the planet, Picard managed to maneuver his vessel below the scout ship. He then forcibly locked the two ships together by means of the docking hatches. This caused them to spiral out of control, and as they plunged towards the ground, the inertial coupling on the shuttlecraft soon exceeded tolerance. Picard refused to let go, however, and rerouted emergency power to the inertial dampers. This allowed Picard to pull them out of the dive and into a stable flightpath.

Worf climbed through the hatch and into Data's

scout ship. He then aimed a modified tricorder at Data, pushing a button. At first nothing happened, so Worf frantically pushed the button again and again as Data lunged at him. It finally worked and Data shut down, collapsing motionless just a few inches from Worf. They had captured Data safely and were able to return him to the *Enterprise*, while both ships remained largely intact.

After their emergency hatches were forcibly docked, both ships were locked together and out of control. Picard only just managed to avoid a catastrophic crash by rerouting power to the inertial dampers.

DATA FEED

Data was assigned to help the joint Federation-Son'a survey team study the Ba'ku when he discovered a plot to have them forcibly relocated. As Data was about to report his findings, he was shot by a Son'a weapon. This caused him to lose his memory, but he entered a self-protection mode in which all he knew was right from wrong. He tried to protect the Ba'ku by exposing the survey team and using the scout ship to attack the Son'a flagship in orbit of the planet.

JUUUI JIIIF

PLAN VIEW

AIR-TO-AIR COMBAT

The scout ship piloted by Data attacked the shuttlecraft being operated by Captain Picard and Lt. Commander Worf in orbit of the Ba'ku planet. To shake off Data's pursuit, Picard entered the planet's atmosphere in the hope that the turbulence from the ionospheric boundary would thwart him. Despite the massive turbulence, the scout ship remained on their tail and Data fired more shots.

As Picard worked hard to stabilize his ship, he came up with a new plan – to distract Data with a burst of song from a Gilbert and Sullivan opera. Data had been rehearsing a part in 'H.M.S. Pinafore' before he left for the Ba'ku mission, and somewhere inside his damaged positronic brain he remembered this and began to sing along. He was so preoccupied with the song that he did not notice Picard's shuttlecraft sliding under his scout ship.

The ships flew closer and closer together until the hatch on top of Picard's shuttlecraft forcibly locked onto an emergency hatch on the scout ship with a magnetic docking clamp. Data rocked the scout ship back and forth in the hope of shaking his ship loose, but it caused both of them to tumble through the sky, seemingly out of control. Just a split second before the ships smashed into the ground, Picard regained control and stabilized their flight with both ships still locked together. Worf was then able to board the scout ship and use a modified tricorder to neutralize Data, before taking him safely into custody.

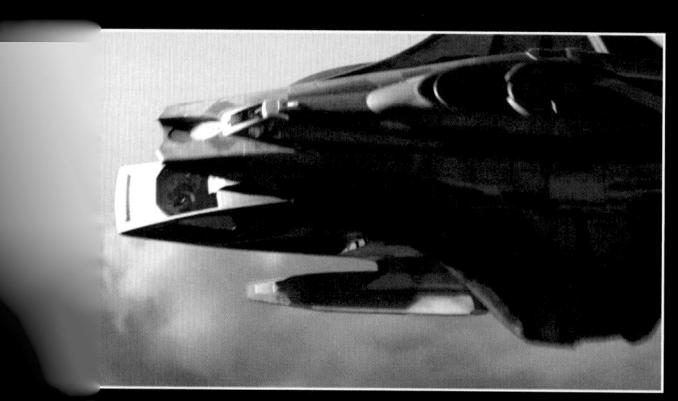

The plan to lock the ships together so Worf could board the scout ship almost ended in disaster until power was rerouted to the shuttle's nertial dampers, pulling them both out of their terminal dive.

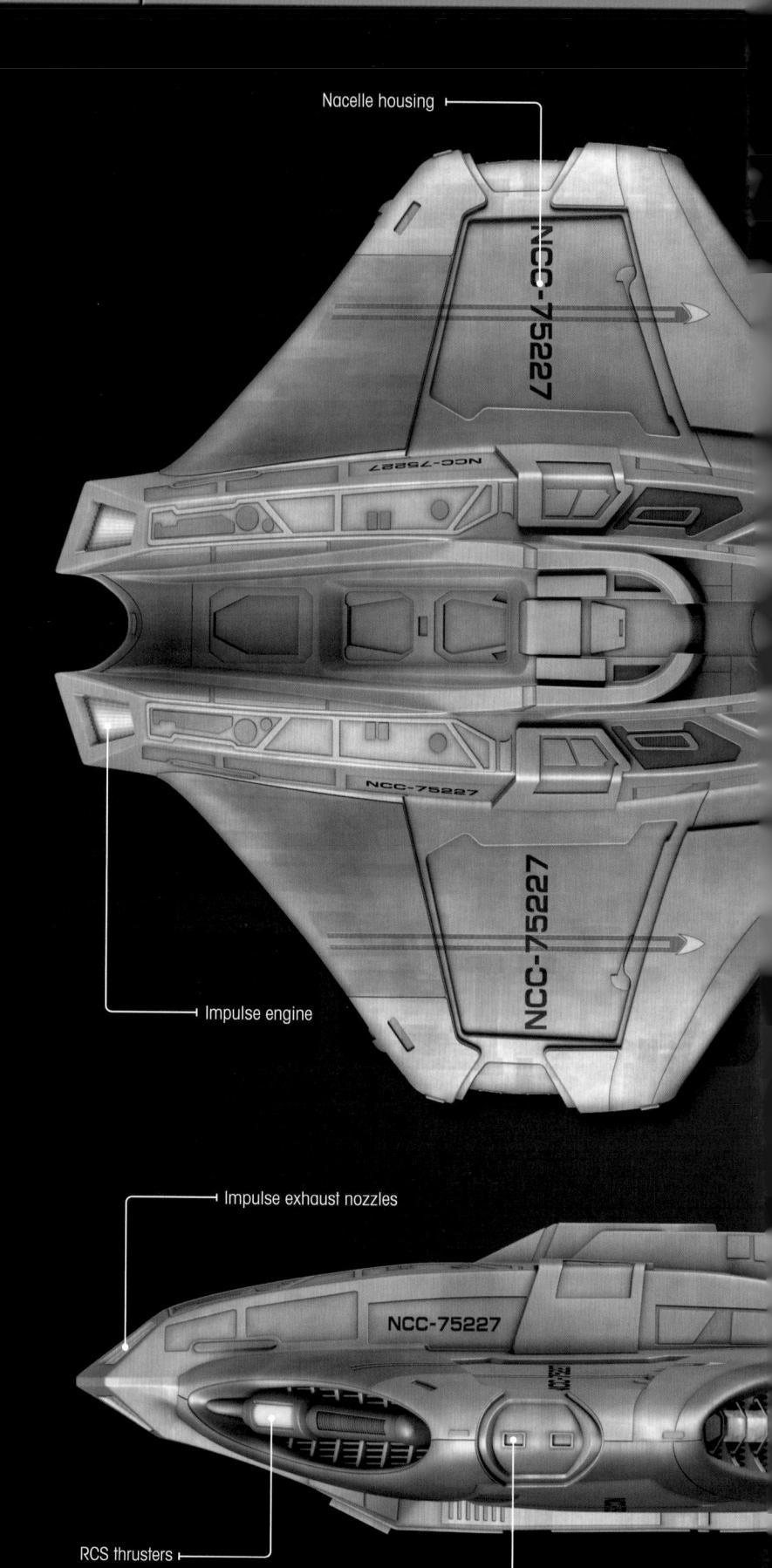

Passenger entry door

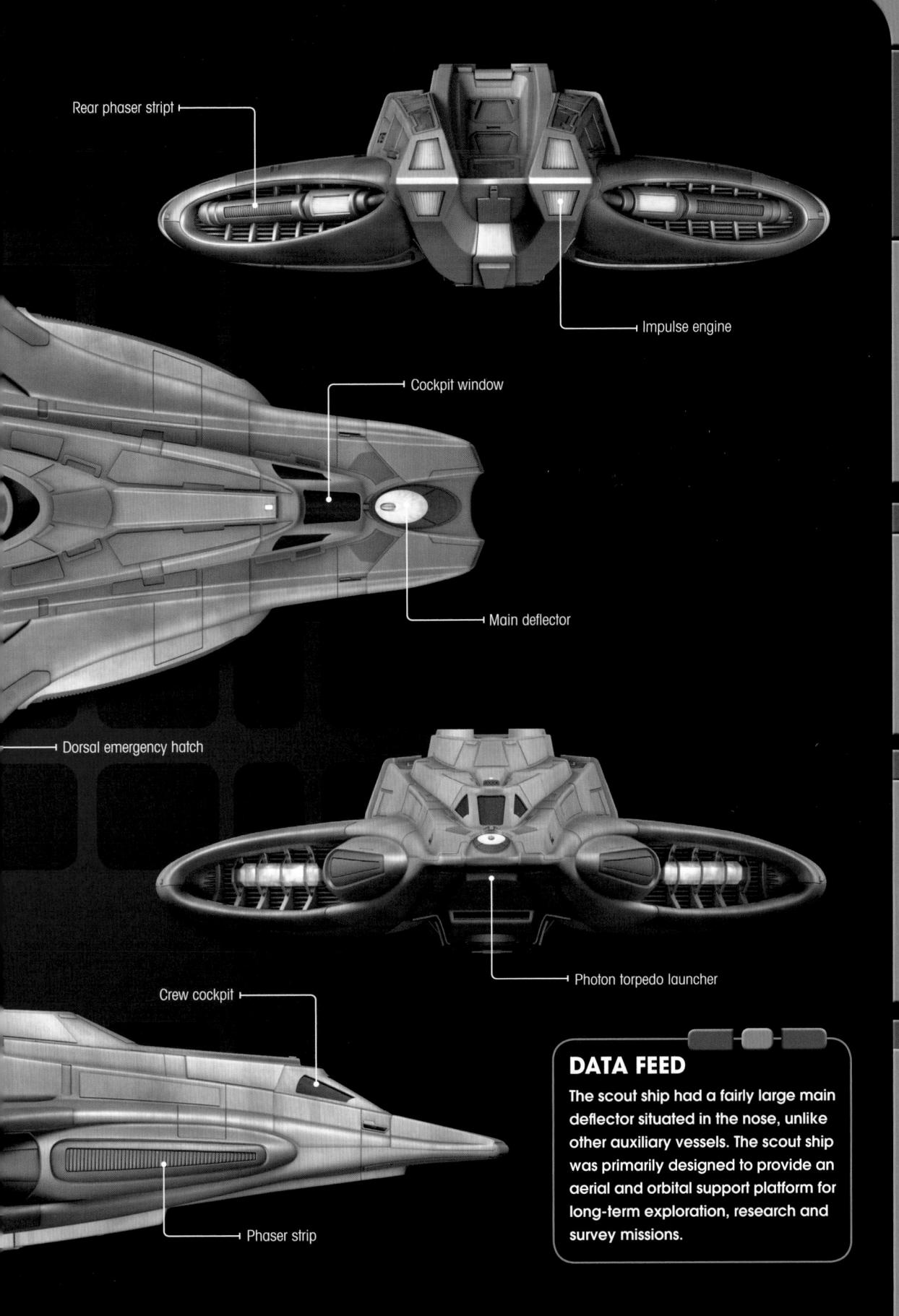

FAMILIAR INTERIOR

The interior sets for the Federation scout ship and the *Enterprise*-E's Type-11 shuttlecraft were modified versions of the sets used for the class-2 shuttle that were first seen in *STAR TREK: VOYAGER*.

DOMINION LINKS

By the 2370s, the Son'a maintained colonies near Cardassia and the Bajoran wormhole. They were also said to produce ketracel-white, the drug that was used by the Dominion to control the Jem-Hadar.

WINDSHIELD SIZE

Michael Piller, who wrote the screenplay for STAR TREK: INSURRECTION, wanted the scenes involving the scout ship and the shuttlecraft to be similar to a World War II dogfight, where both pilots could clearly see each other. This was why both ships had huge windshields.

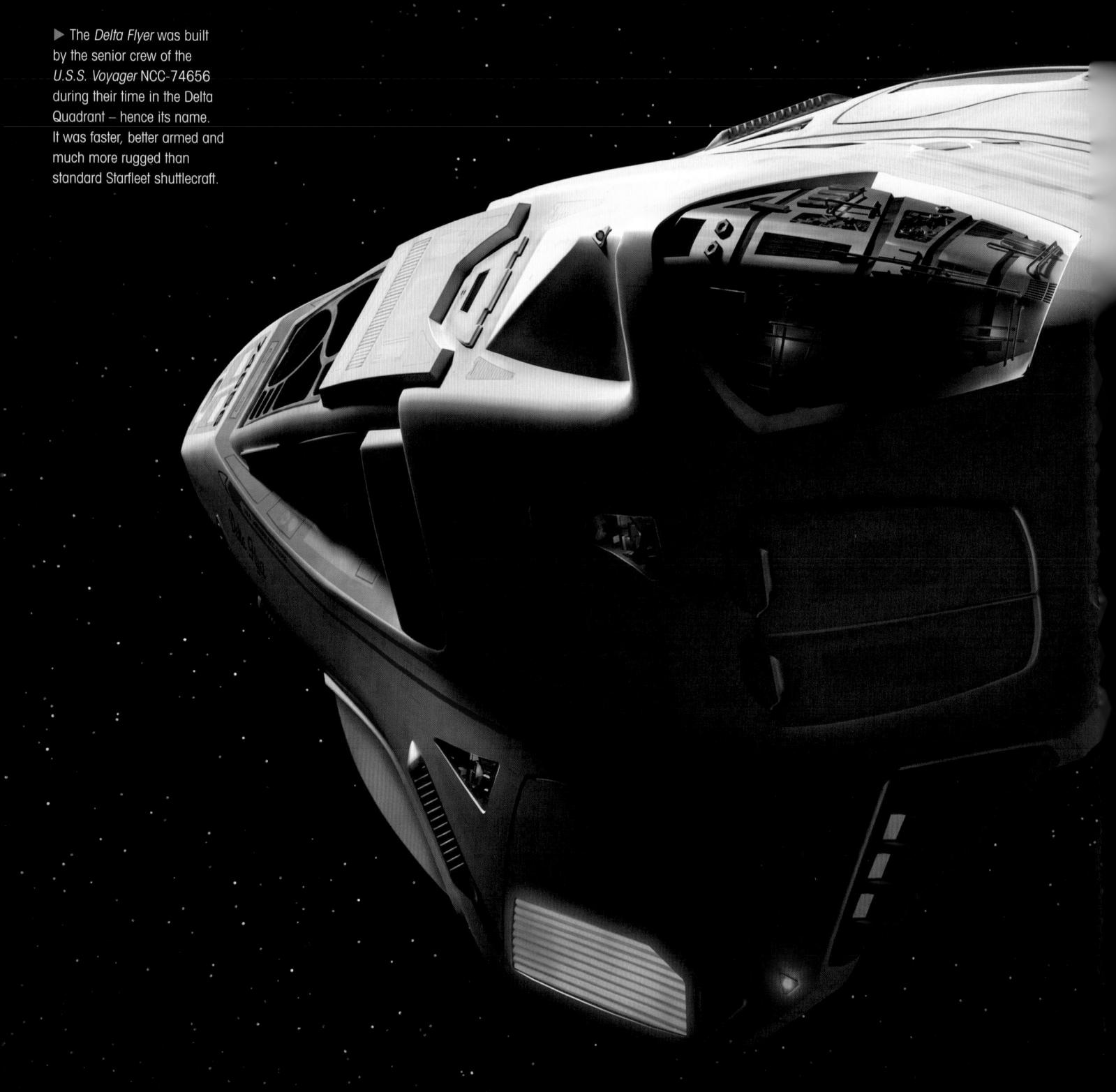

DELTAER

The *Delta Flyer* was a unique shuttlecraft designed to withstand the rigors of life in the hostile Delta Quadrant.

he *Delta Flyer* was a larger, more resilient type of shuttlecraft that was developed by the crew of the *U.S.S. Voyager* NCC-74656 after they were stranded in the Delta Quadrant. It combined traditional Starfleet design principles with Borg technology, and unimatrix shielding designed by Commander Tuvok. At 21 meters in length, it was larger than a Starfleet Class-2 shuttle, but smaller than a *Danube*-class runabout.

The main proponent for the creation of the Delta Flyer was Voyager's helmsman Tom Paris, who repeatedly championed the idea of building a specialized shuttlecraft (in his words, a "hot rod") that was more suited to the crew's needs than normal shuttles. At first, Captain Janeway and Commander Chakotay rejected his suggestion because they felt that the crew did not have the

▶ Working around the clock, the *Delta Flyer* was built in just a few days. Alloys and new design components were replicated, while spare parts from storage were also used in its construction. It featured retractable warp nacelles, unimatrix shielding and Borg-inspired weapons. Tom Paris described it as an "ultra-responsive hot rod."

DATA FEED

The initial idea for the *Delta Flyer* came from Seven of Nine during a mission to survey a proto-nebula aboard a Class-2 shuttle. After hearing B'Elanna Torres and Tom Paris complaining of having "Class-2 claustrophobia," a term used by Starfleet cadets when they were packed into shuttles for weeks at a time as part their training, Seven suggested that they design a larger, more efficient shuttle.

time to design and build a ship from scratch, so Paris began work on the design in his spare time.

BORN OF NECESSITY

In 2375, the argument swung decisively in his favor; the crew had to retrieve a multiphasic probe from the atmosphere of a Class-6 gas giant to prevent it falling into the Malon's hands. Since no alternative was available, Captain Janeway gave the goahead to build the *Delta Flyer*. The entire senior staff contributed to the project, adapting and improving Paris's initial design.

The most serious design problems were related to the *Delta Flyer's* structural integrity system. Retrieving the probe from the gas giant's atmosphere pushed the small craft to its limits. B'Elanna Torres suggested using titanium alloys for the hull, but on Seven of Nine's recommendation the crew chose tetraburnium because of its higher structural integrity characteristics. Even so,

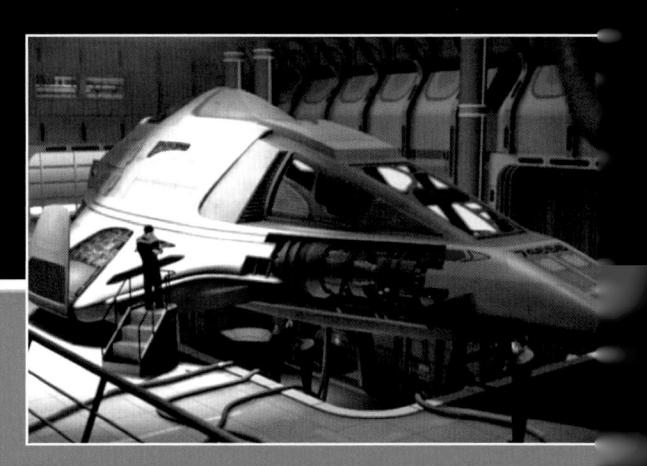

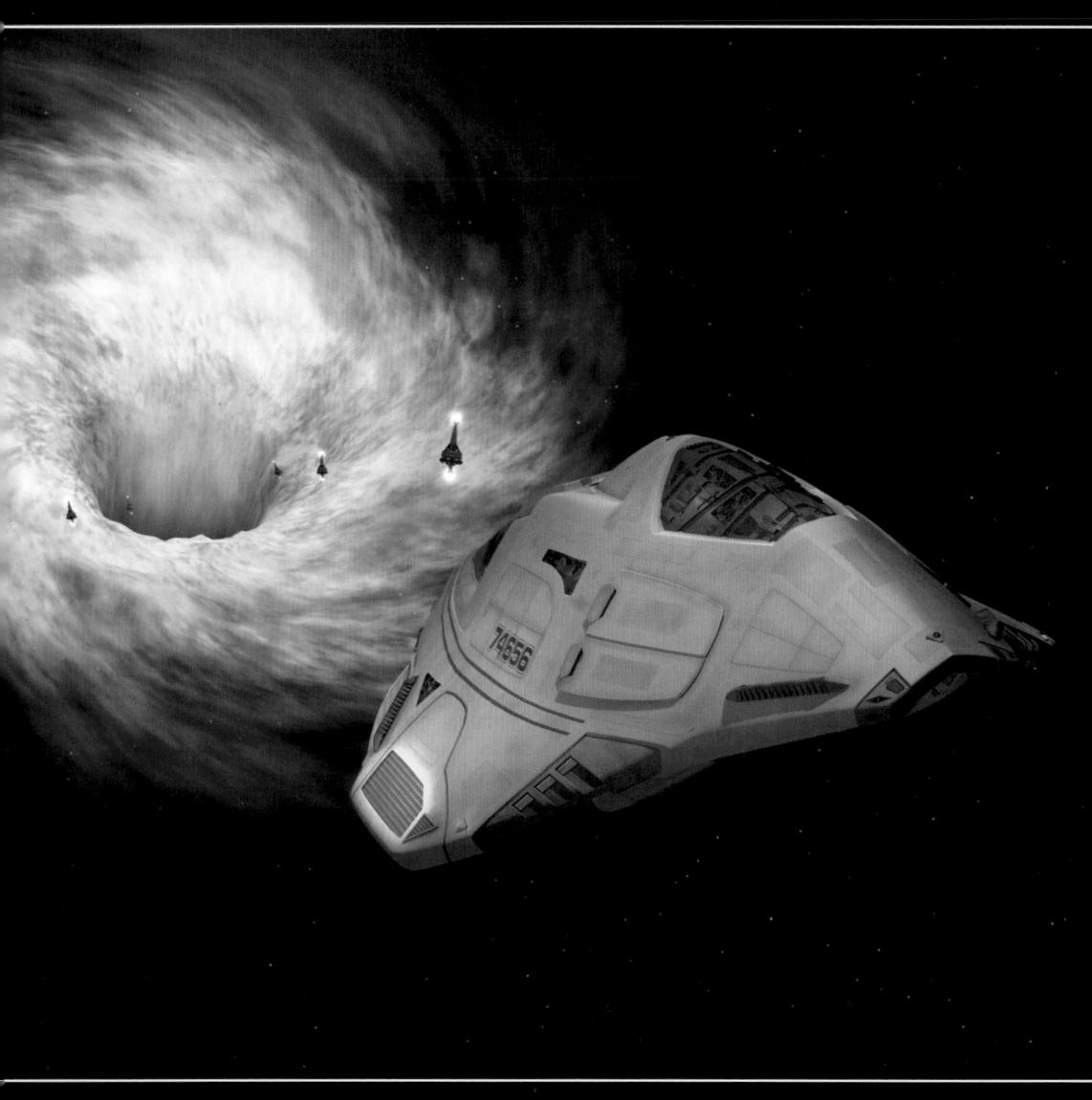

▶ With the addition of immersion shielding, the Delta Flyer had the necessary structural integrity to dive to a depth of nearly 600 km on the Monean ocean world.

▲ The Delta Flyer II could achieve even faster sublight speeds than its predecessor thanks to its pop-out impulse thrusters. These proved especially useful when navigating the course near a Möbius Inversion during the Antarian Trans-Stellar Rally.

the pressures involved were so great that the ship could maintain a structural integrity field for only a few minutes before microfractures began to form in the parametallic hull. The problems were never entirely solved, but the ship successfully retrieved the probe.

ADVANCED SYSTEMS

The Delta Flyer was equipped with warp and impulse engines, a tractor beam emitter, and a narrow beam transporter; it used a tuned, circumferential warp reaction chamber and extendable warp nacelles. When fitted with a Borg transwarp coil, it was more than capable of traveling at transwarp velocities. The ship was also capable of atmospheric flight and landing on the surface of a planet.

Power distribution was maximized by the use of isomagnetic EPS conduits in the plasma manifold,

and many of its systems incorporated Borg enhancements suggested by Seven. In particular, the *Delta Flyer's* weapons systems were inspired by Borg technology; it had fore and aft phaser strips, and a nose-mounted microtorpedo launcher that could fire photonic missiles.

The ship's design proved extremely adaptable. Shortly after the crew constructed the *Delta Flyer*, they modified its thrusters and added immersion shielding so that it could operate deep within the Monean ocean planet. On another occasion, the ship was modified so that it could generate multiadaptive shielding that rendered it invisible to the Borg's sensors, allowing the crew to steal a transwarp coil from a damaged Borg sphere.

The *Delta Flyer*'s resilience was tested time after time, and it even survived a crash landing that resulted in it being buried 3 km beneath the surface of a Class-M planetoid. It also withstood

■ Shield enhancements allowed the Delta Flyer to withstand huge gravimetric distortions and enter a graviton ellipse where it found Ares IV, an early Mars mission command module that had gone missing in 2032.

the extreme subspace distortions inside a graviton ellipse while attempting to retrieve Ares IV, an early Mars mission spacecraft from 2032.

TAKING ON THE BORG

The *Delta Flyer* ultimately met its demise in early 2377, when it was used in a daring raid on a Borg tactical cube as part of a mission to help the drones of Unimatrix Zero. The Borg Queen targeted the *Flyer* and destroyed it, but not before the occupants beamed onto the cube.

The Delta Flyer had proved so useful that the Voyager crew decided to build another one. The Delta Flyer II featured a number of improvements on its earlier incarnation. These included pop-out impulse thrusters that provided greater sublight speeds. The interior was redesigned for greater comfort and its arsenal was supplemented with a pulse-phased weapon system.

The Delta Flyer II was soon put through its paces when it took part in the Antarian Trans-Stellar Rally. This 2.3 billion km long sub-light race was the ultimate test of a ship's design and the pilot's skills, as obstacles included dwarf star clusters, K-class anomalies and subspace distortions. The Flyer II was winning the race when it was discovered that it had been rigged to explode at the finish line. Its destruction was averted at the last second after its warp core was ejected into a Class-J nebula.

As with its predecessor, the *Delta Flyer II* went on to play a vital role in routine scientific and diplomatic missions, as well as being used to scout for supplies, such as dillthium. It also proved pivotal on several occasions in helping to save *Voyager* and its crew, most notably in 2377 when it was used to rescue most of the ship's personnel after they had been abducted and brainwashed by a group of aliens called the Quarren.

▲ After a mission where the Voyager crew stole a Borg transwarp coil, Seven of Nine was captured by the Borg. The coil was then installed on board the Delta Flyer, and used to travel to the vast Borg Unicomplex to rescue Seven.

INTERIOR LAYOUT

The interior of the *Delta Flyer* comprised a cockpit, a small mid section and an aft compartment that featured wall-mounted work stations, a replicator, a retractable biobed and a caged locker containing spacesuits and hand-held weapons.

The cockpit featured distinct workstations for tactical, operations and engineering personnel. A ramp led down to the pilot's seat that sat alone in the nose of the cockpit. In the original *Delta Flyer*, Tom Paris designed several retro control panels that he claimed allowed him to 'feel' how the ship was responding. In the *Delta Flyer II*, the flight controls were updated with two identical joysticks that the pilot used to change course and speed, providing an extremely responsive method of control.

▲ Instead of a standard Starfleet LCARS interface, the pilot's station eatured analogue-style dials, and toggle switches and levers, while he *Delta Flyer II* also featured two manual steering columns.

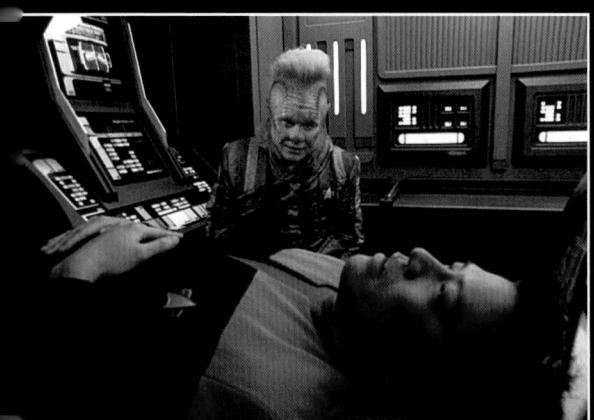

▲ The large aft compartment on the *Delta Flyer* provided the occupants with space to work, relax or sleep. It even featured a retractable biobed in the event of a medical emergency.

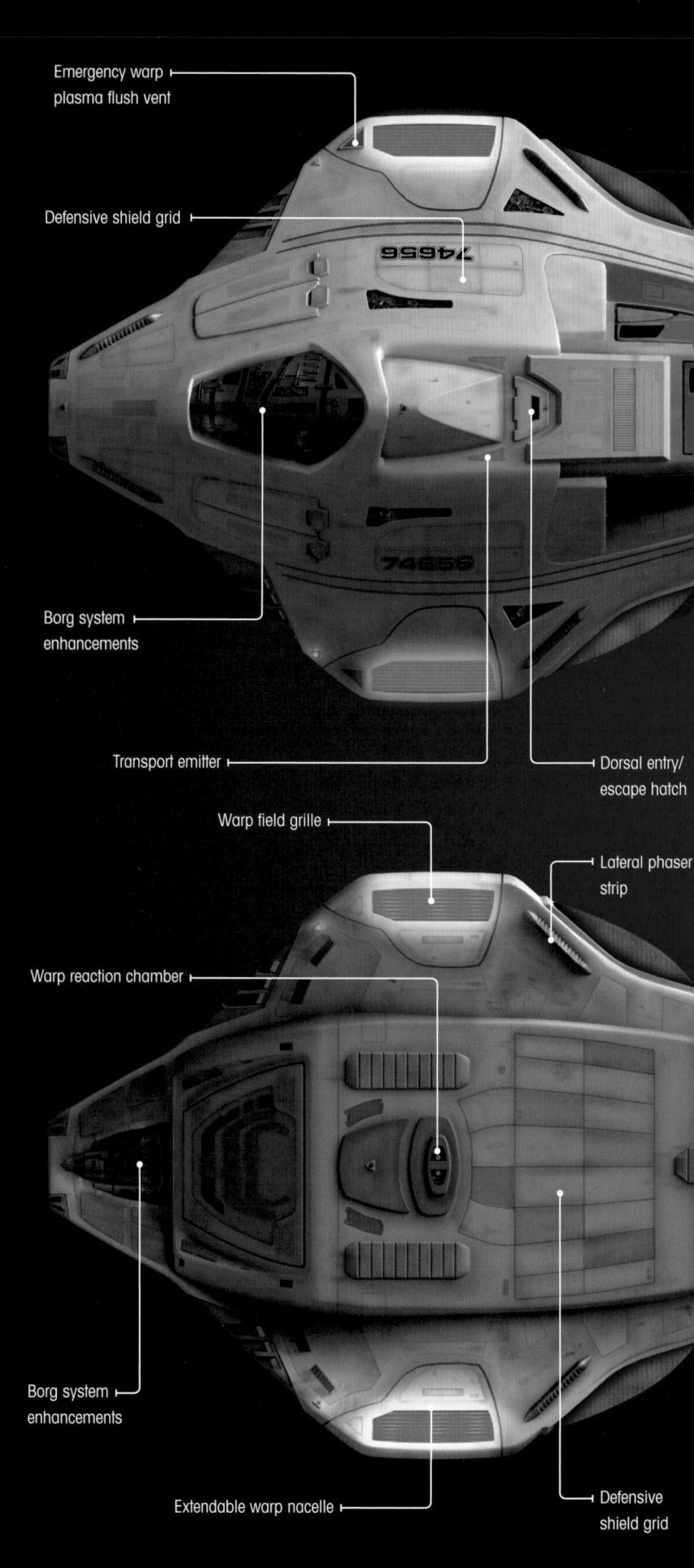

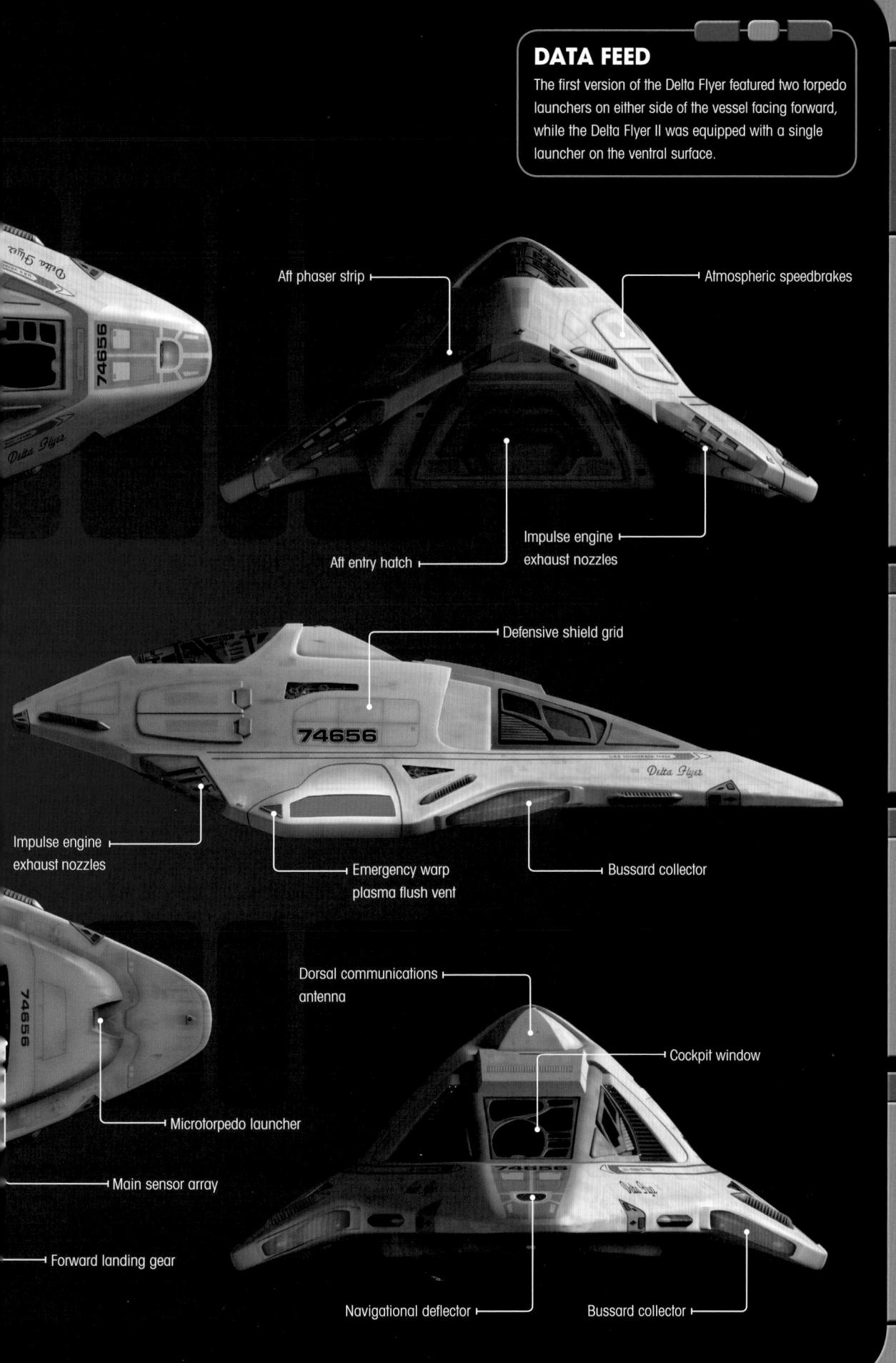

SHUTTLECRAFT LOSS

It was not surprising that the crew of the *U.S.S. Voyager* felt the need to create the *Delta Flyer.* By the end of 2375, they had crashed, destroyed, or otherwise lost a total of 18 shuttlecraft.

WELL SHIELDED

The Delta Flyer was designed to survive extremely hostile environments. In addition to utilizing parametallic hull plating, it also featured unimatrix, immersion and multiadaptive shielding.

NO EMBELLISHMENTS

Tom Paris wanted to add dynametric tail fins to the *Delta Flyer,* as he felt they would help it look "mean" and make other ships think twice before taking it on. But Tuvok told him to take them off as they served no practical purpose.

SMALL TRANSPORTS

SIZE CHART

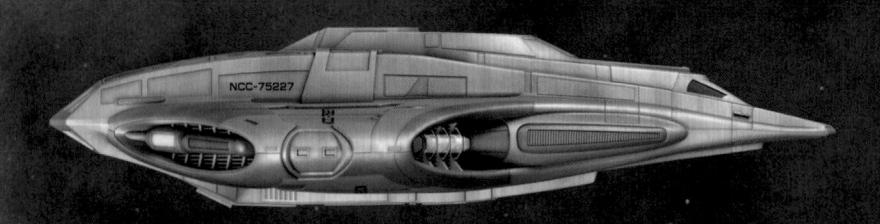

FEDERATION MISSION SCOUT SHIP

24m

STARFLEET RUNABOUT

23.1m

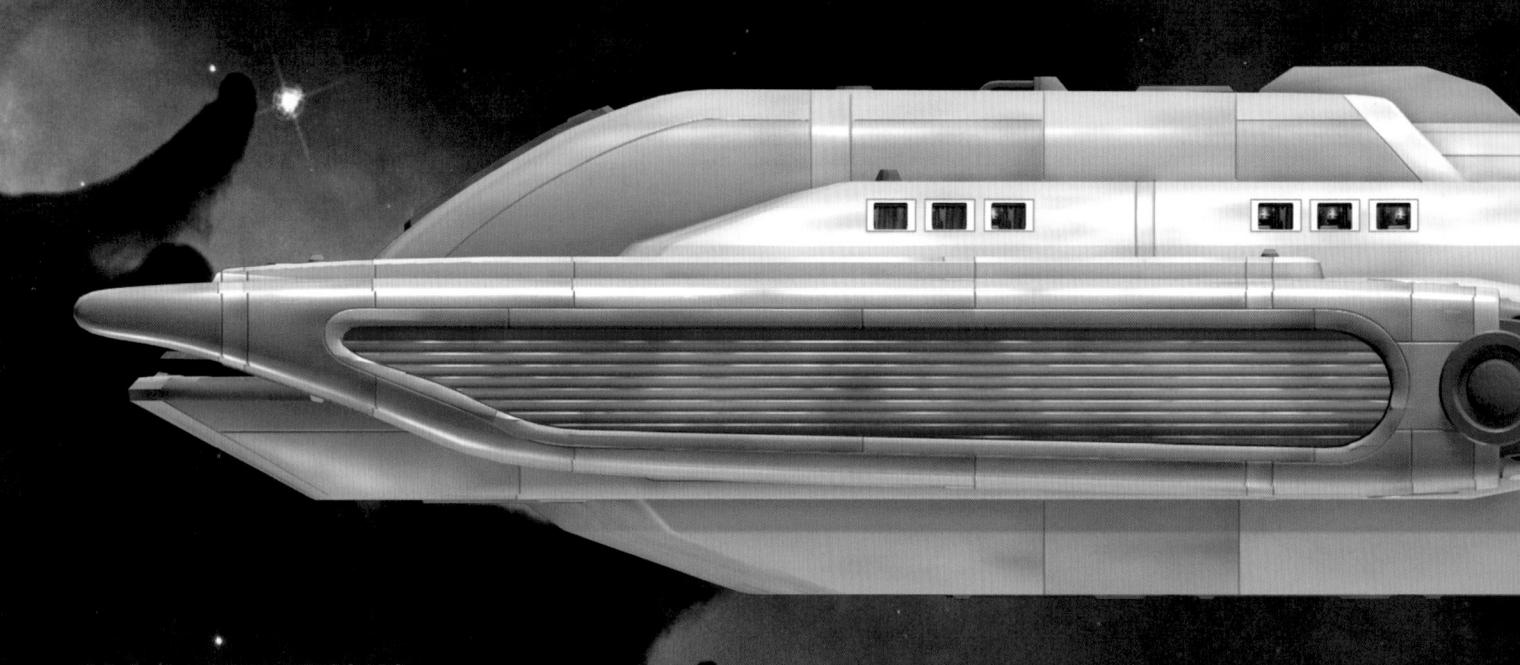

U.S.S. RAVEN NAR-32450

90m
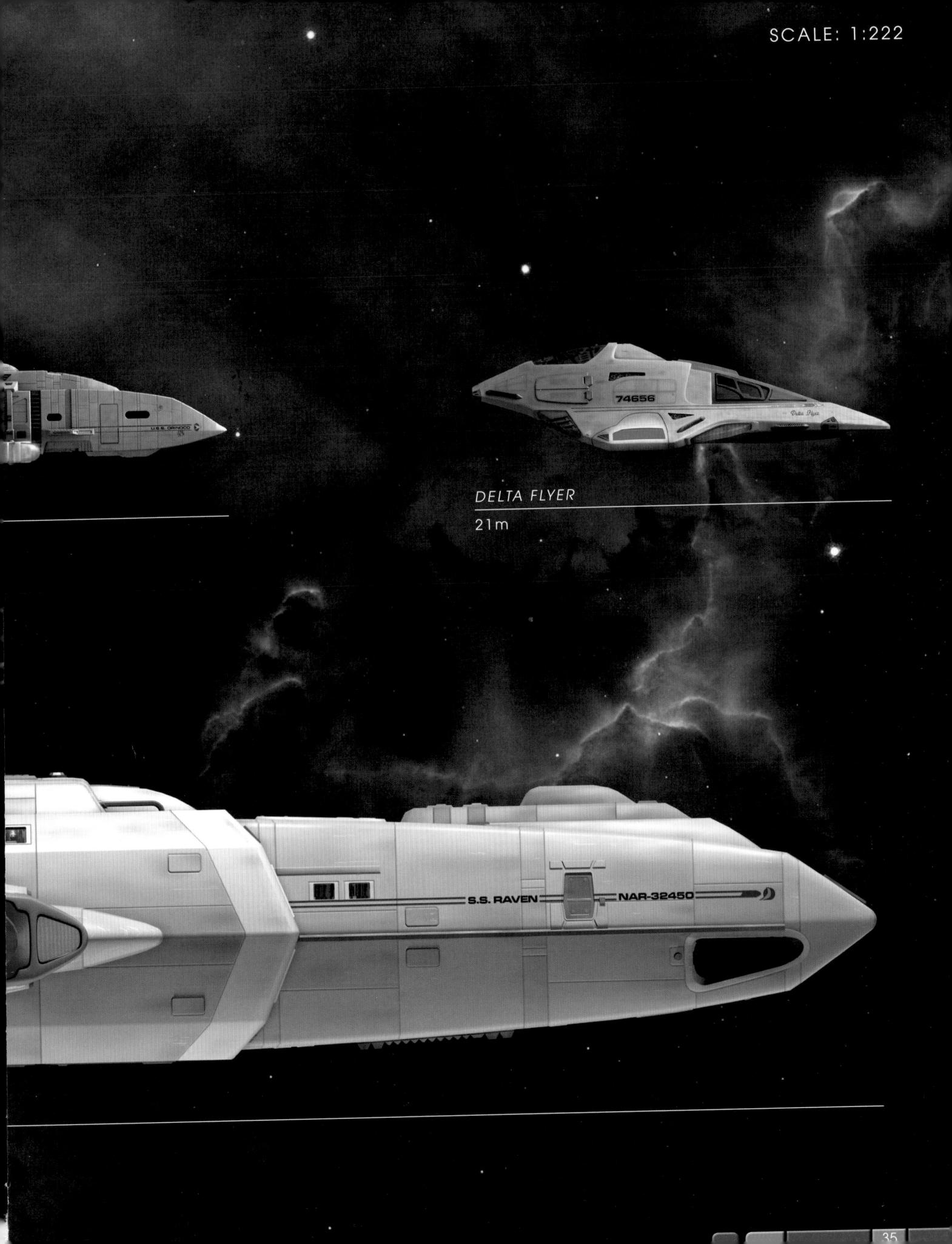

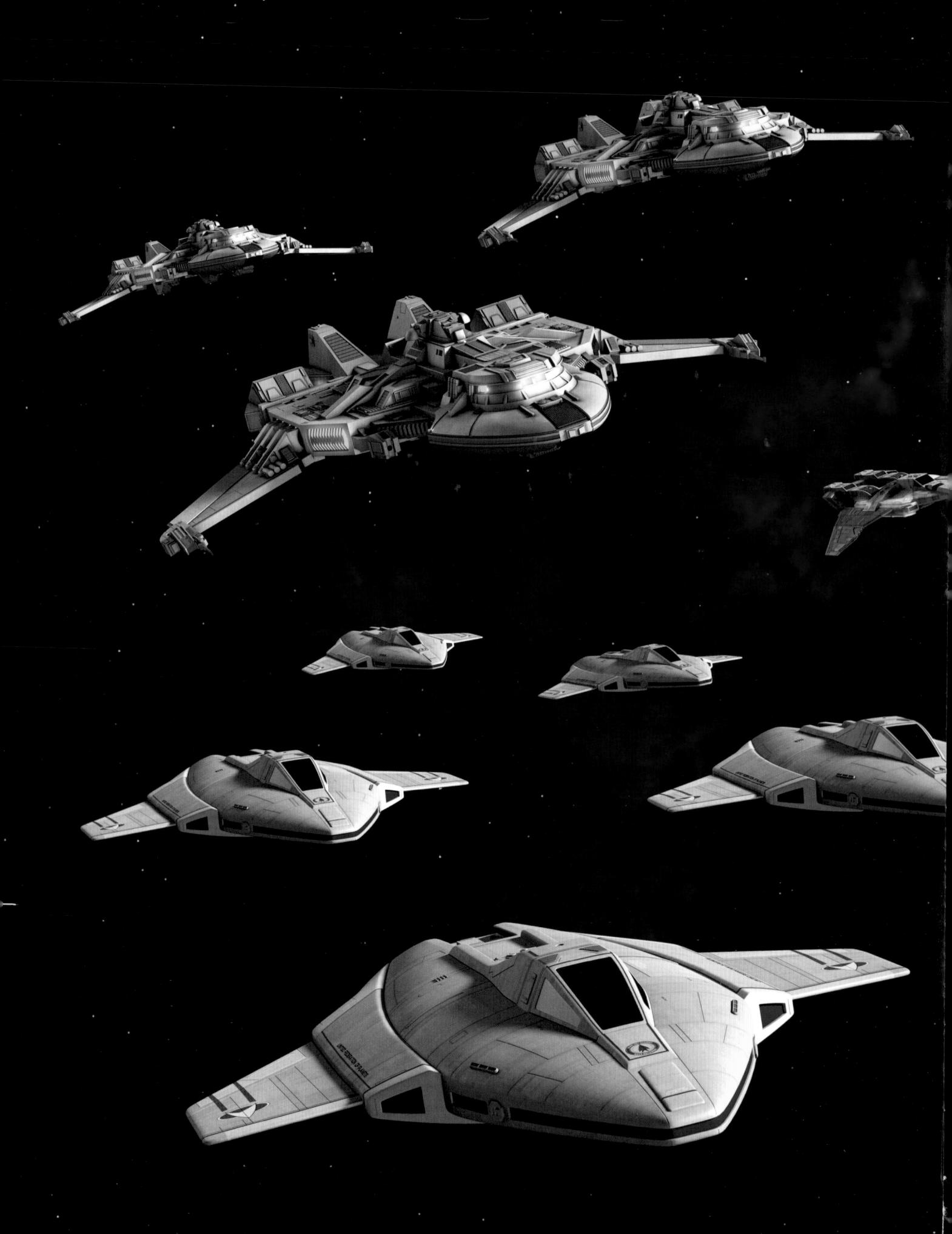

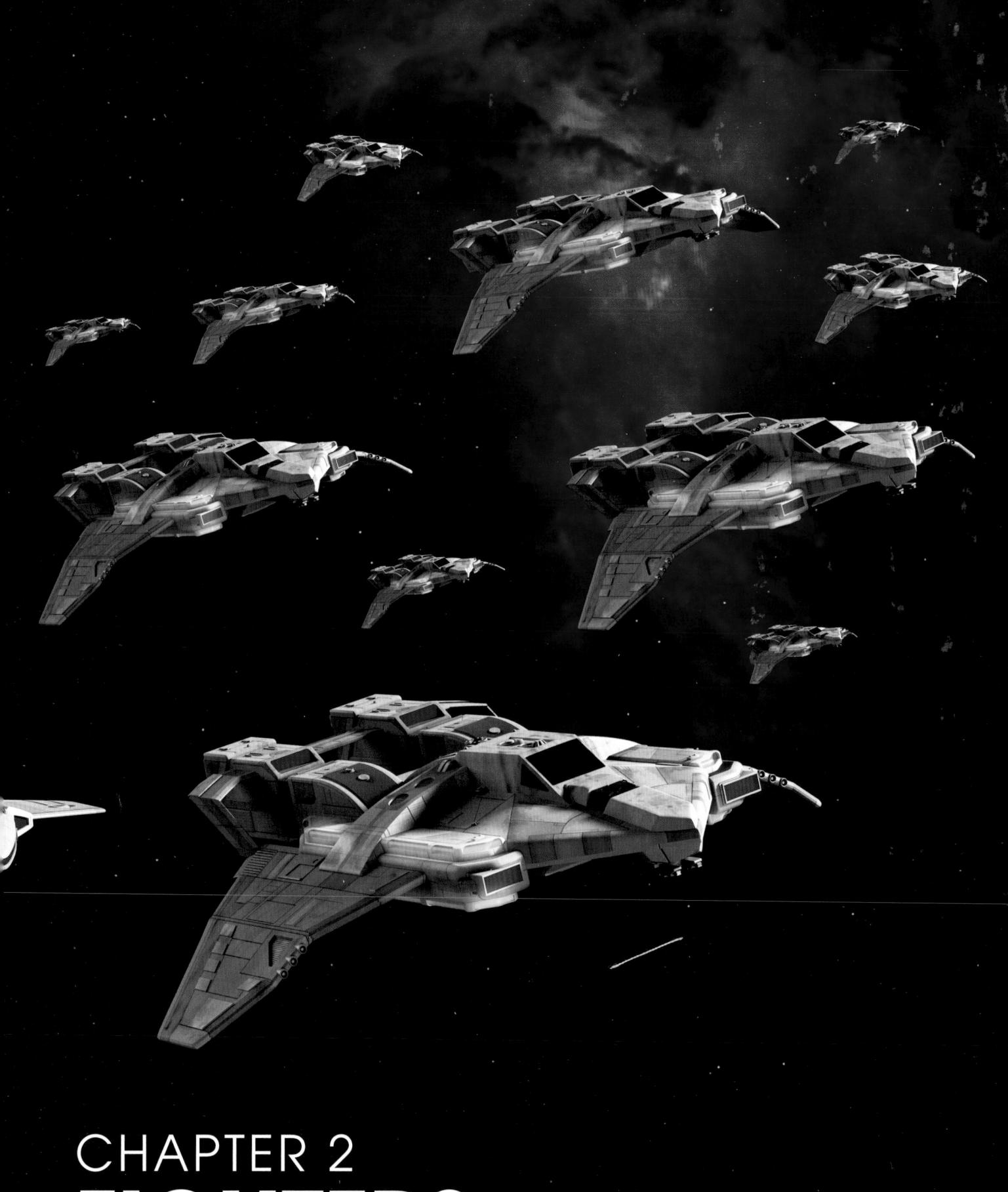

CHAPTER 2
FIGHTERS

mend of Chakotay, was fitted with a ear-old rebuilt engine. This would ate that by 2371 the raiders were well 40 years old. Despite their age, the rs proved highly effective in surprise ks against the Cardassians.

MAQUIS RAIDER

Maquis raiders were upgraded Federation transport ships that were used in covert attacks against the Cardassians.

▲ At 68.5 meters long, the Maquis raider was roughly 20 percent the length of the *U.S.S. Voyager* NCC-74656. Unlike the smaller Maquis fighter, the raider had a more pronounced cockpit structure, while the main body was similar to the secondary hull found on *Yeager*-class ships and could accommodate around 30 personnel.

The Maquis raiders started life as small Federation transport vessels from the early 24th century. In the 2370s they were heavily modified with enhanced engines and weaponry and used by the Maquis to conduct raids on other starships or bases during their conflict with the Cardassians.

These ships were 68.5 meters long with a runabout-style bridge at the front and a rear hull similar in appearance to a *Yeager*-class ship. They also featured two small warp nacelles attached to the ends of wing structures on either side of the main body. They were capable of high warp speeds and flight within a planetary atmosphere.

Before these vessels were utilized by the Maquis, they were mostly deployed as cargo or personnel transport. The rear section could hold at least 30 people or a sizable load of cargo, such as

medical supplies. The had originally been used by Federation colonists to transfer shipments between worlds and bring supplies to new settlements.

WEAPON UPGRADES

By 2370, these simple Federation transport ships had been appropriated by the Maquis and transformed into raiders. Their engines were rebuilt and extra armaments, including photon torpedo launchers and wingtip phaser cannons, were fitted. They then played a crucial part in the Maquis fight against the Cardassian occupation of the former Federation colonies in the Demilitarized Zone.

The Maquis raiders were no match for Cardassian *Galor-*class warships in a straight fight, but they were used in swift but effective strikes on Cardassian freighters and small Cardassian colonies in order to steal their supplies.

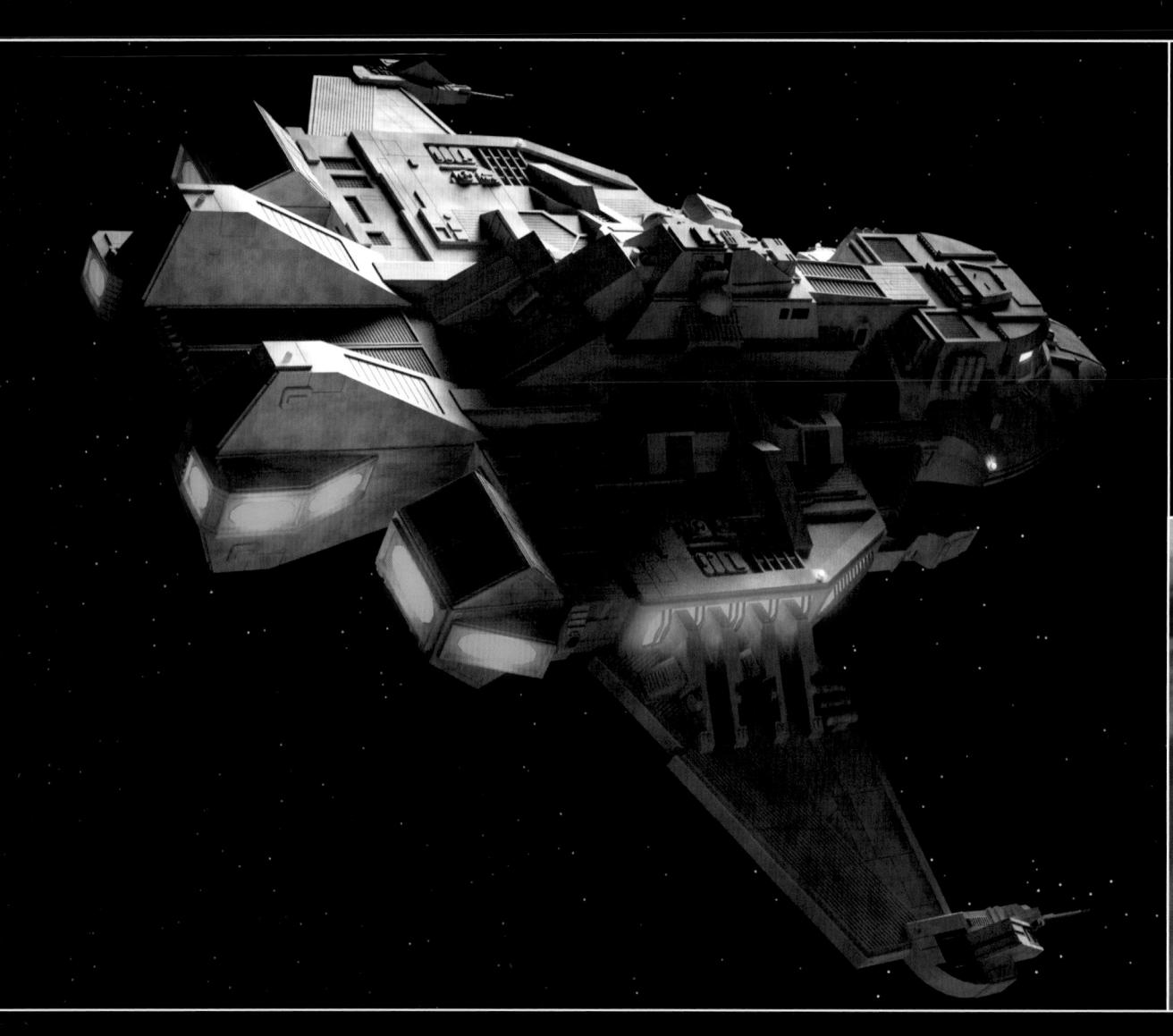

▶ The Maquis outfitted their raiders with wing-mounted phasers, plus fore and aft torpedo launchers. Despite this weaponry, a single raider could barely dent the shields of a Cardassian *Galor*-class warship.

▲ Despite being modified transport vessels, Maquis raiders proved highly effective in conducting precision strikes on starships and bases. They were also used to smuggle vital supplies to Maquis colonies and obtain weaponry through back door channels.

One of the reasons that the Maquis raiders were so successful is that they were able to take advantage of the Badlands. This region of space between the borders of the Federation and the Cardassian Union was filled with intense plasma storms and gravitational anomalies that severely limited sensor ranges. This meant that the raiders could hide here from Cardassian patrols, especially as the larger Cardassian ships did not have the maneuverability to avoid the unpredictable spatial disturbances.

In 2371, a Maquis cell operating under the command of former Starfleet officer Chakotay were aboard a Maquis raider called the *Val Jean* when it was pursued into the Badlands by the *Vetar*, a Cardassian *Galor*-class warship. The *Val Jean*'s weapons were unable to make a dent in the *Vetar*'s shields, but it was able to evade the plasma streamers inside the Badlands, while

the Cardassian ship was hit on the port blade. It seemed the *Val Jean* was going to successfully outrun the *Vetar* when it was suddenly hit by a massive displacement wave and thrown into the Delta Quadrant.

SHIP SACRIFICE

The *Val Jean* was later destroyed when Chakotay set it on a collision course with a Kazon vessel that was attacking the *U.S.S. Voyager* NCC-74656. Chakotay's actions saved *Voyager*, but it meant his Maquis crew no longer had a ship, so they had little choice but to join *Voyager*'s crew.

While Voyager was making its long journey home from the Delta Quadrant, the Maquis in the Alpha Quadrant continued to fight the Cardassian occupation of their homes. In 2373, a number of raiders under the command of former Starfleet officer Michael Eddington launched biogenic

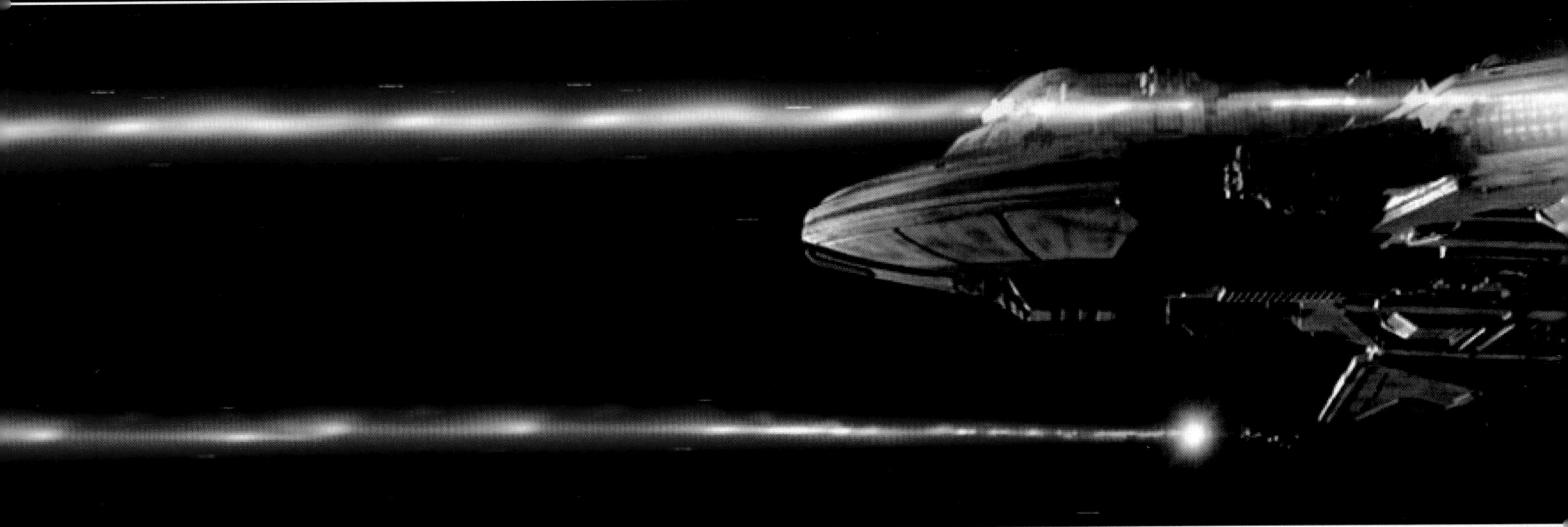

- Maquis raiders were highly maneuverable and able to weave between the dangerous gravitational anomalies and plasma streamers that filled the Badlands.
- ▶ The cockpit of the Val Jean had a similar configuration to a Danube-class runabout and had stations for up to four crew members. Chakotay's crew included a mixture of former Starfleet officers, colonists and criminals.

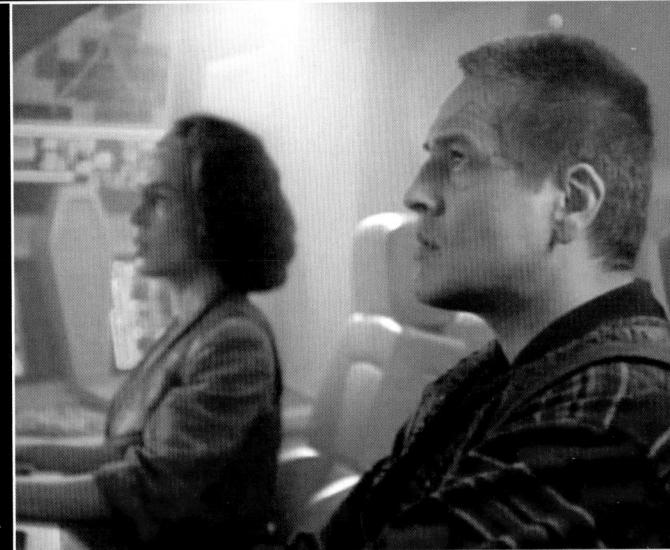

weapon attacks on two Cardassian colonies.

Eddington looked set to drive more
Cardassians from their homes until Captain
Sisko used his own tactics against him. Sisko
detonated a trilithium resin toxin lethal to humans,
but harmless to Cardassians, in the atmosphere
of a Maquis colony on Solosos III. He then
threatened to perform the same action on every
Maquis colony in the Demilitarized Zone unless
Eddington turned over his biogenic weapons and
surrendered himself to Starfleet.

Despite the setback of Eddington's capture, the Maquis were winning their struggle, mainly because the Klingons had launched a major assault against the Cardassians. The Klingons had also supplied the Maquis with 30 class-4 cloaking devices to mount on their ships.

It appeared to be just a matter of time before the Maquis emerged victorious, but then Gul

Dukat announced that the Cardassian Union had become a part of the Dominion. Backed by the might of the huge Jem'Hadar fleet, the Cardassians were able to go on the offensive. The ragtag Maquis fleet comprising mostly raiders and other small fighters stood little chance, and it was not long before every Maquis colony was wiped out, leaving the rebel group defeated.

DATA FEED

Michael Eddington, the former chief of Starfleet security aboard *Deep Space 9*, defected to the Maquis in 2372 and became one of their most important leaders. Captain Sisko took his betrayal personally and became obsessed with bringing him to justice. Eddington proved particularly elusive, however, and used a Maquis raider on more than one occasion to evade capture. He later orchestrated biogenic attacks on Cardassian colonies using Maquis raiders.

SUPPLY AND ATTACK

Maquis raiders were often used to smuggle goods to former Federation colonists living in the Demilitarized Zone. In 2372, Kasidy Yates' freighter, the *Xhosa*, met with a Maquis raider inside the Badlands in order to deliver emergency supplies.

Maquis raiders were particularly effective when used in covert missions, but they could also take on much more powerful vessels by using clever tactics. In 2373, the Maquis raider carrying Michael Eddington was able to trigger a cascade computer virus aboard the pursuing *U.S.S. Defiant* NX-74205 that completely disabled it. The raider then strafed the *Defiant* with phaser fire to add to the damage before escaping into the Badlands.

▲ The Xhosa rendezvoused with a Maquis raider under the cover of he Badlands, where it handed over food and medical supplies that had been smuggled out of Deep Space 9.

▲ A Maquis raider commanded by Michael Eddington fired on the I.S.S. Defiant after he sent a signal that implemented a computer irus on board the Starfleet ship, leaving it completely helpless.

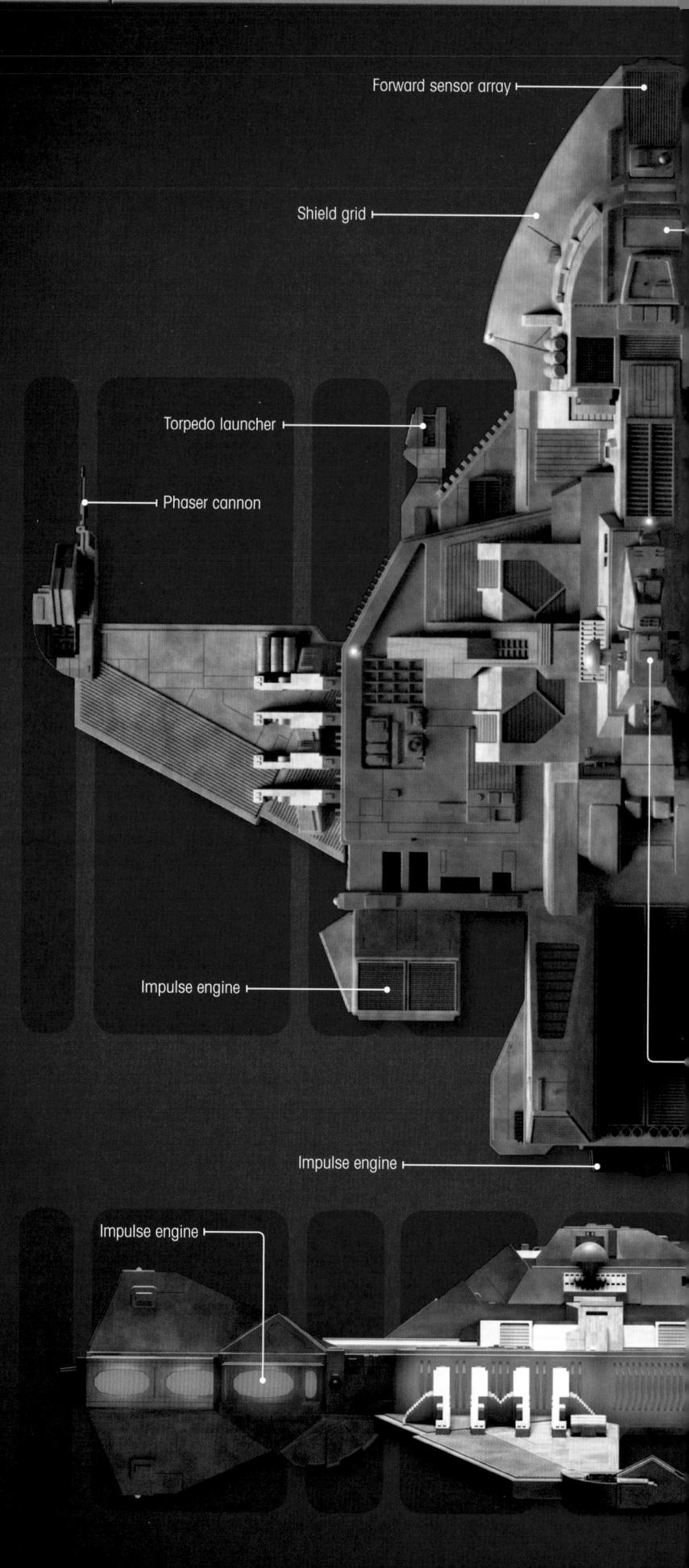

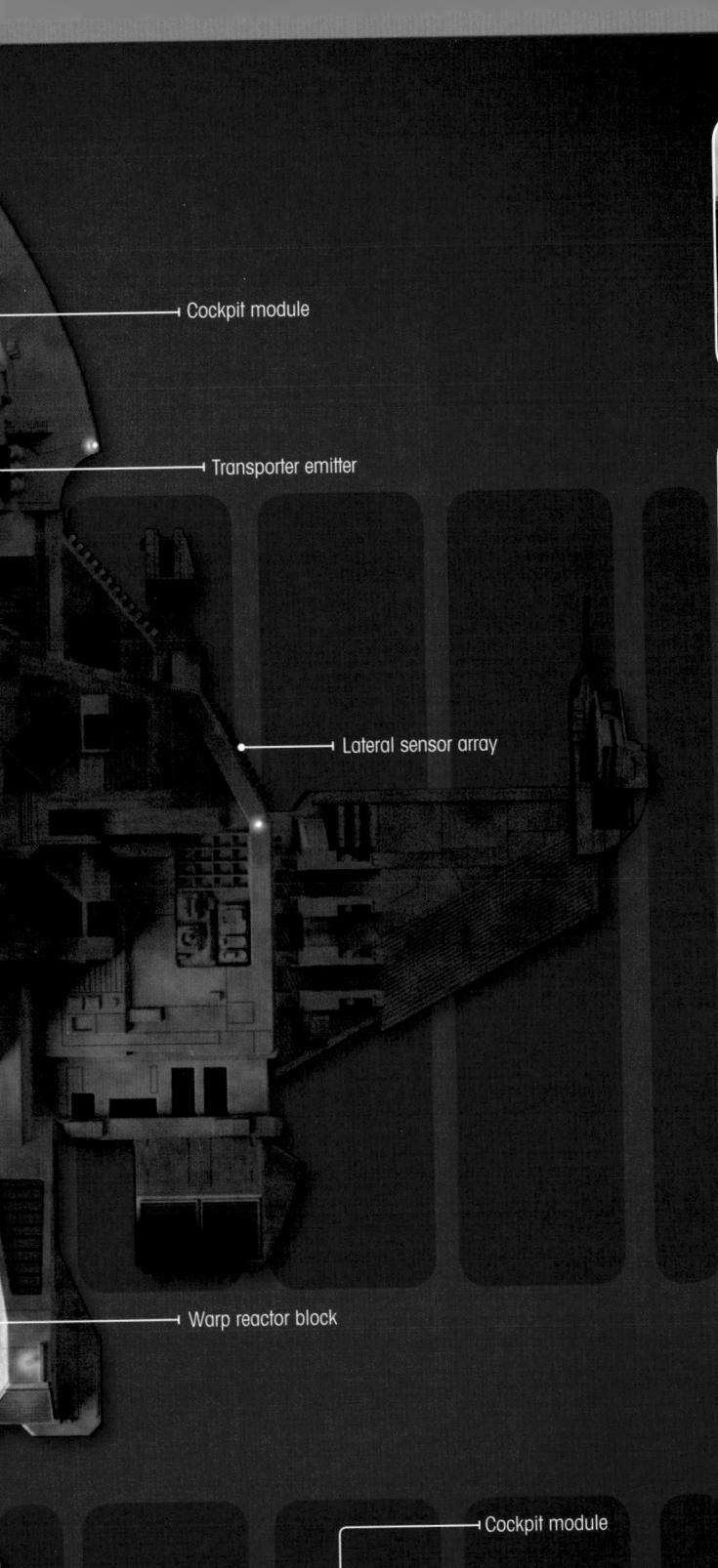

Impulse engines

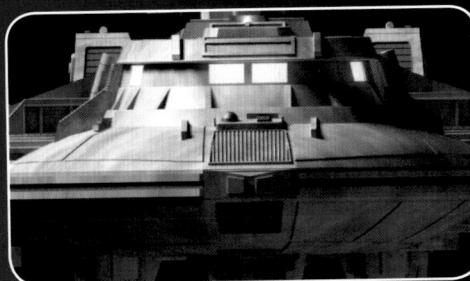

Cockpit module

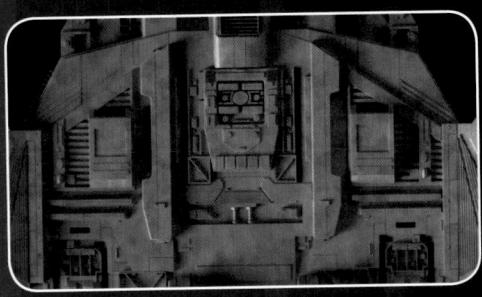

Warp reactor block

Sensor array

MAQUIS FLEET

Apart from raiders, other vessels used by the Maquis included Bajoran raiders, Bajoran interceptors, Federation attack fighters, *Peregrine*class ships, and Maquis fighters.

CREW NUMBERS

It is not known how many Maquis were aboard the Val Jean when it was taken by the Nacene entity the Caretaker, although 22 Maquis crew members were referred to by name during the U.S.S. Voyager's journey.

ILLEGAL ARMS

The Maquis generally had to arm their ships with whatever weapons they could steal or

DATA FEED

It was incredibly difficult to locate a Maquis raider once it had entered the Badlands,

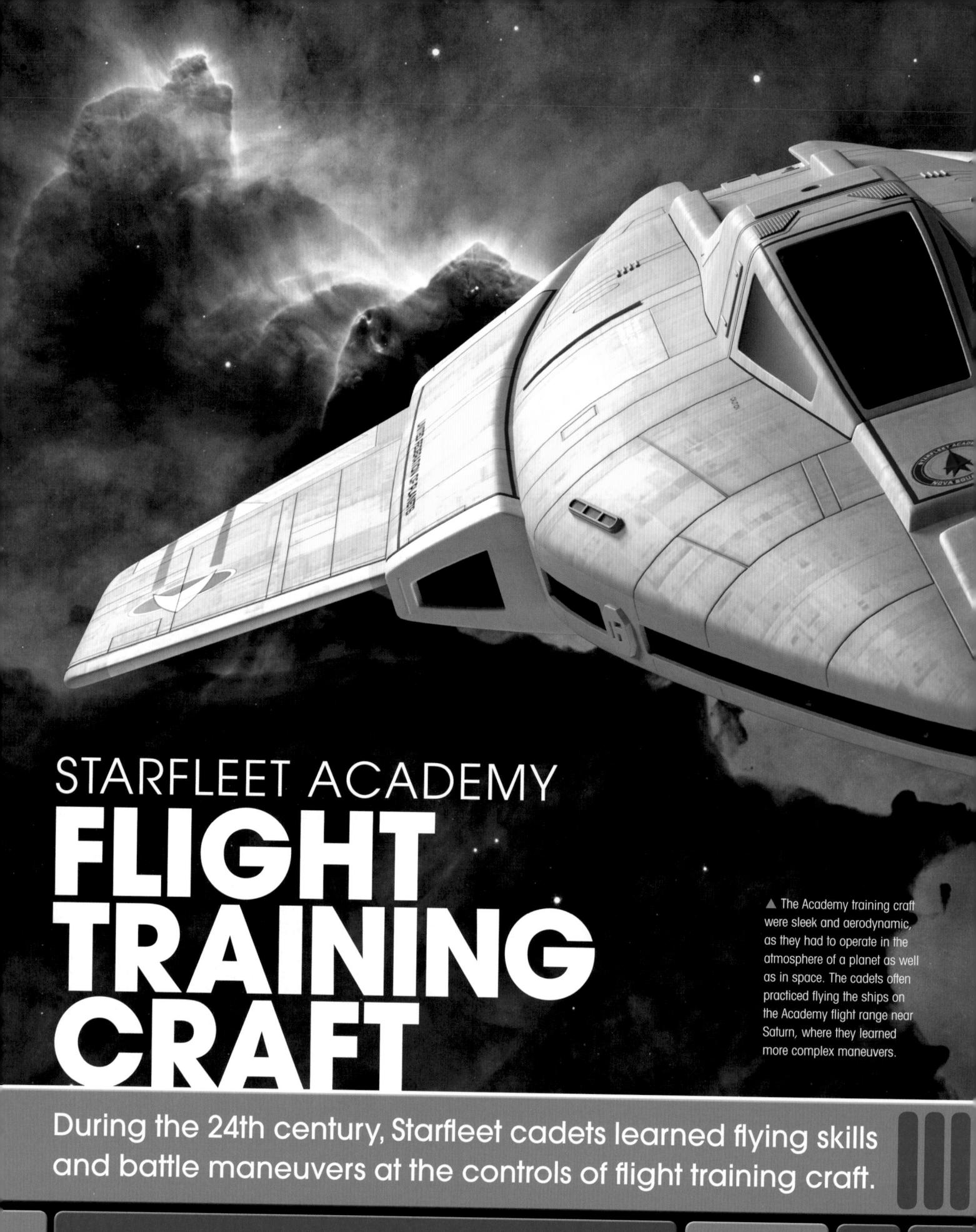

The training craft were 10.99 meters in length, and were similar in appearance to conventional atmospheric aircraft. They featured short, forwardswept stubby wings, a pointed nose and a glass canopy surrounding the pilot's position.

The craft were designed for both atmospheric and space flight, and were highly agile. They were equipped with impulse engines and thrusters only, and were not able to achieve warp flight. They normally flew at speeds of around 80,000 kph. They were also equipped with landing struts for touchdown on planetary surfaces, proximity alarms and emergency transporters.

COCKPIT LAYOUT

The training craft were normally operated by just one pilot, but could accommodate a second person or an instructor if necessary. Instrumentation included various computer readouts showing speed, course, g-forces and sensor information.

The flight training craft gave the cadets a practical education in the art of aerobatics, while also teaching them the fundamentals of starship operations. Students had to learn such disciplines as astrophysics and navigation, subjects that they would need once they had completed their training and were assigned to a starship.

Cadets who excelled during the flight exercises were picked to join an elite flight team at Starfleet

◀ Former ensign of the *U.S.S. Enterprise* NCC-1701-D Wesley Crusher was accepted to Starfleet Academy in 2367. He excelled at flight training and soon became a member of the elite Nova Squadron. During a flight display to mark their graduation ceremony, an accident occurred which cost a cadet his life, and Wesley broke his arm.

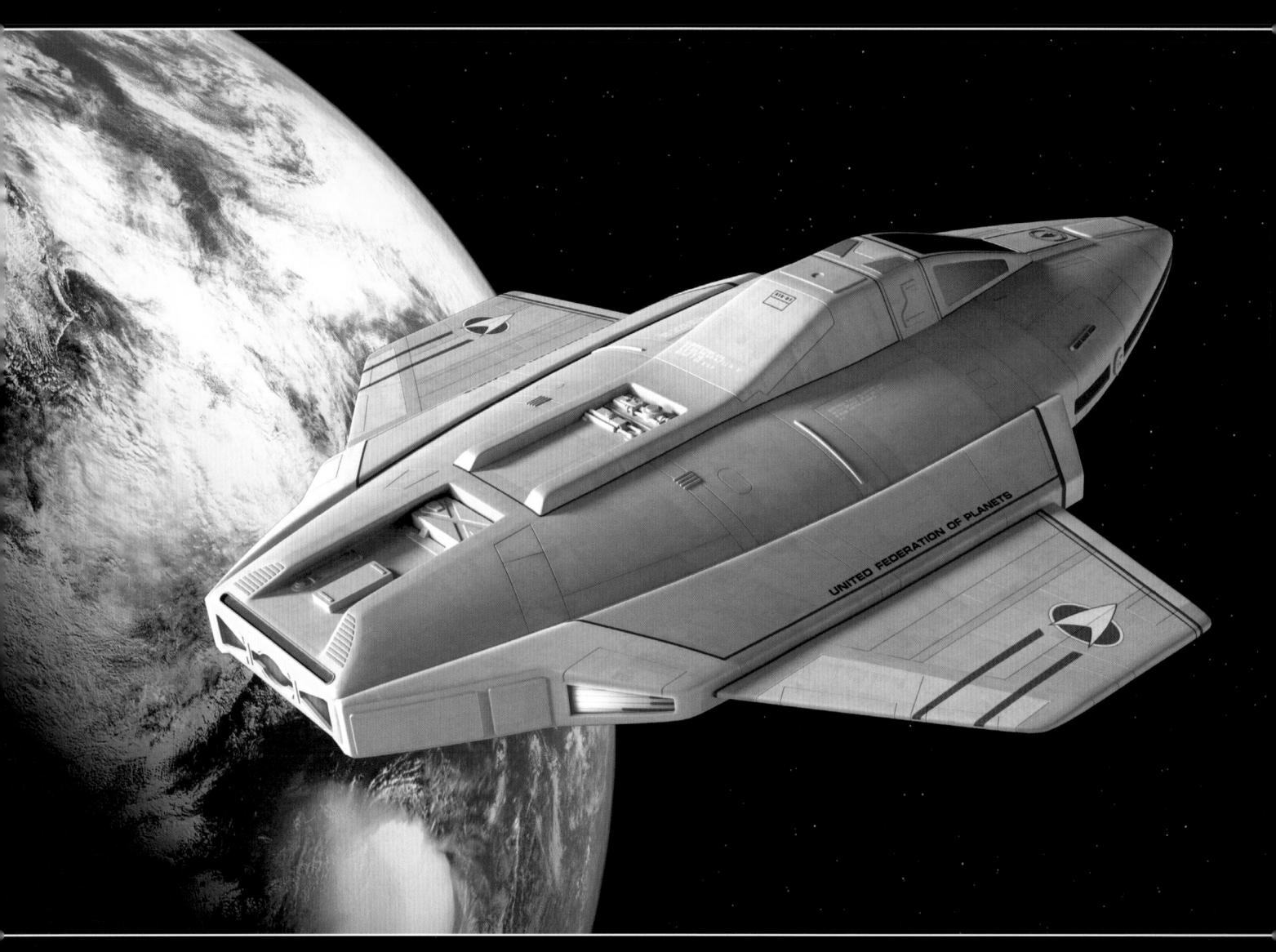

▲ The training craft had a fairly flat cross-section and short wings. They were designed to be able to perform complex aerobatic maneuvers at speeds of at least 80,000 kph. These craft taught cadets not only the rudimentaries of flying, but also what was possible when they were pushed to extremes.

Academy. This was an extremely prestigious position, much like making the football team at a traditional college, and only the most gifted and accomplished cadets were chosen.

These cadets went on to learn and perform various complex formations and maneuvers as a demonstration of their flight prowess. Other students looked up to these cadets, and cheered them on when they competed against other flight schools in competitions like the Rigel Cup.

In 2368, Wesley Crusher, a former ensign aboard the *U.S.S. Enterprise* NCC-1701-D, was part of Nova Squadron, one of the elite flying teams at Starfleet Academy. This five-person team also consisted of Nicholas Locarno, Jean Hajar, Joshua Albert and Sito Jaxa, a Bajoran. Together they had achieved almost legendary status at the Academy by winning the Rigel Cup, which resulted in celebrations that, according to groundskeeper

Mr. Boothby, made the parrises squares champion celebrations of 2324 look like a dinner party.

Driven by the ambition of Locarno, the leader of Nova Squadron, they planned to put on a flight show due to be transmitted to the graduation ceremony of 2368 that no-one would forget. That was exactly what they achieved, but unfortunately for all the wrong reasons.

TRAGIC FATALITY

During practice for the flight demonstration, there was an accident that cost the life of one of the pilots – Joshua Albert. The other members of Nova Squadron managed to transport to safety, and although Wesley suffered second-degree burns and multiple fractures of his arm, they survived.

At first, all the surviving members of Nova Squadron said they could not understand how the accident had happened. They were flying in Nova Squadron practiced on the Academy flight range, vhich was located near Saturn. They were in close formation here vhen there was a collision that destroyed all five ships.

▼ Sito Jaxa and Jean Hajar were also part of Nova Squadron. Like Vesley, they looked up o their team leader, Nicholas Locarno, and vere prepared to do anything he told them to keep their team together.

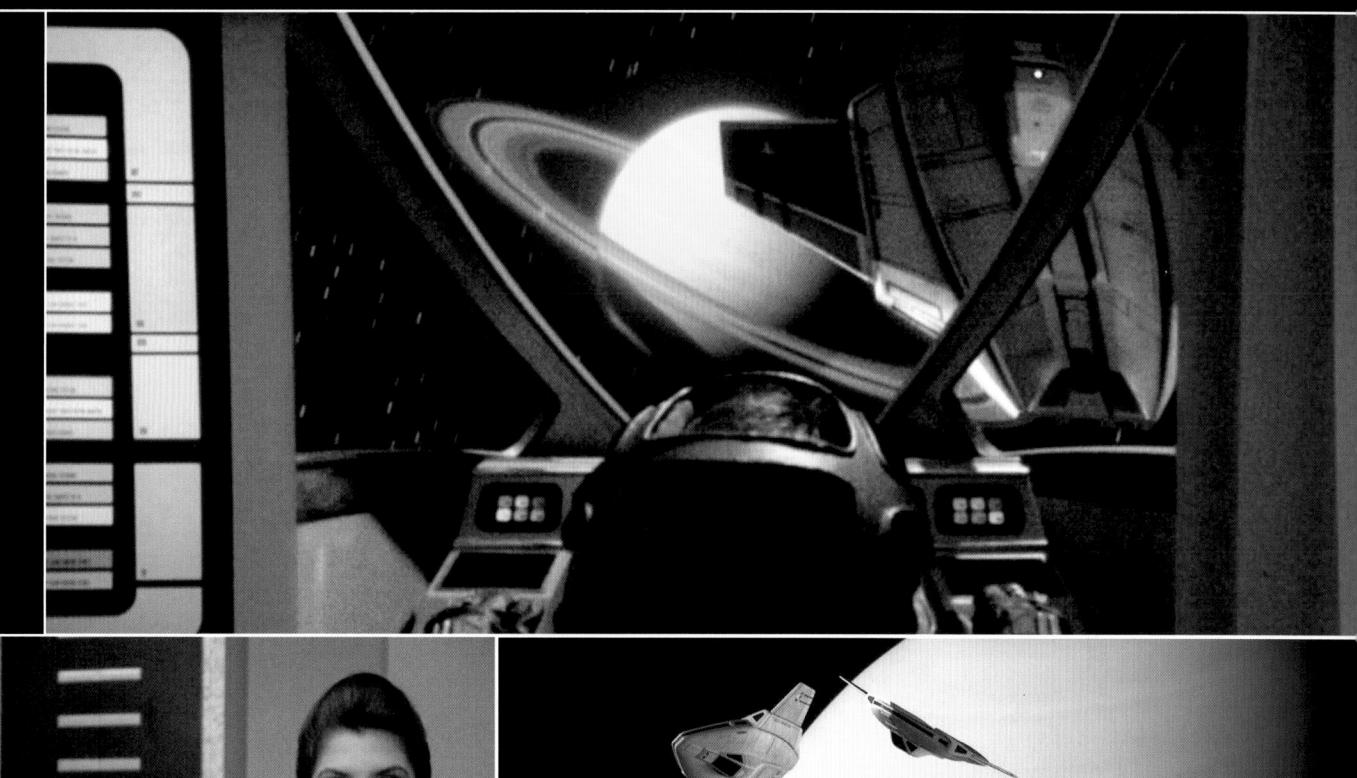

Only one of the ships' data recorders was recovered, but this did not reveal what had happened at the moment of the crash. Locarno claimed that they were preparing for a maneuver known as a Yeager loop when Albert's ship collided with Hajar's craft. They had less than two seconds to perform an emergency beam out to the evac station on Mimas, one of Saturn's moons, but Albert did not make it.

It was only when Captain Picard looked into the matter that the truth emerged. He deduced that the squadron were trying to perform a maneuver known as a Kolvoord Starburst. This stunt required great precision, but it was also very dangerous. In fact, it had not been performed for more than a century, as the last time it was attempted it resulted in the deaths of all five cadets.

In the end, Wesley's guilty conscience led him to tell the truth at the inquest. Locarno was expelled from the Academy, but in an impassioned plea he stated that he alone convinced the others to try the Kolvoord maneuver and it was his idea to cover up the truth. He sacrificed himself to save the rest of the squadron, and Wesley and the others were allowed to remain at the Academy.

▲ To prove their piloting prowess, cadets performed aerobatic maneuvers in close formation. While they looked impressive, these exercises were not about showing off, but prepared them for combat flying.

DATA FEED

Cadet First Class Nicholas Locarno was the leader of Nova Squadron. He was confident, charismatic and appeared to be a born leader. He engendered complete trust and loyalty in his fellow cadets, but he was hugely ambitious. He persuaded his squadron to perform the prohibited Kolvoord Starburst maneuver, so they would become legends at the Academy. When it resulted in a death, he tried to persuade the others to cover up what had really happened.

KOLVOORD STARBURST

The Kolvoord Starburst was the name given to a spectacular, but highly dangerous, aerobatic space maneuver.

Five training craft were needed to execute the display. They began by arranging themselves in a circular formation, coming extremely close together. They then bursted out simultaneously in different directions, igniting their plasma trails in their wake. This produced a spectacular 'starburst' effect, from which the maneuver took its name.

The display was certainly impressive, but a decision was taken to ban it, following the death of five cadets who attempted the stunt. Despite knowing this, Nova Squadron leader Nicholas Locarno wanted to attempt it, and persuaded his team to give it a go, even though they were not given official authorization.

They found out first hand how dangerous it was when the training craft collided during the maneuver and all five vessels were destroyed. Four team members managed to use their emergency transporters just in time and beam to safety, but one – Joshua Albert – did not and he died in the accident.

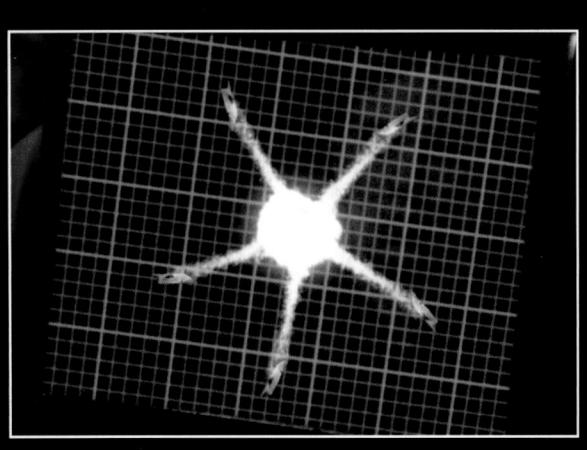

▲ The Kolvoord Starburst took its name from the effect it produced when five ships came together before flying apart while igniting their plasma trails, producing a neon-white star effect in space.

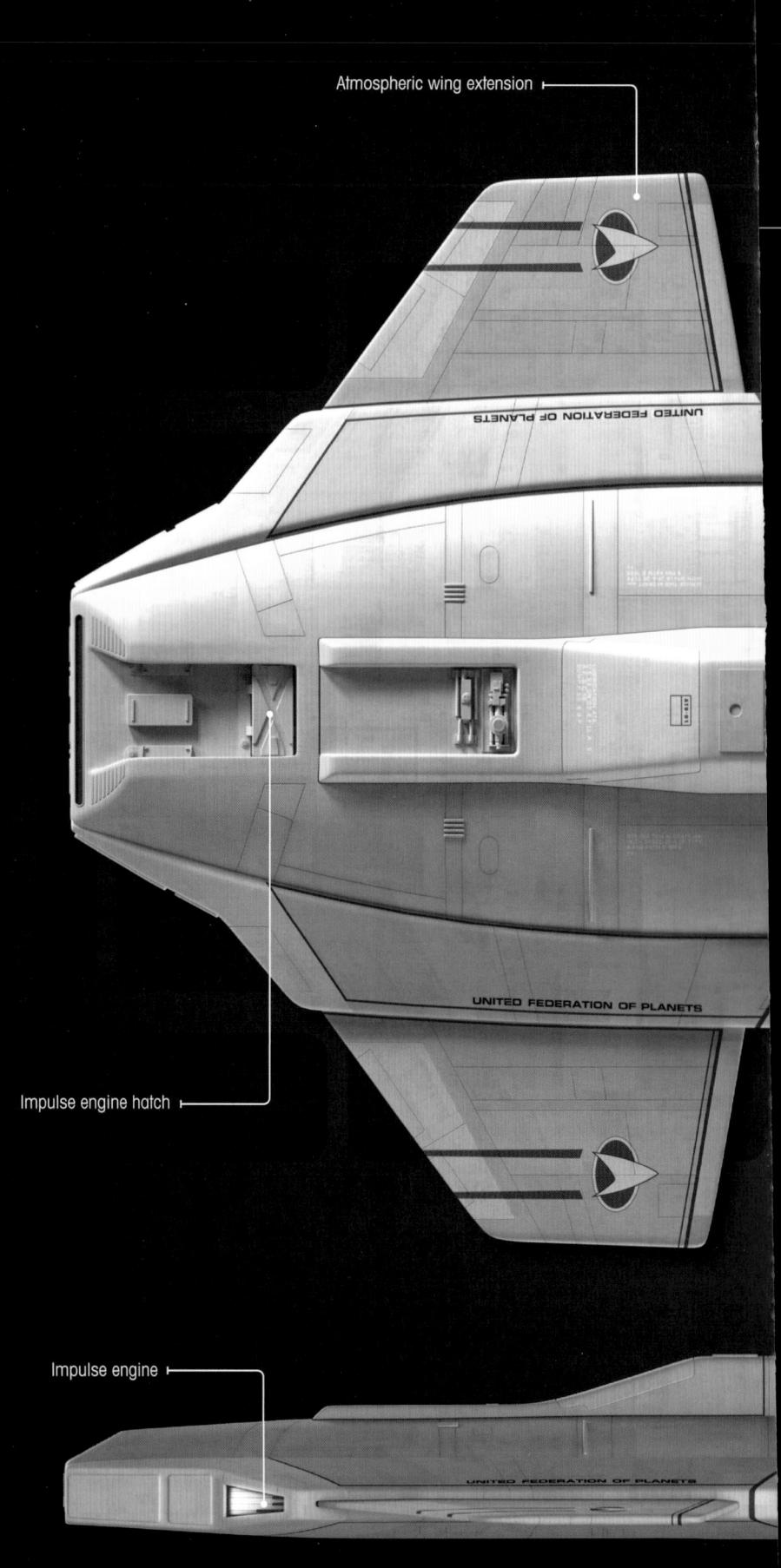

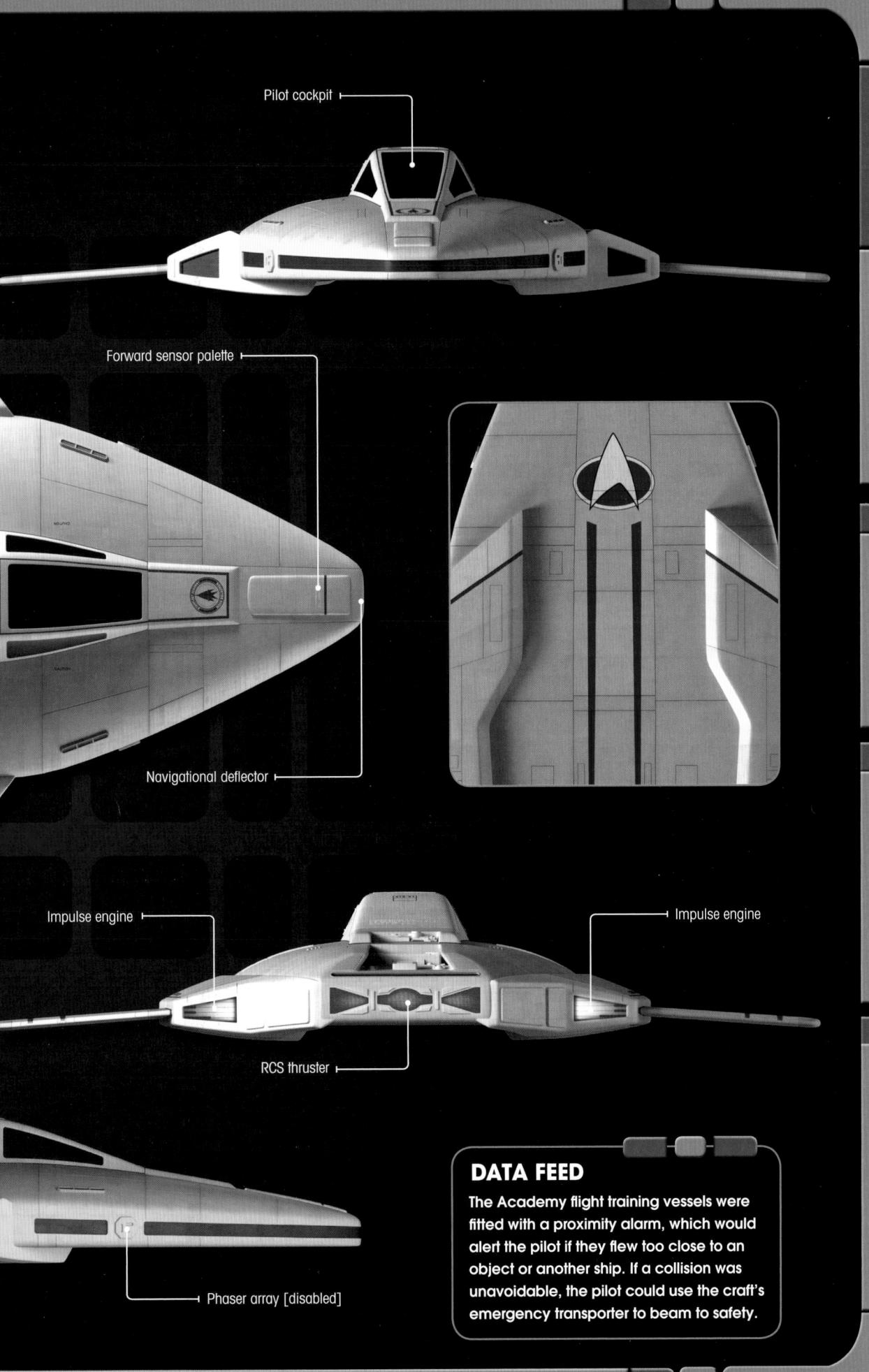

LATIN GRAMMAR

The Starfleet Academy logo featured the Latin phrase *Ex Astra, Scientia*. This was grammatically incorrect and was later updated to *Ex Astris, Scientia,* which meant 'From the stars, knowledge.'

SECOND CHANCE

Sito Jaxa, the Bajoran member of Nova Squadron, was later assigned to serve aboard the U.S.S. Enterprise NCC-1701-D at the request of Captain Picard because he wanted to make sure she had a fair chance to redeem herself.

SQUAD TROUBLE

In addition to Nova
Squadron, Starfleet
Academy also operated
another elite group of
cadets known as Red
Squad. In 2372, a
number of Red Squad
cadets disabled a global
power distribution center
in Lisbon, allowing
Admiral Leyton to
launch a coup attempt.

squadrons of attack fighters fought in the Dominion War.

FEDERATION ATTACK FIGHTER

Federation attack fighters were versatile combat craft that could be configured to fire a wide range of weaponry.

highly maneuverable starship that packed a powerful punch for its size. These warp-capable vessels were used for defense purposes on Federation worlds in the mid- to late 24th century. Many were later appropriated by the Maquis for their insurrection against the Cardassians, and in the mid 2370s, Starfleet employed these vessels in squadrons in the fight against the Dominion and their allies. In appearance, the Federation attack fighter

he Federation attack fighter was a small,

In appearance, the Federation attack fighter was much more like a suborbital aircraft. It featured downward-swept gullwings and two impulse engines fixed to a spar at the rear. These fixtures indicated that the vessels were designed for atmospheric flight as well as space flight. Certainly they were capable of extreme aerobatic-type maneuvers, making them difficult to hit while they carried out attacks.

PROTECTED PROPULSION

These vessels possessed warp engines, while inboard warp nacelles were located between the main body of the ship and the wings. As the nacelles were protected, it made it more difficult for enemy craft to target their propulsion units.

Despite being approximately 25 meters in length, attack fighters could be armed with a formidable array of weaponry. These included pulse cannons located in the wings, energy disruptors, particle accelerators and photon torpedoes. Together with their deflector shields, these weapons meant attack fighters delivered a considerable threat,

▼ Federation attack fighters featured an impressive arsenal including pulse cannons, phaser emitters and torpedo launchers. They could also be retrofitted to fire third-party weapons. For example, in 2370 the Maquis engineered them to fire weapons provided by the Pygorians, including particle accelerators and high-energy disruptors.

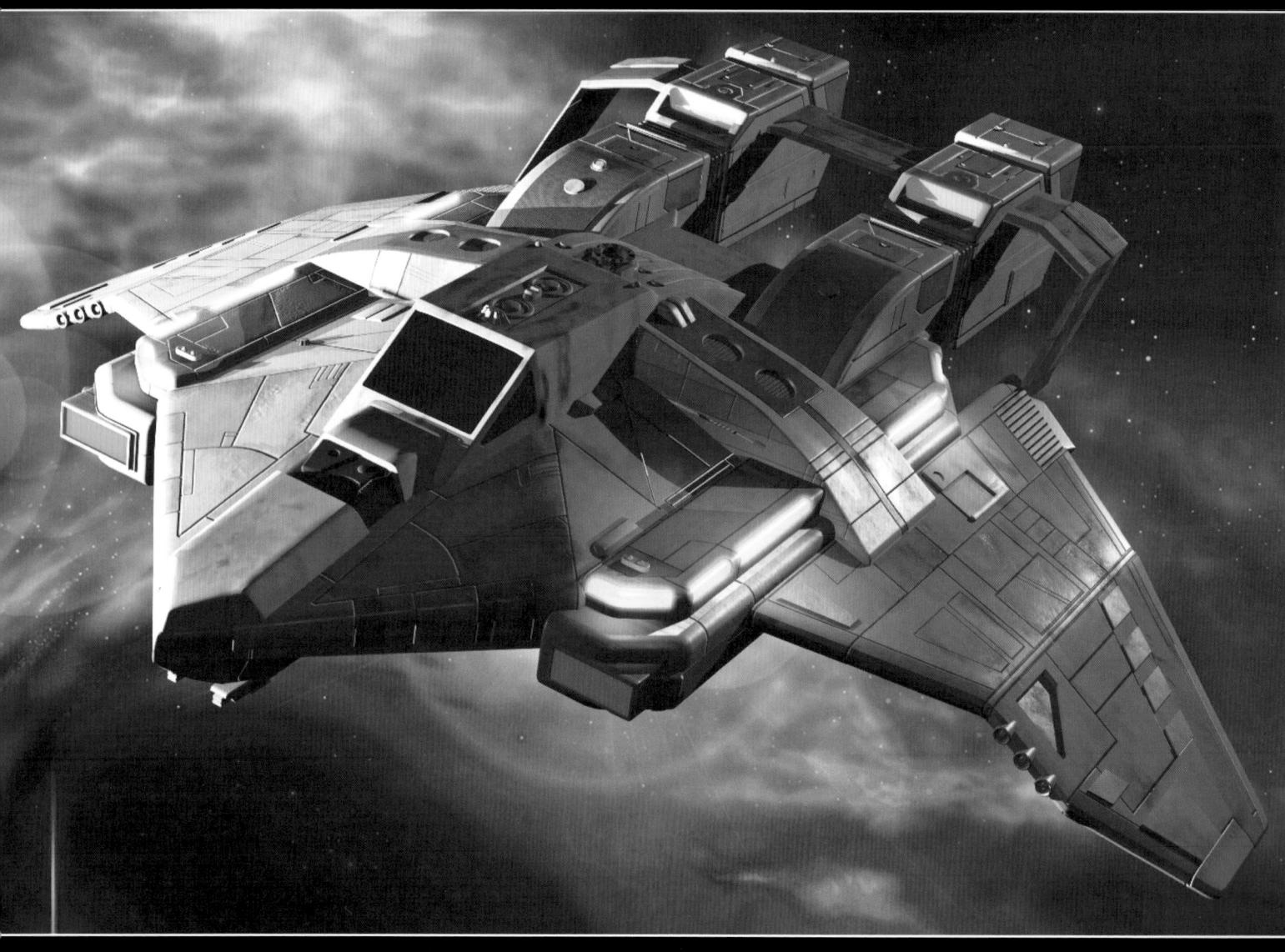

▲ The overall design of the attack fighter was closer to an atmospheric aircraft that a spaceship. The wings provided added stability for extreme flight maneuvers, making it hard to target in combat situations. Its warp nacelles were enclosed within the main body, in much the same way as they were on the Defiant class, helping to keep them protected.

especially when they launched a coordinated assault in numbers. By attacking in formation, these vessels were capable of disabling or destroying much larger vessels.

The cockpit of an attack fighter was very similar to the interior of Starfleet shuttles, and normally contained just two seats for the pilot and co-pilot. At the rear of the cramped cockpit was a single transporter pad.

By 2370, a number of Federation attack fighters had been stolen by the Maquis, and were used to fight the Cardassians. These resistance soldiers had to use any means at their disposal to arm the attack fighters, and using Quark as a go-between, they obtained weapons from the Pygorians. These black market goods included deflector shields, navigation arrays, pulse cannons and energy disruptors that could all be modified to work on the attack fighters.

Calvin Hudson, a former Starfleet officer turned Maquis leader, planned to use two attack fighters to carry out a strike against the Bryma colony, a world that the Maquis believed was being used as a weapons depot by the Cardassians. Commander Benjamin Sisko learned of this imminent attack and managed to put a stop to it using three runabouts, but Hudson and his colleagues got away.

TARGETING THE CARDASSIANS

Later the same year, Gul Evek's Galor-class vessel came under assault from several Federation attack fighters being deployed by the Maquis. According to Evek, these attack ships were armed with photon torpedoes and type-8 phasers. The Cardassian ship would surely have been destroyed had the U.S.S. Enterprise NCC-1701-D not come to its rescue and driven off the attack fighters.

The Maquis managed get their hands on veral attack fighters to lip in their fight against e Cardassians. They led two closely related signs of fighter. The rision Ro used featured larger central cockpit.

The interior of an tack fighter was small, th room for only two cupants. It did have bace for a single insporter pad in the ar, which Lieutenant Rosed to beam medical upplies aboard.

At around the same time, it was decided that more had to be done to stop the Maquis, and Lieutenant Ro Laren was tasked with infiltrating one of their resistance cells. To gain the trust of the Maquis, Ro staged a raid on the *Enterprise* and stole medical supplies using an attack fighter.

Later, Ro was supposed to lure a Maquis cell into a trap set by Starfleet. She was to lead several attack fighters in a raid against a Cardassian convoy that was supposedly carrying components for a biogenic weapon. The plan was that a Starfleet force would ambush them as they began the attack, but in the end Ro's sympathies lay with the Maquis. She exposed the Starfleet vessels that were waiting for them, and the attack fighters turned back at the last minute so they could live to fight another day with Ro by their side.

By 2374, Federation attack fighters were being

Dominion and its allies. During 'Operation Return,' squadrons of attack ships were used in an effort to take back control of *Deep Space 9*. Eight successive waves of fighters were deployed to attack Cardassian ships, hoping to provoke them into breaking formation and creating an opening through which larger Starfleet ships could advance towards *Deep Space 9*.

▲ In the battle to regain control of *Deep Space 9* from the Dominion, Starfleet used several squadrons of attack fighters alongside larger ships to try and punch a hole through the lines of enemy ships.

DATA FEED

Calvin Hudson was Starfleet's attaché to the Federation colonies in the Demilitarized Zone. After years of witnessing the brutal treatment of colonists at the hands of Cardassians, he secretly joined the Maquis. Hudson led two attack fighters in a raid against the Bryma colony that was believed to be storing weapons for the Cardassians. In the end, the mission was stopped by his old friend Benjamin Sisko, but Hudson escaped to continue the Maquis' fight.

'OPERATION RETURN'

Federation attack fighters played a pivotal role in the battle to retake control of *Deep Space 9* in 2374. Captain Sisko devised a plan in which attack ships would swarm Cardassian vessels before retreating in the hope that the Cardassians would follow them. The idea was that this would create a weakness in their defenses through which larger Starfleet ships could punch a hole.

After the eighth wave of attack fighters flew in, Gul Dukat appeared to take the bait, but he was merely laying a trap as he left several *Galor*-class destroyers in reserve. Sisko recognized that it was an ambush, but pressed ahead as he felt that they might not get a better chance. Finally, just the *Defiant* managed to get through the enemy lines, but as it closed in on *Deep Space 9*, the minefield that was preventing Dominion forces coming through the wormhole was brought down.

With hundreds of Dominion reinforcements ready to emerge in the Alpha Quadrant, Sisko ordered the *Defiant* to engage them in the wormhole. Just as they were about to meet the Dominion forces, the Bajoran Prophets intervened. They mysteriously made the Dominion reinforcements simply disappear, much to the bafflement of everybody. By this time, the Starfleet forces had been joined by the Klingons and 200 allied ships had broken through the Dominion lines. The Dominion and Cardassian occupation force had to abandon *Deep Space 9*, while the rest of their fleet had broken off the fight and were in full retreat.

Starfleet destroyer units provided cover as squadrons of attack ighters swooped in on Cardassian vessels, hoping that they would be ollowed and a gap in the Dominion's defenses would be opened up.

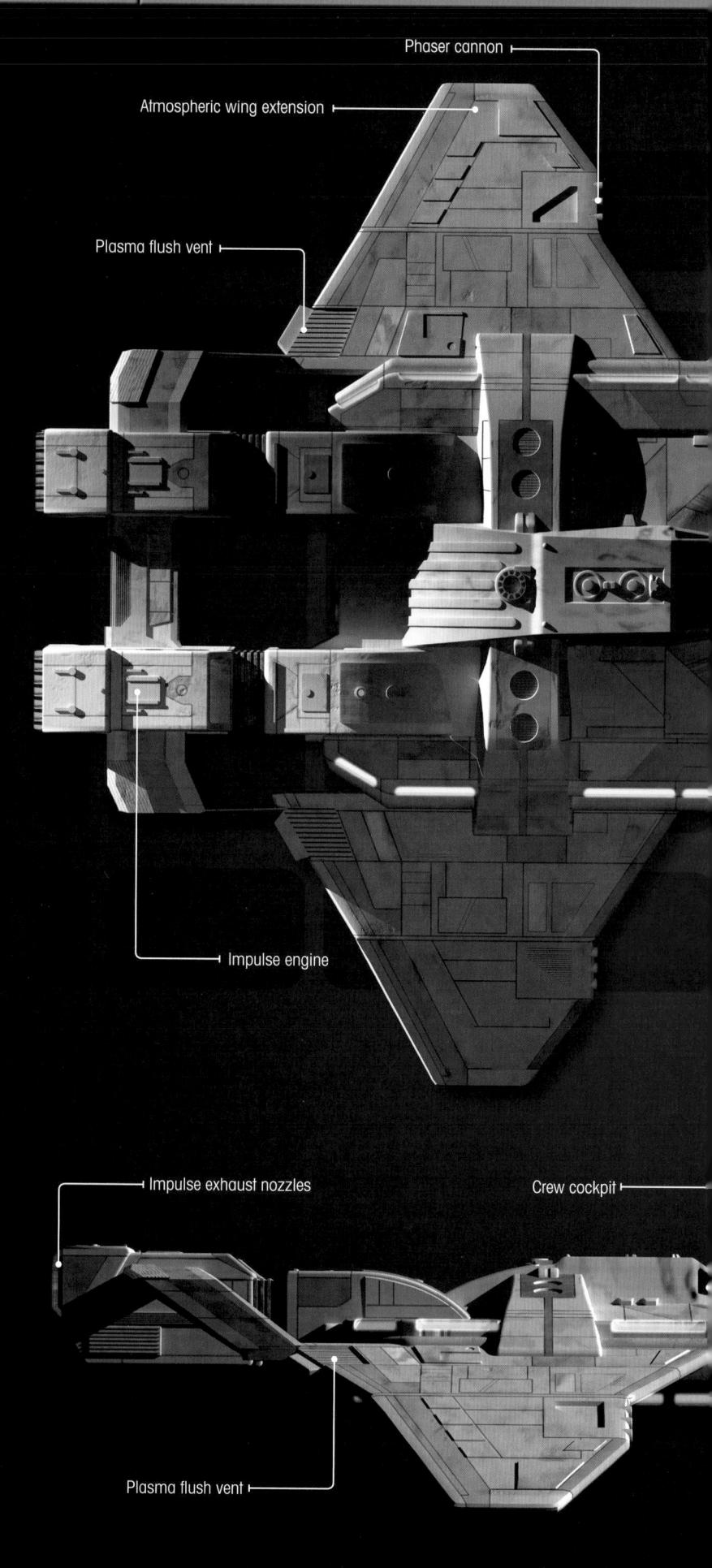

The Maquis referred to the Federation attack fighter that Ro Laren used to stage the raid on the *U.S.S. Enterprise* for medical supplies as 'Alpha Seven.' Later, Ro beamed off this ship to permanently join the Maquis. She transported to another attack fighter that was known as 'Alpha Nine.'

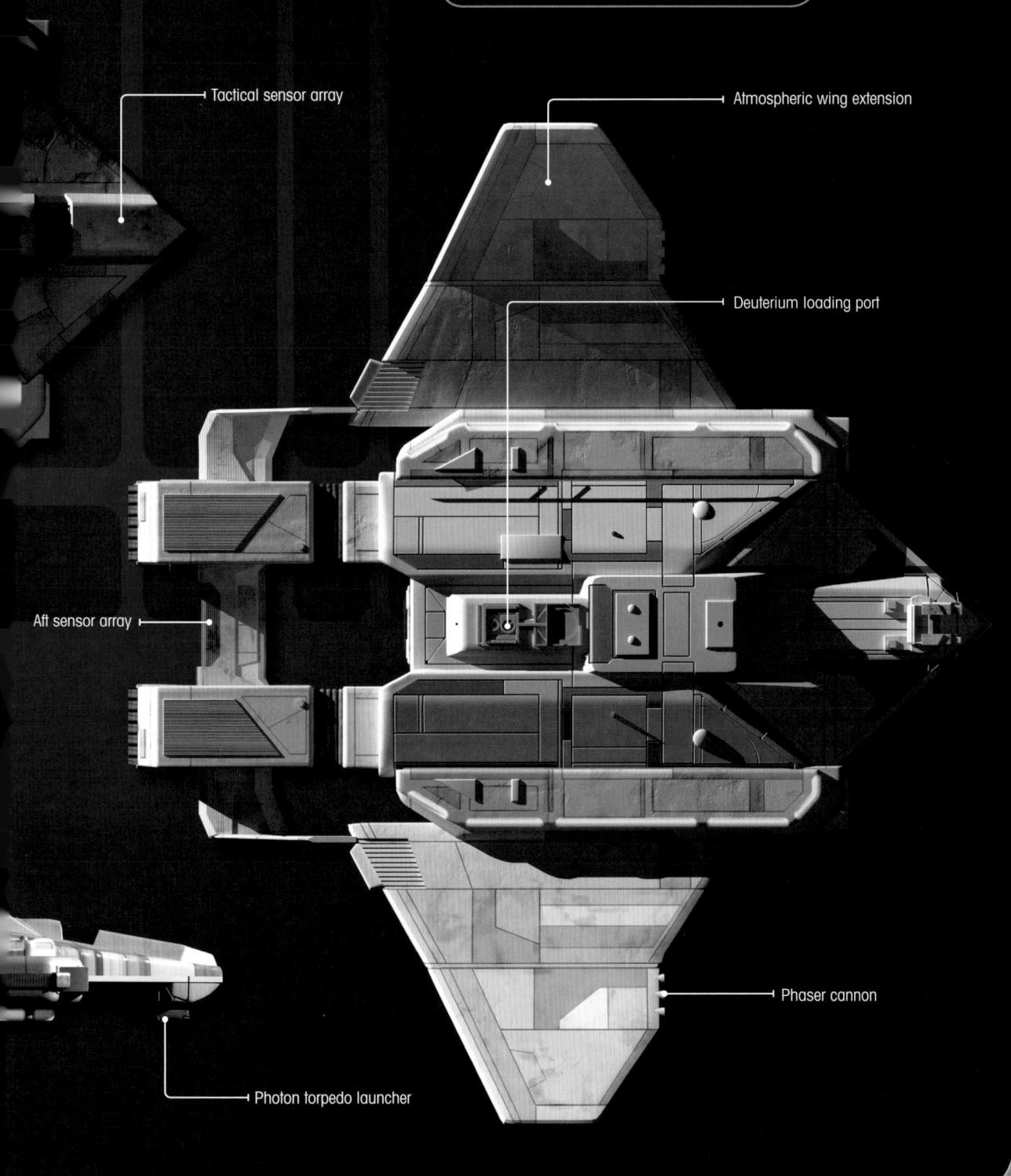

FLIGHT TRAINER

According to an LCARS display screen seen on the *U.S.S.*Voyager NCC-74656, the Federation attack fighter was used as a flight trainer for students at Starfleet Academy.

REBEL DEATH

Calvin Hudson, who was seen piloting an attack fighter in 2370, was killed three years later by the Jem'Hadar. In fact, the Maquis were completely wiped out around this time after the Dominion helped the Cardassians to fight the rebel insurrection.

MAQUIS SHIPS

Ships used by the Maquis included the *Peregrine*-class courier and the Maquis raider. The latter was similar in design to the attack fighter, but larger. Its cockpit had seating for four, while the aff section could accommodate around 40 personnel.

FIGHTERS SIZE CHART

FLIGHT TRAINING CRAFT

10.99m

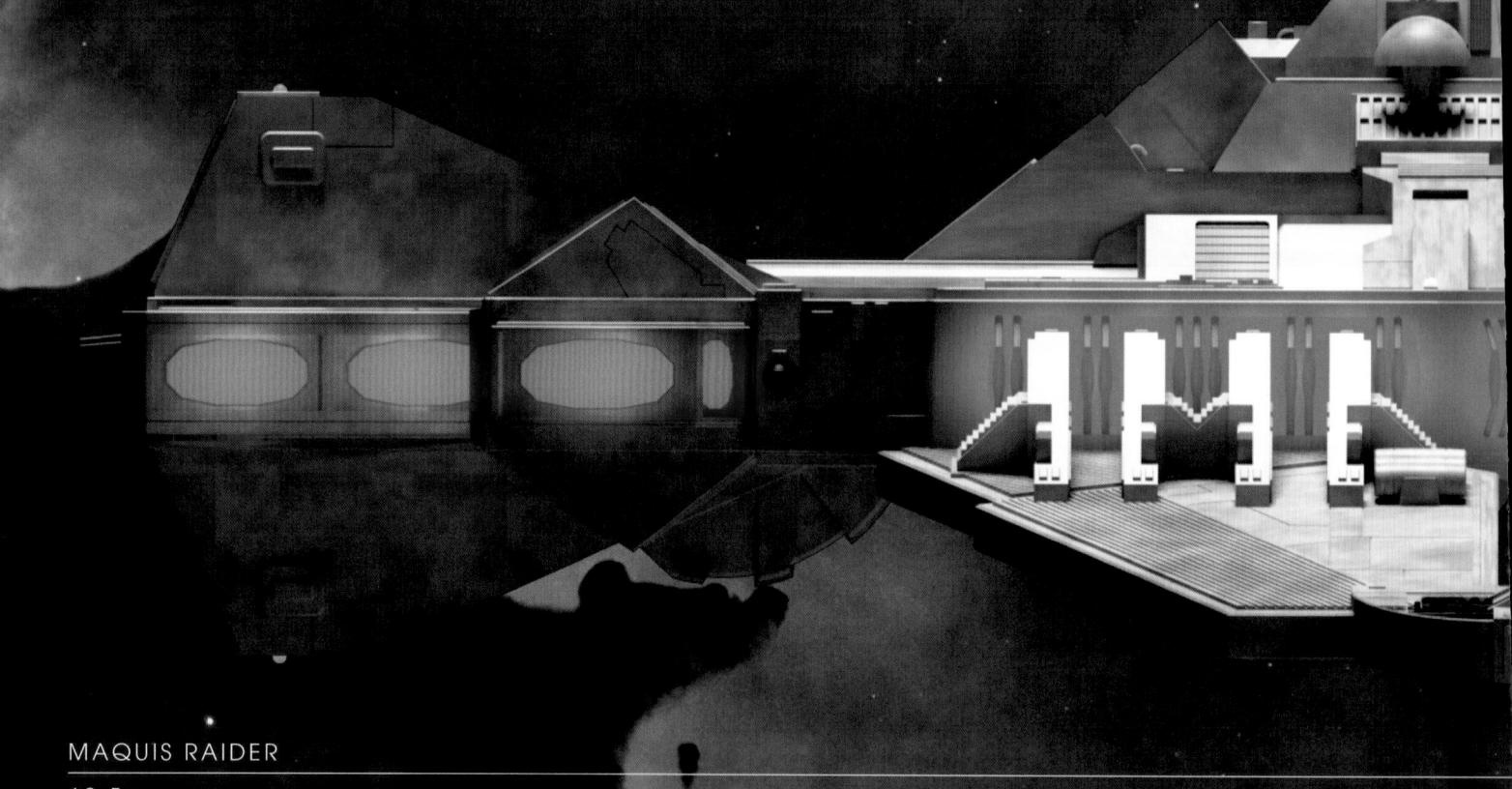

68.5m

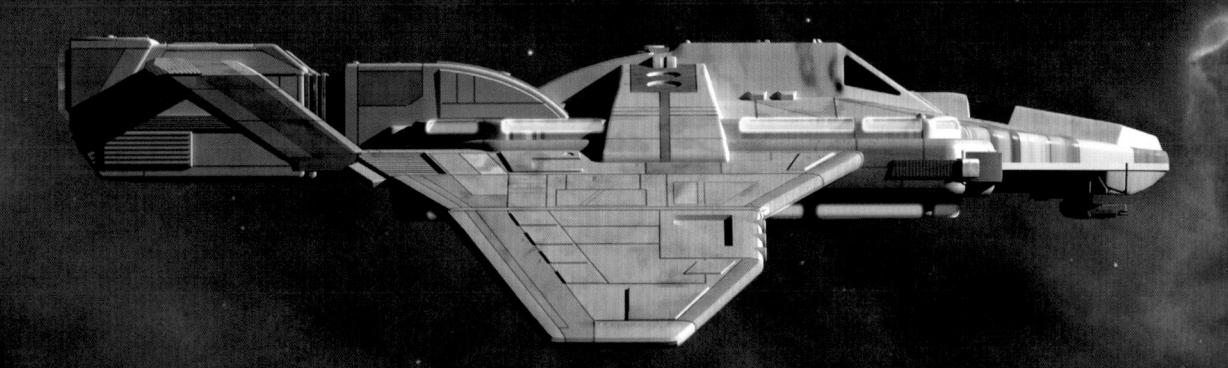

FEDERATION ATTACK FIGHTER

25m

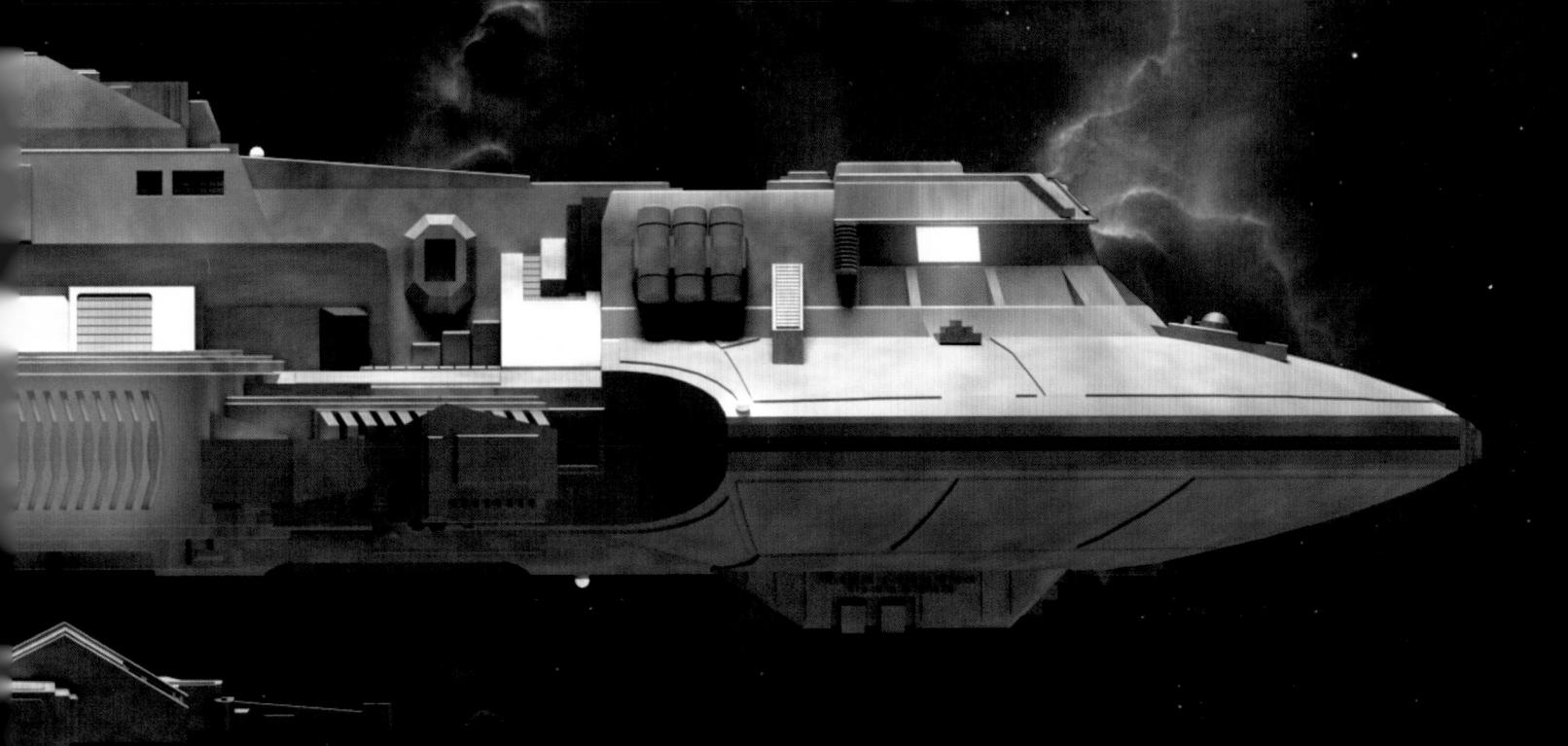

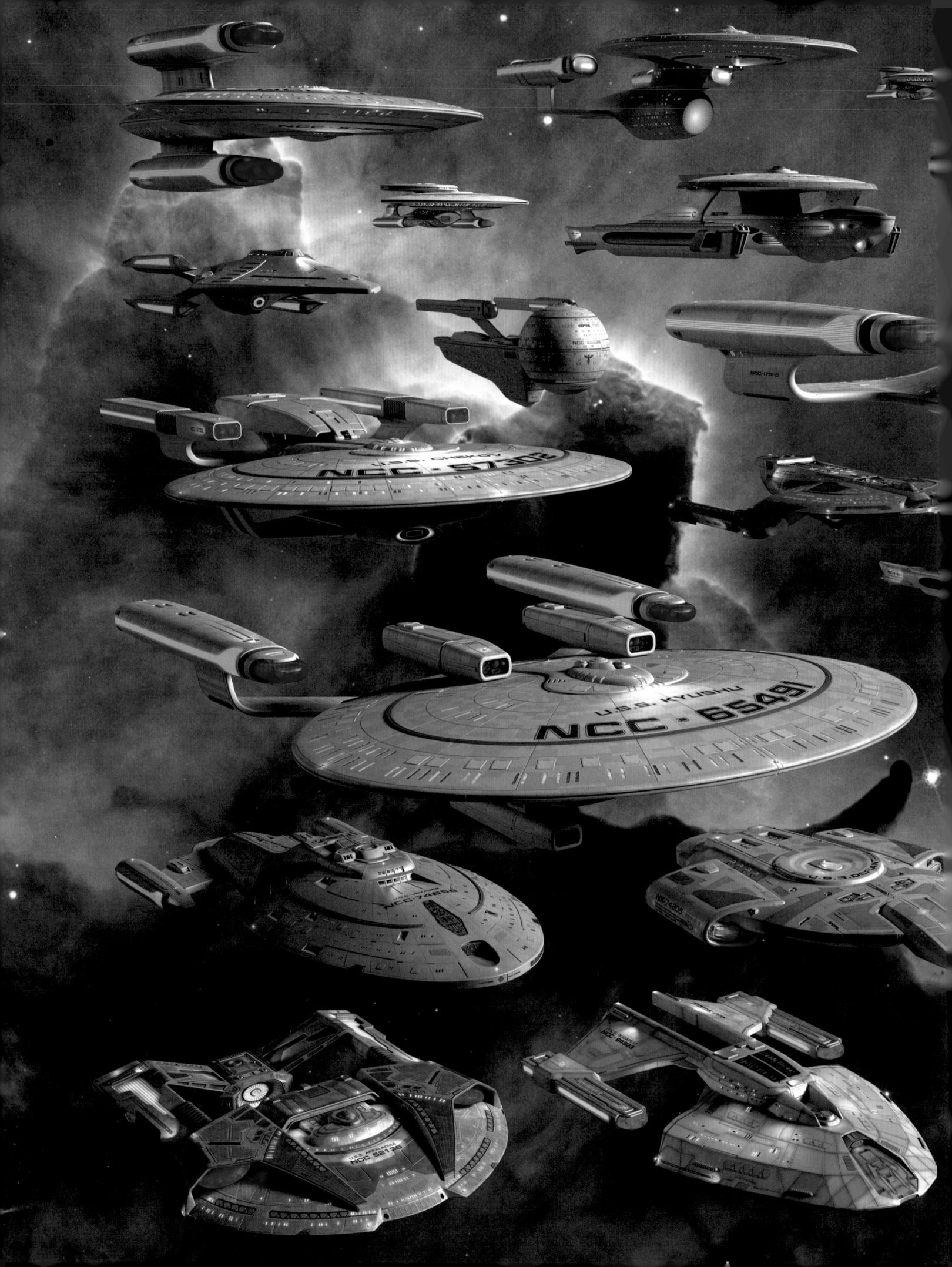

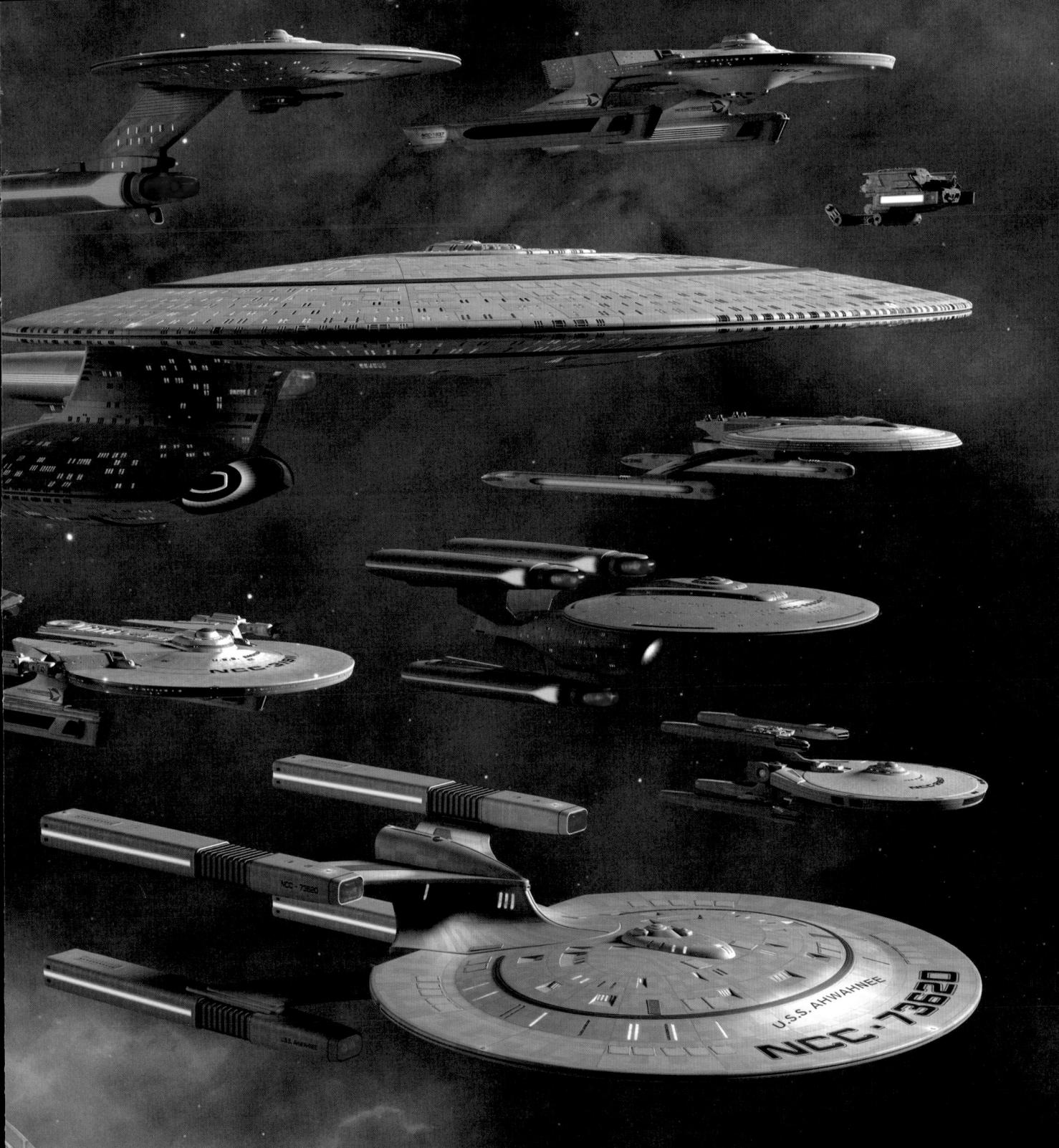

CHAPTER 3
MULTI-MISSION
EXPLORERS

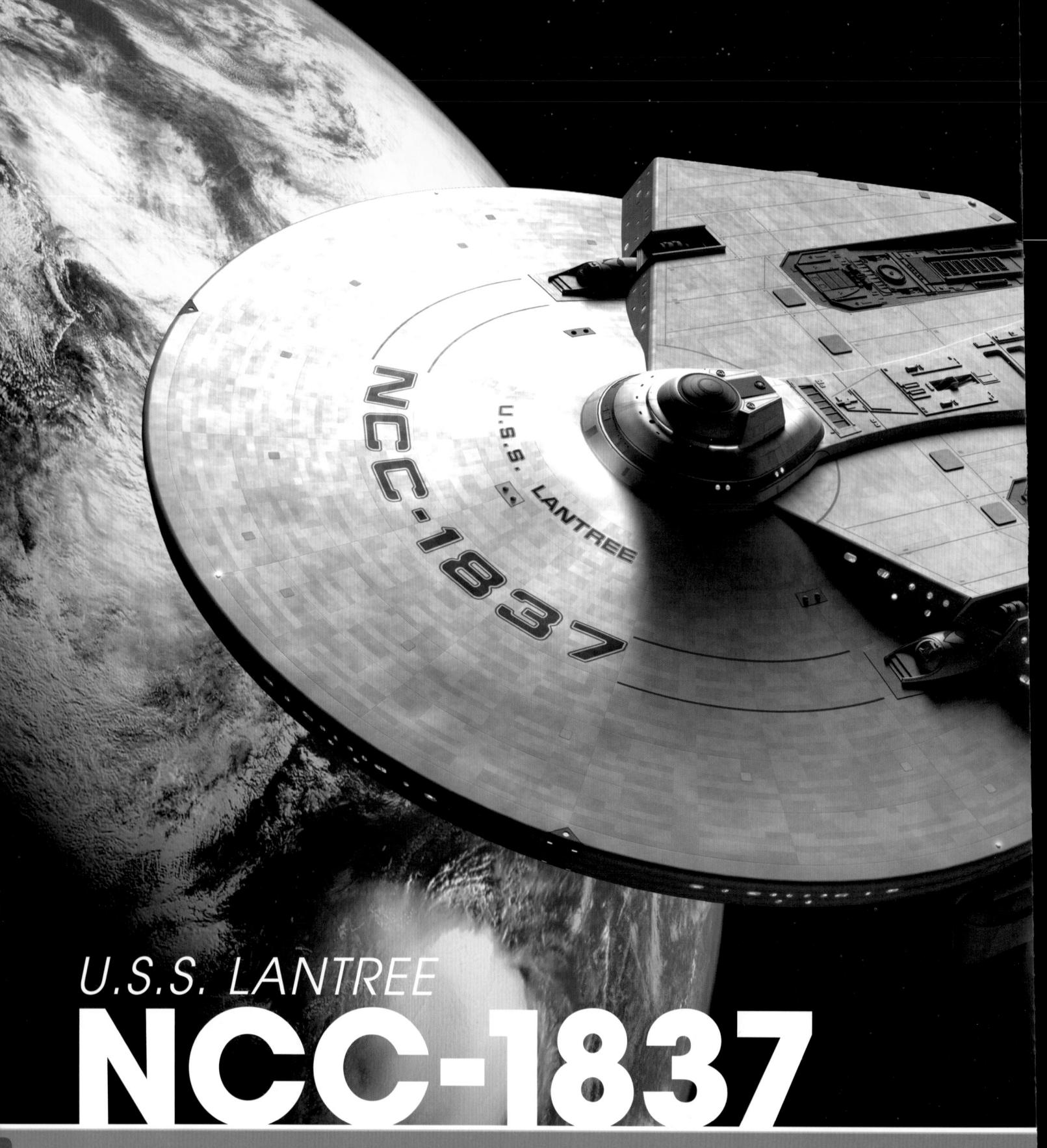

The *U.S.S. Lantree* was a *Miranda*-class ship that was used for supply duties from the late 23rd to the mid-24th century.

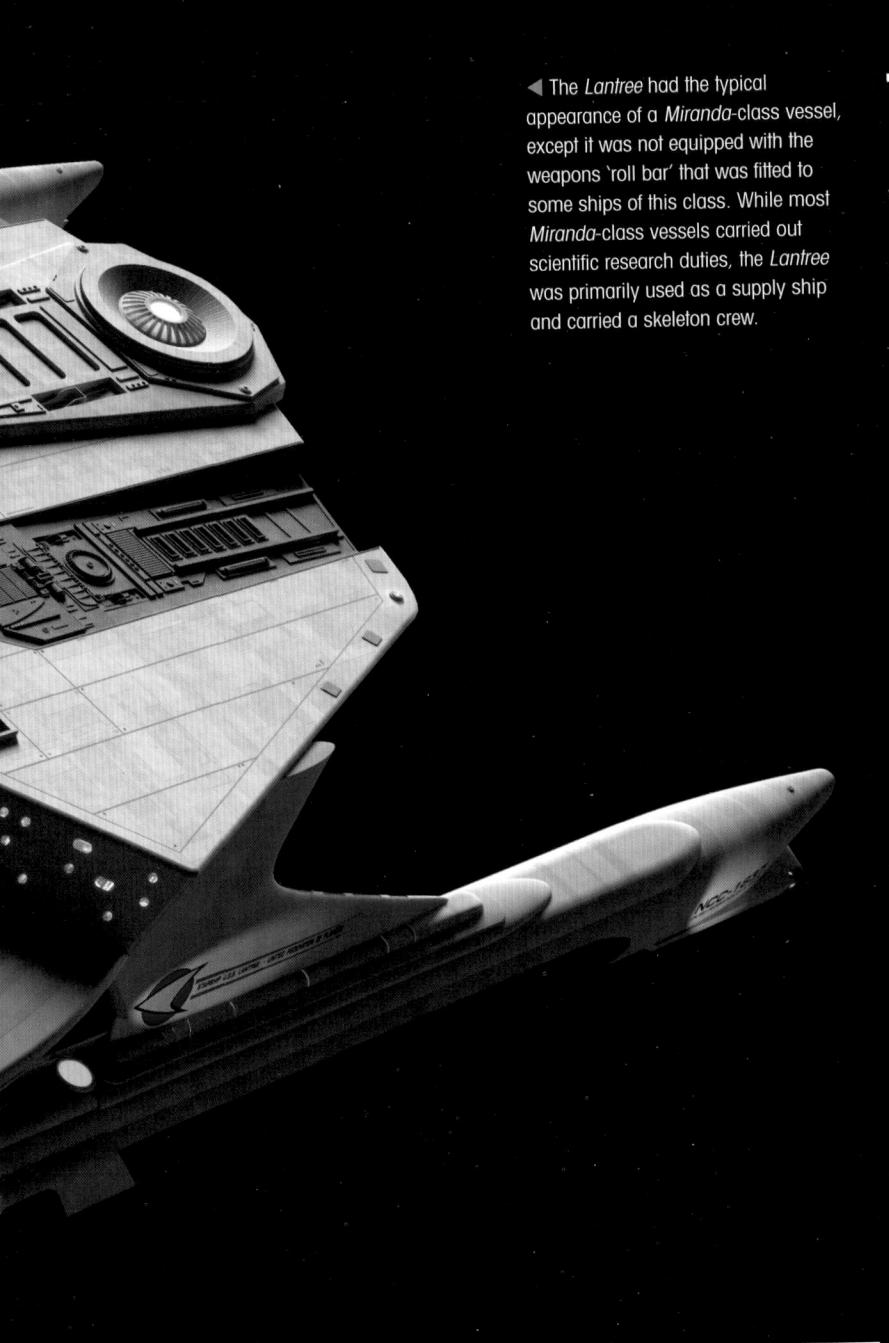

he U.S.S. Lantree NCC-1837 was a Mirandaclass starship that was in use from at least the 2290s through to 2365. In the 2360s, it was commanded by Captain L. Isao Telaka.

Miranda-class vessels were normally assigned to scientific missions or patrol duties, but by the mid-24th century their aging design meant that many had been removed from frontline services and transferred to less demanding tasks. The Lantree, for example, had become a class-6 supply ship, transporting cargo, spare parts and materials to colonies, space stations and other ships. In 2365, it was known that the Lantree operated mainly in Sector Gamma 7, and had a crew complement of just 26, whereas earlier vessels of this class normally operated with around 200 personnel.

STANDARD CONFIGURATION

The outward appearance of the Lantree was very similar to other Miranda-class ships in that it was 243 meters in length, and did not feature a separate engineering hull. Instead, it comprised of an elongated saucer section, with two warp nacelles that were mounted on pylons below. The rear half of the saucer section was given over to its cargo holds, while at the very rear was the impulse engines, and either side of those were two shuttlebays. The Lantree had a top speed of warp 9.2, which it could sustain for 12 hours.

Some Miranda-class ships featured a weapons 'roll bar' that was attached over the saucer section, but the Lantree was not equipped this accessory. In fact, it was relatively poorly armed, and was fitted with only class-3 defensive armaments. This included six type-7 phaser emitters on the saucer and two aft phaser emitters positioned below the impulse engines, plus a photon torpedo launcher.

¶ In 2365, the Lantree was discovered adrift in Sector Gamma 7. The crew of the Enterprise-D had responded to a distress call from the Lantree, but when they approached it, there were no signs of life aboard the supply ship. Captain Picard gained access to the Lantree's systems remotely using an access code to bring it to a full stop.

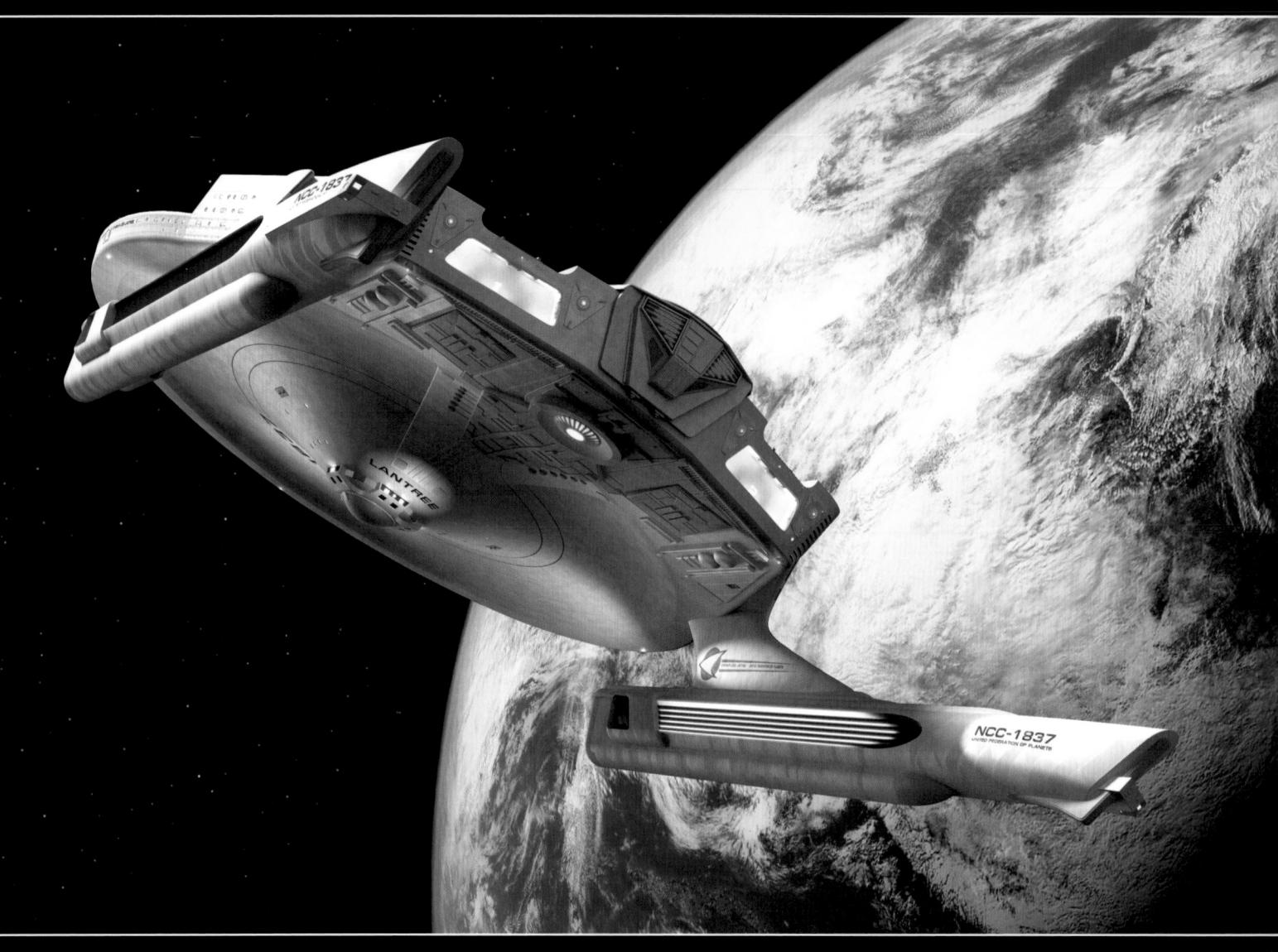

▲ The Lantree, like all Miranda-class ships, did not have a separate engineering hull. Instead, an enlarged squared-off section was fitted to the rear of the saucer. This area contained the ship's warp core and impulse engines, as well as large cargo holds and two shuttlebay doors.

In 2365, the *Lantree* broadcasted a distress signal on an open subspace frequency, which was picked up by the *U.S.S. Enterprise* NCC-1701-D. It was an audio only transmission in which a desperate voice said, "Can't hold out any more. People dying. Too many to help."

When the Enterprise-D reached the Lantree's location, the crew found it adrift, but there were no signs of battle damage and all its systems appeared functional and in good order. They were also unable to pick up any life signs on the Lantree, and it was to all intents and purposes a ghost ship.

Captain Picard was able to take control of the *Lantree* remotely from the *Enterprise*-D and shut down its engines. Picard then activated the Lantree's viewscreen to take a look at the bridge.

The sight that greeted him was unsettling to say the least. Captain Telaka, who was 32 years old, was slumped in his chair and appeared old and

withered. In addition, the rest of the bridge crew had met a similar fate and their appearance had wizened with extreme age. Dr. Pulaski surmised that they had all died of extreme old age, even though in reality none of the crew were anywhere near approaching their elderly years.

LOOKING FOR ANSWERS

The Lantree's ship log was downloaded to see if it offered any clues as to what led to this baffling mystery. They discovered that the crew of the Lantree had undergone a complete medical examination eight weeks earlier, which had found them in perfect health. After that, there was just one recent medical entry noting that five days earlier the first officer had been treated for Thelusian flu. This was a harmless rhinovirus, similar to Earth's common cold, and could not possibly have caused the extreme aging.

The entire crew of the Lantree had died, oparently of old age wen though most of them were young. It was macabre sight, with their thin transparent skin tretched taught over their toothless skulls.

After examining one of the genetically-modified ubjects, Dr. Pulaski aught the infection that aused hyper-accelerated ging. This confirmed there the virus had come om, which killed the rew of the *Lantree*.

The ship's log also recorded that its last port of call was at the Darwin Genetic Research Station on Gagarin IV. Dr. Pulaski reasoned that whatever happened to the crew could have originated there, and at the very least they should warn its inhabitants of a potential fatal virus. Captain Picard agreed, but before they left, he ordered the Lantree's quarantine transmitters and marker beacons to be activated to warn off other ships.

At the Darwin Station, the *Enterprise*-D crew discovered that the head physician, Dr. Sara Kingsley, had been leading a genetic-engineering project to develop children with an immune system that actively sought out disease. When they came into contact with the *Lantree's* First Officer, who was suffering from Thelusian flu, their airborne antibodies attacked it. Unfortunately, it also inadvertently altered the DNA of healthy humans, causing hyper-accelerated aging.

The station personnel, and later Dr. Pulaski, also contracted the disease. Fortunately, a cure was found, which involved using the transporter to rid the disease from those infected.

The *Enterprise-D* returned to the *Lantree's* position, where a single photon torpedo at a range of 40 km was used to destroy it, insuring that no one else would be at risk of contracting the disease.

▲ It was felt that the only way to be absolutely sure—that the virus was wiped out was to destroy the Lantree. With the shields down and from close proximity, it took only one—photon torpedo to blow it to smithereens.

DATA FEED

Dr. Sara Kingsley led the research project on the Darwin Station that sought to develop humans with enhanced powers through genetic modification. Her work led to children, who were telepathic and incredibly healthy. Unfortunately, their immune systems were too advanced and attacked diseases before they entered the human body. Their antibodies inadvertently mutated a Thelusian virus, which caused rapid aging in normal humans.

DEADLY SCIENCE

The deaths of all 26 members of the *Lantree's* crew was caused by the unexpected consequences of cutting-edge medical science. It almost claimed the lives of Dr. Kingsley and her staff at the Darwin Genetic Research Center too, the very people who unwittingly caused the virus in the first place.

Dr. Kingsley was leading a genetic-engineering project to develop children with an immune system that was capable of protecting them from nearly all forms of disease. Their antibodies were so aggressive that they fought pathogens not only in their own bodies, but in the surrounding environment as well. When the children came into contact with the *Lantree's* First Officer, who was suffering from Thelusian flu, their immune systems created airborne antibodies to attack it. Unfortunately, this caused their immune systems to alter the DNA of healthy humans, causing hyper-accelerated aging.

By this point, Dr. Pulaski had also been infected, but the *Enterprise*-D crew found a way to return an infected individual's DNA to normal by using the transporter. Using a previous transporter bio-pattern of a person before they contracted the disease, they were able to remove the offending antibodies and rematerialize them back to health. The station's staff were all cured using this method, but the bio-engineered children could not live among them until a way of controlling their immune systems had been found.

Dr. Pulaski and Dr. Kingsley were both infected by the mutated wirus that caused them to age decades in a matter of hours. It was he same infection that ultimately killed the crew of the Lantree.

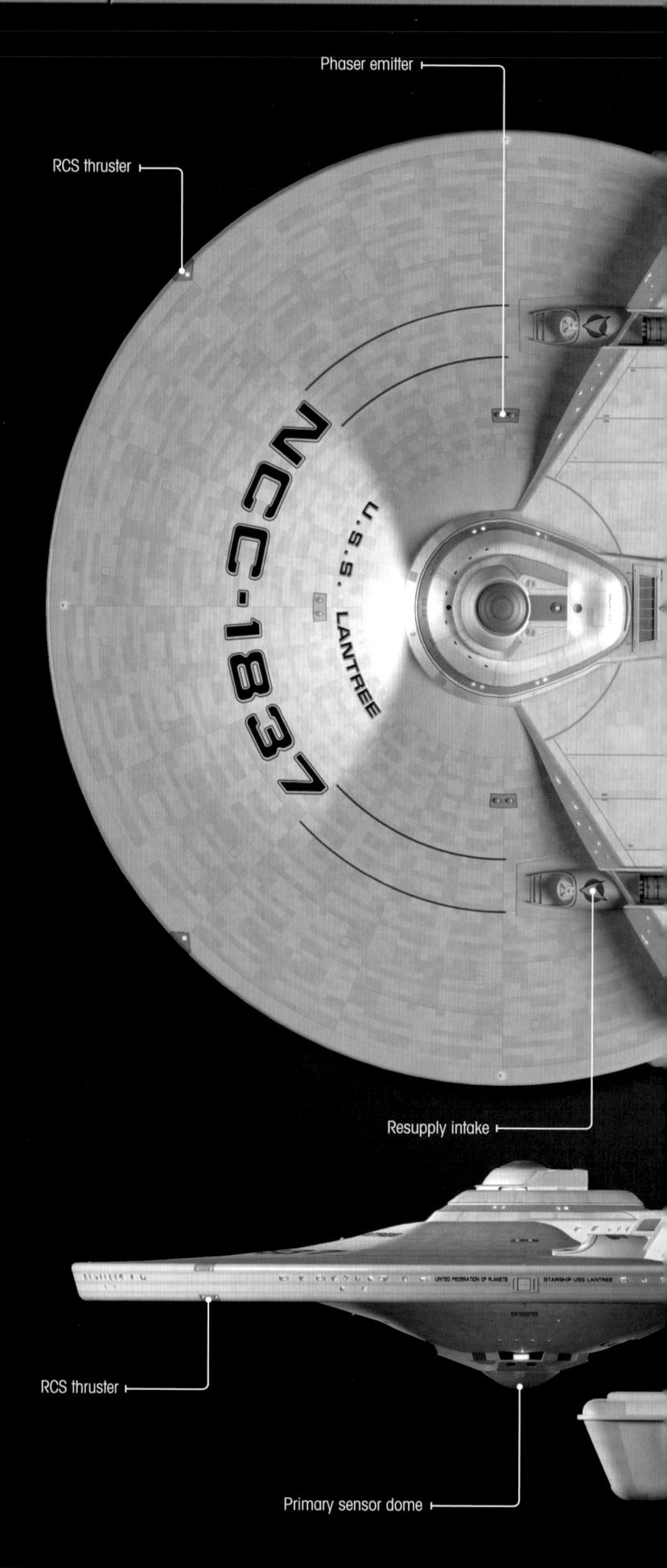

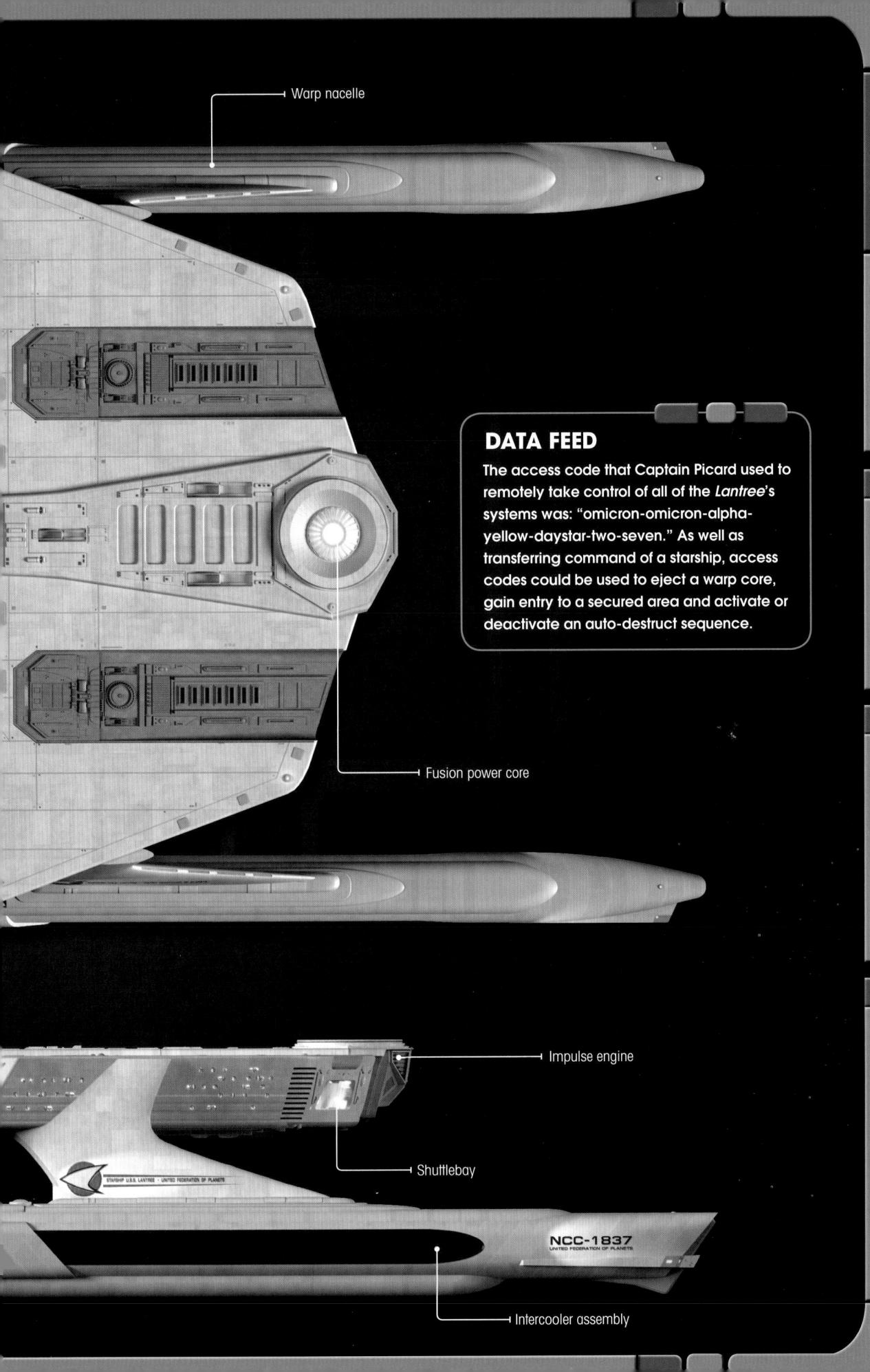

FLIPPED BRIDGE

The bridge of the Lantree was a redress of the Enterprise-D's battle bridge turned 180 degrees. What had been the main viewer behind Captain Telaka was turned into a star chart display.

EARLIER CAPTAIN

A star chart that
was seen as part of
'Operation Retrieve'
in STAR TREK: THE
UNDISCOVERED
COUNTRY listed
K. Glover as the
commander of the
Lantree. He was named
for that film's camera

NAME CHANGE

The Lantree was the first appearance of a Miranda-class starship on THE NEXT GENERATION. It was the same studio model that had previously appeared as the U.S.S. Reliant NCC-1864 in THE WRATH OF KHAN and the U.S.S. Saratoga NCC-1887 in THE VOYAGE HOME, but with the roll-bar removed.

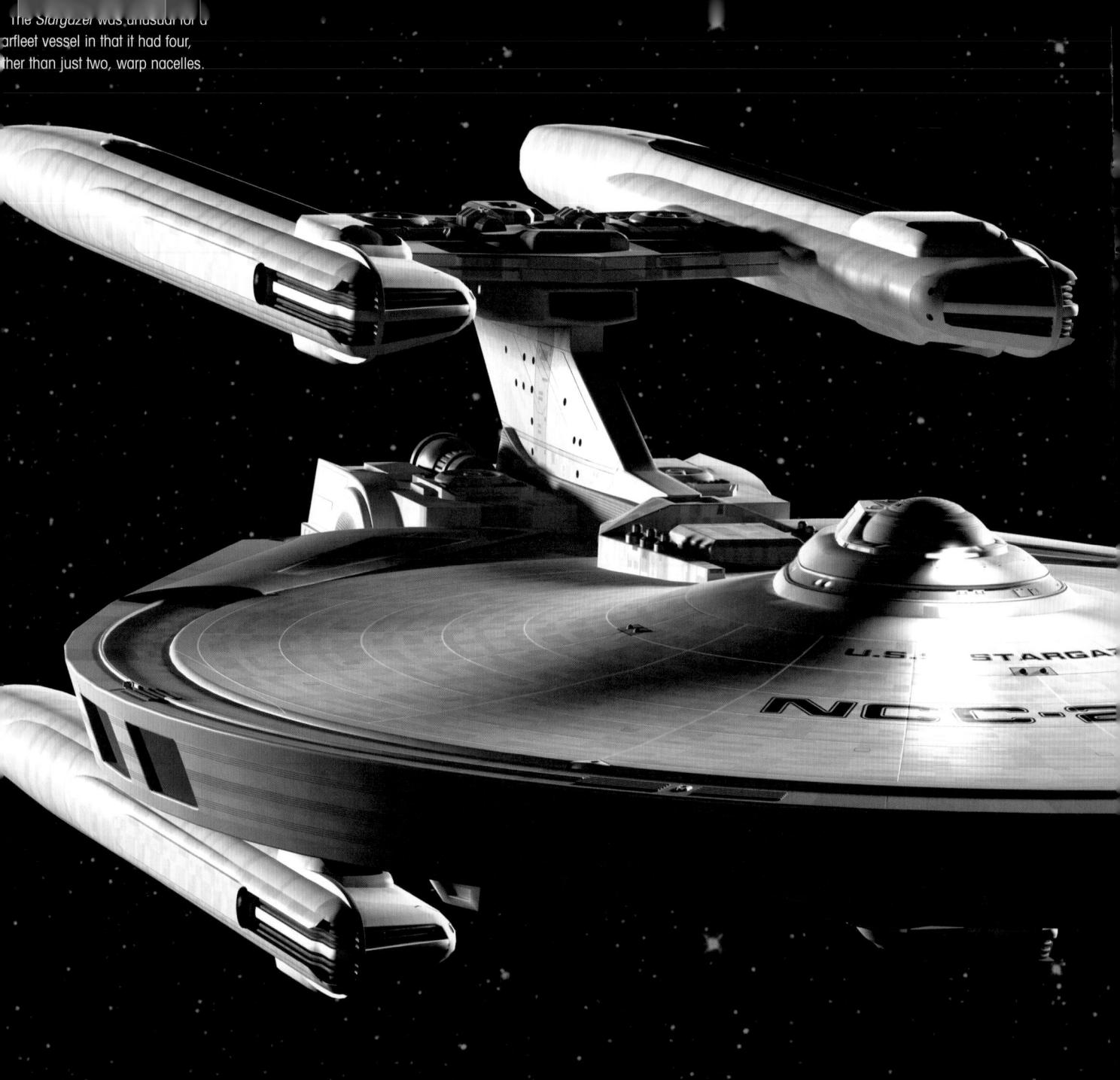

U.S.S. STARGAZER NCCC-2893

The U.S.S. Stargazer was a Constellation-class ship that for much of its service was captained by Jean-Luc Picard.

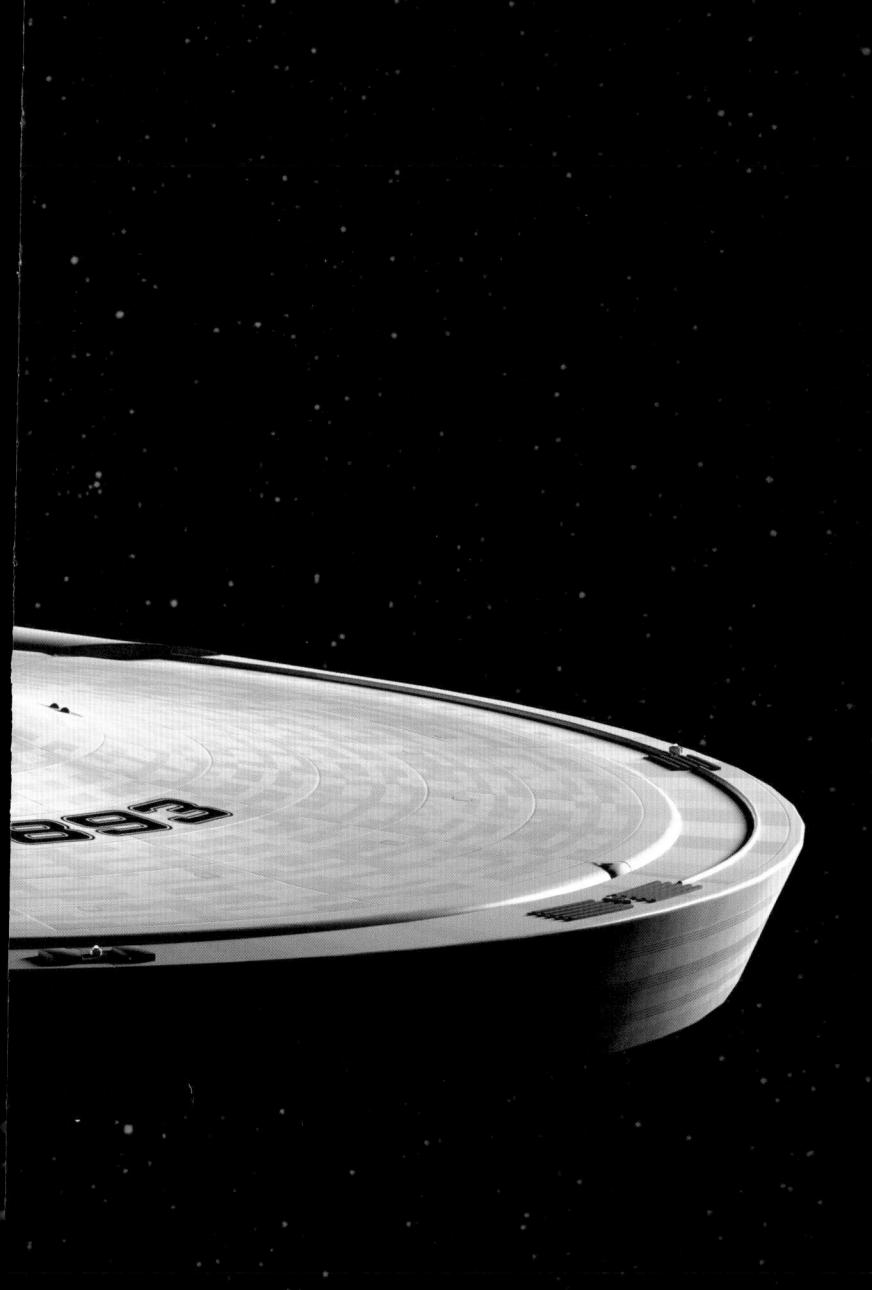

The Constellation-class U.S.S. Stargazer NCC-2893 was primarily designed for deep space exploration and defensive patrol duty. It was built at the San Francisco Fleet Yards on Earth and was in service from the early to mid-24th century.

The Stargazer was only slightly shorter than a Constitution-class vessel and its appearance resembled that of Miranda-class ships in that it did not have a secondary or engineering hull. Instead, its warp nacelles were attached to a spar at the rear of the saucer section.

Unusually for a Starfleet vessel, the *Constellation* class was equipped with four warp nacelles; two were mounted on a pylon above the command saucer, and two hung below.

COLORFUL HISTORY

The *Stargazer* was capable of reaching warp 9, and its warp engine was installed vertically. It was also fitted with fusion reactors and Avidyne impulse engines that were constructed at the Yoyodyne facility at the Copernicus Ship Yards on Luna.

The *Stargazer* carried standard Starfleet weaponry, including phasers and photon torpedoes. It was capable of firing six photon torpedoes in a single spread, and was protected by powerful defensive shields.

▶ In 2333, Lieutenant Commander Jean-Luc Picard was serving as a bridge officer on the *U.S.S. Stargazer* when the ship's captain was killed and the first officer was injured. Picard took control of the situation and saved the ship. His initiative so impressed Starfleet Command that they made him the ship's new captain.

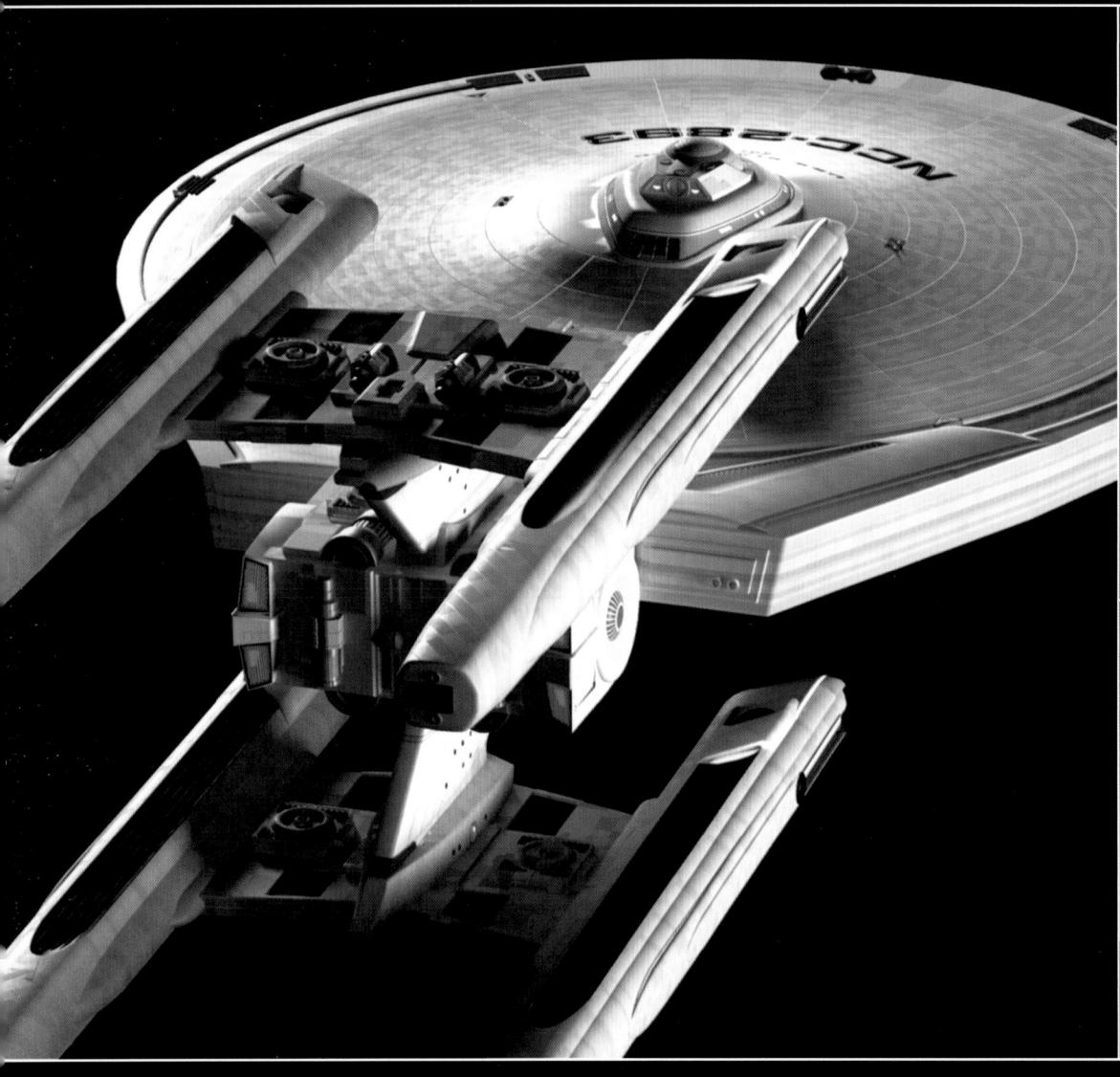

■ The Stargazer was designed as a fast science vessel and was fitted with a substantial hangar bay and a large number of sensor arrays. She was tasked with exploring the edges of Federation space and was responsible for making first contact with more than one species. Unlike the *Galaxy*-class Enterprise-D, she did not carry families. By the 2360s, the Constellation class was considered redundant and the ships were retired.

In 2333, the then Lt. Commander Jean-Luc Picard took charge of the Stargazer after the captain was killed, and, in recognition of the leadership qualities he displayed, he was offered permanent command of the ship. He was just 28 years old at the time, making him the youngest captain in the fleet. The Stargazer remained under Picard's command for the next 22 years.

OPERATIONAL HISTORY

The Stargazer's history consisted mainly of exploration and establishing contact with other races. In 2354, the ship encountered a lawless species known as the Chalnoth. The Stargazer also saw action in the Cardassian Wars. During the exploration of Sector 21503, the Stargazer made contact with a Cardassian warship and lowered its shields as a gesture of good will. The Cardassians opened fire anyway and the Stargazer only just

managed to get away without being destroyed.

The Stargazer's service came to an abrupt end in 2355 when it was traveling at warp 2 through the Maxia Zeta system. An unidentified ship, later learned to be Ferengi, rose from a deep moon crater and fired twice from close range. With the Stargazer's shields failing, Picard improvised, employing what has since come to be known as the 'Picard Maneuver': using his warp drive with pinpoint accuracy, he caused the Stargazer to appear to be in two places at once. This tactic allowed the Starfleet ship to use six photon torpedoes to destroy the attacker, but at a high cost to itself: the Stargazer was badly damaged, and Picard ordered all hands to abandon ship. The crew, in Picard's own words, had to "limp through space in shuttlecraft for weeks" before they reached safety.

As is standard procedure following the loss of a

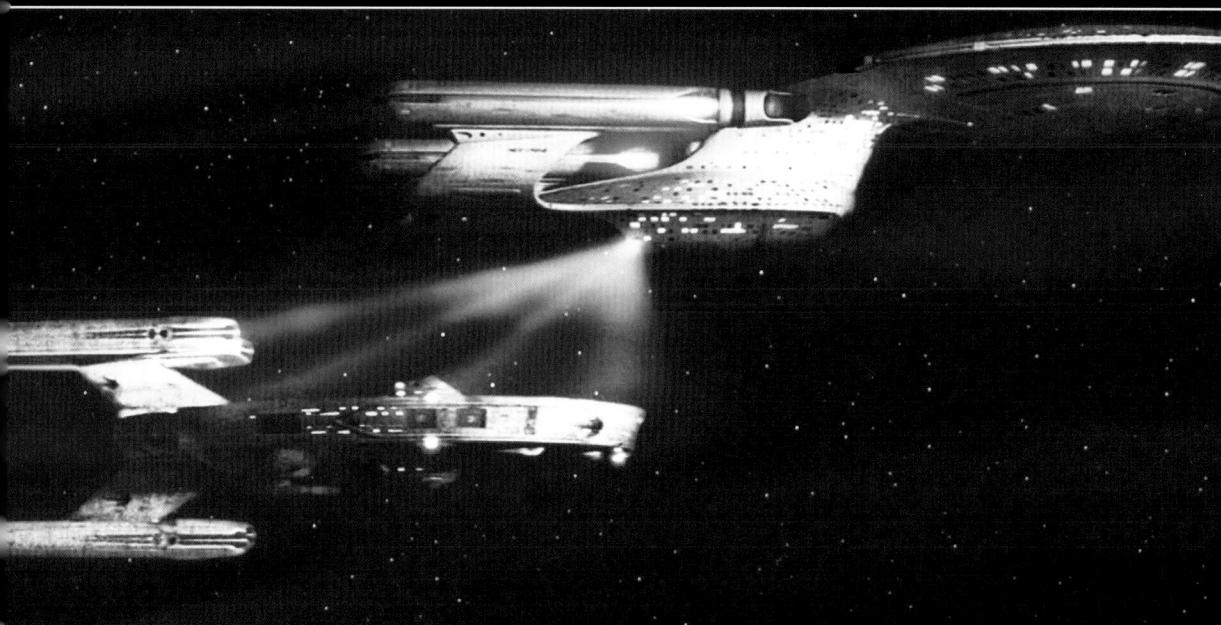

Starfleet believed that the Stargazer was destroyed during its encounter with the Ferengi vessel. She was certainly incapable of supporting life when Picard gave the order to abandon ship. But DaiMon Bok became obsessed with Picard and recovered the damaged ship. After Bok's plans were exposed, the U.S.S. Enterprise-D towed the Stargazer away and it was eventually taken to Xendi Starbase Nine.

■ During the Stargazer's operational history, the crew made first contact with the Chalnoth, a warlike species from the planet Chalna, whose society rejected the rule of law and even the concept of government in favor of a system where the strong prospered. As a result, their species existed in a state of permanent anarchy.

starship, Picard was court-martialed. The trial did not end in a conviction and Picard was cleared of any wrongdoing.

REUNITED

This was not, as might be expected, the end of the story. Nine years after the incident that had become known as the Battle of Maxia, Ferengi commander DaiMon Bok met Picard in the Xendi Sabu system and presented him with the hulk of the *Stargazer*. Bok claimed to have found it adrift in space on the far side of the star system.

Commander Data found a *Stargazer* log entry that seemed to suggest that the ship Picard fired upon did not attack first, but was under a flag of truce, and the fire on the bridge of the *Stargazer* was supposedly caused by an accident in engineering. Though Picard knew the log was false, it still led him to question whether he did the

right thing. Using their technical expertise, Data and conn officer Geordi La Forge proved that the log was a fake, and had been created by DailMon Bok in an act of revenge, as the commander of the destroyed Ferengi vessel was his only son.

Responding to Picard's request, a Starfleet tug met with the *Enterprise* and towed the *Stargazer* to Xendi Starbase 9.

▲ Picard's return to the Stargazer found him siffing through the debris and reminiscing about the 22 years he spent in command of her.

DATA FEED

Lieutenant Commander Jack Crusher served under Captain Picard on the *U.S.S. Stargazer*. The pair were good friends, but in 2354 Crusher was killed during an away mission. Picard found himself in an impossible situation when he saved the life of another team member at the expense of his friend's life. Picard returned Jack's body to his wife, Beverly, and son Wesley, both of whom went on to serve with Picard on board the *U.S.S. Enterprise* NCC-1701-D.

STANDARD BRIDGE

SHIP PROFILE

Over their years of service, various designs of bridge were fitted to different Constellation-class vessels, but the Stargazer bridge had the usual Starfleet configuration, with the captain's chair in the centre. Two duty stations were combined into a single console in front of the captain; navigation was front right of the captain's position, helm was to the left. Personnel stood while on duty at stations around the perimeter bulkhead, which was supported by dark, heavy buttresses. One unusual feature of the bridge was that all duty stations were clearly named in large white letters.

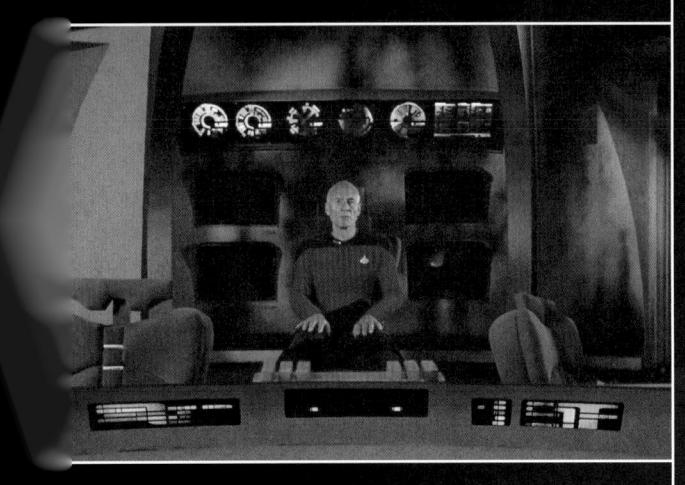

▲ Described as a "cramped little bridge" by Captain Picard, the Stargazer's command centre was very similar to the bridges found on the refit Constitution-class vessels of the late 23rd century.

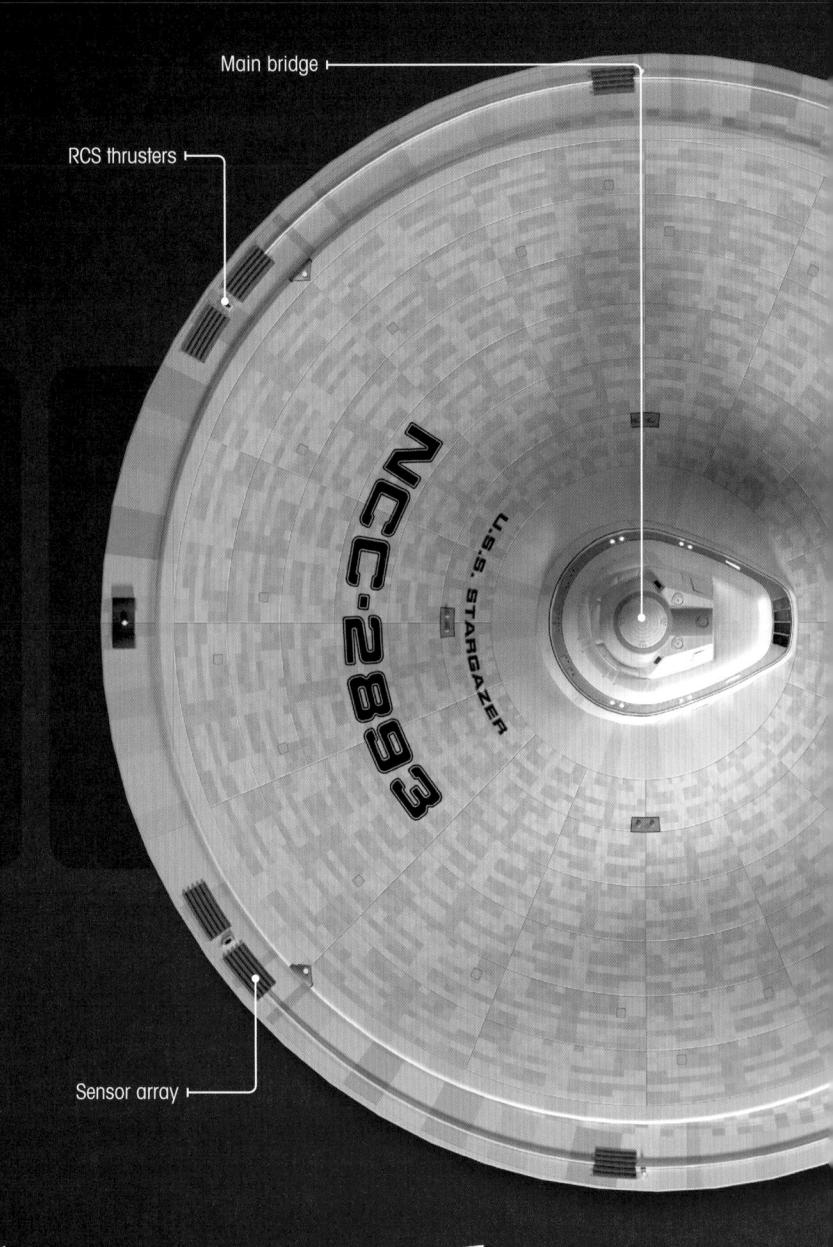

DATA FEED

Other classes of Starfleet ships that featured four nacelles included the Cheyenne class, Prometheus class, and some variants of the Nebula class.

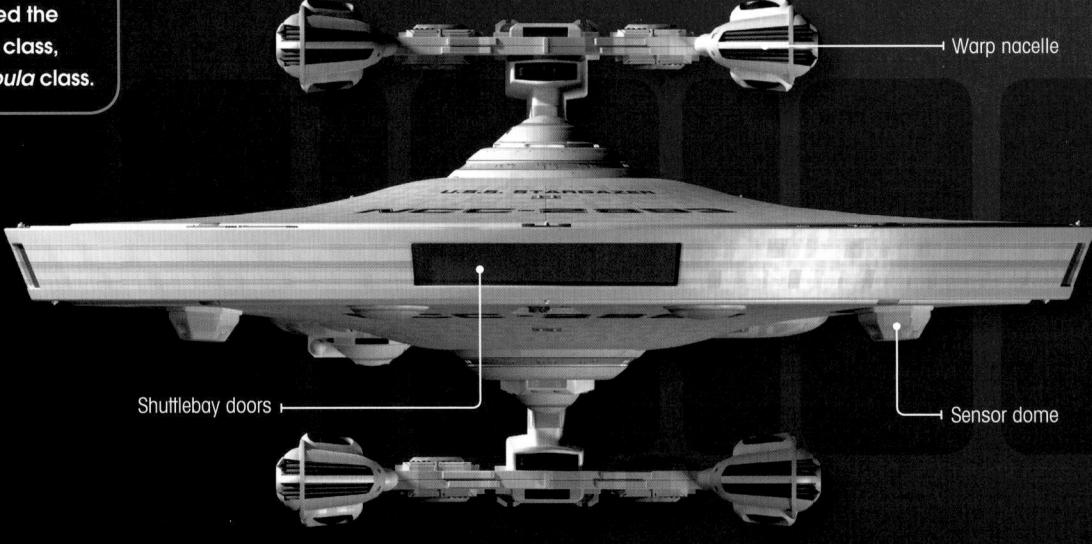
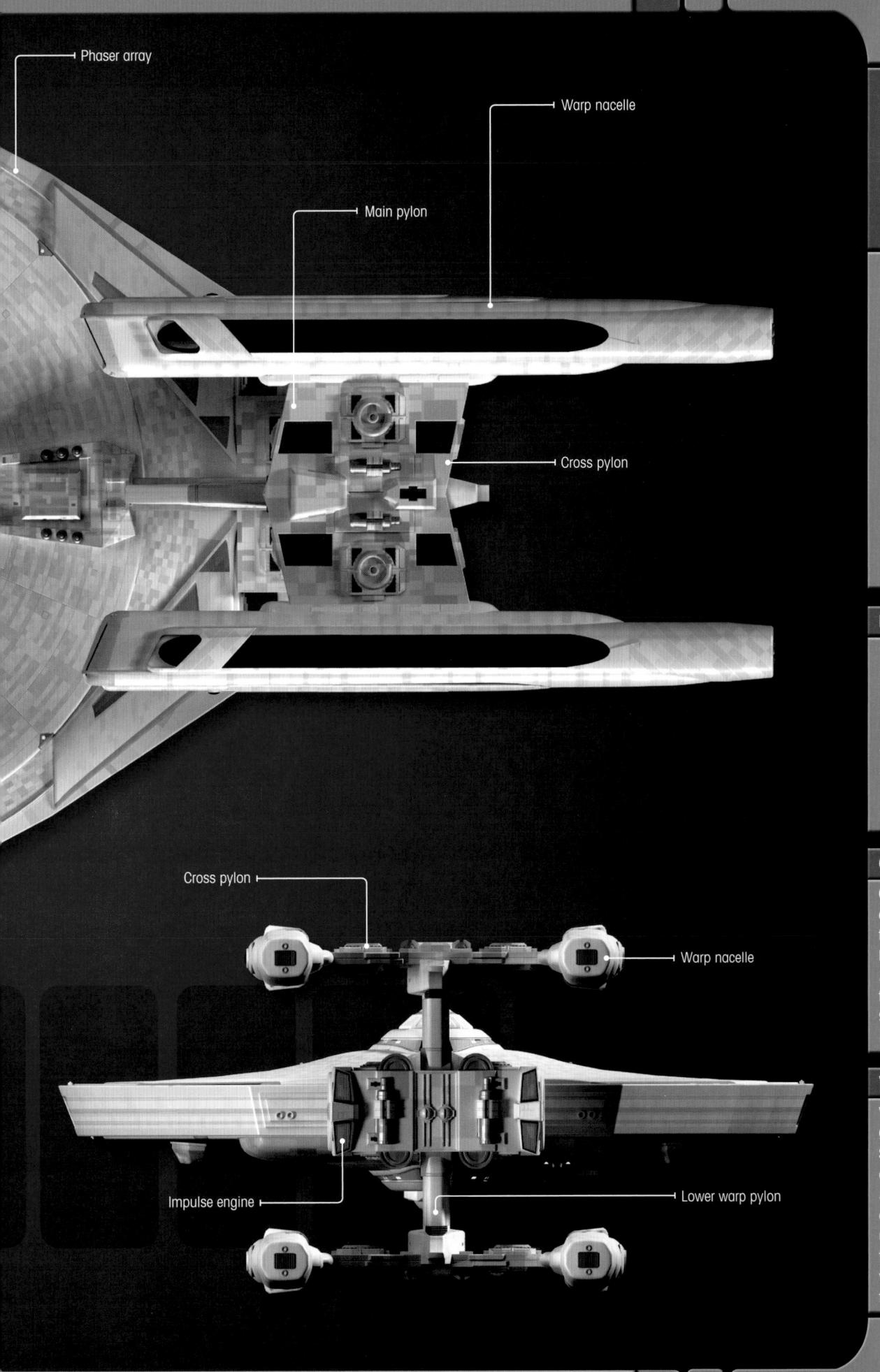

DEDICATION PLAQUE

The dedication plaque on the bridge of the Stargazer bore the motto: "To bring light into the darkness."
This was a quote taken from the novel Flowers for Algernon written by Daniel Keyes.

CONSTELLATION CLASS

Other Constellationclass vessels included the U.S.S. Constellation NX-1974, the U.S.S. Hathaway NCC-2593, the U.S.S. Victory NCC-9754, and the U.S.S. Gettysburg NCC-3890.

WORKHORSE

When talking to Captain Montgomery Scott, Captain Picard described the *U.S.S. Stargazer* as being an "overworked, underpowered vessel that was always on the verge of flying apart at the seams."

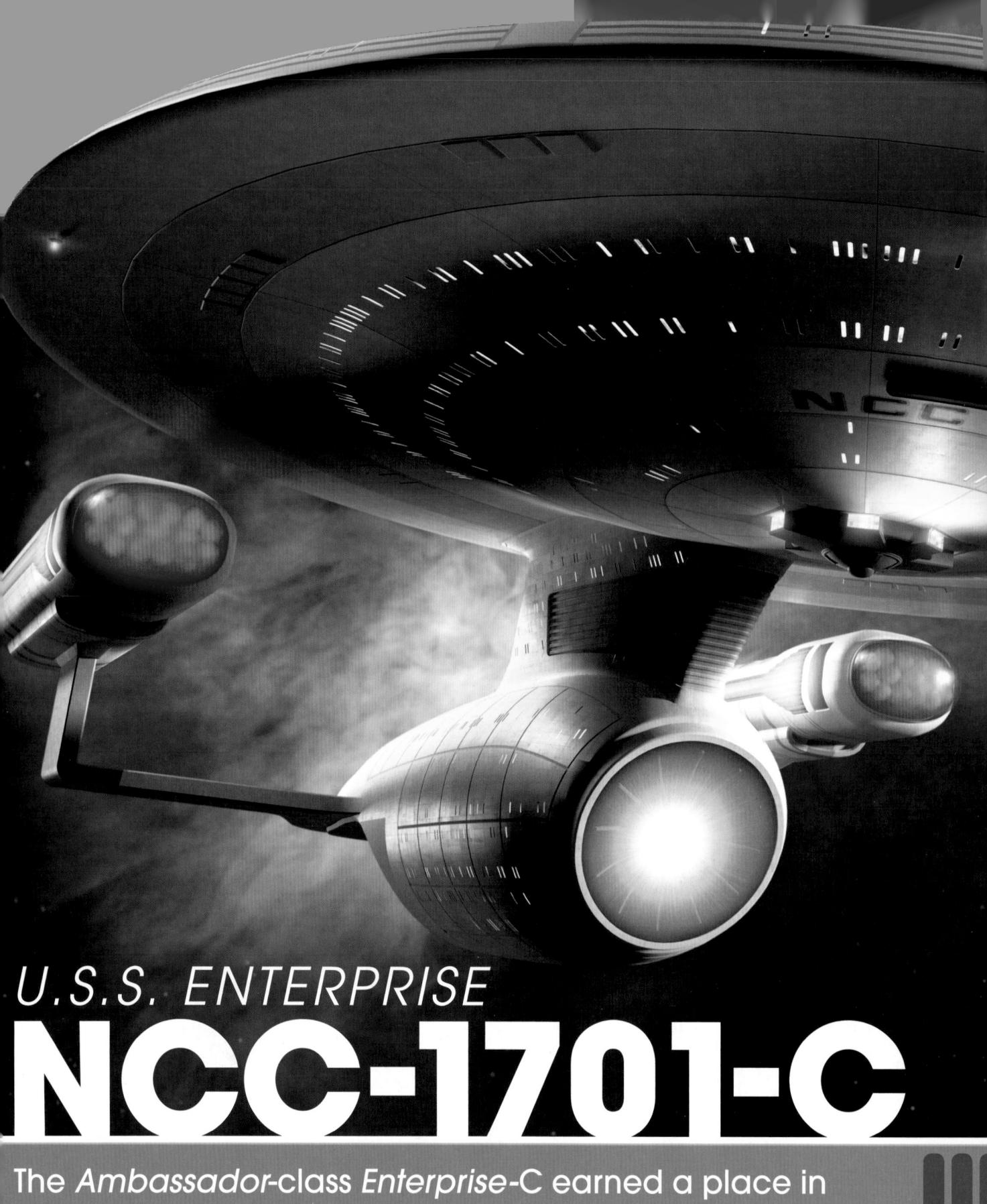

The Ambassador-class Enterprise-C earned a place in history when it was lost defending a Klingon outpost.

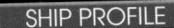

▼ The Enterprise-C was designed for exploration and spent much of its operational life charting stellar phenomena.

The U.S.S. Enterprise NCC-1701-C was an Ambassador-class starship that was operational in the early part of the 24th century. She became famous after she was lost with all hands in 2344 defending the Klingon outpost on Narendra III from a Romulan attack. This act of heroism impressed the Klingon Empire and was instrumental in the forging of a treaty between the Klingons and the Federation.

The Enterprise-C was constructed at Earth Station McKinley during the 2320s and was commissioned in 2332. She was given the name Enterprise after the Enterprise-B was declared lost in 2329 and was the fourth Federation starship to bear the name. Six months before she was launched, she was placed under the command of the then 33-year-old Captain Rachel Garret, who had

previously served as the first officer on the *U.S.S.*Hood. Garrett was the *Enterprise-*C's first and only commanding officer.

The Enterprise-C was the third Ambassador-class ship built by Starfleet. Other ships in the class included the U.S.S. Adelphi NCC-26849, the U.S.S. Zhukov NCC-26136 and the U.S.S. Excalibur NCC-26517. Measuring 526 meters from bow to stern, she was about twice the length of the Constitution-class Enterprise NCC-1701. With 36 decks and a crew of 530, she was one of the largest ships that Starfleet had built to date.

In terms of design, the *Ambassador* class was a clear midpoint between the *Constitution* and *Galaxy* classes. The engines benefited from a number of advances in warp technology, which came about during Starfleet's unsuccessful

▶ When the Enterprise-C was removed from history, it altered the timeline. Without her sacrifice having been recorded, the Federation went to war with the Klingons. Her ships were designed for combat rather than exploration and the crew of the Enterprise-D were soldiers not explorers.

▶▶ By 2366, the Federation was losing the war with the Klingons, and Picard expected Starfleet to surrender within six months.

An antimatter explosion during the battle for Narendra III created a temporal rift that sent the *Enterprise-C* 22 years into the future, where she encountered the Galaxy-class *Enterprise-D*.

► Most of the crew were killed and after Garrett's death the helmsman Richard Castillo was the senior officer.

▲ Captain Garrett was preparing to take the Enterprise-C back in time when the Enterprise-C was attacked by three Klingon ships. She was killed by an exploding piece of shrapnel.

Transwarp Development programme of the 2280s, and the ship was capable of sustaining speeds of Warp 8.4 on the newly redrawn warp scale. The Enterprise-C was also incredibly maneuverable and could easily outperform Romulan vessels of a comparable class. In the event of emergencies, such as a matter/antimatter containment failure, the Ambassador class was one of the first to be designed with a vertical warp core that could be ejected from a hatch in the ventral hull.

The sensor systems were concentrated in a sensor dome on the underside of the saucer directly below the main bridge and in pallets mounted on deck 2, with the main deflector providing long range scans.

The single point phaser emitters, used on previous *Enterprises*, were replaced by five dorsal and three ventral type-7 phaser emitters, which represented a significant upgrade since they could

generate a beam from many more origin points.

The *Enterprise-*C also had forward and aft torpedo launchers.

MANY SHUTTLECRAFT

As the Enterprise-C was intended for deep space exploration, she was equipped with a large number of shuttles. These were housed in two shuttlebays, one located at the rear of the ship and one in the saucer section. Several of these shuttles were specifically designed for cataloguing stellar phenomena at close range, but they were also frequently used for missions where gaseous phenomena made the use of the transporters impossible.

The Enterprise-C spent most of her years in service on peaceful scientific and exploration missions, but in the 2330s and 2340s galactic politics were still fraught. In 2344, the ship was on her way

◀ In the altered version of the timeline, Tasha Yar was still alive, but when she realized that this was 'wrong' she volunteered to return with the crew of the Enterprise-C in the hope of balancing out Garrett's death.

► When the Enterprise-C returned through the temporal rift, it restored the `correct' timeline.

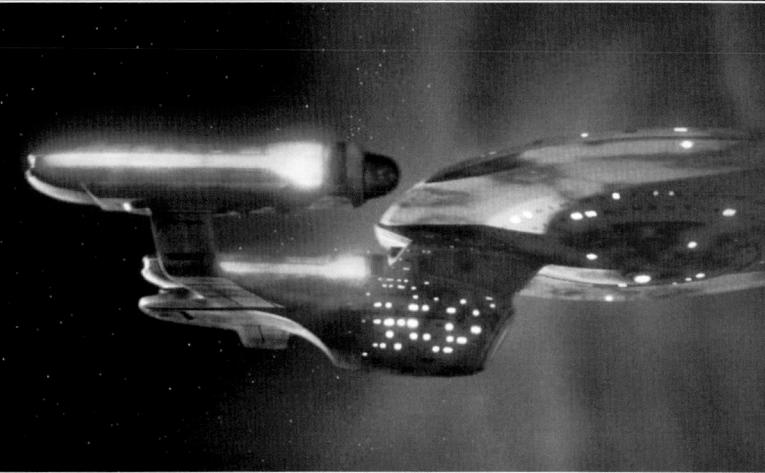

to the planet Archer IV when she responded to a distress call from the Klingon outpost at Narendra III. When the *Enterprise-C* arrived, she found the outpost under attack by the Romulans and attempted to defend it.

The Enterprise-C was lost during the battle, but what no-one realized was that before she was destroyed, she was thrown through a temporal rift that sent her 22 years into an alternate future, where her heroic sacrifice had not been recorded. As a result, in this altered timeline, the Federation and the Klingons were at war. The crew made a choice to return to certain death in their own time, in the hope their sacrifice would earn a better future.

Following the loss of the *Enterprise-C*, it was another 20 years before a new *Enterprise* in the form of the *Galaxy-class U.S.S. Enterprise* NCC-1701-D was commissioned.

DATA FEED

Captain Rachel Garrett spent 12 years commanding the *Enterprise-C*. She took command in late 2332, when she was promoted to captain after a well-regarded tour as the first officer of the *U.S.S. Hood.* She spent the first six months of her command supervising final testing of her new ship, before it was commissioned and assigned to an ongoing mission of deep space exploration.

She died in an alternate future, when the *Enterprise-C* was propelled to the year 2366 and attacked by Klingons. Before her death, she had decided to return to certain death in her own time, hoping that her crew's sacrifice would help to avert a war.

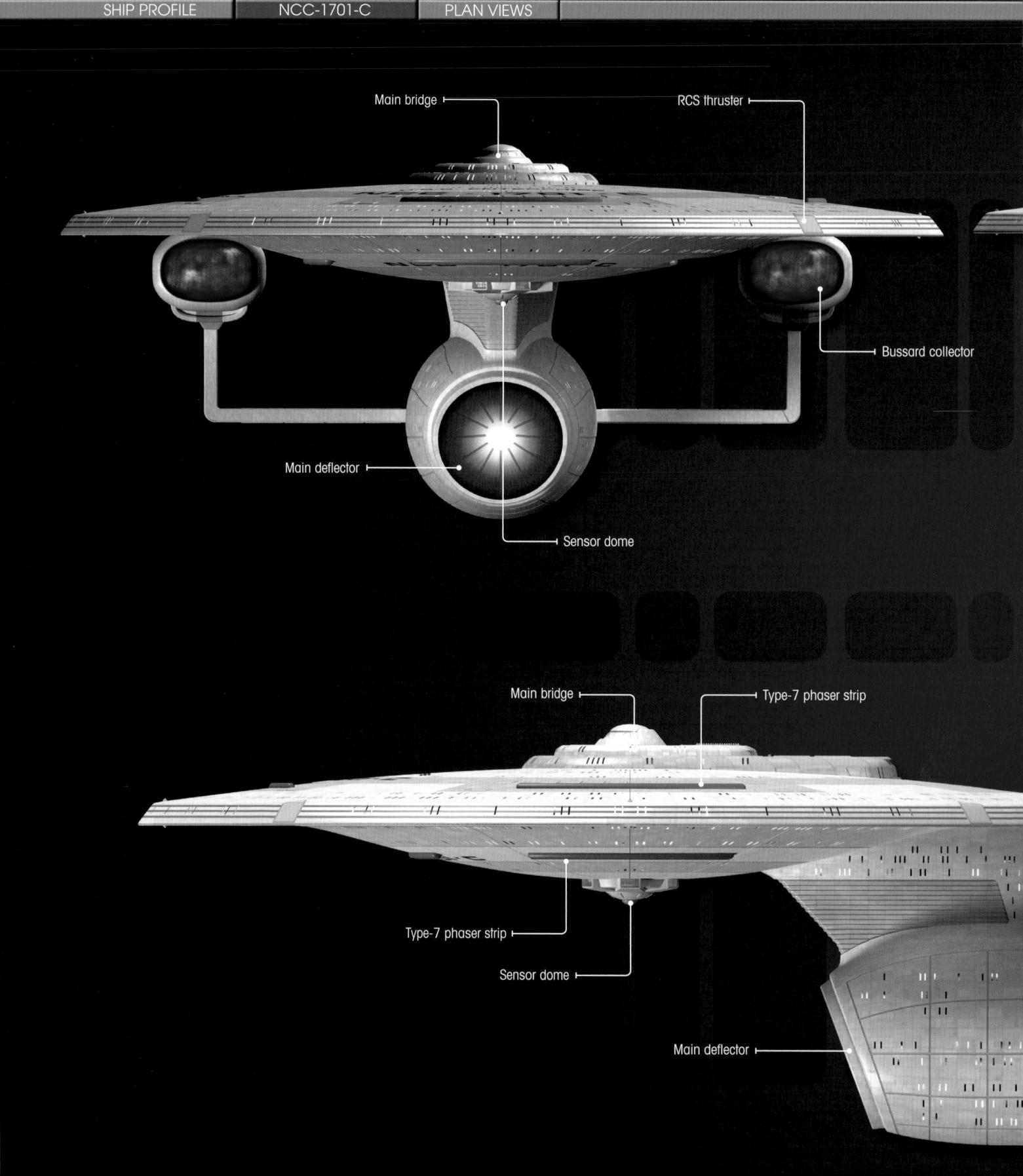

Warp core ejection hatch -

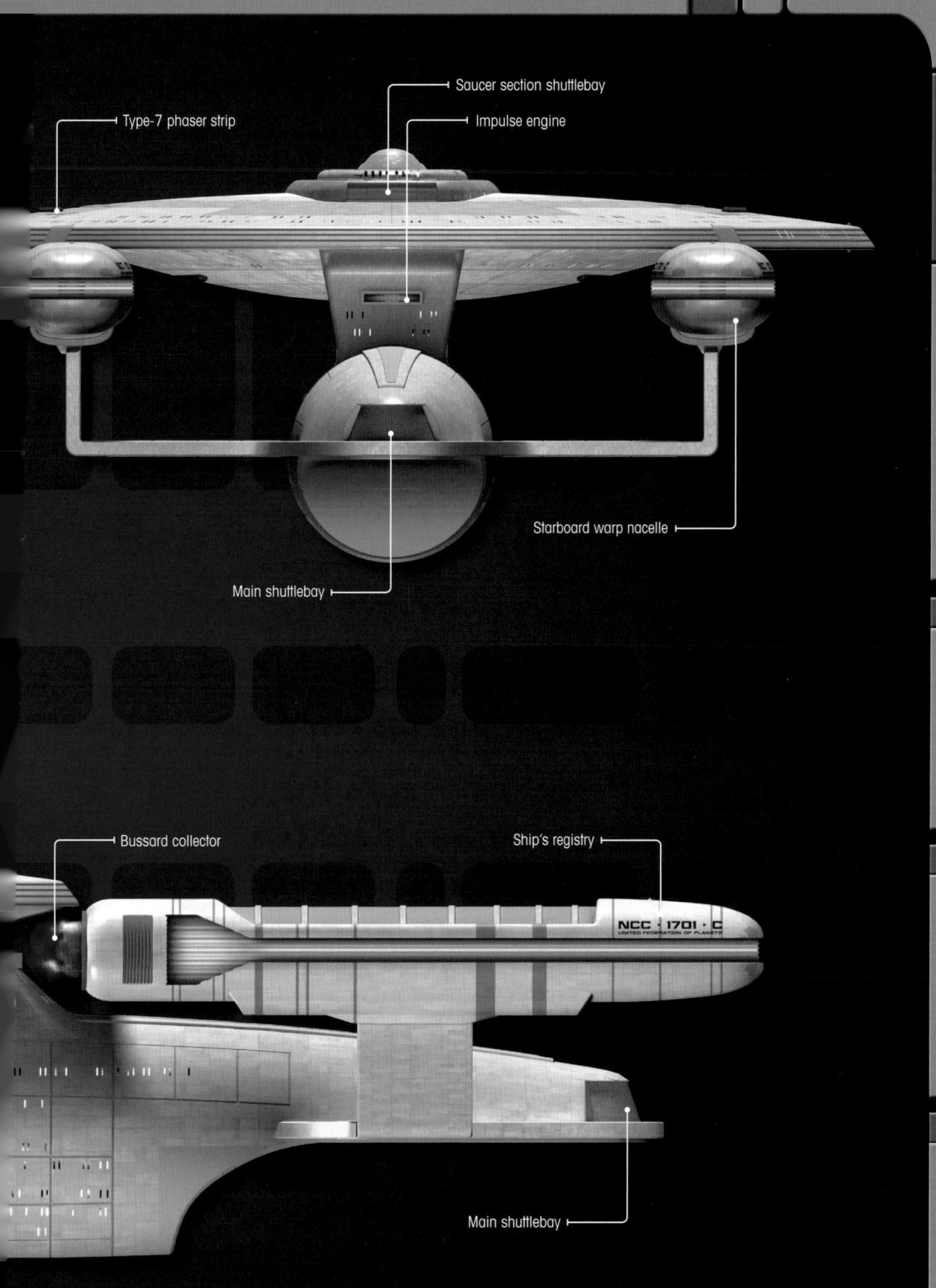

WARP FIELD

Advances in warp field technology meant that the nacelles on the *Ambassador* class were in a lower position relative to the saucer section than on earlier starship vessels.

FIGHTING VESSELS

Although primarily designed for exploration, Ambassador-class ships fought in the Dominion War and helped establish the barricade that restricted Romulan involvement in the Klingon Civil War.

TACTICAL ADVANTAGE

When the Enterprise-C returned to her own time, her systems had been repaired but only to the standards of her own time. She did, however, have the advantage of Tasha Yar's tactical experience

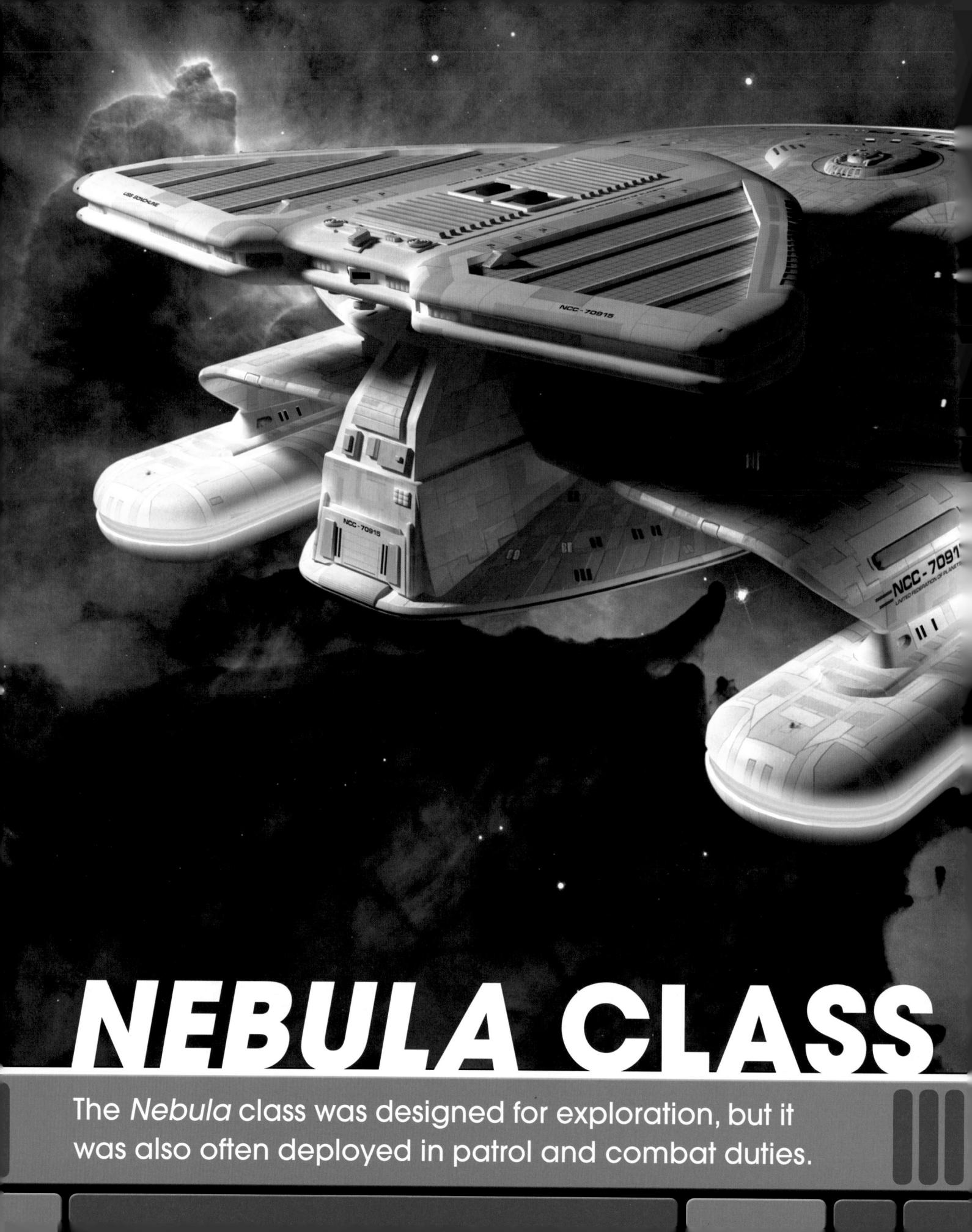

■ The Nebula class's most distinctive feature was an upper equipment module that could be configured for different mission profiles.

ebula-class vessels were a type of starship used by Starfleet in the latter half of the 24th century. They were primarily designed to carry out scientific and exploratory roles, but they often took on patrol and transport duties as well. They could also ably perform combat assignments when required.

The *Nebula* class was a contemporary of the *Galaxy* class and they shared several design features, including a very similar saucer section.

There were, however, several significant differences between them. At 442.23 meters long, the *Nebula* class was about 200 meters shorter than the *Galaxy* class, and its crew complement was normally around 750 compared to 1,000 aboard the larger vessel. The engineering hull on *Nebula*-class vessels was also slightly more curved and rounded than it was on *Galaxy*-class ships. While the two classes of ship shared a similar design of warp nacelles, they hung beside the engineering hull on the *Nebula* class, rather than being supported above the secondary hull as on the *Galaxy* class.

ADAPTABLE MODULE

The most significant difference between the two classes was that the *Nebula* class featured a large equipment module at the rear of the ship that rose up behind the saucer section. This module could be configured for different missions, but most often it carried an array of sensor equipment, although it could also be customized to carry more weapons.

Reflecting its reconfigurable role, the equipment module did not look the same on all *Nebula*-class ships. For example, on the *U.S.S. Phoenix* NCC-65420, this pod rose high above the saucer section

Nebula-class ships swapped their normal exploratory duties for a combat role during the Dominion War.

They fought alongside the U.S.S. Defiant NX-74205 in several major engagements of the war, inlcuding the final assault on Cardassia.

▲ The Nebula class was equipped with two torpedo launchers as standard. The equipment module could be configured to carry additional torpedo launchers, thereby increasing its firepower. The U.S.S. Sutherland is seen here firing a torpedo from its adaptable superstructure.

and was elliptically shaped, while on the *U.S.S.* Sutherland NCC-72015, it was positioned lower and was more triangular.

Like all Starfleet ships, the *Nebula* class was constantly upgraded. For example, in 2368 its top speed was warp 9.3, but by 2370 this had risen to warp 9.5. Chief O'Brien even managed to eke out more power from the *Nebula*-class *U.S.S. Prometheus* NCC-71201's engines so that it could reach warp 9.6 for a short time.

The standard weaponry aboard *Nebula*-class vessels included eight type-10 phaser emitters and two torpedo launchers, while some versions also had extra launchers in the equipment modules.

The shields on *Nebula*-class ships were highly effective and could withstand a direct hit from a Cardassian warship's disruptor weapon, but they did have one slight weakness. Every five and a half minutes a *Nebula*-class ship would perform a

high-energy sensor sweep, but between the sweep ending and another one starting, the shields would have to be realigned. This left the ship unprotected for a fiftieth of a second.

Overall, Nebula-class vessels were designed primarily for exploration like Galaxy-class ships, but were smaller and slightly less powerful. Serving on board a Nebula-class vessel was still regarded as a plum assignment.

PRESTIGIOUS POSITION

Dr. Elizabeth Lense, the valedictorian of Dr. Bashir's Starfleet Medical School class, chose to join the crew of the *Nebula*-class *U.S.S. Lexington*, much to the envy of her classmates. She spent several years on board the *Lexington* on a deep space mission charting unexplored planets.

Ships of this class were also used for specific scientific missions. In 2370, the *U.S.S. Prometheus*

■ In 2373, Nebulaclass ships battled the Borg alongside the U.S.S. Enterprise
NCC-1701-E.

► The U.S.S. Phoenix, commanded by Ben Maxwell, was fitted with an elliptically-shaped equipment module that rose high above the primary hull.

NCC-71201 was assigned to Gideon Seyetik, and aided in his experiment to find out if protomatter could be used to reignite a dead star.

Nebula-class vessels were also used in patrol duties to help protect Federation borders. For example, in the 2360s the *U.S.S. Monitor* NCC-51826 was used to safeguard the Romulan Veutral Zone, while the *U.S.S. Phoenix* performed similar duties in the Demilitarized Zone between Federation and Cardassian space.

Increasingly, Nebula-class vessels were seconded to a combat role. At least one was nvolved and destroyed in the Battle of Wolf 359 against the Borg and more took part in the later 3 org invasion at the Battle of Sector 001.

In 2367-68, the *U.S.S. Sutherland* NCC-72015 was under the temporary command of Lt.

Commander Data when it was used as part of a blockade to stop Romulan ships supplying the

House of Duras with weapons and supplies during the Klingon Civil War.

Nebula-class ships also played a large part during hostilities with the Dominion. The U.S.S. T'Kumbra, which had an all-Vulcan crew, spent six months fighting on the front lines, while the U.S.S. Sutherland was part of the Ninth Fleet that saw action in most of the major battles of the Dominion War.

▲ The U.S.S. Farragut NCC-60597 was a Nebula-class ship that helped recover the crew of the U.S.S. Enterprise NCC-1701-D after its saucer section crashlanded on Veridian III.

DATA FEED

In 2367, Benjamin Maxwell, captain of the Nebula-class U.S.S. Phoenix NCC-65420, went rogue and used his ship to destroy a Cardassian outpost. When the U.S.S. Enterprise NCC-1701-D caught up with him, Maxwell claimed that the Cardassians were stockpiling weapons in preparation for war. Although Maxwell was brought to justice, his accusations against the Cardassians ultimately proved correct.

NEBULA-CLASS BRIDGE

As on most other classes of Starfleet vessel, the bridge on *Nebula*-class ships was located on deck 1 at the top of the saucer section. There were three entrances to the bridge: one on each side of the room and a third at the rear. The captain's chair was in the center of the room with two free-standing consoles on either side, one of which was the science station, while the other could be used to remotely control the ship's shuttlecraft. Separate conn and ops stations were on a lower level in front of the command chair, and as always on a Starfleet vessels, the main viewscreen was at the front where all the bridge crew could see it.

▲ The viewscreen on the *U.S.S. Prometheus* (middle picture) was similar to the viewscreens aboard *Galaxy*-class ships, whereas the __iewscreen on the *U.S.S. Sutherland* (above) was much smaller.

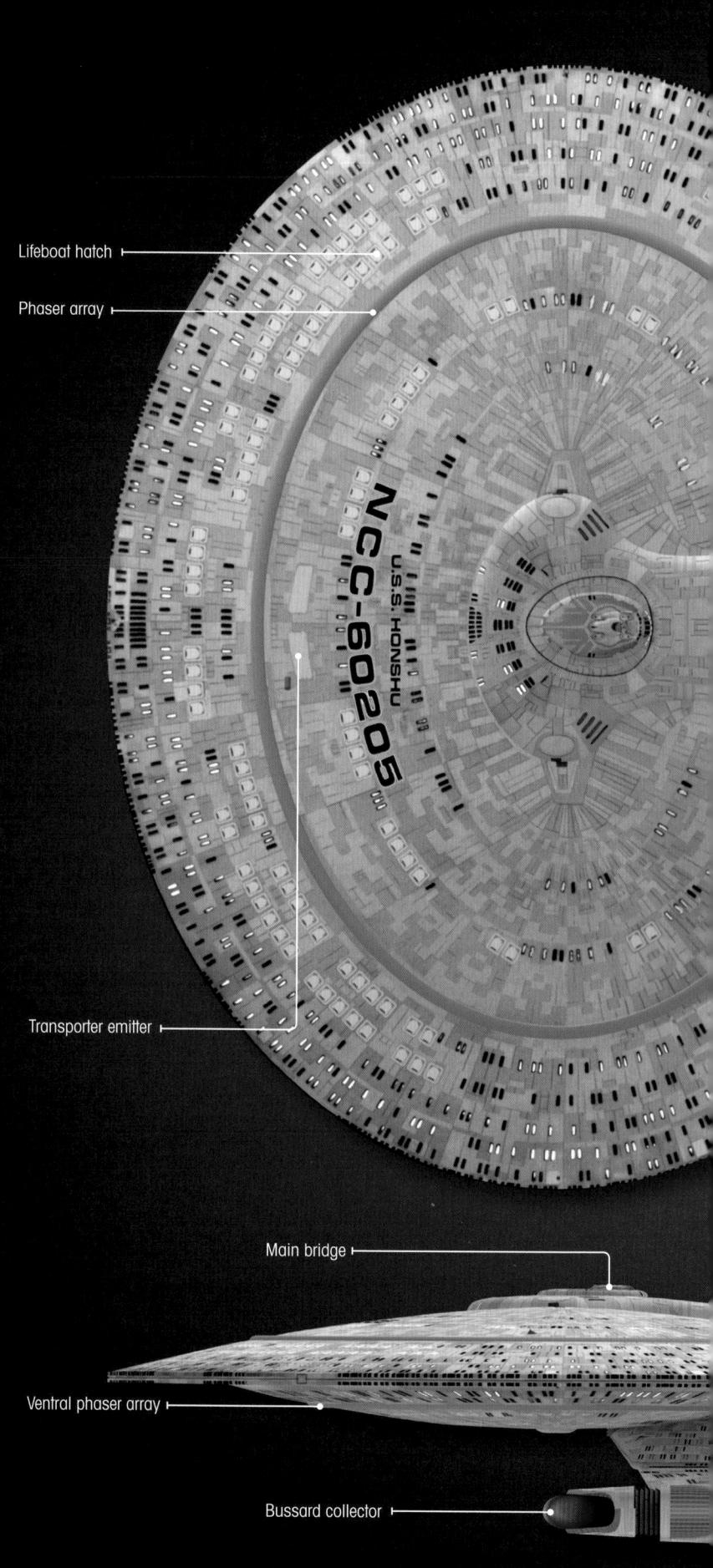

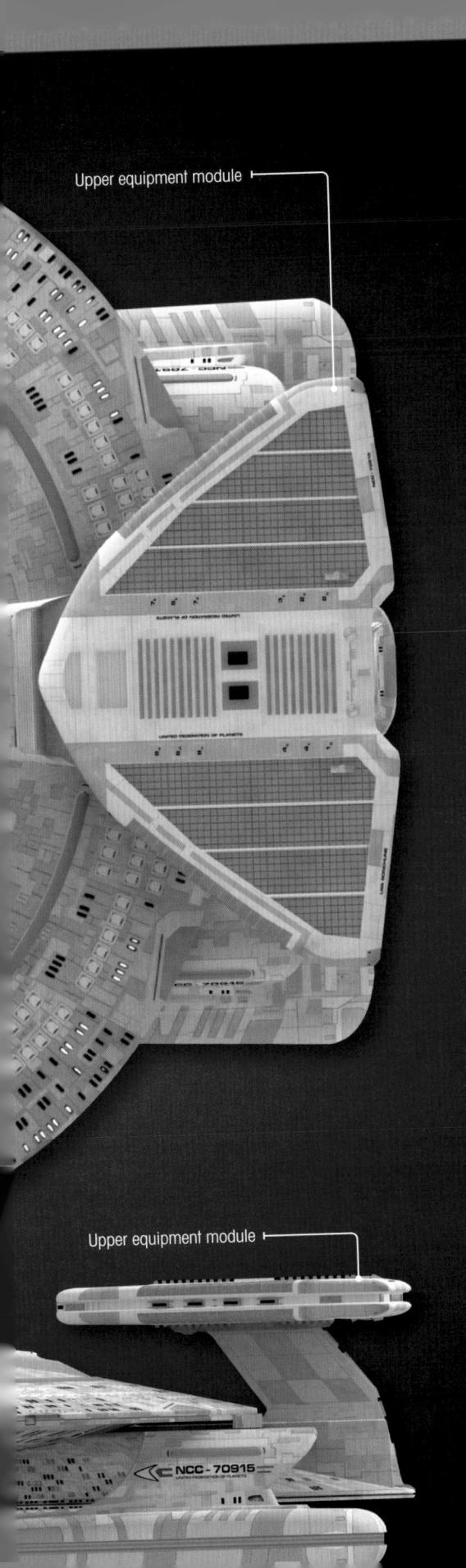

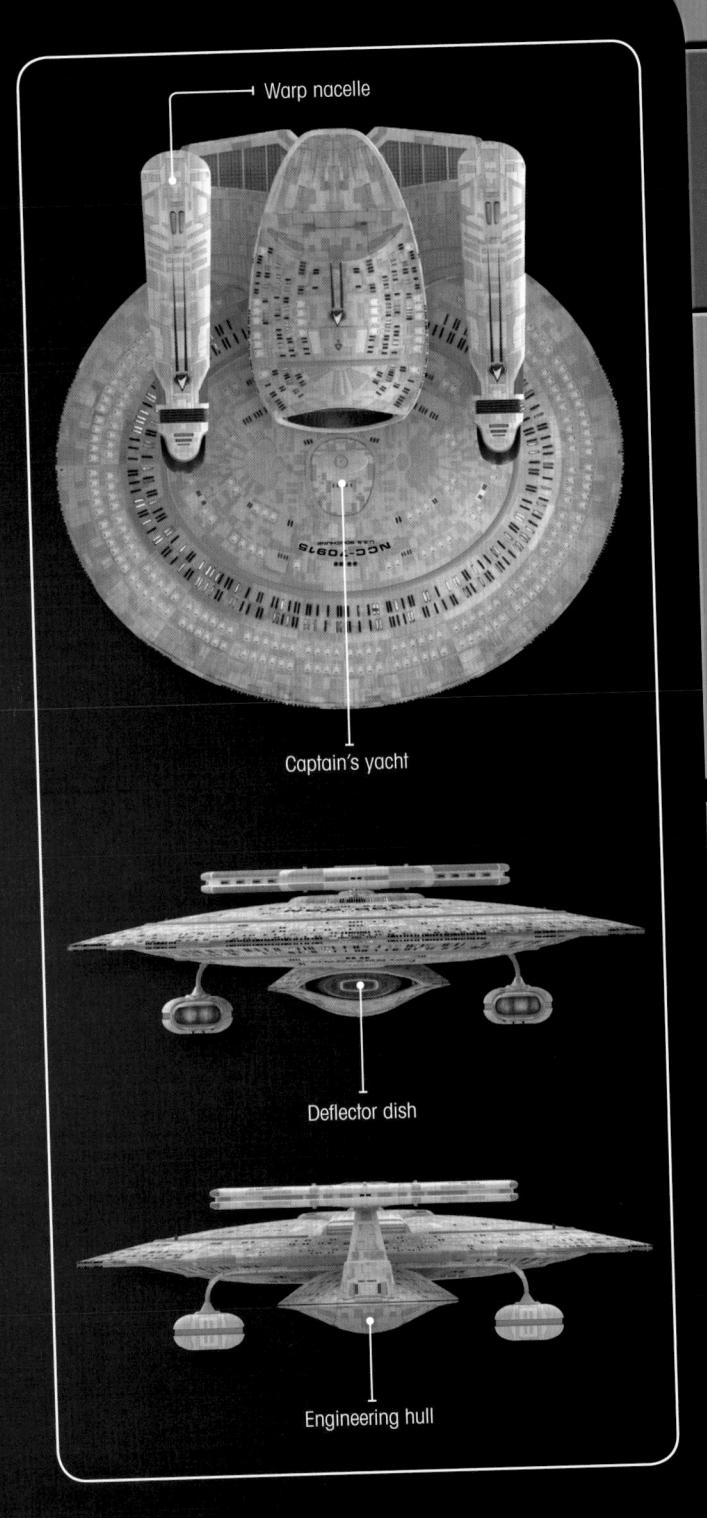

DATA FEED

Nebula-class starships were equipped with a variety of auxiliary craft, including Type 6 and Type 7 shuttlecraft, as well as the smaller Type 15 shuttlepod.

VULCAN CREW

The Nebula-class
U.S.S. T'Kumbra
was commanded by
Captain Solok and
had an all-Vulcan
crew. It spent six
months fighting on the
front lines during the
war with the Dominion.

MISSING IN ACTION

Geordi La Forge's mother, Silva La Forge, was captain of the *Nebula*class *U.S.S. Hera* NCC-62006. It was on a routine courier run when it went missing. Despite a massive search it was never found.

CLASSIC NAME

The Nebula-class U.S.S. Sutherland NCC-72015 was named after Horatio Hornblower's flagship in the C.S. Forester novels. These books served as one of Gene Roddenberry's original inspirations for STAR TREK.

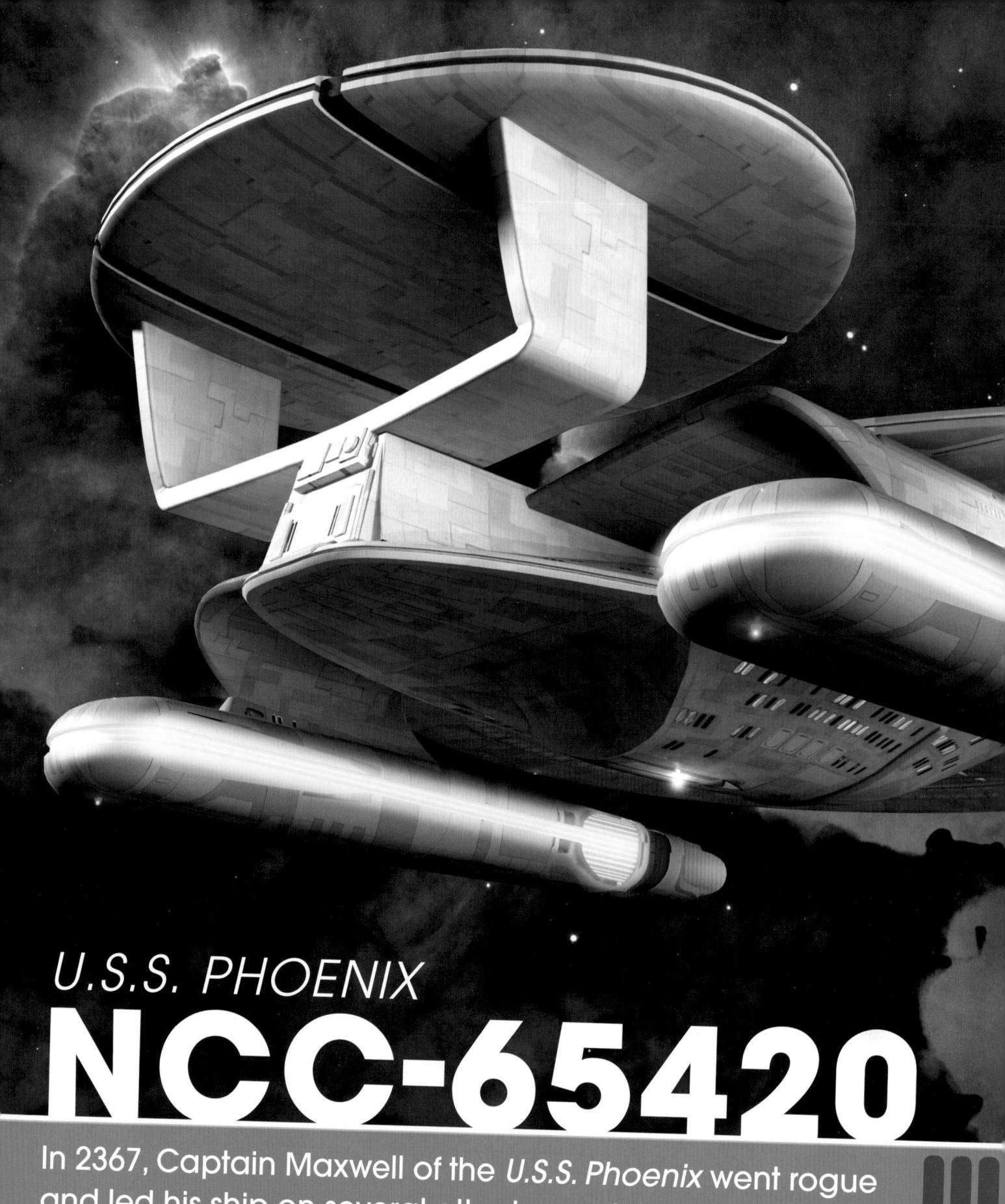

and led his ship on several attacks against the Cardassians.

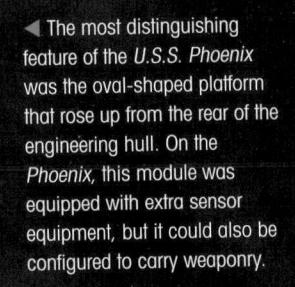

he *U.S.S. Phoenix* NCC-65420 was a Starfleet *Nebula*-class starship that was in operation in the 2360s. It was built by the Yoyodyne Division at 40 Eridani A Starfleet Construction Yards in the Vulcan system in 2363.

The *Phoenix* was constructed around the same time as the *U.S.S. Enterprise* NCC-1701-D, and they shared many design features. For example, the *Phoenix* used an almost identical saucer section and warp nacelles as the *Enterprise*-D, although the *Phoenix*'s secondary hull was different, being shorter and more curved.

At approximately 465 meters in length, the *Phoenix* was roughly two-thirds the length of the *Enterprise-D*, and it was more compact when seen in profile. This was because the *Phoenix* did not have a neck section between the primary and secondary hulls. Instead, the saucer sat directly on top of the engineering section, while the nacelles were suspended just below the secondary hull.

ADDITIONAL MODULE

The *Phoenix* featured an elliptically-shaped module that rose up on two supports from the back of the engineering hull and looked over the saucer section. This module could be configured to carry a variety of equipment depending on mission requirements. On the *Phoenix*, this superstructure was outfitted with extra sensor equipment, but on other *Nebula*-class ships, where this module was triangular, it carried additional weaponry.

The *Phoenix* was a multi-purpose ship and was normally assigned scientific and exploratory

■ The Phoenix was roughly two-thirds the length of the U.S.S.

Enterprise NCC-1701-D, and was outfitted with many of the same
parts. The saucer section and the warp nacelles appeared to be exactly
the same on both vessels, but the engineering hull was shorter and
more curved on the Phoenix, while its deflector dish was squarer.

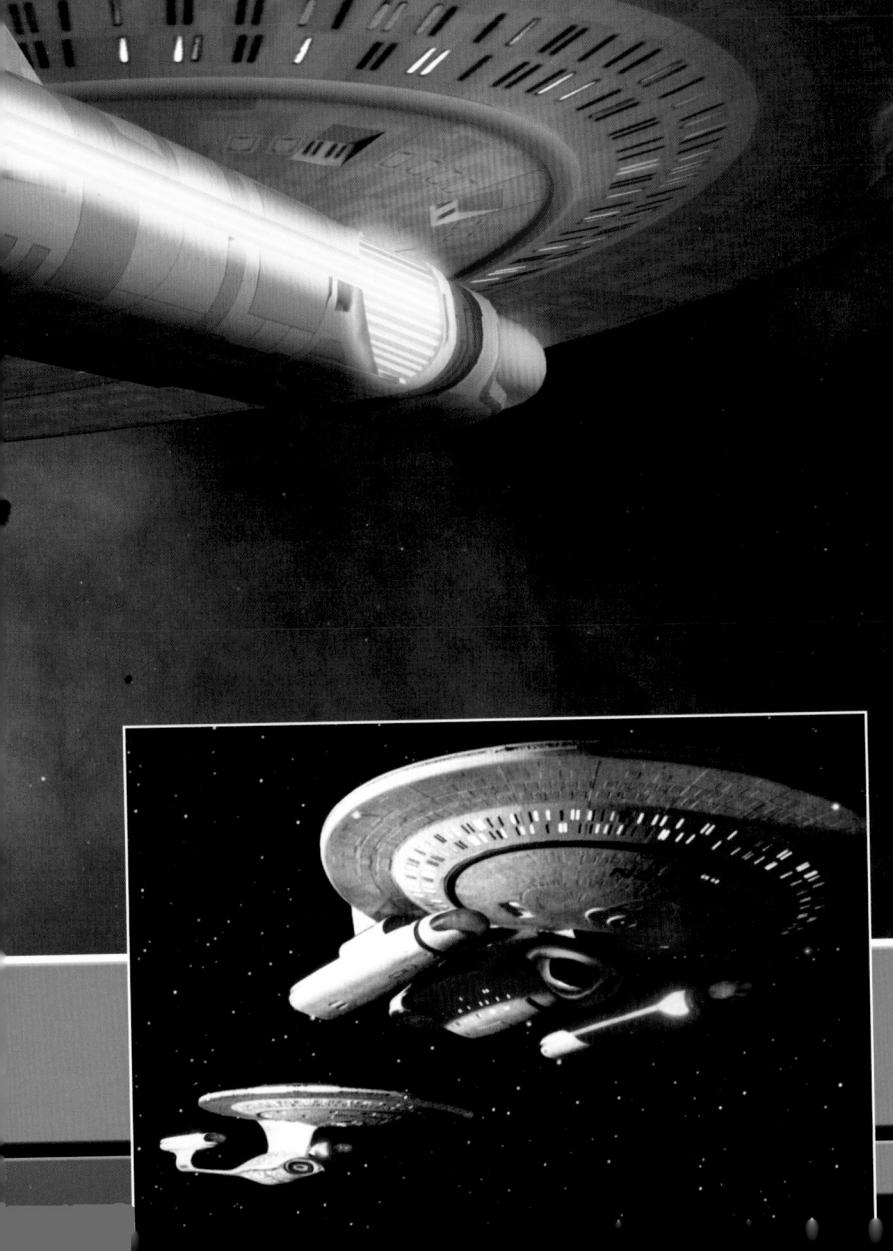

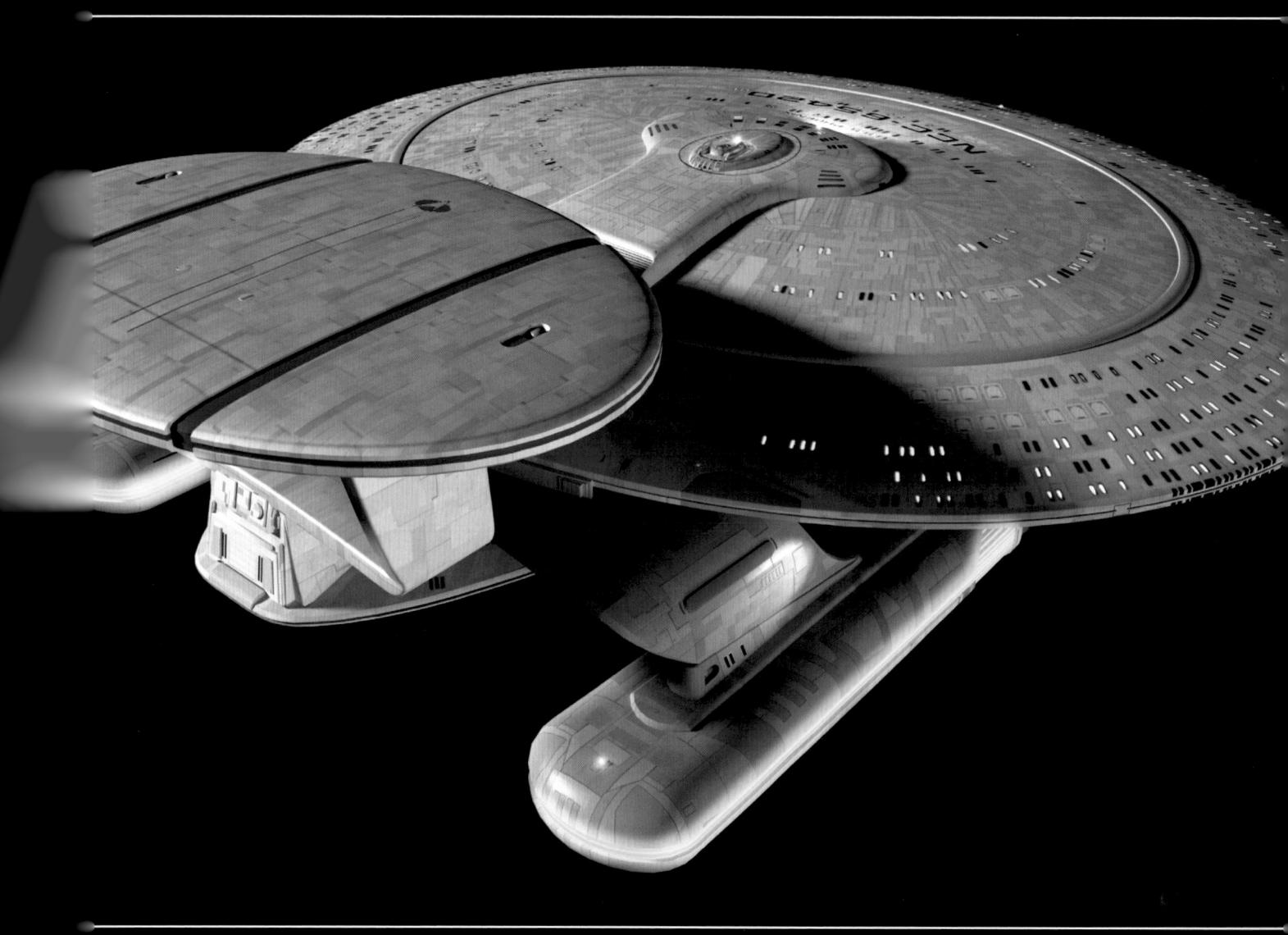

Apart from the large sensor module that rose up from the back of he secondary hull, the hoenix was very similar o the *Enterprise*-D. It may not have been quite s large as Starfleet's lagship, nor have as many facilities, but it was still a powerful ⇒hip. The *Phoenix* had no trouble destroying a Cardassian warship. even after its prefix code nad been used to lower he Phoenix's shields.

missions, but it was equally suited to transport and defensive patrol duties. It had a crew complement of around 750, but other *Nebula*-class ships such as the *U.S.S. Hera* NCC-62006 were known to operate with a crew of just 300.

The typical offensive arsenal of the *Phoenix* included a torpedo launcher located just above the deflector dish on the secondary hull. It also had multiple phaser arrays, with one positioned below the deflector dish and others at various points around the primary hull. Its maximum effective weapons range was slightly below 300,000 km. The *Phoenix* was fitted with warp and impulse drives, and was capable of maintaining a top speed of warp 9.5 for short periods.

In 2367, the *Phoenix* was under the command of Captain Benjamin Maxwell, one of the most highly regarded officers in Starfleet. The *Phoenix* had been assigned patrol duties near the recently

established demilitarized zone between Federation and Cardassian space following a long conflict between the two powers.

GONE ROGUE

It came to Starfleet's attention that the *Phoenix*, apparently unprovoked, destroyed an unarmed Cardassian science station. To avoid a major diplomatic incident, the *Enterprise-D* was tasked with taking three Cardassian officers on board in a transparent effort to show them that they were doing everything to locate the *Phoenix*.

Not long after, the *Phoenix* destroyed a Cardassian warship, taking 600 lives in the process. It then turned its attention to a smaller supply ship and annihilated that too, taking a further 50 lives.

When the *Enterprise*-D eventually caught up with the *Phoenix*, Captain Maxwell explained that the Cardassians were arming again in anticipation

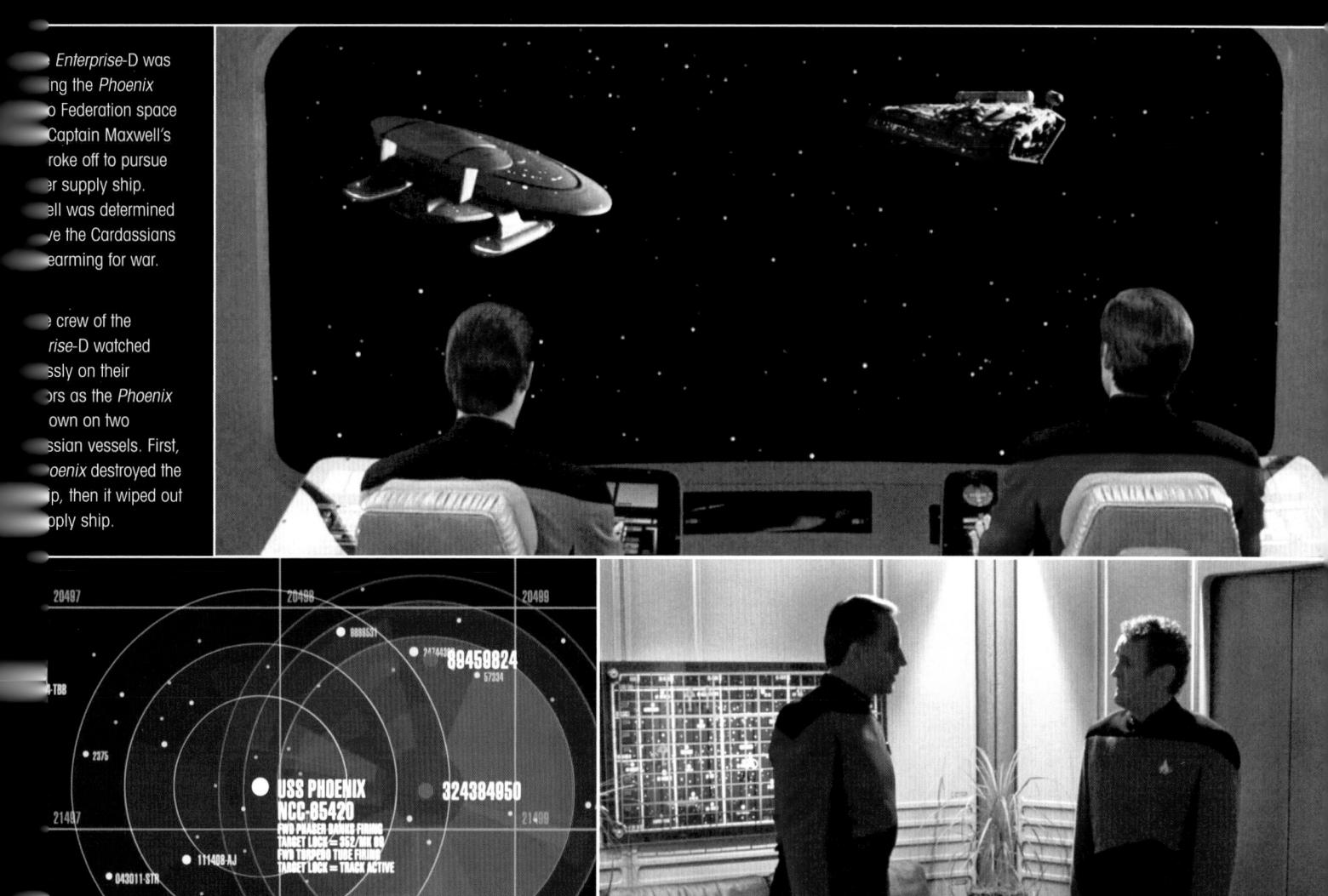

f renewing hostilities with the Federation. He aimed the science station he destroyed was military supply port.

When Captain Picard refused to listen to these nsubstantiated accusations, Maxwell went after nother Cardassian supply ship. Faced with the rospect of having to fire on a Starfleet ship, card called on the advice of Chief Miles O'Brien, ho had previously served with Maxwell.

O'Brien believed he could beam over to the hoenix and talk Maxwell down, even though ne Phoenix's shields were still raised. O'Brien naintained that he could beam through them ecause of the high-energy sensor sweep the hoenix was using. This sweep took five and a alf minutes, after which it reset and began the ycle again. At the moment it reset, the shields so went down for a fiftieth of a second, giving 'Brien a tiny period in which he could beam

through. It required a precise fix on the shield modulation of the *Phoenix*, but O'Brien's theory was correct and he managed to beam over.

O'Brien talked Maxwell around, and he agreed to stand down. The command of the *Phoenix* was handed over to the first officer, and it returned to Federation space while Maxwell was confined to quarters aboard the *Enterprise-D*.

After performing a precise transport through the *Phoenix*'s shields, Miles O'Brien confronted Maxwell in his ready room. O'Brien convinced his former captain to give up his vendetta against the Cardassians.

DATA FEED

Captain Benjamin Maxwell was twice decorated with the Federation's highest citations for courage and valor during the Federation-Cardassian War of the 2340s and 2350s. He felt animosity toward the Cardassians after a sneak attack by their military resulted in the deaths of nearly 100 civilians on Setlik III, including his wife and children. He never trusted the Cardassians after this, and later took it upon himself to destroy their supply ships because he believed they were gearing up for war again.

WATCHFUL EYE

Thanks to the actions of Chief Miles O'Brien, Captain Maxwell was taken into custody without further loss of life, and the peace treaty between the Federation and the Cardassians remained intact.

Captain Maxwell's actions were reckless in the extreme, but that did not mean Captain Picard did not believe him. In fact, Picard was sure that the Cardassians were rearming. It made no sense that so many Cardassian supply ships were visiting a 'science' station that was within easy reach of three Federation sectors, nor that these ships were running with high-energy subspace fields that prevented sensors from reading what they were carrying.

Picard did not want to search those ships because he knew it would end the peace, and he wanted to preserve it at all costs. He told the Cardassians that they would be watching them closely from now on, with the tacit threat that if they truly wanted peace they should cease what they were doing.

▲ Captain Picard left Gul Macet under no illusion that he believed Captain Maxwell's accusations that the Cardassians were rearming, and he told them Starfleet would be keeping a close eye on them.

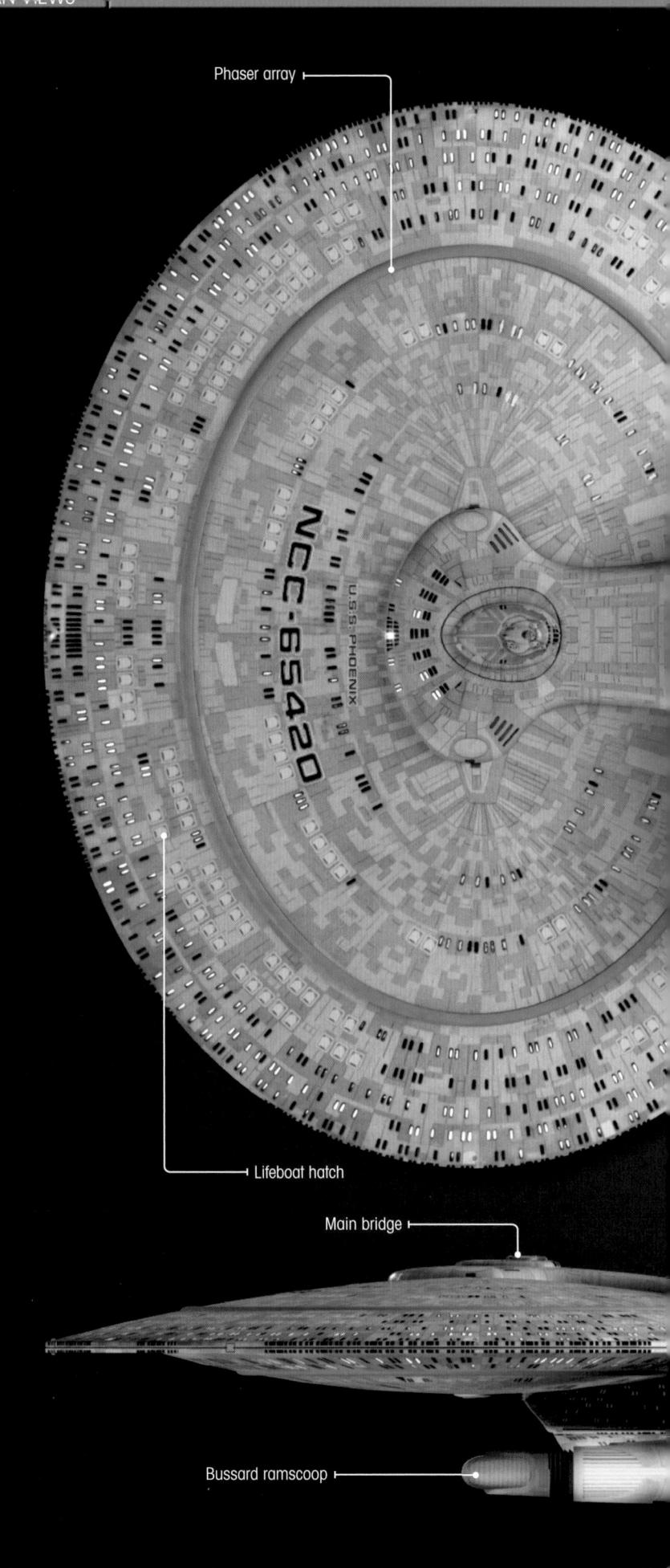

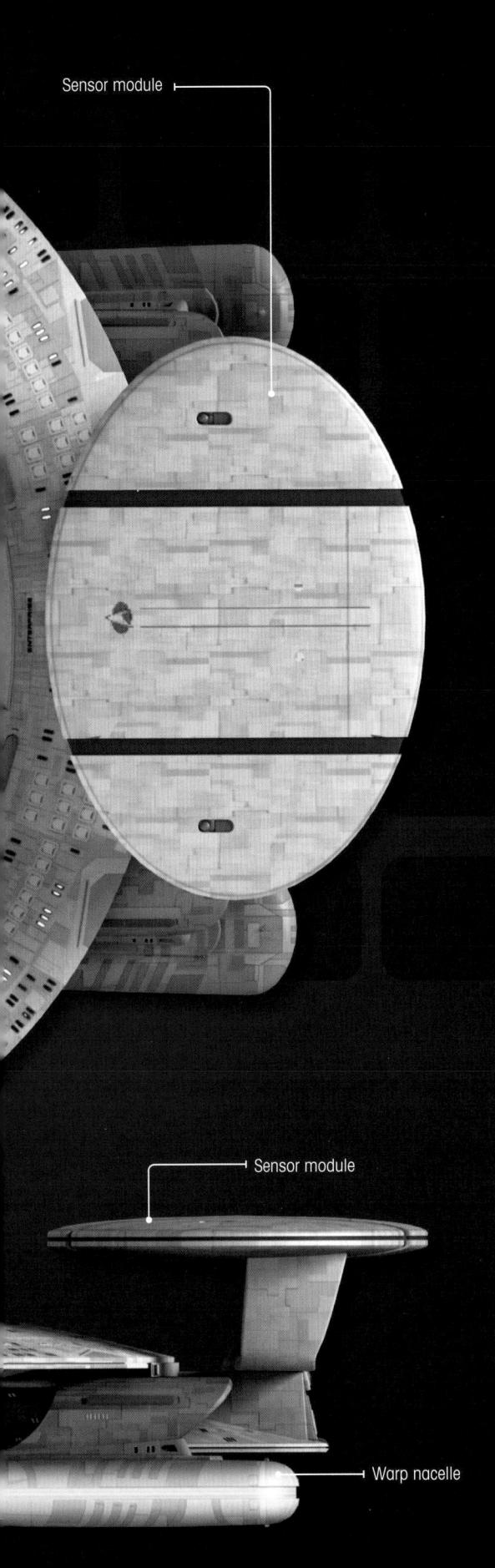

DATA FEED

Captain Picard reluctantly agreed to give the Cardassians the *Phoenix*'s transponder and prefix codes when it threatened two more Cardassians ships. This allowed a Cardassian warship to precisely locate the *Phoenix* and remotely lower its shields. Despite this, the *Phoenix* was still able to come out on top and destroy both Cardassian vessels.

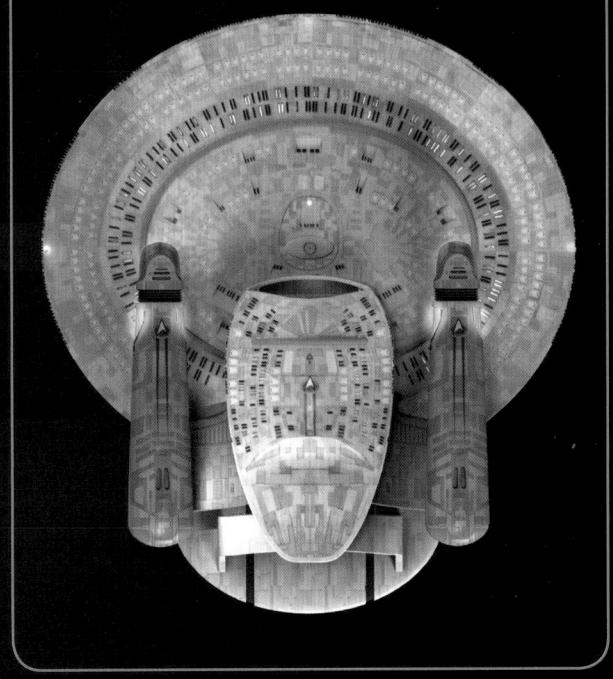

REAR VIEW

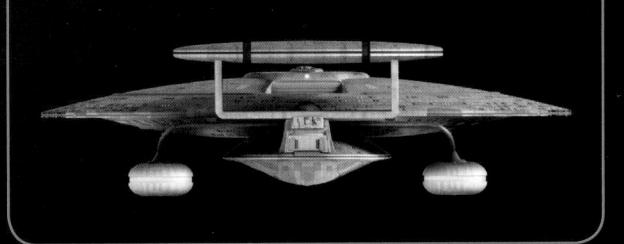

PLAQUE LOCATION

The U.S.S. Phoenix's dedication plaque was seen on the wall of Captain Maxwell's ready room. This was unusual as most ship plaques were normally only seen on the wall of the main bridge.

CRITICAL POSITION

The Phoenix destroyed an unarmed Cardassian science space station in the Cuellar system. Captain Maxwell believed this was a military supply post as it held a good strategic position to launch an invasion of three Federation sectors.

LEGENDARY NAME

The Phoenix was seen several years before STAR TREK: FIRST CONTACT came out. Nevertheless, the STAR TREK: Encyclopedia stated that it was named for Zefram Cochrane's ship of the same name, which of course was humankind's first ship to achieve warp speed.

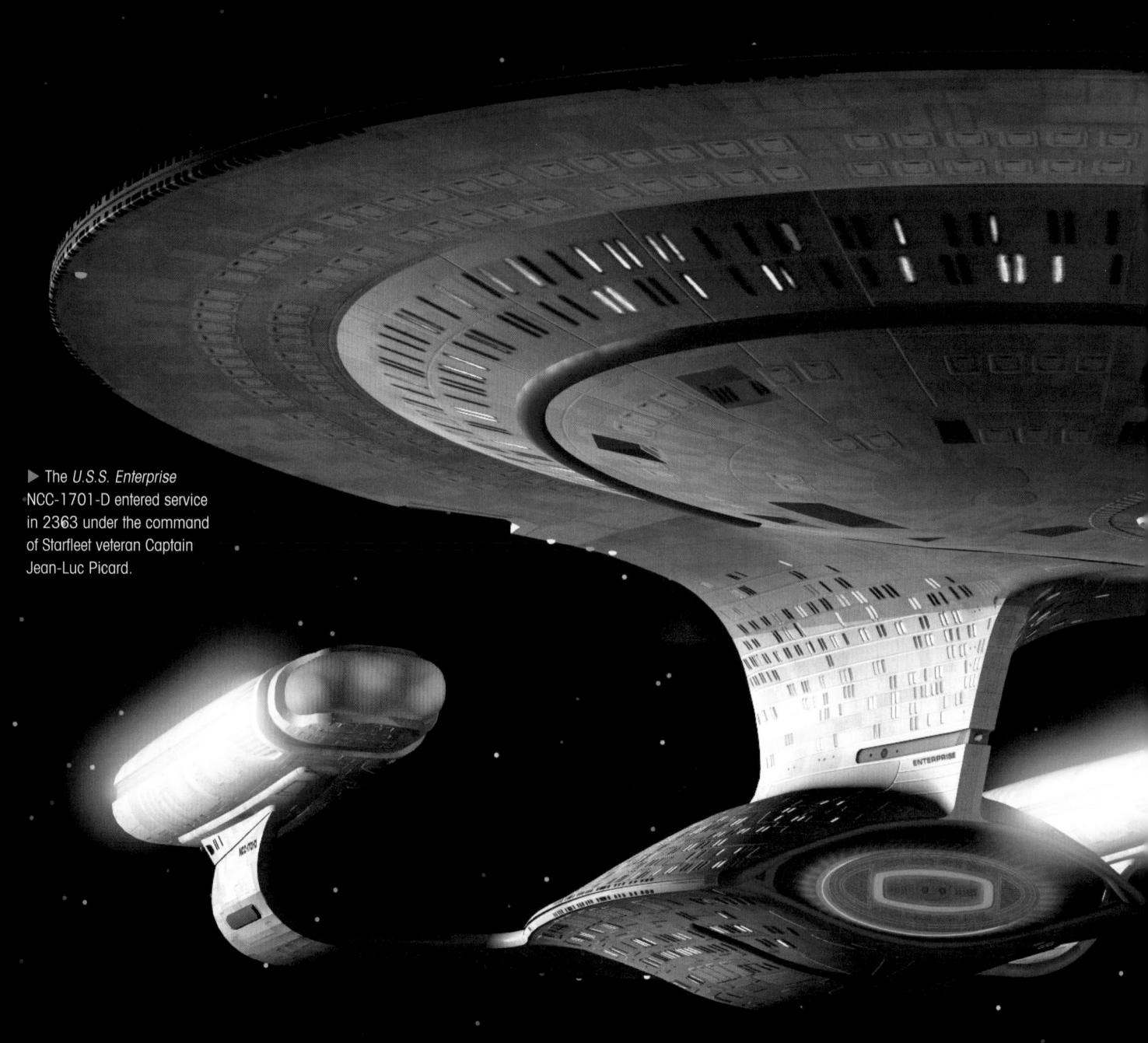

U.S.S. ENTERPRISE

NCC-1701-D

The *U.S.S. Enterprise* NCC-1701-D was more than a third of a mile long, and had a crew of over 1,000 people.

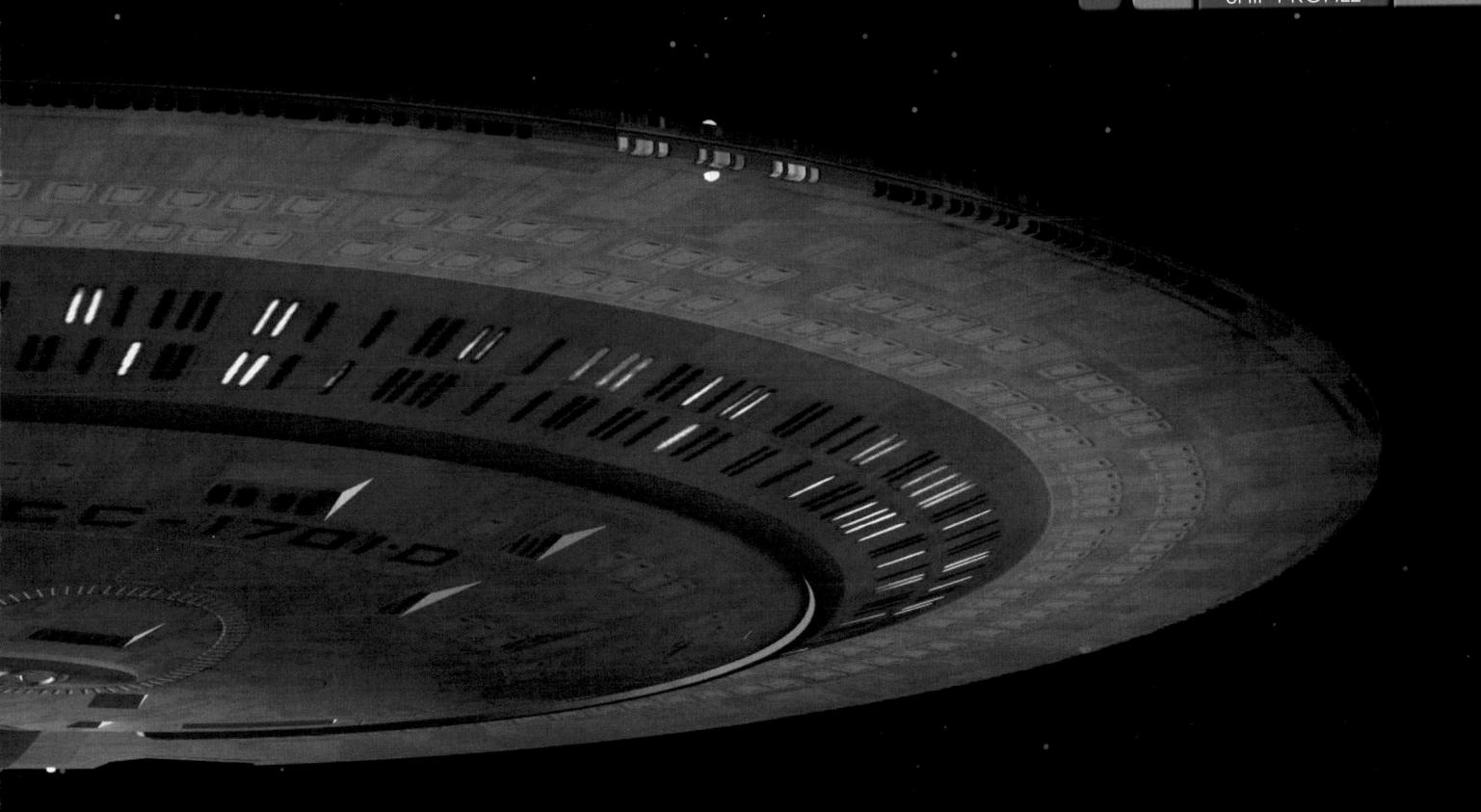

hen the *Galaxy-*class *U.S.S. Enterprise*NCC-1701-D was launched in 2363 –
94 years after Captain Kirk completed
his first, legendary, five-year mission on the *U.S.S.*Enterprise NCC-1701 – it was the largest, most
advanced vessel Starfleet had ever constructed.

The Enterprise-D was an awe-inspiring technical achievement that was the result of 20 years of development work from the finest engineering minds of the Federation Advanced Starship Design Bureau, including Dr. Leah Brahms, who was largely responsible for the design of the warp engines.

The Enterprise-D followed the same basic design layout as previous Enterprises, but it was sleeker

due to advancements in hyperflight dynamics, and the saucer section was larger in proportion to the secondary or engineering hull. At 641 meters in length and with 42 decks covering 3.5 million square metres, it had eight times as much interior space as Captain Kirk's *Enterprise*. This meant there was 110 square meters of living space per person.

A SCIENTIFIC MARVEL

The Enterprise-D's specifications were mind-boggling: it had more than 4,000 internal systems, including two LF-41 warp engines that gave it a top sustainable speed of warp 9.6 (1,909 times the speed of light). It also had a high-capacity shield grid, 12 Type-X phaser arrays, three torpedo launchers and a complement of 250 photon torpedoes.

Facilities on board included three sickbays, 20 transporter systems, and more than 100

■ The outer surface of the Enterprise-D featured phaser strips, transporter emitter pads, subspace radio antennae, active energy forcefields, navigational sensors, escape pod hatches, and hundreds of viewports. The outermost hull layer was made up of AGP ablative ceramic fabric segments approximately 3.7 square meters in size.

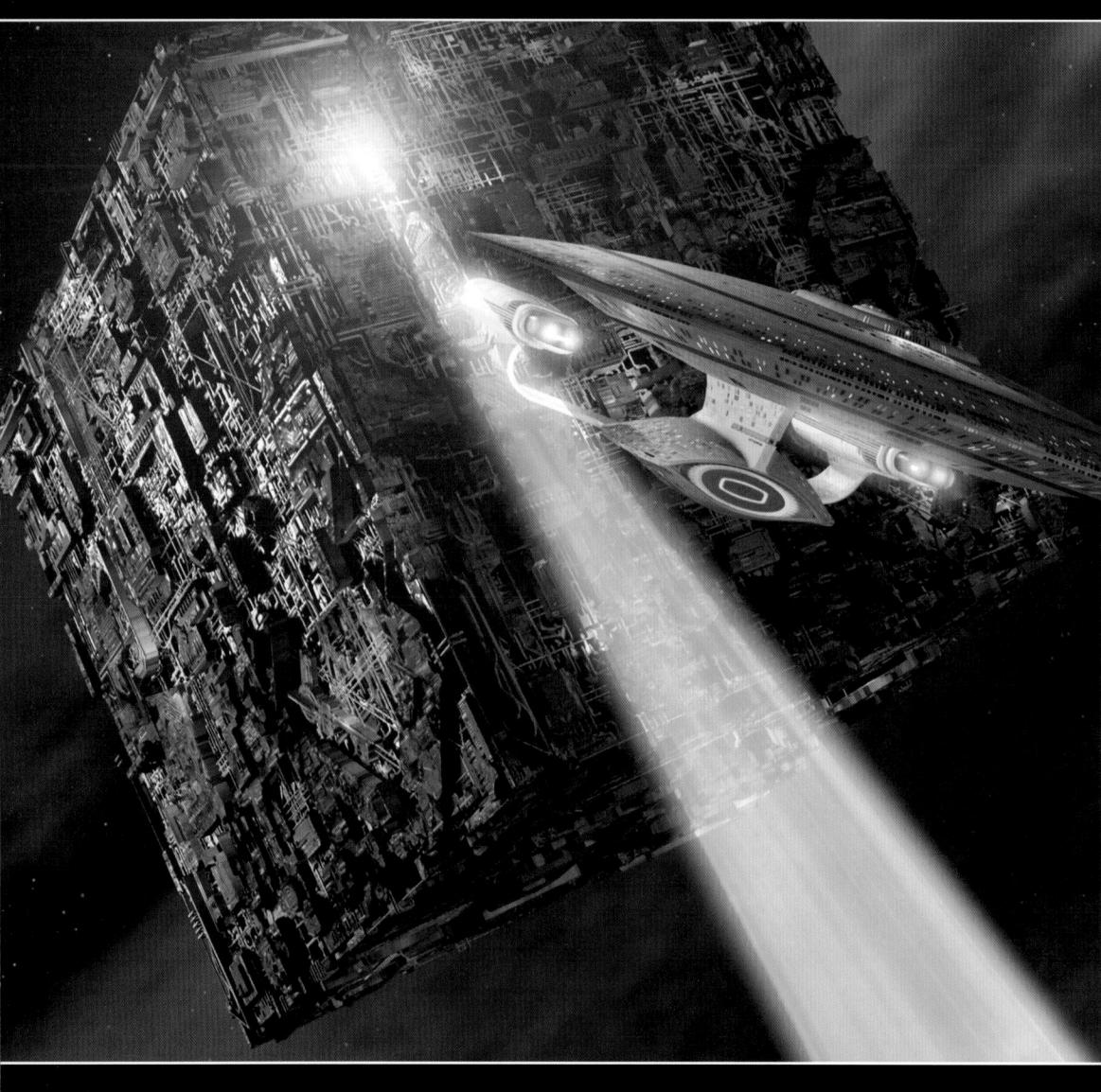

▶ The main bridge, which was located on Deck 1 at the top of the saucer section, was the nerve centre of the ship. Using the stations here a tiny crew could control the entire vessel.

▲ Although the Enterprise's primary mission was deep space exploration, she was involved in a number of significant conflicts. She was the first Starfleet vessel to survive an encounter with the Borg and two years later the crew was the last line of defense when the Federation repelled the Borg invasion of 2367.

research labs dedicated to disciplines such as stellar cartography, exobiology, cybernetics, astrophysics, geosciences, archaeology, cultural anthropology and botany.

Amenities included 16 holodecks, a phaser range, a theatre, a gym, a salon, a restaurant/bar called Ten-Forward, classrooms and even an arboretum. In other words, it had everything the crew of 1,012 could need and it could operate for up to seven years without needing to return to a starbase for refurbishment. Even Captain Picard was "in awe of its size and complexity" and a person could live on it for years and still not know their way around all the parts of it.

The unprecedented size of the *Enterprise-D* and its comprehensive facilities were provided because Starfleet had decided that the crew would include families and children. It was felt that Starfleet personnel were far more likely to sign up

for exploratory missions, which often took years, if they could take their families with them and think of the ship as home.

There are always inherent risks involved in space exploration, but this was a period of unprecedented peace for the Federation. It was after the threat of war with the Klingons and the Romulans had been removed by the Khitomer Accords (2293) and the Treaty of Algeron (2311), and before new dangers emerged in the shape of the Borg and the Dominion. It was therefore felt that it was safe enough to place families on board, especially as *Galaxy-*class starships had a neat trick in an emergency – they could split into two autonomous spacecraft.

All non-essential personnel could be evacuated to the saucer section, which could then detach from the engineering hull and retreat to safety under its own impulse power, while the remaining

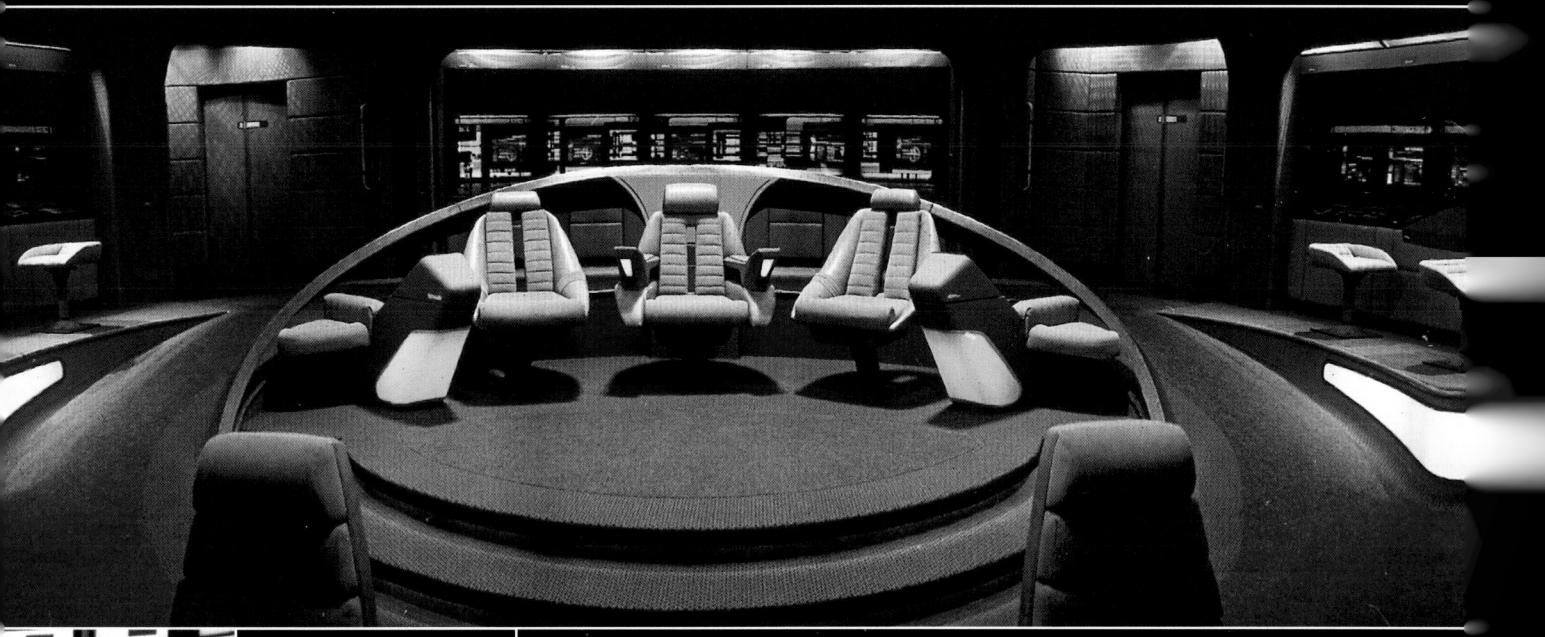

▼ The ENTERPRISE-D
had 20 transporter
rooms, including six
main personnel
transporters. They were
capable of beaming
individuals distances of
up to 40,000km almost
instantaneously.

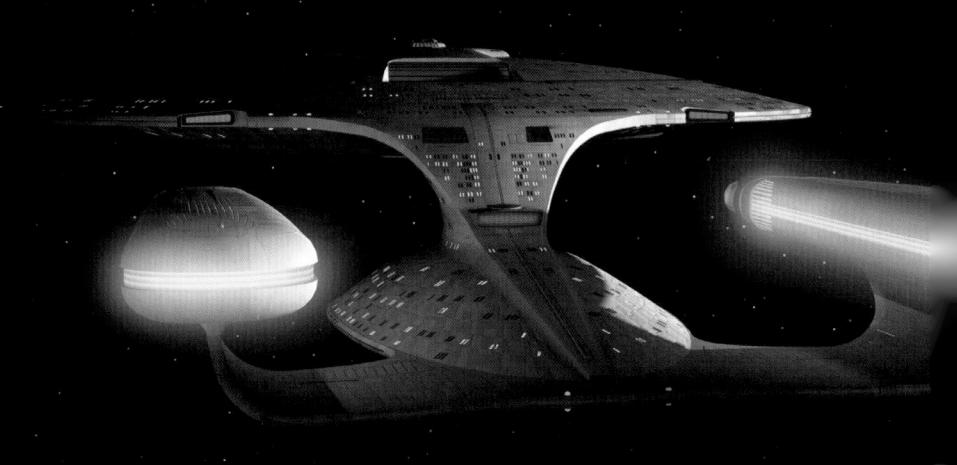

Stardrive section, which was capable of warp flight and optimized for combat, engaged the threat. The two sections could then reattach once the danger was over.

PICARD'S STARSHIP

The Enterprise-D was constructed under the supervision of Commander Orfil Quinteros at the Utopia Planitia Fleet Yards, 16,625 km above Mars. Its primary mission was one of exploration, but it was also regularly tasked with diplomatic and humanitarian missions and defending the security of the Federation.

The ship remained under the command of Captain Picard throughout its career, apart from one brief period when Captain Edward Jellico took command while Picard was on a covert mission. It played a major role in defending the Federation against the Borg (when Riker was given

a field promotion to captain) and in the blockade of Klingon space during the Klingon civil war.

It was designed to be operational for approximately 100 years, with major refits scheduled for every 20 years, but it was in service for just eight years before it was destroyed by a renegade Klingon vessel led by the Duras sisters in the Veridian System in 2371.

▲ The Galaxy class followed the same design principles that Zefram Cochrane established on Earth's first faster-thanlight ship and used twin nacelles to generate fields that warped space.

DATA FEED

The *Enterprise*-D had a crew of 1,012 that included a significant number of civilians such as Mot the Bolian barber and botanist Keiko O'Brien. As you would expect on a Federation ship, the *Enterprise*-D's crew was made up of people from many different planets and species. In 2366, there were said to be 13 different species on board, while in 2369 there were 17 members of the crew from non-Federation worlds, including the Bajoran Ro Laren.

Shuttlebay 3 +

DEFLECTOR DISH

One of the most important features of the *Enterprise*-D was its navigational deflector. This oval shaped device was located on the front of the Stardrive section and pushed space debris clear of the ship's path. At warp speeds even microscopic particles of asteroids or other particulates could cause massive damage if they collided with the ship's hull. The deflector dish projected a powerful graviton beam that swept large objects, such as asteroids, out of the way. At the same time, a low-power beam, created a shield nearly two kilometers ahead of the ship that deflected the microscopic interstellar debris out of the way.

The long range sensors were directly behind the deflector dish. These were located on decks 32-38 and were the most powerful scientific instruments aboard the *Enterprise-D*.

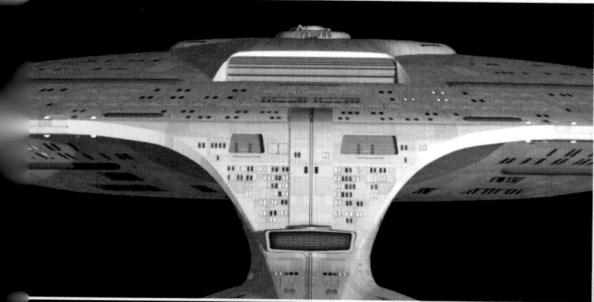

▲ The impulse engines were marked by a red glow on the rear of he Saucer section and at the back of the Stardrive section below he doors for Shuttlebay 2/3.

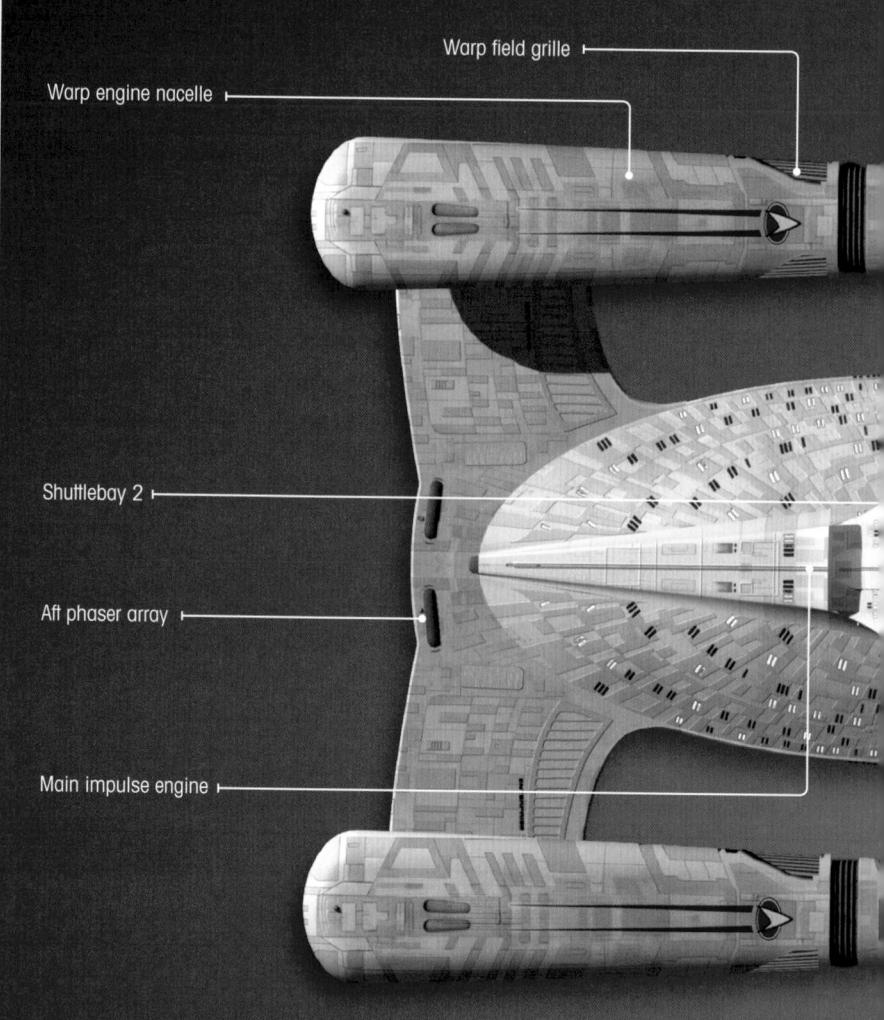

DATA FEED

The Enterprise-D's most powerful weapons were its photon torpedoes. Each one had a yield of 18.5 isotons and had a range of 3.5 million km. Launchers were fitted to the neck and the rear of the stardrive section between the nacelle pylons.

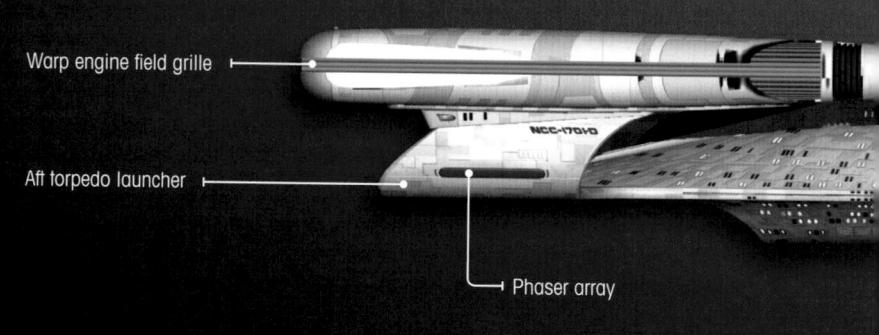

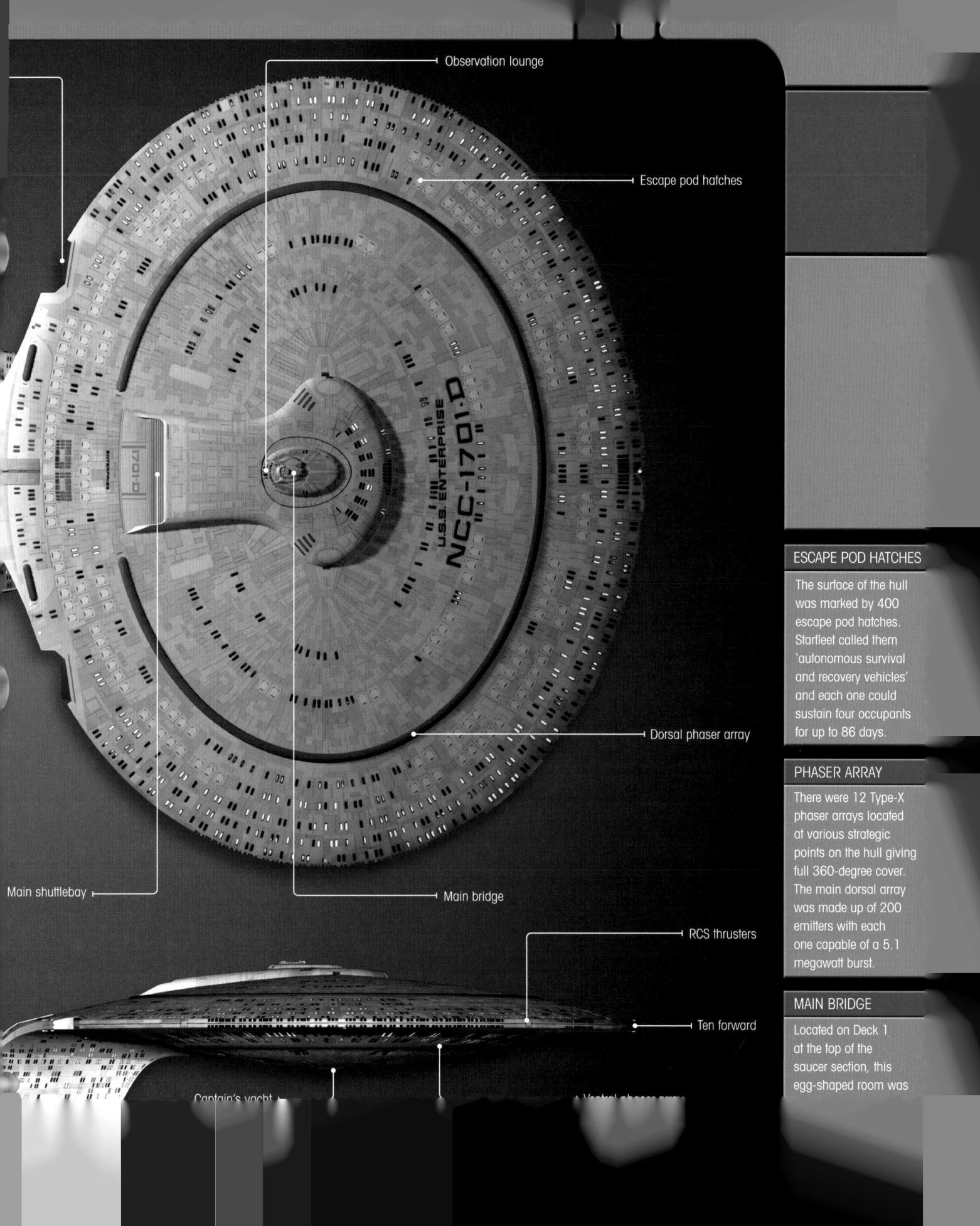

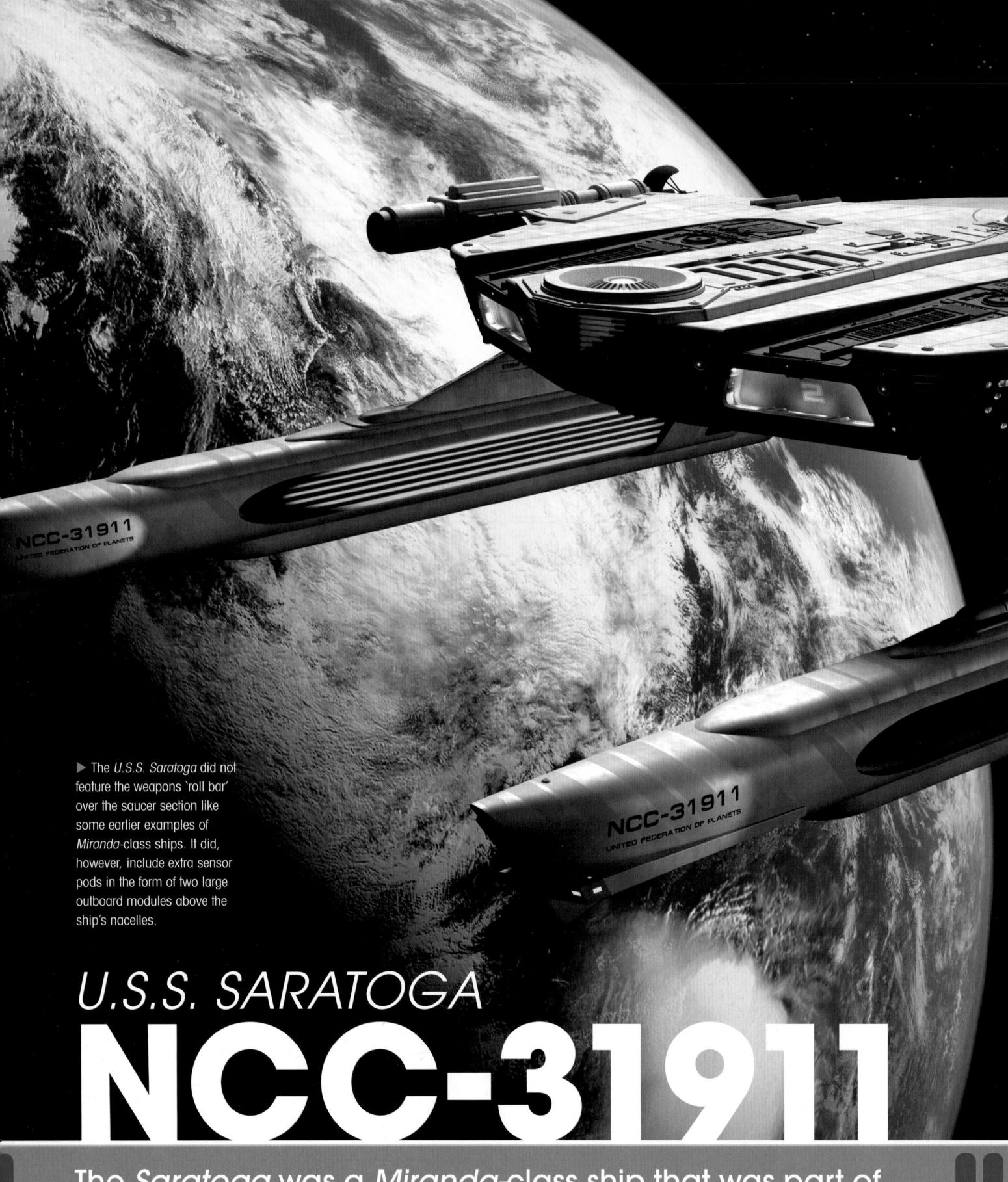

The *Saratoga* was a *Miranda-*class ship that was part of the fleet that fought a Borg Cube at the Battle of Wolf 359.

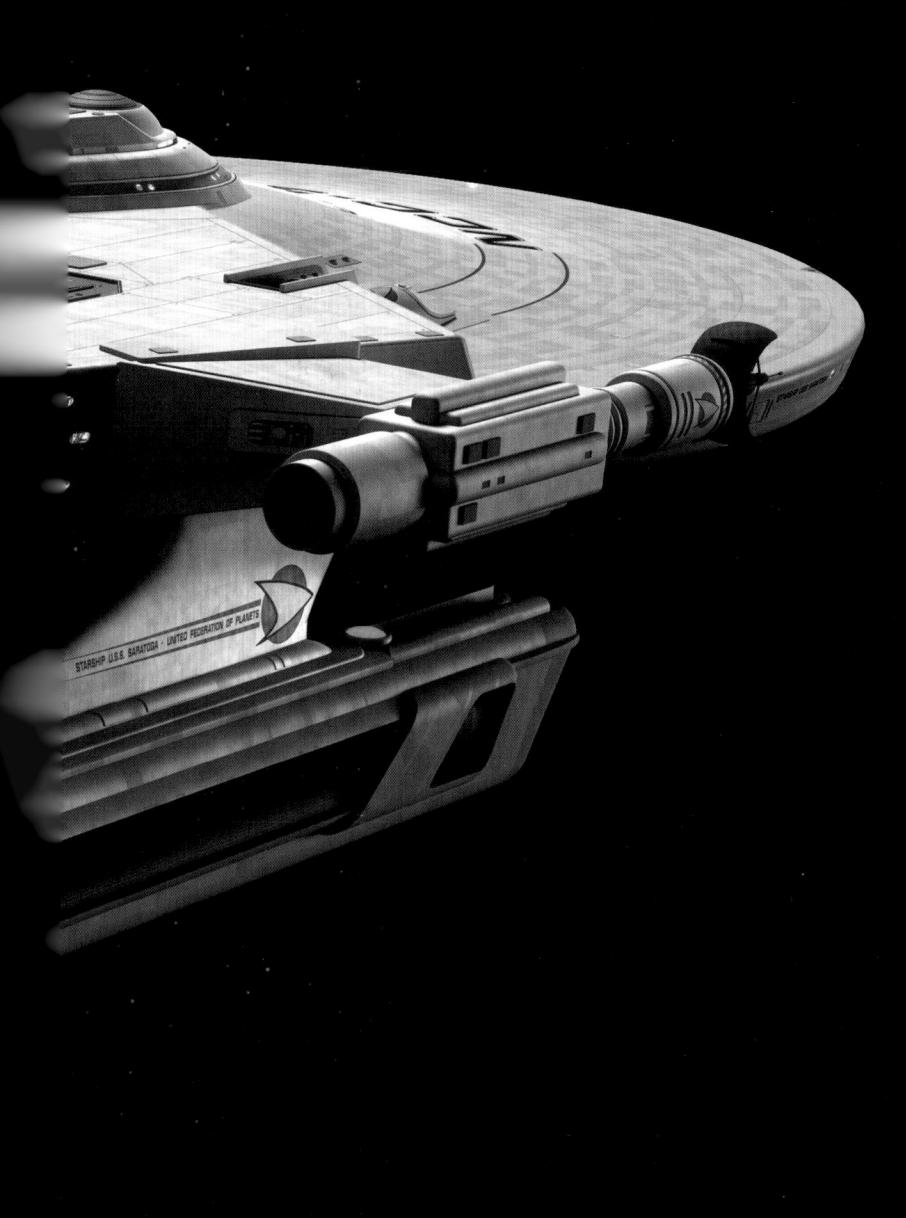

he *U.S.S. Saratoga* NCC-31911 was a *Miranda*-class vessel that was in service with Starfleet during the 24th century. This class of starship had been operating since at least the 2280s, making it one of the longest serving and most successful types of vessel to be used by Starfleet.

They were designed and mainly used for science and patrol missions, but they could also be deployed in combat duties if the need arose. They normally had a crew complement of around 200, and by the middle of the 24th century, they also accommodated crew member's families.

Over the years, *Miranda*-class ships had used slightly different hull configurations, but their overall shape remained basically the same. Like all vessels of this type, the *Saratoga* was 243 meters in length, and did not feature a separate secondary engineering hull. Instead, an enlarged squared-off section was fitted to the rear of the saucer. This area contained the ship's warp core and impulse engines, as well as two shuttlebays. Both of the shuttlebays also contained escape pods capable of transporting several personnel off the ship in an emergency.

LOCATION OF WEAPONS

Some *Miranda*-class vessels were equipped with a weapons 'roll bar' that was fitted above the rear section of the saucer, and it carried additional phasers and torpedo launchers. The *Saratoga* did not feature this roll bar, and just had the standard number of phasers and torpedo launchers. This included six type-7 phaser emitters, three mounted on top of the saucer and three below, including one that was situated on the sensor dome. There

◄ According to a starship deployment chart seen in a courtroom of Starbase 173 in 2365, the Saratoga was captained by Martin Jedlicka while it was on a mission of exploration in Sector 002. By 2367, a Vulcan captain had taken over the command of the ship, while the then Lt. Commander Ben Sisko was her first officer.

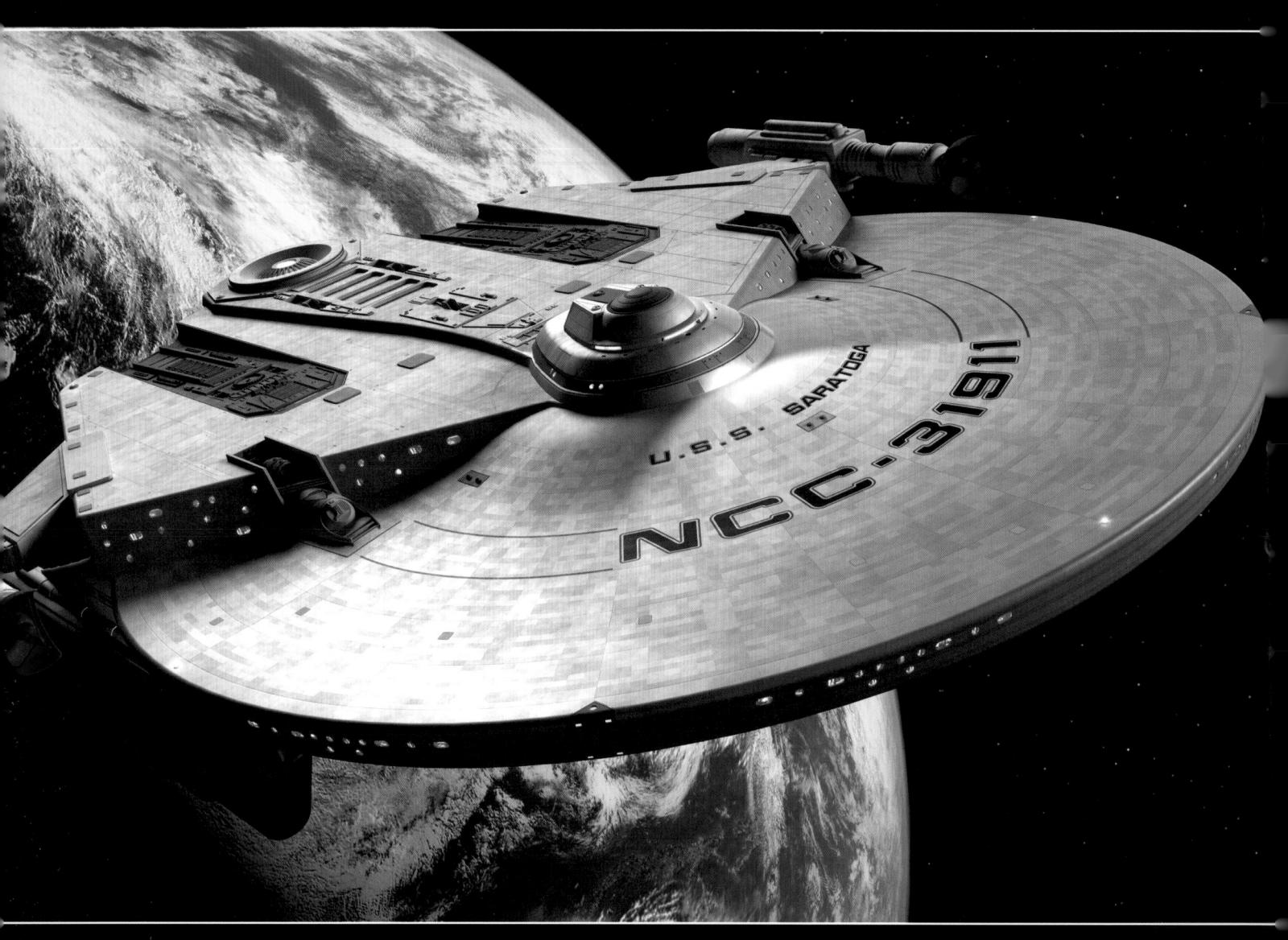

▲ Miranda-class vessels, such as the Saratoga, were normally used for scientific or supply missions. They featured a whole host of upgraded sensor equipment to help them carry out their primary tasks. They were not really designed for combat, but they could be pressed into action if the need arose.

were also two phaser emitters located just below the impulse engines at the rear.

The Saratoga had additional cylindrical sensor pods located below the port and starboard side of the saucer section. These were not standard equipment on all Miranda-class vessels, and obviously enhanced the scanning ability of the Saratoga, providing additional scientific data.

The Saratoga had a vertically installed warp core that spanned several decks, and warp nacelles that hung down below the saucer section. The ship was capable of attaining a top speed of warp 9.2 for short periods, but its standard cruising speed was closer to warp 6.

The main bridge of the Saratoga was located on deck 1 at the top of the saucer section. The layout was similar to that found on Constitutionclass ships, with the flight controller and operations stations were located at the front and the captain's chair in the middle. Two additional standing consoles were located behind the captain's chair, with the tactical station being the one on the port side, while science and communications stations were on the starboard side of the bridge.

SERVICE RECORD

In 2365, according to a starship deploy status chart that was on display in a courtroom of Starbase 173, the Saratoga was under the command of Captain Martin Jedlicka. It was assigned to a deep space exploration mission of Sector 002 along with the U.S.S. Apollo NCC-30000.

By 2367, the *Saratoga* was under the command of a Vulcan captain and its first officer was Lt. Commander Benjamin Sisko, who would later become the commander of Deep Space 9. During that year, it was part of a fleet of at least 40 starships that massed at Wolf 359 to

▶ The Saratoga engaged the Borg cube at the Battle of Wolf 359. It fired a full salvo of phasers, but they had no effect. The Saratoga was then held in a Borg tractor beam, while its shields were drained.

▼ During the encounter with the Borg, the tactical officer aboard the Saratoga was a heavily muscled Bolian. He, along with Sisko, were the only members of the bridge crew to survive the attack by the Borg.

-protect Earth and the surrounding sector from an invasion by a Borg cube.

During the battle, the Saratoga unleashed a full spread of phasers and photon torpedoes at the Borg cube, but they had no effect. The *Saratoga* was rendered immobile by a tractor beam emitted by the cube, while its shields were quickly drained of power. With no defenses, the Saratoga was helpless against the cube's cutting Deam, which sliced apart the hull through decks one to four and caused a massive explosion. The warp core also suffered heavy damage, leading to an antimatter containment failure. Apart from Sisko and the Bolian tactical officer, the entire bridge rew were killed in the attack, while chaos and fires eigned all around them. The entire ship leaned to he left as the stabilizers failed, and it was clear that he Saratoga could not be saved.

Sisko tried to get as many survivors to the

escape pods as he could, before rushing back to his quarters. He managed to rescued his barely conscious son Jake, but he was too late to save his wife, Jennifer, who also died in the attack. As they left in an escape pod along with a dozen others, the *Saratoga*'s warp core breached and the ship exploded in a massive fireball.

A Sisko's wife, Jennifer, had taken refuge in their personal quarters, along with their son Jake, during the Borg invasion. Jake survived the encounter, but Jennifer was killed when an explosion ripped up through the floor.

Following the Battle of Wolf 359 and death of his wife Jennifer, Sisko took up a posting at Utopia Planitia Fleet Yards on Mars. Emotionally devastated, Sisko poured his energy into helping design a prototype *U.S.S. Defiant*. Design flaws emerged and the project was halted, leaving him on the verge of resigning. It was then that one of his former commanding officers, Captain Leyton, recommended him for a command position aboard *Deep Space 9*.

BATTLING THE BORG

The *U.S.S. Saratoga* was one of at least 40 Starfleet ships that fought an invading Borg cube at the Battle of Wolf 359 in 2367.

Early in the battle, the *U.S.S. Melbourne* NCC-62043 was caught in the cutting beam weapon from the Borg cube. As its shields were being drained, the *Saratoga* rushed in to help the stricken vessel, but it was too late. Half of the *Melbourne's* saucer was blown away, and the burning hulk of what remained was rammed by the cube as it pursued the *Saratoga*. It was soon caught in the cube's tractor beam, while its shields were quickly drained. Once they failed, there was a massive explosion that caused huge damage to decks one through four.

Once the smoke had cleared, First Officer Benjamin Sisko realized that he and the Bolian tactical officer were the only bridge crew who remained alive. Damage reports revealed that a warp core containment failure would destroy the rest of the ship in just four minutes. Sisko had no other option but to issue the order to abandon the ship. He then went to his crew quarters to find his wife and child, and while Jake was still alive, his wife Jennifer had been killed by fallen wreckage.

Numb, and with badly burned hands, Sisko found his way to an escape pod where he joined Jake and about a dozen other survivors. The escape pod was launched and then a few seconds later, they watched through the window as the *Saratoga* blew to pieces.

Sisko was lost in his thoughts about his deceased wife as he fled he Saratoga in one of its escape pods. Seconds later, the Saratoga, which could be seen through the window, erupted in a huge fireball.

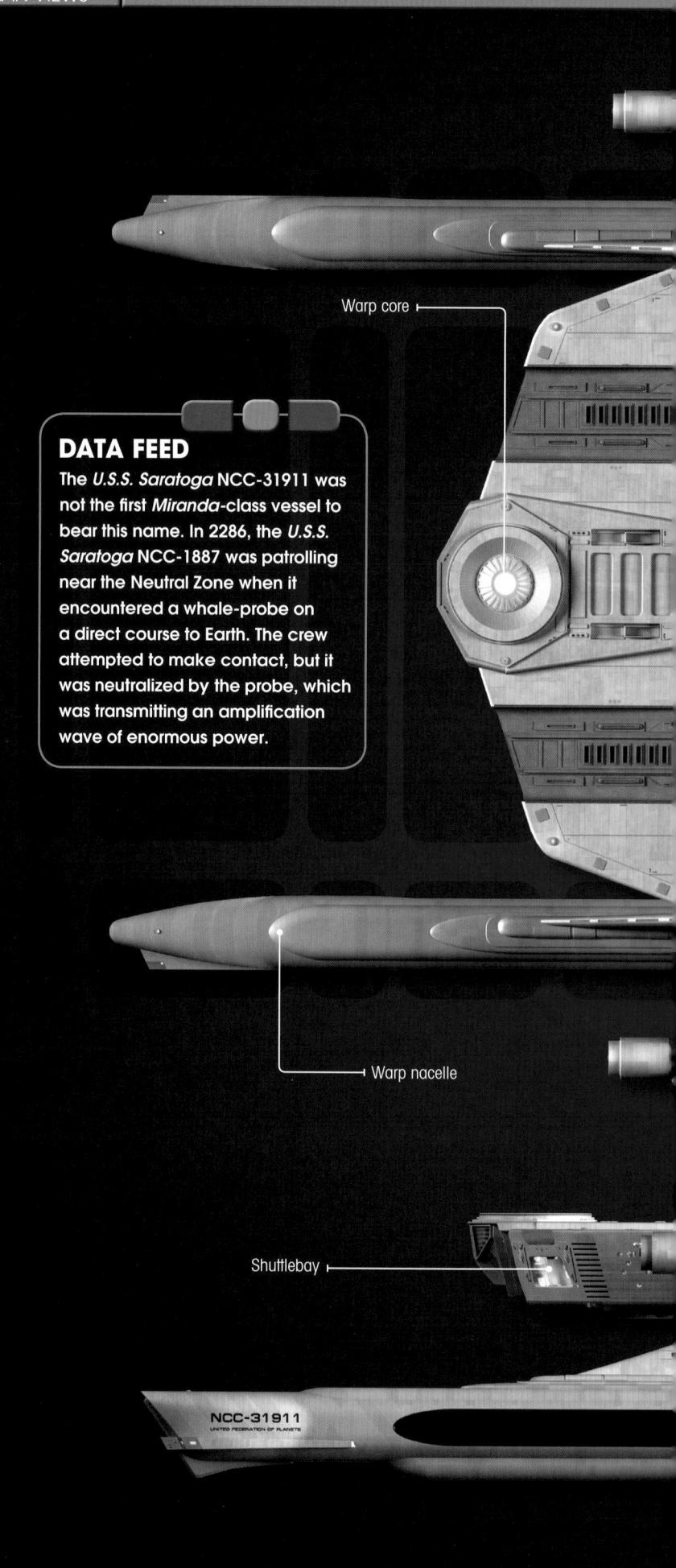

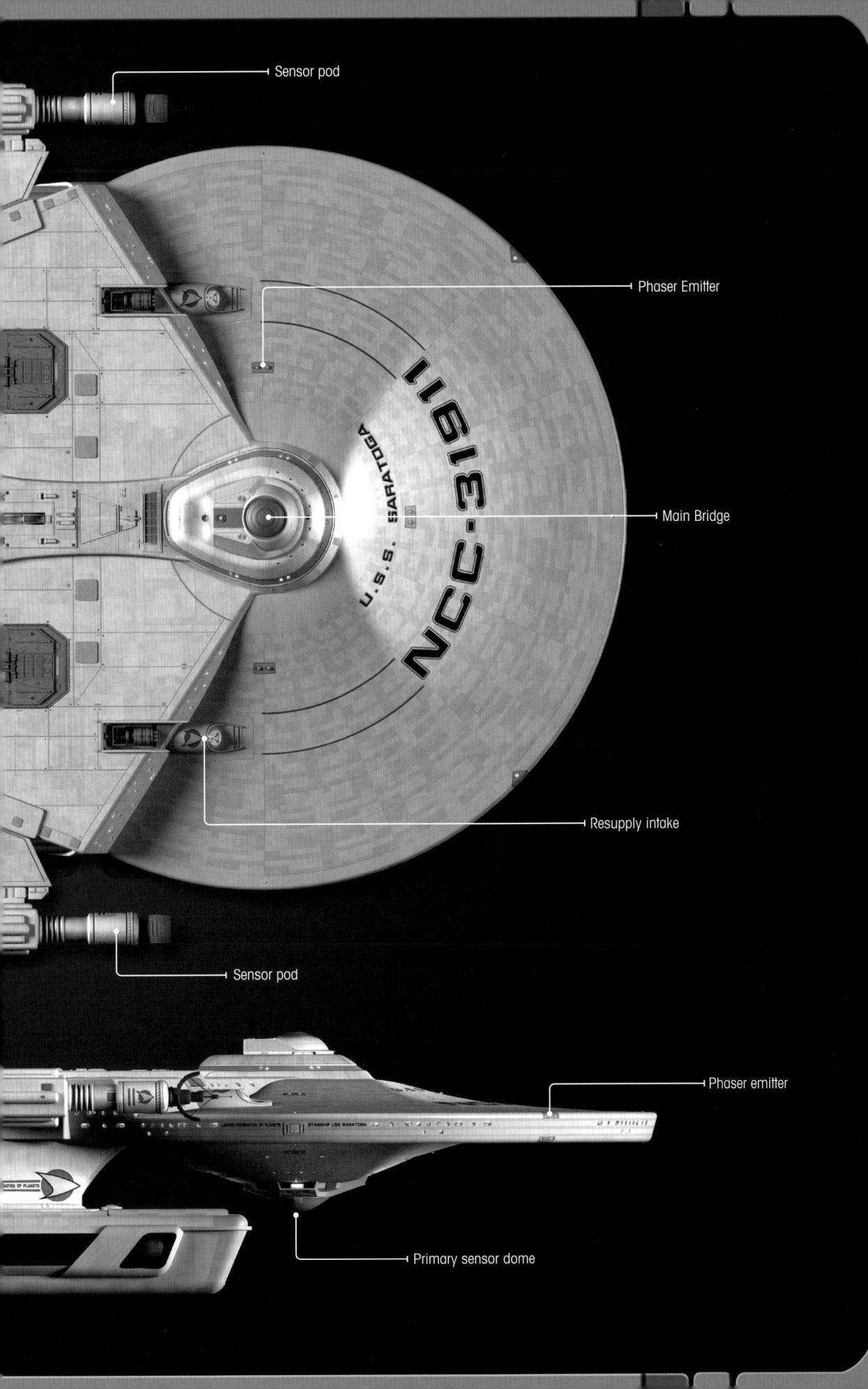

CLOSE NEIGHBOR

Wolf 359 was the primary star in the Wolf system. In reality, it is located in the constellation Leo, approximately 7.8 light years from Earth. It is one of the nearest stars to the Sun.

BOLIAN NAME

The name of the Saratoga's Bolian tactical officer was never given on screen. His name was revealed as Hranok in the novelization of the STAR TREK: DEEP SPACE NINE episode 'Emissary.'

FAMILIAR VOICE

Majel Barrett, the actress who played Nurse Christine Chapel in THE ORIGINAL SERIES and wife of Gene Roddenberry, recorded the lines spoken by the Saratoga's computer voice, as she had done previously for the U.S.S. Enterprise-D's computer voice.

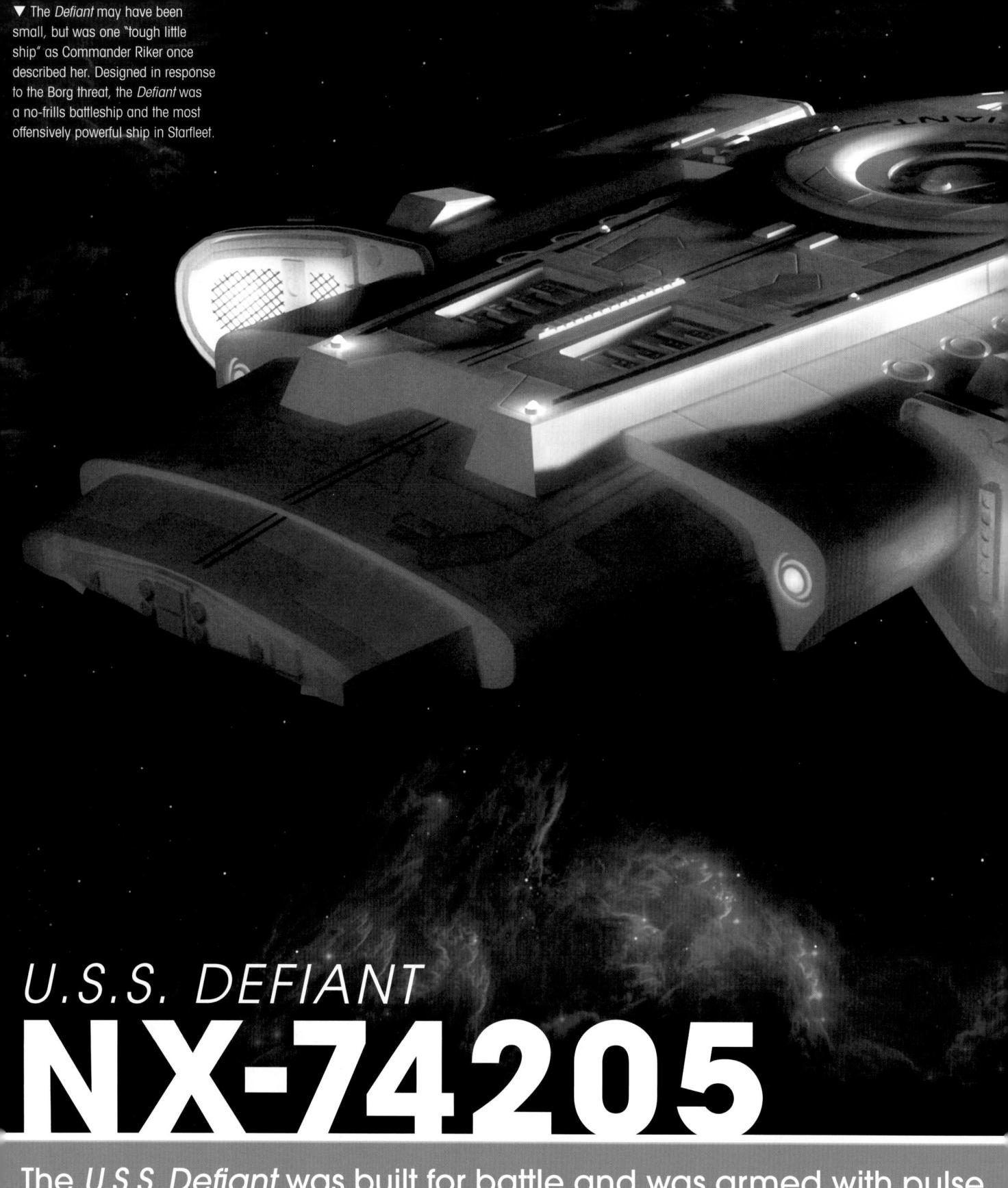

The *U.S.S. Defiant* was built for battle and was armed with pulse phaser cannons, quantum torpedoes, and a cloaking device.

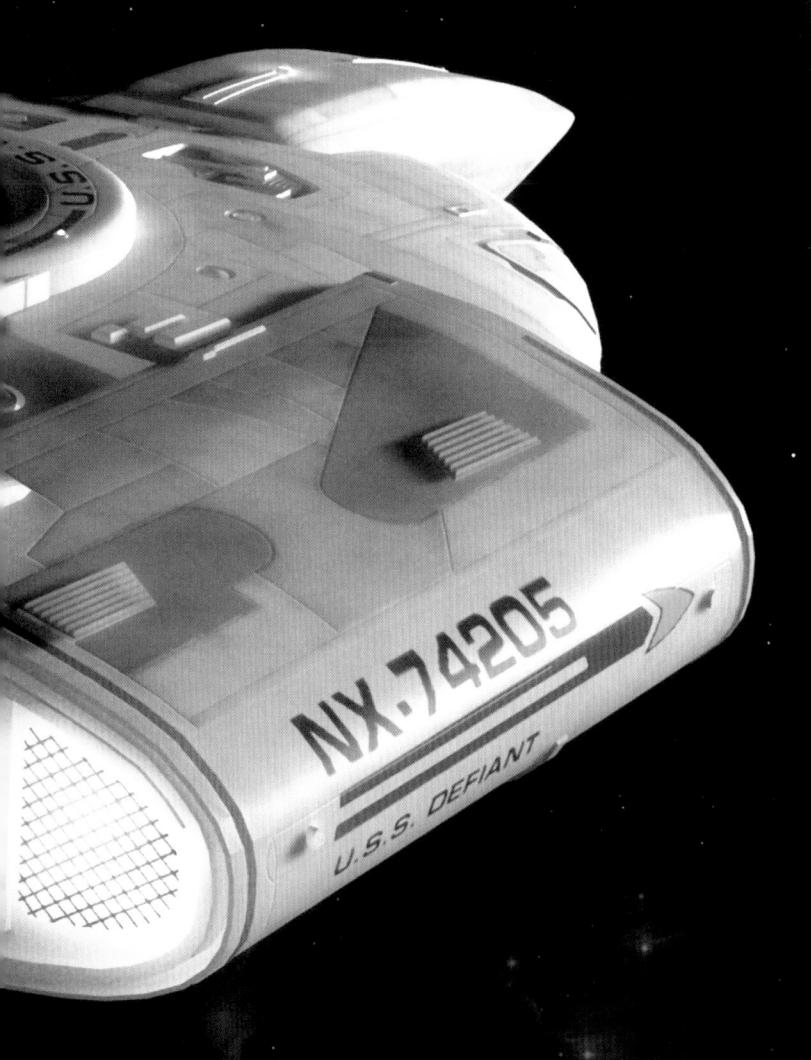

DATA FEED

The U.S.S. Defiant was the first Starfleet ship to be equipped with ablative armor plating. This was a type of protective skin that covered the hull plating. It was designed to disperse the energy from weapons fire, thus protecting the ship even if its shields were not up. Ablative armor was added to the Defiant after its deployment to Deep Space 9 and the technology was so secret that hardly anybody in Starfleet knew it had been installed.

fficially classed as an escort ship, the U.S.S. Defiant NX-74205 was a prototype vessel designed to be Starfleet's first dedicated warship. Developed in response to the threat of a Borg invasion, the Defiant was a heavily armed, highly maneuverable, stripped-down vessel designed for combat rather than exploration.

At just 170.68 meters long and with a standard operational crew of 40 people, the *Defiant* may have been small but it packed a considerable punch. Armed with advanced quantum torpedoes, as well as Mark-VIII and Mark-IX photon torpedoes; plus four twin-pulse cannon phasers, the *Defiant* was the most destructively powerful ship Starfleet ever produced for its size.

In addition to its formidable weaponry, the *Defiant* was covered in ablative armor, a protective skin on the hull of the ship that dissipated the energy of weapons fire. This was an extra layer of defense that meant even if the conventional shields failed, the ship still had some protection.

◄ Although it still had design flaws, the Defiant was assigned to Deep Space 9 in 2371. The spacestation's commander, Benjamin Sisko, who had worked on the development of the Defiant, requested its use to help protect the station from the threat posed by the Dominion.

- ▶ Despite the *Defiant*'s relatively small size, it had provision for several shuttlecraft, which were launched from a circular hatch on the ventral side.

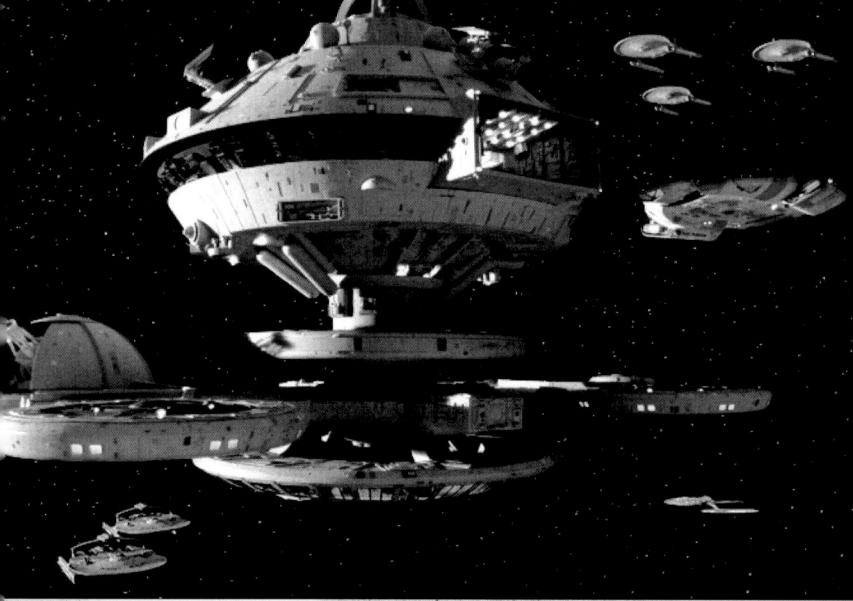

After Starfleet lost control of Deep Space 9 to Dominion forces in late 2373, the Defiant was reassigned to the Second Fleet, which operated out of Starbase 375. This facility acted as a base of operations for the *Defiant* for several months until a combined Federation force retook Deep Space 9, and the Defiant was once again assigned the task of protecting the station.

The *Defiant* marked a radical change in policy by Starfleet in that it had previously only designed ships for exploration, peace-keeping or scientific purposes. The *Defiant* was a response to the threat posed by the Borg after their invasion of the Alpha Quadrant and the massacre at the Battle of Wolf 359 in which Starfleet lost 39 ships and 11,000 lives.

TOO POWERFUL

Development of the *Defiant* began in 2367, with the then Lieutenant Commander Sisko assisting in the design work and flight tests. Launched in 2370 from the Antares Shipyards, the *Defiant* proved to be over-gunned and overpowered for its size and the structural integrity field struggled to prevent the ship from tearing itself apart in battle drills.

Despite the *Defiant's* enormous potential, after several years of development its design flaws had still not been overcome and the project was mothballed, especially as the perceived threat from the Borg was considered less urgent.

It was not until the *Defiant* was assigned to *Deep Space 9* in 2271, at the now Commander Sisko's request, that its design faults were ironed out and it became a vital component in the station's defenses against the Dominion and its allies.

Once assigned to *Deep Space Nine*, the *Defiant* was granted special dispensation to be equipped with a Romulan cloaking device. The Romulans agreed to supply the cloaking technology in return for all intelligence gathered on the Dominion.

The Defiant was equipped with a class-7 warp

▲ Like the rest of the ship, the bridge on the Defiant was configured for maximum efficiency in battle, with the flight control and operations stations combined into one console.

▶ The sickbay was extremely rudimentary, much to Dr. Bashir's annoyance. It contained just four standard biobeds and was ill-equipped to do much more than stabilize a seriously injured patient.

drive and the core spanned three decks in the aft section of the ship. It was extremely powerful for a ship of this size and it could propel the ship at speeds of warp 9.5 for extended periods and even reach warp 9.982 for limited bursts.

NO-FRILLS STARSHIP

As a combat vessel, the interior of the *Defiant* was extremely functional and had no provision for families or recreational activities. Even the science and medical facilities on deck 2 were extremely limited. One of the few communal areas of the ship was a mess hall where the crew could gather and eat meals dispensed from replicators.

The main bridge was the nerve center, but unlike on other Starfleet ships, it was sunk into the center

DATA FEED

A special amendment to the Treaty of Algeron allowed the *Defiant* to be fitted with a Romulan cloaking device. The treaty stipulated that the Federation could not develop cloaking technology. In this instance, the Romulans loaned the *Defiant* a cloaking device, provided it was used only in the Gamma Quadrant and that its operation was overseen by Subcommander T'Rul (pictured). In return, Starfleet shared all intelligence the ship gathered.

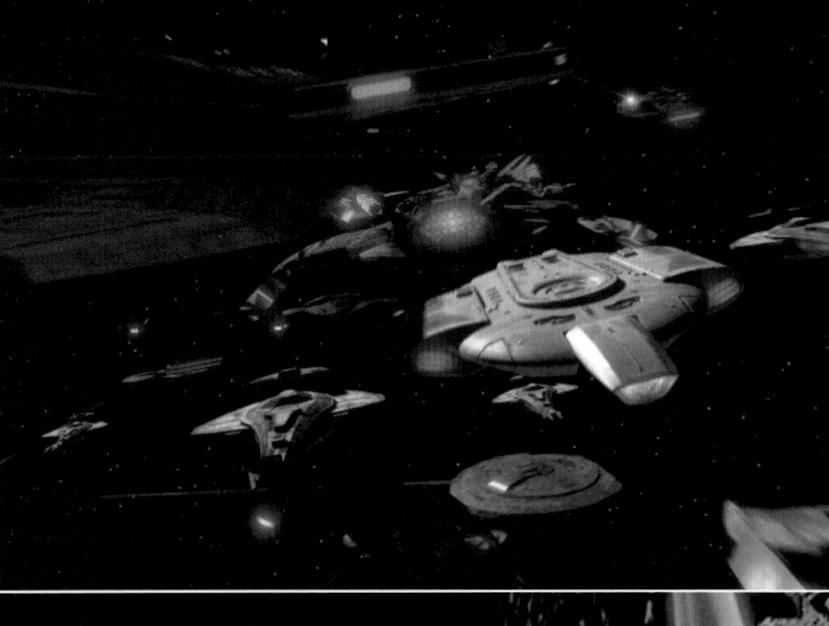

◀ In one of the pivotal battles of the Dominion War, the Defiant led a combined Starfleet and Klingon force in an attempt to win back control of DEEP SPACE 9. Despite the Dominion having twice the number of ships, the operation was successful and Captain Sisko was once again back in charge of the station.

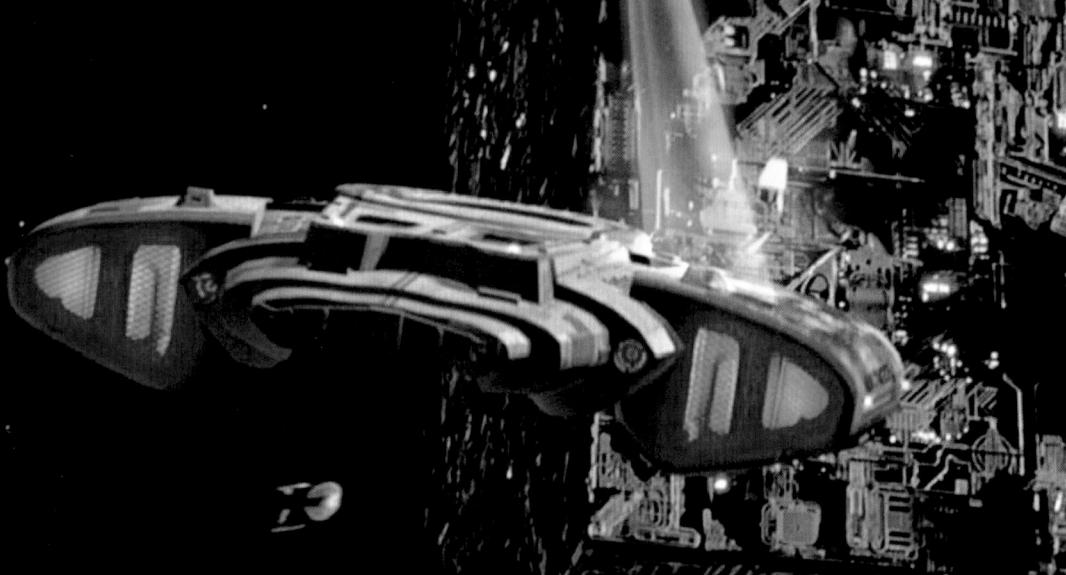

threat posed by the Dominion. Their genetically engineered army, the Jem'Hadar, had recently destroyed a Galaxy-class ship, the U.S.S. Odyssey NCC-71832 and Sisko felt that the station needed an extra line of defense.

It was not long before Chief Miles O'Brien managed to iron out most of the *Defiant's* flaws and the ship proved vital both in the defense of Deep Space 9 and in the later Dominion War.

▲ The Borg's second major incursion into Federation space culminated in the Battle of Sector 001 when the Defiant and about 30 other Starfleet ships engaged a Borg Cube. The fleet was successful in destroying the cube, and although the Defiant took heavy damage it was ultimately salvageable and soon back in service at Deep Space 9.

of the vessel where it was afforded more protection than it would have been if it was exposed on the top of the ship.

LAST RESORT WEAPONRY

In addition to all the Defiant's state-of-the-art weaponry, as a last resort the entire front 'nose' section, which contained several torpedo warheads, could detach and be used as a missile. If this function was deployed, the main body of the ship could then no longer travel at high speeds, but it was equipped with landing gear so it could set down on a planetary surface in an emergency.

The U.S.S. Defiant NX-74205's active service began in early 2371 when it was assigned to Deep Space 9 to help protect it from the escalating

BATTLING THE BORG

In 2373, the *Defiant* was forced into action for the purpose for which it was originally designed when the Borg returned. While many Starfleet ships were destroyed early in the engagement, the Defiant managed to keep fighting for some time, inflicting
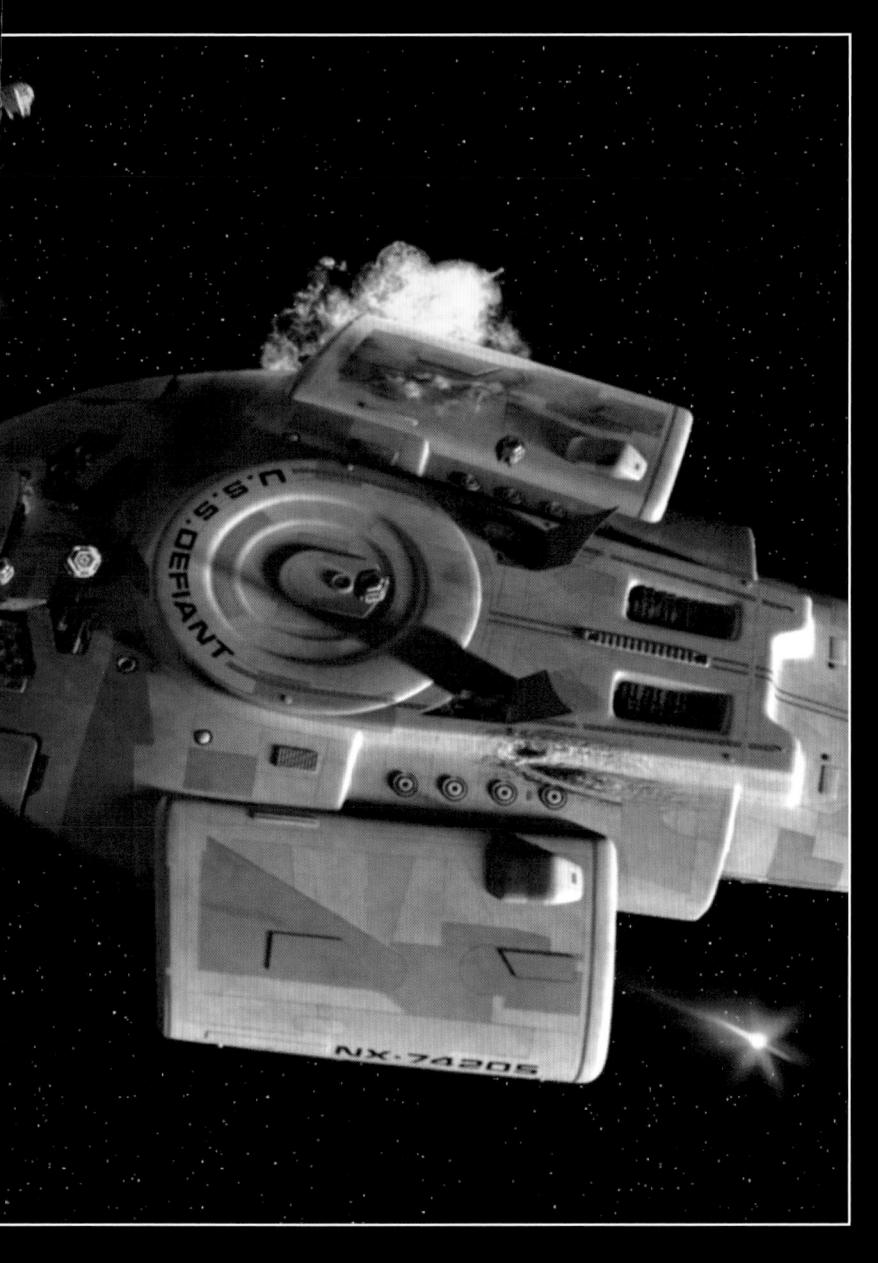

▲ The Breen entered the war on the side of the Dominion at the Second Battle of Chin'toka. The Breen's energy dampening weapon proved decisive in the battle as it completely disabled all of the Allied ship's primary systems, leaving them sitting ducks. The Allied force was wiped out, and even the Defiant was destroyed, although the crew managed to eject in escape pods.

heavy damage on the Borg Cube. Unfortunately, the *Defiant* took serious fire, leading to a loss of main power and it was left adrift in space, but not before the crew were beamed to safety aboard the *U.S.S. Enterprise* NCC-1701-E.

THE DOMINION WAR

The *Defiant* was soon repaired and later the same year was used to mine the Bajoran Wormhole to stop the Dominion's military build-up in Cardassian space. Although this prevented more Dominion forces from entering the Alpha Quadrant, it could not prevent the Dominion from taking control of *Deep Space 9* and all-out war soon followed.

For the next several months, the *Defiant* fought as part of the Second Fleet, operating out of

DATA FEED

The U.S.S. Sao Paulo NCC-75633 was almost identical to the Defiant. It was, however, upgraded with redesigned deflector shield generators to counteract the Breen energy dampening weapon, which was responsible for the destruction of the first Defiant. The bridge was also modified as some of the consoles were redesigned and the aft operations table was replaced with a free-standing console.

Starbase 375. The fighting was long, arduous, and at times seemingly hopeless, but the *Defiant* continued to survive against the odds and won many vital engagements during the war. In mid-2374, the *Defiant* led a force that retook control of *Deep Space 9* and by the end of the year, the war finally seemed to be turning in their favor when the *Defiant* led another fleet to victory in the First Battle of Chin'toka.

DEFIANT'S DESTRUCTION

Unfortunately, in 2375 a new alliance between the Dominion and the Breen swung the war back in their favor and the *Defiant* was among 311 Federation Alliance ships destroyed in the Second Battle of Chin'toka.

A new *Defiant*-class vessel, the *U.S.S. Sao Paulo* NCC-75633 was assigned to *Deep Space 9* and Captain Sisko received special dispensation from Starfleet Chief of Operations to rename the ship after its illustrious predecessor. This second-generation *Defiant* was upgraded with new deflector shield generators that counteracted the Breen energy dampening weapon that had decimated the allied fleet at Chin'toka.

This *Defiant* participated in the final battle of the Dominion War in late 2375, when the Federation Alliance launched an invasion of Cardassia where the Dominion had centered its operations in the Alpha Quadrant.

The *Defiant* found itself in the thick of the action and, despite taking heavy fire, managed to help the Alliance forces to punch a hole through the Dominion's defensive perimeter. The Alliance lost more than a third of its fleet in the battle, but the *Defiant* survived and the Dominion was defeated as they declared an unconditional surrender of all their forces in the Alpha Quadrant.

WEAPONRY AND FIREPOWER

Because its original purpose was to defend the Federation against the Borg, the U.S.S. Defiant was very heavily armed. It was equipped with four forward-facing phaser cannons with two located each side of the ship on the nacelles. They were usually deployed in short, rapid-fire bursts, but they could also be fired as a continuous beam. In addition to these cannons, the Defiant featured conventional phaser emitters as found on other Starfleet vessels.

The Defiant was also equipped with four forward-facing and two aft-facing torpedo launchers. These could be used to fire photon torpedoes or quantum torpedoes. The latter contained a plasma warhead and were more effective than conventional antimatter explosives in penetrating deflector shields.

▲ The Defiant was the most heavily armed vessel in Starfleet and it a vital role in numerous battles during the Dominion War.

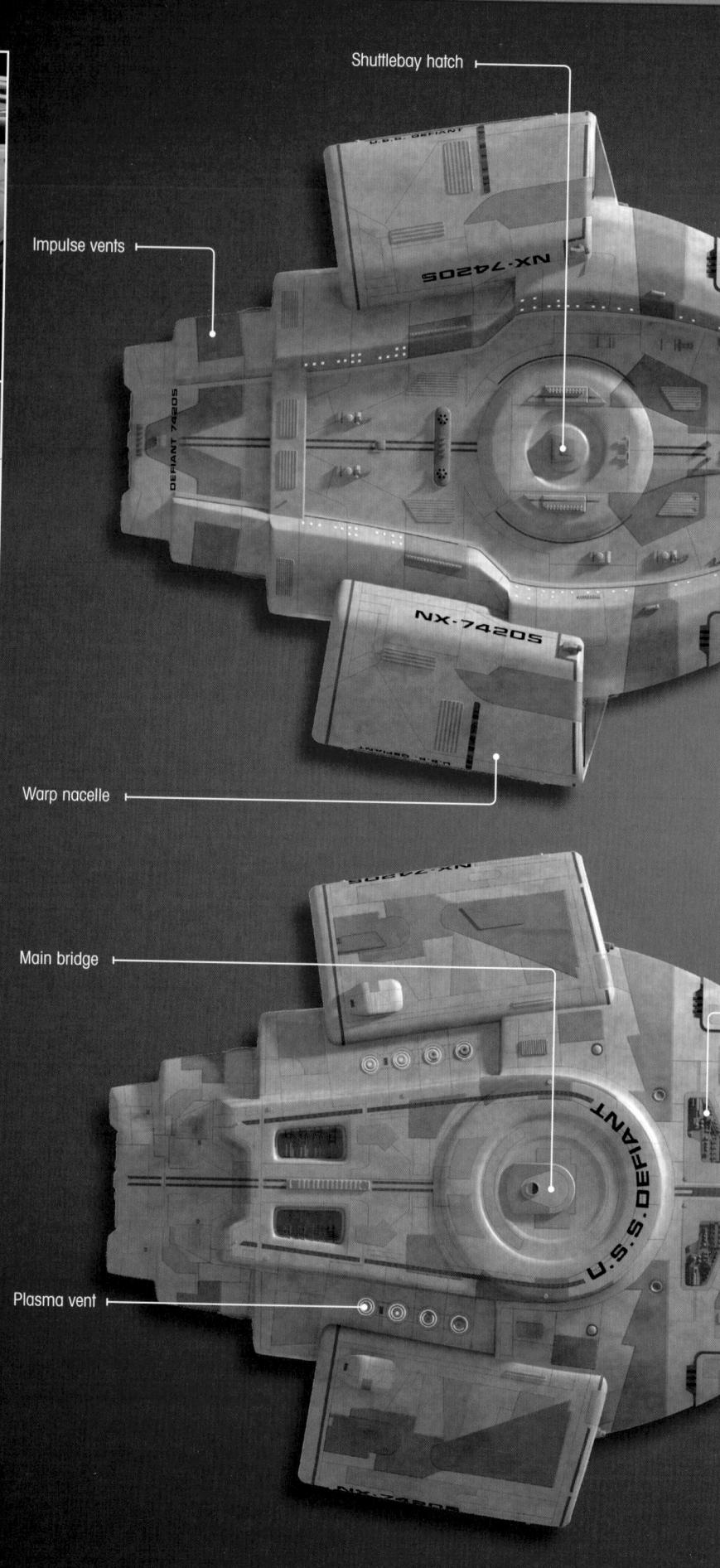

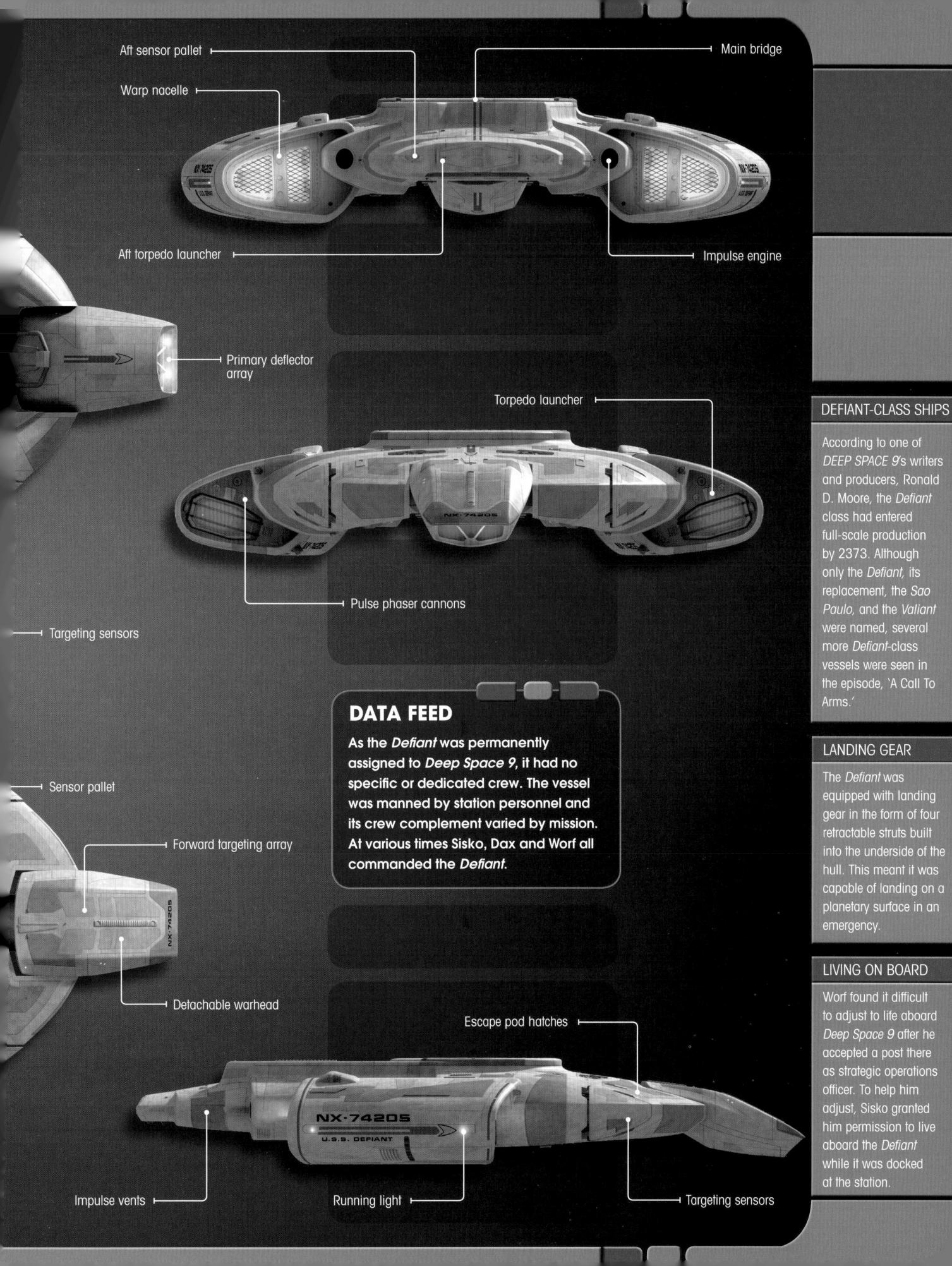

and at least one example fought in the Battle of Wolf 359.

he Cheyenne class was a type of vessel used by Starfleet in the 24th century, an example of which included the Ahwahnee NCC-73620. The most distinctive design feature of this class was that it had four warp nacelles. It was a light cruiser and suitable for deep space exploration and defensive patrol duties.

The Cheyenne class could be seen as an evolution of the Constellation class, which was in service between the 2280s and the 2370s. Both

FLEET TACTICAL STATUS

USS FARALEST IN THE TOTAL NESS FINALIBRE
NCE 47285 IN THE TOTAL NESS FINALIBRE
NCE 47285 IN THE TOTAL NCE 47281 INC. 1701 0

INC. 47285 IN THE TOTAL NCE 47281 INC. 1701 0

INC. 47285 IN THE TOTAL NESS STITEFLAND
NCE 47281 INC. 17281 IN

classes employed four warp nacelles, which were attached to a structure at the back of the saucer section. Despite the extra nacelles, the *Cheyenne* was no faster than other Starfleet ships of the time and had a top of warp 9.6.

DIFFERENCES AND SIMILARITIES

The elliptical saucer section of the *Cheyenne* class was almost identical to the design featured on the *Galaxy* class, but on a smaller scale. The overall length of the *Cheyenne* class was about 362 meters, making it just over half the length of a *Galaxy*-class ship. It did, however, feature a bridge module that from the exterior was a very similar size to one found on a *Galaxy*-class ship.

The rear end of the saucer section on the Cheyenne class was indented. Two structures, similar to the neck section of a Galaxy-class vessel, were fitted here to both the top and bottom of the saucer section on the Cheyenne class. Pylons swept out of these structures, which led to the four warp nacelles, and they were shorter and thinner than those found on the Galaxy class.

The *U.S.S. Ahwahnee* was part of the fleet of 40 ships that fought the Borg at the Battle of Wolf 359 in 2367. It was disabled in this encounter, but unlike all the other ships in the fleet, apart from the *U.S.S. Enterprise* NCC-1701-D, it was not so badly damaged that it could not be repaired.

The following year in 2368, the *Ahwahnee* was part of the fleet of 23 ships that attempted to blockade the Klingon-Romulan border during the Klingon Civil War. It was one of 17 vessels chosen to form a tachyon network, in the hope that it could detect and expose cloaked Romulan ships that were secretly running supplies to the Duras faction.

The Romulans disrupted the tachyon grid with a high-energy burst, forcing the fleet, including the *Ahwahnee*, to retreat and regroup at Gamma Eridon, where it was hoped they could re-establish the tachyon net.

■ Apart from the U.S.S. Enterprise-D, the U.S.S. Ahwahnee was the only ship from the fleet that was put back into service following the Battle of Wolf 359. The following year, the Ahwahnee was part of a tachyon network set up by Starfleet to try and stop cloaked Romulan ships from resupplying the Duras sisters in the Klingon Civil War.

FLEET FAILURE

After Captain Picard and his crew learned of the threat posed by the Borg when Q whisked off the U.S.S. Enterprise NCC-1701-D to the Delta Quadrant in 2365, Starfleet Tactical ordered a review of their defenses. Admiral J.P. Hanson was put in charge of developing defensive strategies and new technologies to combat a potential incursion by the Borg. Under Admiral Hanson's supervision,

Lt. Commander Shelby was put in charge of tactical analysis and defensive planning. Together, they developed what they thought would be adequate preparations to see off a potiential Borg invasion.

Unfortunately, it would be proved that they had severely underestimated the Borg. In late 2366, the *U.S.S. Lalo* NCC-43837 reported that it had come under attack from a cube-shaped vessel while it was on a freight run. This was the first sign that the Borg had invaded the Alpha Quadrant. Admiral Hanson quickly amassed a fleet of 40 starships at Wolf 359, 7.8 light years from Earth, to meet the Borg.

Utilizing the tactical knowledge of Captain Picard, who had earlier been assimilated and given the designation 'Locutus,' the Borg decimated the fleet in a matter of minutes. Admiral Hanson's ship was destroyed, along with 37 others, and only the *U.S.S. Ahwahnee* was salvageable after the battle.

By the time the *Enterprise-D* arrived, nearly 11,000 lives had been lost, and there were no power readings from any of the ships.

▲ The U.S.S. Bellerophon and the U.S.S. Yamaguchi rushed to the aid of the U.S.S. Saratoga after it was held in the Borg's tractor beam, but their efforts were in vain as the cube easily destroyed all three ships.

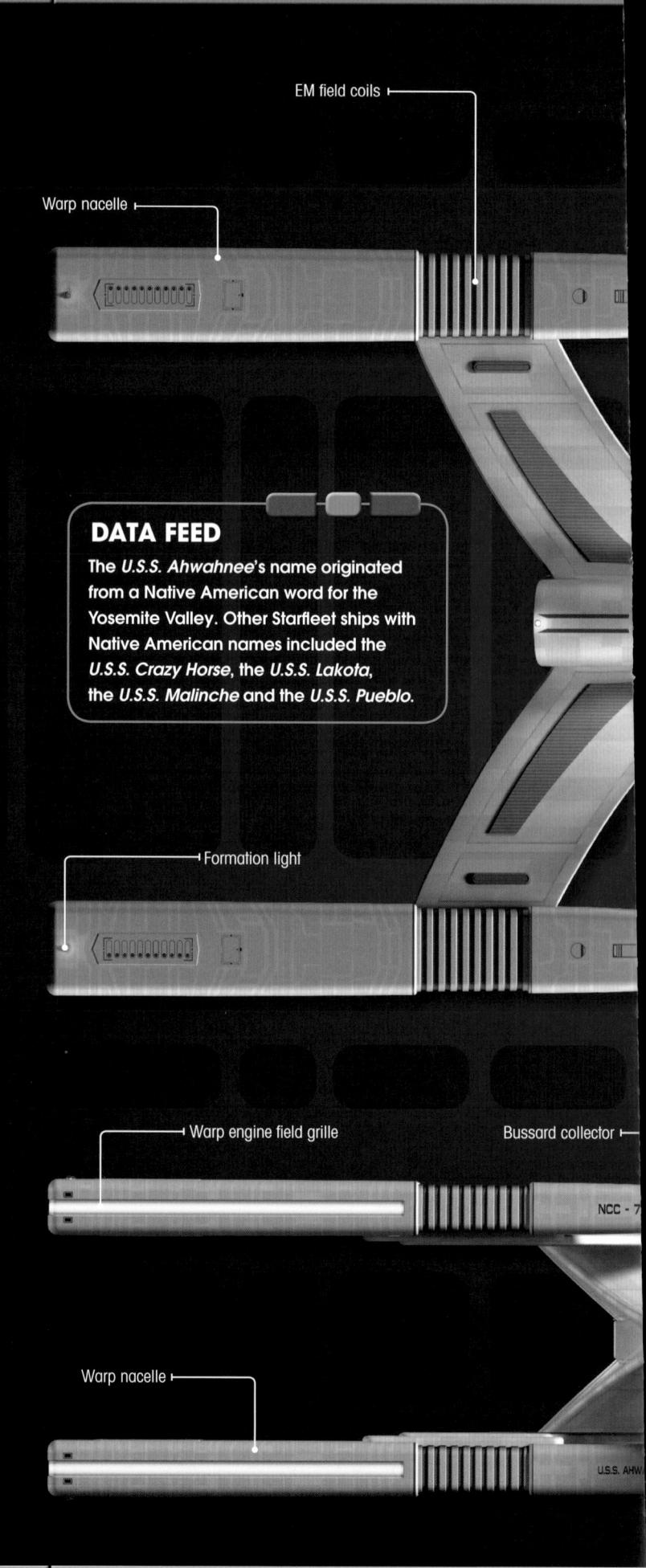

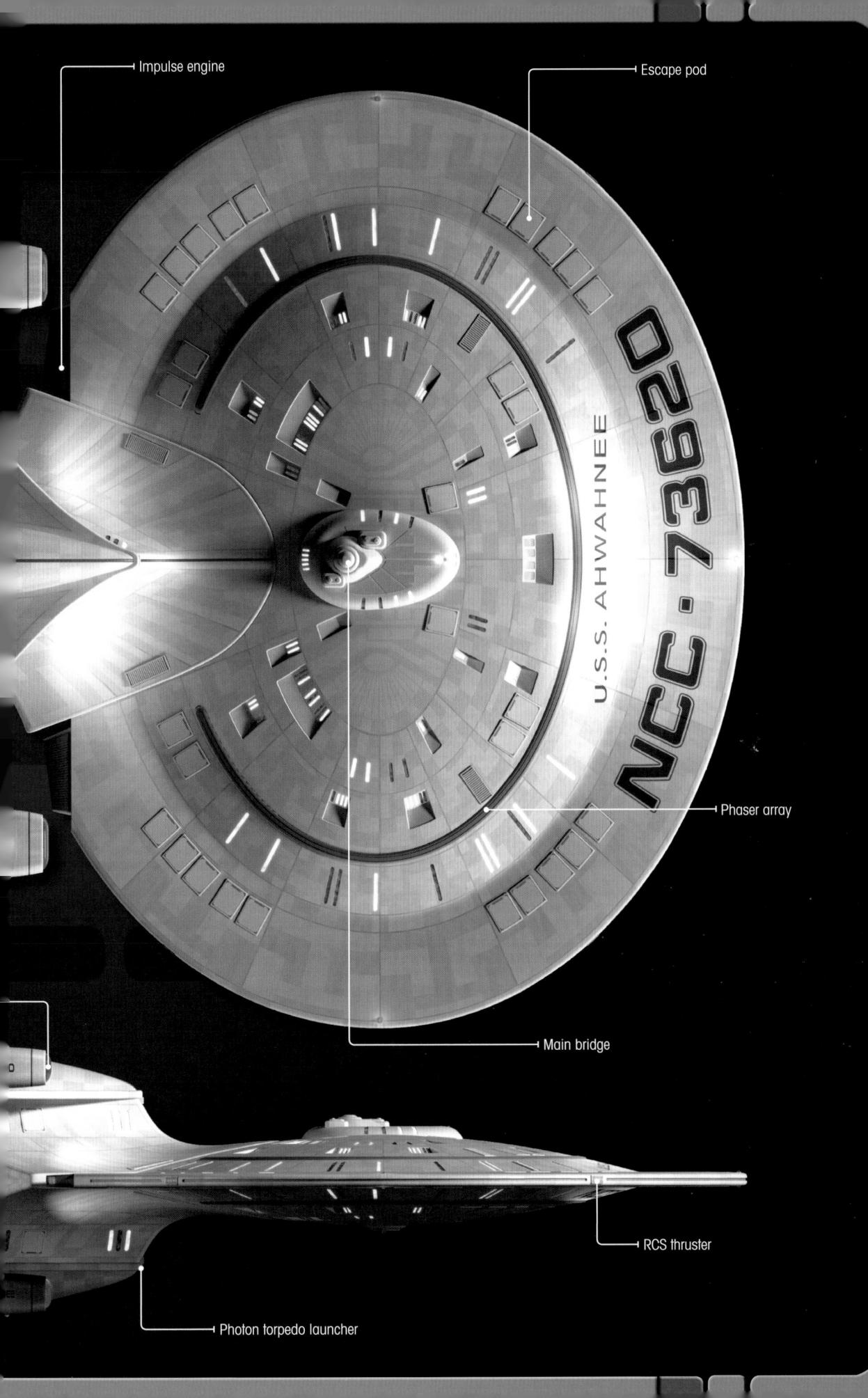

FOUR NACELLES

The Cheyenne class was one of the few types of Starfleet ships to have more than two nacelles. The other classes that had four warp nacelles were the Constellation class and the Prometheus class.

EXCELSIOR MODELS

Two more four-nacelle vessels could be seen at the Qualor II surplus depot from THE NEXT GENERATION episode 'Unification, Part I.' These were both study models of the Excelsion class that had been created at Industrial Light & Magic.

FAMILIAR SPECIES

Commander Chakotay encountered a Borg Cooperative in the Delta Quadrant in 2373. This group included several familiar races, including Klingons, Romulans, Cardassians and humans. They had been assimilated during the Borg's earlier incursion into the Alpha Quadrant.

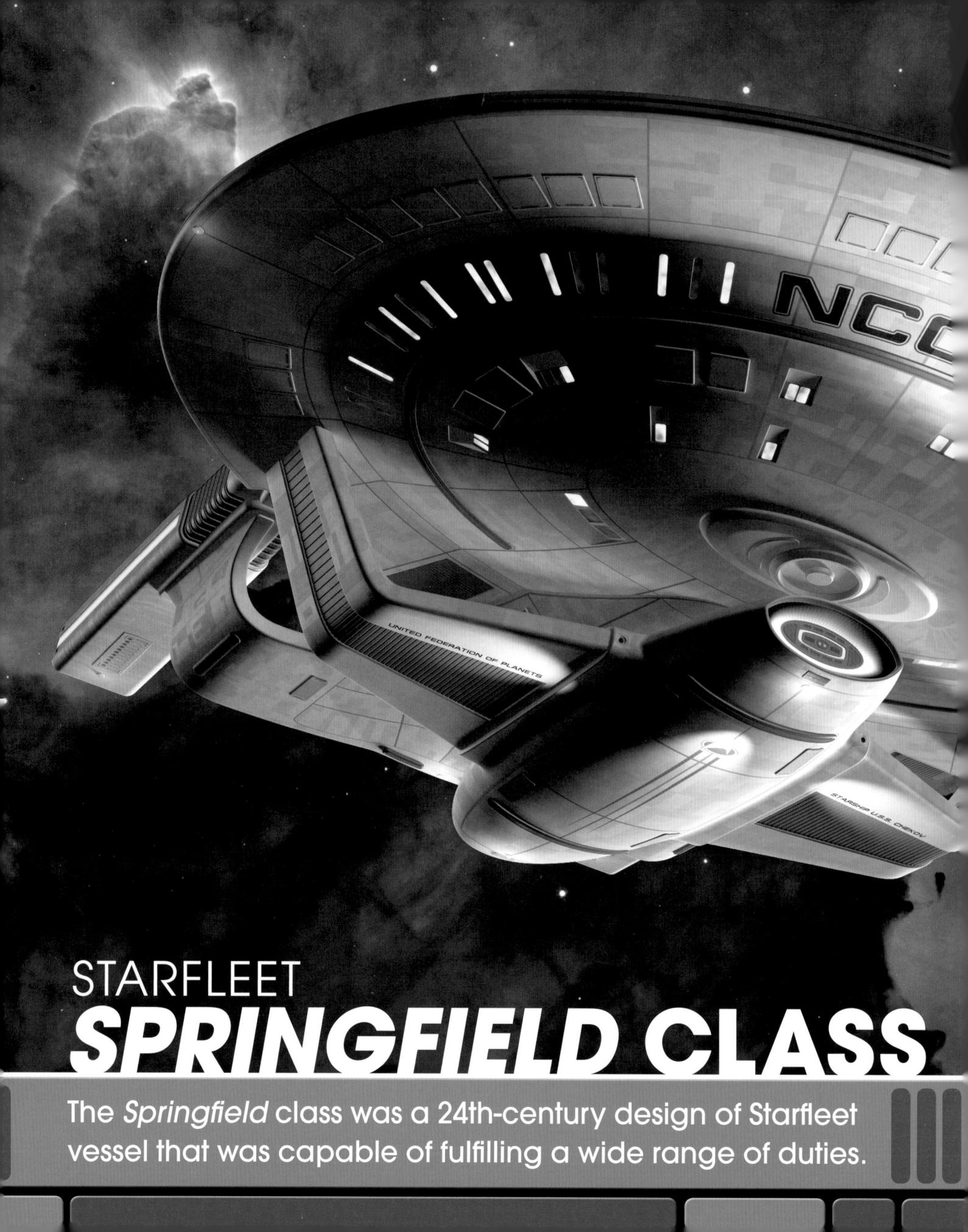

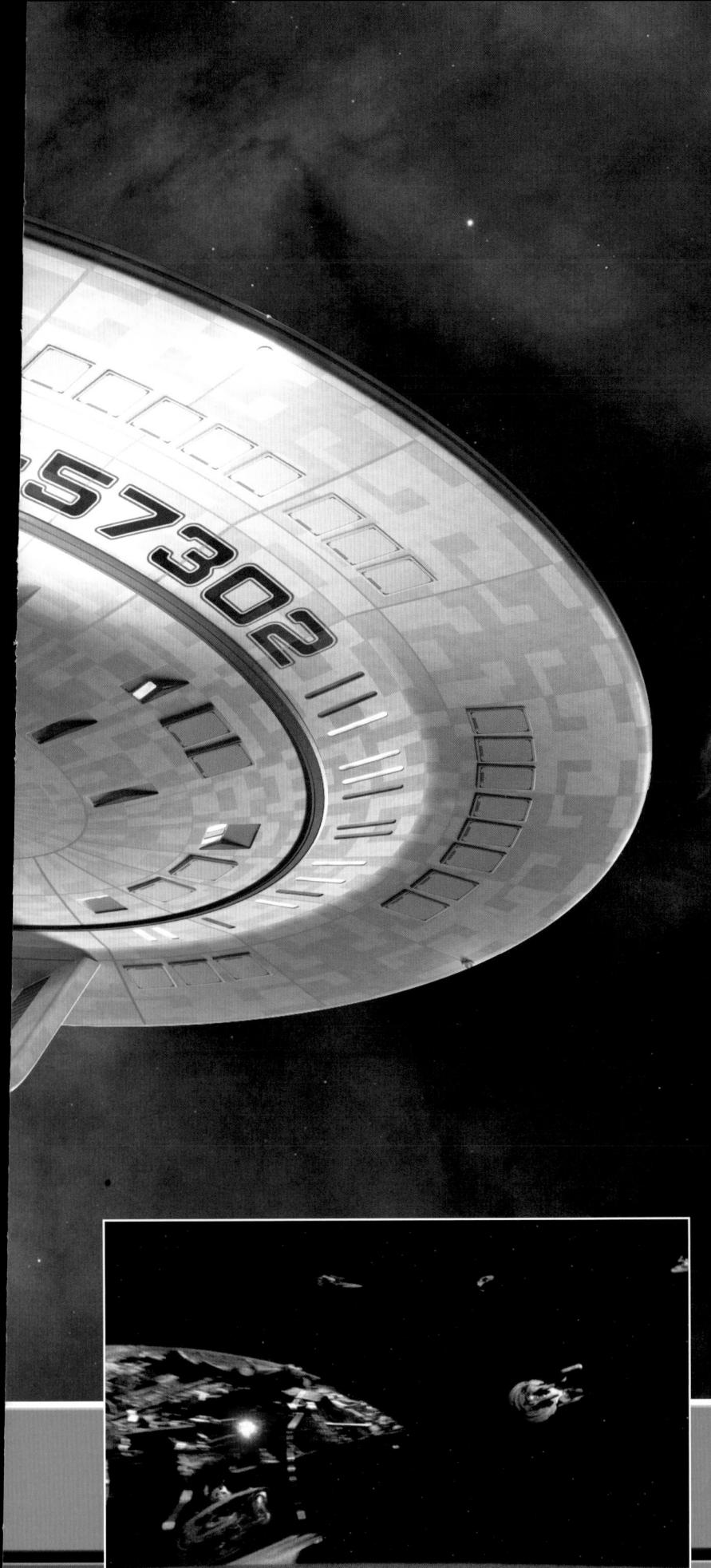

he *Springfield* class was a type of vessel used by Starfleet in the 24th century, an example of which was the *U.S.S. Chekov* NCC-57302. It was classified as a frigate, and was mostly used for deep space exploration and patrol duties.

It was 325 meters in length, and had a standard crew complement of around 430. It was capable of a top speed of warp 9.2 for short periods, while its maximum sustainable speed was warp 7.5. It was armed with several phaser banks, distributed in phaser arrays at various points along its hulls, and two photon torpedo launchers.

The Springfield class comprised a saucer section that was similar in style to that used on Galaxy-class ships, but on a smaller scale. It also had a v-shaped structure cut into the back of the saucer. This provided a link to a mission-specific module that sat above and behind the saucer. It could be configured to carry more sensors, cargo or weapons depending on the assignment it had been given. Two thin warp nacelles, similar in style to those fitted on Cheyenne-class starships, were positioned either side of the module and they were attached by wing-like pylons.

A secondary hull was suspended below the saucer via downward-turned pylons. This section contained main engineering, and the main navigational deflector was built into the front of it.

In 2367, the *Chekov* was part of the fleet of 40 ships gathered together to fight the Borg cube at the Battle of Wolf 359. The *Chekov* appeared to be the only *Springfield*-class vessel in the fleet, and it was obliterated by the Borg along with the other Starfleet ships during the engagement.

■ When the U.S.S. Enterprise NCC-1701-D arrived at the aftermath
of the Battle of Wolf 359, it navigated slowly through the wreckage of
dozens of Starfleet ships that had been left by the Borg cube. Through
the viewscreen, the bridge crew could just about make out the remains
of the Springfield-class Chekov on the upper left.

LAST OF ITS KIND?

By the time the *U.S.S. Enterprise* NCC-1701-D reached Wolf 359, the 40-strong fleet of Starfleet ships had been decimated by the Borg cube. The eerie and devastating sight of the lifeless hulks of the entire fleet floating in space stunned the crew of the *Enterprise*-D into silence as they tried to take in the enormity of what had just happened. Thirty-nine vessels had been damaged beyond repair, and around 11,000 lives had been lost to the Borg in a matter of minutes.

The *U.S.S. Chekov* was just one of the ships that had been rendered inert by the Borg cube, and it was left drifting among the flotsam from the devastated fleet. It appeared to be the only *Springfield*-class vessel that had taken part in the battle, but there was so much debris left floating in space, it was difficult to identify which class of ship all the various remains had belonged to originally.

A Springfield-class ship was never seen again, not even during the Dominion War, perhaps indicating that this class was retired from service and replaced by another class that was dedicated to combat.

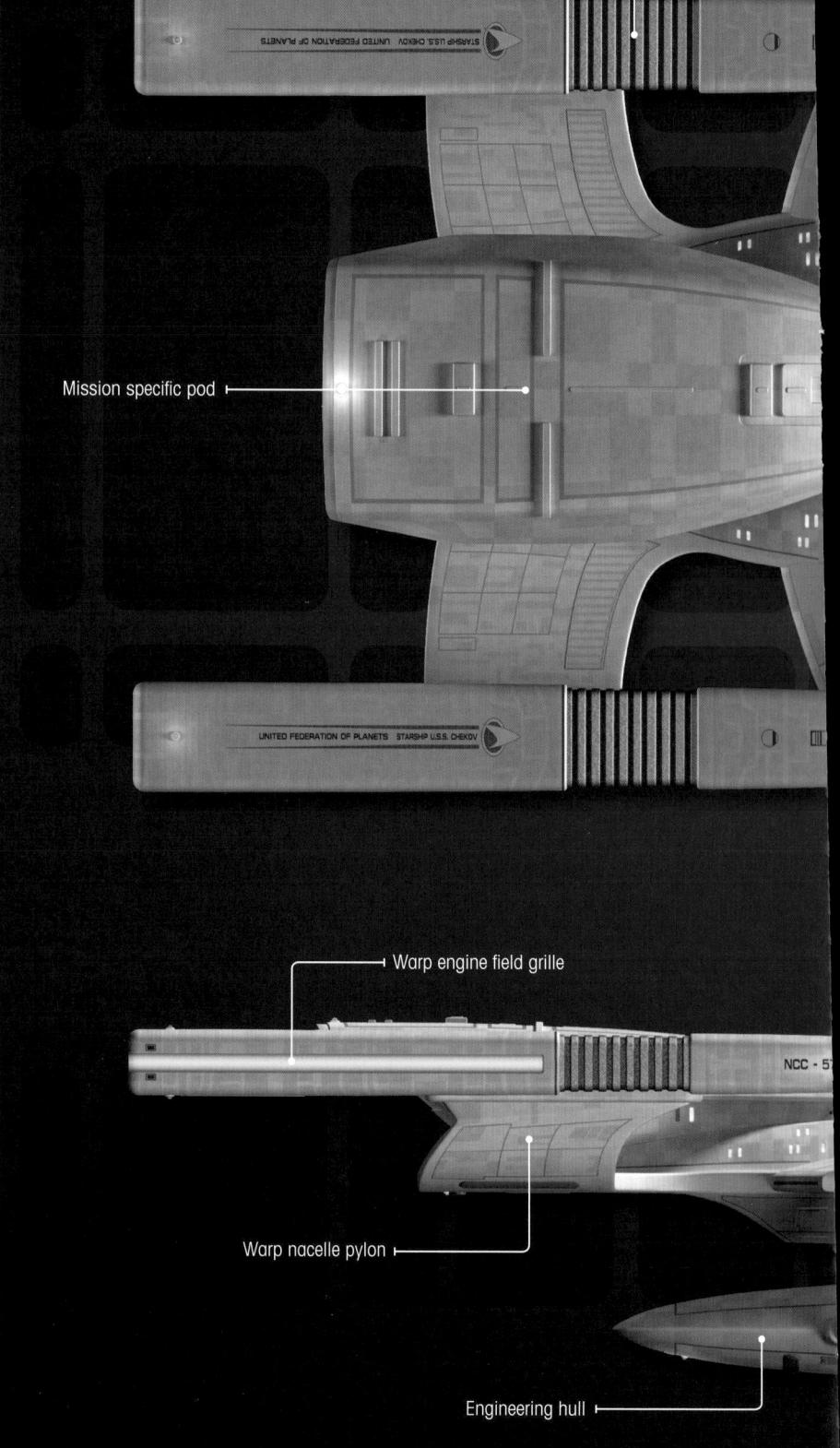

EM field coils ⊢

▲ By the time the *Enterprise-D* had repaired its deflector dish and reached Wolf 359, it was already too late. It was met by the dispiriting sight of the fleet either on fire or floating uselessly in space.

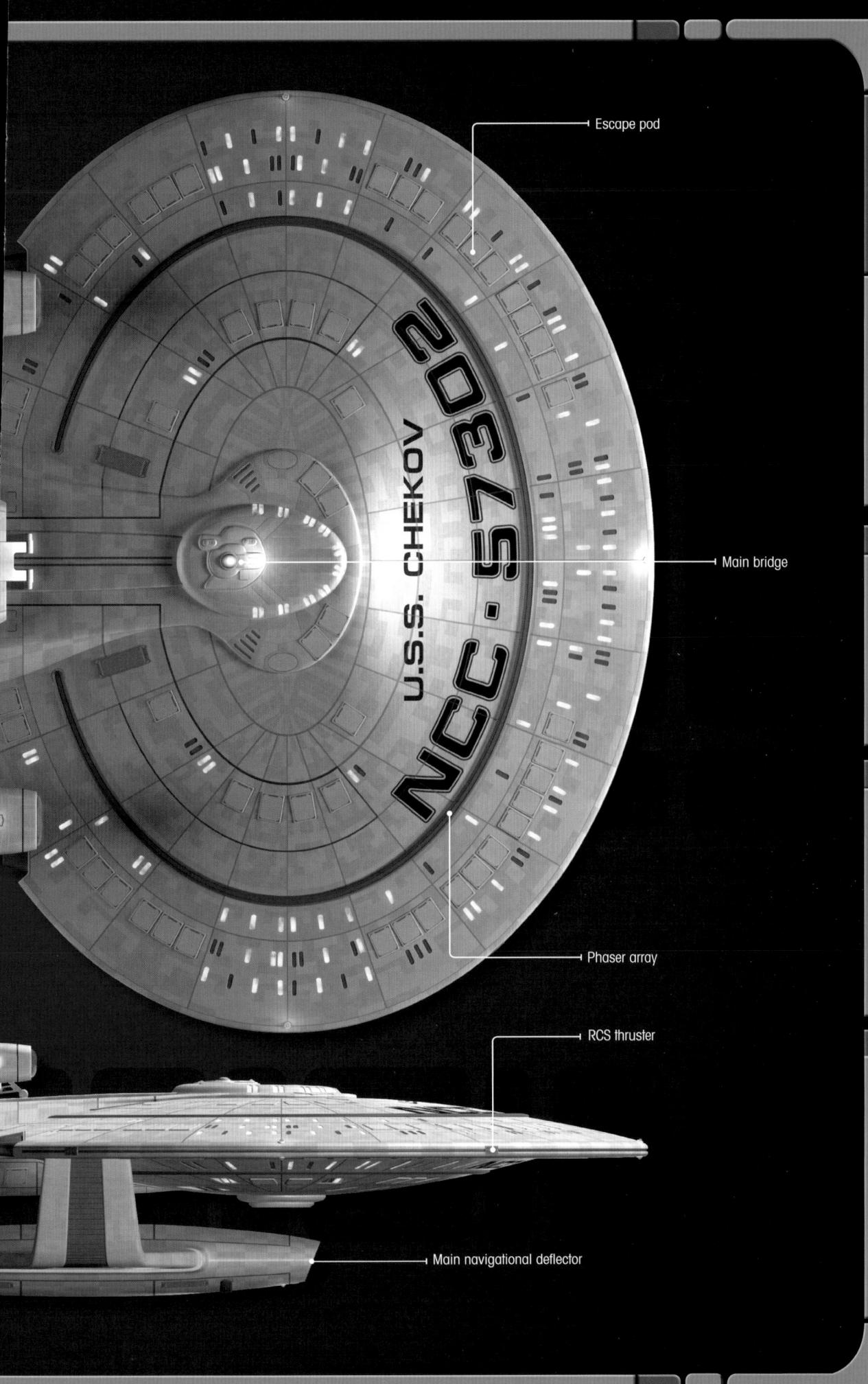

CHEKOV OR CHEKHOV

The writers of *The*Best of Both Worlds,
Part II intended for
the U.S.S. Chekov to
be named 'Chekhov'
after the Russian writer
Anton Chekhov, but the
lettering on the model
read 'Chekov.'

MIARECKI SHIPS

The U.S.S. Chekov studio model was one of the ships built by Ed Miarecki specifically for the 'graveyard' scene in The Best of Both Worlds, Part II, along with the U.S.S. Buran, the U.S.S. Melbourne and the U.S.S. Kyushu.

NAME CHANGE

Originally, the Chekov was one of the wrecked ships mentioned by name by Lt.
Commander Shelby, but in the aired episode the Chekov was changed to the Tolstoy. It was fell the situation was too somber to name check the original series character Pavel Chekov.

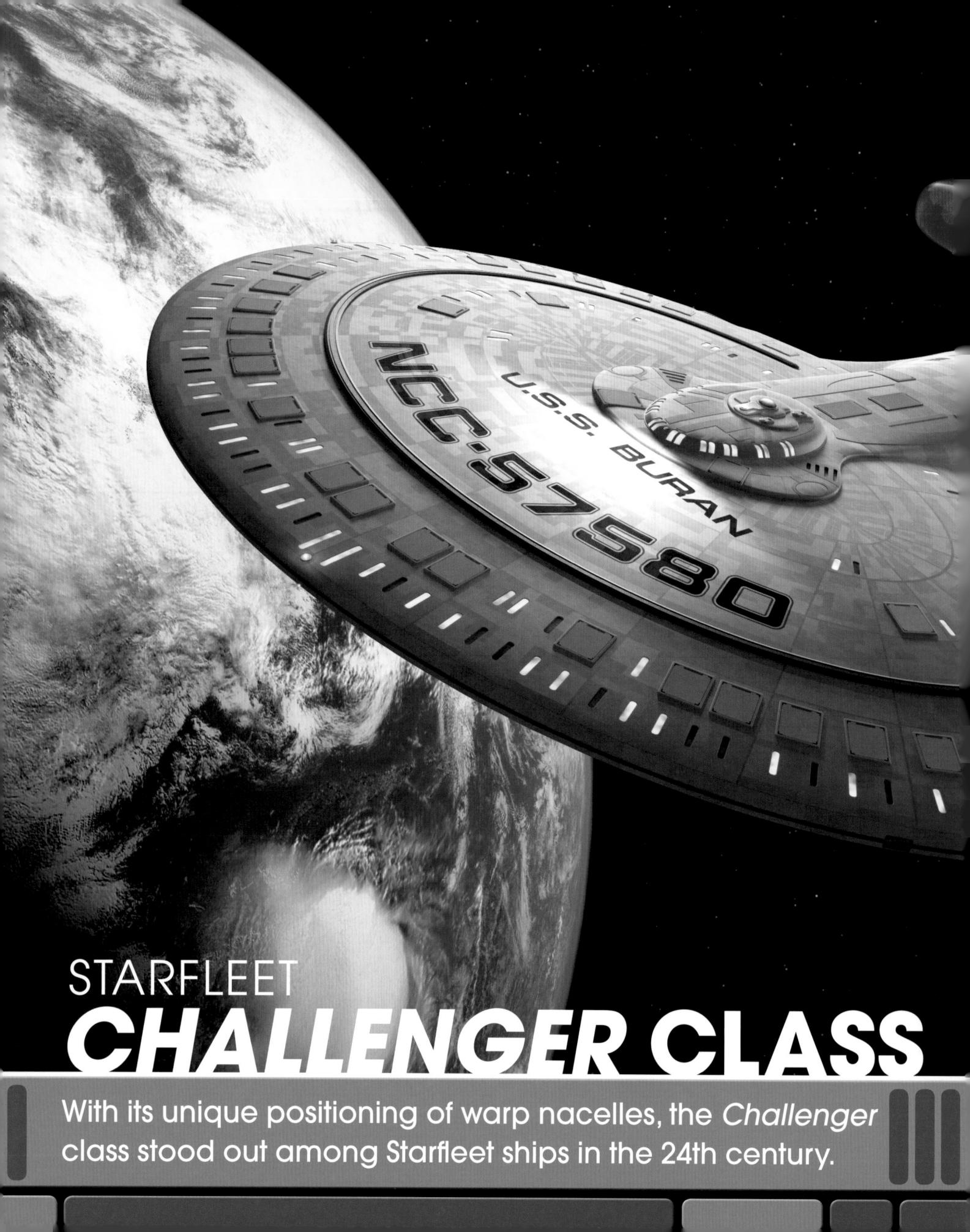

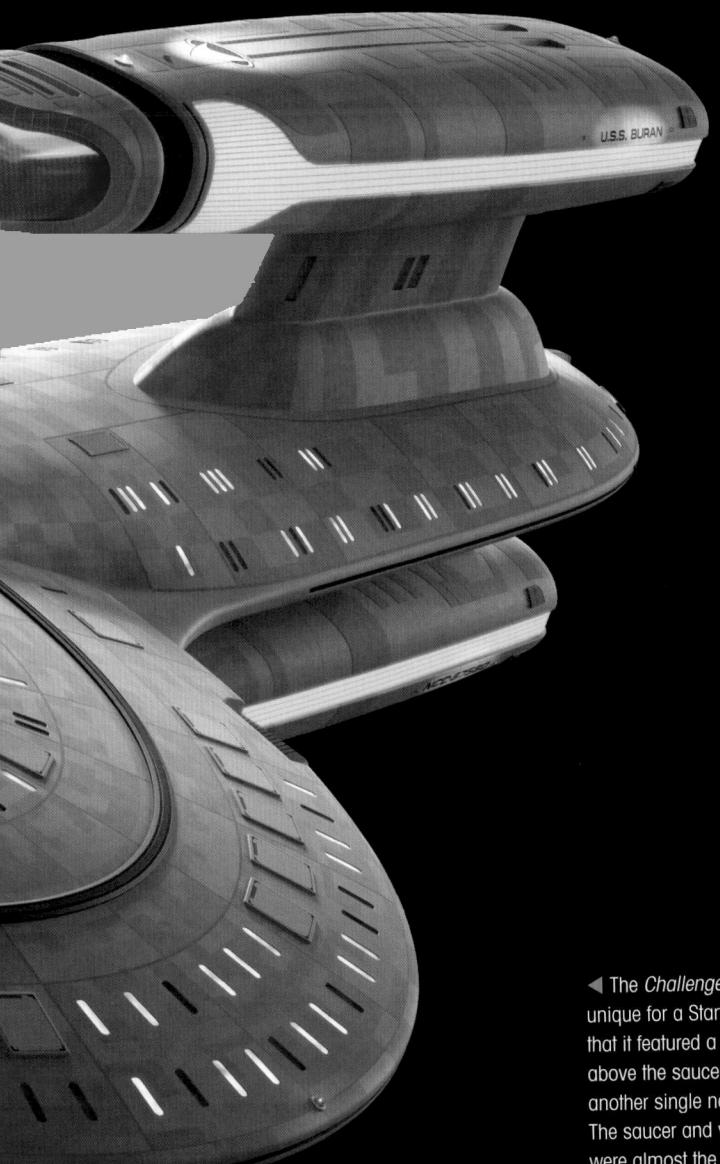

■ The Challenger class was unique for a Starfleet vessel in that it featured a single nacelle above the saucer section and another single nacelle below. The saucer and warp nacelles were almost the same design as those found on the Galaxy class, but slightly smaller.

that was in service with Starfleet in the 24th century. It was a contemporary of the *Galaxy* class, and its saucer and nacelles were very similar in design to that class, but roughly two thirds of the size. The *Challenger* class was about 390 meters in length, and mainly used for exploration and diplomatic duties.

The most distinctive feature of the Challenger class was that although it had two warp nacelles, one was positioned above the saucer and one was located below. It was the only known class of Starfleet vessel that had this configuration.

Another unusual aspect of the design was that the secondary hull was attached directly to the rear of the saucer. This contained the engineering section, and it was slightly longer than the saucer hull, but thinner.

NACELLE PYLONS

A small, thin pylon attached the warp nacelle to the bottom of the secondary hull, but a longer, wider, more substantial element connected the top nacelle to the ship. This part was far more than a pylon, and resembled the 'neck' section found between the saucer and secondary sections on other Starfleet vessels.

The Challenger class had similar abilities and facilities as the Galaxy class, meaning it could attain a top speed of warp 9.6 for short periods, and it was armed with multiple phaser arrays and at least two photon torpedo launchers.

The *U.S.S. Buran* NCC-57580 was a *Challenger*-class vessel, and it fought the Borg at the Battle of Wolf 359 where it was destroyed along with 39 other Starfleet ships.

■ The U.S.S. Enterprise NCC-1701-D arrived at the aftermath of the
Battle of Wolf 359 in time to see the fire that raged through the U.S.S.
Buran after it engaged the Borg cube. Its remains could just be seen
in the bottom right of the viewscreen, while other Starfleet ships had
already burned out and hung lifelessly in space.

CARNAGE AT WOLF 359

In 2366, all contact with the New Providence colony on Jouret IV was lost. The *U.S.S.*Enterprise NCC-1701-D was sent to investigate what had happened to this settlement on the border between the Alpha and Beta Quadrants. When it got there, the crew discovered that the entire outpost had been scooped from the planet's surface, just like in the earlier attack by the Borg on System J-25. This was the first sign that the Borg were on the doorstep of Federation space and were planning an invasion.

Admiral Hanson, who had been working on countermeasures for just such an attack, made his way to Starbase 324 to discuss strategy with Starfleet Command. He put together a fleet of 40 starships, and led them into battle against the Borg cube at Wolf 359, a star system about eight light years from Earth.

The fleet did not stand a prayer and all the Starfleet ships, including the *U.S.S. Buran*, were sliced apart in a matter of minutes by the Borg cube. It was only the heroic efforts of the crew of the *Enterprise*-D that eventually brought the Borg incursion to an end.

The wreck of the *Buran* was later towed to Surplus Depot Z15 near the planet Qualor II, where it was seen by the crew of the *Enterprise*-D in 2368.

▲ Damage to its deflector dish meant that the *Enterprise-D* arrived ate to the Battle of Wolf 359. When it reached the star system, the entire fleet had already been wiped out by the Borg cube.

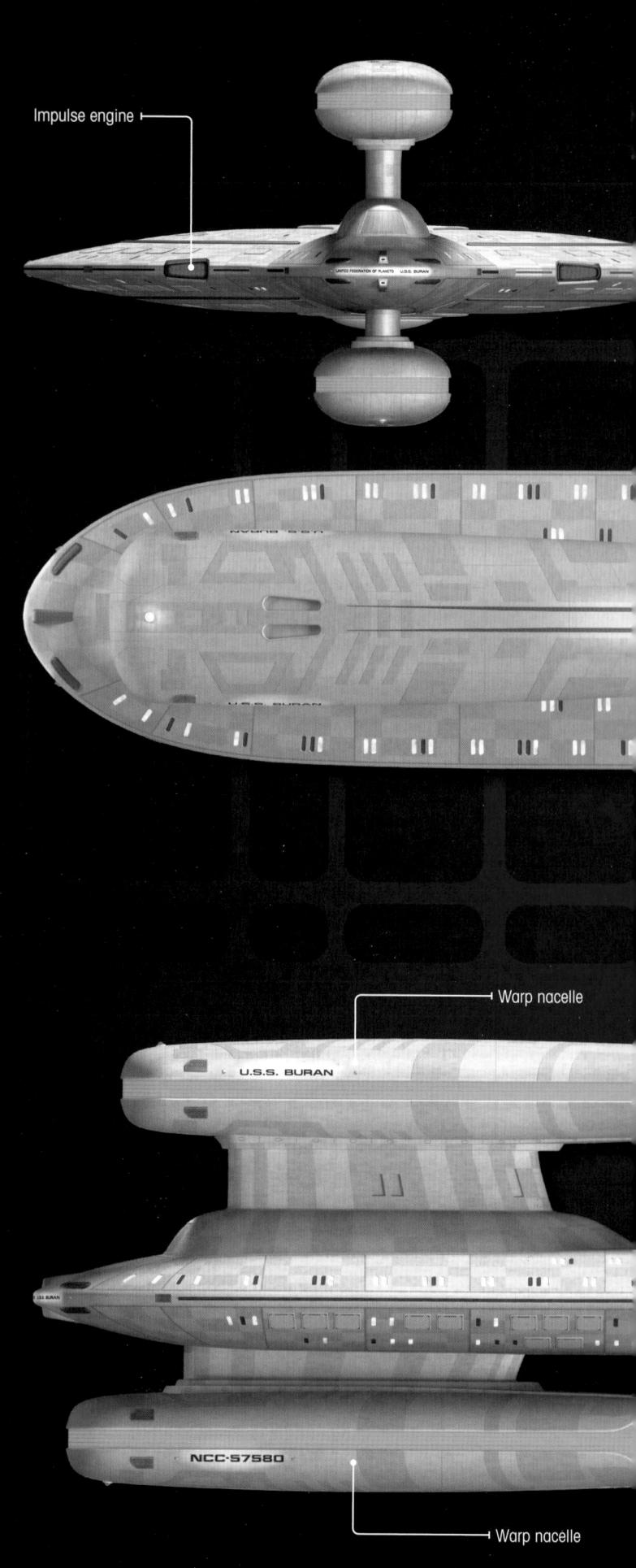

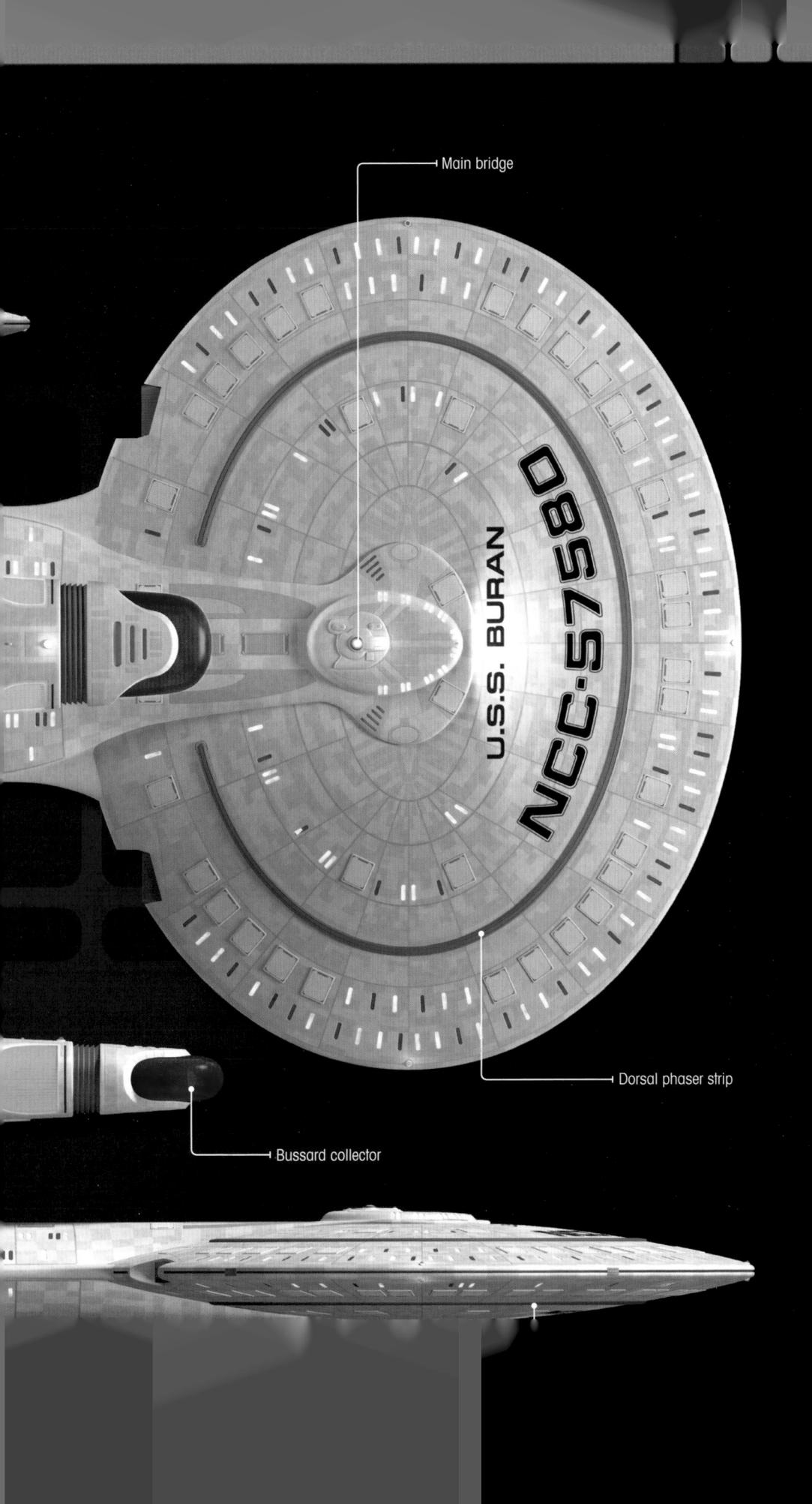

RUSSIAN NAME

The U.S.S. Buran NCC-57580 was named by Ed Miarecki, who designed and built the filming model. He named it for the Russian space shuttle, and Buran in Russian means 'snowstorm.'

UNEVEN NACELLES

The Challenger class was the only known type of Starfleet vessel where the warp nacelles did not exactly line up. Although the nacelles were the same length, the top nacelle was mounted several meters further forward than the bottom nacelle.

SAME CLASS

According to the STAR TREK Encyclopedia, the U.S.S. Armstrong NCC-57537 and the U.S.S. Kearsarge NCC-57566 were both Challenger-

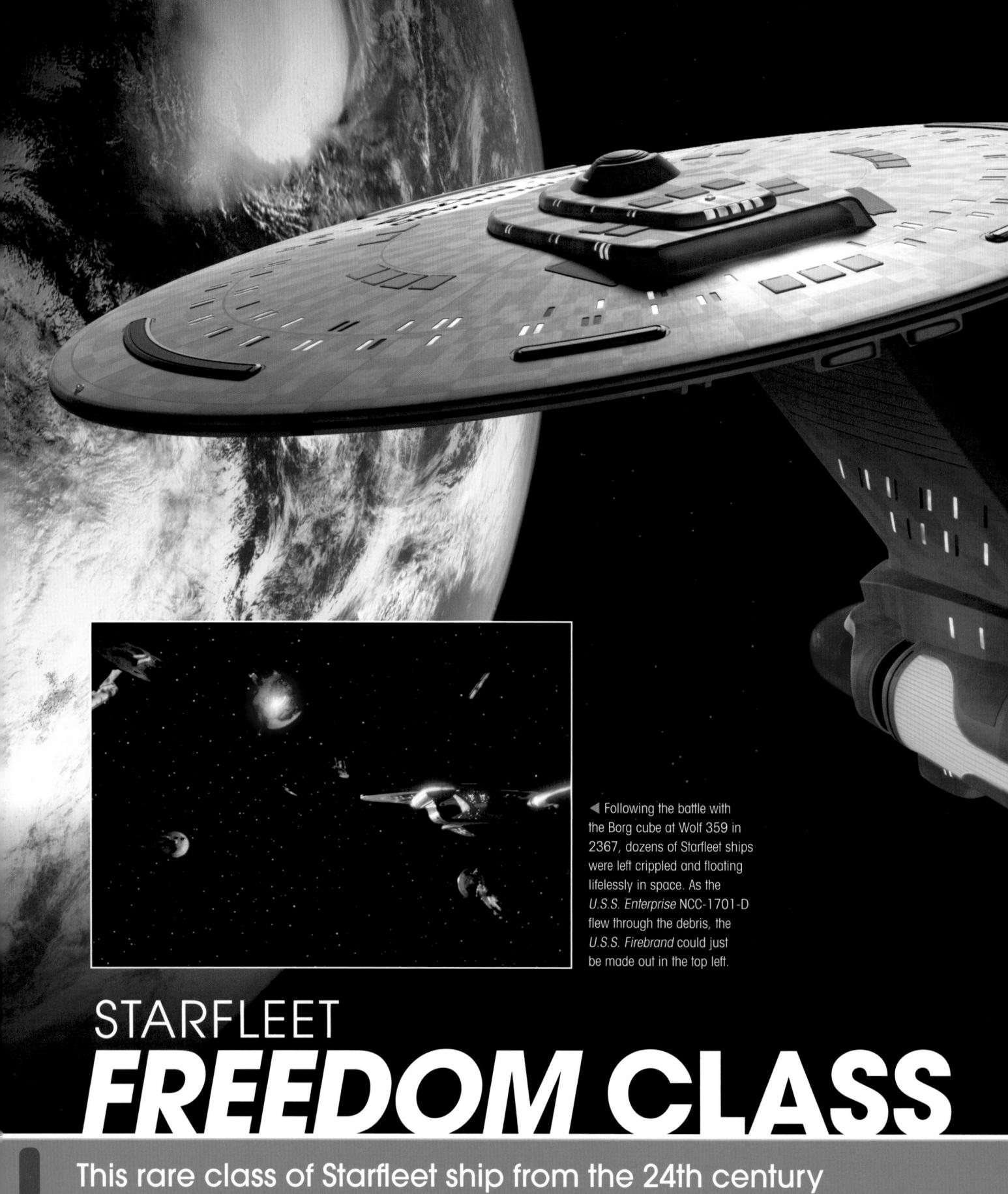

This rare class of Starfleet ship from the 24th century was unusual in that it featured just one warp nacelle.

reedom-class ships, such as the U.S.S.

Firebrand NCC-68723, were Starfleet vessels that were in operation in the second half of the 24th century. This class was highly unusual in that it featured just one warp nacelle.

The *Freedom* class was designed to carry out tasks such as light exploration or planet surveys, but it was also capable of defending Federation borders and guarding supply convoys.

The Freedom class did not have a separate engineering hull, and its single nacelle was attached directly to the neck section, which in turn supported the saucer module.

The nacelle was very similar in appearance to the ones used on *Galaxy*-class ships, and the neck section looked like it was taken from the late 23rdcentury *Constellation* class. The saucer, meanwhile, utilized a fairly rare design, as the only other type of starship it was seen on was *Niagara*-class ships, such as the *U.S.S. Princeton* NCC-59804.

SHUTTLEBAY LOCATION

As the *Freedom* class had no engineering hull, the shuttlebay was repositioned underneath the main bridge at the center of the saucer section.

In 2367, the *Freedom*-class *Firebrand* was part of a fleet that was assembled by Admiral J. P. Hanson to engage a Borg cube that had invaded the Alpha Quadrant and was on its way to assimilate Earth. The *Firebrand* was destroyed with all hands, along with the rest of the fleet, by the Borg cube at the Battle of Wolf 359.

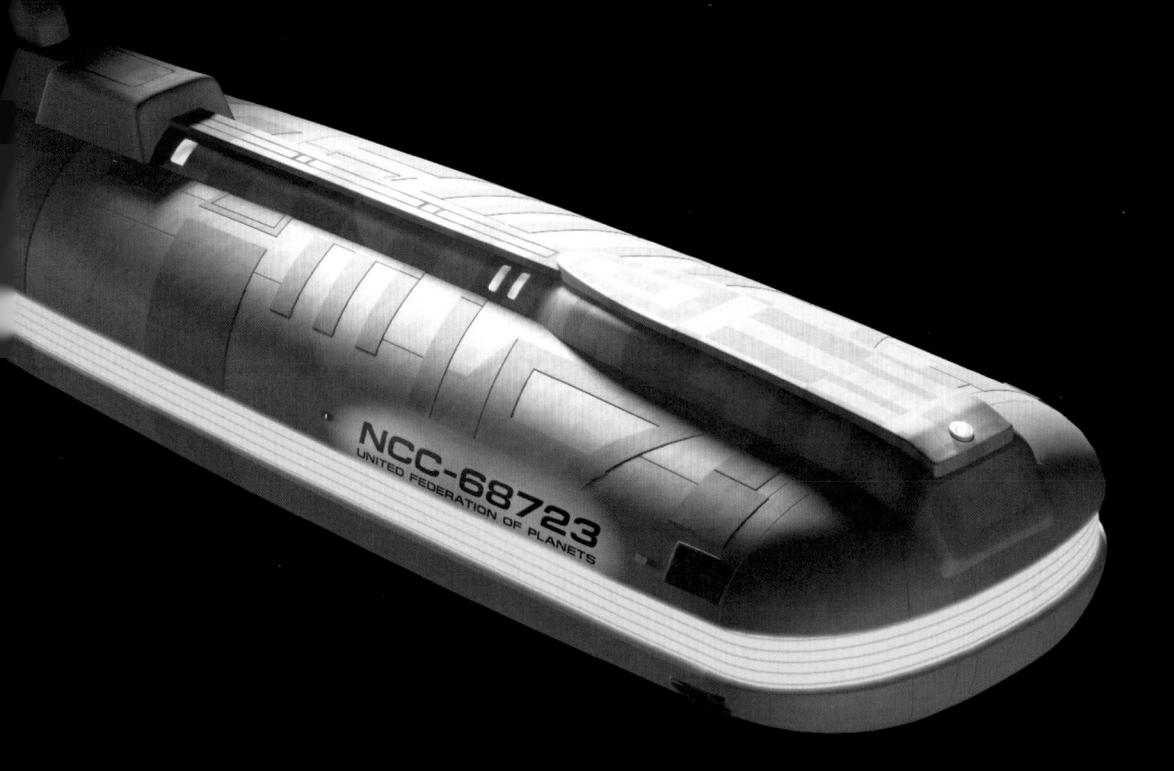

■ Despite having only one nacelle, Freedom-class vessels were still able to reach a top speed of warp 9.2 for limited periods. The downside was that if anything happened to the nacelle, and it became inoperable, the ship would only be capable of impulse speeds.

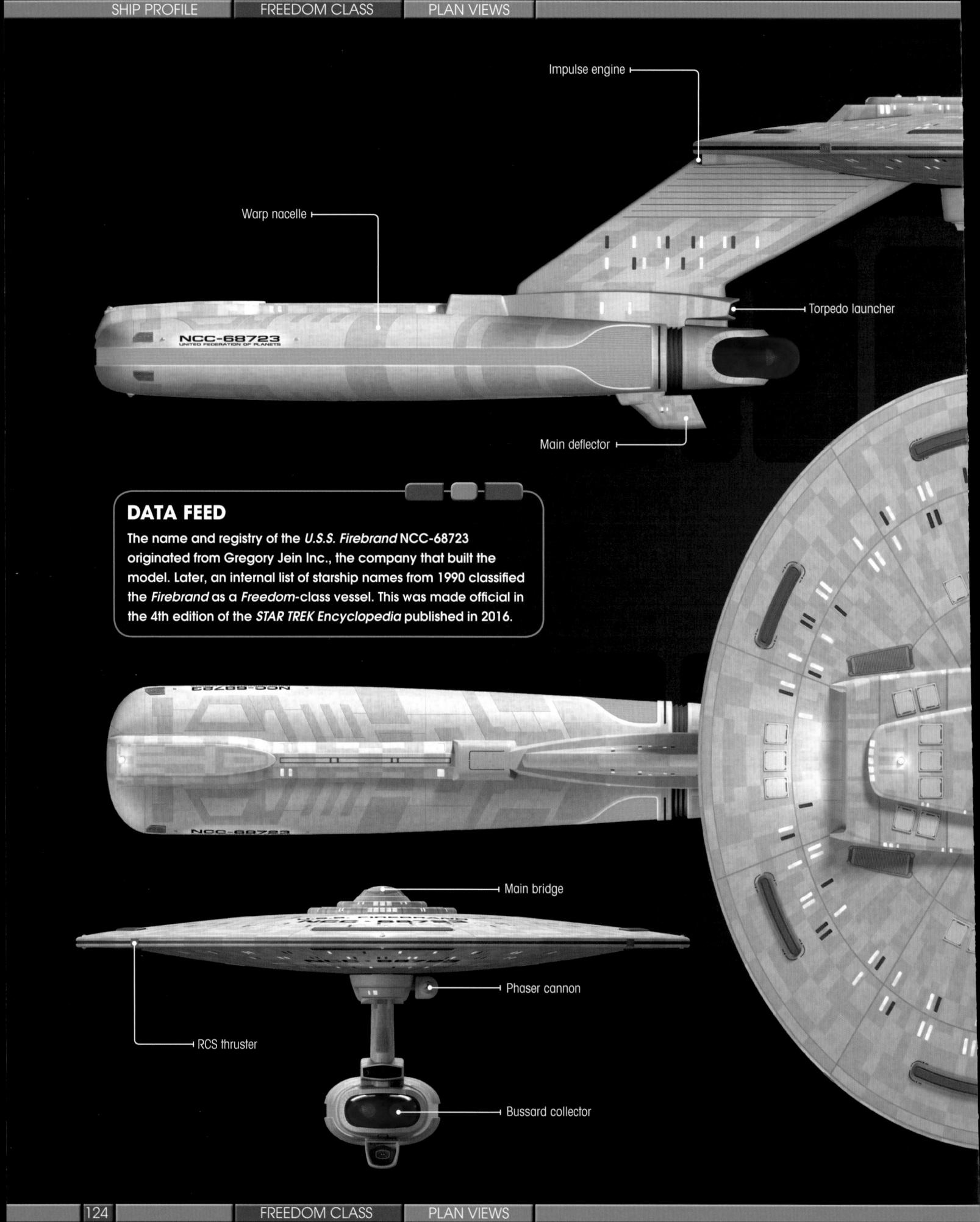

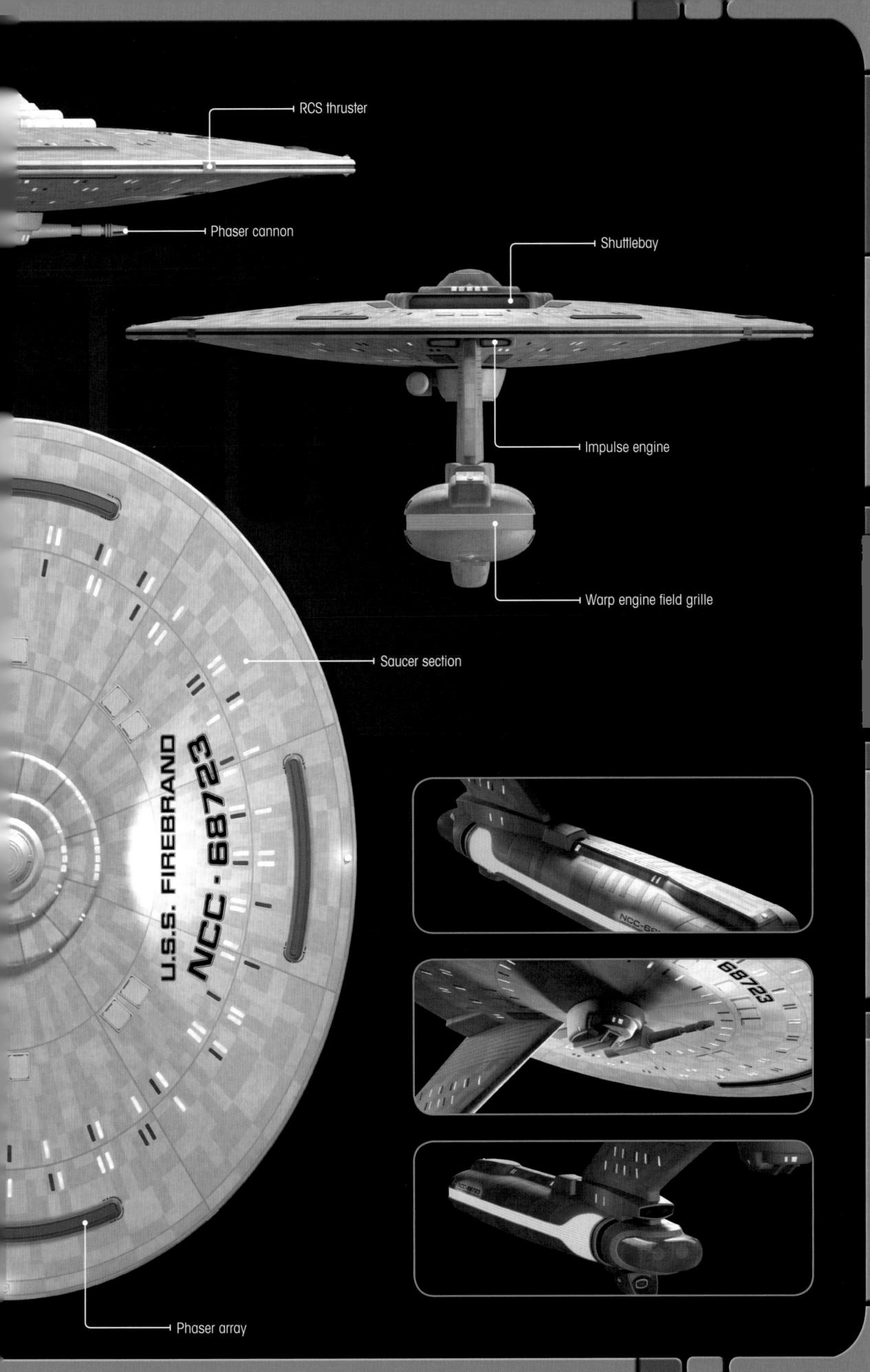

SINGLE NACELLE

JEIN MODEL

Unlike most of the other ships made for the 'graveyard' scene in The Best of Both Worlds, Part II, the Freedom class was not a 'kitbash' from commercially available model kits, but was built with damage by modelmaker Greg Jein.

CEREAL DEBRIS

When filming the 'graveyard' scene, where the U.S.S. Enterprise NCC-1701-D flies through the remains of the decimated fleet of vessels, the visual effects team used flakes of granola to simulate some of the debris left floating in space.

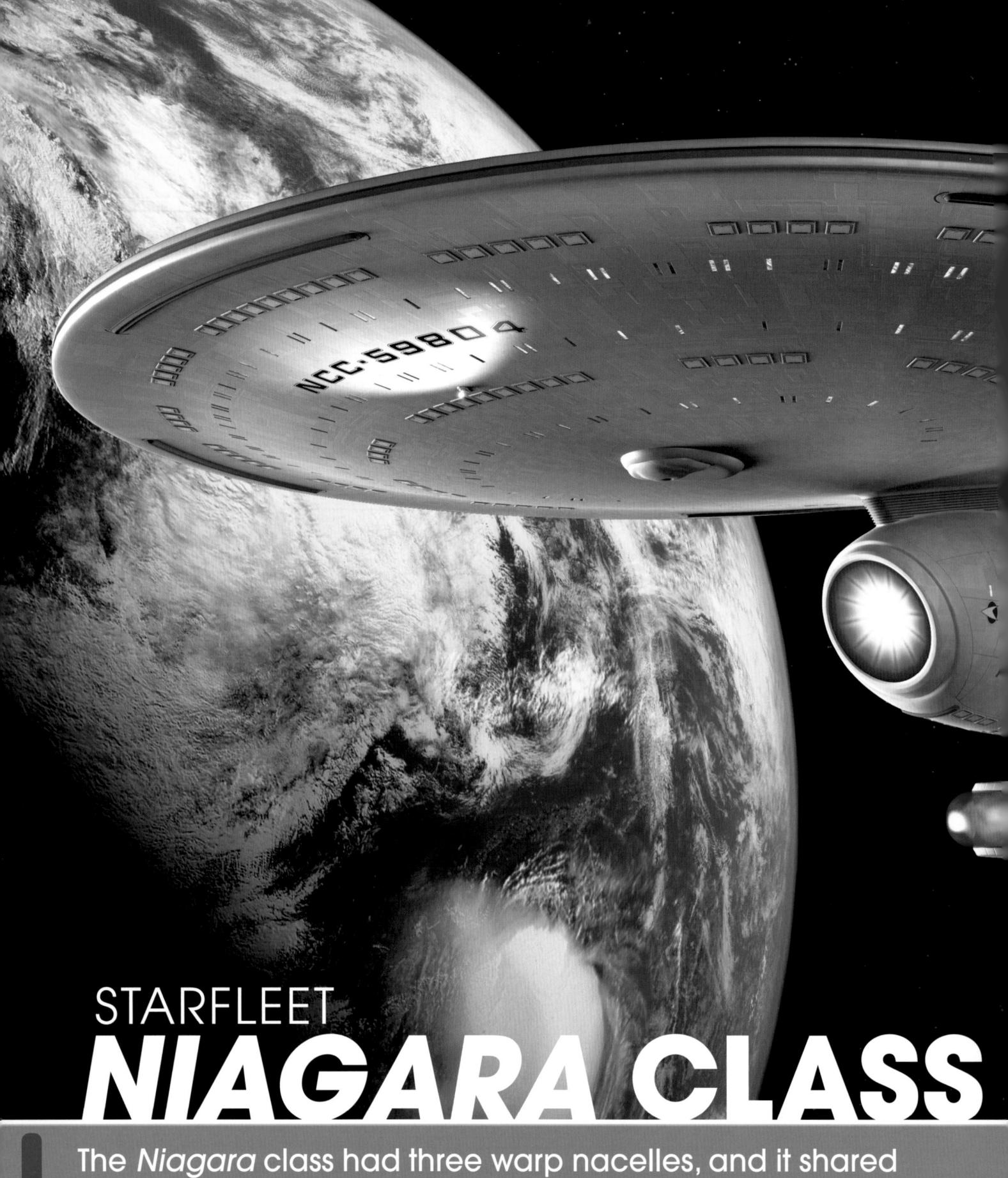

The *Niagara* class had three warp nacelles, and it shared parts found on both the *Galaxy* and *Ambassador* classes.

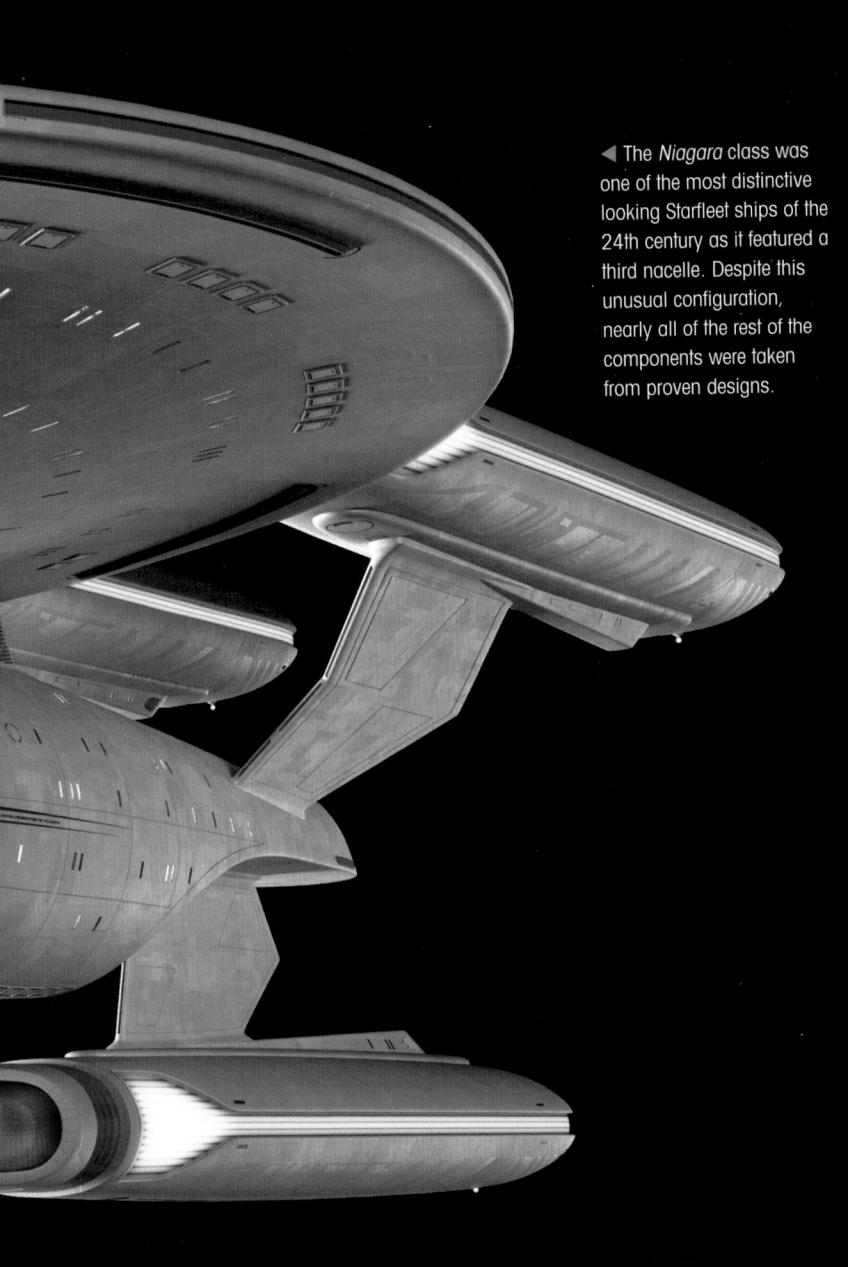

the Niagara class was a type of Starfleet starship that was in service in the 24th century. It was highly unusual in that it was the only known Starfleet starship to feature three warp nacelles. Examples of the Niagara class included the U.S.S. Princeton NCC-59804 and the U.S.S. Wellington NCC-28473.

The *Niagara* class was approximately 565 meters in length, and its crew complement was around 530. It comprised of a fairly rare saucer design that featured an elongated bridge module, and an engineering hull that was identical to that found on *Ambassador*-class ships such as the *U.S.S. Enterprise* NCC-1701-C. The *Niagara* class was equipped with warp nacelles that were the same as those found on *Galaxy*-class ships like the *U.S.S. Enterprise* NCC-1701-D, but the shape of the *Niagara*'s nacelle pylons were unique.

PRIMARY DUTIES

The Niagara class's primary roles were ones of exploration and diplomacy. It was equipped with numerous sensor arrays and scientific laboratories to aid in the study of planets and stellar phenomena. It also featured extensive diplomatic facilities, which ensured it was capable of handling multi-species conferences.

Nearly all Starfleet ships featured an even number of warp nacelles, with most featuring a two-nacelle configuration as Federation propulsion experts determined that this was the ideal layout for optimal warp field efficiency and vessel control. This did not stop Starfleet experimenting with alternative nacelle configurations, however, and there were one-nacelle designs, such as the *Freedom* class, and the three-nacelle layout of the *Niagara* class.

While there were some disadvantages to this

■ The wreckage of the U.S.S. Princeton NCC-59804, a Niagaraclass ship, filled the top right of the U.S.S. Enterprise NCC-1701-D's viewscreen. The Princeton was part of the 39-strong ship fleet that had been assembled by Starfleet to stop an invading Borg cube at Wolf 359, but the entire armada was decimated in a matter of minutes.

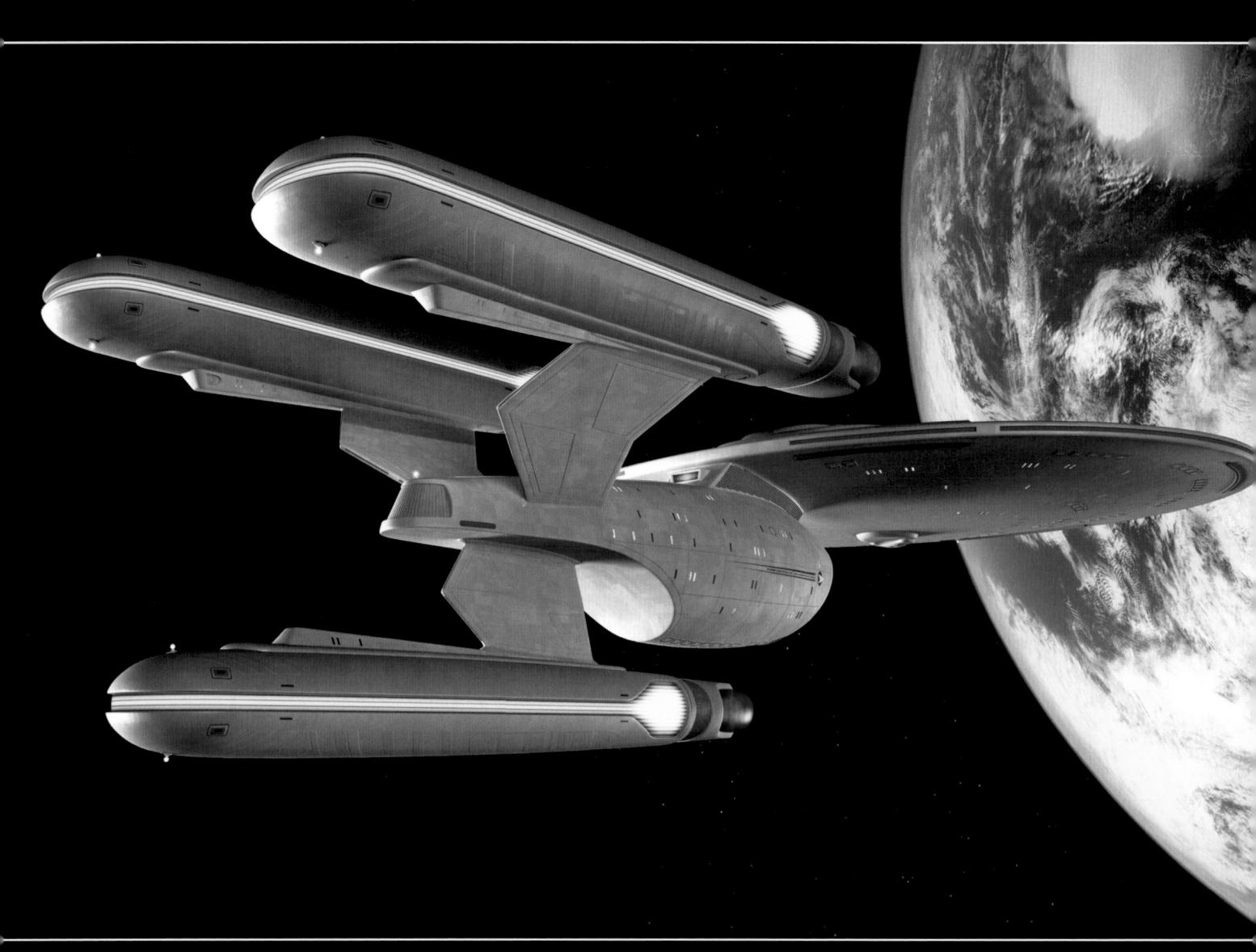

▲ The Niagara class would have looked like any conventional Starfleet ship of the 24th century without the third nacelle hanging below the engineering hull. The additional power created by the third nacelle increased the strength of its weapons, shield and sensor systems.

odd numbered design, there were certain benefits too. *Niagara*-class ships were able to operate on their upper nacelle pair only and keep the lower nacelle in reserve, or vice versa. This extended the life of the components, and added another layer of redundancy if a nacelle failed.

The Niagara class was therefore more suited to deep space missions when it would be far from any starbases or repair facilities, although it did not mean that it had a higher top speed. Like many Starfleet vessels of this era, the Niagara class had a maximum velocity of warp 9.6, but its cruising speed was higher than normal at warp 8.

The architecture of the *Niagara*'s saucer section was found on only one other Starfleet ship - the Freedom class. It was oval in shape and fairly thin compared to other Starfleet ships. The bridge module was located in the middle of the saucer section and it sat on top of a secondary

shuttlebay. The main shuttlebay was located in the more usual position at the rear of the secondary hull. The primary hull also featured numerous windows and lifeboat hatches, as well as several type-7 phaser arrays.

SECONDARY HULL

The short neck section that joined the saucer to the rest of the ship was unique to the Niagara class, but the engineering hull was the same shape as that found on *Ambassador*-class ships. This was a substantial structure and looked almost round when seen from the front. The warp core ran the entire height of the secondary hull, and it could be ejected in the event of a catastrophic matter/ antimatter containment failure.

As has been said, the *Niagara* class was mainly used for deep space exploration missions, but its multiple phaser arrays, as well as fore and aft

The engineering JII of the Niagara ass shared the same Itward design as that und on Ambassadorass ships like the S.S. Enterprise NCC-701-C seen here on e right.

The Borg cube that iped out the entire fleet Wolf 359 was helped Captain Picard, who ad been partially ssimilated. His tactical nowledge of Starfleet's attle strategy handed the org a huge advantage.

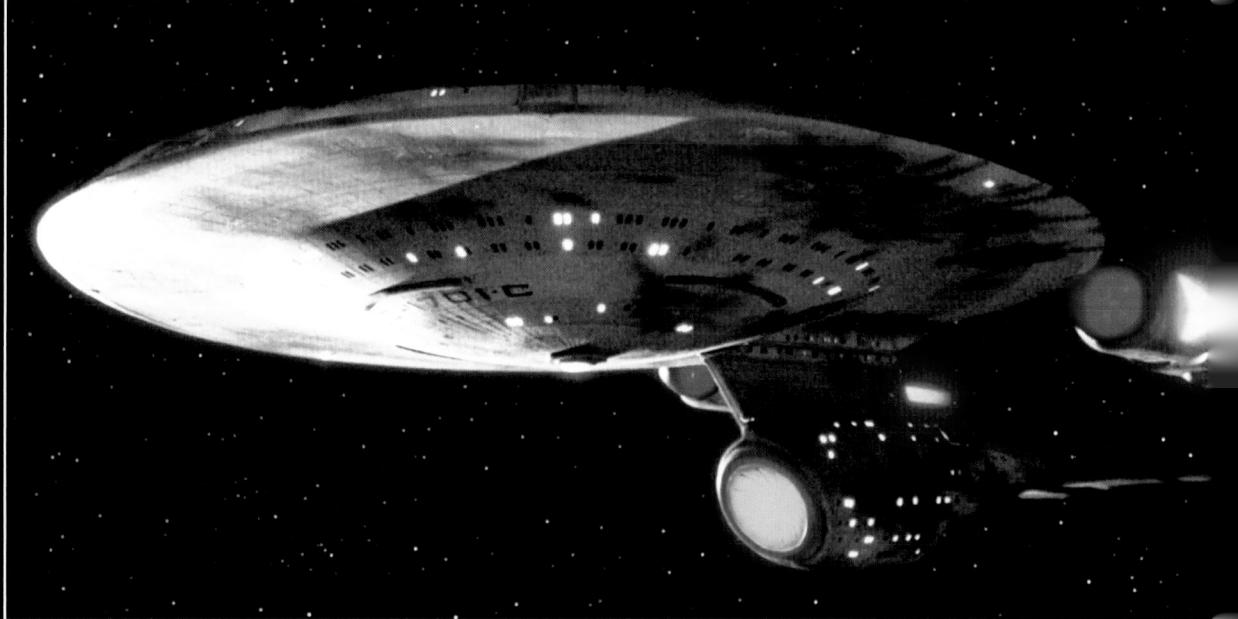

photon torpedo launchers, meant it possessed significant firepower. Add in its robust defensive shields combined with the extra power generated by its third warp nacelle and the *Niagara* class was well up to the task of performing combat and defensive duties.

This was certainly true against familiar enemies in the Alpha and Beta Quadrants that Starfleet found itself up against, but in 2367 it was heavily outmatched by an invading Borg cube. The Niagara-class U.S.S. Princeton lined up with 38 other Starfleet ships to engage the Borg. It was swatted aside with ease as almost half its saucer section was torn off by the Borg cube's cutting beam, and all three of its nacelles suffered heavy damage. Most of the crew perished in the attack, and the ship was damaged beyond repair. Its lifeless hull was later towed to the starship junkyard at Surplus Depot Z15 located in orbit of Qualor II.

The *U.S.S. Wellington*, the other known *Niagara*-class ship, had its computers upgraded in 2364 at Starbase 74 by Bynar technicians. The then-Lieutenant Ro also served on the *Wellington*. She provoked an incident on Garon II that resulted in the death of eight fellow officers. She was court-martialed for her actions, demoted to the rank of ensign and sentenced to imprisonment on Jaros II.

▲ The wreckage of the Princeton was later towed to the Surplus Depot Z15 in orbit of Qualor II. The ship could be seen in a vertical orientation as the Enterprise-D passed it on the way to the salvage yard.

DATA FEED

Ro Laren served aboard the *Niagara*-class *U.S.S.*Wellington, where she attained the rank of lieutenant. In the mid-2360s, she took part in a fateful away mission to Garon II. The specifics of the assignment were vague, but she disobeyed direct orders and as a direct consequence eight members of the away team lost their lives. Ro refused to speak in her own defense at the trial, leaving the court to find her guilty and sentencing her to prison on Jaros II.

NACELLE OPERATION

The warp nacelles were the most important part of a Starfleet ship's propulsion system. They were even given their own series of internal ship coordinates to help the engineering staff pinpoint any potential problems, and their operation and maintenance was overseen from a warp nacelle control room.

Like the rest of the ship, the nacelles were constructed from duranium, and overlaid with gamma-welded tritanium that was 2.5 meters thick. The pressures exerted on the nacelles were extreme, and this was countered by three levels of cobalt cortenide that lined the structure's inner hulls. The power contained within the nacelles was so potent that they could be extremely dangerous if they malfunctioned, so safety features were incorporated that allowed them to be jettisoned in an emergency; explosive structural latches could be fired, driving the nacelles away from a ship at a rate of 30 meters per second.

Most Starfleet ships had two warp nacelles and maneuvered in space by creating slight imbalances in the warp field produced by each nacelle; in simple terms, this was the same principle upon which a kayak is maneuvered, by paddling more quickly on one side than the other.

Complications arose when using a threenacelle design, but a well-balanced warp field was made to work on the *Niagara* class. The idea did not catch on though, as the extra resources needed for an additional nacelle did not justify the slight increase in power.

The interior components of the warp nacelles on the *Niagara* class vere the same as those used on *Galaxy*-class ships. This meant that here were 18 warp field coils, arranged in pairs, on the inside.

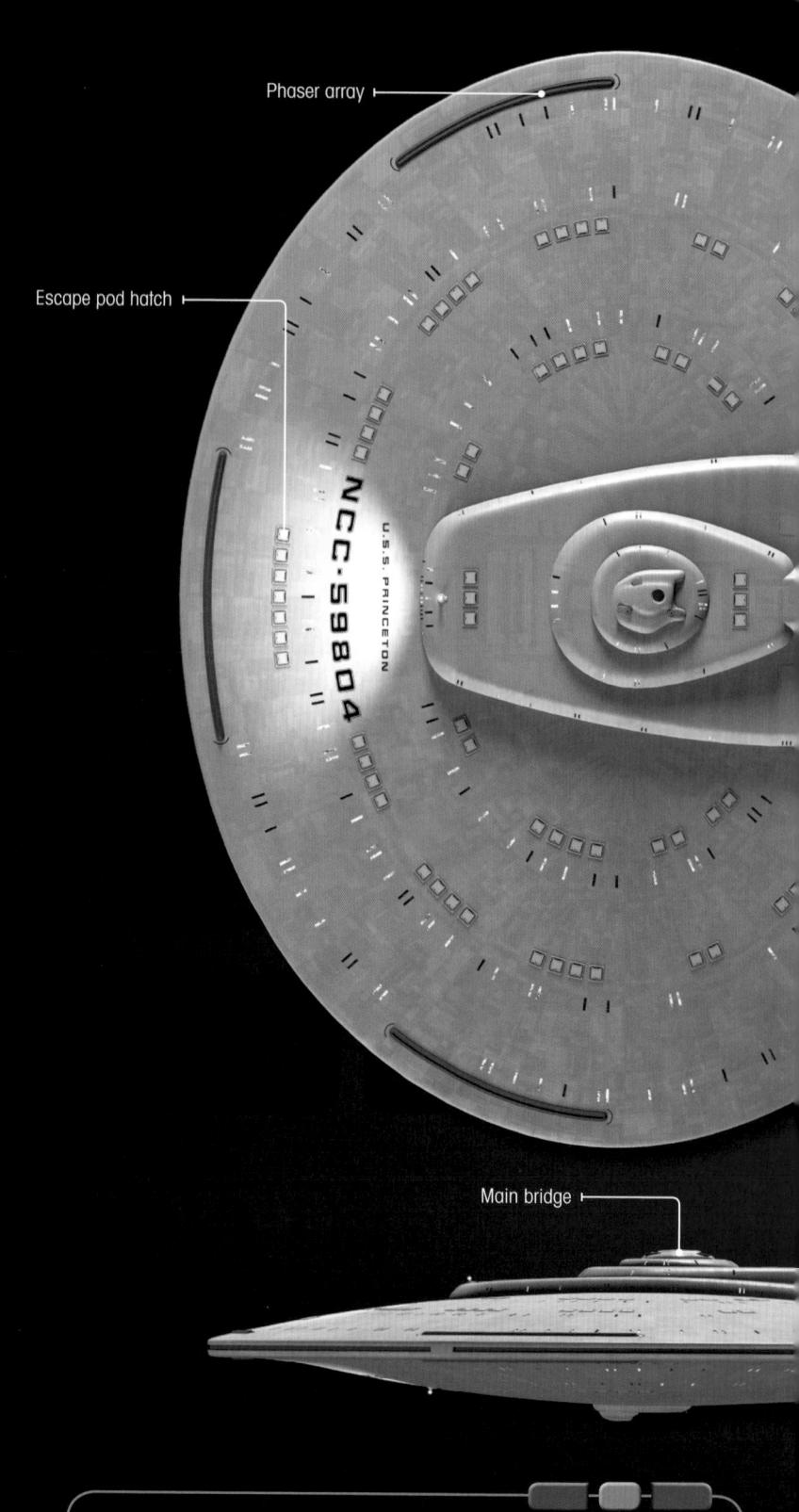

DATA FEED

Most Starfleet vessels had two nacelles, although they could operate with one nacelle at reduced speed. There were Starfleet vessels built with just one nacelle such as the *Freedom* class. The *Niagara* class was the only type of Starfleet ship that had three nacelles in the prime universe, although a schematic seen on a display monitor aboard the *U.S.S. Enterprise* NCC-1701 appeared to show the *Freedom* class as having three nacelles.

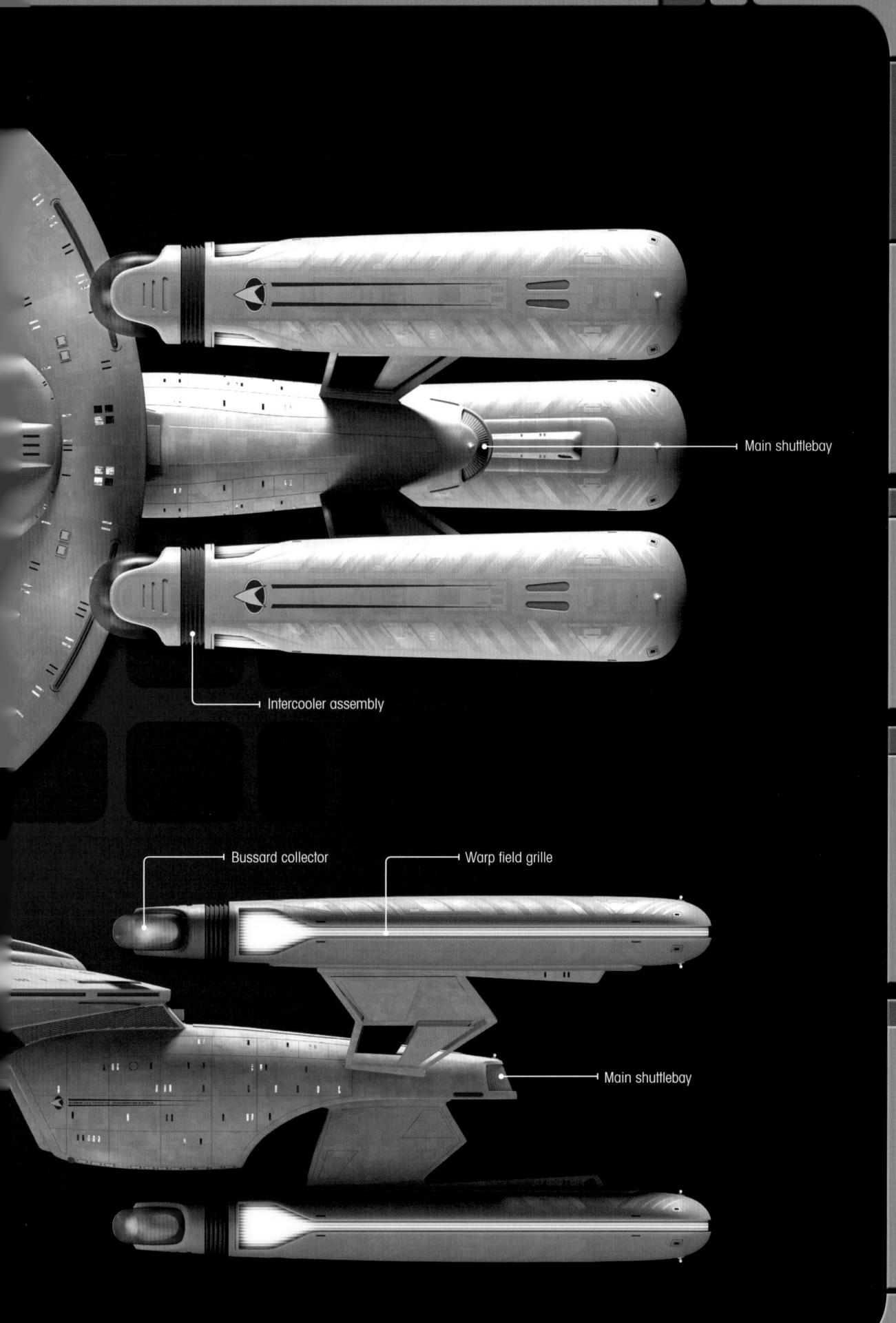

ALTERNATE FUTURE

The only other Starfleet vessel seen equipped with three nacelles, apart from the Niagara class, was the U.S.S. Enterprise NCC-1701-D from an alternative future in the episode 'All Good Things...'

WELLINGTON CAPTAIN

Captain Thomas Pucer was the commanding officer of the *Niagara*-class *U.S.S. Wellington* in 2365. According to a computer readout screen at Starbase 173, the *Wellington* was assigned to patrol the Neutral Zone in Sector 130.

SAFETY FEATURE

According to the 'STAR TREK: THE NEXT GENERATION Technical Manual,' Galaxy-class ships were able to jettison nacelles in the event of an emergency. As Niagara-class ships used the same nacelle design as the Galaxy class, they probably had this facility too.

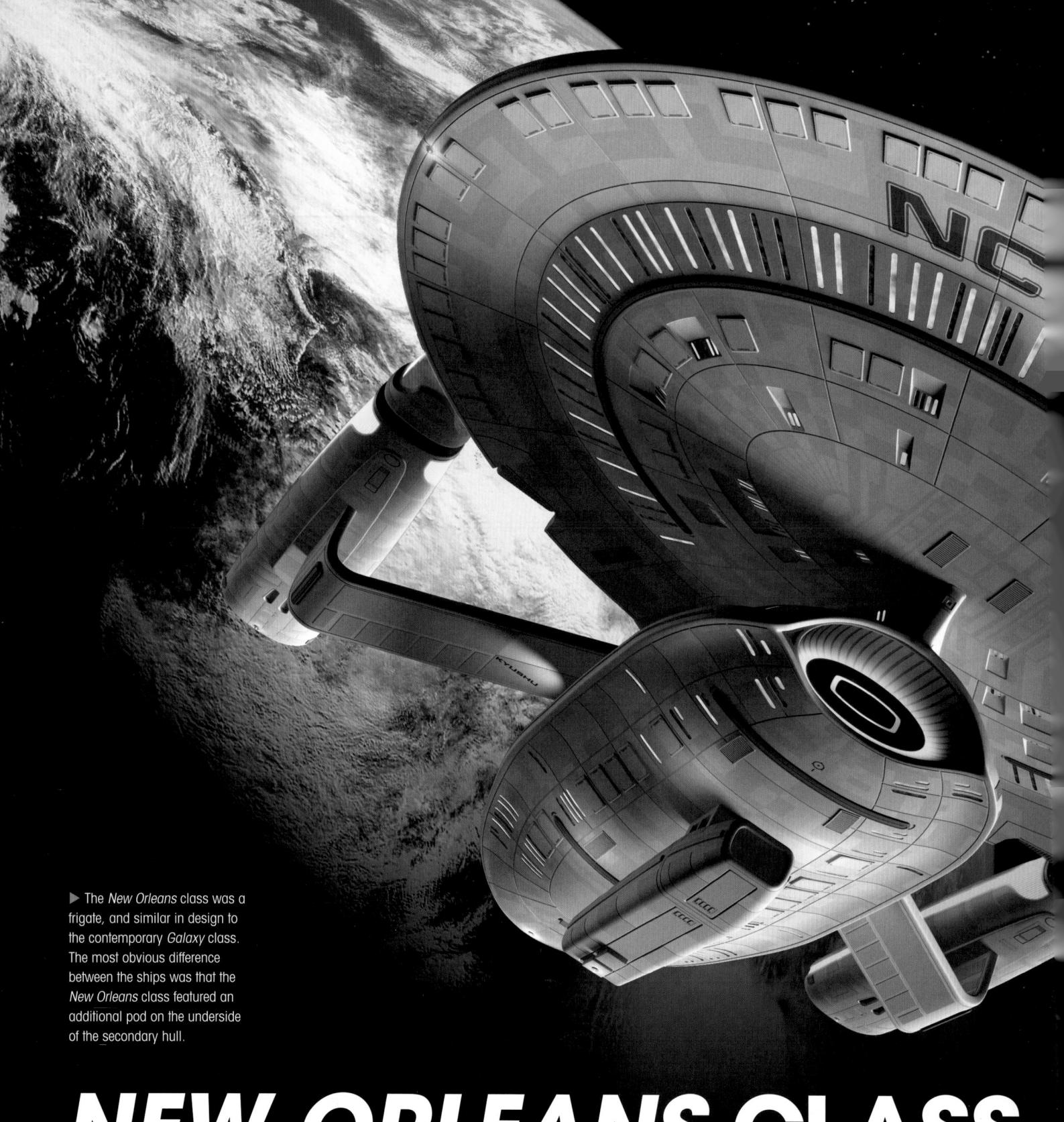

NEW ORLEANS CLASS

New Orleans-class vessels were like Galaxy-class ships in both appearance and ability, but about half the size.

The New Orleans class was a type of Starfleet vessel that was in use in the 24th century. Its appearance was similar to a Galaxy-class ship, but at approximately 340 meters in length, it was significantly smaller.

The saucer section of the *New Orleans* class was elliptical in shape and featured the same style of windows and escape pods as the *Galaxy* class. It was smaller, however, and two oblong structures were attached on top at the rear of the saucer. The main bridge was situated on deck 1 in the center of the saucer, but it was slightly larger in relation to the saucer section as a whole than it was on the *Galaxy* class.

FAMILIAR DESIGN

The engineering hull and warp nacelles on the New Orleans class were also almost identical in shape to those on the Galaxy class, but were larger in proportion to the rest of the ship.

The most obvious outward difference between the two classes of ship, apart from the size, was that the *New Orleans* class featured a tubular structure on the underside of the engineering hull.

Less obvious differences could also be found in the neck of the ship between the saucer and engineering sections, and the shape and positioning of the warp pylons. The neck structure was much shorter on the *New Orleans* class, meaning that the saucer and the engineering hulls were much closer together. Meanwhile, the nacelle pylons were attached just over halfway along the engineering section and swept back,

■ Captain Rixx was in command of the New Orleans-class
 U.S.S. Thomas Paine NCC-65530 in 2364. Rixx was a Bolian and considered to be one of Starfleet's most accomplished captains at the time. According to records, the Thomas Paine was on a diplomatic mission to Epsilon Ashanti III in 2367, and to Alderaan in 2368.

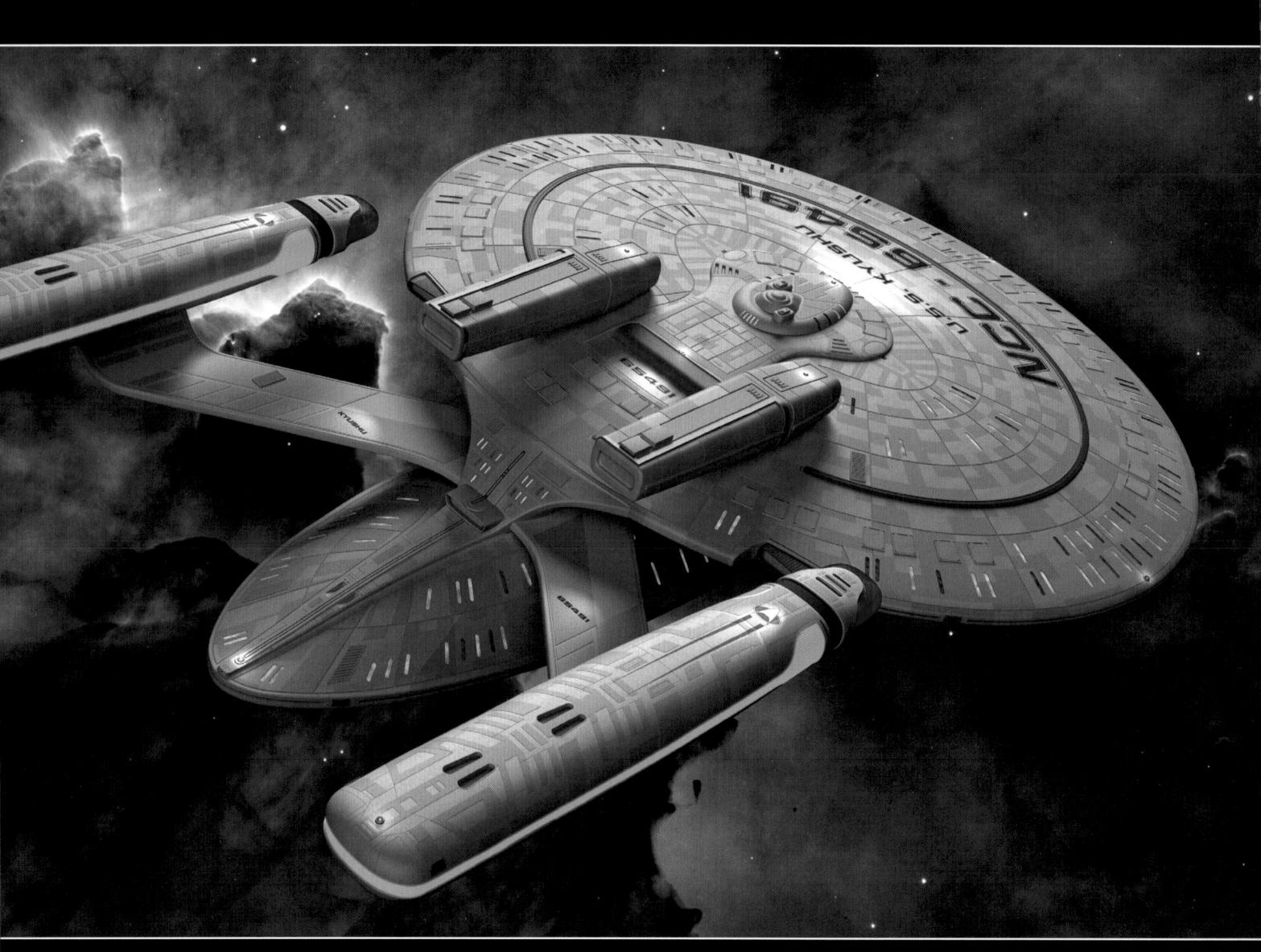

▲ The surface detail on the New Orleans class was almost identical to that found on the Galaxy class, in particular the windows, escape pods and phaser strips. Seen from above, however, there were a couple of distinctions as the New Orleans class featured two additional structures attached to the rear of the saucer section, and the positioning and design of the warp pylons was different.

whereas the pylons on the Galaxy class were positioned at the very rear of the engineering hull and swept straight out horizontally.

As the New Orleans class was about half the length of the Galaxy class, it followed that its crew complement was significantly less. Whereas the Galaxy class normally carried just over 1,000 people, the New Orleans usually operated with a crew of around 500.

The New Orleans class had slightly less powerful engines and armaments compared to the Galaxy class, too. The warp engines on the New Orleans class gave it a top speed of warp 9.3 sustainable for 12 hours, and a cruising speed of warp 6. It was equipped with a high-capacity shield grid, 10 Type-X phaser arrays, plus three photon torpedo launchers.

Other facilities on board the New Orleans class included sickbays, transporter rooms, holodecks

and several specialized research labs. In many ways, it was very similar to the Galaxy class, but just on half the scale.

ALIEN CONSPIRACY

In 2364, two New Orleans-class vessels were called to a secret rendezvous at an abandoned mining colony on Dytallix B along with the U.S.S. Enterprise NCC-1701-D. Captain Walker Keel of the U.S.S. Horatio NCC-10532 called the meeting after he suspected that a neural parasitic alien intelligence was trying to take over Starfleet Command.

The meeting was attended by Captain Picard, Captain Rixx and Captain Tryla Scott. Rixx was in command of the New Orleans-class U.S.S. Thomas Paine NCC-65530, and was considered one of Starfleet's best captains, while Scott was captain of the New Orleans-class U.S.S. Renegade NCC-63102. She attained the rank of captain faster than

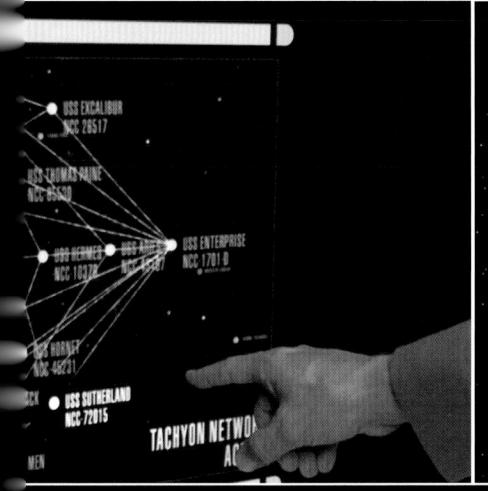

ory of Starfleet, which made legend.

Orleans-class Thomas Paine successful fleet that prevented rom transporting supplies to the ng the Klingon Civil War. The one of 17 ships that formed a

tachyon detection grid that was set up to detect cloaked Romulan warships entering Klingon space. Once they had been exposed, the convoy of Romulan ships was prevented from sending further supplies to the House of Duras, and Gowron was able to hang on to power as the legally appointed leader of the Klingon Empire.

▲ The Romulans tried to supply the House of Duras with weapons in its attempt to take control of the Klingon Empire during their civil war. They were defeated after the convoy of Romulan ships was detected.

Captain Tryla Scott was in command of the *New Orleans*-class *U.S.S. Renegade* in 2364. She was an outstanding officer and became widely celebrated after she had become captain faster than any other person in Starfleet history. Along with Captain Picard and Captain Rixx, she was called in to investigate the infiltration of Starfleet Command by parasitic life forms. Unfortunately, she was infested by one of these parasites and Commander Riker was forced to fire at her with a phaser set to kill, in order to stop her.

The New Orleans-class U.S.S. Kyushu NCC-65491 was just one of 39 Starfleet vessels that tried to repel an invading Borg cube at the Battle of Wolf 359 in 2367. Not all the names of the Starfleet ships that made up this armada were known, so it was possible that more New Orleans-class vessels were part of this tactical force, but they were not seen and no reference was made to them.

The New Orleans class was primarily built for exploration rather than combat, but its offensive and defensive capabilities were considerable if not quite up to the standards of larger Galaxy-class ships. Nevertheless, the Kyushu, along with the other ships in the armada, was easily defeated by the Borg cube. Part of this was down to the fact that Captain Picard had been partially assimilated and his knowledge of Starfleet ships and tactics was therefore known by the Borg.

Another part was down to the fact that the Starfleet armada used the wrong strategy. The ships attacked one at a time because they did not want to risk hitting their own vessels in the crossfire. Unfortunately, this meant the Borg cube could easily pick them off one by one, with no danger of it being overwhelmed.

As it happened, it would not have made much difference what tactics were used, or even if Captain Picard had not been turned into Locutus. The simple fact was that the Starfleet armada was no match for the Borg.

Captain Picard was captured by the Borg and transformed into .ocutus. All Picard's knowledge of Starfleet's defenses was assimilated by the Borg, making it even easier for them to destroy Starfleet's ships.

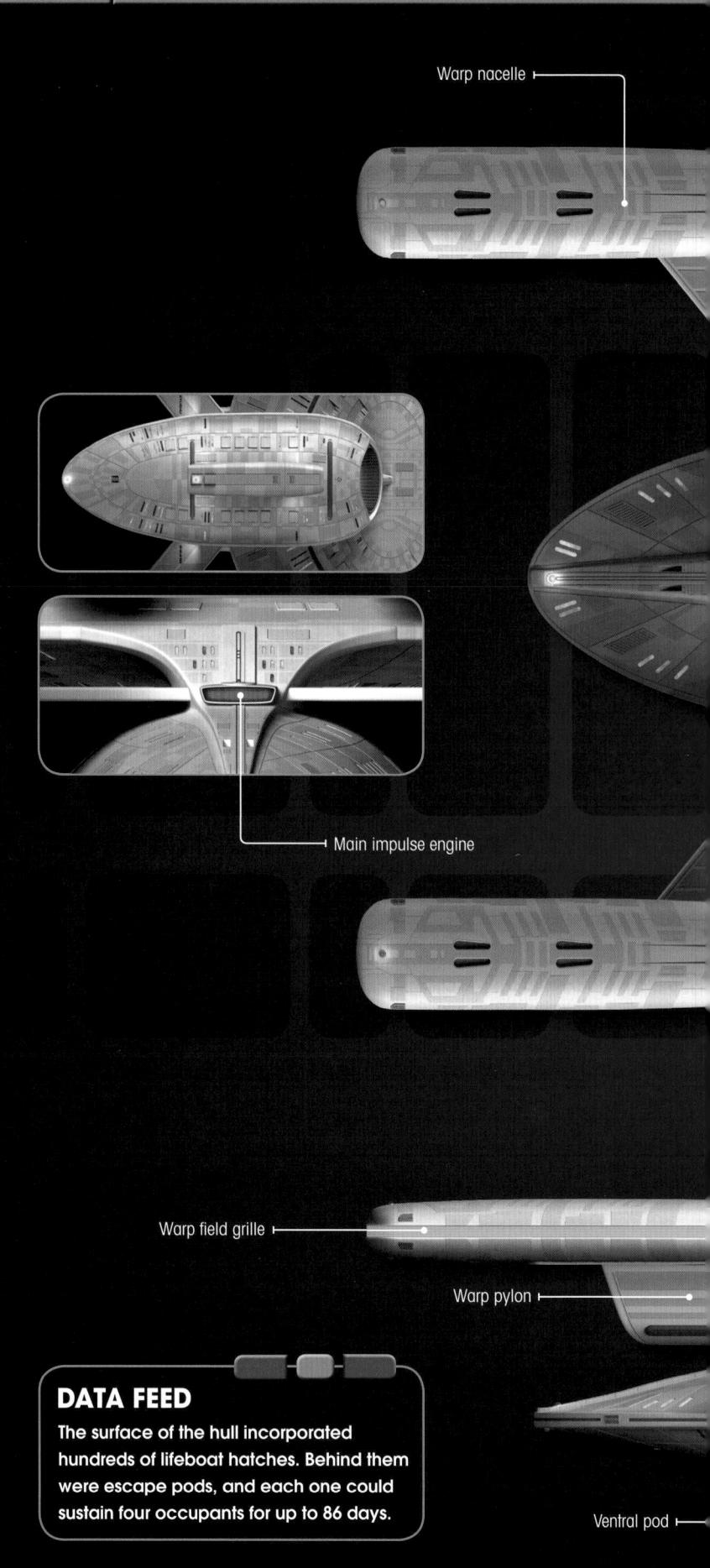

ISLAND NAME

The New Orleans-class U.S.S. Kyushu was named for one of the four main islands of Japan. It was also referenced in the DEEP SPACE NINE opening episode 'Emissary', but the line was later cut

FIRST MENTION

The first on-screen reference to the New Orleans class came from a display graphic on the bridge of the U.S.S. Enterprise-D. This was in the fourth season episode Brothers, in which the U.S.S. Thomas Paine was labeled as a New Orleans-class vessel.

INSIDE HUMOR

In 2369, the New Orleans-class U.S.S. Thomas Paine was on a diplomatic mission to Alderaan. This was an in-joke by the production staff, as Star Wars' Princess Leia claimed to be on a mission to Alderaan when she was captured by Darth Vadar.

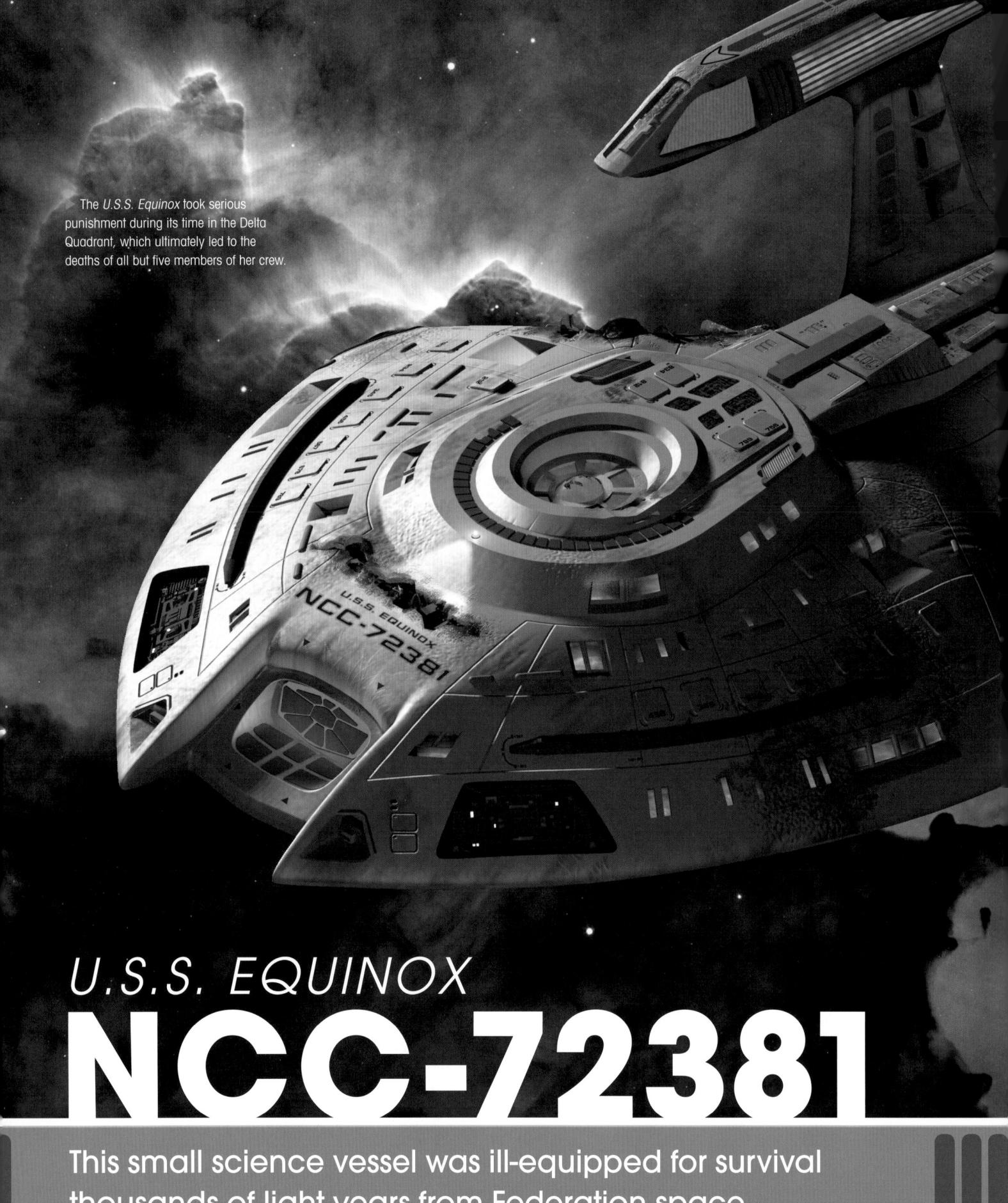

thousands of light years from Federation space.

DATA FEED

The Equinox was one of several ships that the entity known as the Caretaker pulled into the Delta Quadrant. Originally an explorer from another galaxy, the Caretaker had remained in the Delta Quadrant to care for the Ocampa after accidently ruining the atmosphere on their planet. Finding himself close to death, the Caretaker sought to find a successor from anywhere, but abandoned every species that he deemed unsuitable.

The Nova-class U.S.S. Equinox was built at the Utopia Planitia Fleet Yards and was designed to function as a science and scout vessel, making it perfect for short-term planetary research and analysis rather than long-range tactical missions. As a result the Equinox had a top speed of only warp 8 and was fitted with minimal weaponry, although it was one of the first ships to be equipped with an Emergency Medical Hologram.

Measuring 221.74 meters in length with eight decks, the *Equinox* was a relatively small vessel. The *Nova-*class spaceframe was originally developed as part of the *Defiant Pathfinder* project which

was established to deal with the Borg threat in the 2360s. However, when the *Defiant* project took a different approach, the *Nova* prototype. was reclassified as a science vessel. Four of its torpedo launchers were torn out and replaced with sensor platforms. Additional sensor platforms were located around the perimeter of the saucer section and in the dome on the underside of the saucer. The secondary navigational deflector at the front of the saucer section further enhanced the ship's scanning abilities.

The *Nova* class did however retain several design features from those early days, including a recessed bridge protected from conventional attacks by an outer ring. From here the entire ship could be operated by as few as two officers.

Like Intrepid-class ships, the Equinox was designed to land on a planet's surface and was fitted with retractable landing struts located in the

◀ The Equinox's captain, Rudolph Ransom (left), and first officer, Maxwell Burke, broke many of Starfleet's rules in order to survive in the Delta Quadrant. As the ship suffered serious damage they became less and less concerned with morality and eventually resorted to murder to shorten their journey home.

- The Equinox was commanded by Captain Rudolph Ransom III, a well-regarded officer. However, when his ship was trapped in the Delta Quadrant he made some crucial mistakes that resulted in the loss of many members of his crew.
- ► A meeting with a race known as the Ankari led Ransom to discover a nucleogenic life form.

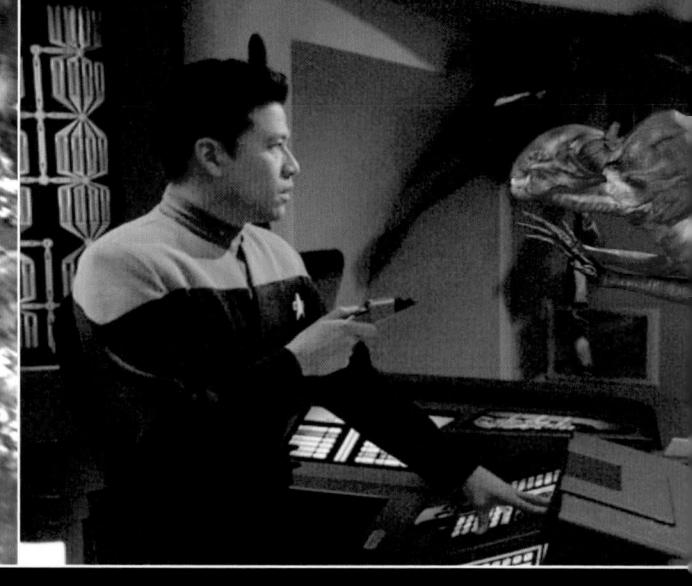

▲ When Voyager's commander, Captain Janeway, discovered what Ransom had done she attempted to arrest him, but he and his surviving crew members took the Equinox and hid near a planet with a pathogenic atmosphere that masked the ship from sensors.

lower decks of the engineering hull. The Equinox also carried a number of shuttlecraft including a hypersonic Waverider shuttle, which was docked on the underside of the saucer section. Similar to the captain's yachts on Galaxy-class vessels, the Waverider shuttle was designed to operate within a planetary atmosphere and could reach speeds in excess of Mach 5.

LOST IN THE DELTA QUADRANT

The *U.S.S. Equinox* was commissioned on Stardate 47007.1 and placed under the command of Rudolph Ransom III, a well-known and admired exo-biologist who, after making first contact with the Yridians, a species previously thought to be extinct, was promoted to the position of captain. In 2371, the *Equinox* was one of a number of vessels that was pulled into the Delta Quadrant by the entity known as 'The Caretaker', who abandoned

the crew 70,000 light years from Earth.

Even travelling at her top speed of warp 8, it was clear it would take decades for the ship to reach home. Nevertheless, Ransom set a course for Earth. Within a matter of days the Equinox had unwittingly entered an area of space controlled by a species known as the Krowtonan Guard who ordered them to leave their territory. However, since a detour would add six years to their journey, Ransom opted to maintain course. The Krowtonan Guard launched a series of vicious assaults that resulted in the loss of half the Equinox crew and severe damage to the ship. Although the Equinox survived, she was not equipped for long-term survival away from Starfleet support facilities, and within a few years the ship was on the point of collapse, with the remaining crew facing starvation.

The ship managed to enter orbit around an M-Class planet, whose inhabitants, known as the

- Ransom and his crew hoped to study the nucleogenic life forms, and summoned one but their attempts to keep it in normal space went wrong and resulted in its accidental death.
- ▶ The remains of the nucleogenic life form provided an incredibly efficient fuel source that allowed the *Equinox*'s engines to reach the high warp 9.9s.

■ When the U.S.S. /oyager came to the Equinox's assistance, he nucleogenic life forms started to attack both ships, convinced that there was no difference between he two crews. Voyager eventually managed to communicate with the life orms and promised to counish Ransom.

→ Janeway pursued

Ransom and in the

Pansuing battle Voyager

Inflicted serious damage

In the Equinox.

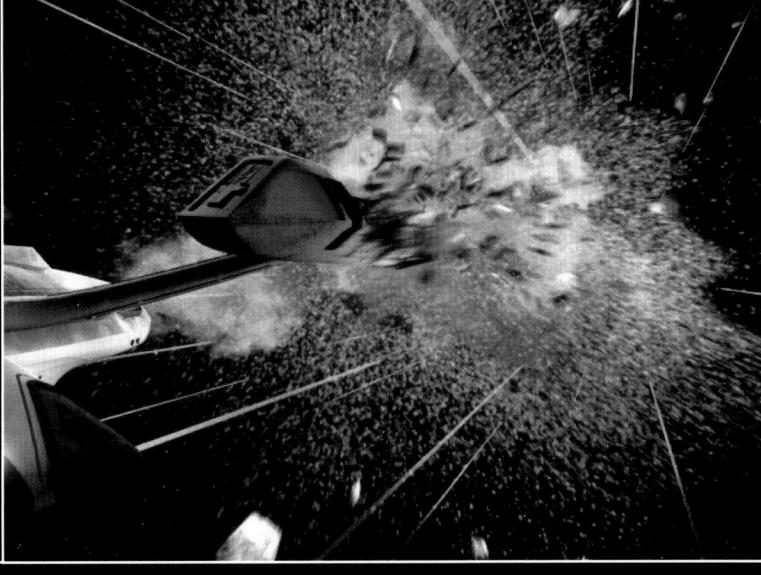

Ankari, summoned their 'Spirits of Good Fortune' o bless the crew. Discovering that the spirits were in fact nucleogenic life forms who emitted nigh levels of antimatter, Ransom and his crew captured and accidentally killed one of the aliens. 'hey used the remains to enhance the Equinox's varp drive.

MORAL SHORTCUT

The new power source enabled the ship to travel over 10,000 light years in just two weeks. Ransom and his crew continued to capture and kill the aliens in a bid to shorten their journey to Earth.

However, the aliens retaliated by attacking the ship, killing many of the remaining crew members. In early 2376, after one such attack left the ship almost crippled, Ransom sent out a distress call, which was picked up by the U.S.S. Voyager, another Starfleet vessel trapped in the Delta.

Quadrant. Accepting *Voyager*'s help, Ransom hid the reason behind the alien attacks. When the truth was exposed, Janeway attempted to arrest him and his crew and to make peace with the nucleogenic life forms. The *Equinox* fled and in the ensuing battle, Ransom realized what he had done, beamed his crew to *Voyager*, and destroyed the *Equinox*, with himself aboard.

A Ransom was willing to surrender but his first officer, Maxwell Burke, wasn't. Ransom elected to destroy the ship, killing both himself and Burke. The five surviving crew members joined Voyager's crew.

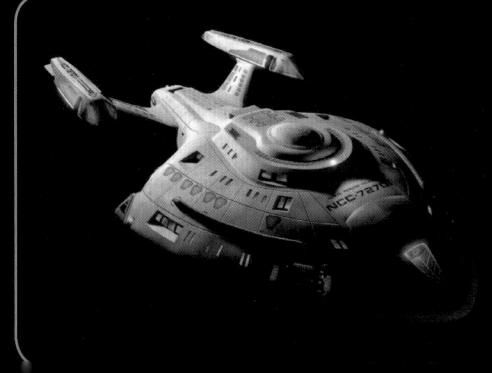

DATA FEED

In one version of the future, Harry Kim was the captain of the *U.S.S. Rhode Island*, a design of Starfleet vessel that had clearly evolved from the *Nova* class. The most obvious difference was that it had a filled-in nose section.

Master Systems Display

The Equinox was a small vessel that was designed for relatively short-range scouting and scientific survey missions. Her eight decks provided quarters for a crew of 80, which were located on the upper decks. The lower decks in the engineering hull were largely taken up by the navigational deflector, which crossed Decks 6 and 7 and main engineering, where the vertical warp core ran between Decks 5 and 8, with a hatch in the bottom of the hull allowing

it to be ejected in an emergency. The impulse engines were on Deck 2 at the rear of the saucer section. The main computer core was also located in the saucer section and ran between Decks 2 and 4. The *Waverider* shuttle was docked just forward of this on Deck 4, where it nestled into the ship behind the secondary deflector dish. Other shuttlecraft were housed in a shuttlebay at the rear of the ship on Deck 3, which also housed a variety of science labs.

BRJO 9 ALPE
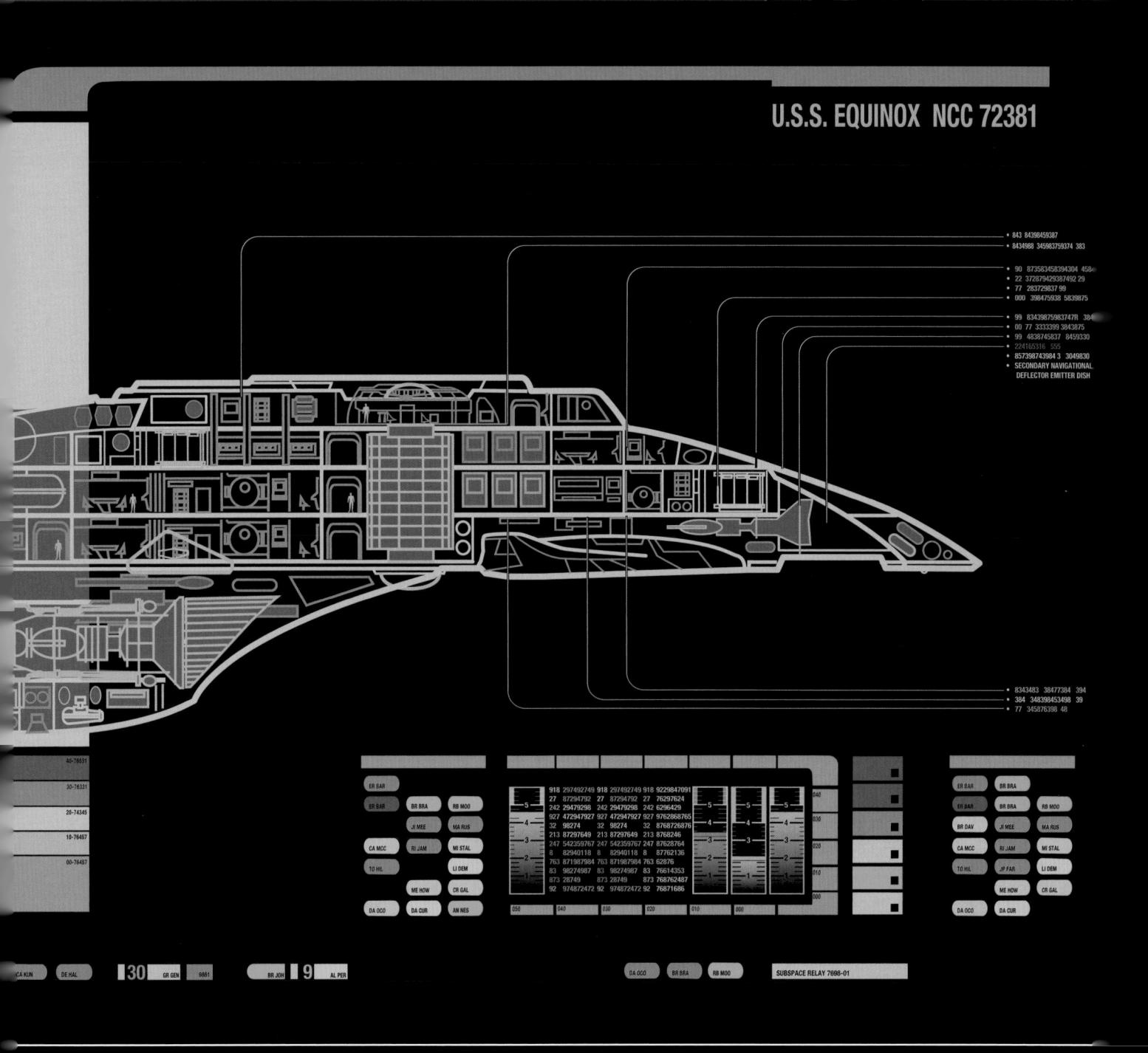

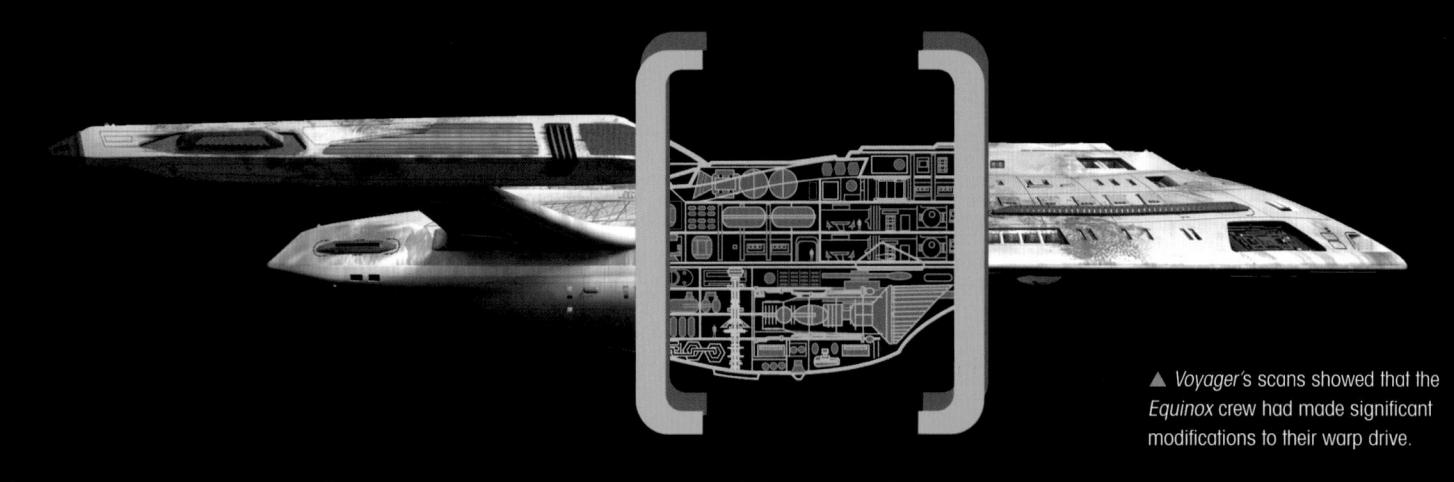

ADVANCED PHASERS

The *U.S.S. Equinox* may have been relatively lightly armed, but it was fitted with the most advanced form of phasers available to Starfleet. The Type Xb phasers were an advance on the Type X phasers that were in use on Galaxy and Intrepid-class starships. This improved design had a new hot-standby feature where a low power pulse was constantly running through the central EPS conduits. The design of the Type X phaser had been further refined by the time the Prometheus class was being tested. This class of ship was fitted with Type Xc phasers, where the hot-standby filament was exposed to space, and ran at a higher power level.

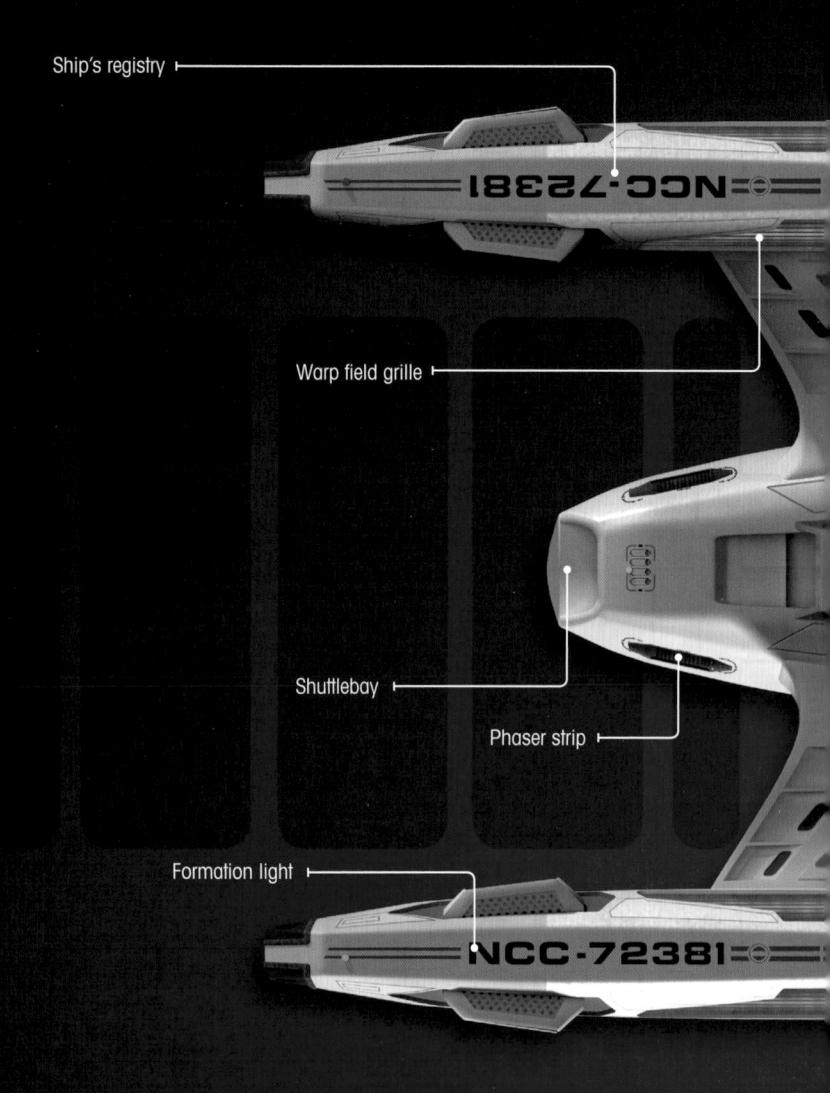

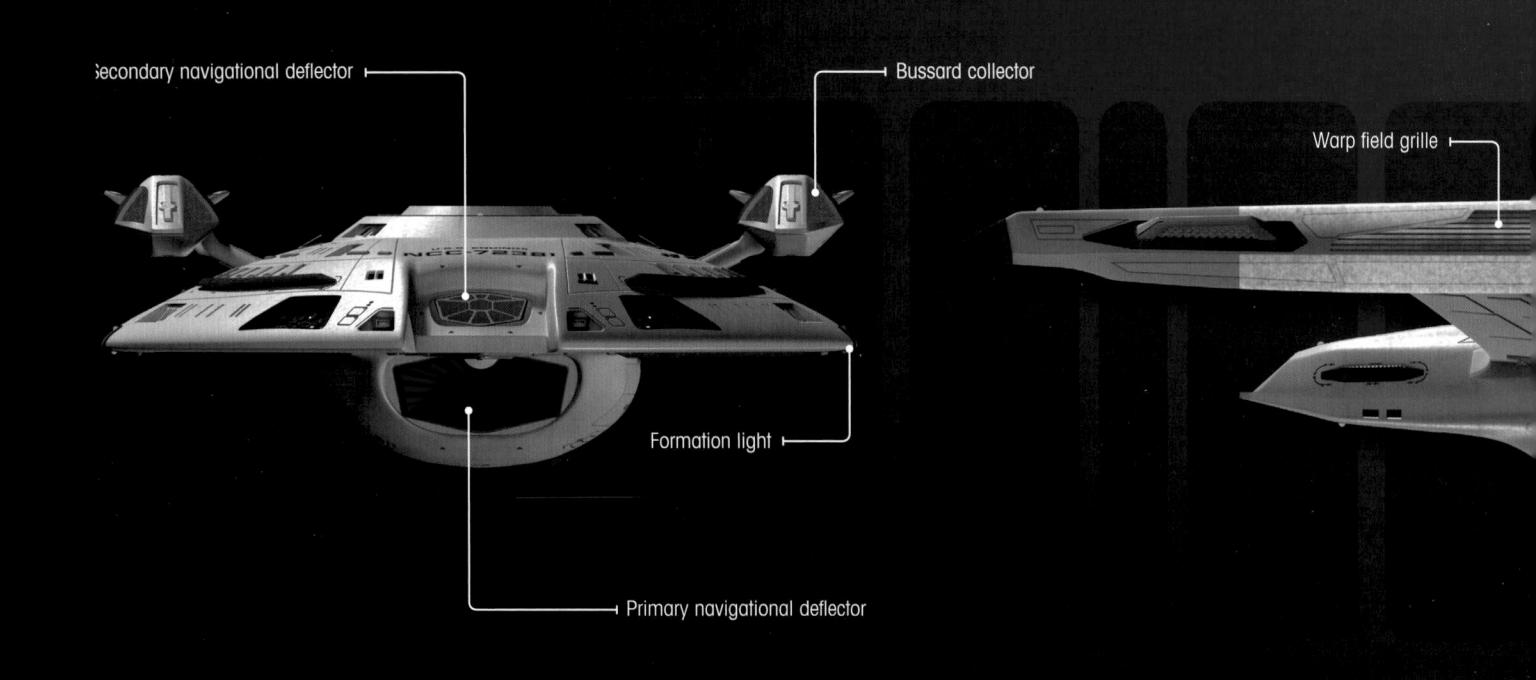

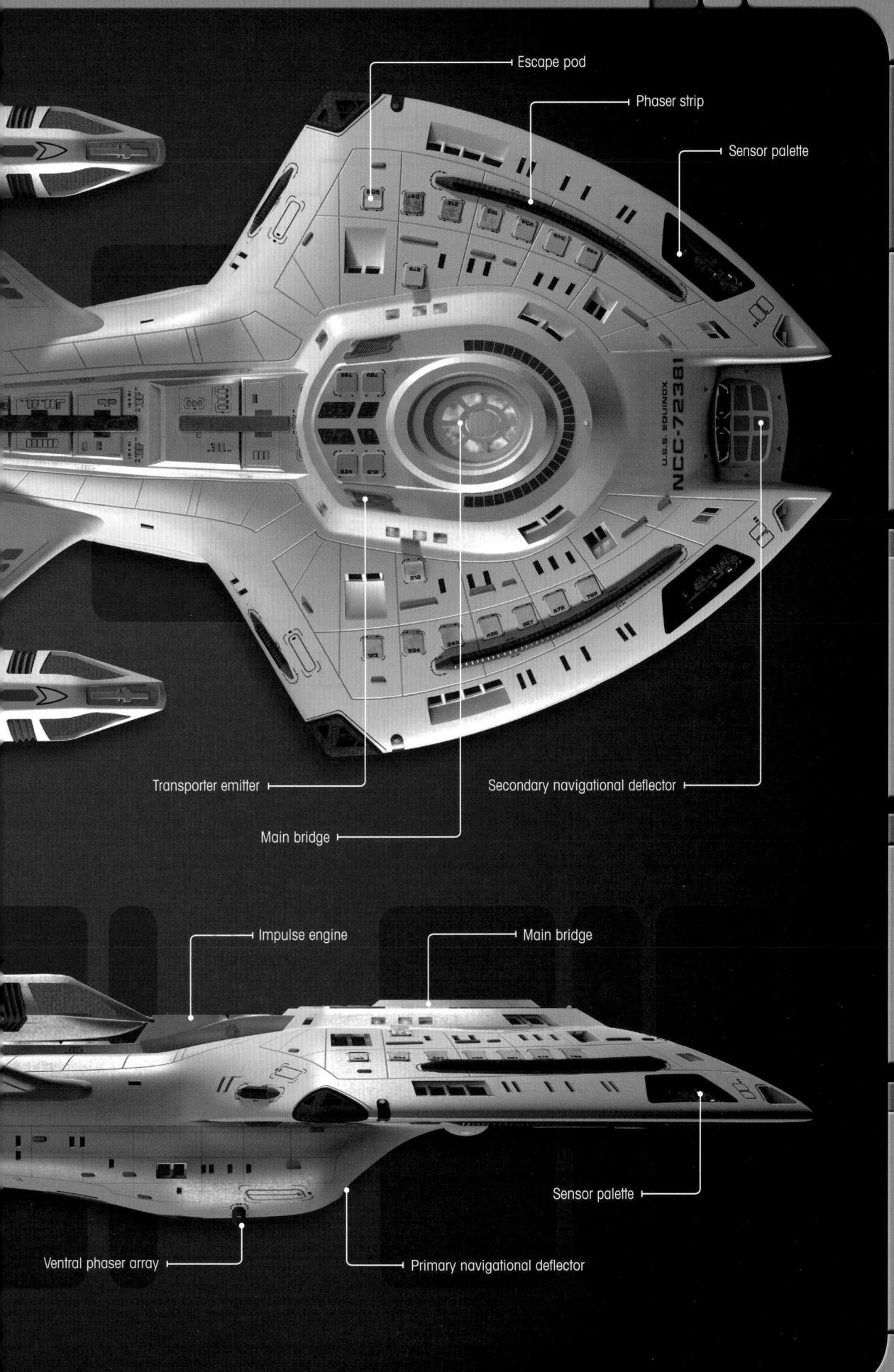

SICKBAY

The majority of the experiments on the nucleogenic life forms were carried out in the *Equinox*'s sickbay on Deck 4 and were performed by the ship's EMH, who only cooperated after Ransom deleted his ethical subroutines.

SHIELD MODIFICATION

The Equinox crew were able to defend themselves from the alien attacks by establishing a network of multiphasic force fields around the ship that prevented the aliens moving in and out of normal space.

WAVERIDER SHUTTLE

The Waverider shuttle was an auxiliary craft docked to the underside of the saucer and accessed from Deck 4. It was designed for medium-range missions and was larger and more comfortable than a standard shuttle.

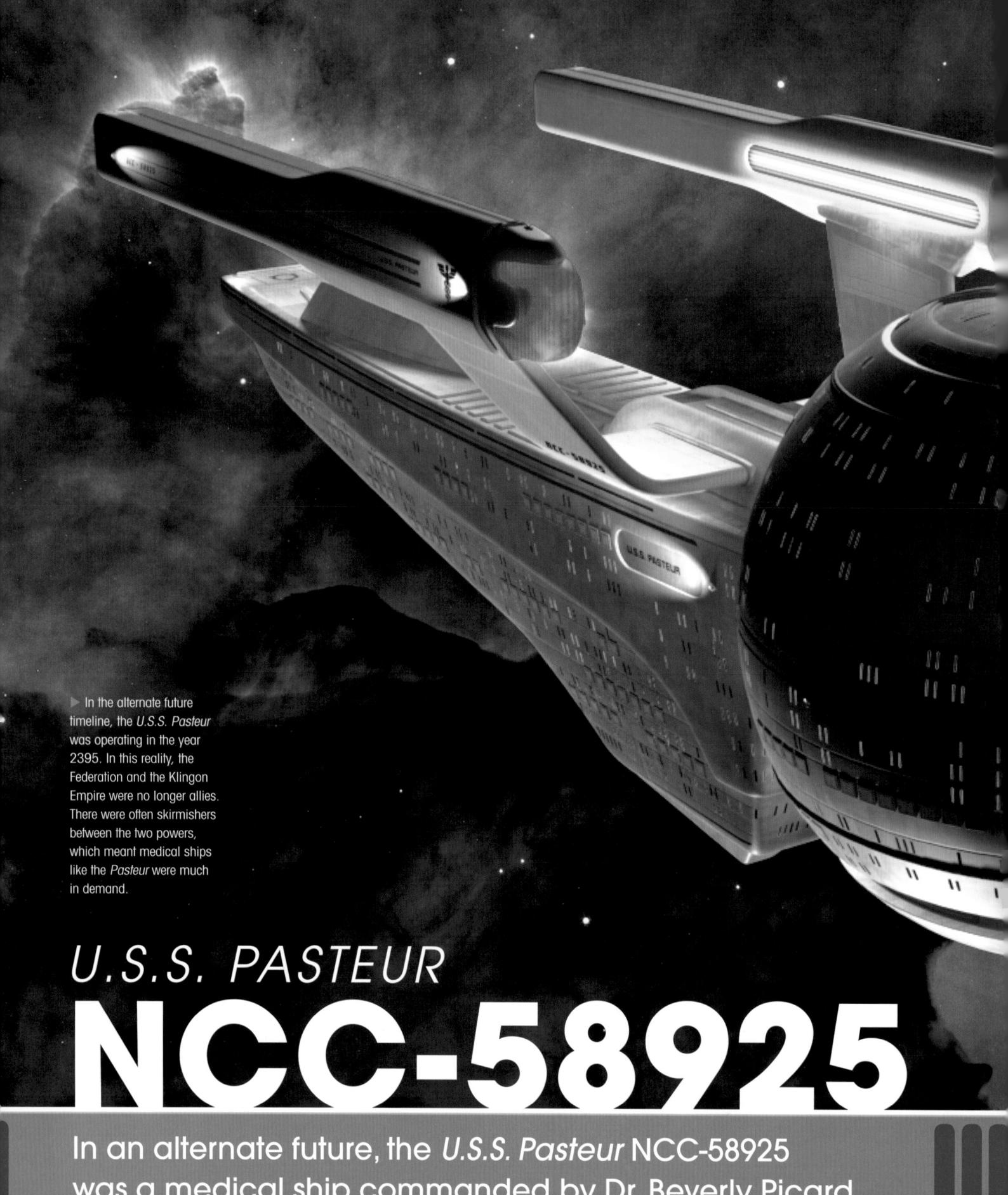

was a medical ship commanded by Dr. Beverly Picard.

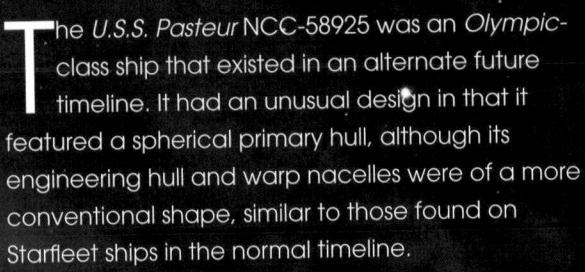

The *Pasteur's* other distinctive features included a deflector strip, rather than a deflector dish, and a shuttlebay located in a large structure on top of the flat secondary hull.

The *Pasteur* was a purpose-built hospital ship and featured the caduceus, the ancient symbol of the medical profession, prominently displayed on its hull in several places, clearly indicating its status as a medical ship. As such, it was designed to deal with medical emergencies rather than exploration or combat missions, and it had several transporter rooms to cope with emergency evacuations, as well as numerous sickbays.

LIMITED TACTICAL ABILITIES

The *Pasteur's* defenses were minimal, and unlike. most Starfleet vessels in this alternate timeline, it was not fitted with a cloaking device; also its sensor sweeping range was limited to one light-year. The ship could, however, travel as fast as warp 13, meaning that in this timeline warp speeds had once again been redefined.

The interior design was simple and sparse. On the bridge, the caduceus appeared on the front of the control console pedestals. Just off the bridge was Captain Beverly Picard's ready room, which also doubled as a place for staff meetings.

In the alternate future, Dr. Beverly Picard agreed to take Jean-Luc Picard to the Devron system aboard the *Pasteur* after he became convinced that there was a spatial anomaly there that

■ The Pasteur was under the command of Captain Beverly Picard,
who in this timeline was the ex-wife of Jean-Luc Picard. It was clear
that the pair had divorced some years prior, but there was still a great
deal of affection between the couple and she agreed to help him find
the spatial anomaly he was looking for, despite the potential danger.

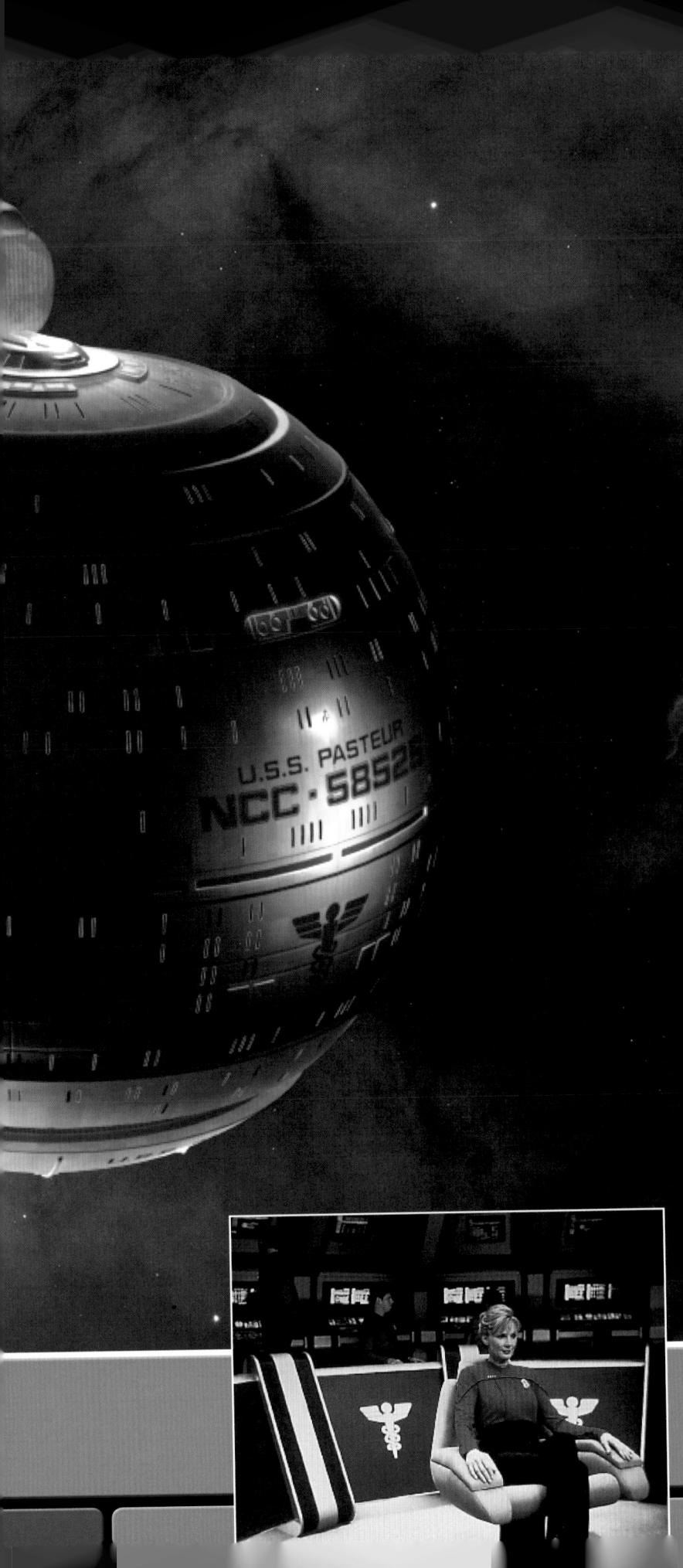

U.S.S. PASTEUR

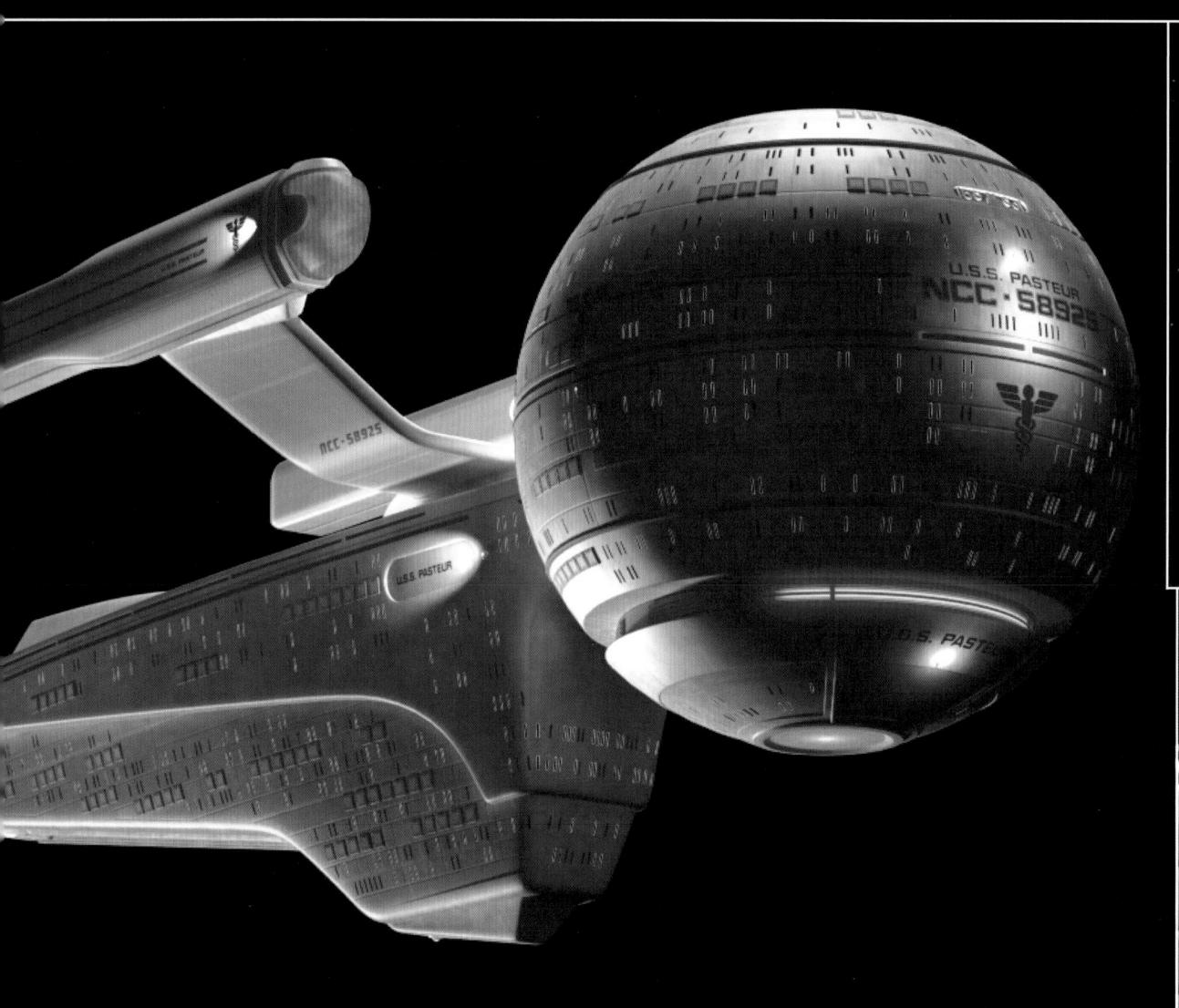

▲ Olympic-class vessels, such as the Pasteur, were easily identifiable by their spherical primary hull. The majority of the interior was given over to sickbays and medical labs, meaning they were equipped to deal with widespread casualties.

threatened the very existence of the universe. In the normal timeline, this star system was in the Romulan Neutral Zone, but in the alternate future the Klingons had taken over the Romulan Star Empire. Consequently, this region of space had now become a no-go area for Federation ships, as the Klingons had closed their borders.

The exception to this rule was that medical ships had been granted permission to cross the border to help the Romulans fight off an outbreak of the Terrellian plague. Dr. Picard was far from convinced that her ex-husband was correct about the existence of the spatial anomaly because he was suffering from Irumodic Syndrome, a rare neurological condition similar to Alzheimer's disease. She nevertheless agreed to take him, even though she believed that entering Klingon territory was "insane." Once they were given clearance to cross the border by Worf, who insisted on going with them, Beverly ordered the ship to proceed to the Devron system at warp 13.

This mission was particularly dangerous for a ship such as the *Pasteur*, as it was only lightly armed with phasers and did not appear to carry photon torpedoes. In addition, its shields were not particularly strong and Beverly Picard knew that they would not last long in a fight if they encountered any Klingon ships. She made it perfectly clear to her ex-husband that they would immediately return to Federation space if they encountered any serious opposition.

Once the Pasteur reached the Devron system, a full sensor sweep out to one light year of their location was initiated, but it did not detect any temporal anomalies. At this point, Worf, who had been monitoring Klingon communication channels, heard that several warships had been dispatched to search for a "renegade Federation vessel."

- Despite its status as a medical ship, the Klingons attacked the Pasteur after it crossed their borders. The Pasteur had limited weaponry, and very few defensive systems, making it an easy target for the much more powerful Klingon attack cruisers.
- ▶ In the future Q showed Jean-Luc Picard the Pasteur was destroyed by the Klingons, but the senior staff were beamed to safety on the Enterprise-D.

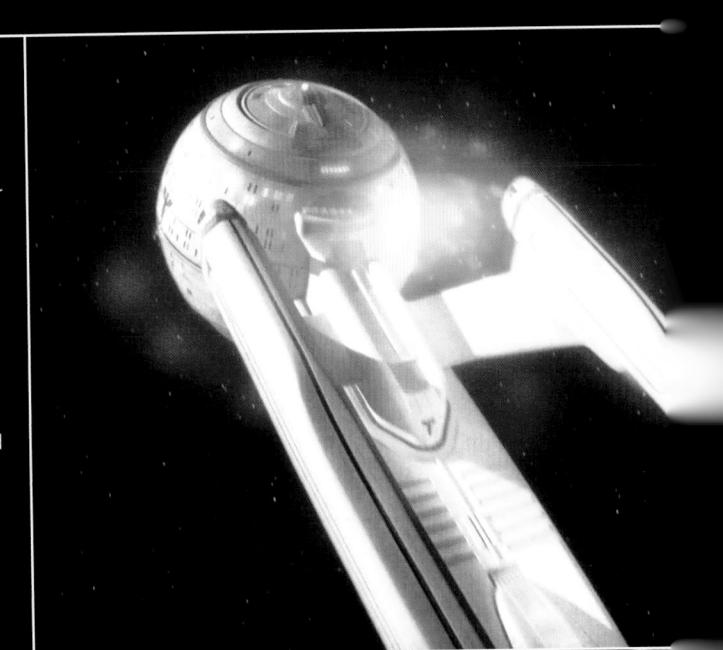

- Ensign Nell Chilton
 was the flight controller
 on board the Pasteur.
 She was killed when the
 ship came under attack
 from the Klingons.
- The Pasteur was essentially a traveling hospital, and was ideally suited to that task, but it lacked some of the sensor and tactical abilities of other ships.

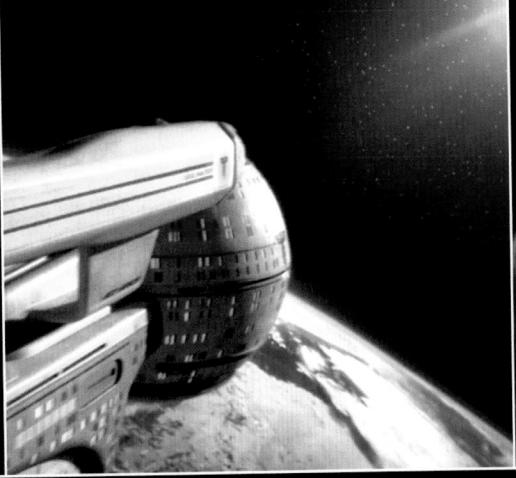

Beverly wanted to leave before the Klingon ships arrived. But Jean-Luc persuaded her to stay a little longer while Data modified the main deflector to increase the limited sensor equipment of the *Pasteur*, so it could scan beyond the subspace barrier.

UNDER ATTACK

Unfortunately, before they could complete the sensor sweep, two Klingon attack cruisers decloaked and attacked the *Pasteur*. In the first volley of disruptor fire, the *Pasteur's* shield strength was nearly halved and warp power was knocked offline. The *Pasteur's* phasers were not powerful enough to penetrate the Klingon ships' shields, and in the following wave of attacks the *Pasteur's* shields collapsed, while helm officer Nell Chilton was killed when her console exploded. It looked

until the *U.S.S. Enterprise* NCC-1701-D suddenly arrived and launched a furious volley of phaser fire and torpedoes that destroyed one Klingon ship and forced the other to retreat. This gave them just enough time to beam the crew of the *Pasteur* aboard before the medical ship's warp core breached, blowing it to smithereens.

DATA FEED

In the alternate future, Worf was no longer on the Klingon High Council as the house of Mogh had been forced from power. Instead, he was now governor of H'atoria, a small Klingon colony near the border with the Federation. Although this position was largely ceremonial, Worf still had enough influence to grant permission for the *Pasteur* to enter Klingon territory. Also in this future, Will Riker had become an admiral and had chosen the refitted *U.S.S. Enterprise* NCC-1701-D as his flagship.

INTERNAL CONFIGURATION

The bridge of the *U.S.S. Pasteur* NCC-58925 was much more compact than those found on other Starfleet vessels. Nevertheless, it conformed to a similar configuration, with the captain's chair in the middle, surrounded by other work consoles, such as the science station, built into the walls of the room. The flight controller sat alone at a large semi-circular work station at the front of the bridge.

In addition to sickbays and medical labs, the internal layout of the *Pasteur* featured at least two transporter rooms, which could be used for emergency evacuations, and crew quarters located on deck 5.

Most of the Pasteur's main flight and operational controls could be
 perated by the large semi-circular console that was positioned
 n front of the captain's chair, facing the main viewscreen.

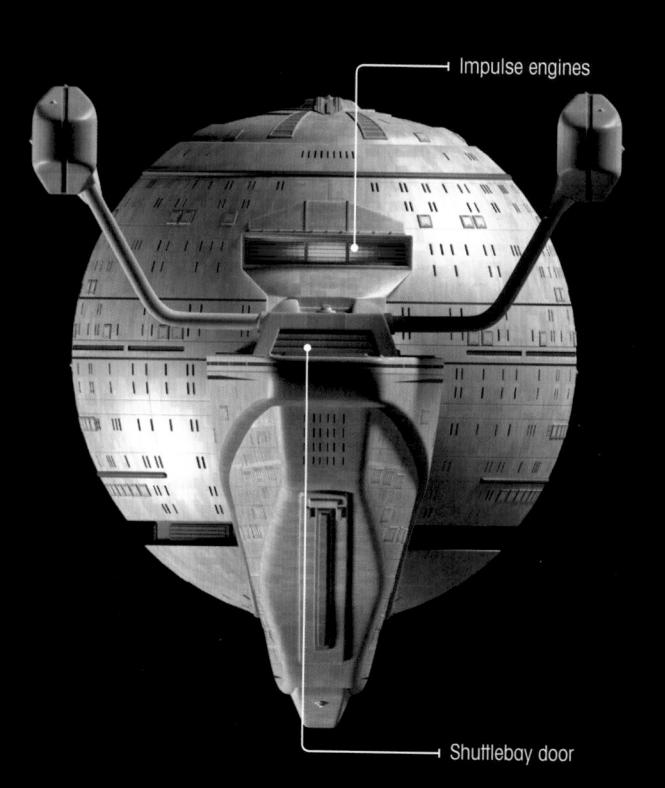

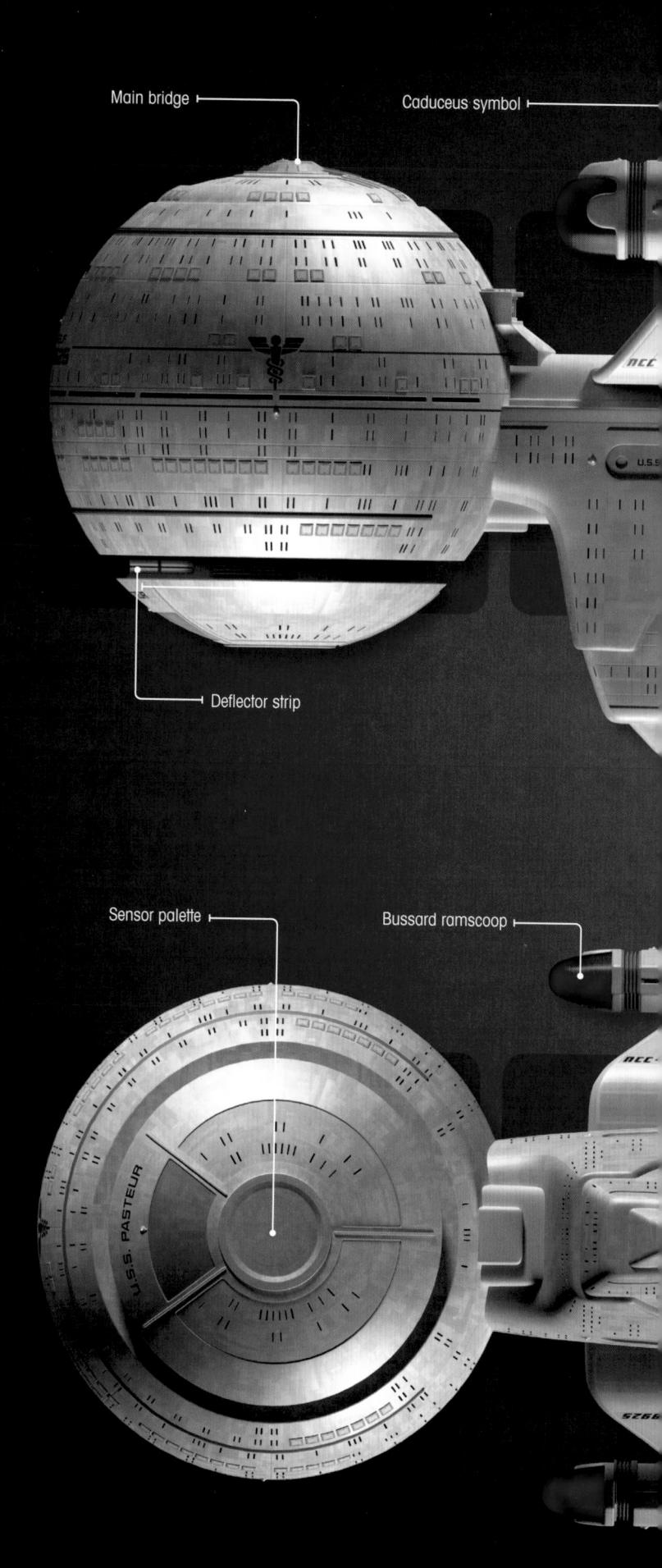

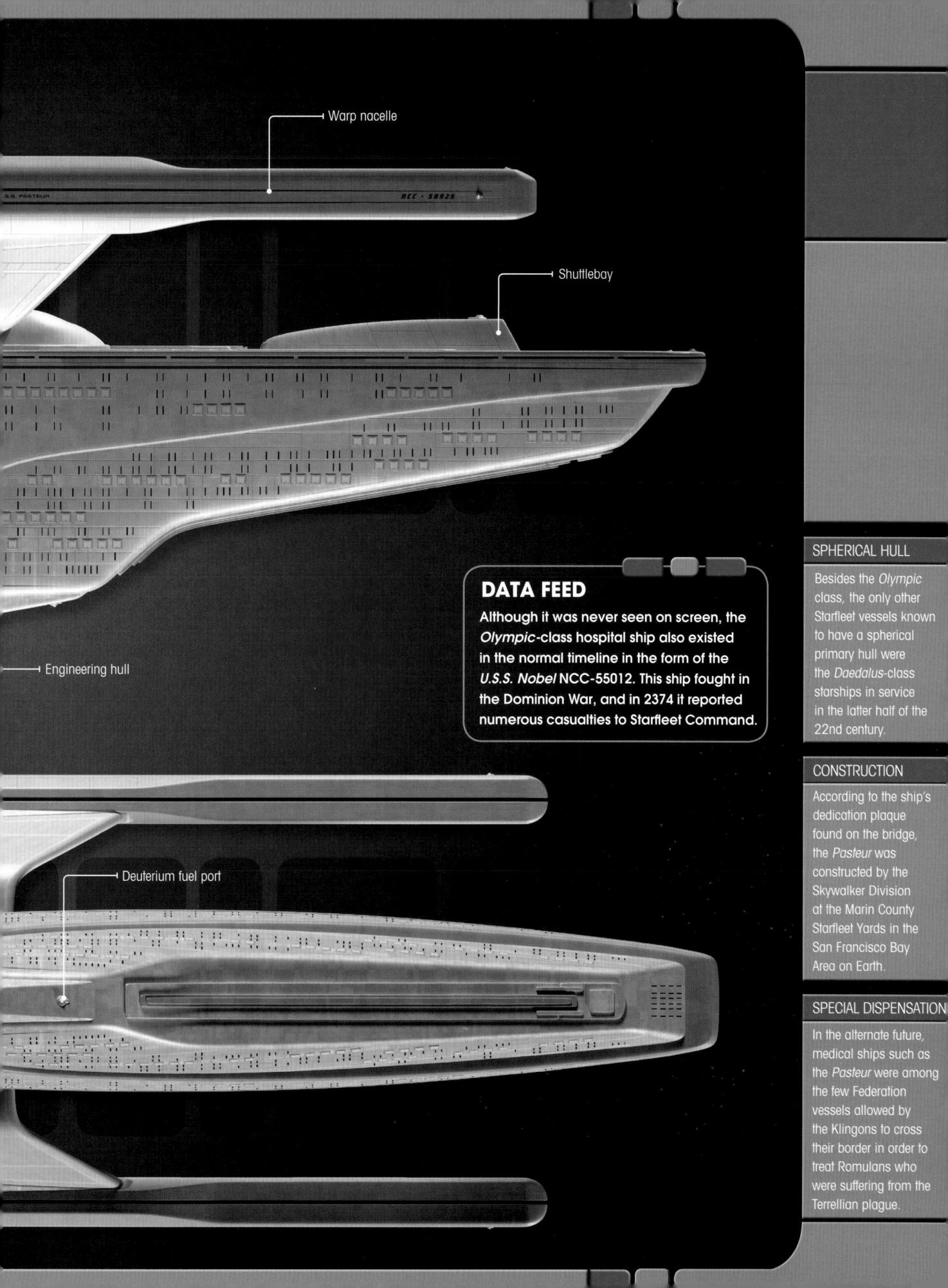

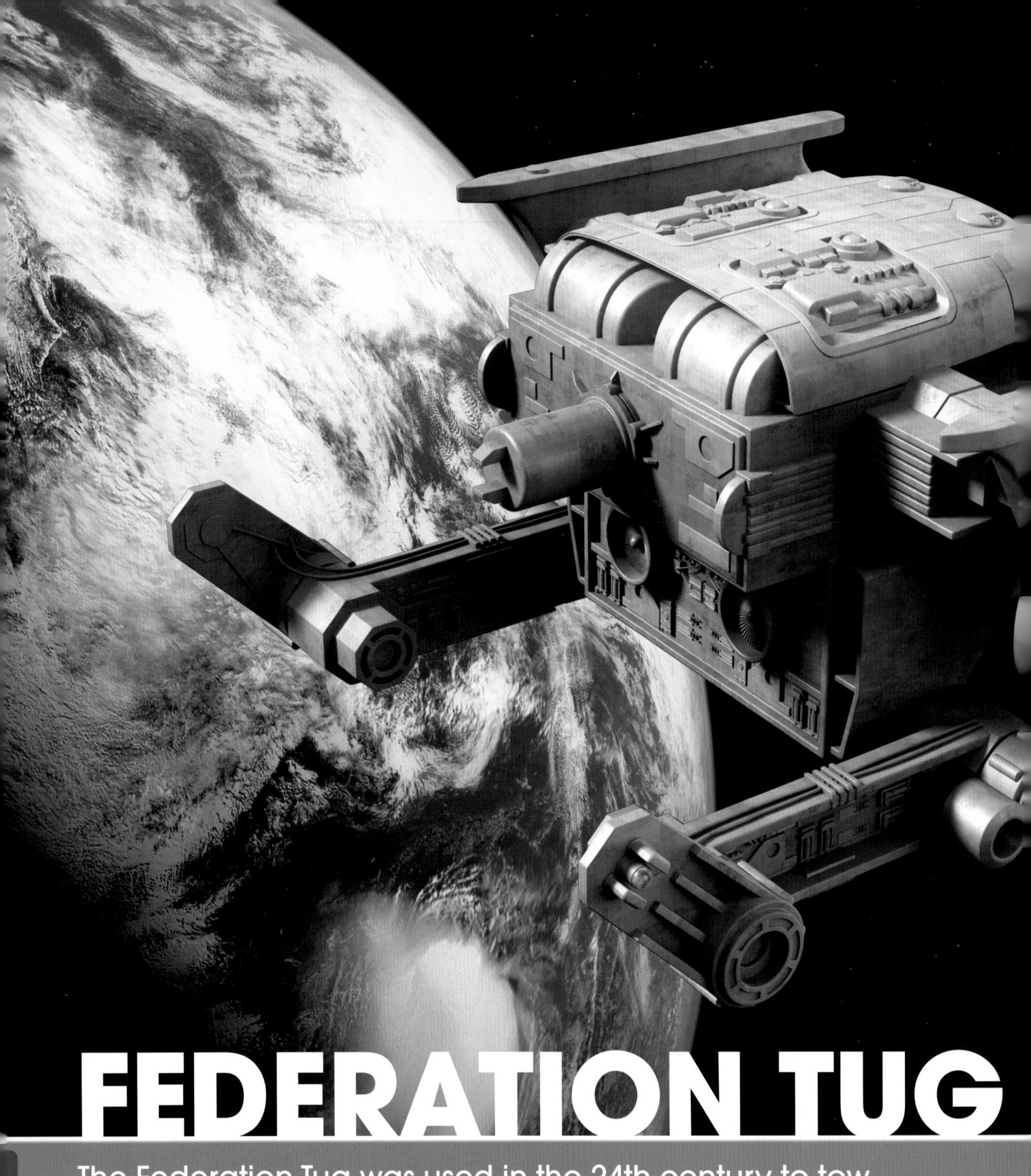

The Federation Tug was used in the 24th century to tow stranded vessels back to repair facilities or junkyards.

▲ The Federation Tug was an odd looking ship, but it was built from a purely practical point of view. It was designed to be able to remove partly detached parts, or twist them back in place with its mechanical arms, making a stranded ship secure for towing. Its powerful tractor beams could then haul the vessel to safety.

Federation Tug was a small warp-powered ship used for towing inoperable or severely damaged starships to a suitable place where they could be restored to full working order. It was used by the Federation and Starfleet in the 24th century, and ships of this type operated out of starbases and orbital ship building facilities.

The Federation Tug was approximately 90 meters in length, and operated by a small crew of engineering specialists. It was capable of low-to-mid warp speeds, and was equipped with powerful twin tractor beams capable of towing large vessels over considerable distances. It also possessed long mechanical arms, which could be used to clamp onto damaged or loose parts and pull them clear to secure a ship ready for towing.

DEEP SPACE RESCUE

A Starfleet ship was capable of using its tractor beam to tow another vessel, but normally only at sublight speeds for safety reasons. A specialized Tug could perform the task at warp speeds, meaning it could retrieve a stranded ship that was light years from a starbase. The Tug could also be used to haul large components to space stations, and its repair crew could fit these parts.

In 2364, the *U.S.S. Enterprise* NCC-1701-D requested that a Tug be sent to tow the wrecked hulk of the *U.S.S. Stargazer* NCC-2893 back to Xendi Starbase 9 after it had been found adrift by the Ferengi.

Federation Tugs were more widely used during the Dominion War when countless ships were disabled by Jem'Hadar forces. In 2374, the U.S.S. Fredrickson NCC-42111 was seen being towed away by a Federation Tug from a battle zone after the Second Fleet were forced to retreat in the early weeks of the Dominion War.

■ A Federation Tug latched onto the saucer section of the U.S.S.
Fredrickson with two tractor beams and towed it to safety after the starship had lost propulsion during a battle with Dominion forces.

The Tugs were worth their weight in gold during the Dominion War, as they were able to retrieve ships that would have otherwise been lost.

SALVAGING SHIPS

Federation Tugs were used extensively throughout the Dominion War. It was paramount that Starfleet and its Allies kept as many starships in working order as they could in order to fight the might of the Dominion.

For example, the Second Fleet, of which the U.S.S. Fredrickson was a part, suffered greatly during the first three months of the war. It was reduced to a third of its original size during these early battles, and it was vital that as many ships that could be salvaged were saved. This was where the Federation Tugs came in, and their invaluable efforts to rescue vessels, such as the Fredrickson, kept Starfleet in the fight at a time when they were suffering one demoralizing defeat after another. Battleready ships were in extremely short supply, as Starfleet could not build new ships fast enough to replace those that were lost. It was therefore extremely important to reuse any resources that they had, and thanks to the Federation Tugs they were able to save many vessels that would otherwise have been lost.

▲ Without the Federation Tugs, which saved numerous ships like the --- redrickson, it was very possible that Starfleet might have run out of ressels with which to fight the Dominion during the war's early days.

RARE SIGHT

A Federation Tug was mentioned twice in *THE NEXT GENERATION* – in episodes 'The Battle' and 'Phantasms' – but one was not actually seen until the *DEEP SPACE 9* episode 'A Time to Stand.'

EARLIER SIGHTING

The U.S.S. Fredrickson, which was towed to safety by a Federation Tug in 2374, had been seen three years earlier when it was docked at Utopia Planitia Fleet Yards at the same time that the U.S.S. Voyager was about to embark on its maiden voyage.

TUG RESCUE

In 2370, when the Enterprise-D suffered a series of engine problems caused by interphasic organisms, Vice Admiral Nakamura suggested that he could send a tow ship to bring the Enterprise-D to Starbase 84, where Captain Picard was due to attend a banquet.

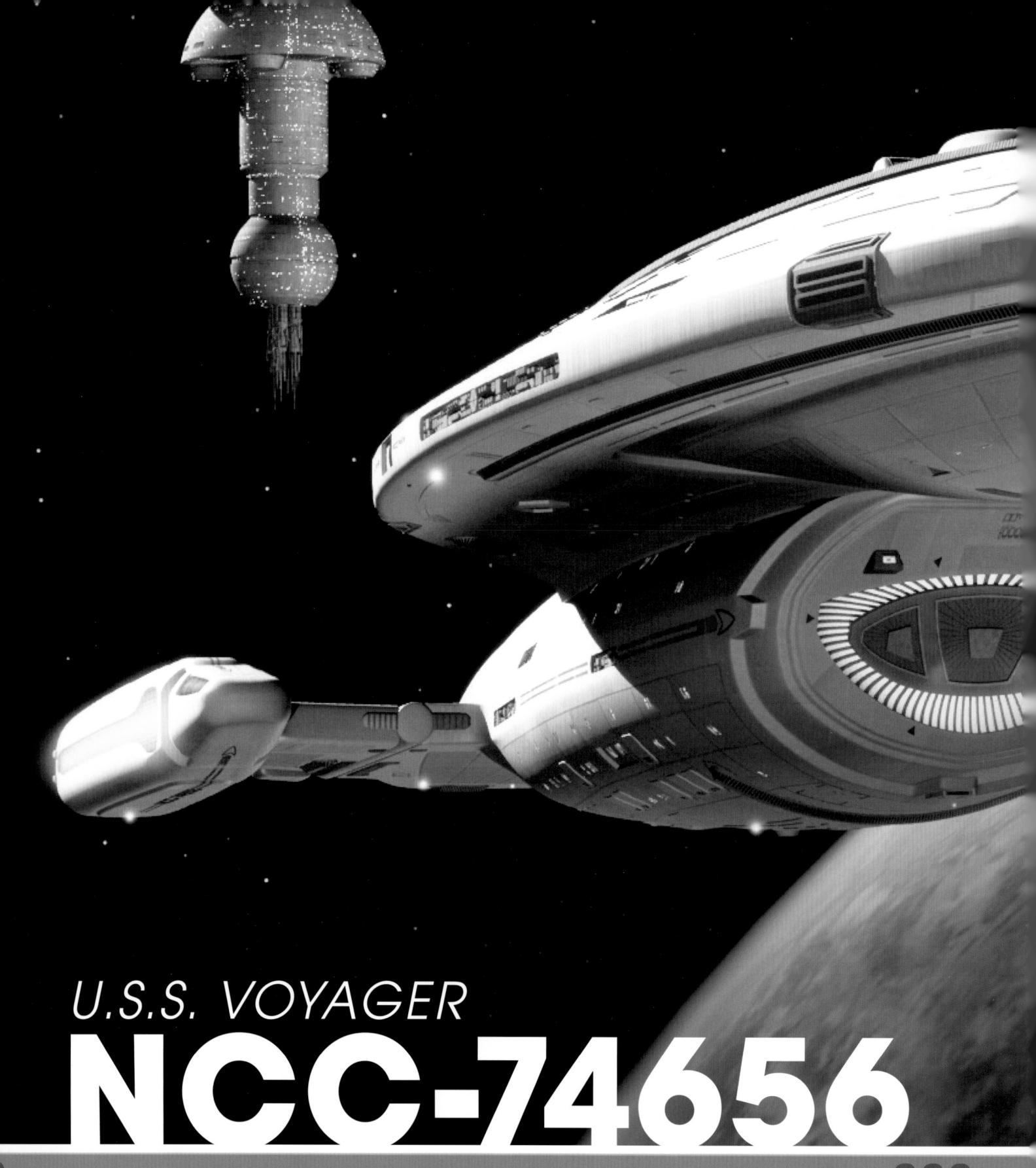

Voyager was lost in the Delta Quadrant, 70,000 light years from Earth, and made an epic journey home.

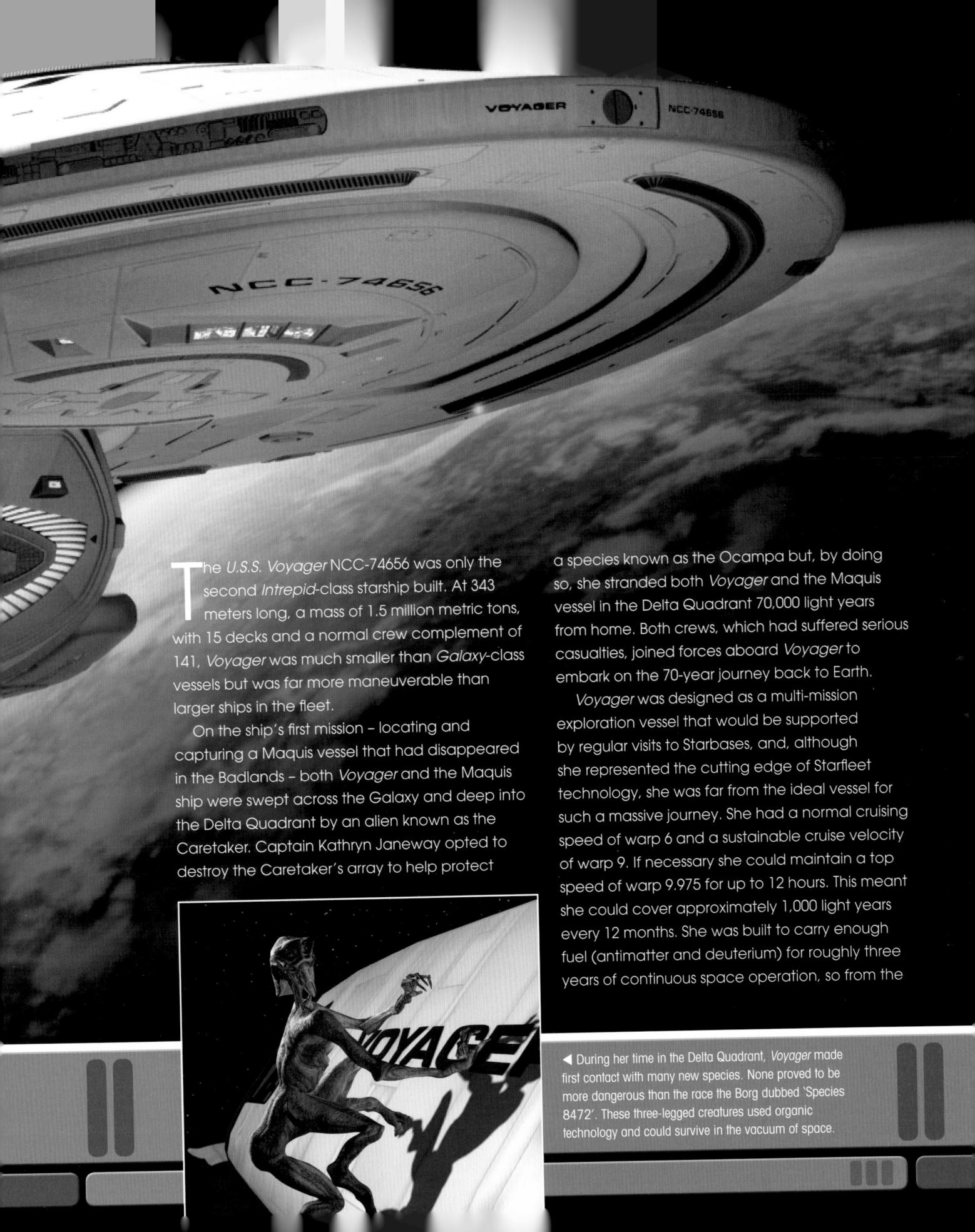

▲ Voyager used a number of advanced technologies to make the 70,000 light year journey to Earth in a relatively short period of time. They used a graviton catapult to cut three years off the journey and completed the last leg using Borg transwarp conduits.

beginning it was clear that the crew would have to modify their ship.

Systems were re-routed to conserve as much power as possible. In particular, the use of replicators was severely restricted. The captain's private dining room was removed and replaced with a galley that provided the crew with freshly cooked meals using vegetables grown in the hydroponics garden, which had been established in the cargo bays. The mess hall doubled as a reception area for diplomatic events and was also used by crew members as a rec room. To further let the crew relax, they were able to use *Voyager's* two holodecks, albeit on a strictly rationed basis.

Crew quarters were also affected by the modifications. *Voyager* had never been intended to accommodate families, so quarters located on decks 3 through 6 were modified to enable crew members to have the option of marrying and

raising children during the 70 years it would takefor them to return home.

The most serious casualties involved the loss of the ship's entire medical staff. Fortunately, Voyager's state-of-the-art sickbay incorporated advanced holographic systems that generated an Emergency Medical Hologram. The EMH, which was programmed with the experience o 47 doctors, was left active and developed an unexpected level of independence.

Unwilling to accept that the journey would to generations, the crew worked on several engine projects using the ship's holodecks for extensive flight simulations vital to the development of the ground-breaking warp 10 engines that were tes on the Cochrane shuttle. In 2375, Voyager itself was equipped with a quantum slipstream drive, which enabled it to travel 300 light years closer Earth within a short space of time. Both method

- Voyager's shuttlebay was located at the rear of the main hull. The ship carried a variety of Class-2 and Class-6 shuttles, all of which were warp capable. The shuttles were regularly sent on reconnaissance and diplomatic missions.
- During the journey home the crew lost many of their shuttles but fortunately they had the resources to build new ones. They also built an advanced ship known as the Delta Flyer (right), which incorporated Borg technology provided by Seven of Nine.

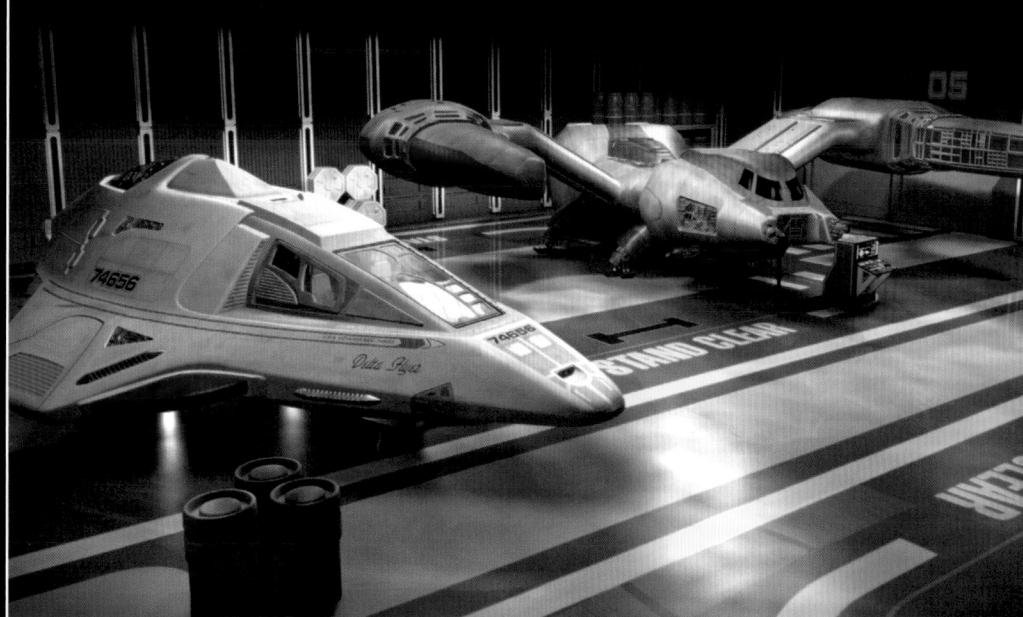

- In emergencies Voyager
 could eject the warp core from
 a hatch in the underside of the
 main hull. Assuming the core
 did not detonate it could be
 retrieved, repaired and
 reinstalled in the ship.
- ◄ If the ship were lost, the crew could use escape pods that were under small hatches around the hull. Each escape pod had a small engine and enough shielding to allow it to make planetfall.

propulsion were, however, ultimately deemed to be too unstable.

The crew also used Borg technology to update *Voyager's* astrometrics laboratory and enhance the ship's navigational sensors. The new astrometric sensors measured the radiative flux of up to three billion stars simultaneously. The upgraded system allowed the crew to plot a new course home that shaved five years off their original projected journey.

After initially assuming the ship to have been lost, Starfleet learned of *Voyager*'s fate. A Starfleet project named Pathfinder was quickly put in place, with the aim of making contact with the ship through a Federation communications array, known as MIDAS, and via a micro wormhole and the Hirogen communications network.

From 2377 onwards, the crew was able to send and receive orders and instructions from

Starfleet and messages to and from their loved ones back home in the form of monthly data streams. With the help of the Pathfinder project and the destruction of a Borg transwarp hub, used to deploy vessels anywhere in the quadrant within a matter of minutes, *Voyager* was finally able to return to Earth a mere seven years after the crew was stranded in the Delta Quadrant.

The Captain's ready room was located on Deck 1 to the port of the main bridge. It provided Captain Janeway with a working area where she could perform her administrative duties and talk to crew members.

DATA FEED

The *U.S.S. Voyager* was commanded by Captain Kathryn Janeway who assumed control of the ship as soon as it was launched. The crew was trapped in the Delta Quadrant on the ship's first mission, and she decided it was more important to protect the Ocampa than to get home. Under her command, *Voyager* made the journey to Earth in a tenth of the time that was expected, and on her return she was promoted to Admiral.

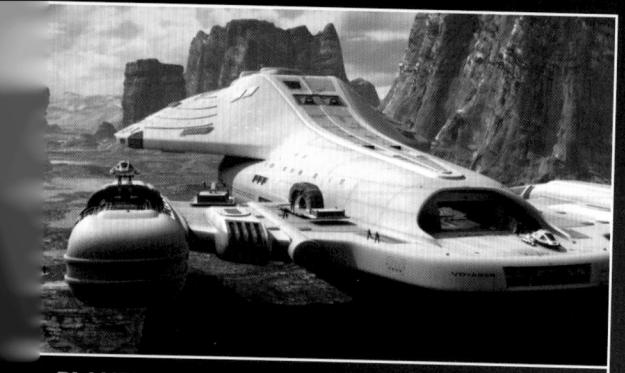

PLANETARY LANDING

Unlike most large Starfleet vessels, Voyager was designed to land on a planet's surface. The landing procedure starts with the Chief Engineer taking the warp core offline and venting plasma from the nacelles. The Conn officer then brings the landing mechanisms online and sets the inertial dampeners and structural integrity fields to maximum. The Ops officer monitors for any EM discharges. On the final stage of approach the four landing struts are deployed and immediately before touchdown the structural integrity field is adjusted to match planetary gravity. After landing, the engines are disengaged and the thruster exhaust is secured.

The U.S.S. Voyager used variable geometry warp nacelles that wung into position when the ship went to warp. This was part of a edesign that prevented the warp systems from causing permanent Jamage to the fabric of space.

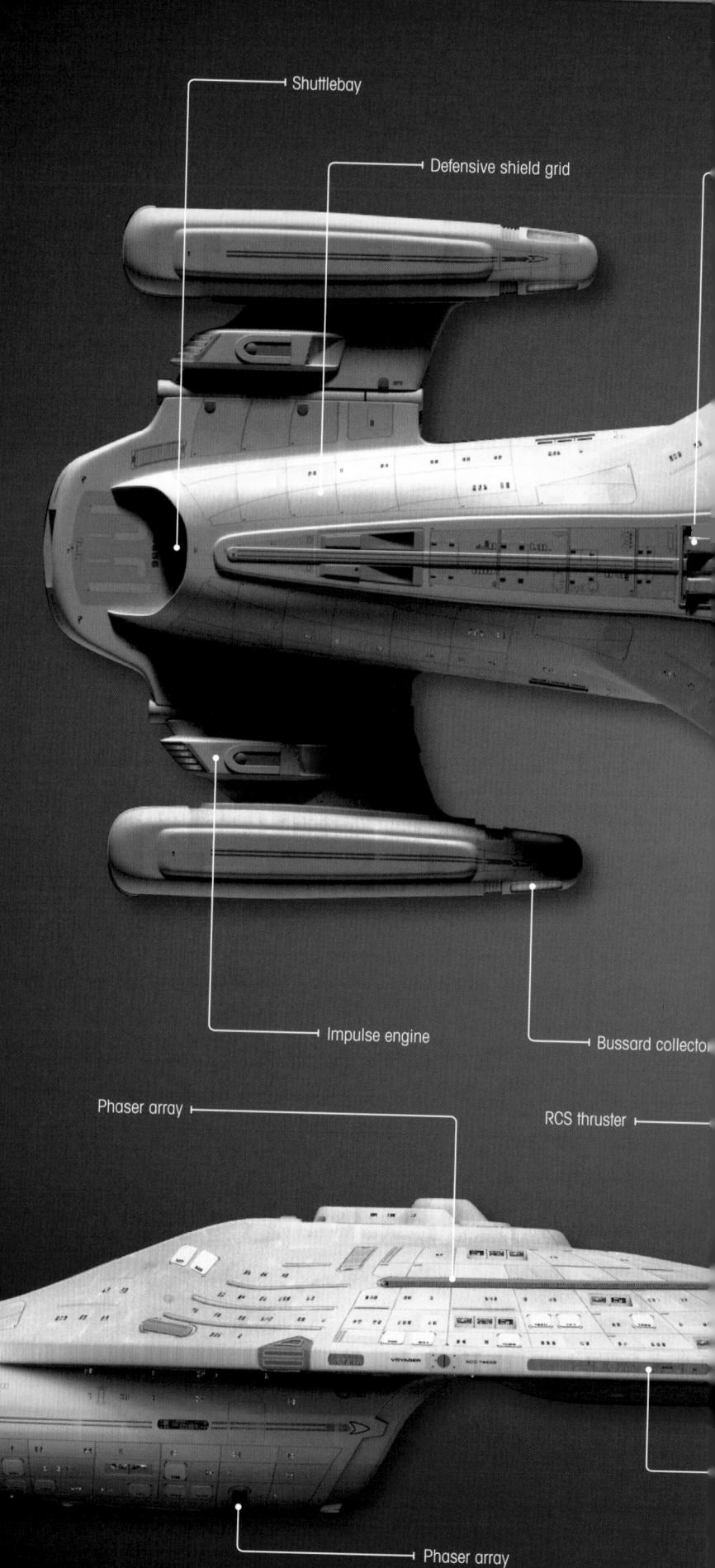

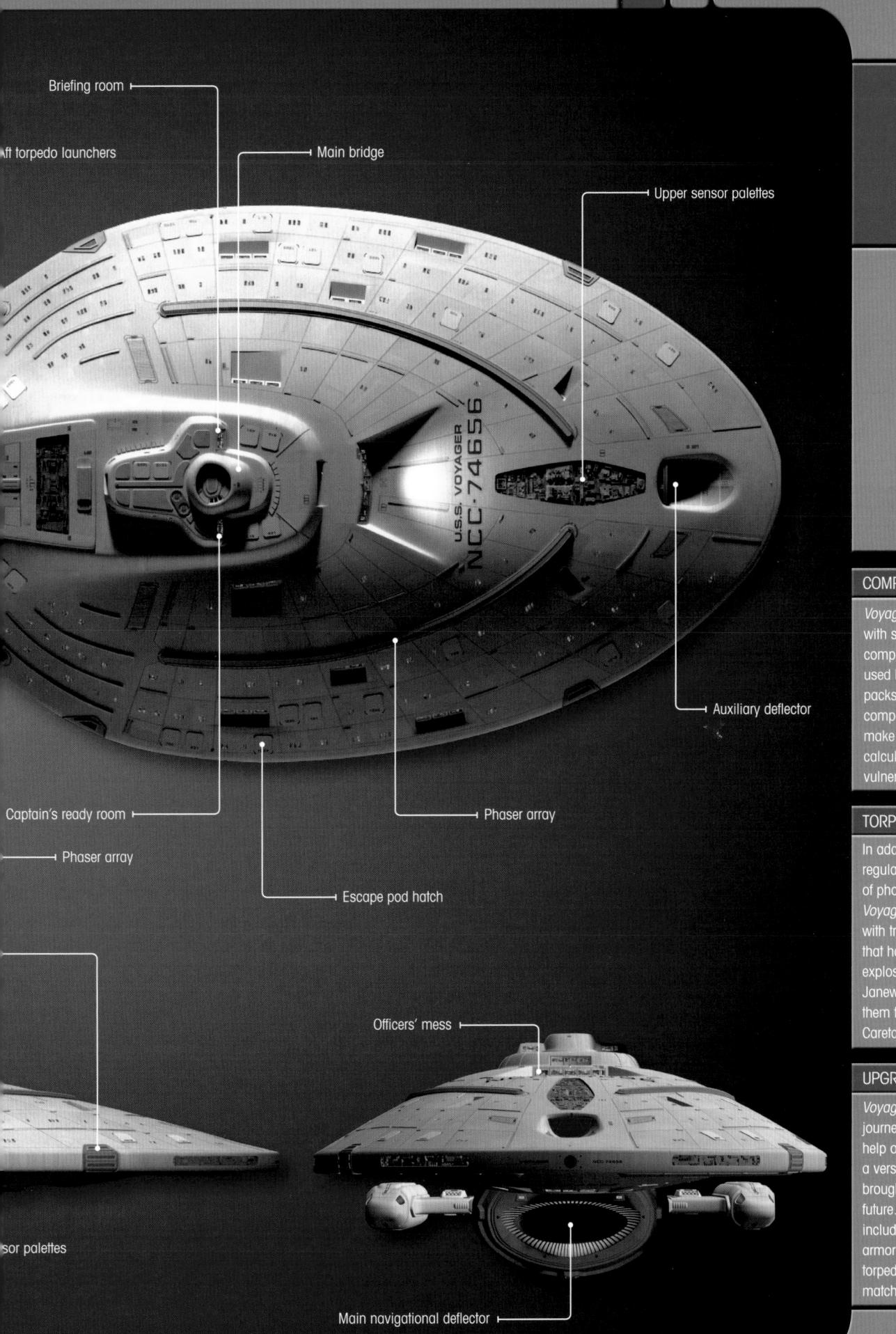

COMPUTERS

with state-of-the-art computers that used bio-neural gel packs. These organic components could make extremely fast vulnerable to disease

TORPEDOES

In addition to the regular complement Voyager was issued with tricobalt charges, explosive yield. Janeway used two of

UPGRADES

Voyager completed the journey to Earth with the help of technology that brought back from the future. The technology, included advanced armor and transphasic torpedoes that were a

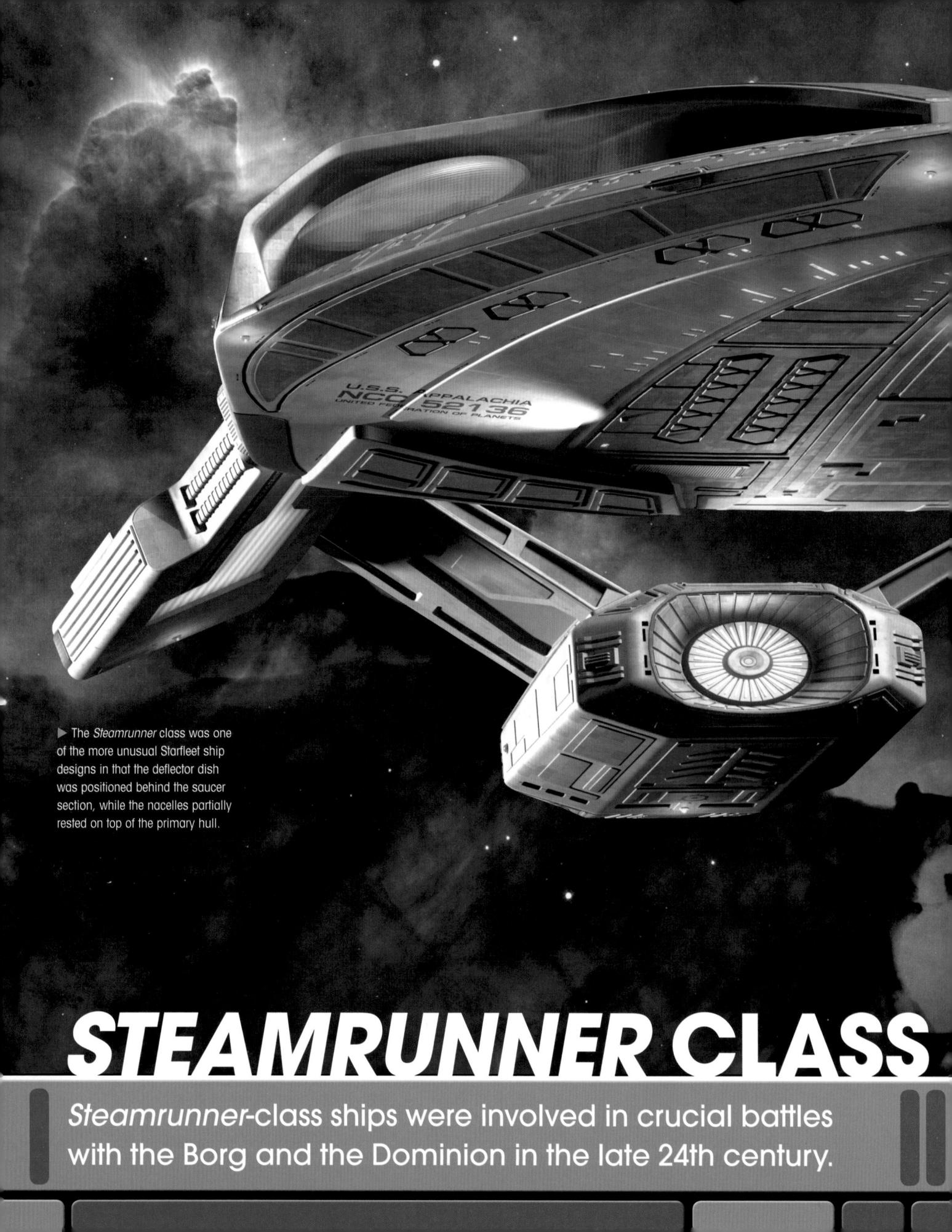

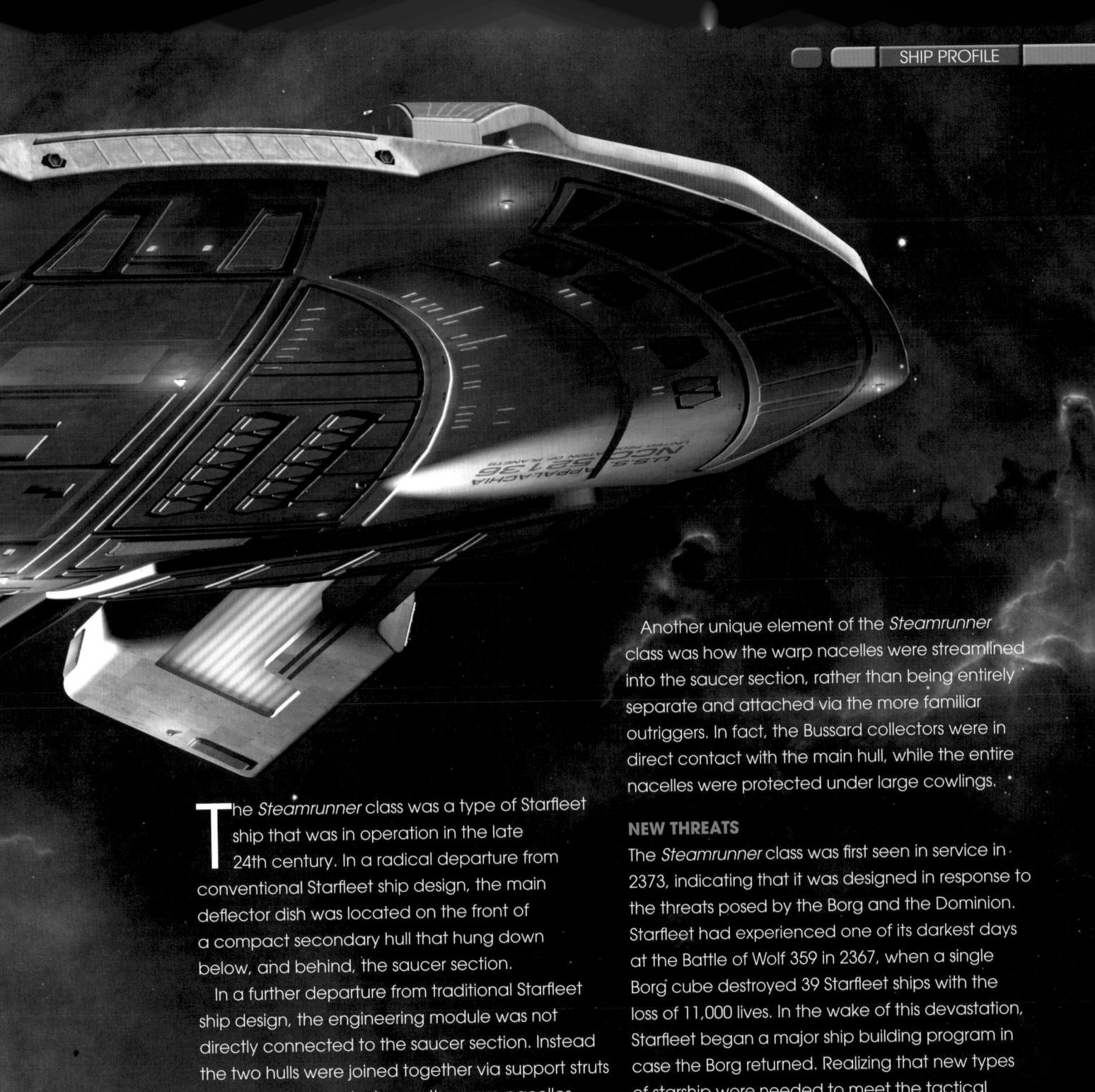

that angled down between the warp nacelles.

of starship were needed to meet the tactical requirements of facing a far superior enemy, Starfleet designed vessels that were more focused on combat than exploration and discovery.

This new type of dedicated combat vessel

◆ The Steamrunner class was one type of ship, along with the Defiant class, that was rushed into service to meet the ominous threat posed by the Borg. These tactically advanced vessels that were designed mostly with combat in mind were part of the fleet that engaged an invading Borg cube at the Battle of Sector 001 in 2373.

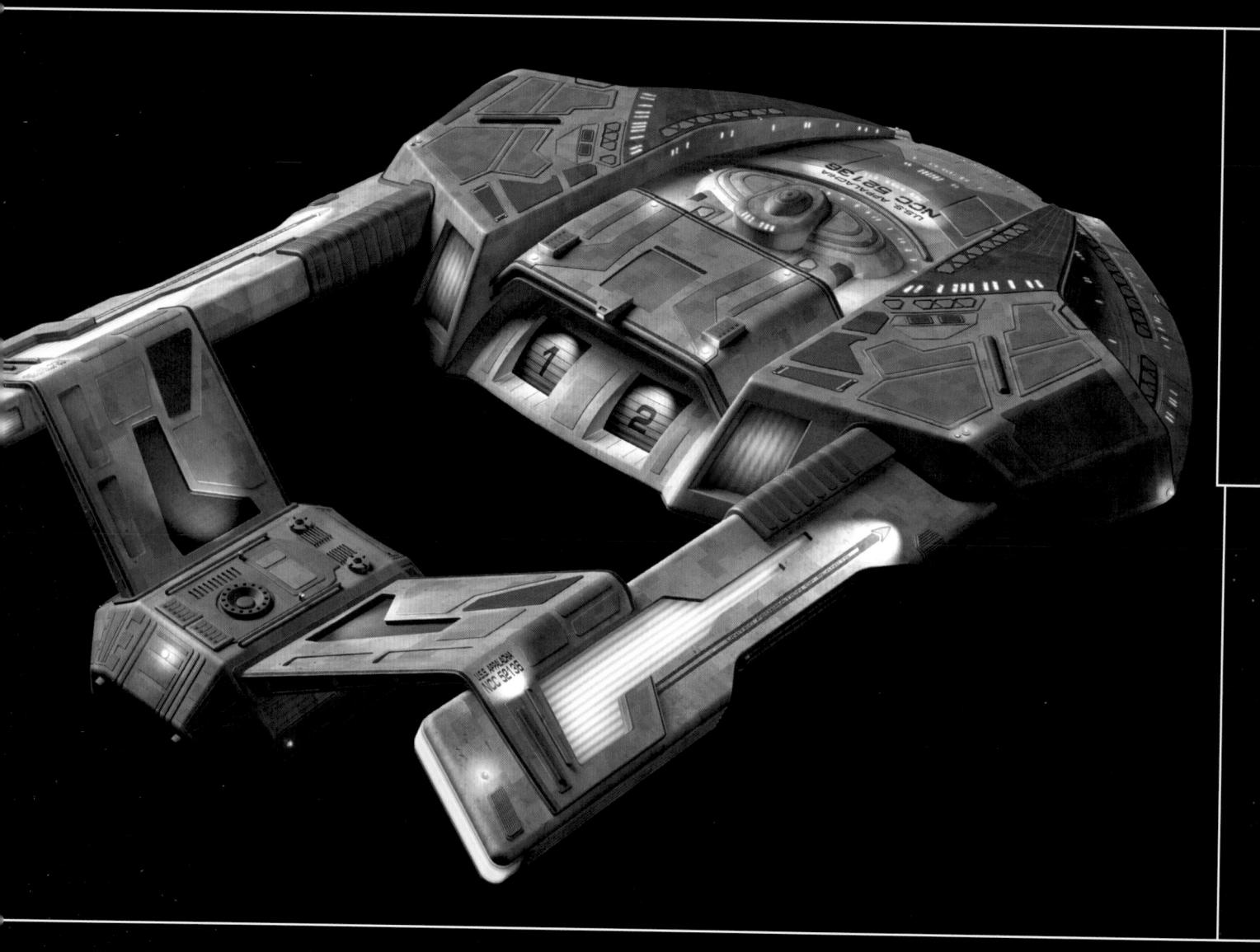

▲ The engineering hull on Steamrunner-class ships was much more compact than it had been on earlier designs of Starfleet vessels. Despite its smaller size, the engineering systems were just as powerful as they had been on larger ships, and Steamrunnerclass ships were capable of reaching speeds of up to warp 9.6.

was best exemplified by the Defiant class, the prototype of which was so powerful that it almost shook itself apart during trial runs. Lessons learned during its development filtered down to other designs being fast tracked into production, one of which was the Steamrunner class, along with the Akira, Saber and Norway classes.

NARROW PROFILE

Like the Defiant class, the Steamrunner class featured a sleek profile by doing away with the long neck section between the primary and secondary hulls. This much narrower profile meant that the Steamrunner class provided less of a target in combat. This was made possible by advancements in warp technology, which meant that the engineering hull could be much more compact than it had been on earlier Starfleet ship designs, while providing similar levels of power.

While the dimensions of the engineering hull on the Steamrunner class were greatly reduced compared to earlier designs, there was still enough space to accommodate the deflector dish on the front. Its location towards the rear of the vessel may have appeared odd, especially as its primary function was to clear asteroids and assorted space debris from the ship's path. But as it hung down below the saucer it still had a 'clear line of sight' in front of the ship to do its job. The fact that a major component with the importance of the deflector dish was placed towards the rear of the ship also offered it more protection, a move that made a great deal of sense given the combat design considerations of the class.

The main bridge and shuttlebay on the Steamrunner class were also positioned and integrated in such a way as to offer them enhanced protection. Although not as protected

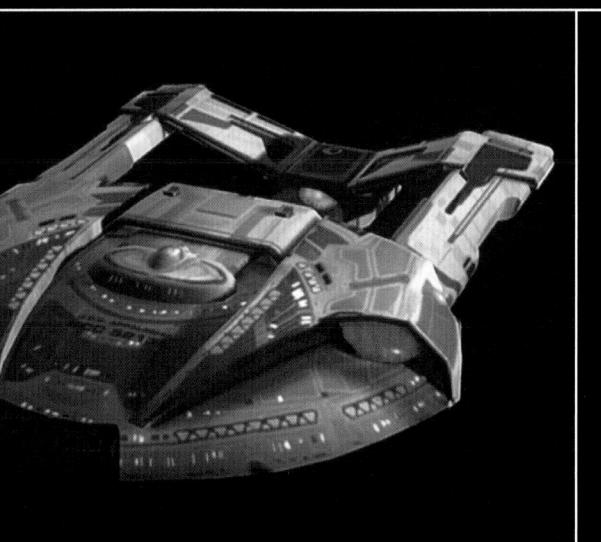

- The main shuttlebay was located at the rear of the saucer section on the Steamrunner class. Its location, between the nacelles, provided a relatively sheltered entry and exit point for shuttles.
- The nacelles on the Steamrunner class were embedded into the saucer section in order to offer them greater protection. The bridge was also well sheltered by the raised sides of the saucer.

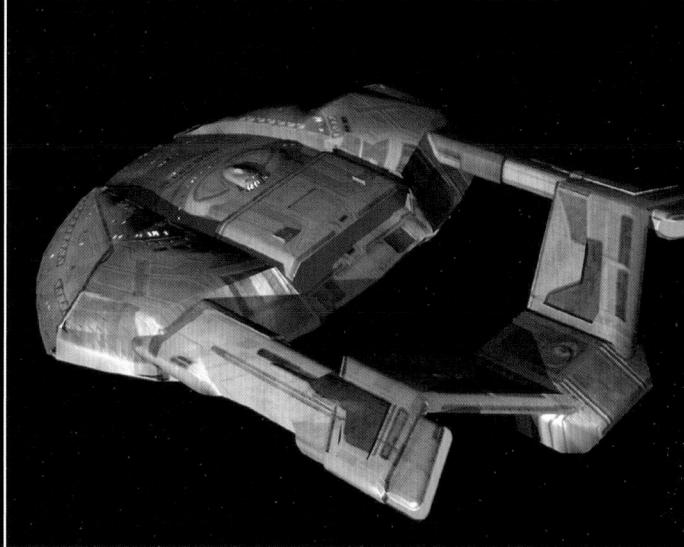

■ Several Steamrunner-class ships were part of the fleet that fought the Borg cube at the Battle of Sector 001. At least one Steamrunner-class ship was among the 20 or so Starfleet vessels that were destroyed during the engagement. The losses were not in vain, however, as their actions bought enough time for the Enterprise-E to join the fray and defeat the Borg.

as the sunken command module on the *Defiant* class, the bridge on the *Steamrunner* class was still partially shielded by the raised sides of the saucer. Meanwhile, the main shuttlebay was located at the rear of the saucer, where its doors offered a safe and calm entry point as they were tucked down between the nacelles.

SHARED DESIGN

The shape and design of the hull plating and escape pods on the *Steamrunner* class closely resembled those found on *Sovereign*-class ships, such as the *U.S.S. Enterprise* NCC-1701-E. This clearly indicated that they were contemporary designs, having been developed and constructed around the same time. Indeed, the first time the *Steamrunner* class was seen was at the Battle of Sector 001 against the Borg in 2373, just after the *Enterprise*-E had completed its shakedown tests.

Steamrunner-class ships later saw action in many crucial battles during the Dominion War as part of the Second Fleet. This proved that the Steamrunner class, along with other types of Starfleet ships that were developed in the late 24th century, were a potent tactical force and a match for some of the most serious threats the Federation had ever faced.

DATA FEED

Vice Admiral Hayes was initially in command of around 30 ships that made up the armada tasked with engaging the Borg cube when it invaded Federation space in 2373. Captain Picard subsequently took command of the fleet after several Starfeet vessels, including Hayes' flagship, were destroyed.

SHIP PROFILE

In 2373, several Steamrunner-class ships belonged to the Second Fleet, an alliance of Federation and Klingon ships that fought the Dominion. During the second Battle of Deep Space 9, a number of Steamrunner-class ships made up part of a task force that crossed the Cardassian border and destroyed vital Dominion shipyards on Torros III.

Later, at least one Steamrunner-class ship was part of an Alliance fleet that attacked Cardassian space in the Chin'toka system. This invasion was ultimately successful, even though the Cardassians had deployed hundreds of automated orbital weapon platforms in the system.

In late 2375, Steamrunner-class vessels were part of the huge combined Allied fleet that ultimately defeated the Dominion in the final battle of the war at Cardassia Prime.

Steamrunner-class ships fought alongside several other classes of Starfleet vessel as part of the Second Fleet during the Dominion War.

DATA FEED

Although at least two Steamrunner-class ships were destroyed during the Battle of Sector 001, the remaining vessels in the fleet managed to coordinate a successful attack on the Borg cube. This was largely due to Captain Picard knowing precisely where to target the cube after he learned where it was most vulnerable during his time as Locutus.

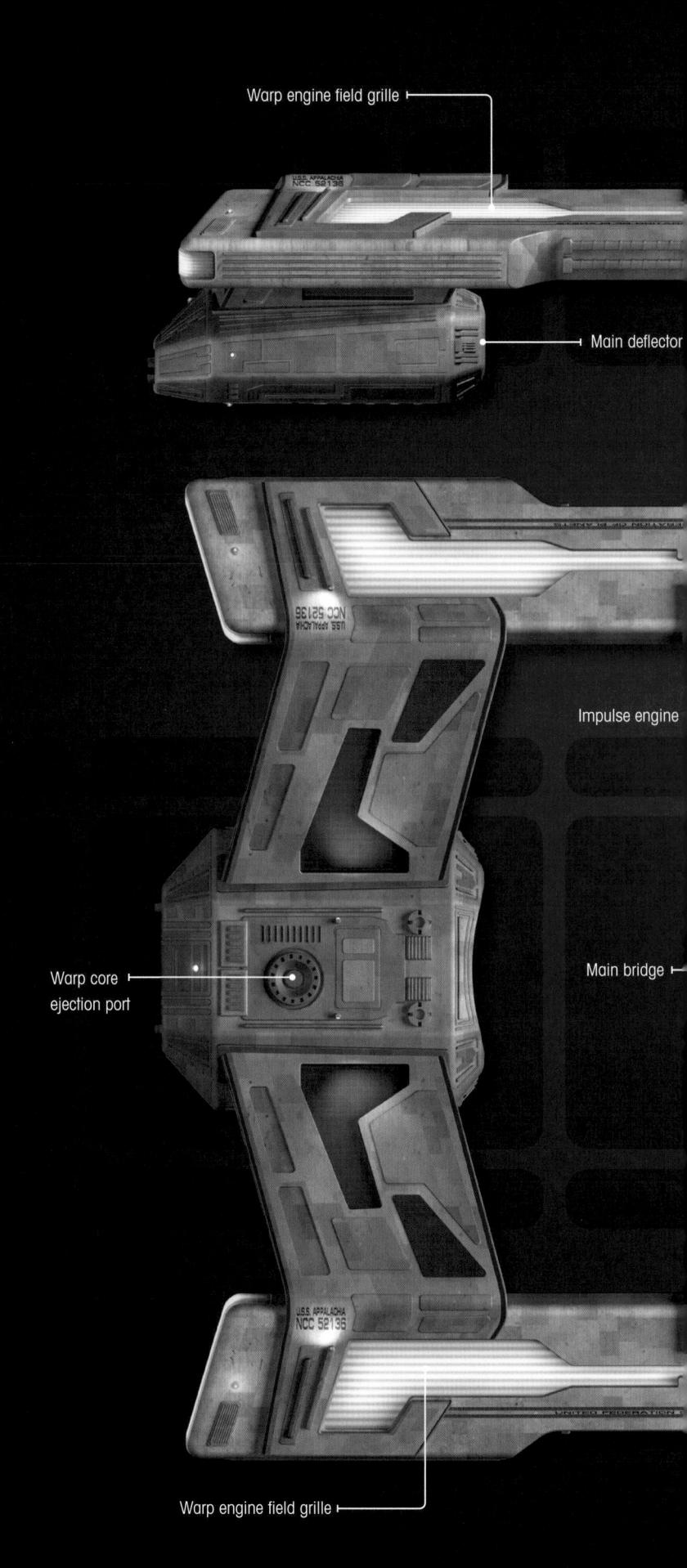

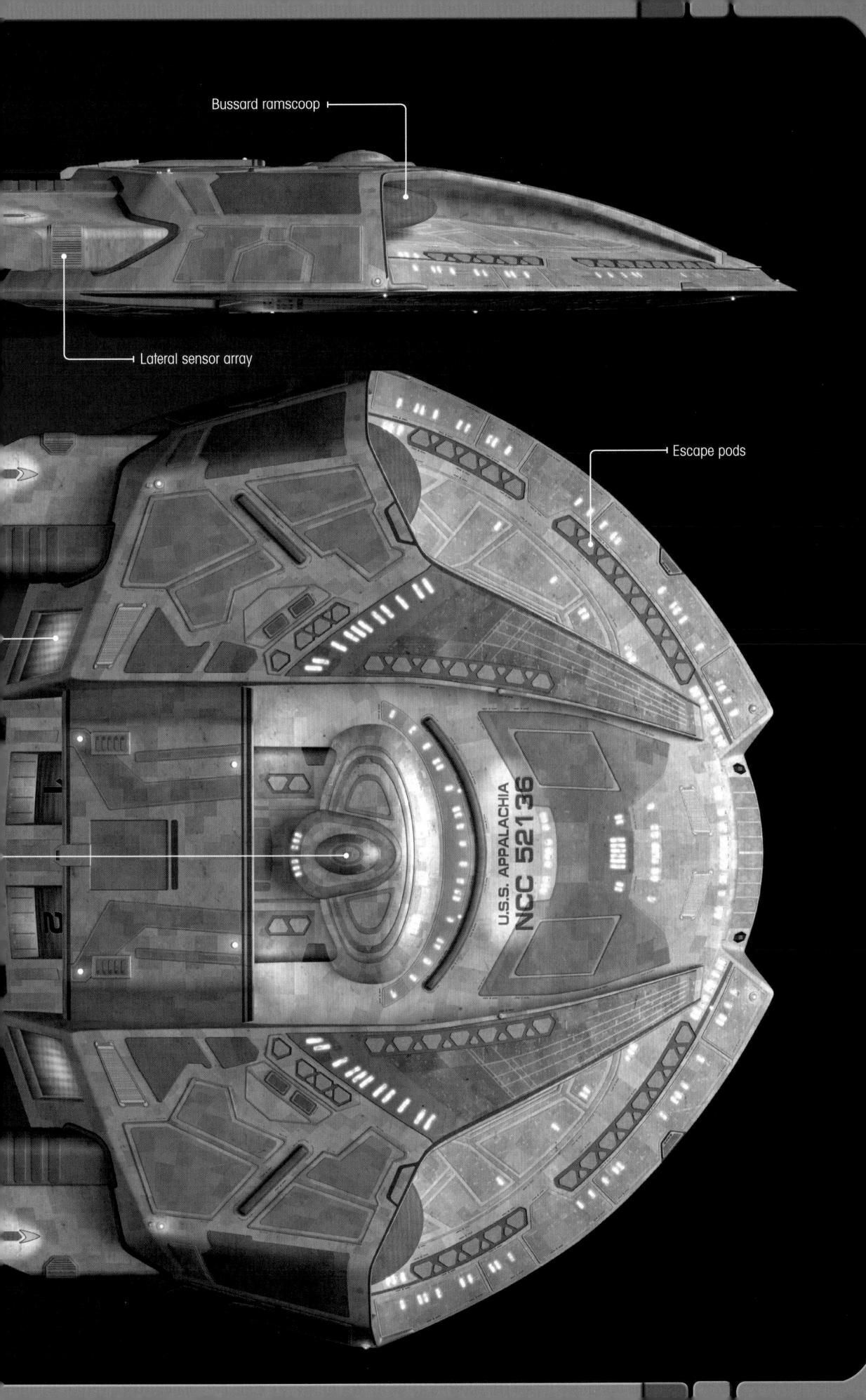

BLOWHARD OFFICER

Vice Admiral Hayes survived the encounter with the Borg despite his flagship being destroyed. He was later described by Captain Janeway as a "good man, fine officer, a bit of a windbag."

SECOND FLEET SHIPS

As well as ships from the Steamrunner class, the Second Fleet comprised vessels from the Galaxy class, Defiant class, Miranda class, Excelsior class, Saber class and Akira class, as well as ships from the Klingon fleet.

SINGLE NAME

Although several Steamrunner-class ships have been seen in action, only one has been officially named. That was the U.S.S. Appalachia NCC-52136, which was destroyed during the Battle of Sector 001.

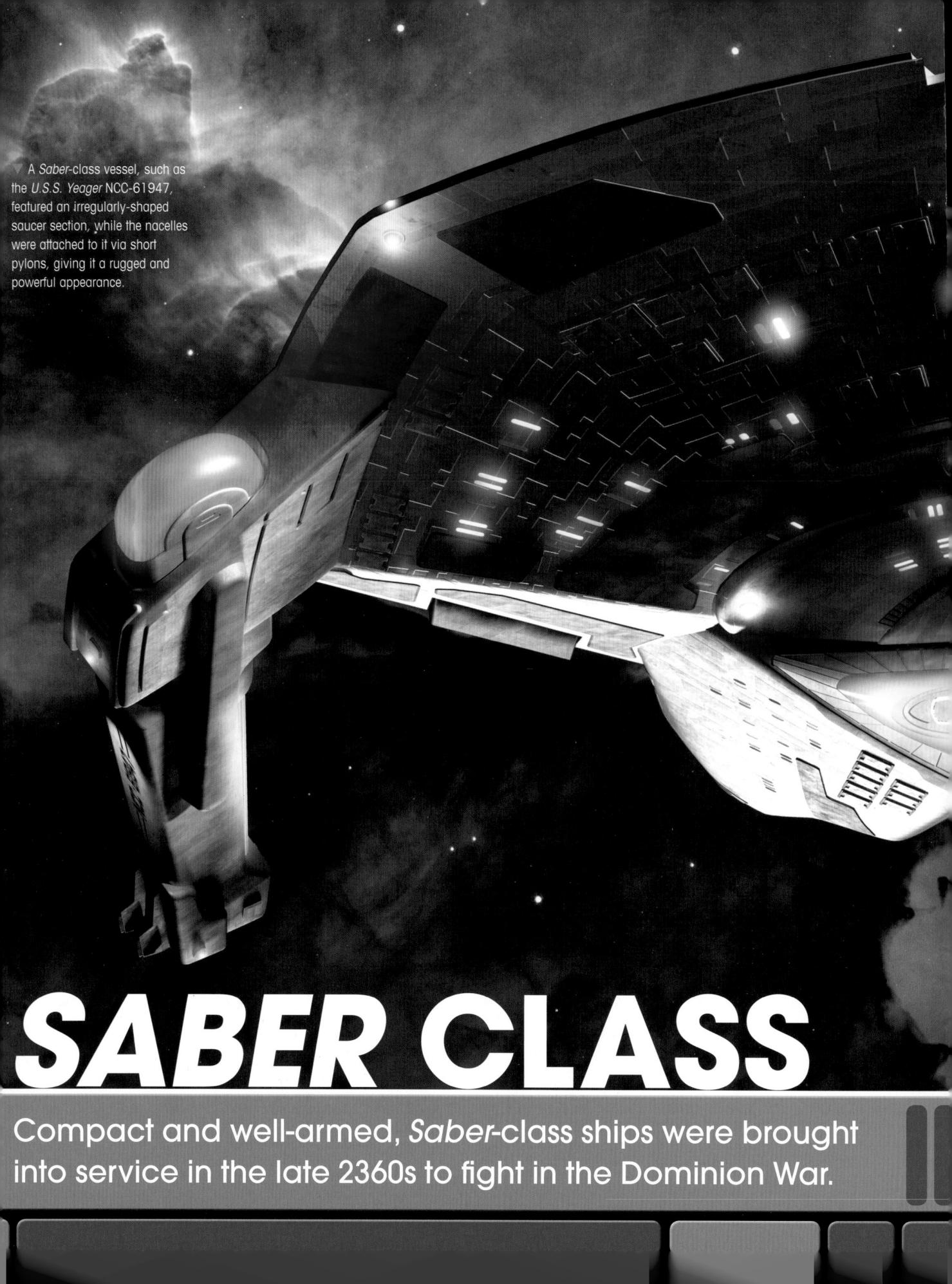

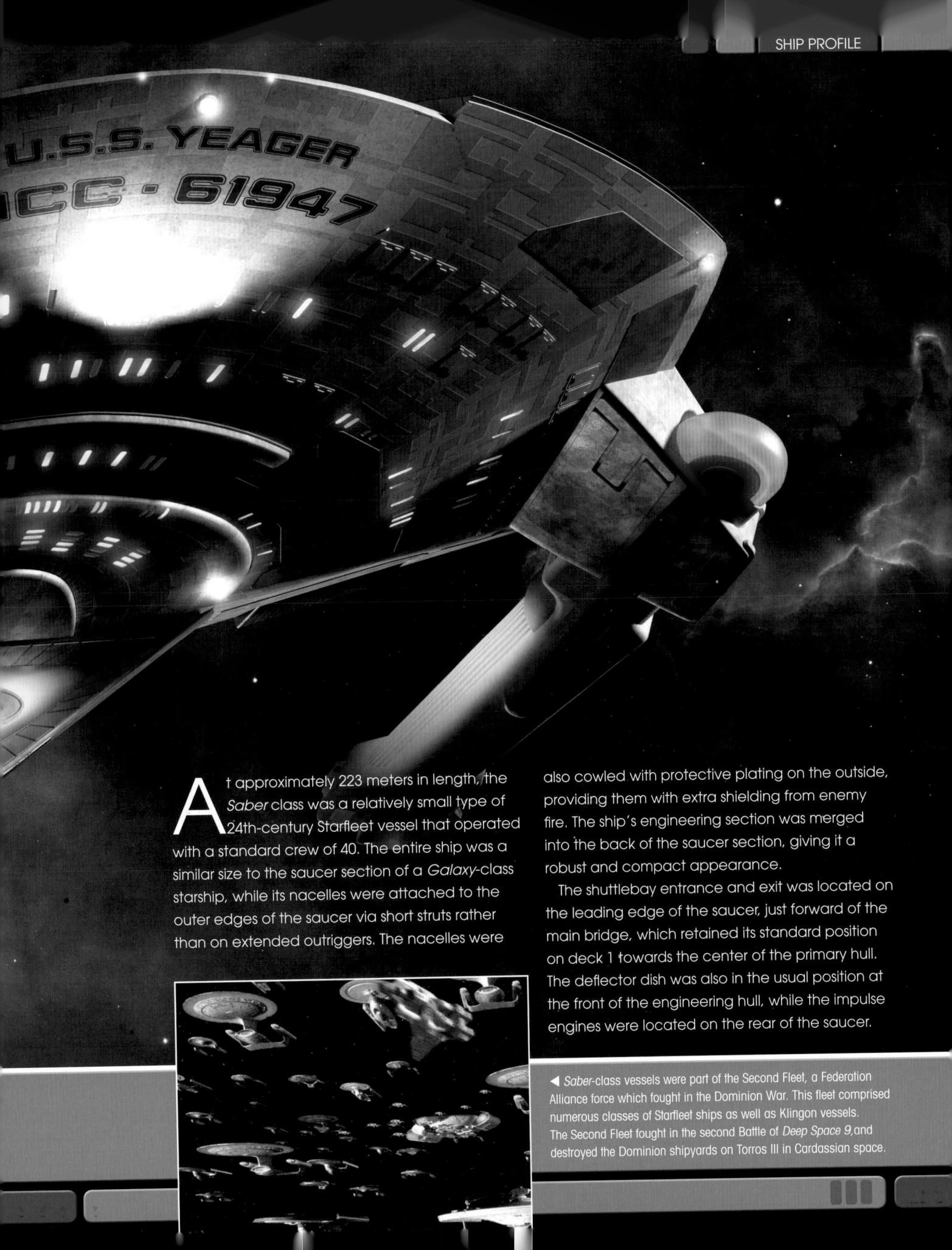

■ Unlike most Starfleet ships that had the shuttlebay at the rear of the engineering section, Saber-class ships featured a shuttlebay at the front of the saucer section.

▼ The outer hull of Saber-class vessels featured much more surface detail than many other Starfleet vessels, particularly in the area behind the main bridge.

▲ The engineering hull on the Saber class had a distinctive triangular shape, while the main navigational deflector was surrounded by copper-colored panels. The surface of the hull also featured prominent escape hatches that were of a similar shape and design to those found on the Defiant class, indicating they were built around the same time.

The warp core was located near the rear of the secondary hull, with the ejection hatch clearly visible on the underside.

The design of the hull plating and escape pods on the *Saber* class was similar to that found on the *Defiant* class. This appeared to indicate that both classes were developed and constructed around the same time in the late 2360s.

Both classes of ship were designed in response to the Battle of Wolf 359 in 2367, when a Borg cube ripped through Starfleet's defenses, destroying 39 starships in a matter of minutes. While the Federation had faced threats to its security before, nothing had ever matched the magnitude of the danger presented by the Borg. In response, Starfleet developed new types of starship. While the *Defiant* class was nothing less than a warship, the *Saber* class was more of a light cruiser. It was nevertheless heavily armed

with numerous type-10 phaser emitters and two photon torpedo launchers. Its compact dimensions meant it provided less of a target, particularly in profile, while it was still capable of a top speed of warp 9.7, ensuring it could respond quickly to emergency situations.

UNDER CONSTRUCTION

The Saber class was first seen in 2371 when two of these starships were in drydock at the Utopia Planitia Fleet Yards in orbit of Mars, while the *U.S.S. Voyager* NCC-74656 was undergoing its final phases of construction.

The Saber class was next seen in 2373 during the Borg's second invasion of the Alpha Quadrant. Several Saber-class ships, including the U.S.S. Yeager NCC-61947, made up part of a fleet assembled by Vice Admiral Hayes to intercept a Borg cube at Sector 001.

- During the Dominion War, small maneuverable ships such as the Saber class and the Defiant class were often used to defend larger vessels from attack, allowing them to concentrate on breaking through enemy lines.
- ▶ Saber-class vessels were among the fastest in Starfleet in the late 24th century. Their nacelles were partly cowled for extra protection against enemy fire.

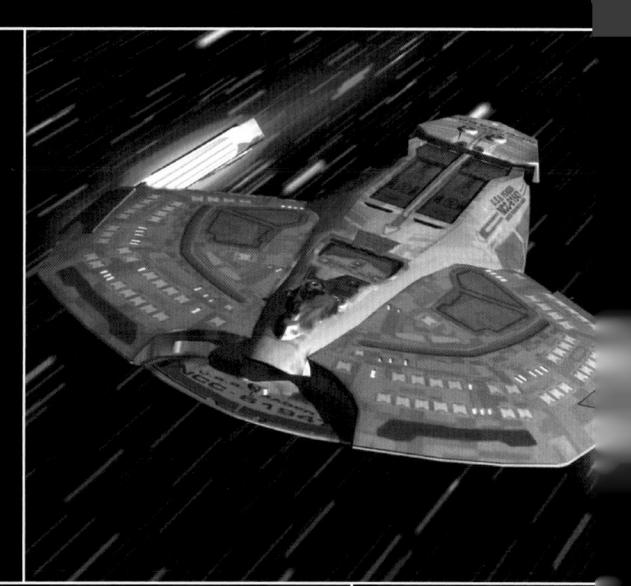

Several Saber-class ships were part of the tas force that engaged the Borg cube at the Battle of Sector 001. Seen from the perspective of the viewscreen on the U.S.S. Enterprise NCC-1701-E, the Starfleet armada coulc be seen taking heavy losses as it assaulted the cube from all sides. The Borg were only stopped when Captain Picard coordinated the fleet's attack on a vulnerable area of the cube.

Later the same year, a number of *Saber*-class vessels were assigned to the Second Fleet, an alliance of Federation, Klingon and later Romulan hips that fought in several crucial engagements during the Dominion War.

Saber-class ships were often used to flank larger starships, helping to draw fire and protect them as they attempted to punch through enemy ines. Some of the conflicts they were involved in included the second Battle of Deep Space 9, he raid on the Dominion's shipyards on Torros III, and the First Battle of Chin'toka the first Federation Alliance offensive into Cardassian territory.

In 2378, Saber-class ships were among the leet that was hastily assembled by Admiral Paris and sent to an area less than a light year from Earth where a Borg transwarp conduit had been detected. Starfleet knew that only one race

used transwarp conduits, and that was the Borg. Fully prepared to engage whatever Borg vessels emerged from it, the fleet were shocked when first a Borg sphere emerged from the conduit only for it to explode and the *U.S.S. Voyager* NCC-74656 to materialize out of the debris. The fleet then accompanied *Voyager* back to Earth.

DATA FEED

Saber-class ships made up part of the Second Fleet when it launched an attack on the Chin'toka system. The Federation Alliance fleet had to overcome powerful automated orbital weapon platforms to gain control of this strategically vital system, which was located on the Cardassian border.

MARTIAN SHIPYARDS

Two Saber-class vessels were undergoing construction, refitting or repairs at the Utopia Planitia Fleet Yards in 2371 at the same time as the U.S.S. Voyager NCC-74656 was entering the final stages of its construction. These facilities were positioned in synchronous orbit 16,625 kilometers above the Utopia Planitia region on Mars. The shipyards included a number of drydocks and space stations, and were one of Starfleet's largest and most important vessel construction and design facilities in the 24th century. They also included large drafting rooms for starship design, as well as several buildings on the surface of Mars. Much of the design and construction of the Galaxy class took place at these shipyards, while later Ben Sisko worked here on the development of the Defiant class.

▲ The Utopia Planitia Fleet Yards in orbit of Mars featured mushroomshaped spacedocks and dozens of cage-like drydocks, which ⇒ncased starships while they were being built.

DATA FEED

A human settlement known as the Utopia colony was established on Mars at least as early as 2155. Tom Paris' idea of a perfect date was to visit the hills overlooking the Utopia Planitia plains in a 1957 Chevy. The Doctor took his advice and programmed the scenario into the *U.S.S. Voyager* NCC-74656's holodeck for his date with Denara Pel.

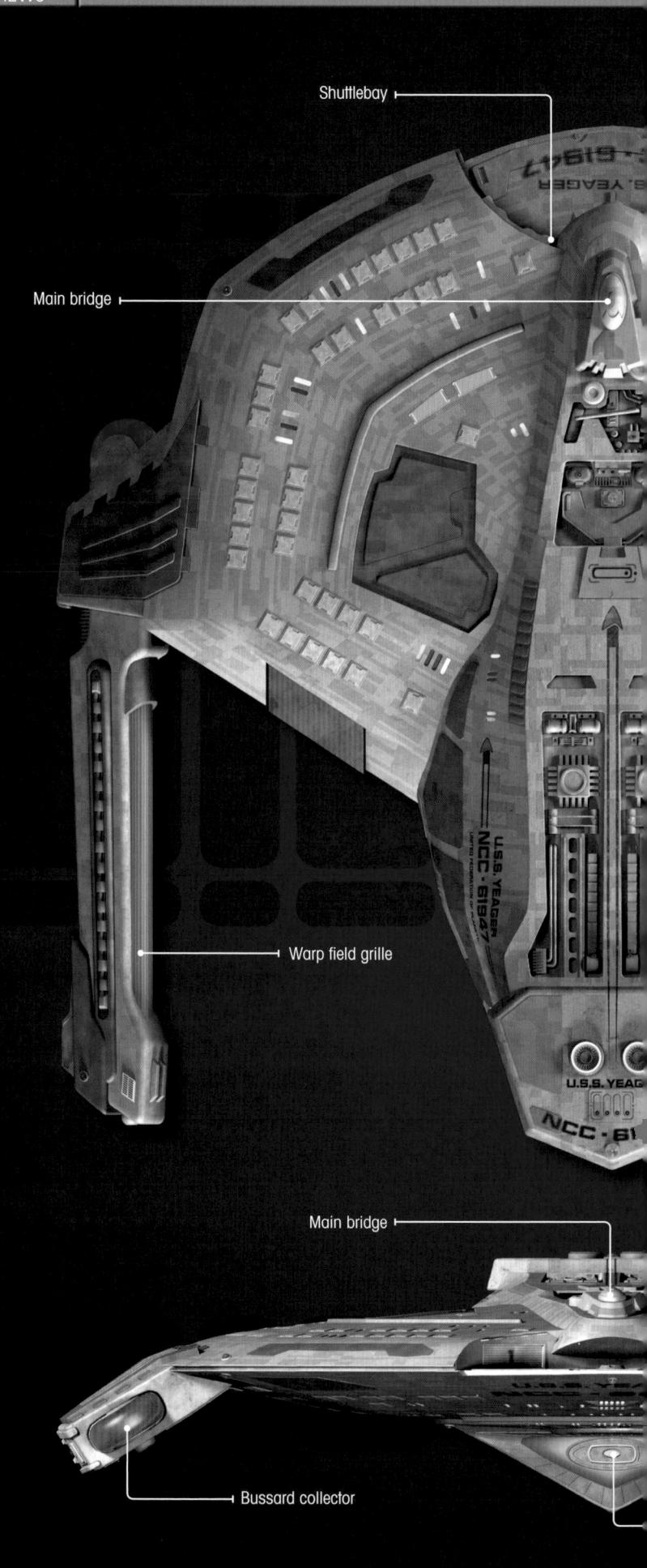

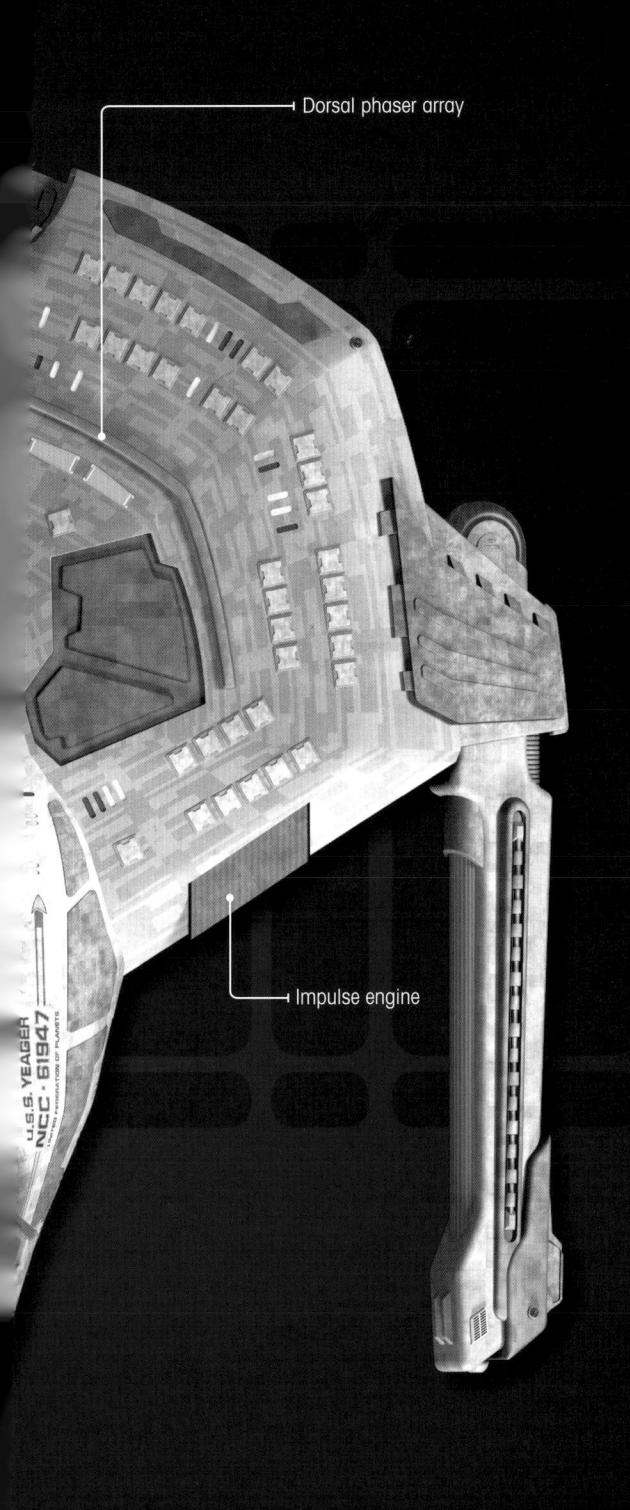

VENTRAL VIEW

AFT VIEW

FORE VIEW

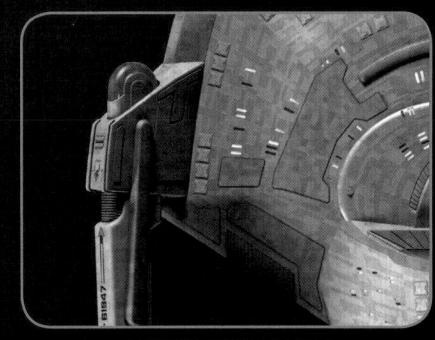

VENTRAL NACELLE VIEW

LEGENDARY NAME

The Saber-class U.S.S. Yeager NCC-61947 was named in honor of Chuck Yeager, the US test pilot who was the first man confirmed to have broken the sound barrier on October 14, 1947 in the Bell X-1.

PRODUCTION BASE

According to the STAR TREK: DEEP SPACE 9
Technical Manual, the production base for Saber-class starships was the Advanced
Starship Design Bureau Integration Section,
Spacedock 1, Earth.

MAJOR BATTLES

Some of the conflicts that Saber-class ships were involved in during the Dominion War included the Battle of Torros III, the Battle of the Tyra System, Operation Return, the Battle of Chin'toka, and the Battle of Cardassia.

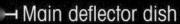

→ Shuttlebay 2 doors

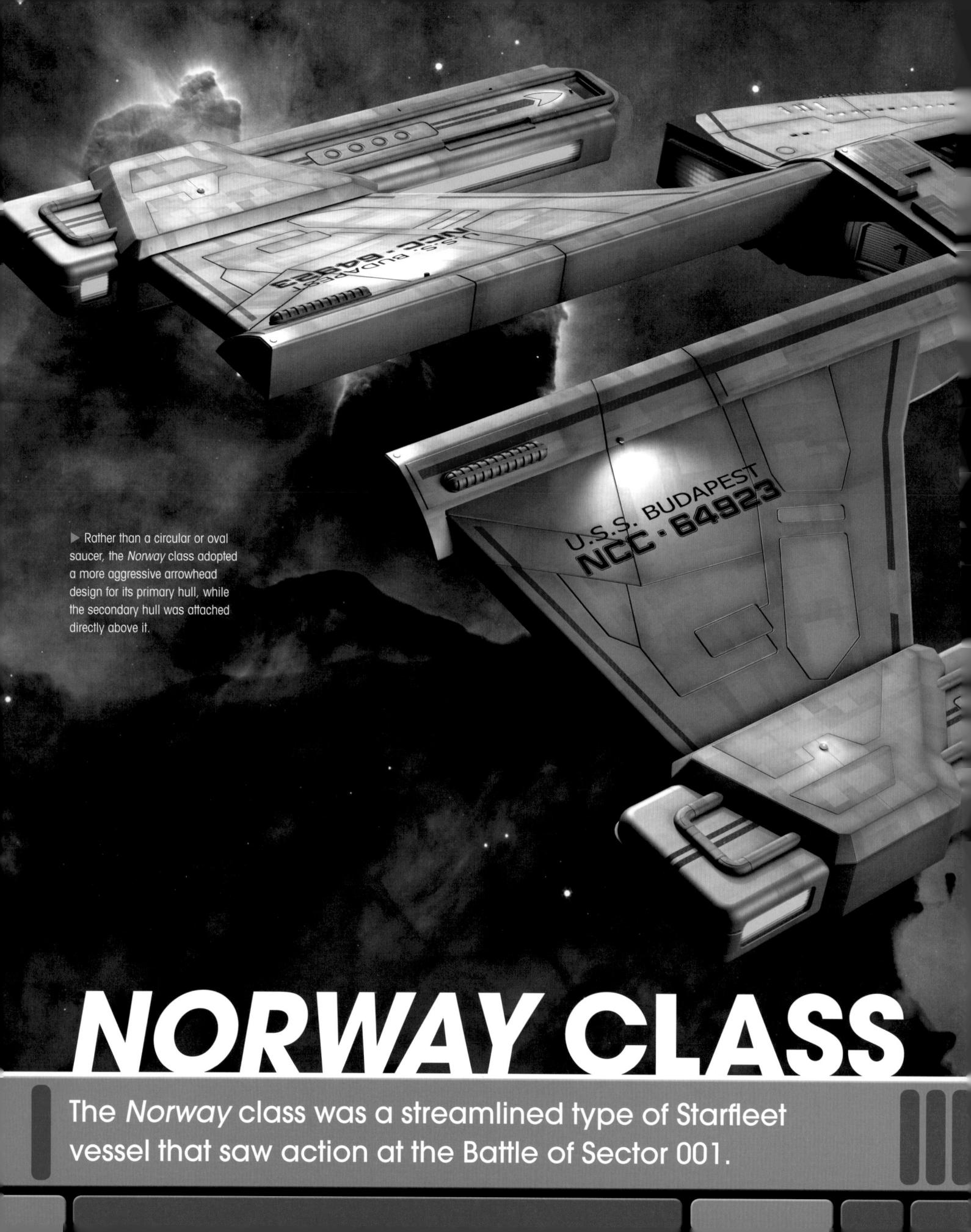

Two rectangular beams emerged from the rear of the engineering hull in a catamaran-style configuration to which flat-mounted nacelles struts supported the short nacelles.

The main bridge was located on deck 1 on top of the saucer section, and provided control of all the ship's main systems from engines to weapons. It was partly concealed between the struts of the catamaran-style beams that led back to the nacelles. This meant that the bridge had enhanced protection from the sides, and was not as exposed as it had been on earlier types of ship.

POWERFUL ENGINES

Despite the relatively short engineering section and nacelles, the *Norway* class was still capable of a top speed of warp 9.7. This was thanks to advancements in propulsion technology, which meant powerful engines could be incorporated into a much smaller area.

The deflector dish was inset into the saucer section, not in the engineering hull as it had been on many other Starfleet designs. It was also pushed much further back from the leading edge of the ship, but provided it had a 'clear line of sight' into open space this was not a problem.

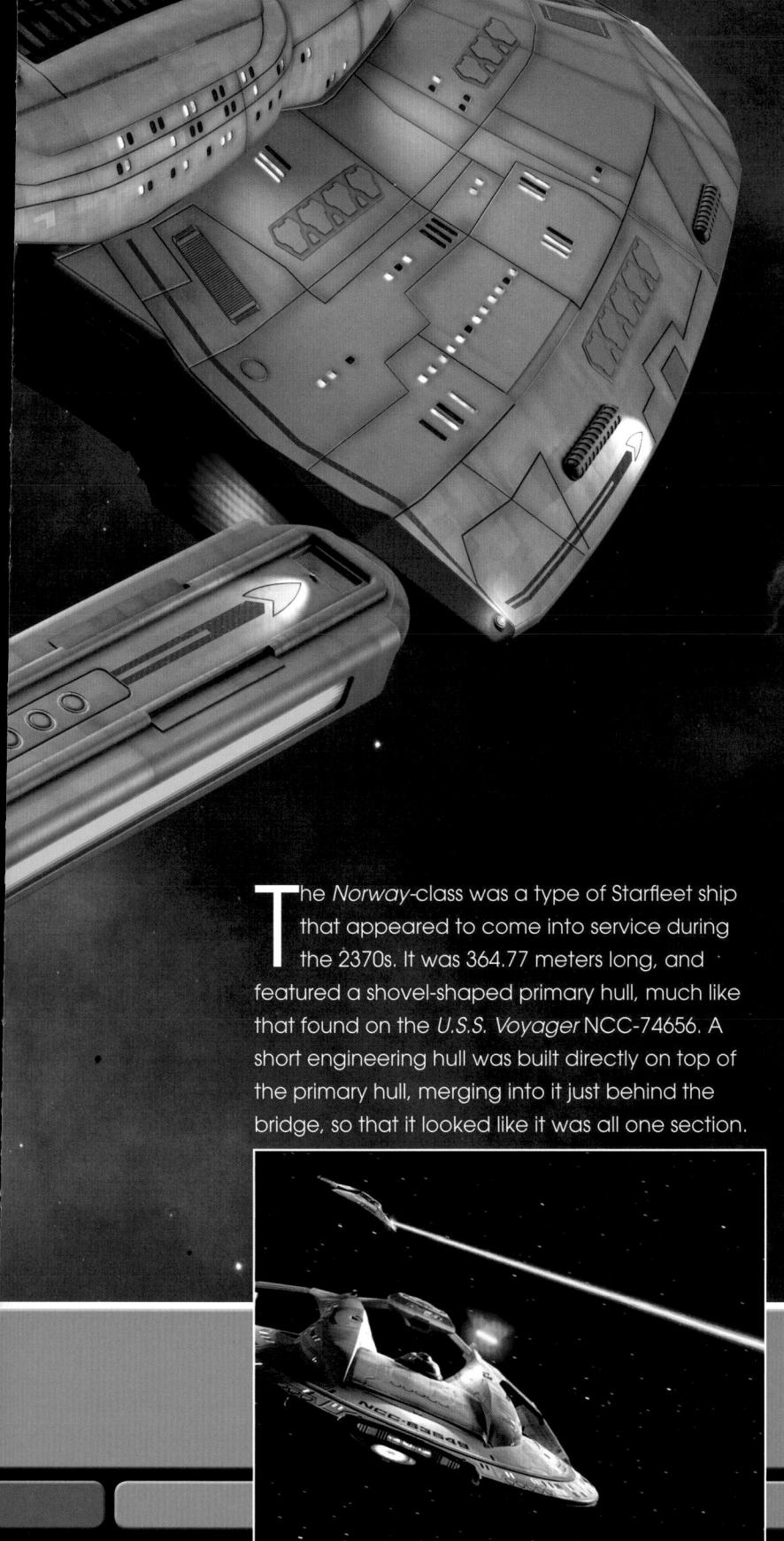

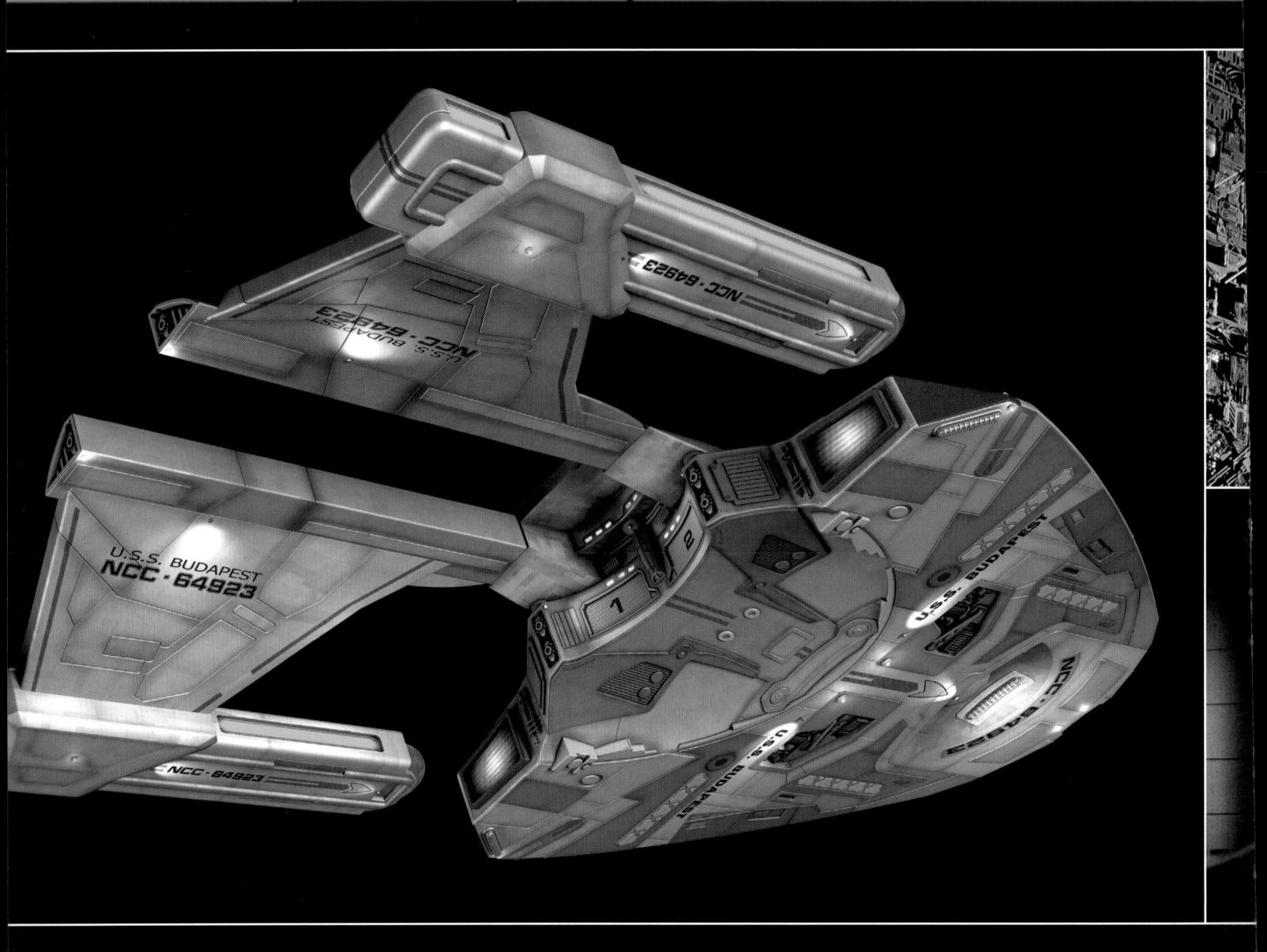

▲ The *Norway* class had a primary saucer that was a very similar shape to the one found on the U.S.S. Voyager NCC-74656. It also featured an atypically small number of windows on the external hull, while the surface detail was a mixture of that found on the U.S.S. Enterprise NCC-1701-D and the U.S.S. Defiant NX-74205.

Weapons on the Norway class included six type-10 phaser emitters at various points around the hull, including on the trailing edge of the split hull struts. There were also two photon torpedo launchers, one located just below the main deflector dish and another at the rear.

The overall design of the *Norway* class was compact, and from the side it presented a very narrow profile. This made it a much smaller target compared with earlier Starfleet designs that featured long neck structures between the saucer and engineering hulls, or elongated nacelle struts between the engineering hull and warp nacelles.

This flat design was very deliberate by Starfleet. They had an aging fleet, and its combat deficiency was all too apparent at the Battle of Wolf 359 in 2367, when a single Borg cube destroyed 39 Starfleet ships with the loss of 11,000 lives.

This new round of shipbuilding resulted in the Akira, Saber, Steamrunner and Norway classes all of which were rather more combat-oriented than the average Starfleet design. The preceding centuries had seen periods of conflict and tension for Starfleet, but these years had been largely peaceful, as the Federation had grown to include more than 150 worlds that lived in a spirit of mutual cooperation. Starfleet had developed ships largely for exploratory, scientific and diplomatic purposes during this time, but the threat of the Borg changed all that.

CALLED INTO ACTION

It was not long before all these new ships saw action at the Battle of Sector 001 in 2373, when reports came in that a Borg cube had destroyed a colony on Ivor Prime. Vice Admiral Hayes mobilized a fleet that included at least four Norway-class

■ By the time the U.S.S. Enterprise NCC-1701-E joined the battle, a large portion of the fleet had been lost, but they had also caused heavy damage to the Borg cube's outer hull.

► The Norway class had a very flat design, with the nacelles in line with the saucer section. This meant that in battle it offered a narrow profile, making it harder to hit.

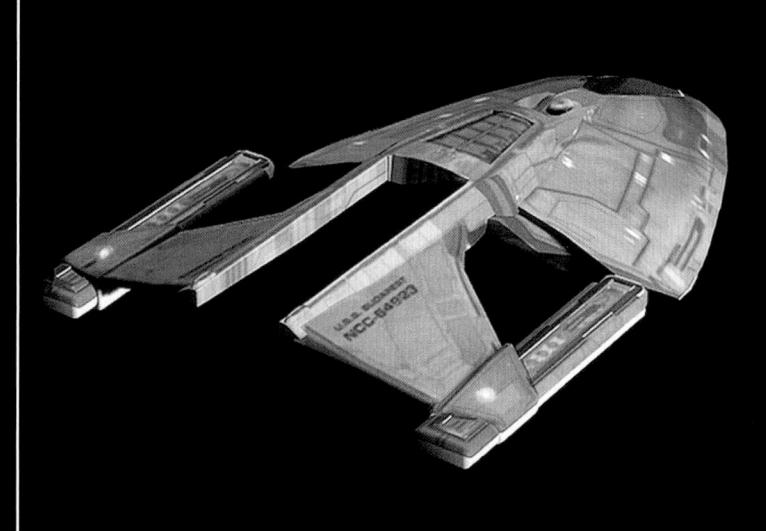

■ Seen from the perspective of the Enterprise E's bridge, the battle with the Borg appeared to be a melee, with numerous Starfleet ships, including Norway-class vessels, performing strafing runs on the cube. Under Captain Picard's orders, the fleet targeted a seemingly unimportant area of the cube that caused it to explode.

ships to intercept the Borg in the Typhon sector. The fleet failed to stop the cube, however, and Hayes was forced to request reinforcements as the Borg continued unrelentingly towards Earth.

Many Starfleet ships were disabled or destroyed completely by the time the *U.S.S. Enterprise* NCC-1701-E joined the fight in orbit of Earth. As the battle raged on, the combined force of the fleet slowly wore down the cube's defenses. The crucial factor in the battle was Captain Picard's inside knowledge of the Borg after his earlier assimilation. He directed the fleet to fire on a seemingly unimportant area of the cube, and it was eventually destroyed. This left the *Enterprise*-E free to pursue the sphere that had emerged from the cube shortly before its destruction.

After this, the *Norway* class was not seen in action again, although a computer display graphic did show one of these ships at Starbase

375. This space station acted as a gathering point for the Second and Fifth Fleets prior to 'Operation Return' and the retaking of *Deep Space 9* from Dominion forces in late 2373. The fact that the *Norway* class was displayed in a graphic prior to this battle appeared to indicate that at least some of these ships were present during the conflict.

DATA FEED

Sector 001 was not only home to the Sol system and Earth, but included the 40 Eridani A system, where additional Starfleet construction yards were located. It also included the Tarsas System, where Starbase 74 (pictured left) was positioned, and the Orion Sector Tactical Command outpost.

NEW TACTICS

At the earlier Battle of Wolf 359, roughly eight light years from Earth, the Starfleet armada of 40 ships employed a tactic of attacking the Borg cube in formation, so there was little danger of damaging friendly ships.

Unfortunately, this did not work as it allowed the cube to pick off the Starfleet ships one at a time. For the Battle of Sector 001, where Starfleet were using a number of relatively new starships, including the *Norway* class, they learned their lesson and instead opted for a swarm tactic. This met with some success, as after the *U.S.S. Enterprise* NCC-1701-E arrived, Data reported that the cube had sustained heavy damage – something not even closely achieved at the earlier battle. The Starfleet armada still suffered major losses, but eventually, with the help of Captain Picard, they managed to defeat the Borg cube.

▲ Norway-class ships fought alongside several other classes of Starfleet vessel as part of a swarm tactic to defeat the Borg cube.

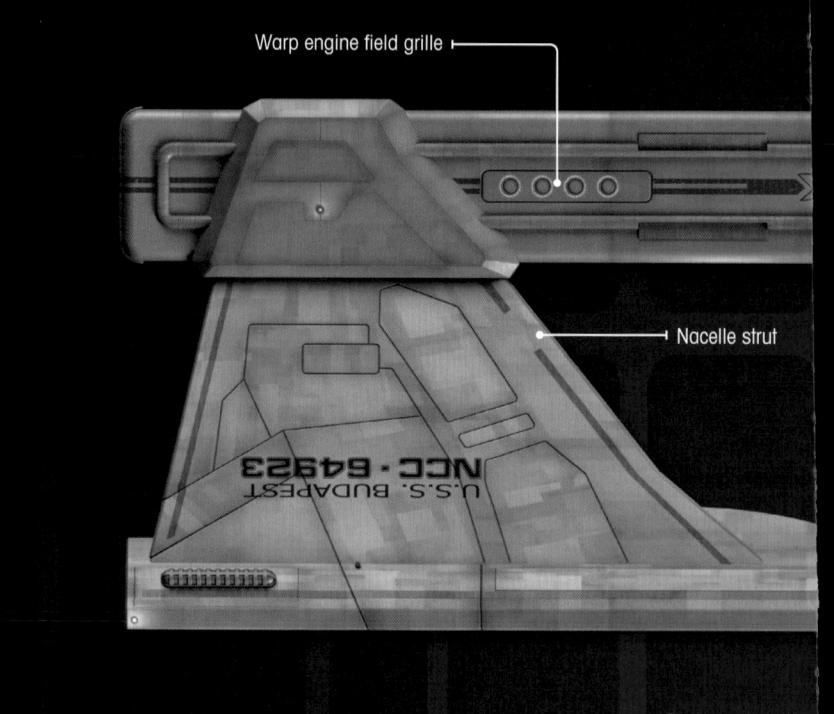

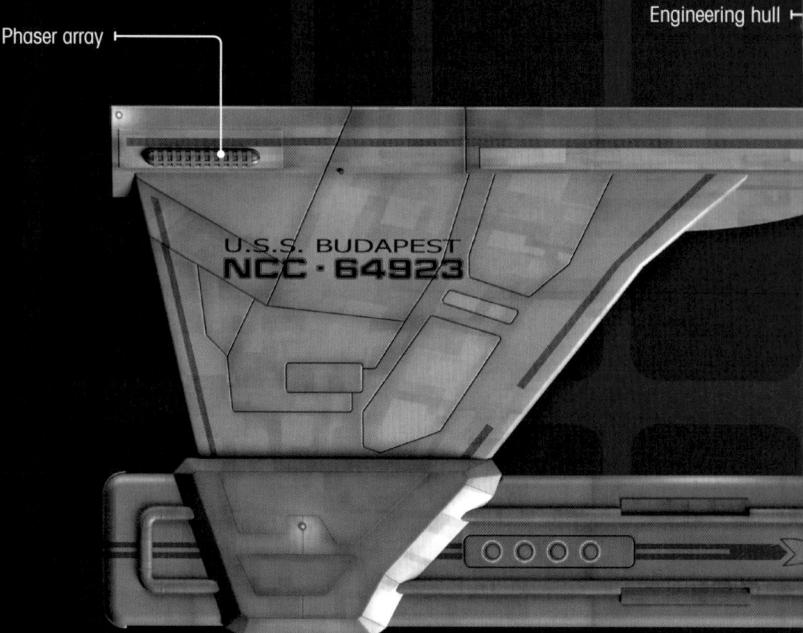

BU.S.S.ard ramscoop +

DATA FEED

Alex Jaeger designed four Starfleet vessels - Akira, Saber, Steamrunner and Norway classes - for STAR TREK: FIRST CONTACT. Three of these vessels went on to make further STAR TREK appearances, but the Norway did not. According to DEEP SPACE NINE's visual effects supervisor David Stipes, this was because the CG files for the Norway were corrupted.

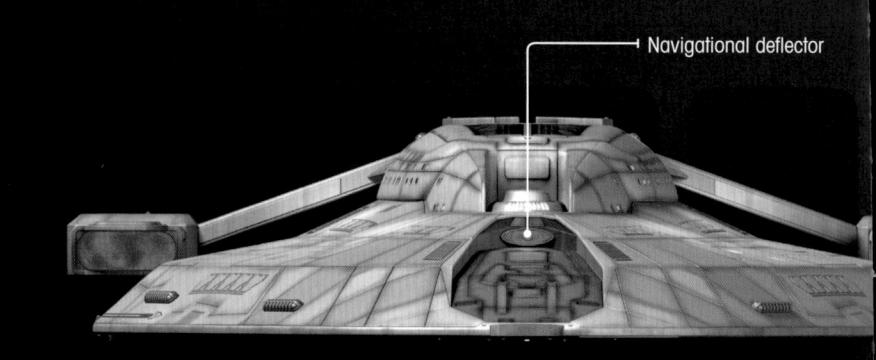
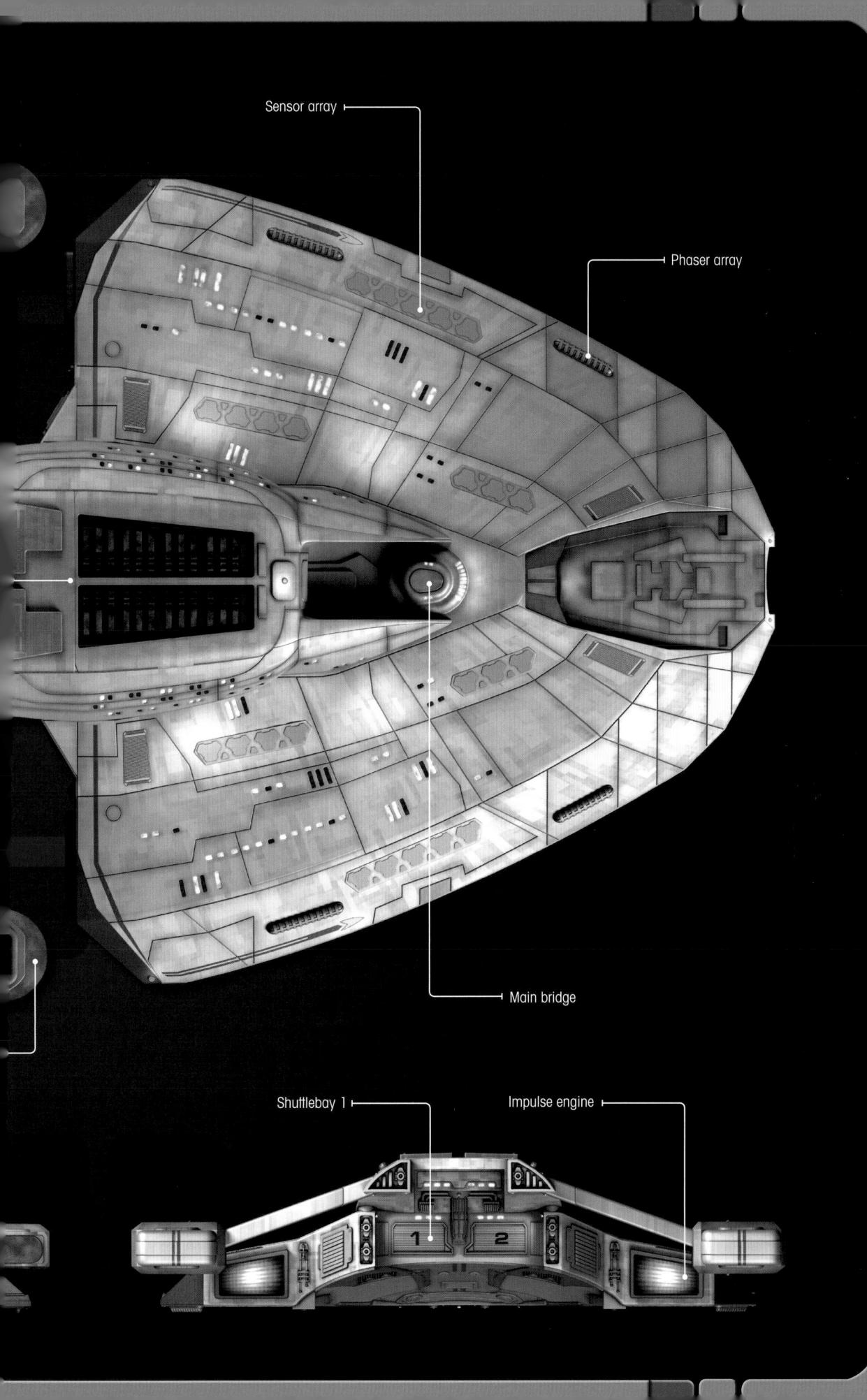

FLEET REBUILDING

After the Battle of Wolf 359 in which Starfleet lost 39 ships Commander Shelby took command of a special task force assigned to build the fleet up to previous deployment levels.

PRODUCTION BASE

According to the STAR TREK: Deep Space Nine Technical Manual, production on the Norway class was based out of the Advanced Starship Design Bureau Integration Section at Spacedock 1, Earth.

NORWAY NAME

According to the STAR TREK Encyclopedia, one of the Norway-class vessels that fought against the Borg at the Battle of Sector 001 was the U.S.S. Budapest NCC-64923. It was named after the Hungarian capital.

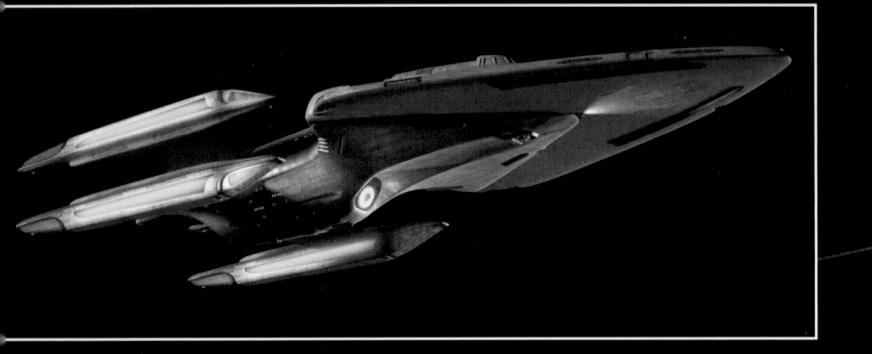

he *U.S.S. Prometheus* NX-59650 was a prototype vessel that was launched from the Beta Antares Shipyards in 2374. It was one of Starfleet's few warships; it was developed in response to the Dominion threat and was designed specifically for deep-space tactical assignments. It was larger and more powerful than the *Defiant-*class vessels and thanks to four warp nacelles, which gave her a sustainable cruising speed of warp 9.99, it was the fastest ship in the fleet, a title previously held by the *Intrepid-*class vessels that were capable of a warp speed of 9.975.

EXPERIMENTAL WARSHIP

At the time of her launch, the *Prometheus* was so highly classified only four people were trained to operate the bridge. Even access to most onboard systems, including communications, was restricted to personnel with level-four clearance.

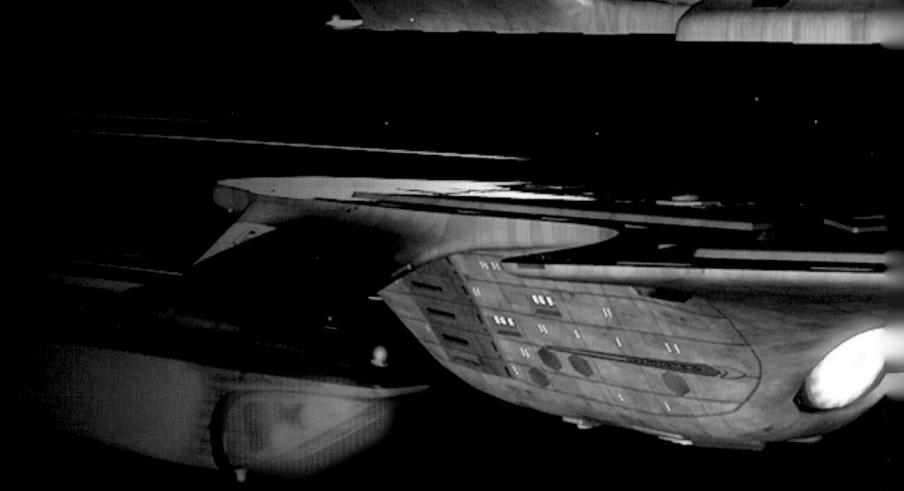

U.S.S. PROMETHEUS NX-59650

This experimental vessel was designed to split into three to mount a devastating attack.

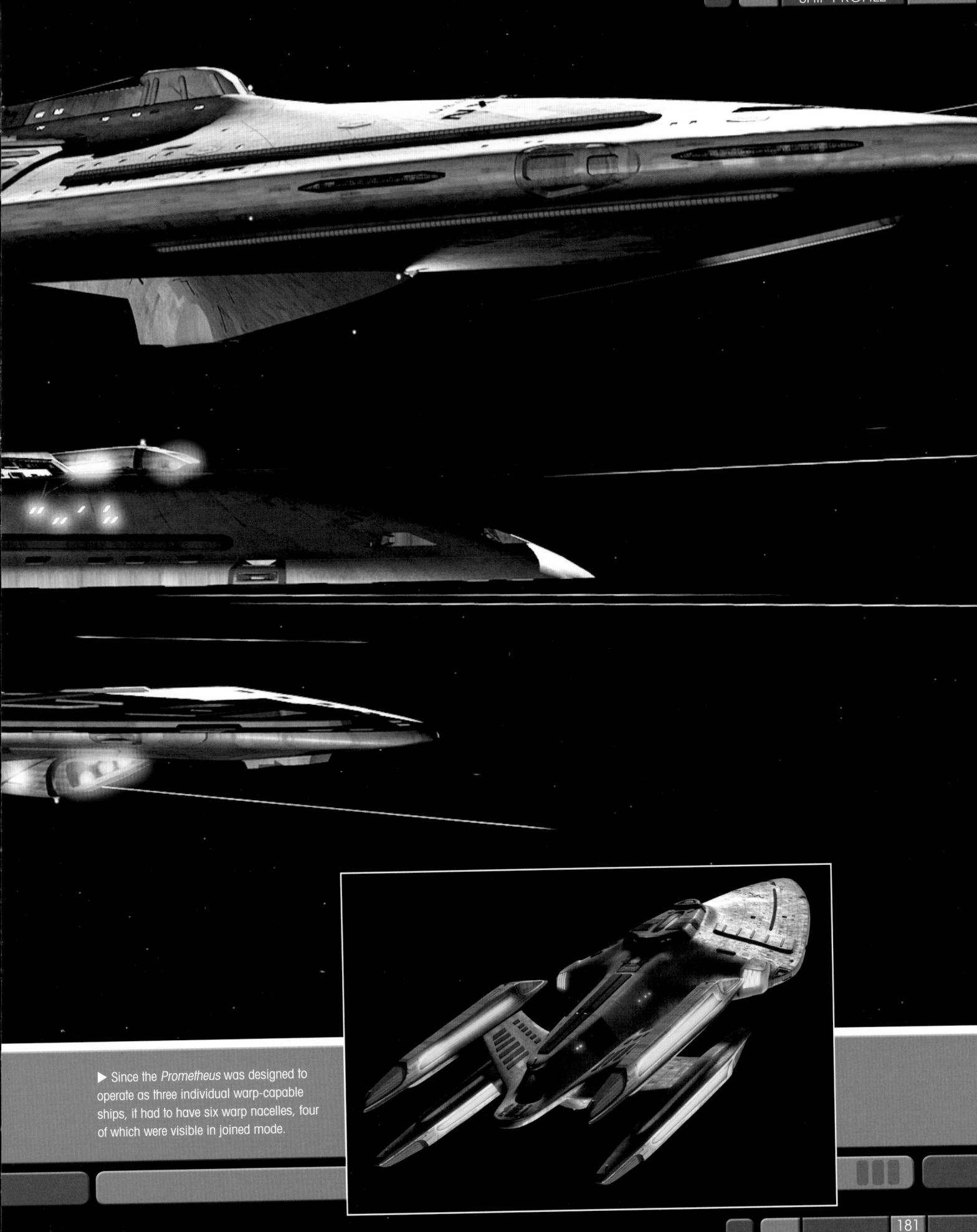

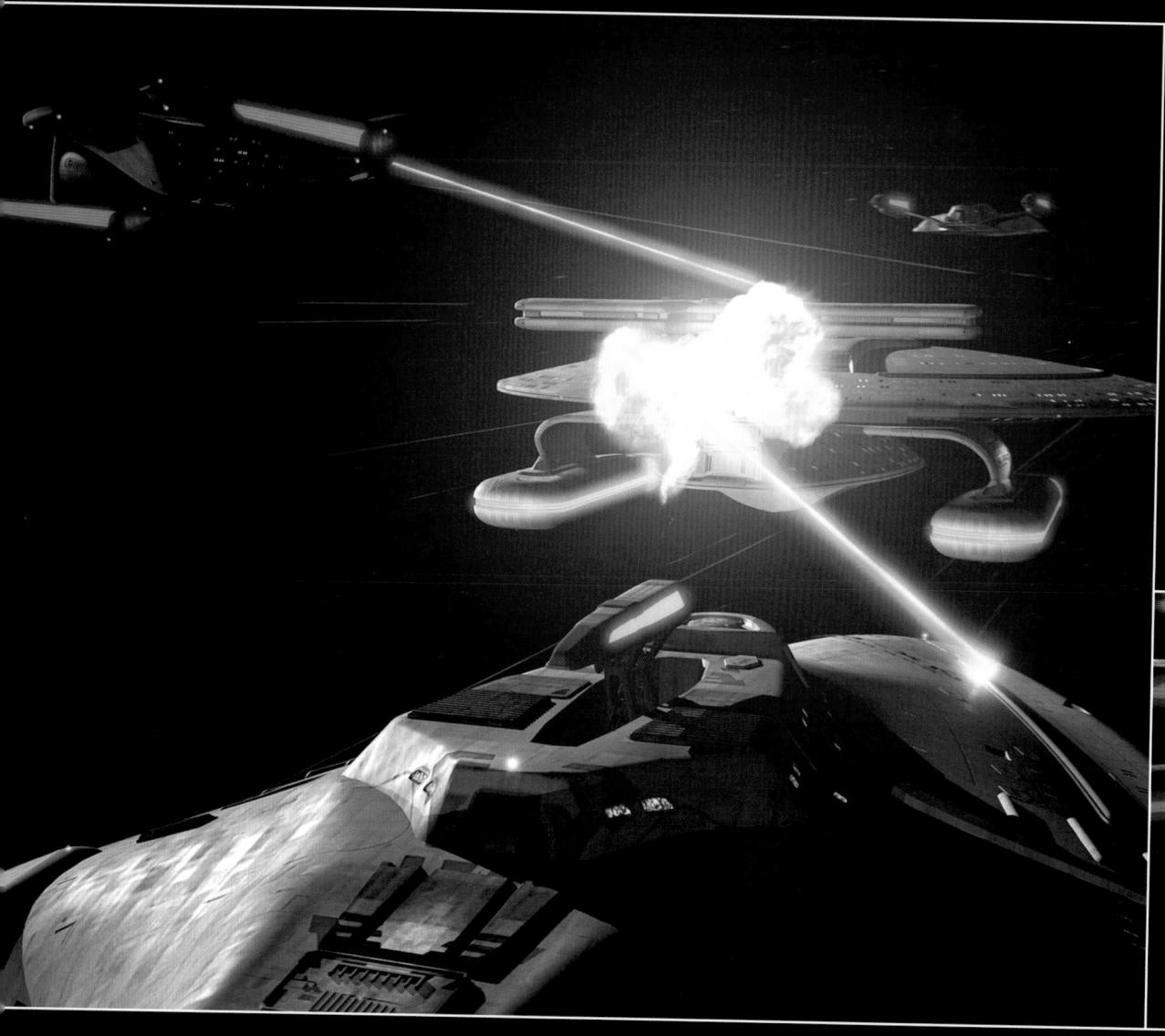

▶ When Voyage's crew made contact with the Prometheus, they were able to transmit their EMH. Most of the ship was fitted with holoprojectors and this allowed the EMH and his counterpart on the Prometheus to travel to all parts of the ship, including the bridge.

▼ The Prometheus
was fitted with the
latest defensive
technologies, including
regenerative shields and
ablative armor.

▲ Once the *Prometheus* had separated into three, it was designed to mount a combined assault on an enemy target. All three component vessels were heavily armed and programmed with a variety of attack patterns. The first time the system was operated in field conditions, the ship was under Romulan control and attacked the *U.S.S. Bonchune*.

The high level of security was necessary due to the *Prometheus* being equipped with a number of cutting-edge systems. These included regenerative and metaphasic shields augmented by a polaron modulator, ablative hull armor (an outer layer that vaporized under weapons fire, dissipating energy and protecting the ship's interior), and multiple Type-XII phaser arrays, together with photon and quantum torpedoes.

ASSAULT SQUADRON

But its most impressive feature was the multivector assault mode. By using advanced compartmentalization and automaton systems, the *Prometheus* was able to split into three separate vessels. All three sections were warp capable, with each having independent maneuvering and attack capabilities. The *Prometheus* could then operate as a mini squadron, able to launch a coordinated three-pronged assault on a target.

By default, each section was remotely controlled by the ship's sophisticated tactical computer, which was based on the main bridge of the main hull. Once the ship had separated, the computer requested an attack pattern and a target. Alternatively, an experienced Tactical Officer could control all three sections either semi-manually in emergency combat situations, or each section could be manned by a skeleton crew. The decoupling could be achieved in a matter of seconds and reintegrated just as quickly.

The ship boasted fifteen decks, comprised of officers' quarters, engineering and shuttlebays.

The sickbay was packed with state-of-the-art technology including the latest incarnation of the Emergency Medical Hologram – the Mark II programme. This improved version of the EMH had an updated subroutine that gave it a friendlier

▶ Voyager contacted the Prometheus after the crew found an ancient network of subspace relays. After their initial attempts to contact the ship failed, they sent their EMH through the network. When he arrived, he discovered the Starfleet crew were dead but managed to work with the Prometheus's EMH to regain control of the ship.

and more approachable bedside manner. It also featured advanced security features.

Thanks to holographic emitters dotted throughout the vessel, the EMH had the ability to operate outside of sickbay, so it was able to reach any area of the ship in order to treat injuries sustained during battle.

HOLOGRAPHIC RESCUE

This aspect of the design was crucial in recovering the ship when, during a test shortly after its launch in 2374, Romulan hijackers took command of the *Prometheus* and, using the multi-vector system, were able to successfully disable the *Nebula*-class *U.S.S. Bonchune*. The *Prometheus* was eventually recaptured by two EMHs who disabled the attackers and destroyed a *D'deridex*-class Romulan warbird before Starfleet managed to recover the ship.

DATA FEED

The Prometheus was field-tested on the edge of Federation space in 2374. During the tests, a team of 27 Romulans, led by Commander Rekar, took control of the ship and killed the Starfleet crew. They were pursued by the U.S.S. Bonchune but used the Prometheus's untested multi-vector assault mode to overpower it. Rekar then planned to enter Romulan space and hand the Prometheus over to the Romulan secret police, the Tal'shiar. However, before he could do so, the Prometheus's EMH disabled his team with neurozine gas. The EMH, working with his Voyager counterpart, then used the automated systems to destroy one of the Tal'shiar's warbirds, forcing them to retreat.

SHIP PROFILE NX-59650 MULTI VECTOR

DATA FEEDAll three sections of the *Prometheus* were fitted with state-of-the-art weapons, including Type-XII phaser arrays and photon and

quantum torpedoes. During battle they were linked to a central tactical computer that coordinated their attack pattern to inflict maximum damage on their target.

Ship Separation

he *Prometheus*'s ability to split into three required Starfleet's Advanced Starship Design Bureau to radically rethink her design. Vessels had been designed to split into wo for many years, but in those cases the intention had always been to effectively use the saucer module as an enormous escape module. For the *Prometheus*, the intention was to create three independent warships.

The biggest challenges involved the design of the Warp Propulsion System (WPS). The system required three reaction chambers. In the engineering section, which split into two, this vas achieved by using a unique design of warp core. During normal operation, matter was fed in at the top of the core and antimatter at the bottom. The fuel streams then passed

directly through upper and lower reaction chambers before continuing to their meeting point in a conventional central reaction chamber. The central reaction chamber lay on a separation plane, which was shut down when the ship split. Additional matter and antimatter feeds were then activated to feed the now independent reaction chambers.

When separated, the primary hull operated using an independent, horizontal *Defiant*-style warp core, which was kept in hot standby mode until it was needed. While the combined engineering WPS was able to operate on an efficiency level comparable to and, in fact, in excess of any contemporary starship, in separated mode it lost a degree of efficiency but could still maintain high warp speeds.

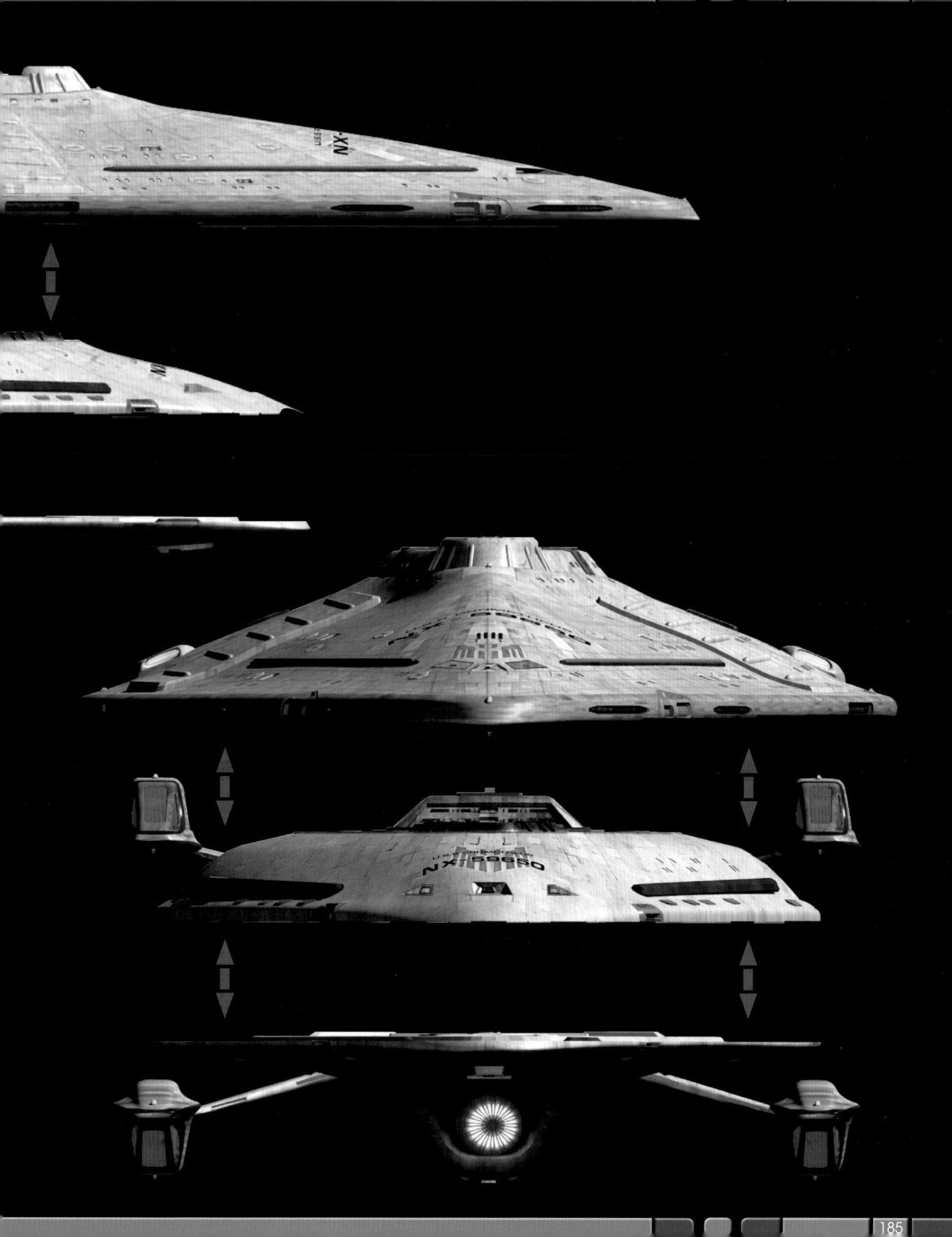

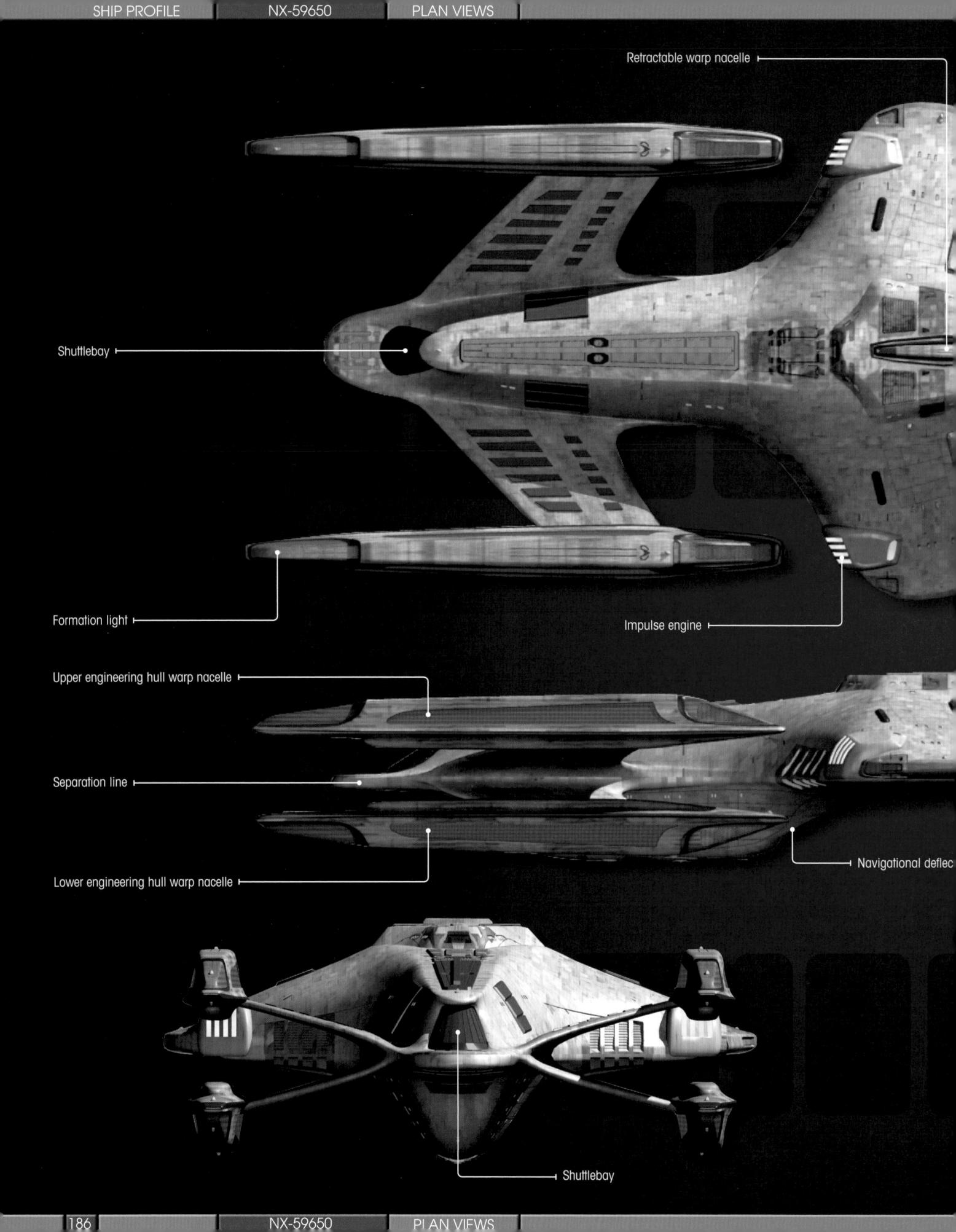

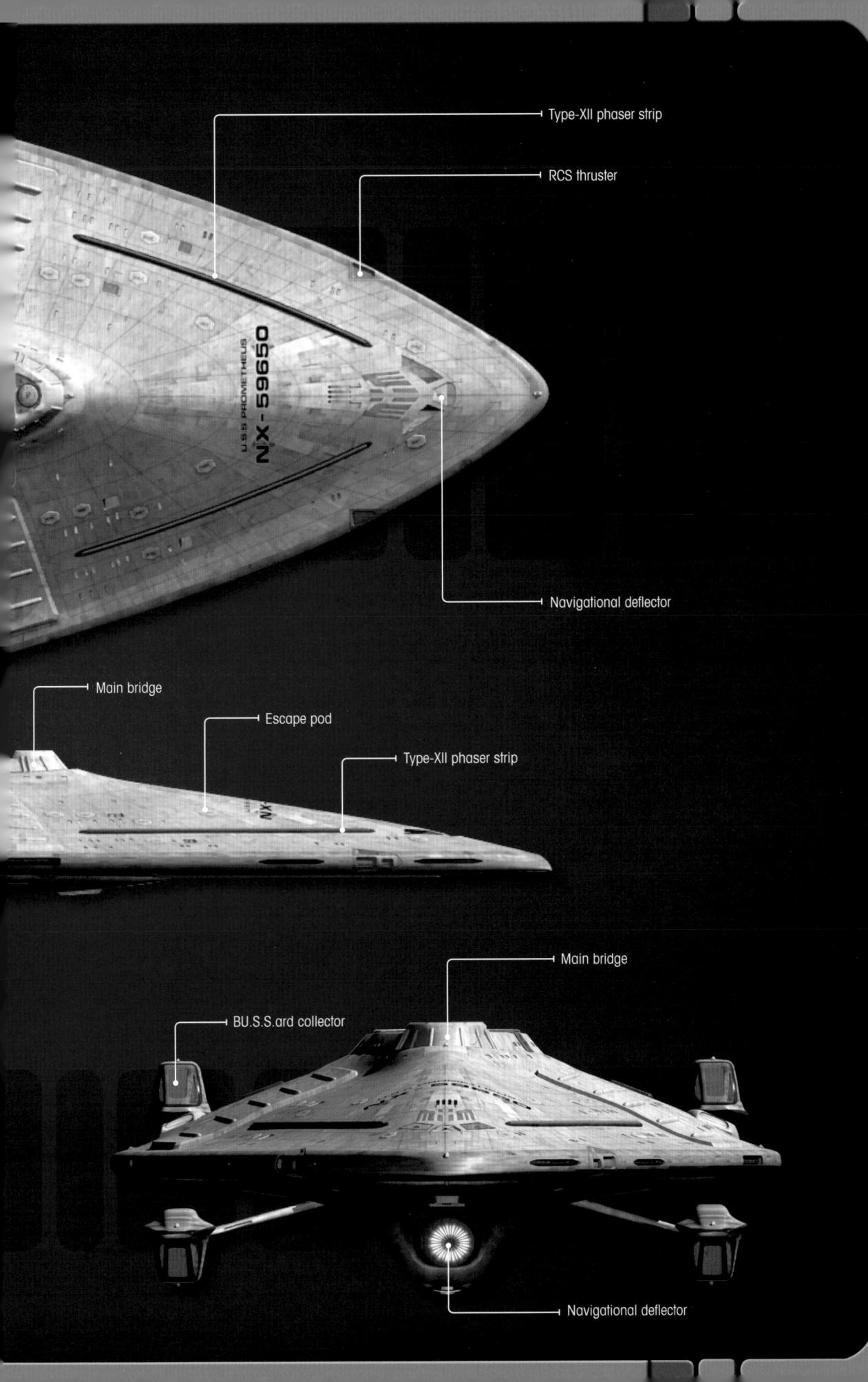

EFFICIENT SYSTEM

It took the *Prometheus* just over 10 seconds to decouple the three sections. While it was in the process of decoupling, warning lights flashed blue throughout the ship.

SAUCER NACELLES

The main hull – or saucer section – used twin retractable warp nacelles that were positioned above and below the hull rather than on the sides. Only the upper nacelle was visible when the ship was in joined mode.

ABLATIVE ARMOR

The Prometheus used ablative armor, which was first fitted to the Defiant class in 2371. A similar technology was also employed by the Borg.

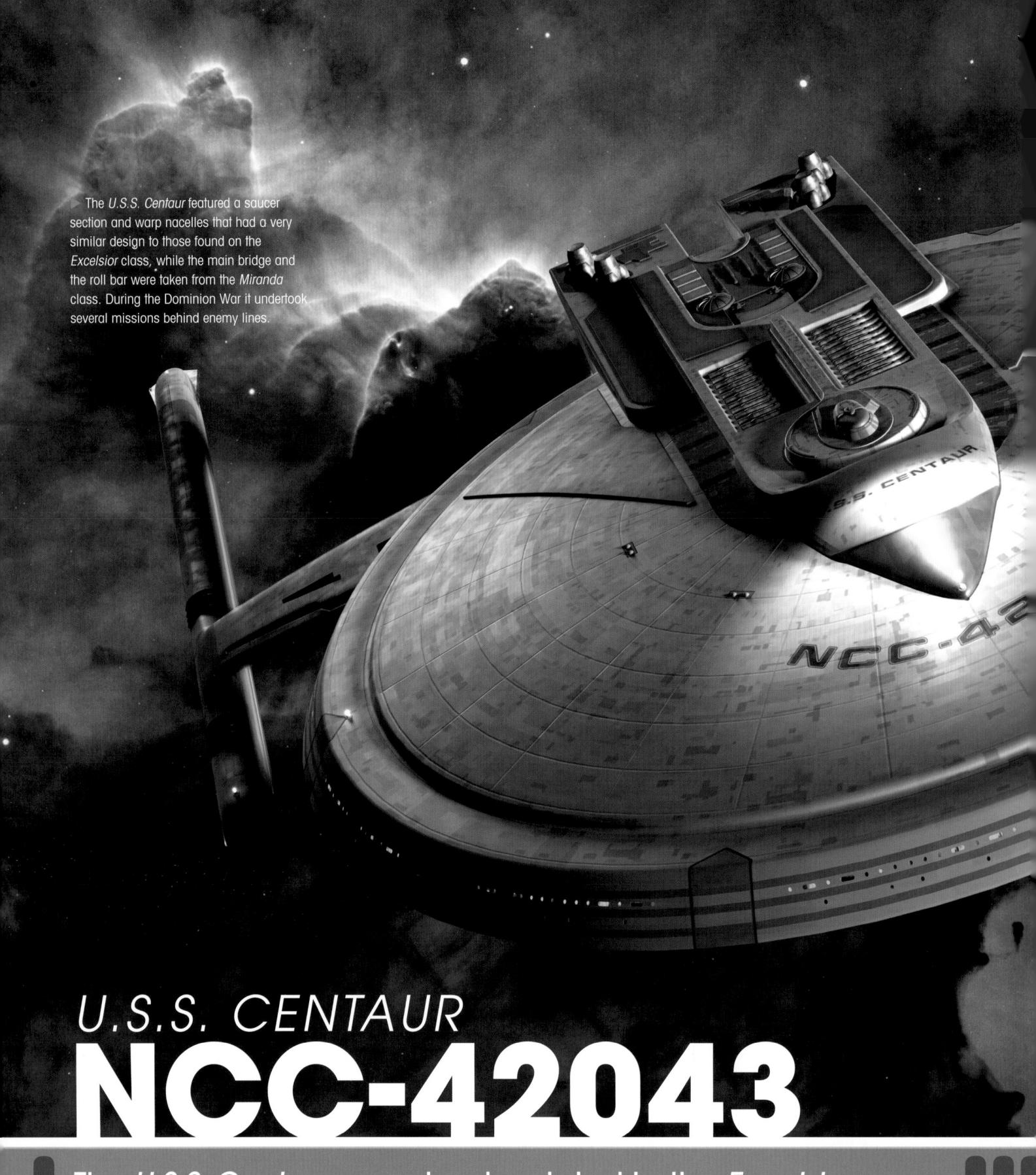

The *U.S.S. Centaur* was closely related to the *Excelsior* and *Miranda* classes, and saw action in the Dominion War.

The Centaur was constructed after Starfleet suffered huge losses in the opening months of the war with the Dominion, leaving its fleets severely depleted. For example, the Seventh Fleet was dispatched to the Tyra system to prevent Dominion forces advancing further into Federation space, but the counteroffensive was nothing short of a disaster. Out of 112 ships in the Seventh Fleet, only 14 survived the engagement and made it back to their lines.

COMPOSITE DESIGN

Devastating losses such as this meant that Starfleet had to accelerate its shipbuilding programs to compensate. With resources stretched thin, this inevitably meant that compromises had to be made and ships had to be constructed from partial builds, salvaged components and serviceable warp engines. The *Centaur* was almost certainly a result of this expedited assembly process, resulting in its hybrid appearance.

The Centaur's design was closely related to both the Excelsior and Miranda-classes. The saucer section and its long, thin warp nacelles were highly reminiscent of those found on the Excelsior class, although much smaller. The main bridge module in the center of the saucer was identical to that used on the Miranda class. The nacelle pylons on the Centaur were very similar to the inverted shape of the spars that connected the weapons pod

■ Unusually for a Starfleet vessel, the Centaur's main shuttlebay was not located at the rear of the vessel, but at the front of the saucer, in-between the bridge module and the registry number. The shape of the copper-colored shuttlebay doors was identical to those found at the rear of the Excelsior class.

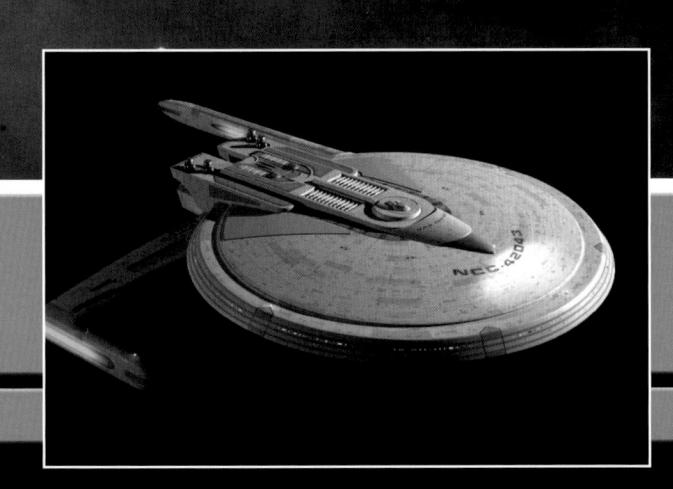

SHIP PROFILE

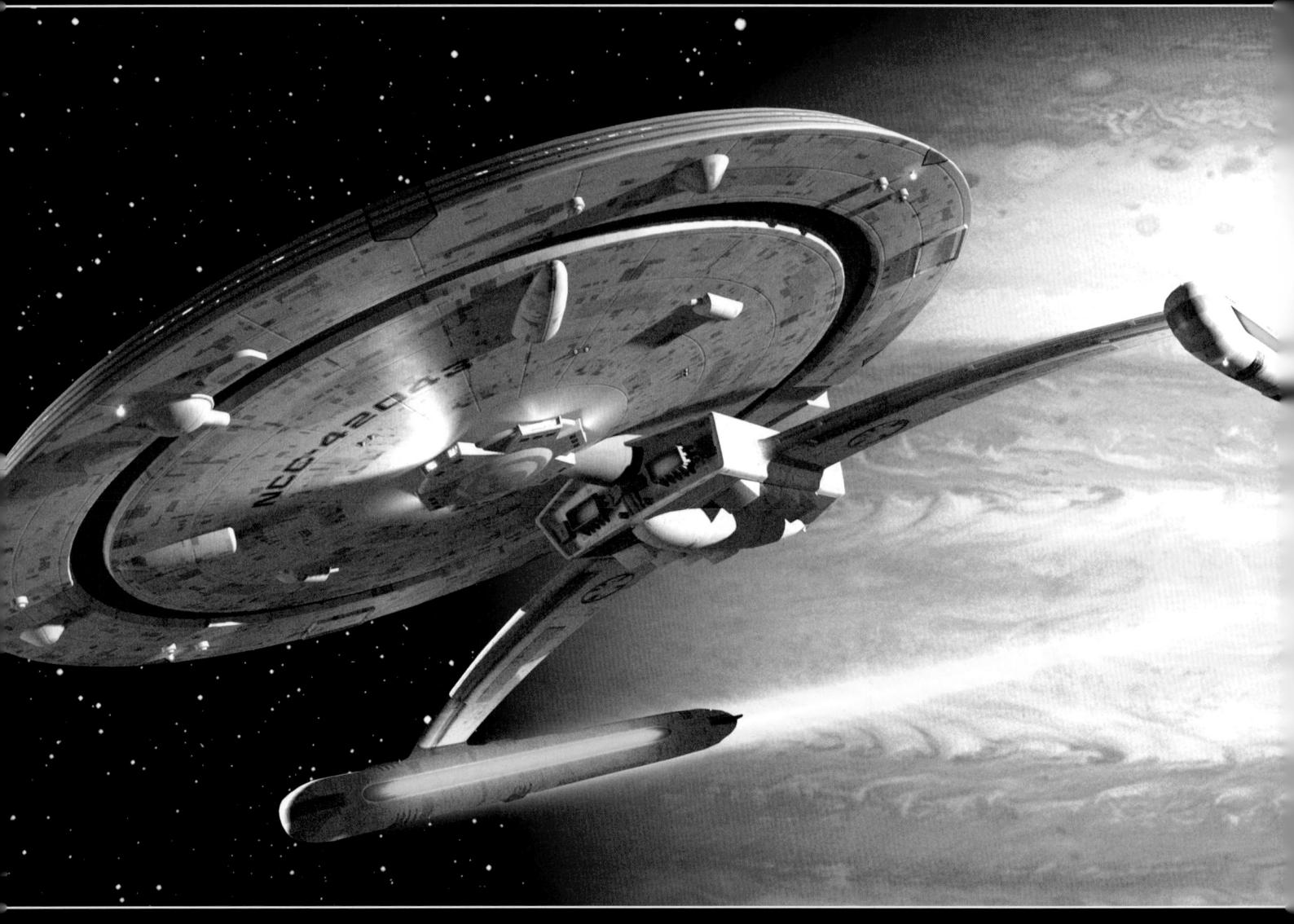

▲ The weapons pod that was located on a roll bar above the saucer on the *Miranda* class was turned upside down for use on the *Centaur*. This pod featured fore and aff torpedo launchers and greatly increased the *Centaur*'s firepower.

above the saucer on the *Miranda* class. Finally, the weapons pod itself from the *Miranda* class appeared to have been turned upside down and used as the small secondary hull at the rear and below the saucer on the *Centaur*. This module provided two forward- and two rear-facing torpedo launchers, and supplemented its type-9 phaser emitters that provided full 360 degree covering fire around the hull of the ship.

HIDDEN DEFLECTOR

One surprising feature for a Starfleet ship was that the *Centaur* featured a forward-facing shuttlebay. It was located in front of the bridge module on top of the saucer section. While its location may have been unusual, the shape and design of the copper-colored shuttlebay doors were identical to those found at the rear of the engineering hull on *Excelsior*-class ships.

Despite its overall close similarities with the *Excelsior* and *Miranda* classes, the *Centaur* did possess some unique features. These included some copper-colored arrays behind the bridge module and similarly colored turrets above the impulse engines, all of which were designed for long range sensing. There were also various raised features on the underside of the saucer, including a sensor dome located in the center.

The Centaur may have been constructed in haste and featured a mish-mash of styles, but it was just as capable as established classes. It had a top speed of warp 9.6, and was equipped with sensitive long-range scanning equipment as well as a formidable array of weaponry.

All these attributes made the *Centaur* ideally suited to border patrol and incursion, providing early warning and a first line of defense against invading Dominion and Jem'Hadar forces.

- ► The twin impulse engines on the *Centaur* emitted a deep red glow and were positioned on top of a wedge-shaped structure at the rear of the saucer section.
- The Centaur had a bridge shaped like the one found on a Mirandaclass ship. It was positioned behind a raised segment that helped to protect it from enemy fire.

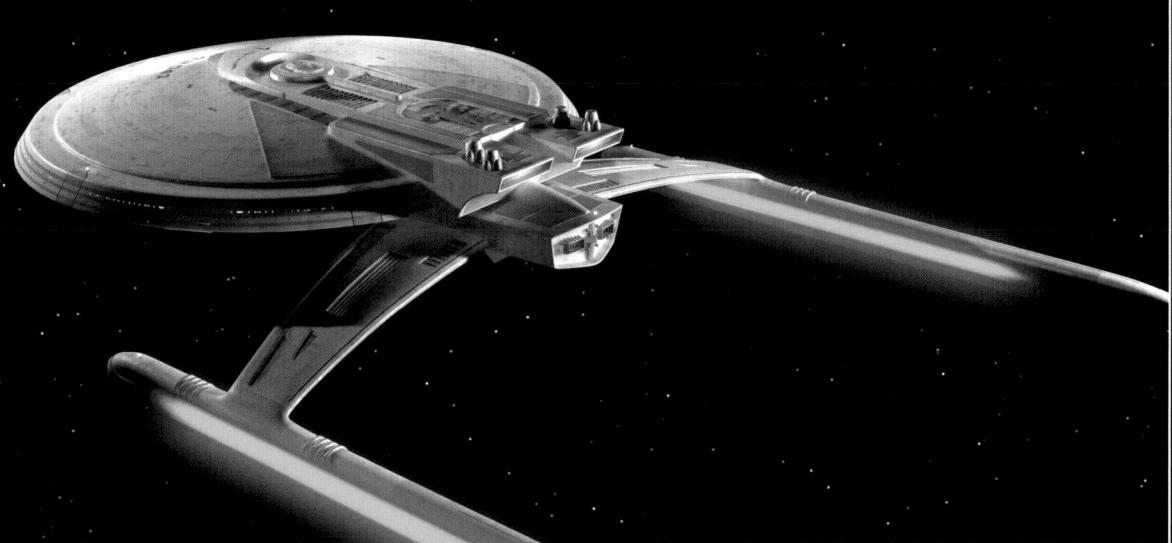

The warp nacelles appeared to be extremely long and thin on the Centaur because of its truncated secondary hull In fact, the nacelles and saucer were in proportion to one another as they were almost identical to those found on the Excelsior class. The nacelles and warp engine combined to give the Centaur an impressive top speed of warp 9.6.

In 2374, the *Centaur* was on the edge of Federation-controlled space when it encountered what was believed to be a lone Jem'Hadar attack ship returning to Dominion lines.

SPACE BATTLE

Captain Reynolds decided to engage the smaller vessel, and opened fire. However, he did not know that the Jem'Hadar vessel was actually under the control of Starfleet officers, led by his old friend Captain Benjamin Sisko, and was on a secret mission to destroy a ketracel-white production facility deep in Cardassian space.

Sisko's mission was so secret that other Starfleet vessels had not been told about it. A brief dogfight ensued, as Sisko tried not to cause serious damage to the *Centaur* by avoiding hitting its engines and targeting only its weapons. The battle ended only when three more Jem'Hadar attack

ships appeared and Reynolds was forced to retreat at speed back into Federation space.

Later in the Dominion War, the Centaur operated out of Starbase 375 along with the Second and Fifth Fleets, where they fought in several crucial theaters of combat before helping to retake *Deep Space 9* from Dominion forces.

DATA FEED

When Elim Garak was taken prisoner by Jem'Hadar troops in 2374, he claimed that he was Kamar, a member of the Cardassian Intelligence Bureau. He told them he had been working for the Founders when he was captured by the *U.S.S. Centaur*, a story that was completely false.

OPERATION RETURN

One of the most important battles of the Dominion War was Operation Return. This was a massive military undertaking in which Starfleet and its Klingon allies attempted to retake *Deep Space 9* from the Dominion. Captain Sisko assembled a huge task force that combined elements of the Second, Fifth and Ninth Fleets. Among the Starfleet ships known to have fought in this battle were the *U.S.S. Centaur, U.S.S. Cortez, U.S.S. Galaxy, U.S.S. Hood, U.S.S. Magellan, U.S.S. Majestic, U.S.S. Sarek, U.S.S. Sitak, and U.S.S. Venture.* The Allied fleet was confronted by 1,254 enemy vessels and outnumbered by about two-to-one, but still managed to win back control of *Deep Space 9*.

DATA FEED

Deep Space 9 became the headquarters of the Ninth Fl General Martok was made its supreme commander after recaptured from the Dominion. Vessels assigned to the Fleet included the U.S.S. Akagi, U.S.S. Exeter, U.S.S. Poter U.S.S. Sutherland and Martok's Bird-of-Prey, the IKS Rota

Warp field grille

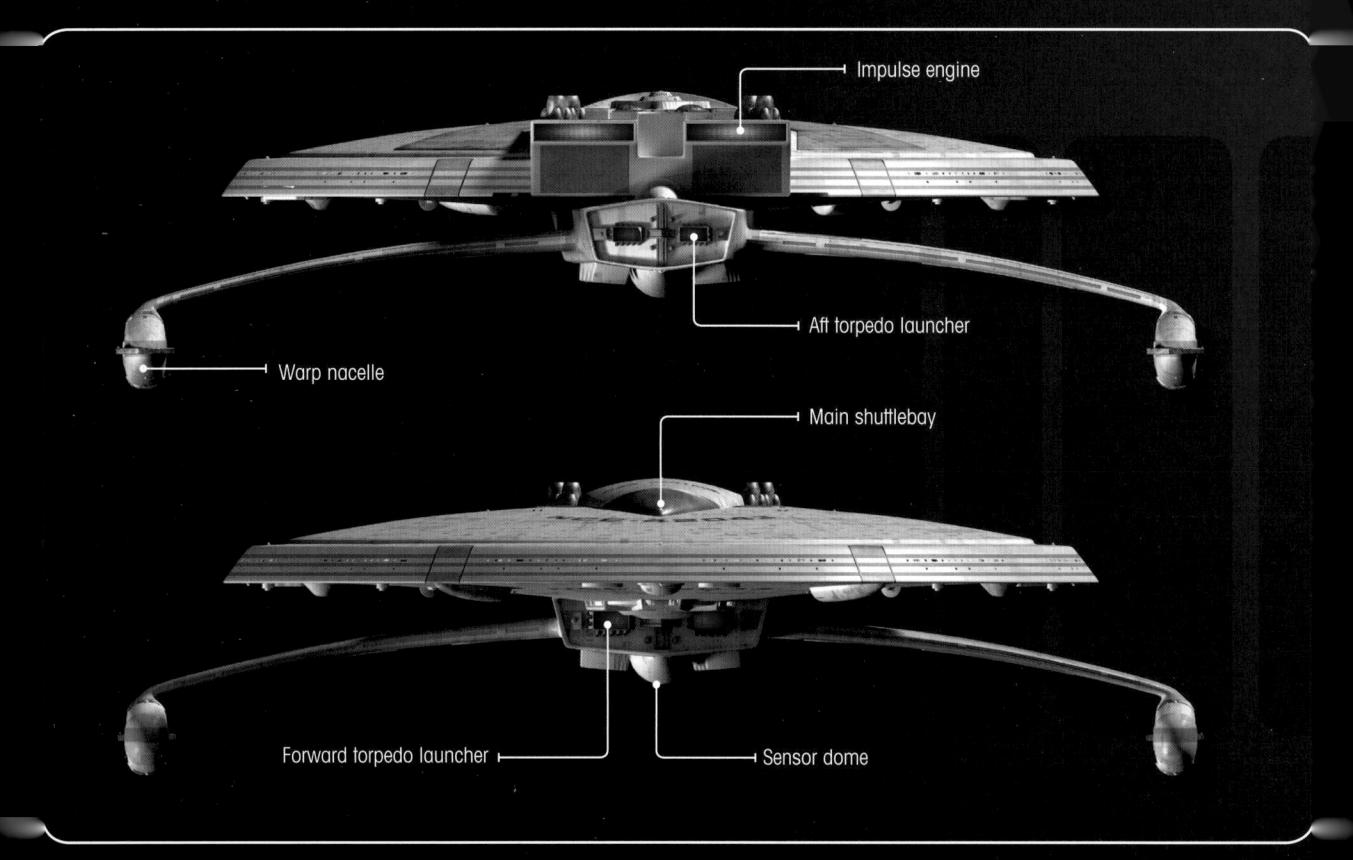

192 U.S.S. CENTAUR PLAN VIEWS

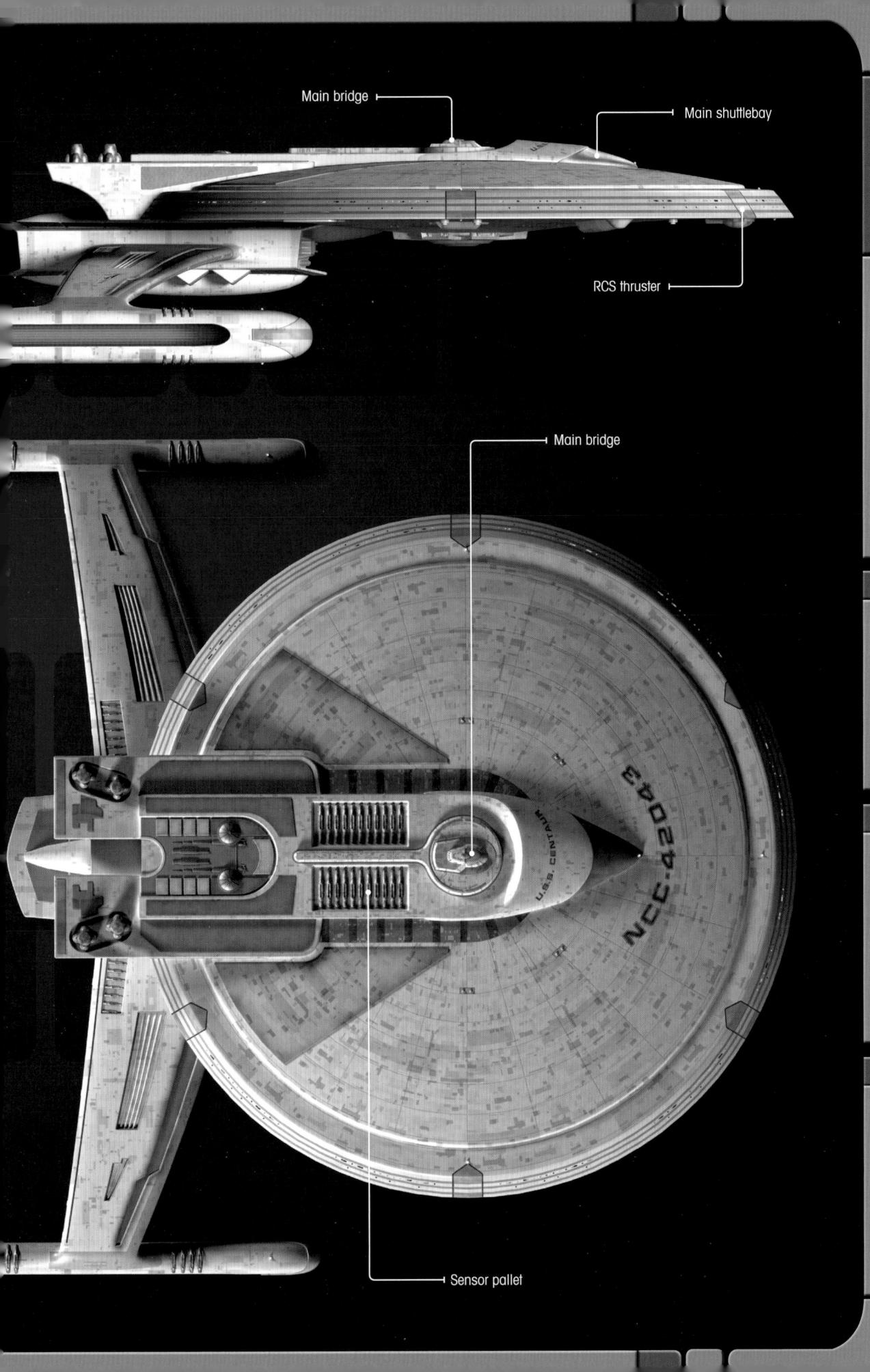

BOLD CAPTAIN

Charlie Reynolds, the captain of the *U.S.S.*Centaur, was described by Captain Sisko as someone who "never did know when to quit" and someone who liked to "swing for the fences."

MYTHIC NAME

The U.S.S. Centaur was probably named for the Greek mythological creature that had the head, arms and torso of a human and the body and legs of a horse. It was said to be the embodiment of untamed nature.

NAME CHANGE

The U.S.S. Centaur model was originally labeled the U.S.S. Buckner after the visual effects supervisor who built it. The name was never readable on screen, allowing it to be changed to Centaur in dialogue on screen.

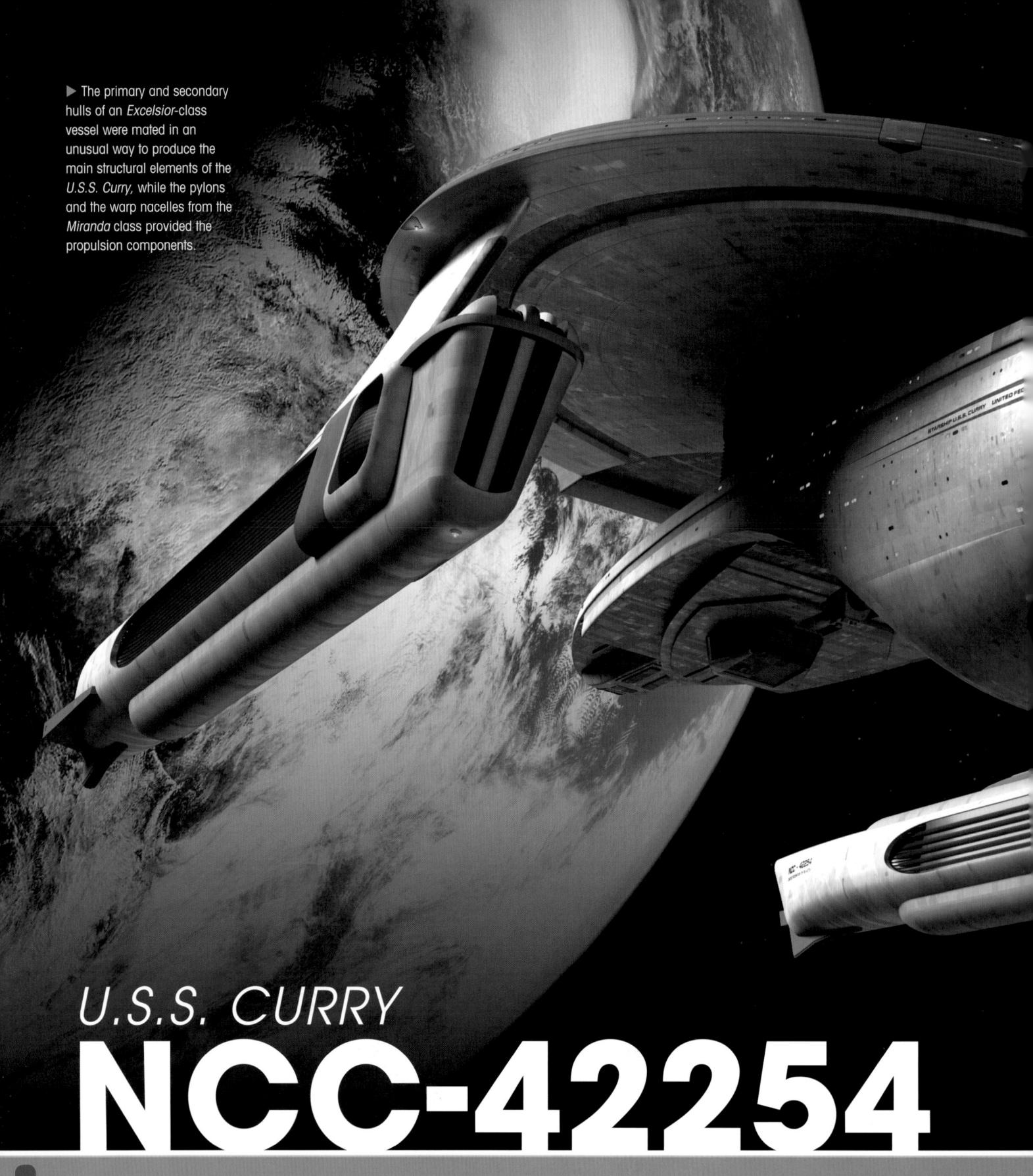

The *U.S.S. Curry* was hastily assembled from various classes of ship in order to fight in the war against the Dominion.

The U.S.S. Curry NCC-42254 was a 24th-century Starfleet vessel that fought with the Second
Fleet during the war with the Dominion. The Curry was unusual in that it was assembled from parts taken from different classes to meet the threat posed by the might of the Dominion.

The saucer and engineering hulls of the *Curry* were the same as those used on the *Excelsior* class. However, the secondary hull was moved much further forward, and connected to the middle of the saucer section rather than at the back. This meant that the front of the engineering hull extended out well beyond the front of the saucer, giving the ship a very distinct profile.

UNUSUAL CONFIGURATION

Another singular feature of the *Curry* was that the shuttlebay and the shuttlebay doors had been moved from the rear of the engineering hull, as they had been on the *Excelsior* class, to the front.

The warp nacelles and pylons on the *Curry* were very similar in shape and style to those found on the *Miranda* class, a type of ship that had first entered service over 100 years earlier. Despite their aging look, the nacelles were fitted with more advanced propulsion technology, and were capable of propelling the ship to a top speed of warp 9.6 for short periods.

In fact, although the different elements that made up the *Curry* came from classes that had been in service for some considerable time, many of the systems had been upgraded to late 24th-century specifications. For example, its sensors

◄ The Curry fought with the Second Fleet for a short time during the opening engagements of the Dominion War. This large armada was comprised of a number of Starfleet and Klingon ships, and included vessels from the Excelsior class, Miranda class, Steamrunner class, K't'inga class, Galaxy class, Vor'cha class and Saber class.

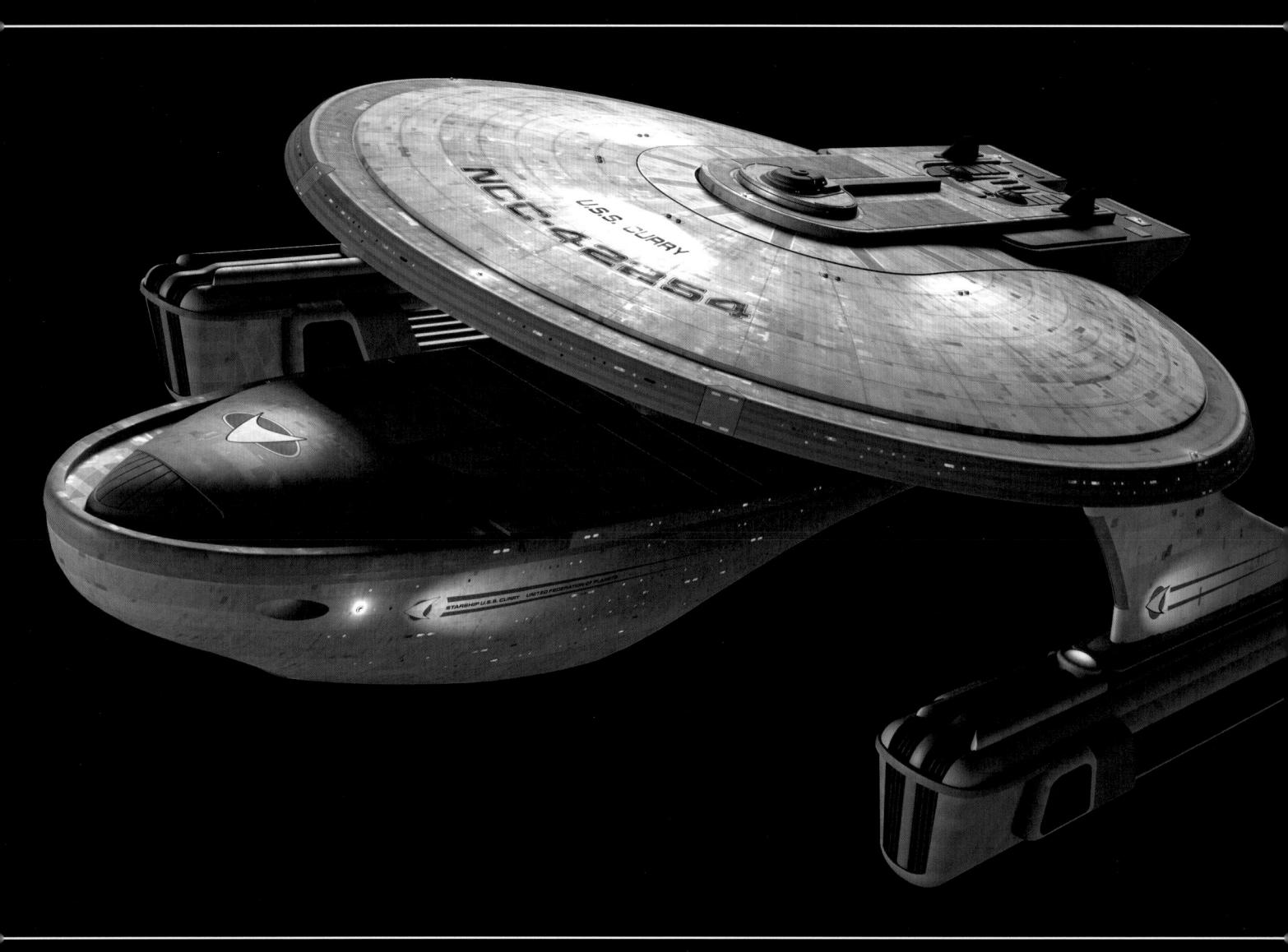

▲ The Curry looked a bit ungainly with its secondary hull jutting out beyond the saucer section, but it was effective. Starfleet needed all the ships it could muster to fight the Dominion, and refurbishing parts from salvaged vessels was a quick way of adding more vessels to the fleets that fought in the war.

had been upgraded, while its armaments, which included ten phaser emitters and two photon torpedo launchers, had also been modernized.

This latter feature was of particular importance, given the situation that the Federation had found itself in. After first contact had been made with the Dominion in 2370, a state of cold war had developed following the destruction of the *U.S.S. Odyssey* NCC-71832 by the Jem'Hadar. From that point on, many thought it was only a matter of time before the Dominion invaded.

Realizing that if they were going to be able to repel the legions of the Dominion's Jem'Hadar soldiers, Starfleet needed ships – and fast. Starship production was ramped up in all fleet yards, with Starfleet engineers using whatever resources they could find. Parts and systems from vessels that were going to be scrapped were instead salvaged, reconditioned and upgraded.

This led to ships like the *Curry*, which included elements from several different classes. In order to expedite the building of these vessels and get them into service as quickly as possible, some of the internal layout was left empty. This meant facilities such as holodecks and research labs were not fitted as they normally were on Starfleet ships of this time. Instead, it was important that vessels like the *Curry* were launched as soon as their defensive and combat systems were ready.

WAR BREAKS OUT

The Curry joined the Second Fleet, an alliance of Starfleet and Klingon vessels that numbered in the hundreds. By 2373, the Second Battle of Deep Space 9 signaled the start of war with the Dominion. The Dominion captured the station, but Captain Sisko was able to evacuate all Starfleet personnel, and activate a minefield within the

- ▶ An Excelsior-class ship, like the one pictured here, provided much of the framework of the Curry, including both the main hulls. The engineering hull was moved much further forward on the Curry.
- ▼ The Curry, seen here in the bottom right of the picture, was badly damaged in fighting with the Dominion. A large part of its saucer had been blown away, and its secondary hull was etched with scorch marks.

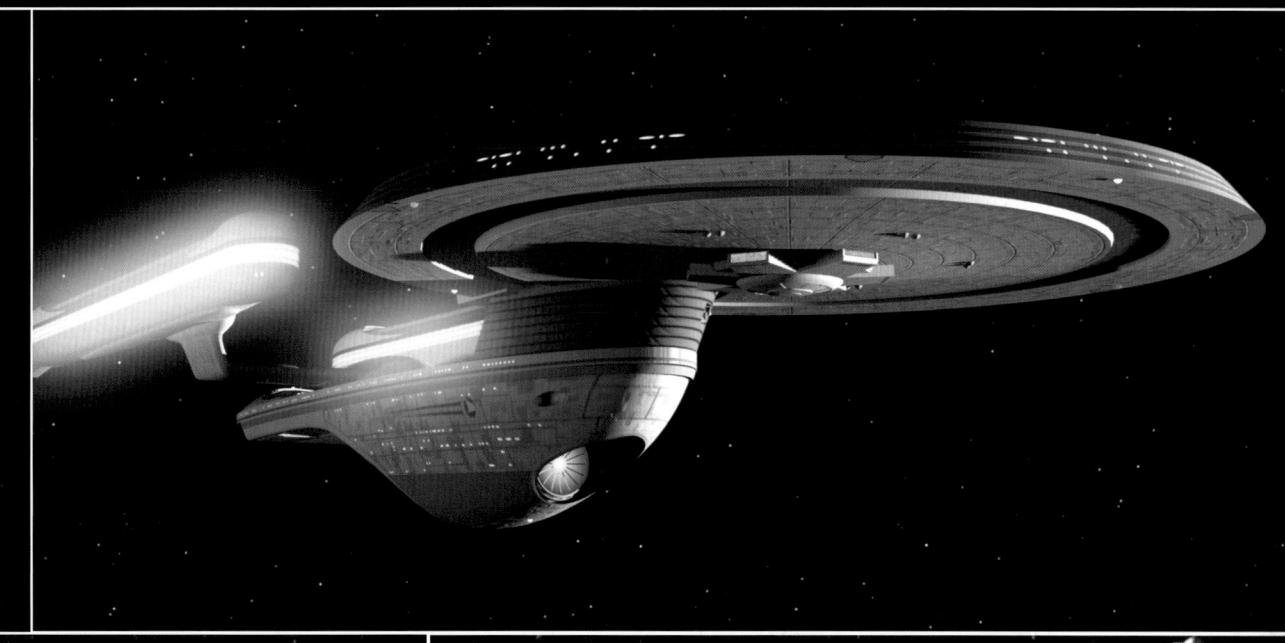

Bajoran wormhole that prevented Dominion reinforcements from the Gamma Quadrant joining the war. While this was going on, the Second Fleet crossed the border into Cardassian territory and destroyed a major Dominion shipyard at Torros III.

This proved to be one of the few successes for the Allies at the beginning of the war. Just three months later, Allied fleets were in disarray, as they were forced to continually retreat in the face of overwhelming Dominion opposition. The once proud and powerful armada that made up the Second Fleet had been reduced by the ravages of war to a third of its original size.

After one particular bruising encounter, the remaining ships of the Second Fleet limped back to Federation space, all looking battered and much the worse for wear. Some were leaking plasma, others were towed, unable to proceed under their own power, while the *Curry* had

suffered a massive hull breach to its saucer section and was barely operational.

This was the last time that the *Curry* was seen, even though the Second Fleet took part in many more engagements during the Dominion War. It may have been that the *Curry* was too badly damaged to be repaired, and any parts that were salvageable were used to build more ships.

▲ The U.S.S. Fredrickson NCC-42111, an Excelsior-class ship, fought alongside the Curry in the Second Fleet. It suffered even more damage than the Curry, and had to be towed back to Federation space.

DATA FEED

Captain Sisko commanded the Second Fleet from the *U.S.S. Defiant* NX-74205 in many of the engagements with the Dominion in the first three months of the war. This was a grim time for the Federation and its Allies, as their fleets were constantly forced into retreat by the Jem'Hadar. Sisko tried to remain positive for the sake of morale, but even he felt hopeless rage when he heard that the Seventh Fleet had been decimated by the Dominion.

MIXED CLASSES

At the time the *U.S.S. Curry* was part of the Second Fleet, this task force was made up of a number of different classes of Starfleet and Klingon ships. While many of the Starfleet vessels were from familiar classes, a few, like the *Curry*, were comprised of parts taken from various classes.

The most notable of these was the *U.S.S.*Raging Queen NCC-42264, which shared much in common with the *Curry*. The *Raging*Queen mainly used parts from the *Excelsior* and *Miranda* classes in a similar configuration, but the nacelles were connected at the rear of the saucer with an additional pair of corrugated pylons.

In addition, there were more hybrid classes in the Second Fleet in the shape of the *U.S.S. Centaur* NCC-42043 and the *U.S.S. Elkins* NCC-74112. The *Centaur* was also largely made up of *Excelsior* and *Miranda*-class parts, but it did not feature a secondary hull. The *Elkins*, on the other hand, featured a very similar saucer hull to that of *Intrepid*-class vessels, and this was mated to a secondary hull, which looked similar to the one used on a Maquis raider.

▲ In 2374, the battle-weary Second Fleet retreated to the relative safety of Federation space. The armada included several 'mongrel' ships, such as the *Curry*, the *Raging Queen*, the *Centaur* and the *Elkins*.

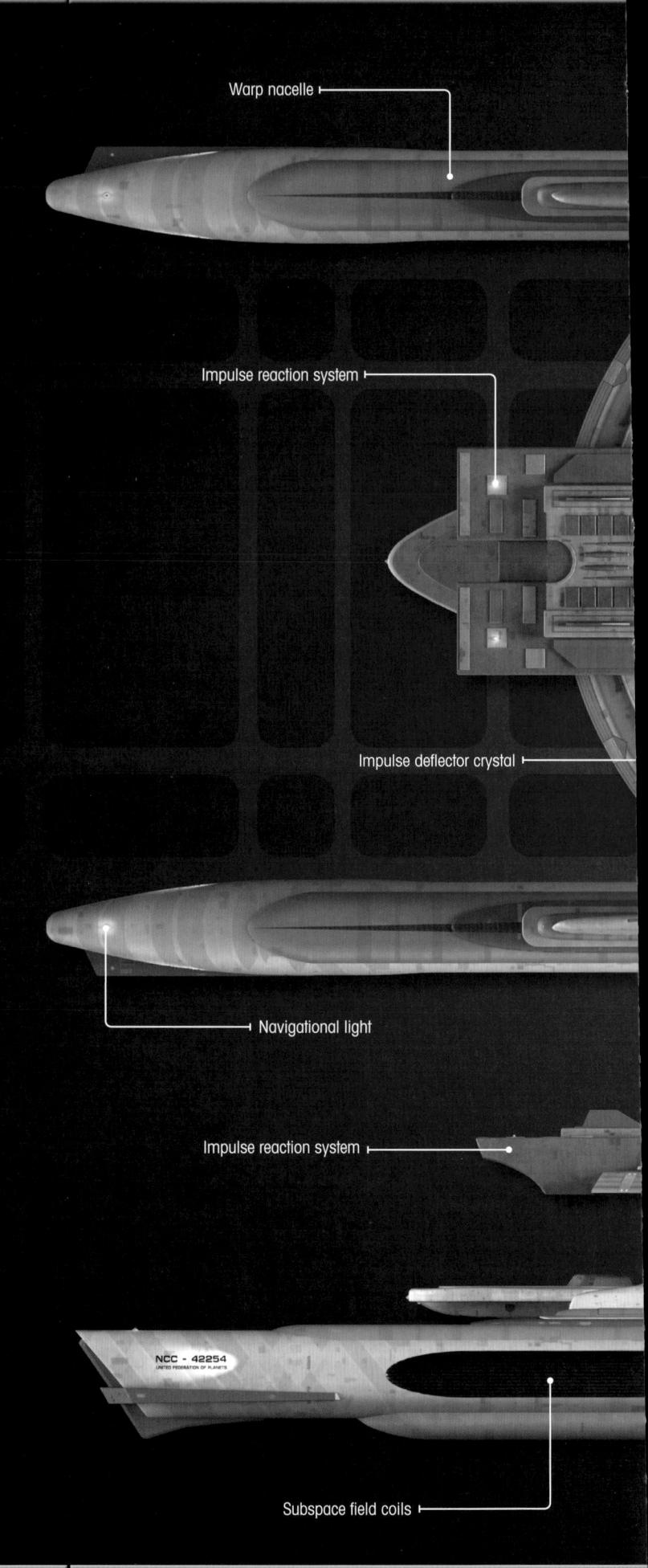

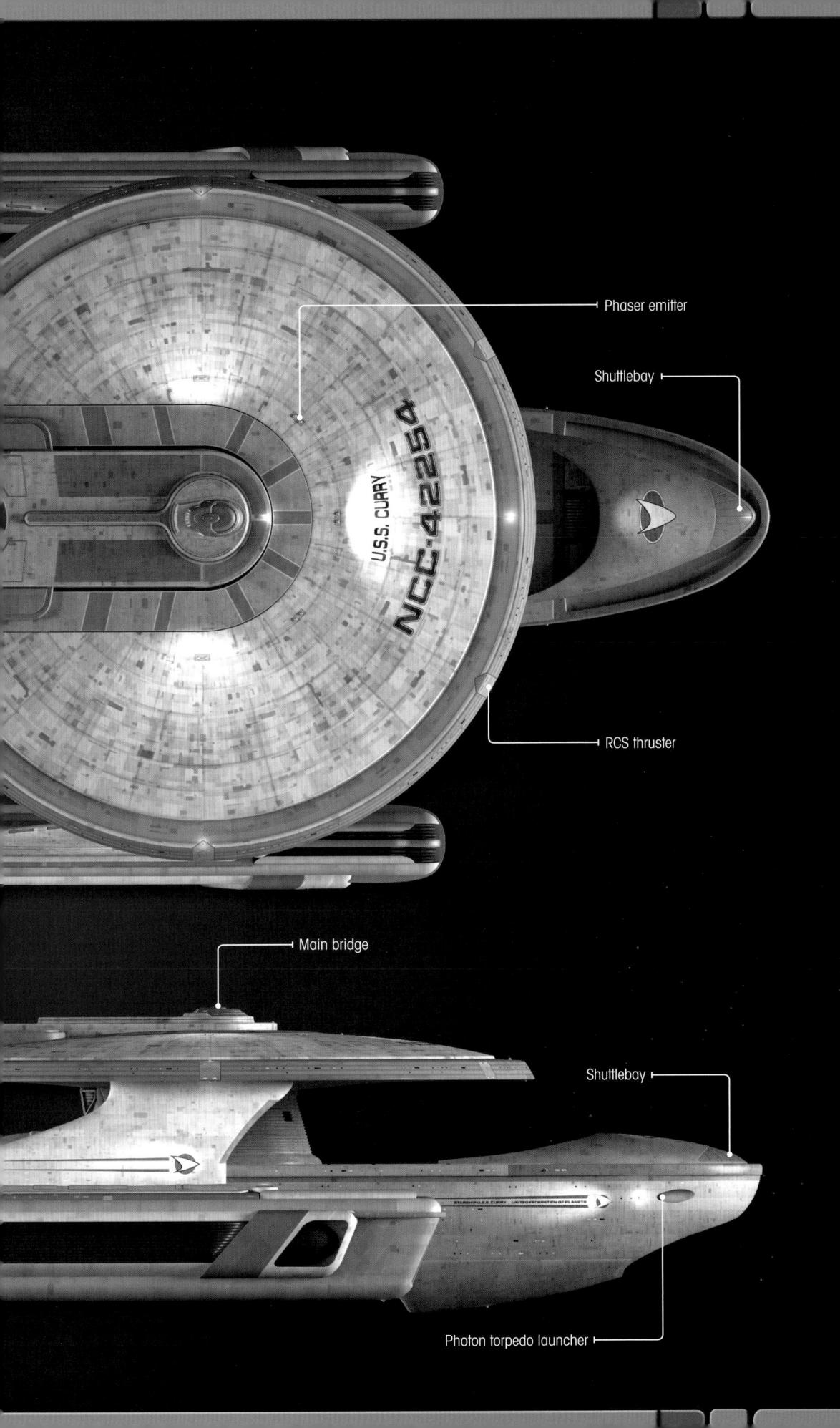

HUGE OPERATION

In order to retake *Deep Space 9* from the Dominion, Captain Sisko put together a task force that comprised elements from the Second, Fifth and Nine Fleets — around 800 ships.

FAILED ASSAULT

Later in the Dominion War, the Second Fleet tried three times in a month to retake Betazed from occupying forces. Unfortunately, they were unable to do so because the Dominion kept sending in reinforcements and fortifying their position.

COMEDY NAME

The lettering of the Raging Queen was never seen on screen. It was only discovered later when photos of the studio model surfaced. The name 'Raging Queen' came from a pirate vessel, which featured in a Saturday Night Live sketch starring Michael Palin.

U.S.S. ENTERPRISE

NCC-1701-E

The Sovereign-class Enterprise-E was designed as a sleek and tough ship that was ready to fight the Borg.

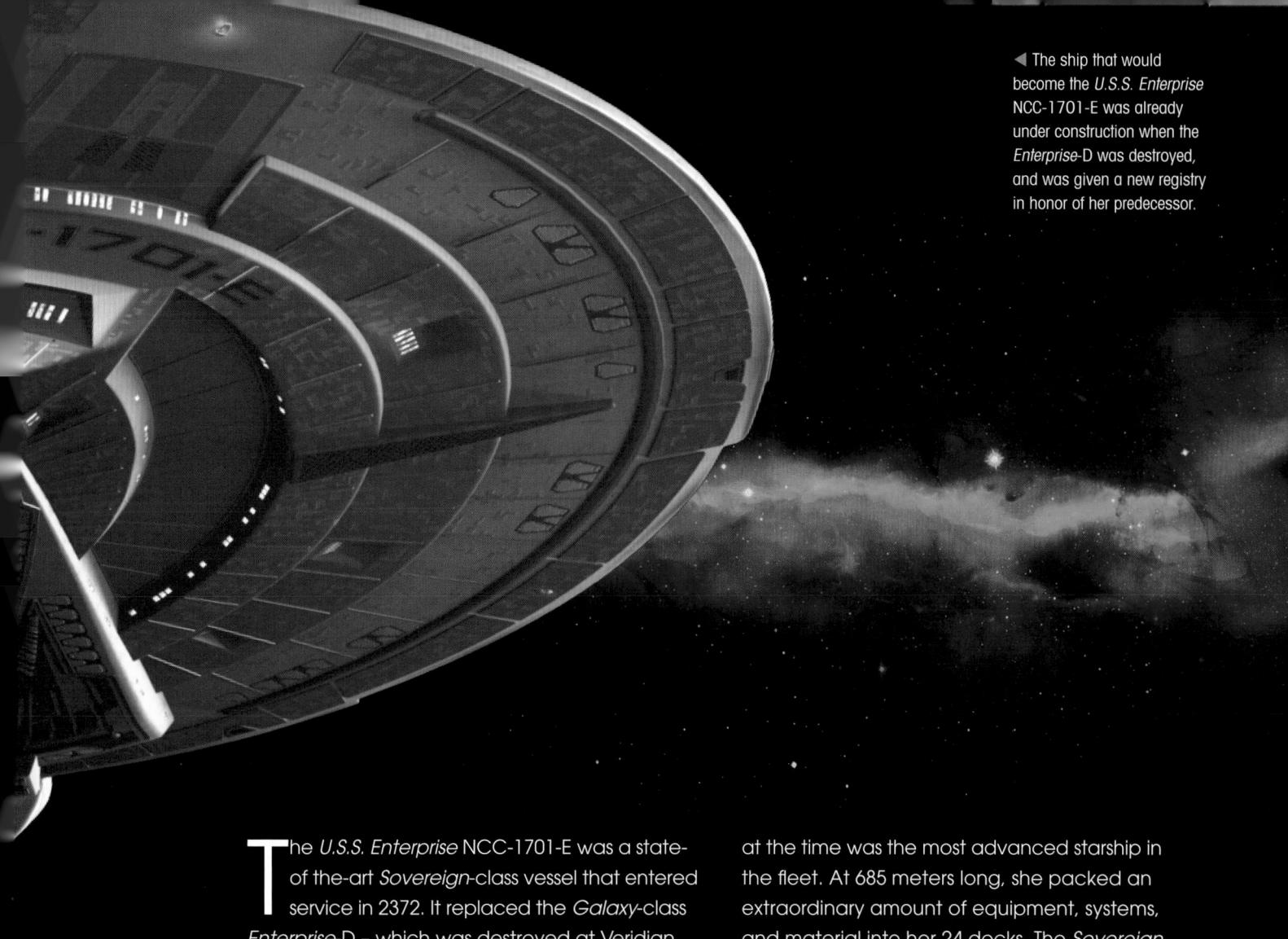

Enterprise-D - which was destroyed at Veridian III the previous year - becoming Starfleet's new flagship and the sixth Federation vessel to bear the name Enterprise.

The new Enterprise was constructed at the

The new *Enterprise* was constructed at the San Francisco ship yards in orbit of Earth, and

at the time was the most advanced starship in the fleet. At 685 meters long, she packed an extraordinary amount of equipment, systems, and material into her 24 decks. The *Sovereign* class was designed with the threat from the Borg in mind, and when the *Enterprise*-E launched, she was armed with 12 Type-XII phaser strips, each of which had an output of 7.2 megawatts. The phasers could be set to automatically remodulate, making them more effective against the Borg's adaptive shields. The *Enterprise*-E was also fitted with five torpedo launchers, each of which could fire a spread of 12 torpedoes. In addition to regular photon torpedoes, the ship also carried the latest evolution of torpedo design – quantum torpedoes, which used zero-point energy to create a high-

■ The Enterprise-E was the third ship to be commanded by Jean-Luc Picard, who brought most his senior staff with him from her predecessor, the Enterprise-D. The E proved pivotal in stopping separate Borg and Romulan attacks on Earth. She also served with distinction during the Dominion War.

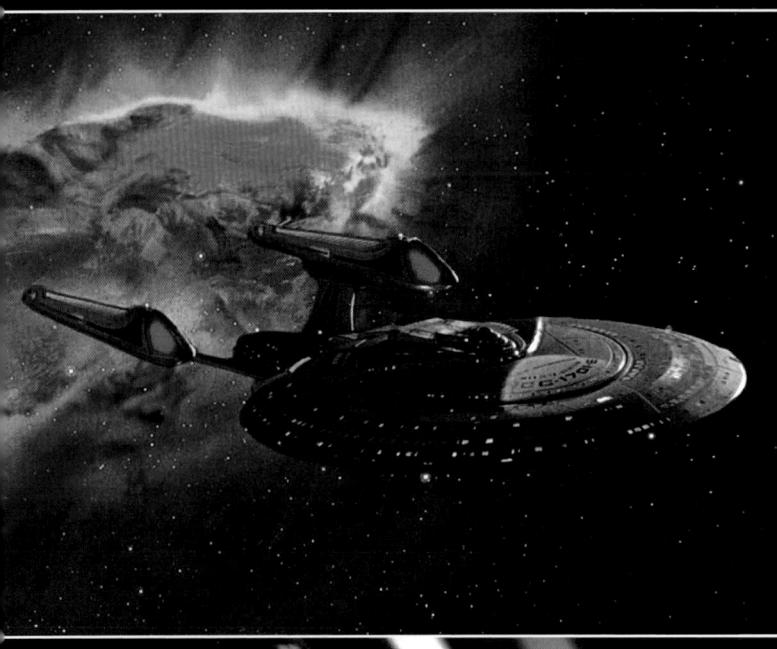

- When the Borg attacked in 2372, the Enterprise-E was the most advanced ship in the fleet. But with Picard having once been assimilated by the Borg, Starfleet Command feared that the captain could be unreliable and assigned the ship to patrol the Romulan Neutral Zone.
- ▶ Picard disobeyed his orders and the *Enterprise* joined the Battle of Sector 001, taking command of the fleet. Picard's innate understanding of the Borg then proved instrumental to defeating them.

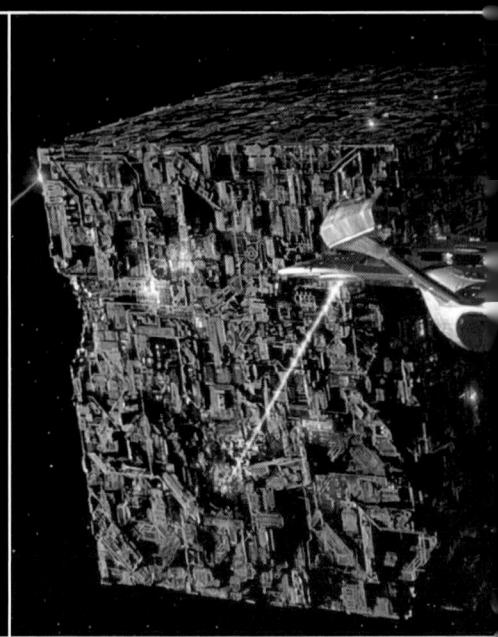

▲ Like the Enterprise-D, the Enterprise-E was fitted with a Captain's Yacht, which was docked on the underside of the saucer section. This large and somewhat luxurious shuttle was designed for diplomatic missions.

energy yield. The *Enterprise*'s shields were also designed to automatically remodulate, making them more resistant to Borg weapons fire. In 2376, the *Enterprise* underwent a refit, which included adding a further four phaser arrays, and five more torpedo launchers.

The vessel was fitted with redesigned warp engines and nacelles that were superior to those of the *Galaxy* class. The new design allowed the ship to maintain a cruising velocity of warp 8, while its high warp velocity was around 9.95. Emergency plasma purge vents in the nacelle support pylons provided the ships' engineers with a secondary safety buffer, allowing them to bleed-off heated plasma before it reached the warp field coils. In some circumstances, this obviated the need to shut down systems or eject the warp core.

As had become standard practice by the late 24th century, the *Sovereign* class carried

a diplomatic shuttle known as the Captain's Yacht, which was normally docked on the underside of the saucer. It also had the ability to separate the saucer section from the main engineering hull.

LIVING COMPUTERS

The computer systems featured advanced bioneural circuitry, which employed synthetic cells rather than optical technology. This semi-organic system could process 6,200 kiloquads of data per second, but was still in its infancy and was vulnerable to attack and infection. Accordingly, it functioned in concert with aconventional Optical Data Network (ODN).

The Enterprise-E was also one of the first vessels to be fitted with an Emergency Medical Hologram (EMH), which was designed to provide short-term assistance by supporting or even replacing the ship's medical staff in an emergency. During an

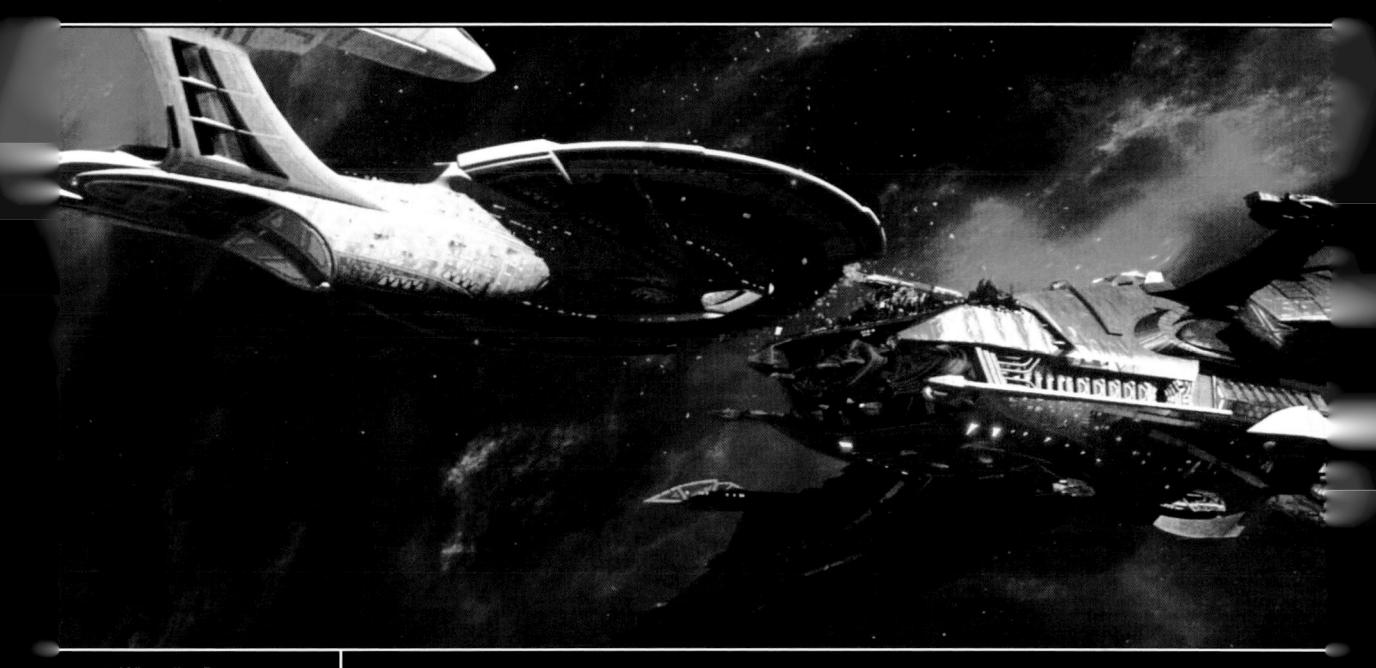

▲ When the Reman leader Shinzon attacked Earth, the Enterprise-E was overpowered by his flagship, the Scimitar. Picard only managed to stop him by ramming his ship into the Scimitar.

■ Following the Borg invasion of 2372, the Enterprise-E pursued the Borg into the past, where she was temporarily assimilated, forcing the crew to abandon ship.

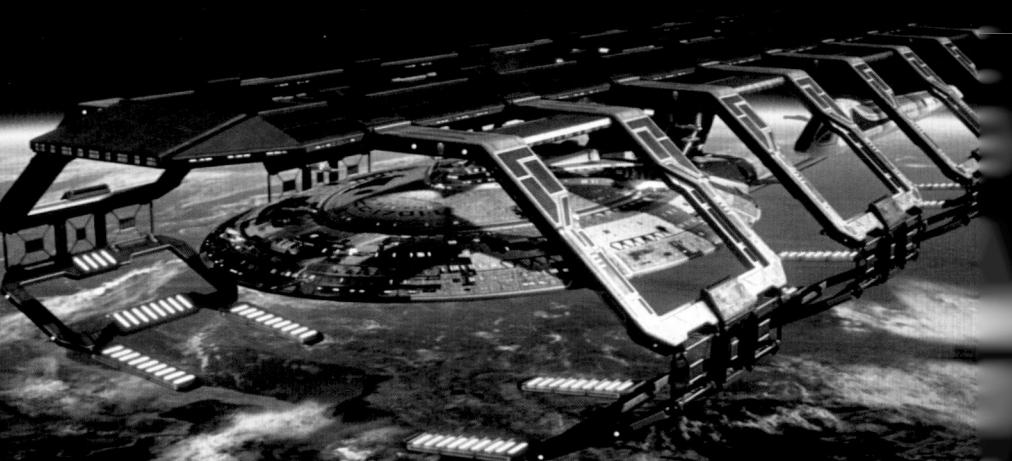

rprise by the Borg, the EMH was distraction, allowing the medical tients to escape from sickbay.

terprise-E had the same basic s as her predecessor, she did ans or family members. Instead, ntirely by Starfleet personnel, d with exploring space and e and new civilizations.

AREER

ise had substantially the same s her predecessor. Captain ommand on launch and was eating the Borg invasion of 2373 Sa'ku crisis of 2375. However, by crew were ready to move on, liam Riker was promoted to a command of the U.S.S. Titan.

On their final mission together, the ship was nearly destroyed by the vast Reman warbird *Scimitar*, and Picard took the radical step of ramming the enemy vessel. Victorious but badly damaged, the *Enterprise* then returned to spacedock where she underwent substantial repairs. She also took on a new first officer, Commander Martin Madden, before resuming her mission of exploration.

▲ The Enterprise survived her collision with the Scimitar and returned to spacedock where she underwent substantial repairs.

DATA FEED

Though Captain Picard remained in command of the *Enterprise*-E throughout its career, several of his senior staff eventually left the ship. Commander Riker was promoted to Captain and assumed command of the *U.S.S. Titan*, while Commander Data was lost in the final battle with the Reman leader Shinzon.

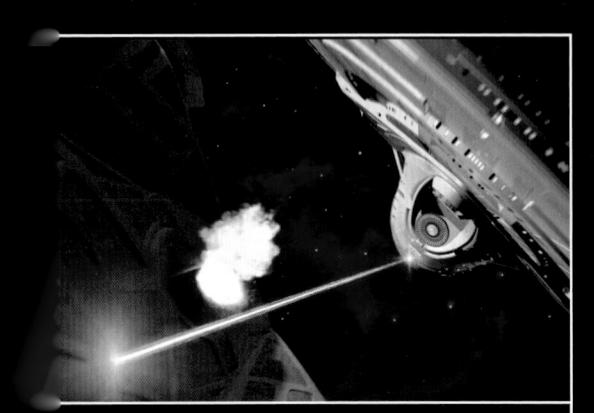

REGULAR REFITS

SHIP PROFILE

During its operational life, the Enterprise-E underwent a number of refits and upgrades that increased the amount of weaponry she carried and enhanced the efficiency of her engines. The first refit involved repairing damage inflicted by the Borg and upgrading the weaponry by adding more torpedo launchers. A second refit involved moving and shortening the nacelles, reducing the ship's length from 685 to 673 meters.

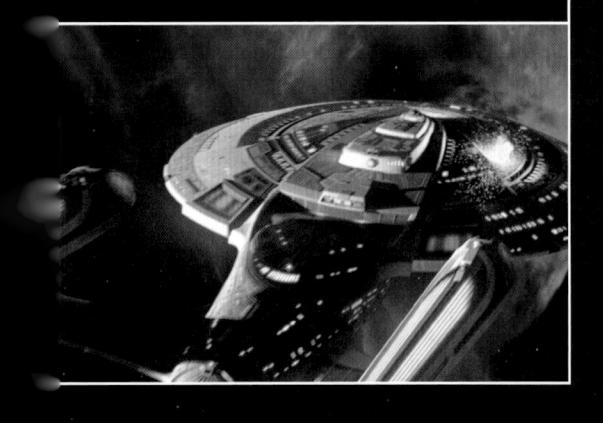

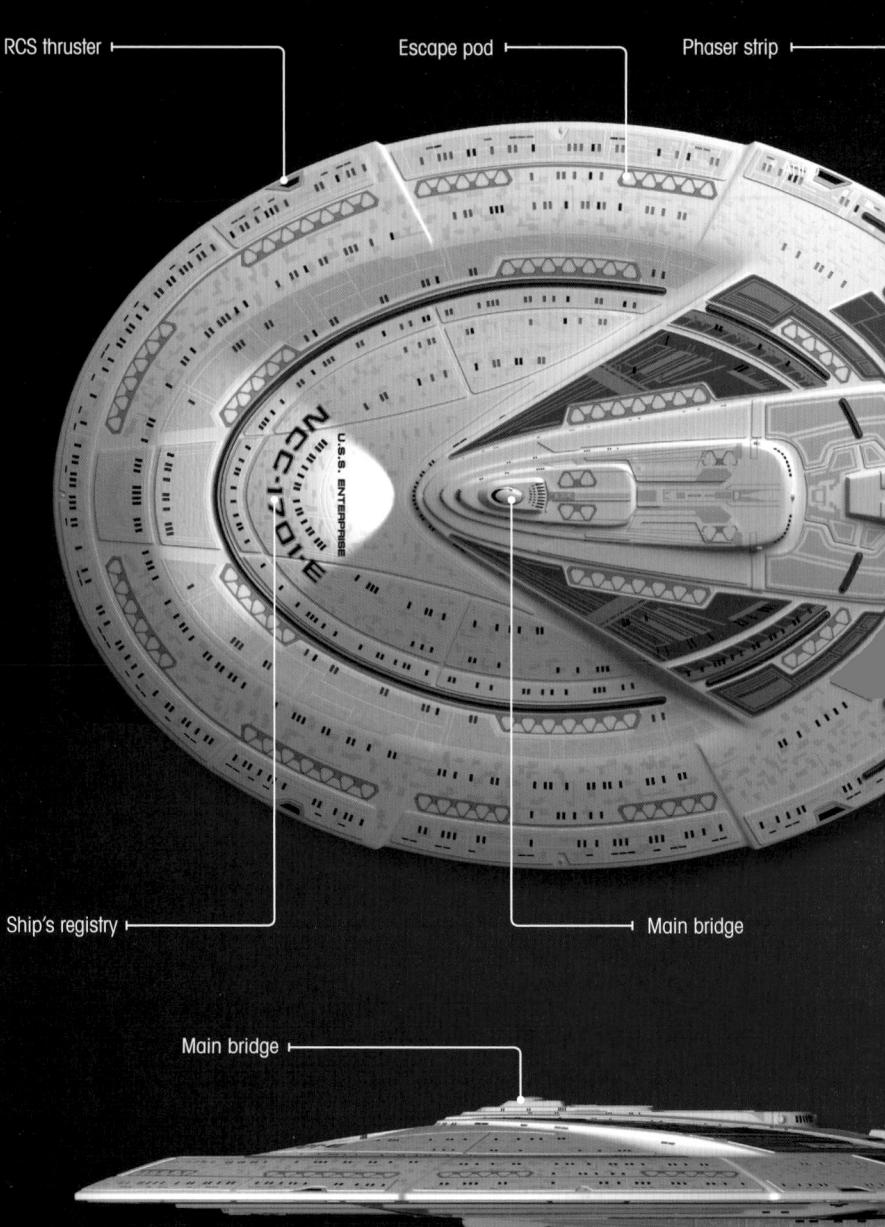

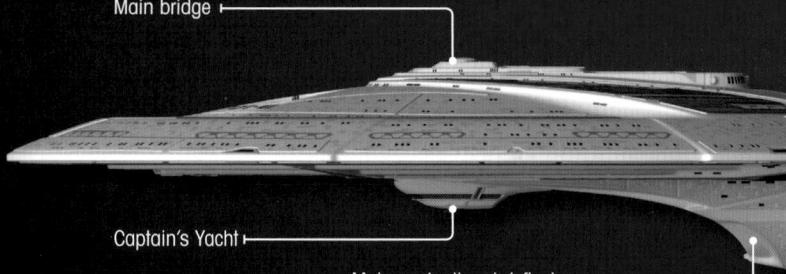

Main navigational deflector +

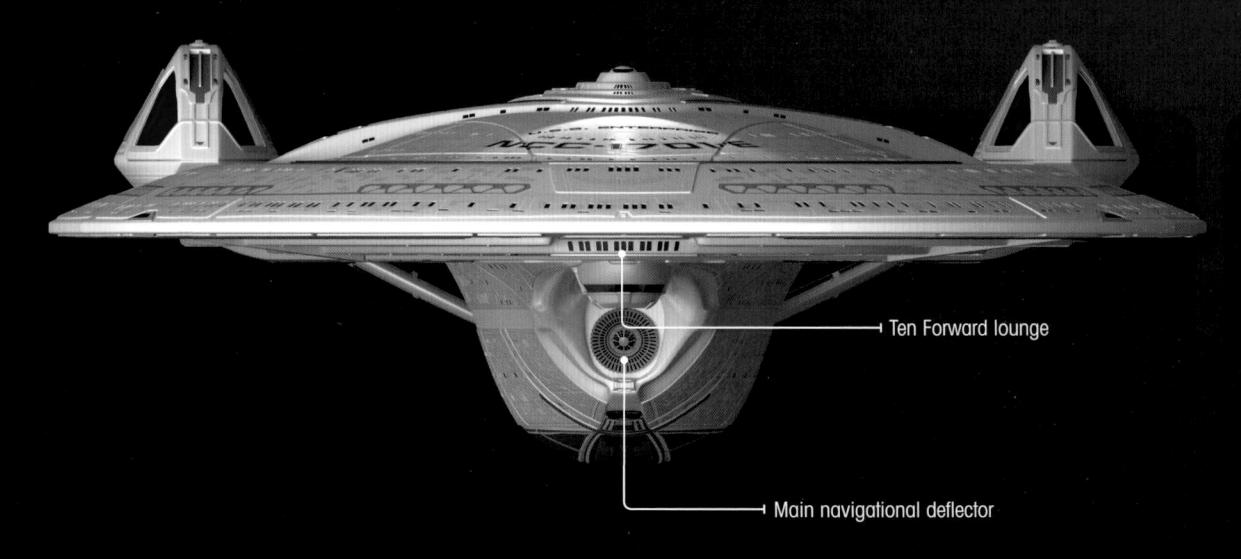

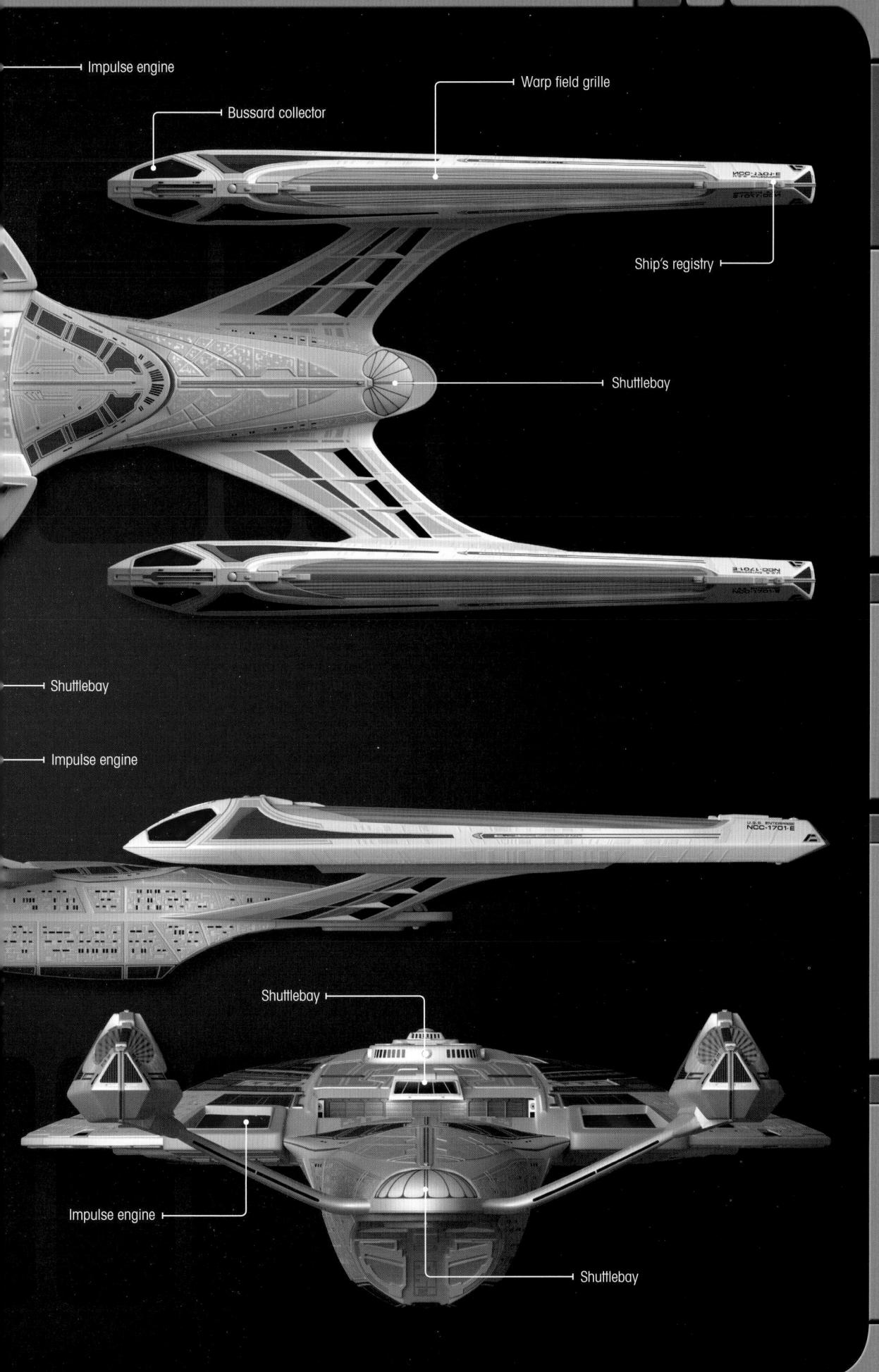

QUANTUM TORPEDOES

The Enterprise-E carried both standard photon torpedoes and quantum torpedoes. The latter generated high-yield explosions by creating miniature versions of the "big bang" event.

NAME CHANGE

The ship that became the *U.S.S. Enterprise* NCC-1701-E was originally slated to have a different name and registry number, but this was changed after the *Galaxy*-class *Enterprise*-D met its fate at Veridian III.

DOMINION WAR

The Enterprise-E did see service in the Dominion War. Assigned to other vital duties, she did not take part in any of the major conflicts, such as the Battles of Chintoka or Cardassia.

MULTI-MISSION EXPLO

SIZE CHART

U.S.S. VOYAGER NCC-74656

343m

U.S.S. STARGAZER NCC-2893

310m

U.S.S. CENTAUR NCC-42043

210m

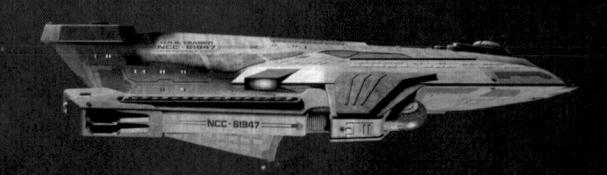

SABER CLASS

223m

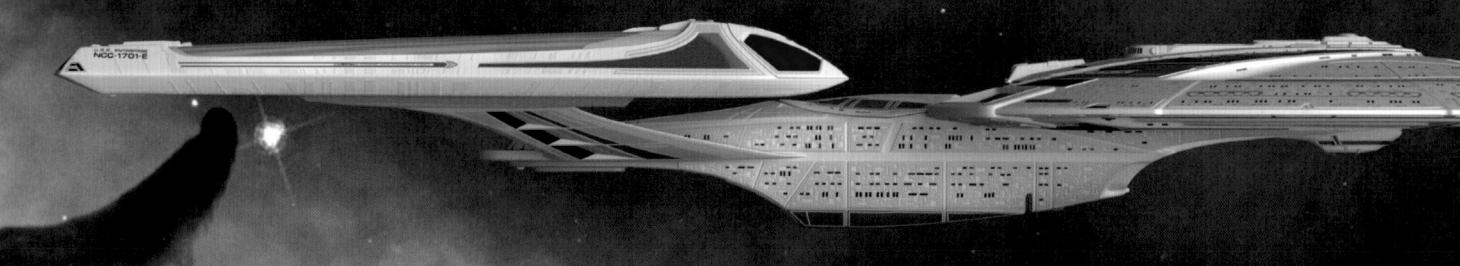

U.S.S. ENTERPRISE NCC-1701-E

685m

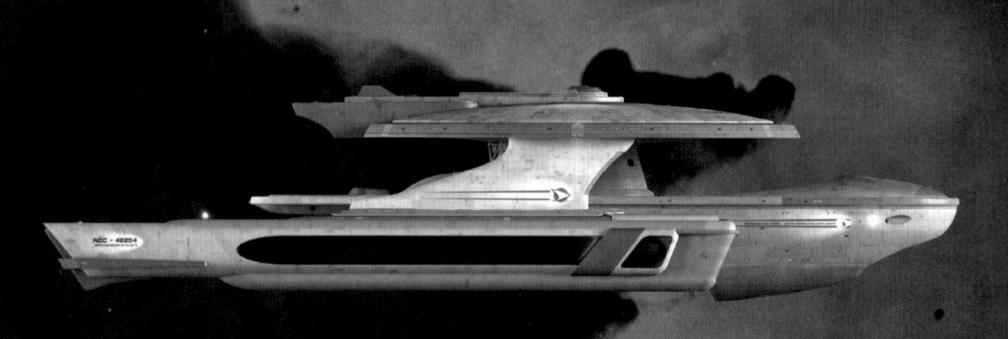

U.S.S. CURRY NCC-42254

210m

STARFLEET CHEYENNE CLASS

RERS

SCALE: 1:3000

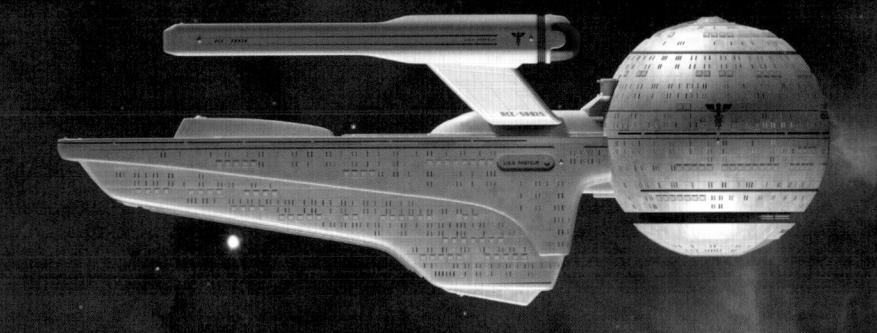

U.S.S. PROMETHEUS NX-59650

126m

U.S.S. PASTEUR NCC-58925

320m

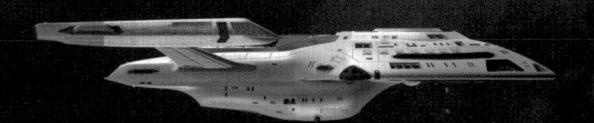

U.S.S. EQUINOX NCC-72381

222m

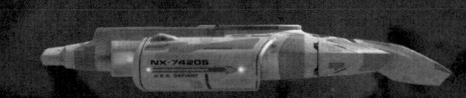

U.S.S. DEFIANT NX-74205

170.68m

STARFLEET TUG

90m

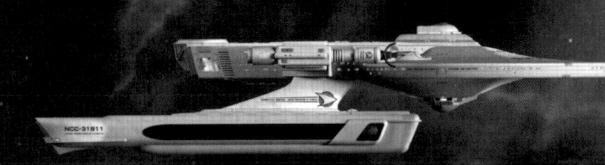

U.S.S. SARATOGA NCC-31911

243m

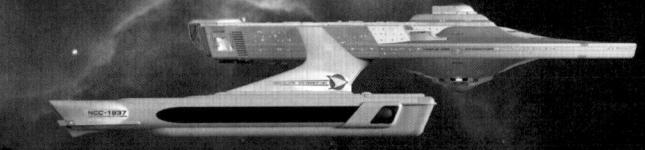

U.S.S. LANTREE

243m

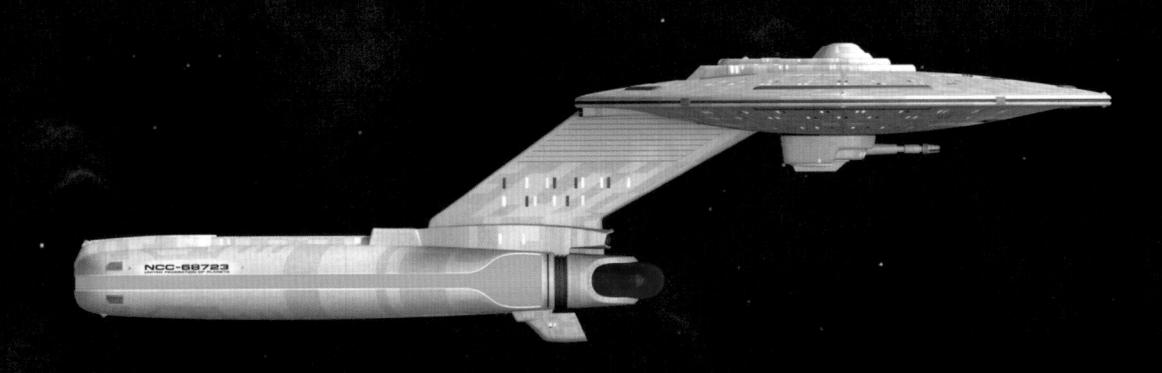

STARFLEET FREEDOM CLASS

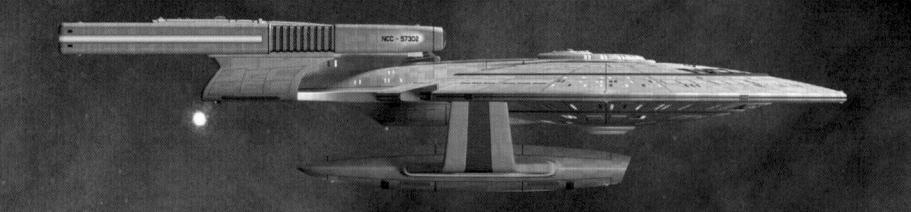

STARFLEET SPRINGFIELD CLASS

325m

STEAMRUNNER CLASS

343m

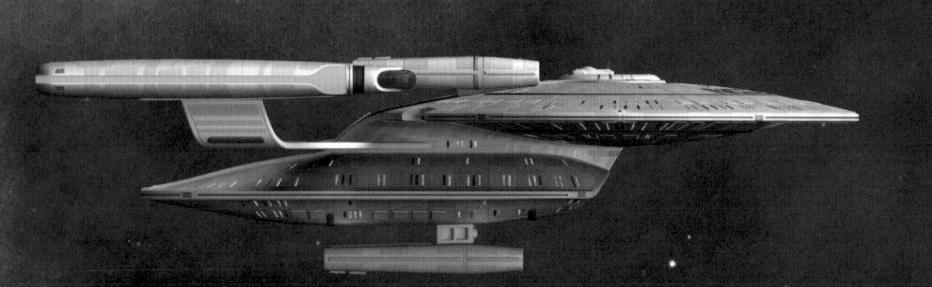

NEW ORLEANS CLASS

340m

STARFLEET CHALLENGER CLASS

390m

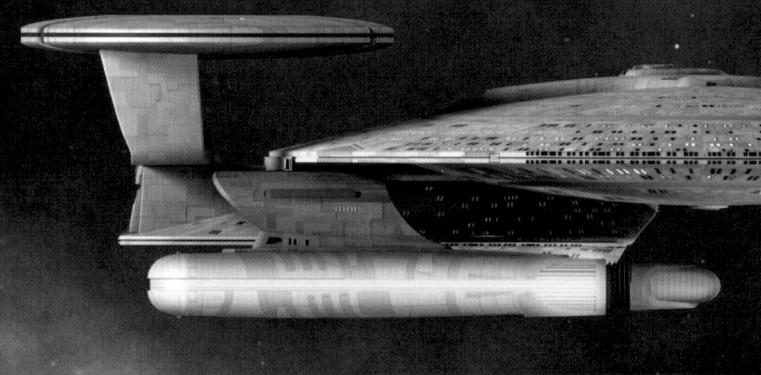

U.S.S. PHOENIX NCC-65420

465m

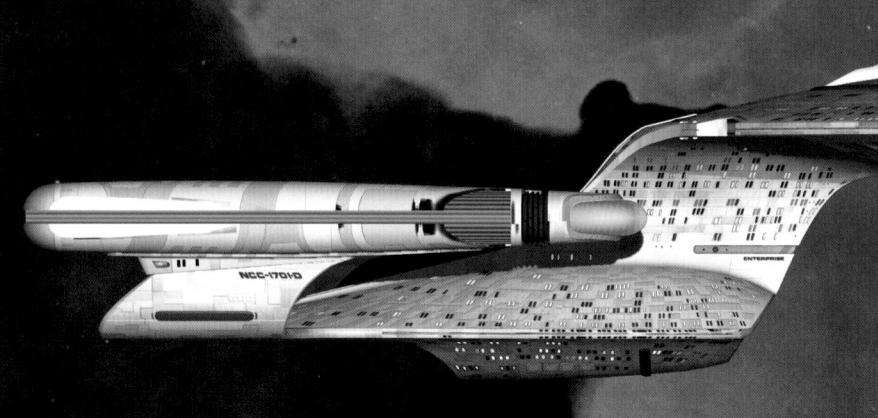

U.S.S. ENTERPRISE NCC-1701-D

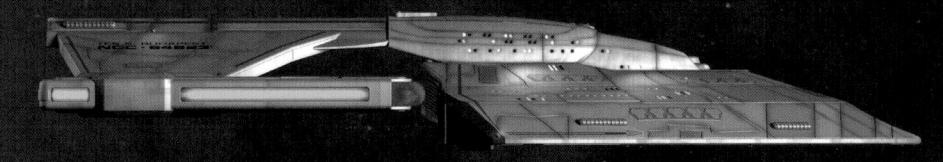

NORWAY CLASS

364.77m

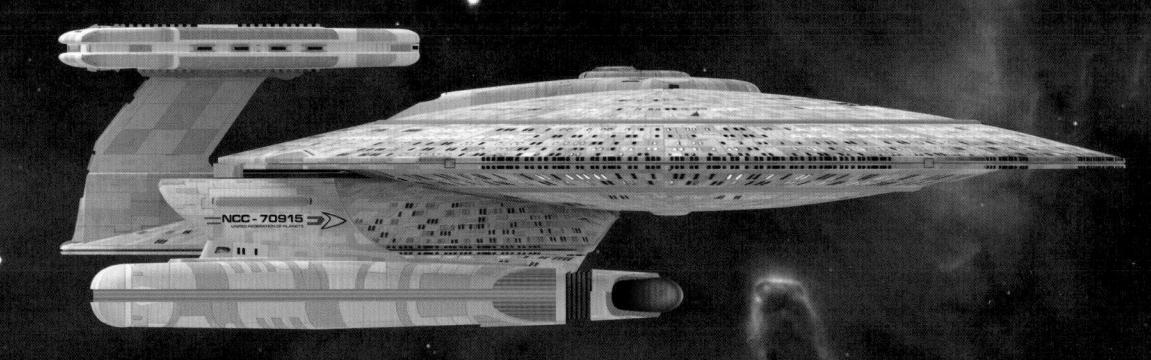

THE NEBULA CLASS

442.23m

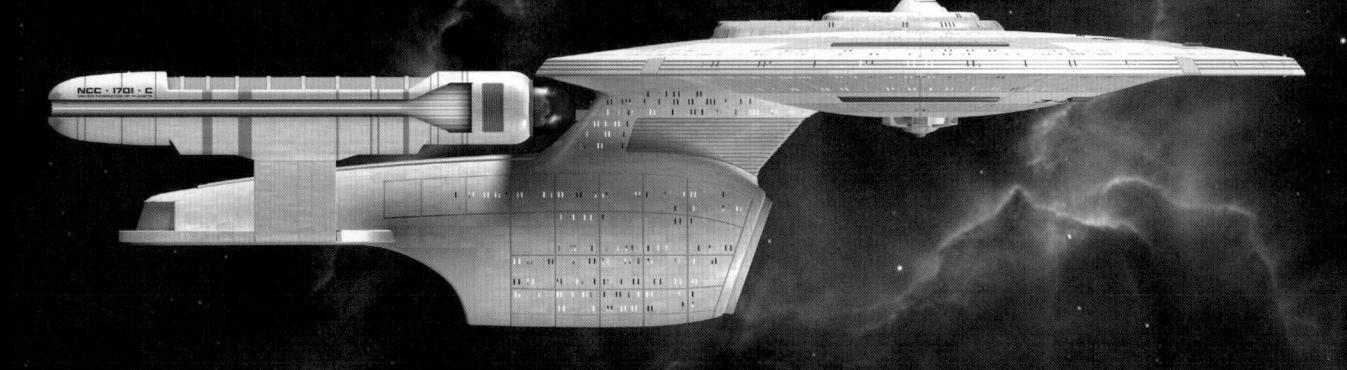

U.S.S. ENTERPRISE NCC-1701-C

520m

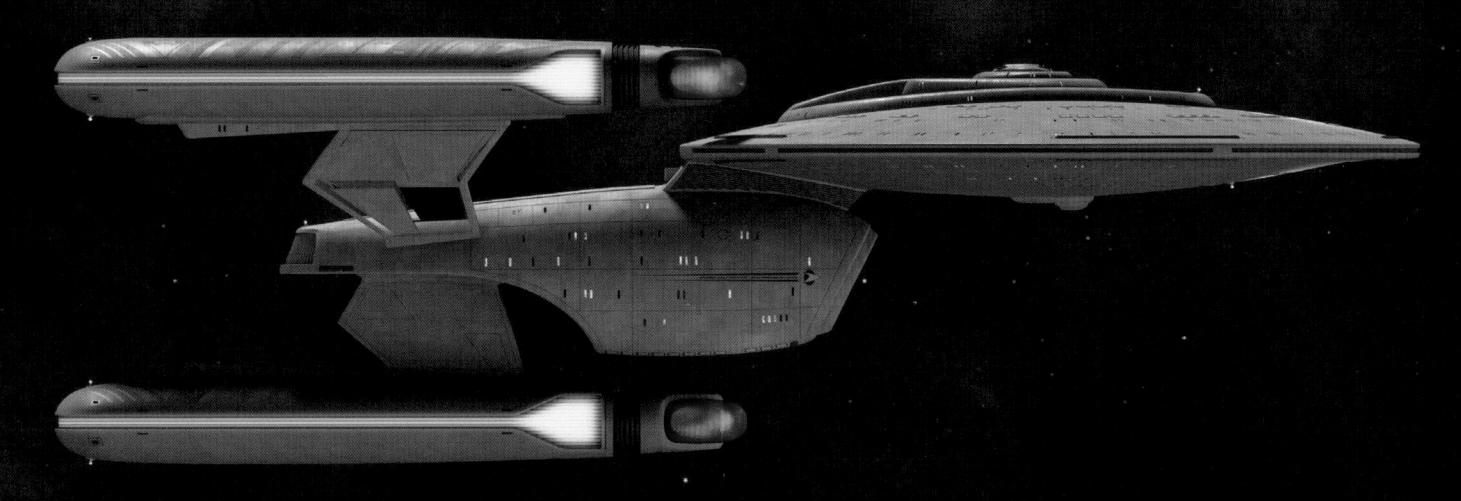

STARFLEET: NIAGRA CLASS

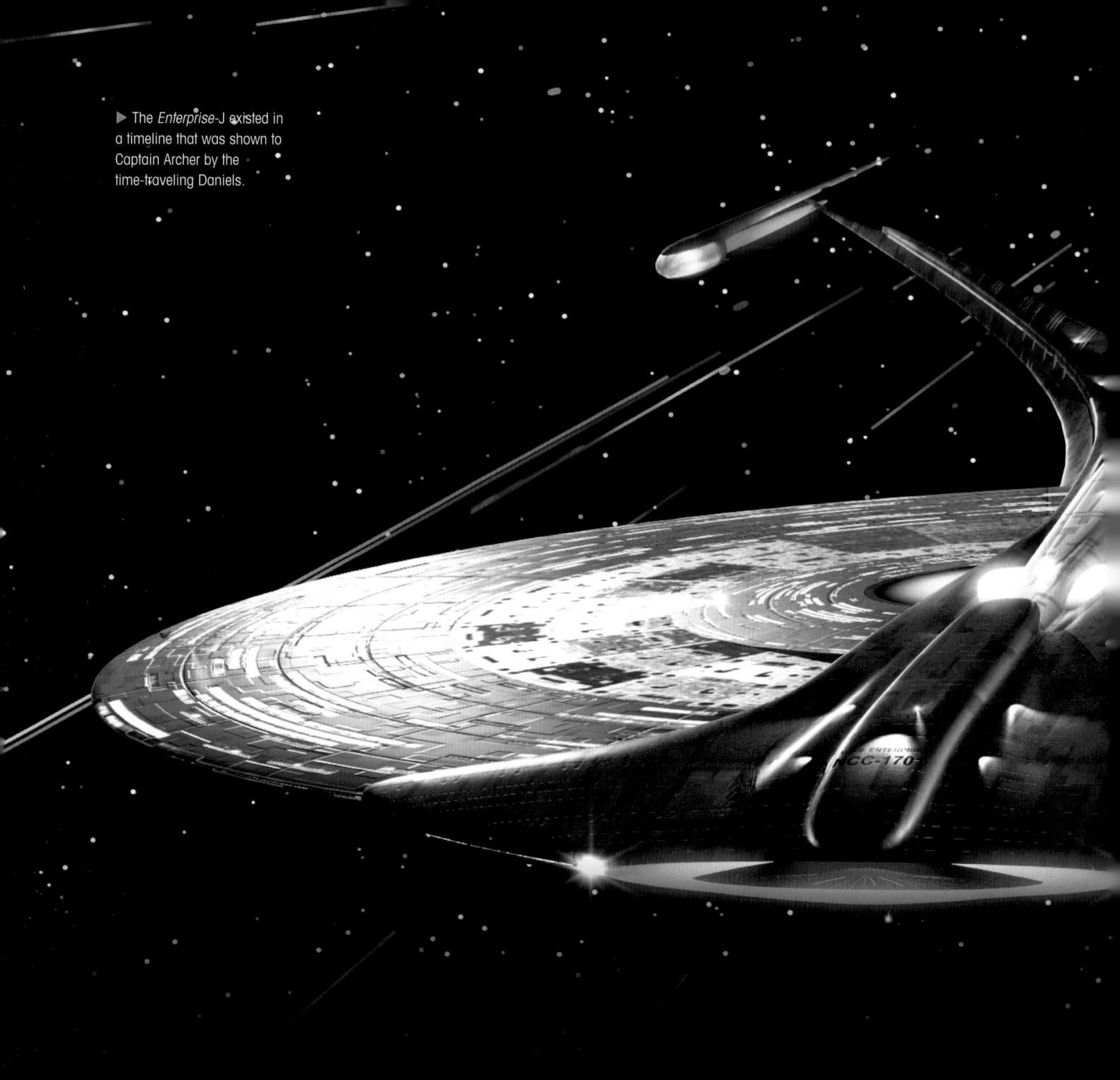

U.S.S. ENTERPRSE-J

There was still an *Enterprise* in the 26th century: a massive ship that played a part in an historic battle.

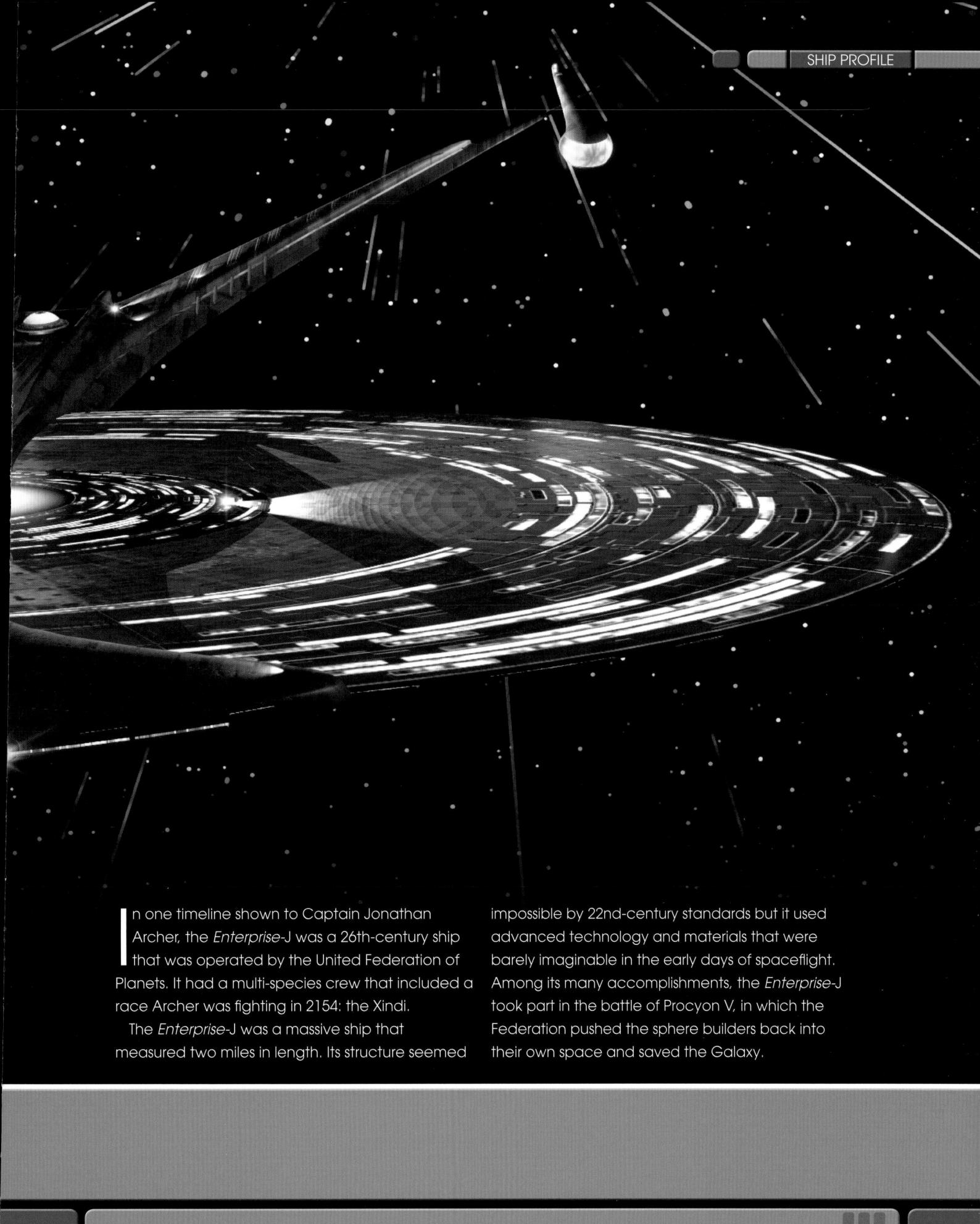

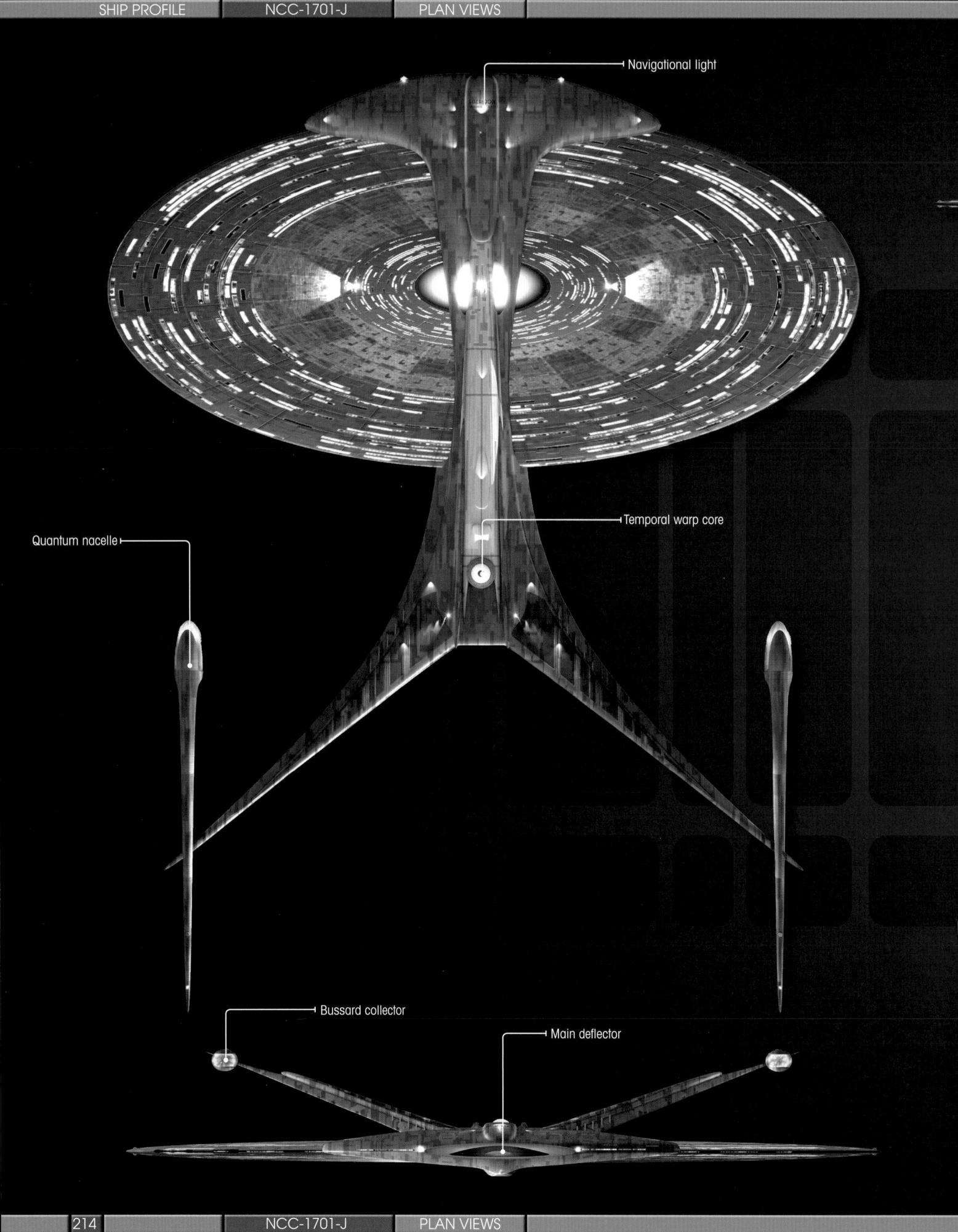
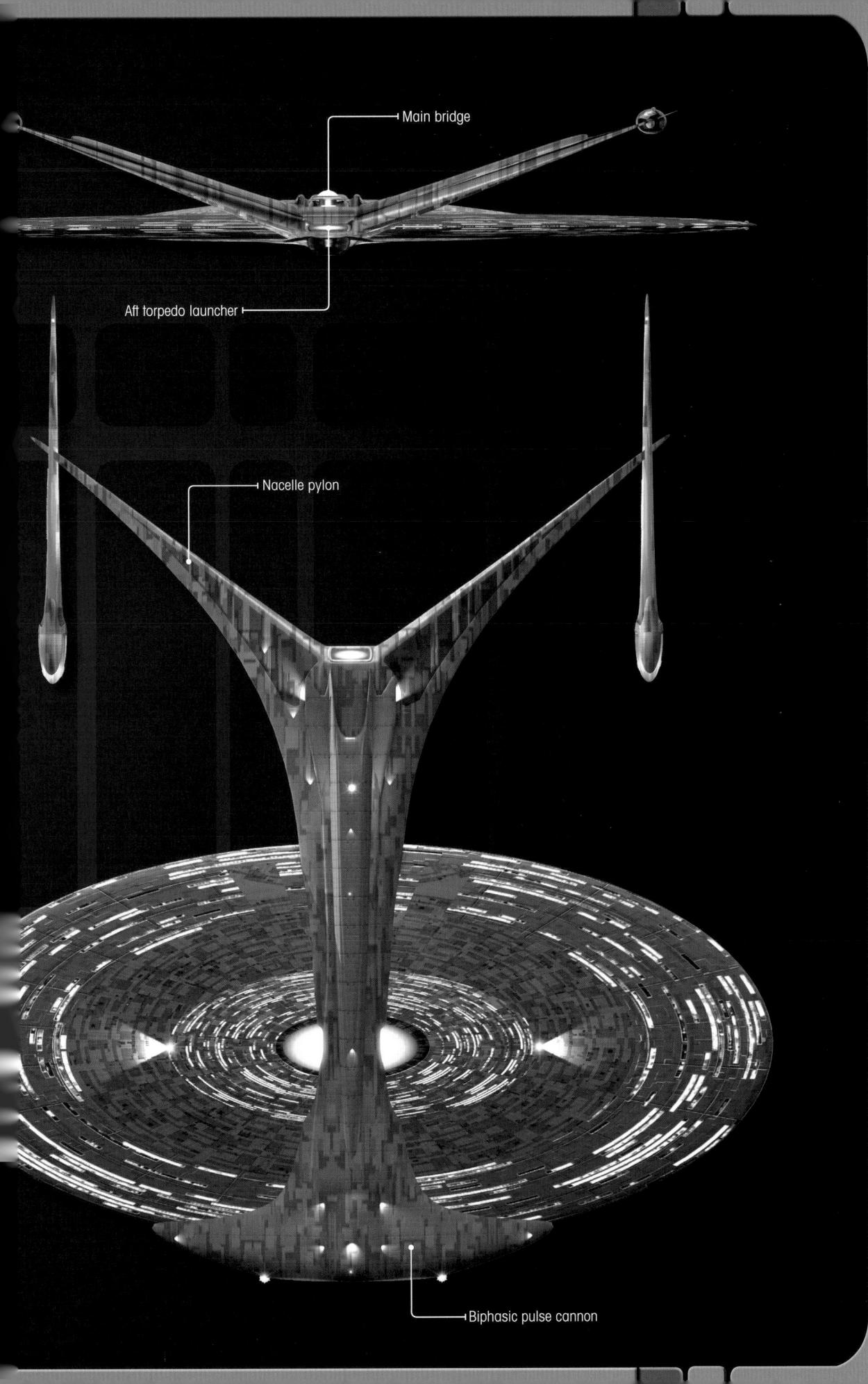

FUTURE SHIP

The Enterprise-J
'existed' in a timeline that was shown to Captain Archer as part of a temporal cold war, and it is unclear whether it is part of the future that will come to pass.

REGISTRY

Although Daniels told Archer that the ship they were on was the *Enterprise-J* the registry on the hull simply reads NCC-1701, as it did on the *Constitution-*class ship commanded by captains Pike and Kirk in the 23rd century.

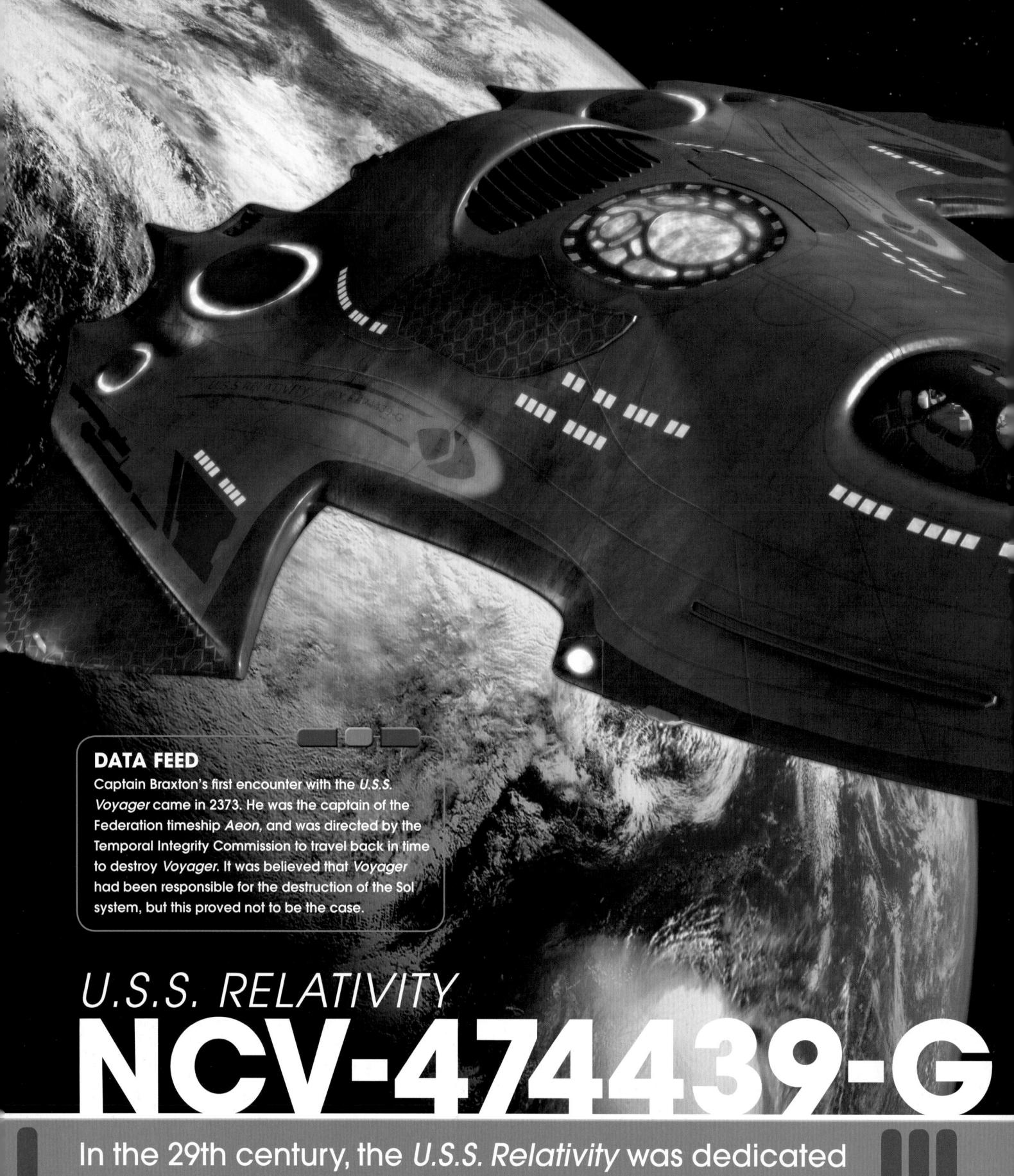

In the 29th century, the *U.S.S. Relativity* was dedicated to protecting the timeline from dangerous incursions.

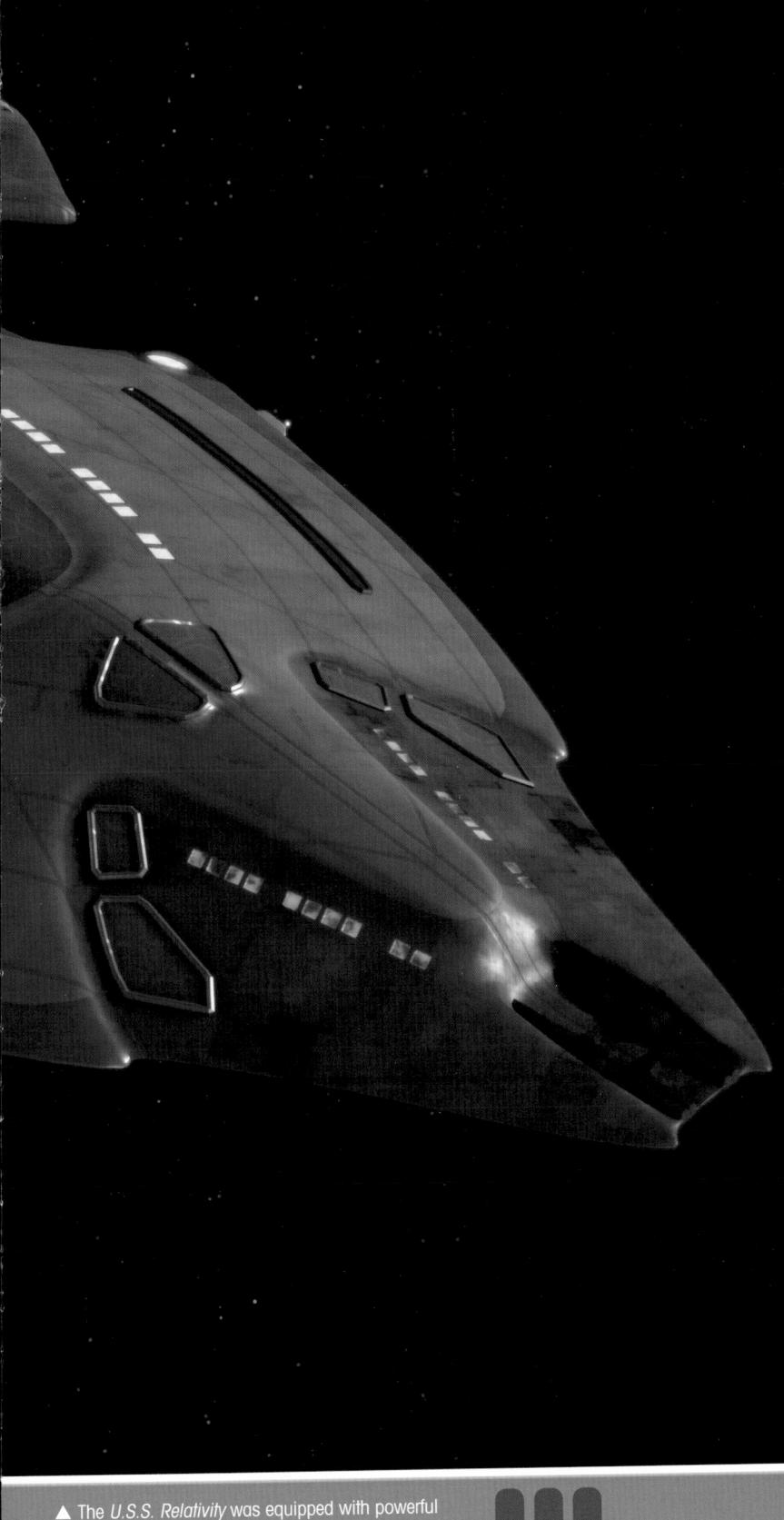

The U.S.S. Relativity NCV-474439-G was a 29th-century vessel operated by the United Federation of Planets. It was a Wells-class ship and was the seventh vessel to bear the name. Its mission was to protect the timeline from disruptions and the temporal anomalies that were caused by time travel. It was staffed by Starfleet officers under the direction of the Temporal Integrity Commission.

The *Relativity's* systems were far in advance of anything available to Starfleet in the 24th century. The familiar LCARS terminals had been superseded by TCARS interfaces that were operated by touch or by simply moving a hand over them. Interestingly, this latter approach was favored by Starfleet designers in the 2250s.

In order to perform its duties, the *Relativity* was equipped with sophisticated sensors that could monitor the timestream. The majority of these sensors were concentrated in arrays around the front and sides of the ship. They were extremely powerful and could be used to monitor events hundreds of years in the past and thousands of light years away from the *Relativity*'s position.

TEMPORAL WARP CORE

The *Relativity* was equipped with warp and impulse engines. Matter for the engines was brought in through a substantial intake on the top of the ship, which was just behind the temporal warp core. This was the central element of the ship that allowed it to make journeys into the past.

The *Relativity* was designed to make journeys through time. However, the Temporal Integrity Commission appeared to favor making temporal transports, or sending smaller one-man vessels, such as the timeship *Aeon*, wherever possible.

▲ The U.S.S. Relativity was equipped with powerful sensors that were capable of scanning through space and time in order to protect the timeline against temporal incursions. It could then send in an undercover operative to restore the timeline.

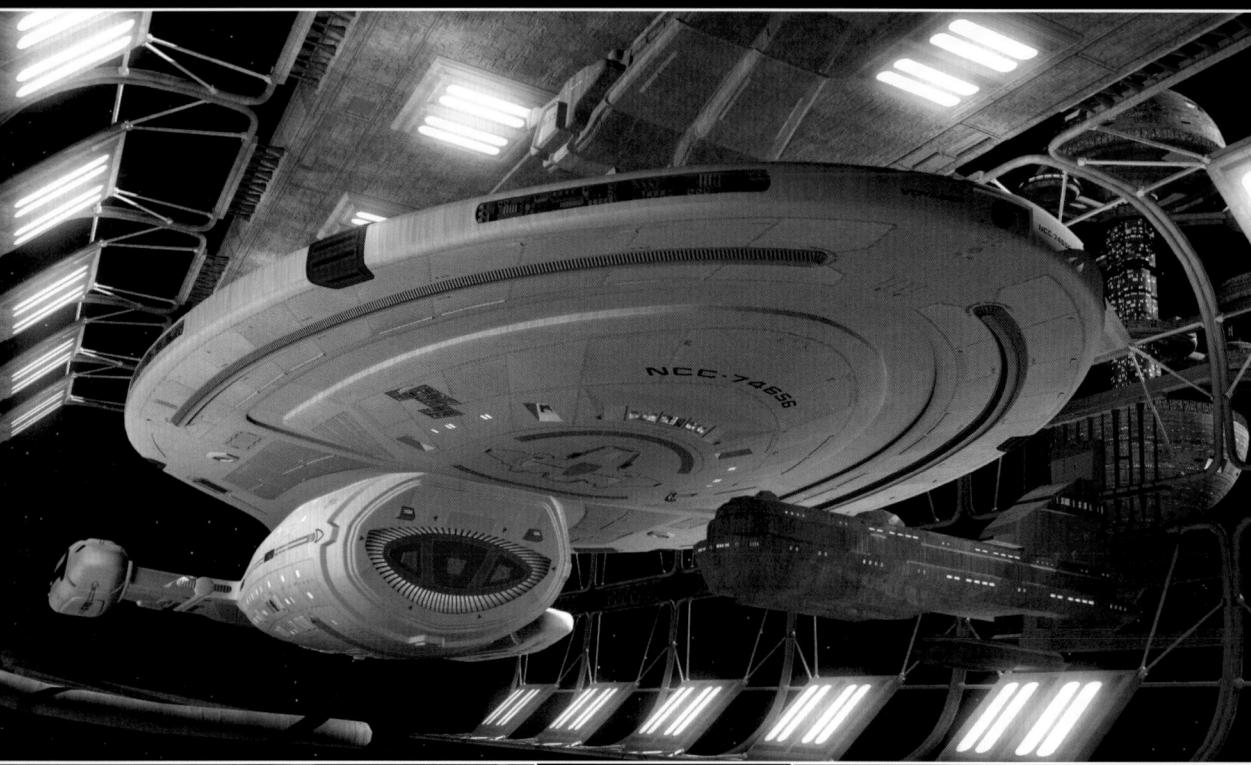

■ The Relativity sent
Seven of Nine back to
when the U.S.S. Voyager
NCC-74656 was
undergoing its final
phases of construction.
Here, Seven was
disguised as an ensign
and managed to find the
weapon that would blow
apart the ship. She was
not able to disarm it,
however, and she had to
be beamed out before
she was discovered.

▶ The crew of the Relativity recruited Seven from 2375 to help find the device because her ocular implant was capable of detecting it. Seven was altered in order to look human, and sent to several time periods. Unfortunately, Seven died twice before discovering that Braxton was responsible.

▲ The station at the front of the bridge was principally used to monitor the timestream and control the main viewer. This TCAS console could be activated by touch or by simply waving a hand over the controls.

The Relativity's hull had been specifically designed for time travel and had carefully crafted temporal geometry contours. In order to make a journey through time, the ship had to generate a temporal field; the ship's temporal matrix had to be carefully calibrated or the journey may have had catastrophic consequences. For example, a smaller timeship arrived in the 29th century with an incorrectly calibrated matrix and created an explosion that destroyed the entire Sol system.

Although its mission was peaceful, the *Relativity* was armed, and disruptors were positioned at various locations around the hull, with the powerful main disruptor in the ship's nose. The command center (or bridge) was positioned on the top of the ship toward the front.

The *Relativity* was equipped with all the facilities familiar to Federation vessels, including a number of holomatrix rooms (the 29th-century equivalent of holodecks). The holomatrix rooms were often used to run simulations before operatives were sent into action, and to ensure that everything went to plan.

TEMPORAL TRANSPORTERS

The *Relativity* was also provided with temporal transporters that could beam individuals across time. A temporal transporter pad was located on the bridge. Before a transport was initiated, the crew raised the shields and targeted a specific time and location.

The temporal transporters were extremely advanced. They could pinpoint a specific location

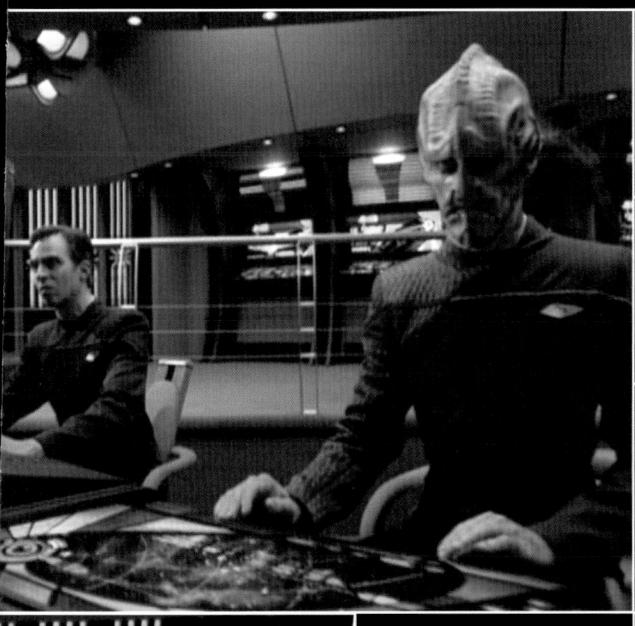

■ Some of the Relativity's crew were drawn from races that were not discovered by the 24th century.

▶ Lieutenant Ducane was serving aboard the *Relativity* and took command after Captain Braxton was arrested.

▼ By the 29th century, Starfleet had abandoned the traditional two-hulled design. It still retained 'wings' in the position once taken by the warp nacelles.

■ The temporal transporter pad on the bridge was designed to send an individual back in time. This was much simpler than sending the Relativity back in time, where it might be discovered. If an individual was sent back to correct an incursion, it was much more likely that they would remain undiscovered. The crew could stay in contact with the operative through a temporal communicator.

with ease, and were so accurate they could be targeted to the microsecond.

Once an operative had been sent into the past, the *Relativity's* crew could stay in contact by using the ship's temporal communications system. Like the transporter, this could cross time with ease. Visual communication was not usually possible, so the crew had to rely on audio contact.

Normally, the inhabitants of the past had no memory of the *Relativity's* involvement with their time, but on at least one occasion, it used operatives from the 24th century, and allowed them to retain their memories. As a consequence, two people from 2375 – Seven of Nine and Captain Janeway – remembered visiting the timeship and encountering its crew.

DATA FEED

The Relativity was involved in a mission to avert the destruction of the U.S.S. Voyager. Seven of Nine was recruited from that time period to apprehend the person responsible. It was eventually discovered that the saboteur was, in fact, a future version of Captain Braxton. He came to see that the Voyager crew were responsible for his eventual forced retirement and that by obliterating it from the timeline, none of the events that caused his illness would have occurred.

MAIN BRIDGE

At the front of the bridge there was a rectangular viewscreen, which was used to display data about the timestream and the timeframe being monitored by the ship. In front of the viewscreen was a large helm console that had seating for two officers. On the port side of the upper level was the captain's chair, while elsewhere on the bridge was a temporal transporter. This allowed a person to be beamed into the past, with the temporal sensors permitting the precise moment and location to be chosen.

▲ The seating in front of the viewscreen allowed the crew members to locate past problems in the timeline, and find a way to put them right without anyone from the past being aware that they were there.

Secondary temporal field generator

- Central temporal impeller

Main bridge

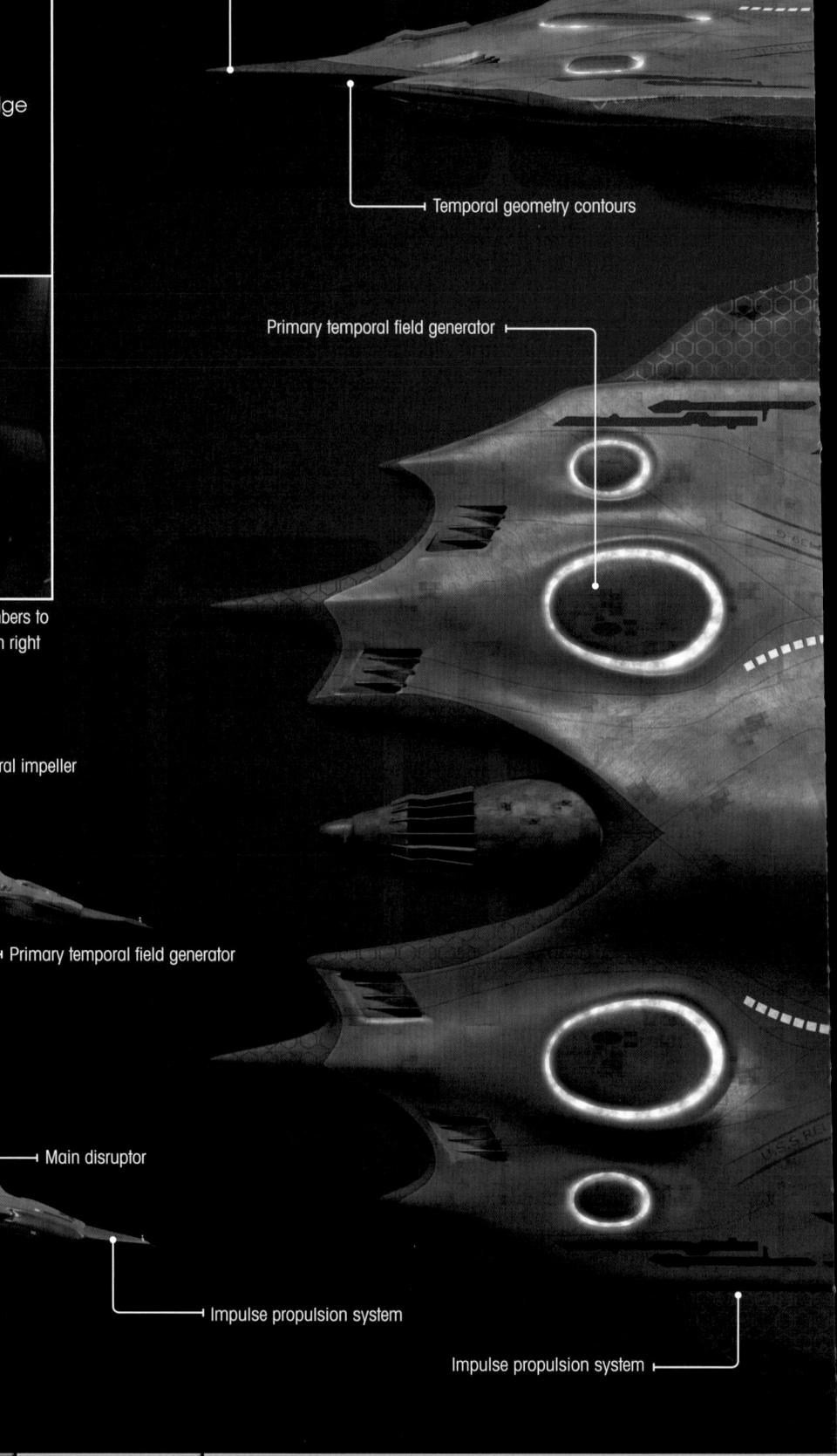

- Central temporal impeller

Forward sensors +

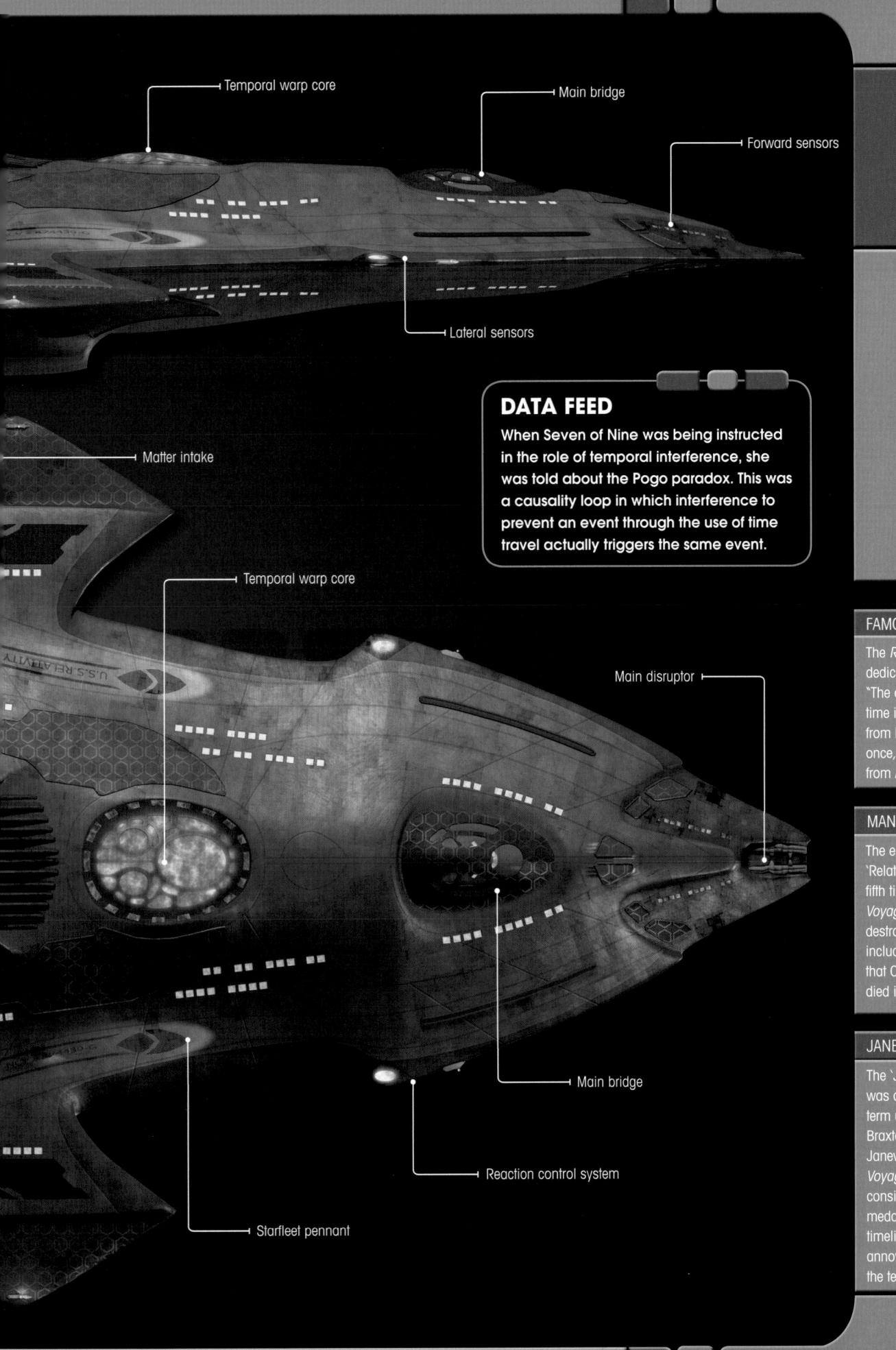

FAMOUS QUOTE

The Relativity's dedication plaque was: "The only reason for time is to stop everything from happening at once," — a quote taken from Albert Einstein.

MANY LIVES

The episode entitled 'Relativity' marked the fifth time that the *U.S.S. Voyager* was completely destroyed. It also included the eighth time that Captain Janeway died in the series.

JANEWAY MEDDLING

The 'Janeway Factor' was an informal term used by Captain Braxton about Captain Janeway of the *U.S.S. Voyager*. Braxton considered Janeway's meddling with the timeline a major annoyance, and coined the term to describe it.

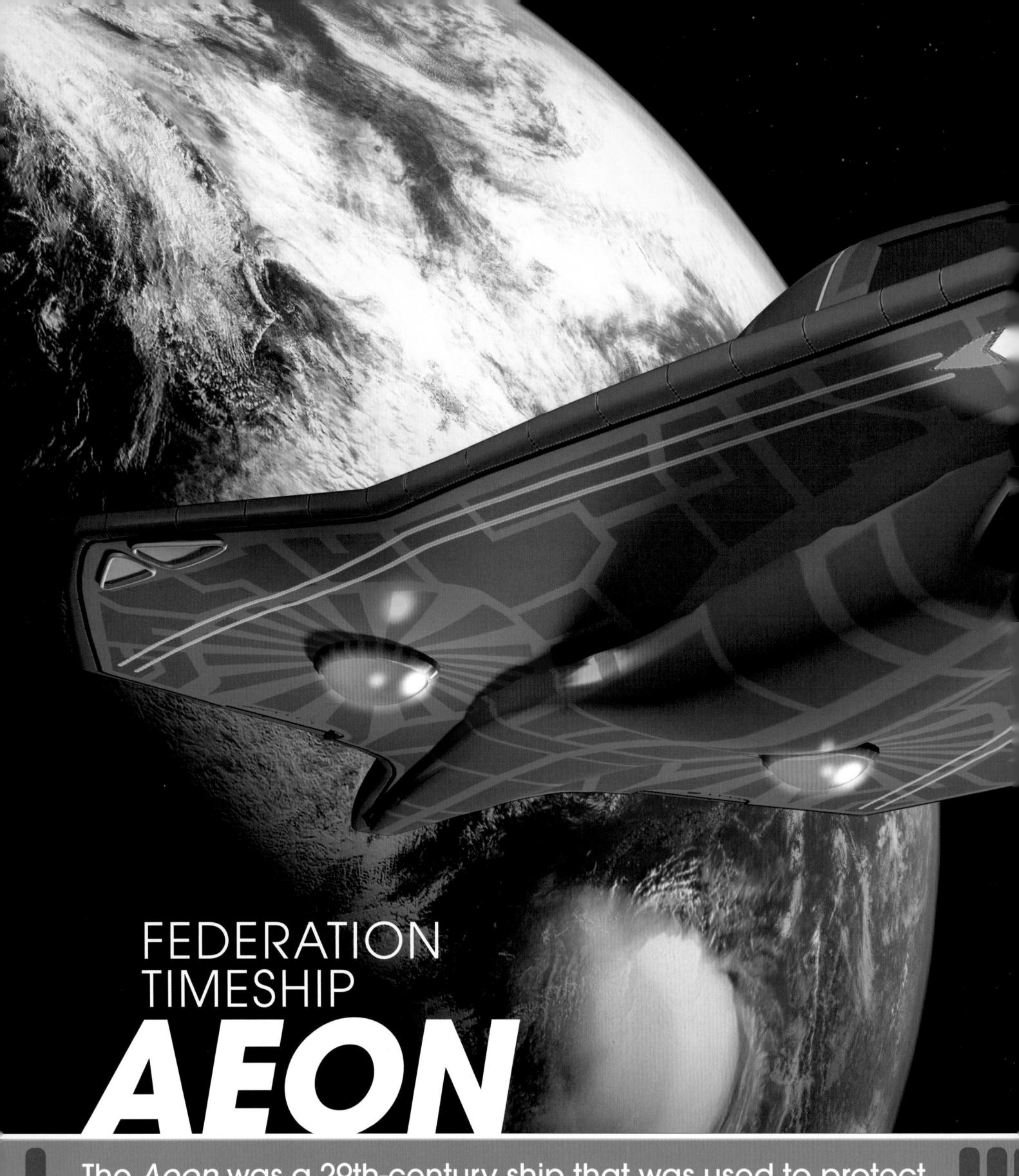

The *Aeon* was a 29th-century ship that was used to protect the timeline from anyone seeking to interfere with history.

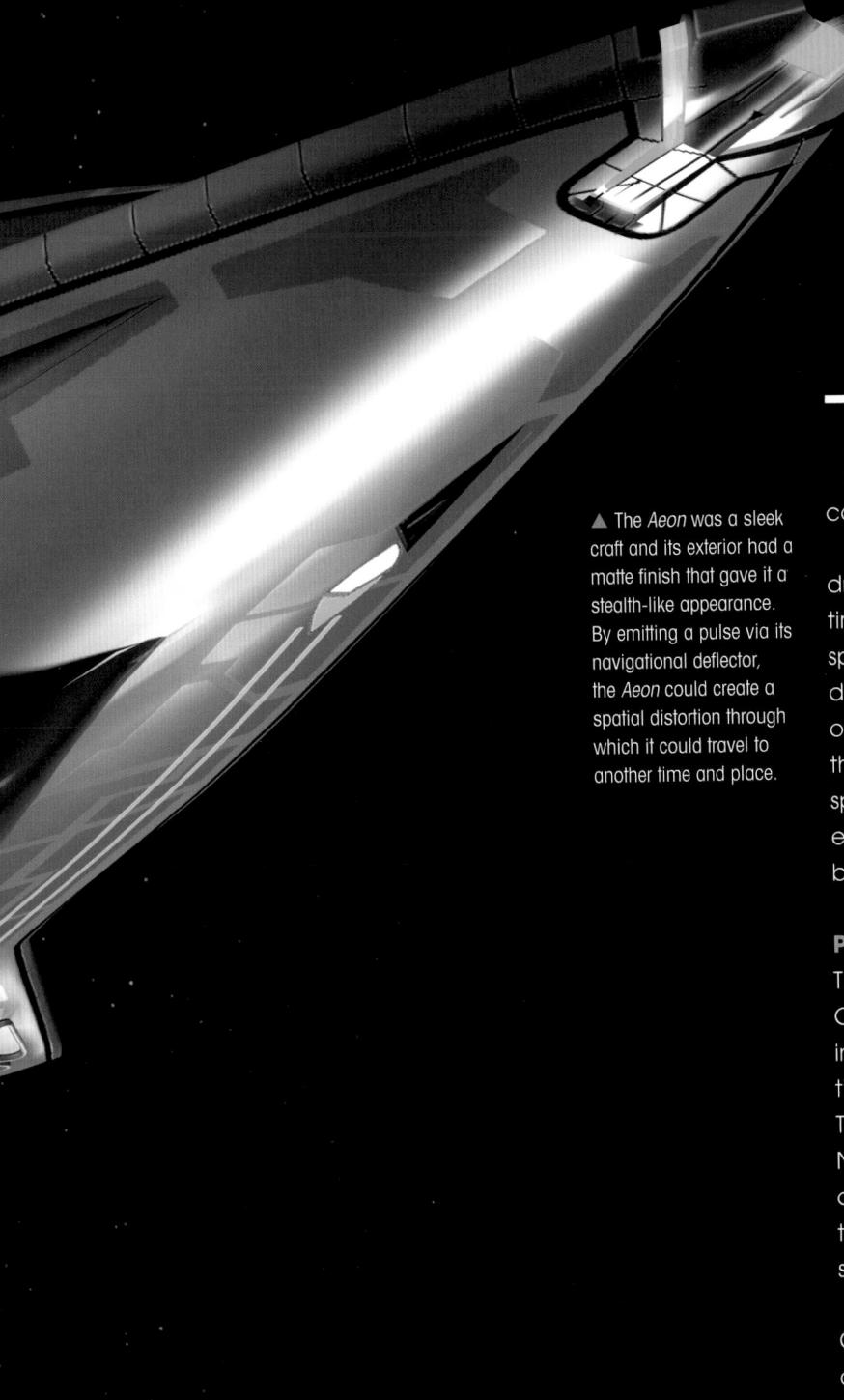

The Aeon was a small Federation timeship from the 29th century. At approximately six meters long, it was a single-seater craft and its cockpit had barely enough room for the pilot.

The Aeon was equipped with a hyper-impulse drive, but it was also capable of traveling to any time and place in the universe. By emitting a specialized kind of pulse through its navigational deflector beneath the nose of the ship, it could open an artificial spatial rift. This was a distortion in the space-time continuum – a kind of rip or tear in space – through which the craft could enter and emerge in a particular time and place that had been set by the pilot.

POLICING THE TIMELINE

The Aeon was part of the Temporal Integrity Commission, an agency set up by the Federation in the 29th century. Its purpose was to protect the timeline from any changes caused by time travel. This organization believed that the U.S.S. Voyager NCC-74656 was responsible for a monumental catastrophe in the 29th century, in which a temporal explosion destroyed all of Earth's Solar system, taking billions of lives in the process.

In order to prevent this disaster from happening, Captain Braxton was ordered to take the *Aeon* and travel back in time to the Delta Quadrant to destroy *Voyager*. The *Aeon* emerged from a spatial rift in 2373 directly in front of *Voyager*. Without explanation, Braxton immediately charged his ship's subatomic disruptor and fired at *Voyager*. Despite the *Aeon*'s small size, its

In the aftermath of the destruction of the solar system in the 29th century, debris from the U.S.S. Voyager's secondary hull was found in the wreckage. This led the people of that time to believe Captain Janeway's ship was responsible for the disaster, and the Aeon timeship was sent to 2373 in order to destroy Voyager.

▶ Captain Janeway and her crew eventually tracked the Aeon to a secret room in Henry Starling's building. He had studied the ship's advanced technology and understood it enough to reverse engineer a whole host of computer hardware that was new to the 20th century.

▲ Back in the 20th century, Janeway, Chakotay, Tuvok and Paris donned appropriate clothing and beamed down to California to search for the Aeon. Their investigations revealed that although the Aeon had entered the riff just a few moments before Voyager, it had emerged in 1967, almost 30 years before them.

advanced weapon took out *Voyager's* shields and knocked them off-line with just one shot. *Voyager* tried returning fire with full phasers, but they had absolutely no effect on the *Aeon's* 29th-century shields. *Voyager's* molecular structure began to come apart under the attack, and Janeway was forced to be more inventive in fighting back.

Desperately trying to save her ship, Janeway had *Voyager*'s deflector beam adjusted to match the frequency of the *Aeon*'s disruptor, thus this overloaded its emitter. The subspace rift began to destabilize, pulling both ships inside. In an instant, they emerged halfway across the galaxy in orbit of Earth. It was not all good news though. While they had finally reached home, the year was not 2373, but 1996. The *Voyager* crew later learned that although the *Aeon* had entered the rift just seconds before them, it emerged in 1967.

It transpired that Braxton had been forced to

perform an emergency beam out before his ship crashed in a remote mountain range. Before he could get back to the *Aeon*, it was taken by a young man named Henry Starling. He created a microcomputer revolution by cannibalizing the technology aboard the ship. In the following years, he became one of the wealthiest and most influential people on the planet.

TERRIBLE REALIZATION

Meanwhile, Braxton realized that it was not Voyager that caused the huge catastrophe in the 29th century, but his own ship. He knew that if someone unfamiliar with the Aeon's controls tried to fly it into the future without recalibrating the temporal matrix, it would cause a massive explosion that could destroy the Solar system.

This was exactly what nearly happened. Starling planned to launch the *Aeon* and travel to the

▶ The Aeon had a large cockpit canopy that was opaque, while its wings had semi-spherical red orbs built into the top and bottom of them. The ship's powerful sub-atomic disruptor was located in the nose.

▼ The Aeon was launched through the roof of Starling's Chronowerx building. He planned to acquire more technology from the future and then bring it back to the 20th century, where he could exploit it for more profit.

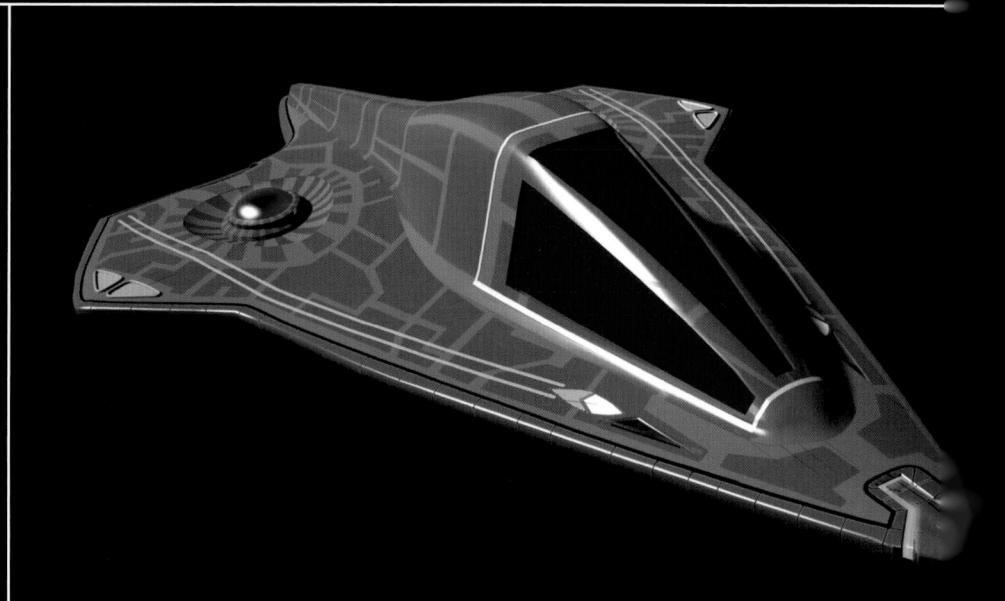

future where he could acquire more technology. He could then bring it back to his own time and exploit it to make more money.

Janeway and her crew tried to stop Starling, but he managed to elude them. Eventually, he activated the *Aeon*'s hyper-impulse drive and smashed through the top of a skyscraper where he kept the ship. Once in orbit, Starling jumped to warp 1 and initiated the *Aeon*'s temporal core. Just as he was about to enter the subspace rift, *Voyager* fired a photon torpedo that hit the *Aeon*, blowing it to pieces and closing the rift.

Seconds later, the rift reopened and the *Aeon* appeared. Captain Braxton opened communications with *Voyager*, but he had no knowledge of what had just happened. For him, the timeline in which he had traveled to the 20th century and Starling had been a computer mogul never happened. He was there because his ship's

sensors had alerted him to *Voyager*'s presence in the 20th century and he had been sent to correct that anomaly. Janeway asked if he could return them to Earth in the 24th century, but this was against the temporal prime directive. Instead, he opened a rift back to the precise time and location in the Delta Quadrant where *Voyager* had first encountered the *Aeon*.

Starling would not believe Janeway's warnir that he would cause a massive explosion in the 29th century if he tried to travel there. Fortunately, Voyager managed to destroy the Aeon before it could travel to the future.

DATA FEED

When Captain Braxton first found himself in the 20th century, he tried to confront Henry Starling and get his ship back. Unused to the customs in late 20th-century California, Braxton was out of his depth. No one in authority listened to him and he was dismissed as a mad man. Eventually, he was confined to a mental institution and pumped full of antipsychotics. By the time Captain Janeway found him he was living on the streets and really had become mentally ill.

CHARMED LIFE

In 1967, Henry Starling was just a young man when he witnessed the extraordinary sight of a strange object crashing to the ground in the High Sierras of California. Upon investigation, he found the Aeon, largely intact.

Over the next 30 years, Starling used his primitive understanding of the *Aeon's* technology to launch numerous computer innovations to the market. This made him a very wealthy man as he built a corporate empire called Chronowerx Industries.

Like many of his time, Starling's greed knew no bounds and he wanted more wealth and more acclaim. He planned to launch the *Aeon* and travel to the future, where he could acquire more technology. He could then bring it back to his own time and exploit it to make more money.

When Captain Janeway tracked the *Aeon* down to Starling's building, she tried to convince him that if he did not precisely calibrate the temporal matrix in the *Aeon*, it would cause a massive explosion when it emerged in the 29th century. Starling refused to believe her, or just did not care, and would not give up the ship.

Eventually, Starling paid with his life as the crew of *Voyager* managed to blow up the *Aeon* seconds before it entered a spatial rift to the 29th century. This reset the timeline so that Starling never did discover the *Aeon*, nor became one of the most powerful magnates on the planet.

Thanks to his discovery of the *Aeon*, Henry Starling was able to use its 29th-century technology to develop a number of computer nnovations in the late 20th century that made him a wealthy man.

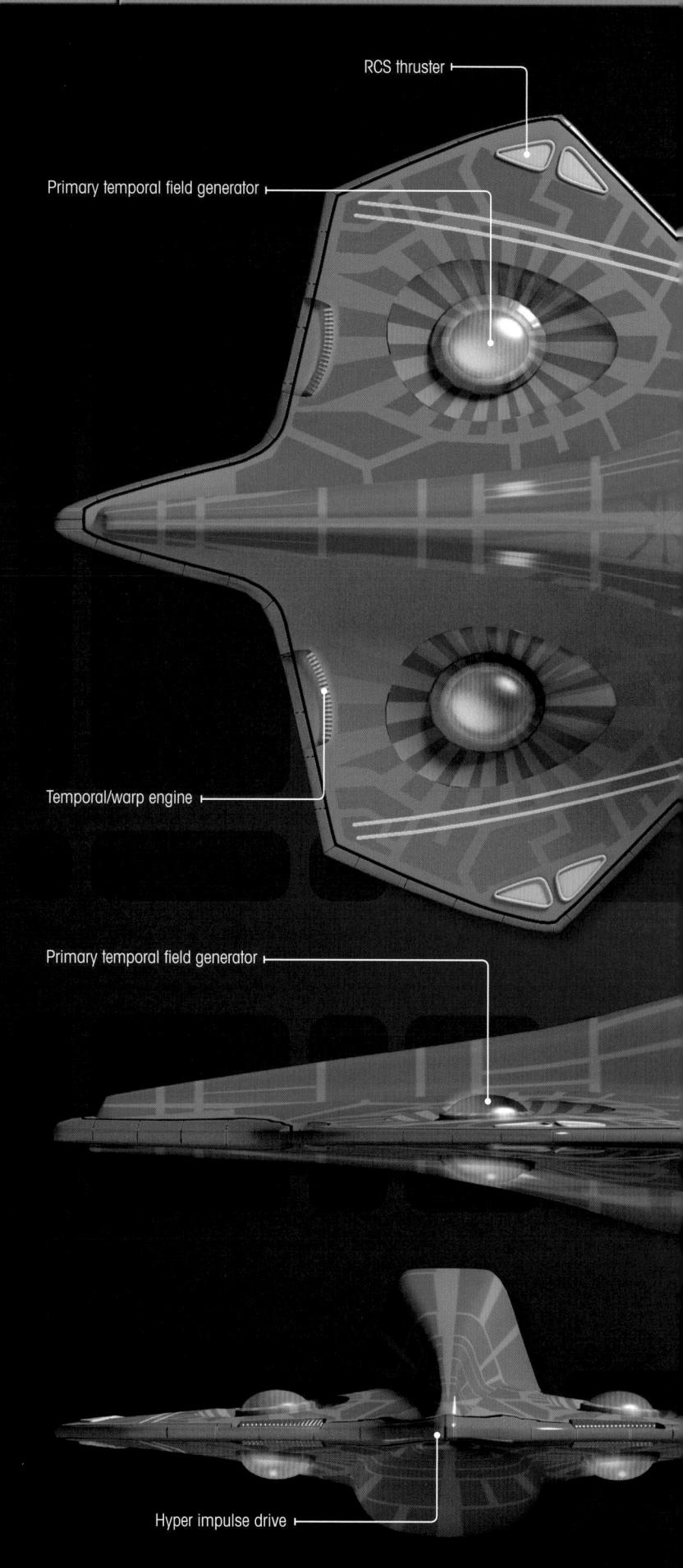

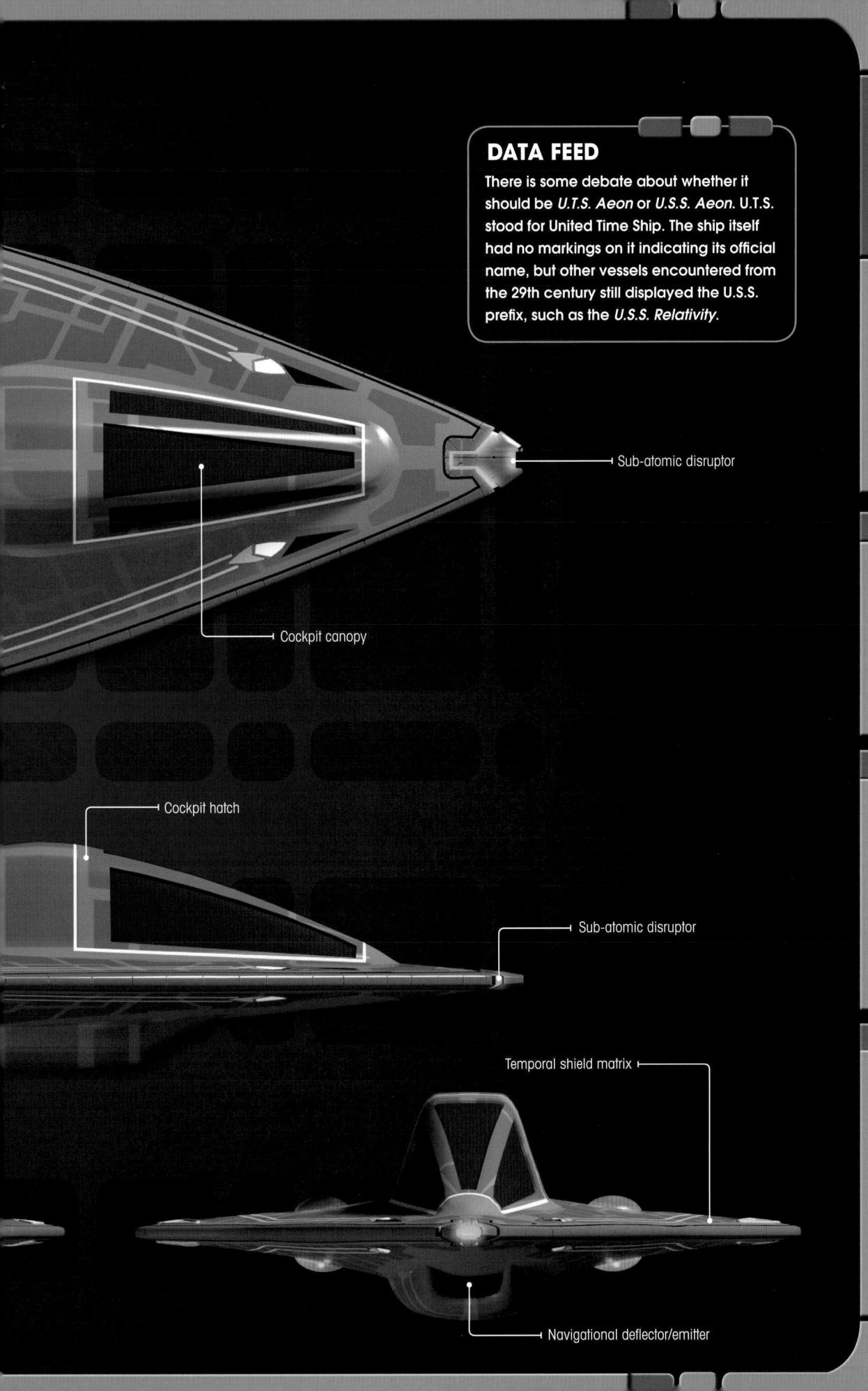

INSULTING THE COPS

When Captain Braxton was trapped in the 20th century, he called a police officer a "quasi-Cardassian totalitarian." This comment was perhaps why he was sent to a mental institution.

L.A. EARTHQUAKE

Captain Janeway said that the area around Santa Monica beach in L.A. sank under 200 meters of water after the Hermosa quake of 2047. It then became one of the world's largest coral reefs, home to thousands of marine species.

HISTORY REPEATING

When Captain Janeway has to manually type to gain access to Henry Starling's computer, she comments that using this technology is "like stone knives and bearskins." Spock used this exact phrase when the Guardian of Forever portal sent him back to the early 20th century.

THE FUTURE SIZE CHART

U.S.S. RELATIVITY NCV-474439-G
193m

FEDERATION TIMESHIP AEON 6m

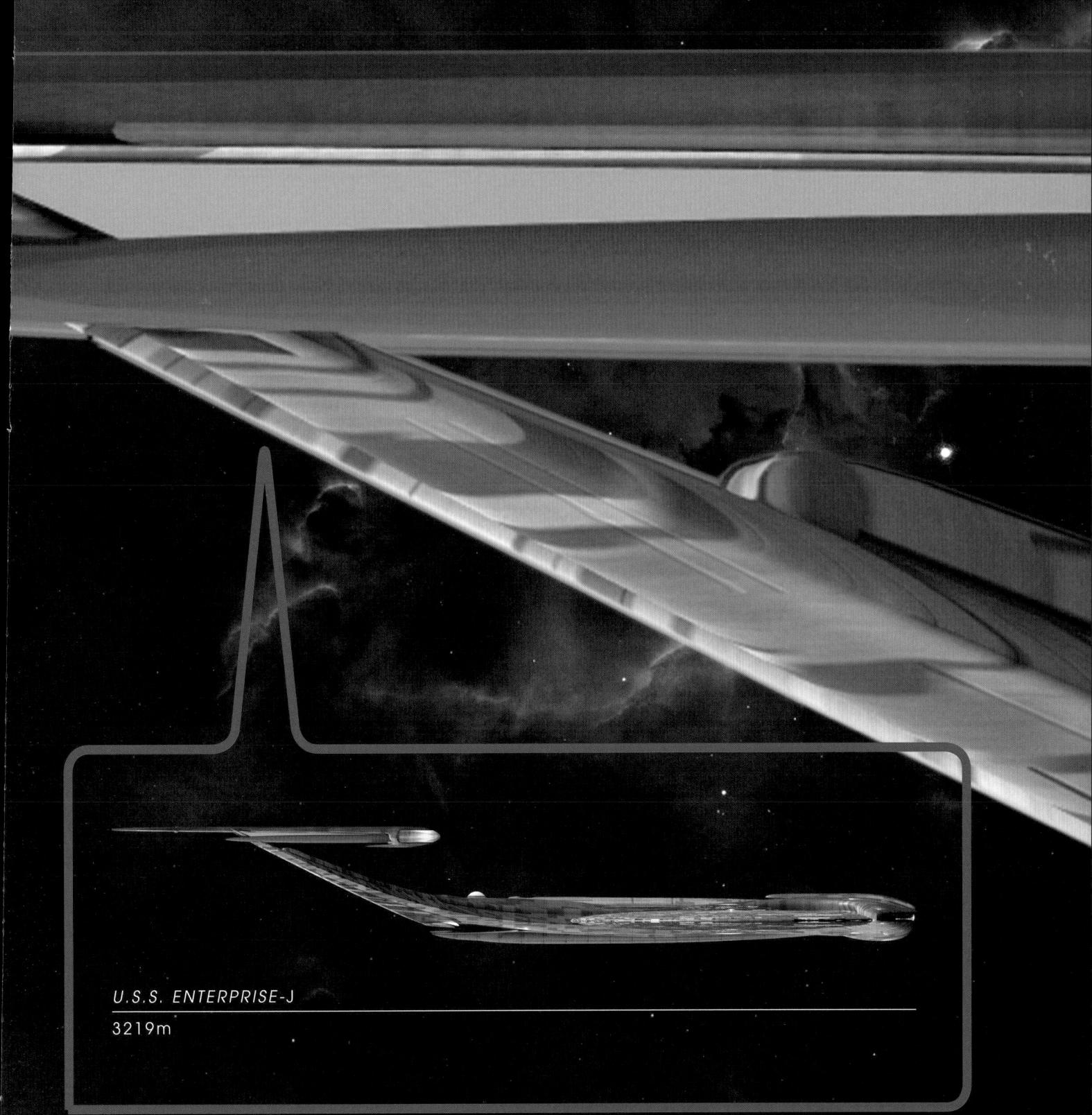

CLASS LISTING

Raven type

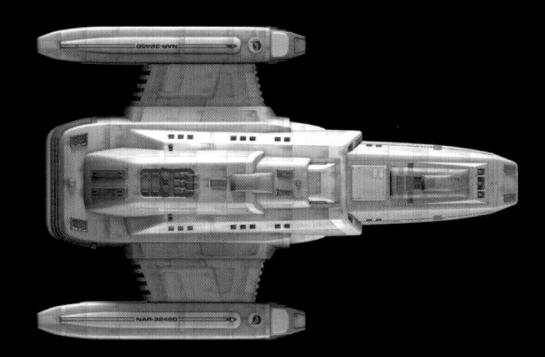

U.S.S. Raven NAR-32450

page 10

Danube class

Federation runabout

page 16

Other:

U.S.S. Gander NCC-72311

U.S.S. Ganges NCC-72454

U.S.S. Mekong NCC-72617

U.S.S. Orinoco NCC-72905

U.S.S. Rio Grande NCC-72452

U.S.S. Rubicon NCC-72936

U.S.S. Shenandoah NCC-73024

U.S.S. Volga NCC-73196

U.S.S. Yangtzee Kiang NCC-72453

U.S.S. Yukon NCC-74602

Delta Flyer type

Delta Flyer

page 28

Other: *Delta* Flyer II

Constellation class

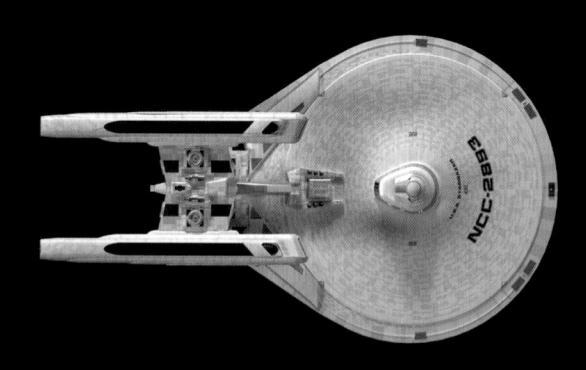

U.S.S. Stargazer NCC-2893

page 68

Other

U.S.S. Constellation NX-1974

U.S.S. Hathaway NCC-2593

U.S.S. Victory NCC-9754

Ambassador class

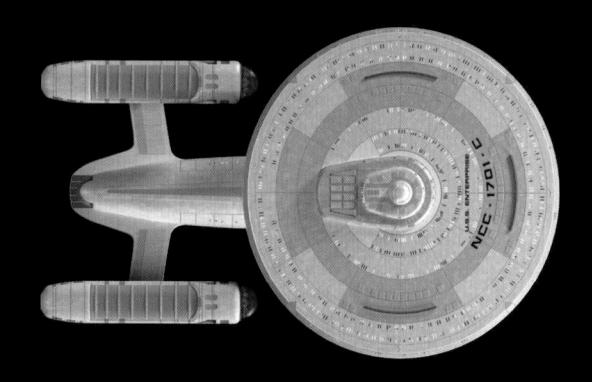

U.S.S. Enterprise NCC-1701-C

page 74

Other

U.S.S. Excalibur NCC-26517

U.S.S. Horatio NCC-10532

U.S.S. Yamaguchi NCC-26510

U.S.S. Zhukov NCC-26136

Nebula class

page 80

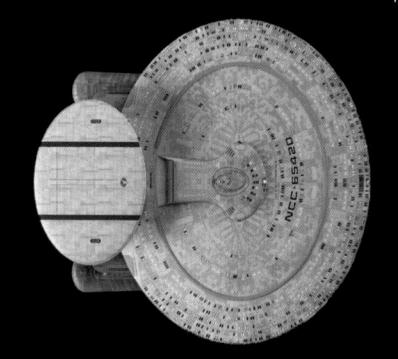

U.S.S. Phoenix NCC-65420

page 86

Other:

U.S.S. Bellerophon NCC-62048

U.S.S. Bonchune NCC-70915

U.S.S. Farragut NCC-60597

U.S.S. Honshu NCC-60205

U.S.S. Leeds NCC-70352

U.S.S. Lexington NCC-30405

U.S.S. Merrimac NCC-61827

U.S.S. Monitor NCC-61826

U.S.S. Prometheus NCC-71201

U.S.S. Sutherland NCC-72015

U.S.S. T'Kumbra NCC-62100

Galaxy class

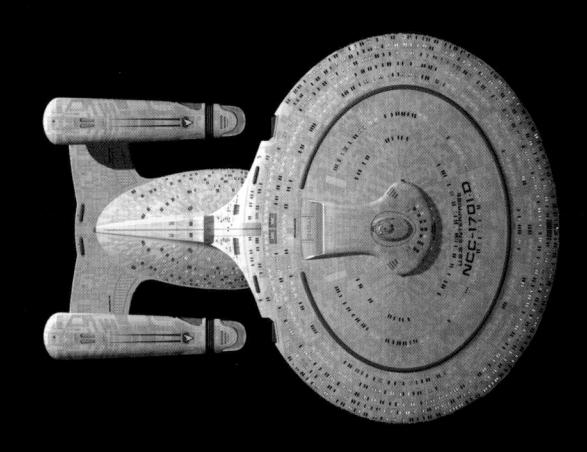

U.S.S. Enterprise NCC-1701-D

page 92

Other:

U.S.S. Challenger NCC-71099

U.S.S. Galaxy NCC-70637

U.S.S. Odyssey NCC-71832

U.S.S. Venture NCC-71854

U.S.S. Yamato NCC-71807

Miranda class

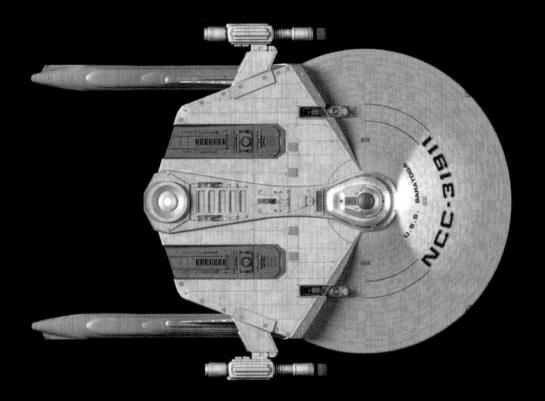

Other:

U.S.S. Antares NCC-9844

U.S.S. Brattain NCC-21166

U.S.S. Lantree NCC-1837

U.S.S. Majestic NCC-31060

U.S.S. Nautilus NCC-31910

U.S.S. Reliant NCC-1864

U.S.S. Saratoga NCC-1887

U.S.S. ShirKahr NCC-31905

U.S.S. Sitak NCC-32591

U.S.S. Tian An Men NCC-21382

U.S.S. Trial NCC-1948

Defiant class

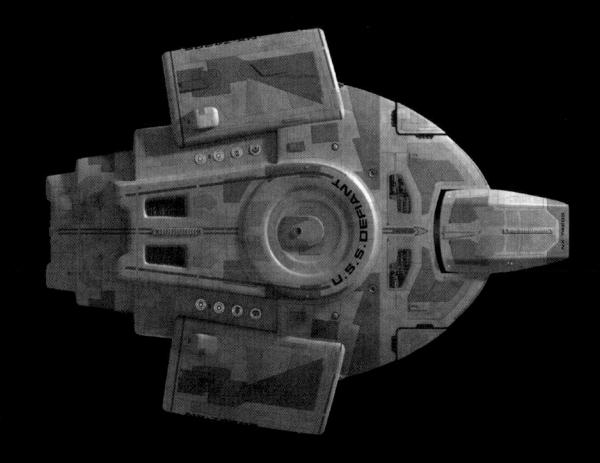

U.S.S. Defiant NX-74205

page 104

Other:

U.S.S. Valiant NCC-74210

Cheyenne class

page 112

Other: U.S.S. Ahwahnee NCC-71620

Other: U.S.S. Chekov NCC-57302

Challenger class

page 120

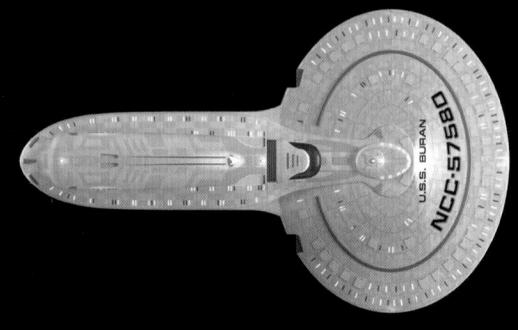

Other: U.S.S. Buran NCC-57580

Freedom class

page 124

Other: U.S.S. Firebrand NCC-68723 U.S.S. Franklin NX-326

Niagara class

page 126

New Orleans class

Other: U.S.S. Kyushu NCC-65491 U.S.S. Thomas Paine NCC-65530

Nova class

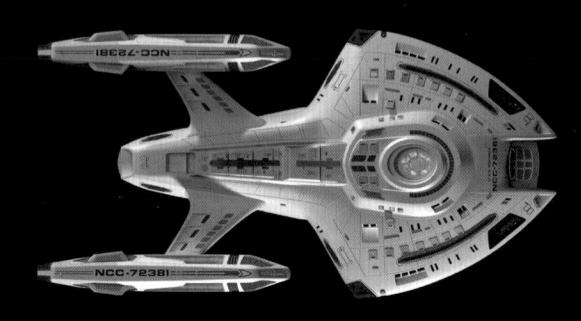

U.S.S. Equinox NCC-72381

page 138

Other: *U.S.S. Rhode Island* NCC-72701

Olympic class

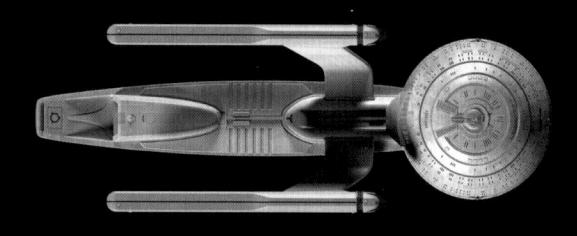

U.S.S. Pasteur NCC-58925

page 146

Intrepid class

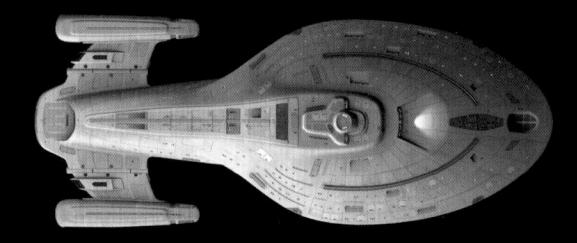

U.S.S. Voyager NCC 74656

page 158

Other: *U.S.S. Bellerophon* NCC-74705

Steamrunner class

page 164

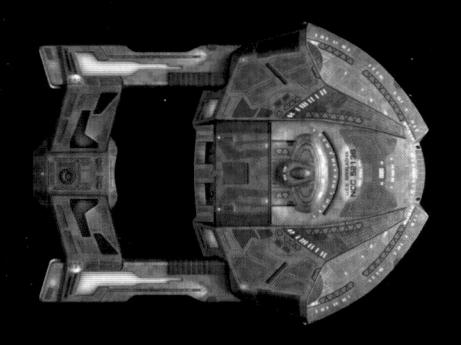

Other: U.S.S. Appalachia NCC-52136

Saber class

page 170

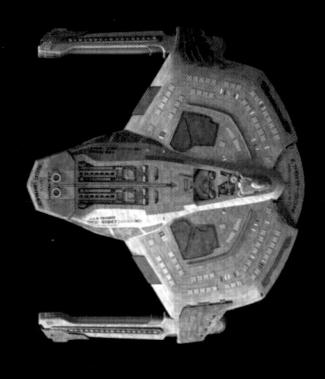

Other: U.S.S. Yeager NCC-61947

Centaur type

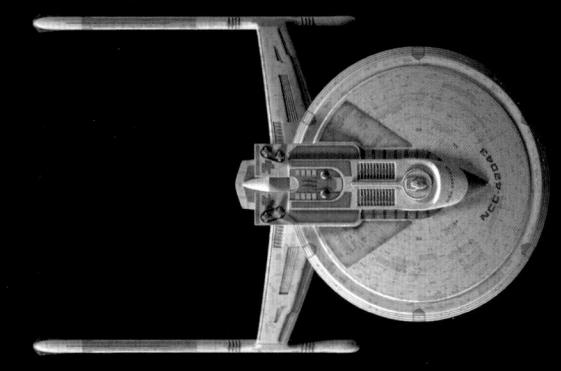

U.S.S. Centaur NCC-42043

page 190

Curry type

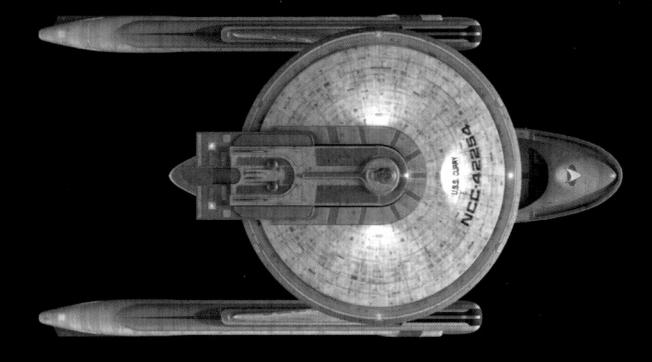

U.S.S. Curry NCC-42254

page 196

Sovereign Class

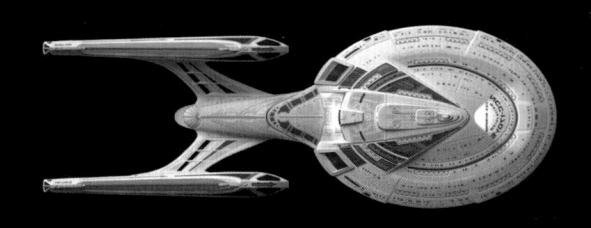

U.S.S. Enterprise NCC-1701-E

page 200

Universe class

U.S.S. Enterprise NCC-1701-J

page 216

Wells class

U.S.S. Relativity NCV-474439-G

page 220

Epoch class

U.T.S. Aeon

SHIPS		Challenger	118 110
U.S.S. Ahwahnee NCC-73620	110	Cheyenne Constellation	66
Aeon	222	Curry type	194
U.S.S. Appalachia NCC-52136	162	Danube	16
U.S.S. Budapest NCC-64923	174	Defiant	102
U.S.S. Buran	118	Delta Flyer type	28
U.S.S. Centaur NCC-42043	188	Freedom	122
U.S.S. Chekov NCC-57302	114	Galaxy	90
U.S.S. Curry NCC-42254	194	Intrepid	156
U.S.S. Defiant NX-74205	102	Miranda	60,96
Delta Flyer	28	Nebula	78,84
U.S.S. Enterprise NCC-1701-C	72	New Orleans	132
U.S.S. Enterprise NCC-1701-D	90	Niagara	126
U.S.S. Enterprise NCC-1701-J	212	Norway	174
U.S.S Equinox NCC-72381	138	Nova	138
Federation Attack Fighter	50	Olympic	146
Federation Mission Scout Ship	22	Prometheus	180
U.S.S. Firebrand NCC-68723	122	Ptolemy	152
Flight Training Craft	44	Raven type	10
U.S.S. Honchu NCC-60205	78	Saber	168
U.S.S. Kyushu NCC-65491	132	Springfield	114
U.S.S. Lantree NCC-1837	60	Sovereign	200
Maquis raider	38	Steamrunner	162
U.S.S. Pasteur NCC-5892	146	Universe	212
U.S.S. Phoenix NCC-65420	84	Wells	216
U.S.S. Princeton NCC-59804	126		
U.S.S. Prometheus NX-59650	180	COMMANDING C	EEICEDS
U.S.S. Raven NAR-32450	10	COMMANDING	FFICERS
U.S.S. Relativity NCV-474439-G	216	Braxton	216, 222
Runabout	16	Garrett, Rachel	72, 75
U.S.S. Saratoga NCC-31911	96	Hanson, Magnus	10
U.S.S. Stargazer NCC-2893	66	Hayes	165
Federation Tug	152	Hudson, Calvin	50
U.S.S. Voyager NCC-74656	156	Janeway, Kathryn	159
U.S.S. Enterprise NCC-1701-E	200	Jedlicka, Martin	96
U.S.S. Yeager NCC-61947	168	Maxwell, Benjamin	81, 84,87
		Picard, Beverly	146
CLASS OR TYPE		Picard, Jean-Luc	66, 90, 200
		Ranson, Rudolph	138
Aeon type	222	Reynolds, Charlie	188
Ambassador	72	Sisko, Benjamin	99
Centaur type	188	Telaka, L. Isao	60

www.startrek-starships.com www.eaglemoss.com/discovery

CREDITS

Editor: Ben Robinson

Project Manager: Jo Bourne

Writers: Ben Robinson, Marcus Riley, and Matt McAllister

Illustrators: Fabio Passaro, Ed Giddings, Adam 'Mojo' Lebowitz,

and Robert Bonchune

Jacket Designer: Stephen Scanlan

Designers: Stephen Scanlan, and Katy Everett

Additional research: Reka Turcsanyi **Packaging designer:** James King

With thanks to Alice Peebles, Terry Sambridge, and Guy Sawtell

 $^{\rm IM}$ & © 2018 CBS Studios Inc. STAR TREK and related marks and logos are trademarks of CBS Studios Inc. All Rights Reserved.

Text and Illustrations originally published in STAR TREKTM – The Official Starships Collection and STAR TREKTM DISCOVERY – The Official Starships Collection by Eaglemoss Ltd. 2013-2018

Eaglemoss Publications Ltd. 2018 1st Floor, Kensington Village, Avonmore Road, W14 8TS, London, UK.

ALSO AVAILABLE

ALSO AVAILABLE

		,		
ų.				
	The Control of the Co			